KENNETH CLARK

Also by James Stourton

The Dictionary of Art (contributor)
Great Smaller Museums of Europe
Great Collectors of Our Time: Art Collecting Since 1945
The British as Art Collectors: From the Tudors to the Present
(with Charles Sebag-Montefiore)
Great Houses of London

JAMES STOURTON

KENNETH CLARK

LIFE, ART AND *CIVILISATION*

**WILLIAM
COLLINS**

William Collins
An imprint of HarperCollins*Publishers*
1 London Bridge Street
London SE1 9GF
WilliamCollinsBooks.com

First published in Great Britain by William Collins in 2016

2

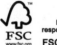

MIX
Paper from
responsible sources
FSC C007454

To Colette, Jane and Fram

Contents

WORLD WAR II

ARTS PANJANDRUM

TELEVISION

SALTWOOD 1953–68

CIVILISATION

Illustrations

Unless otherwise stated, images are from the Clark family archives.

Sudbourne Hall, Suffolk.

Kenneth Mackenzie Clark the elder.

Clark as a child in Suffolk.

Miss Lamont ('Lam'), Clark's childhood governess.

William Strang, *Portrait of Charles Francis Bell*, 1913. © Ashmolean Museum, University of Oxford.

Maurice Bowra, 1958. © National Portrait Gallery, London.

Clark in the Gryphon Club, Oxford, 1925.

Bernard Berenson and Nicky Mariano.

Jane Clark, photographed by Man Ray. © Man Ray Trust/ADAGP, Paris and DACS, London 2016.

Clark circa 1941.

Clark, King George V and Queen Mary leaving the National Gallery, 25 March 1934.

Bellevue, on Philip Sassoon's Port Lympne estate.

Graham Sutherland, John Piper, Henry Moore and Clark. Reproduced by permission of The Henry Moore Foundation.

John Piper at Fawley Bottom. © Bill Brandt Archive.

Clark enjoys a bibulous train journey to Leeds with Henry Moore, Myfanwy Piper and Colin Anderson.

Alan and Colette, with Tor. Photograph by Douglas Glass.

Upton House in Tetbury Upton, Gloucestershire.

Van Dyck stuck under a bridge, heading for the Manod Caves. © National Portrait Gallery, London.

Queues for a wartime concert at the National Gallery. © National Portrait Gallery, London.

Clark conducting Leopold Mozart's Toy Symphony at a National Gallery concert on New Year's Day 1940.

Clark and Jane at home at Upper Terrace House, Hampstead.

Seurat, Cézanne and Renoir in the sitting room at Upper Terrace.

Colin Anderson and Henry Moore with Clark, Jane and Colin.

Clark's muse and confidante, Janet Stone.

Clark speaking at the inaugural banquet for independent television at the Guildhall, 22 September 1955. © TopFoto.

Clark at Saltwood. Photo by Terence Spencer/The LIFE Images Collection/Getty Images.

Clark in the study at Saltwood. Photo by Terence Spencer/The LIFE Images Collection/Getty Images.

Filming the opening scene of *Civilisation*. © BBC Photo Library.

Clark in the great hall at Saltwood. Photo by Terence Spencer/The LIFE Images Collection/Getty Images.

Clark with Nolwen at the Garden House, Saltwood.

Nolwen's château, Parfondeval, Normandy. © Guillaume de Rougemont.

Clark filming *In the Beginning* in Egypt, November 1974.

The drawing by John Betjeman on page 195 is from *John Betjeman: Letters, Vol I: 1926–1951*, edited by Candida Lycett Green. Reproduced by permission of Methuen Publishing Limited.

While every effort has been made to trace copyright holders and to obtain their permission for the use of copyright material, the author and publisher would be grateful to be notified of any errors or omissions in the above list that can be rectified in future editions of this book.

Foreword

In his memoirs Kenneth Clark complained that Harold Nicolson 'could not resist shampooing' his account of a dinner party, and added the warning that 'the historian who uses "original documents" must have a built in lie-detector'.[1] This is equally true of published material. Clark's own two volumes of memoirs are exceptionally entertaining, and are both friend and foe to the biographer. Friend, because they cover most of Clark's life and tell his story more beautifully than any biographer ever could; foe, because Clark wrote them mainly from memory, which was not always reliable – and sometimes verged on the mytho-poetic. Every event needs to be checked against alternative sources; the chronology is loose, and Clark occasionally puts himself at events at which he was demonstrably not present. This was not deliberate on his part, but simply due to the passage of time. The memoirs tell many good stories, although I have reproduced only a tiny handful of them, as they are usually about other people. Since Clark's own voice is always eloquent I quote him whenever possible; where he has written an alternative and usually earlier account of an event, I have used this for a fresh perspective. An example is the manuscript containing fragments of an art-historical autobiography that he wrote at the end of his life, *Aesthete's Progress*, now in his publisher John Murray's London archive.

Clark did have an eye to history; he kept all his letters to his parents, and rarely threw anything out, even occasionally annotating documents in his own archives. The Clark Archive held at Tate Britain is of a daunting scale, with thousands of letters and documents full of biographical treasures. Clark, however, offered a second warning to a would-be biographer: 'One realises how little the historian, who must rely on letters and similar documents, can convey a personality. So much depends on the accident of whether or not a character can get himself into his letters.'[2] Clark had a famous dislike of both receiving and writing letters, and whenever he

could he would dictate them to an assistant. He was too busy to put art into them, but even the briefest will contain a striking phrase; he was incapable of writing a dull sentence. The majority of the letters quoted here are from carbon copies retained by Clark's various assistants for reference. I have altered Clark's pervasive use of ampersand to 'and', for reasons of flow. Quotations from the Berenson–Clark letters are taken from the excellent Yale edition edited by Robert Cumming.

For the second half of Kenneth Clark's life we have the astonishing series of letters that he wrote to Janet Stone, which provide a vivid self-portrait, and offer a depth and nuance hitherto unavailable. In these letters his true unbuttoned character is displayed – they were a safety valve, just as a diary was to Pepys or a wartime journal to Lord Alanbrooke. It is tempting to compare these letters to his son Alan's diaries, but their motivation – beyond the love of writing – was different. The letters to Janet Stone are held at the Bodleian Library in Oxford under a thirty-year moratorium (for reasons explained on page 396). Fortunately, when Dr Fram Dinshaw of St Catherine's College, Oxford, was appointed to be the original authorised biographer of Kenneth Clark in the 1980s, he was given permission by Janet Stone to read them. All the Stone letters I quote are from Dr Dinshaw's selected transcriptions.

The biographer of Kenneth Clark is fortunate that both his sons, Alan and Colin, left behind such compelling accounts of their parents. I was equally fortunate in having his daughter Colette, and daughter-in-law Jane, ready to answer questions, and I put it on record that neither of them has at any time attempted to alter anything I have written apart from correcting factual errors. I am lucky to have known some of the main players in the story, John and Myfanwy Piper and Reynolds and Janet Stone, which makes it easier to understand why Clark found them so attractive, and their houses such blessed plots. Virtually all the crew of *Civilisation* are alive and were able to give me interviews except for Michael Gill, who I met before his death, but alas before I knew I would be so concerned with his story. Perhaps the greatest surprise of all was to find Clark's favourite television producer from his ATV days in the late 1950s and early 1960s, Michael Redington, not only alive and well but living just three streets away from me in Westminster.

A word on nomenclature: Clark was always known as 'K' by family and friends. In 1938 he became Sir Kenneth Clark, and in 1969 he was given a peerage and became Lord Clark of Saltwood – but I refer to him throughout as 'Clark'.

Clark studies will continue to produce new interpretations and information. This work must be seen as 'notes towards a definition' – space restricted me on nearly every subject covered – and it should be taken as an encouragement to other scholars to investigate his life and achievements further.

JAMES STOURTON
London, 2016

1

'K'

Everything about Lord Clark is unexpected.

ANTHONY POWELL, reviewing *Another Part of the Wood*[1]

At 12 noon on Sunday, 25 March 1934, King George V and Queen Mary climbed the steps of the National Gallery in London. It was the first time a reigning monarch had visited the gallery. The ostensible reason for the visit was to see the gallery's collection of paintings, but the real purpose was to meet the new thirty-year-old director, Kenneth Clark. The trustees had been told not to disturb their weekend – a gentle instruction that their presence was not required – the King wished to see the director. Clark had only been at the gallery for three months, and his appointment had been greeted with universal approval – except at Windsor Castle. The King and Queen had been advised two years earlier by Owen Morshead, the Royal Librarian, that Clark would be the perfect candidate for the anticipated vacancy of Surveyor of the King's Pictures. But Clark neither wanted the job nor felt that he could possibly combine it with his heavy duties as director of the National Gallery. The sixty-nine-year-old King Emperor, in an extraordinary move, decided that he would directly intervene and go down to Trafalgar Square to invite the young man to work for him. He had resolved that Clark was the man he wanted, and where his courtiers had failed, he would persuade him personally. The visit was a success, and the two men – as different as can be – found much to enjoy together. Clark later described how just after proclaiming that Turner was mad, the King 'stopped his routine progress, faced me and said':

'Why won't you come and work for me?'

'Because I wouldn't have time to do the job properly.'

The King snorted with benevolent rage: 'What is there to do?'

'Well, sir, the pictures need looking after.'

'There's nothing wrong with them.'

'And people write letters asking for information about them.'

'Don't answer them. *I want you to take the job.*'[2]

There is no other recorded occasion of George V making such an effort – for instance, he never visited Downing Street – let alone for a thirty-year-old aesthete whose interests were as far as can be imagined from those of a gruff, pheasant-shooting, philistine sailor King. What was it about Kenneth Clark that made him so ardent? Clark had already had a similar effect on a series of distinguished elders, who all seem to have believed that they had discovered him: Monty Rendall, his headmaster at Winchester; Charles Bell, the keeper at the Ashmolean Museum at Oxford; Maurice Bowra, the Warden of Wadham College; Bernard Berenson, the most famous connoisseur in the world; and Sir Philip Sassoon, the chairman of the National Gallery. He was a *Wunderkind* from a brilliant generation of Oxford undergraduates; everybody recognised from the beginning that he would achieve great things (so often a recipe for lassitude in later life). Intelligence, charm and charisma played an important part in his story, but he was not alone in possessing these. What set him apart was his focus and complete absorption in art at a time when – artists aside – this was a singular quality. And he brought to this absorption an unusually synthetic power of analysis, expressed in a supple prose style that was able to fuse thought and feeling.

Early in life Clark discovered a sensibility to works of beauty: 'Ever since I can remember, that is to say from about the age of seven, the combination of certain words, or sounds or forms has given me a peculiar pleasure, unlike anything else in my experience.'[3] He called it 'a freak aptitude', and told a friend, 'What is certain is that without it I would have been no more than an obscure and timid playboy.'[4] This love of art in all its forms sustained him, and in one of the characteristically teasing yet self-revealing passages of his autobiography he remarked: 'A strong, catholic approach to works of art is like a comfortable Swiss Bank … I never doubted the infallibility of my judgements … This almost insane self-confidence lasted until a few years ago, and the odd thing is how many people have accepted my judgements. My whole life has been a harmless confidence trick.'[5] The confidence of youth was followed by the doubt of age.

Self-doubt is the last quality that anybody meeting Clark for the first time would have suspected. Most people were terrified of him and feared being snubbed, an attitude that baffled Clark himself, who was always

expected to be one thing but was invariably something else. A folklore grew up around him – 'impossibly, implausibly, supernaturally debonair'; 'delicately poised between diffidence and disdain'; 'a tranquil ruthlessness'; 'he measured people and turned on an appropriate amount of charm' – were all opinions offered about Clark. Most descriptions refer back to his solitary and protected childhood. His introversion suggested to many that he possessed no 'radar', or much perception of other people's feelings; he could appear self-absorbed, and often cut people without even realising it. Yet those who worked for him – cooks and secretaries adored him – found him easy, and even cosy. There was a private Clark and a public Clark, one funny and warm, the other formal.

As Anthony Powell suggested, everything about Clark was surprising – he might have added contradictory and paradoxical: the writer who loved action, the scholar who became a populariser, the socialist who lived in a castle, the committee man who despised the establishment, the inde-fatigable self-deprecator whom many found arrogant, the shy man who loved monsters, the 'ruthless' man who hated confrontation, the brilliantly successful man who considered himself as a failure, the mandarin who had a passion for lemonade and ice cream. The impenetrably smooth performer had a highly emotional side, weeping in front of works of art and subject to spiritual and religious experiences. Graham Sutherland, who knew him as well as anybody, and lived in his house during the war, said: 'of course K is a divided man … & of all my friends the most complex'. Behind all this was a mania for independence – never wishing to be caught or identified with any group except artists. As one confidante put it, 'He was nervous of contamination.'[6]

There are many Kenneth Clarks to describe: the museum director, the courtier, the darling of society, the Leonardo expert, the man of action, the wartime publicist, the would-be contemplative scholar, the lecturer and journalist, the administrator and the professor, the television mogul and performer, the public intellectual, the non-academic art historian, the collector, the patron, the committee man, the conservationist, the family man and the lover – the sum of the man is equal to the parts. Describing Clark's apparently detached progress through life, his younger son Colin thought that parents, schooling, wife, child and art all just flowed by like interesting scenery, and his father was scarcely aware that 'there were other human beings on the planet until he was about twenty-eight years old'.[7] Worldly or unworldly, Clark expected to go onto boards and for women to fall in love with him. It did not seem odd to him that he was offered the

chairmanship of the Independent Television board without ever having owned a television.

An appetite for public service, born out of the ethos of Winchester, informed Clark's life; a belief that the elite justified their position through *pro bono* public works. What was unique about him was his position, through which the creative and academic worlds met those of power and influence. As early as 1959 the *Sunday Times* thought that 'It will be difficult to write the definitive history of England in the twentieth century without some reference, somewhere, to Sir Kenneth McKenzie Clark.'[8] His role in public life, broadcasting apart, is less obvious to us today; the evidence lies in the minutes of meetings preserved in archives such as Bournemouth (the Independent Broadcasting Authority) and Kew (the Ministry of Information). There are, however, the astonishing outcomes: his hand helped build and guide arts institutions that we all take for granted today: the Arts Council, the Royal Opera House, Independent Television, the National Theatre and countless others. Everybody agreed that his writ ran everywhere: 'K Clark doesn't think much of it' was a knockout blow in debate.[9] His success on committees was based on an exceptionally careful reading of the papers, an acute analysis of the options, and a well-thought-out response. He would rarely be the first to speak, and waited to be asked his opinion, which was usually the one that counted. Everybody wanted to know what Clark thought. This was rarely predictable, and in writing this biography I have found that it was impossible to be sure what Clark would think on any subject. Anita Brookner wrote of the 'unshakeable fairness of outlook [which] may have been his most extraordinary achievement'.[10] Clark, however, rarely looked back with satisfaction, and even had a sense of disappointment with his contribution to most of the institutions and boards he joined – except for Covent Garden and the Scottish National Gallery.

What is certain is that Clark never wasted a minute more than he wanted to with people, subjects or institutions. He was extraordinarily disciplined with his time. Everything was timetabled – even friendship and love affairs. He was a master of disengagement. His only relaxation was to write, and what a master of prose he was. If his books are still read today, it is as much as anything because of the pleasure of reading about art described in such beautiful language. Books, lectures, essays and letters poured from his pen in those snatched moments when he was not engaged in public life. The constant question I asked myself while writing this book was, how on earth did he manage to do it all?

Clark always portrayed himself as something of a loner; he honed his lecturing skills as a child, soliloquising on country walks. But he needed an audience; he was a natural teacher who could make any subject interesting. When he was not lecturing to the public, his audience was invariably female – Clark was always most at ease with women. His greatest pleasure in life was to share his interests with a woman. The first of these was his wife Jane. What an extraordinary figure she was: moody, mercurial, expansive, generous, clever, rash, destructive, fascinating, pathetic and magnificent. No single description could ever remotely describe Jane, who Clark needed as ivy needs oak. Her unusual powers of sympathy were exercised on everyone from Margot Fonteyn to the station porters at Sandling, and were matched at home by a shrew-like anger of astonishing force. She is the key to understanding Clark – she was to support him and persecute him, and this cycle was the pattern of their life together. Clark and women are inseparable – they fascinated him, and he made the second half of his life unusually complicated by a series of *amitiés amoureuses*. But Jane was the greatest love affair of his life, however strange this may appear as the story unfolds.

Clark's sharpest critics were drawn from his own profession. As the *Burlington Magazine* pointed out: 'It has become almost a habit, among a very small minority, to sneer at Clark's lifestyle.'[11] The fact that he lived in a castle made him an irresistible target, and so did his inability to fit into the world of professional art history. With notable exceptions such as Ernst Gombrich and John Pope-Hennessy, his professional peers increasingly viewed him from the 1960s onwards as a non-academic television presenter and literary figure. He did himself no favours by once comparing their scholarly minutiae to knitting. But to the world beyond the Courtauld Institute of Art, whether highbrow or middlebrow, Clark came to represent the popular idea of an art historian. He became an emblem of art and culture to the public. Clark's own hero in this endeavour was the great nineteenth-century writer and thinker John Ruskin. His debt to Ruskin can never be sufficiently emphasised, and it informed many of his interests: the Gothic Revival, J.M.W. Turner, socialism, and the belief that art criticism can be a branch of literature. But above all, Ruskin taught Clark that art and beauty are everyone's birthright – and he took that message into the twentieth century. This is the central point of Kenneth Clark's achievement.

2

Edwardian Childhood

I have been reading … your memoirs. What a strange and
lonely childhood – a psychologist's dream.

DAVID KNOWLES to Kenneth Clark,
27 August 1973[1]

Kenneth Clark's autobiography has one of the most memorable openings in the language: 'My parents belonged to a section of society known as "the idle rich", and although, in that golden age, many people were richer, there can have been few who were idler.' His account of his *belle époque* childhood is a minor masterpiece, both subtle and comprehensive. There are virtually no other sources to challenge its veracity, nor is there any reason to doubt its essential truth; despite lapses, Clark had extraordinary recall, not only for events, but also of his feelings and awakenings. Perhaps in this, as in so much of his life, he was following John Ruskin, whose own autobiography *Praeterita* told the story of the making of an aesthete. Like Ruskin, Clark was an only child, one who was exceptionally sensitive to the visual world and for whom the act of recollection was a reconstruction of his inner life. He was to paint an elegiac picture of his childhood, and even the parts he found distasteful (such as the pheasant shoots) are described with a poetic eye.

When Clark described his childhood he frequently changed his point of view. His children believed that he was unhappy, the victim of dysfunctional parents. His younger son, Colin, summed it up: 'My father felt very strongly that his parents had neglected him. He thought of his father as a greedy, reckless drunk and always described his mother as selfish and lazy.'[2] Yet to others, Clark painted a sunny picture of solitary bliss.[3] Both positions can be demonstrated to be true; there were moments of great happiness, and periods of melancholy solitude. It was by any standards a

peculiar upbringing. What is perhaps most striking is that young Kenneth had no friends of his own age to play with, and in consequence never learned to relate to other children. Even in infancy he started to build around himself the carapace that Henry Moore later called his 'glass wall'.

'I am the type of local boy makes good,' Clark once wrote to his friend Lord Crawford, 'like Cecil Beaton as opposed to the Sitwells.'[4] As he came from an extremely privileged background, and was educated at Winchester and Oxford, this statement might seem puzzling, but there is a truth behind it. The Clark family were in the mezzanine floor of English society – no longer trade, landed but not gentry. They played no part in traditional county social life, and drew their friends from a raffish band of Scottish industrialists, entertainers and shooting boon companions. Clark was brought up with none of the hereditary culture of the Sitwells. His parents were without any intellectual interests, and he could justifiably see himself as self-created. In practice what his parents failed to provide he sought elsewhere, and few young men have attracted so many mentors or used them to such good effect.

'Family history has very little charm for me,' Clark told his biographer. 'I find I always skip the first ten pages of a biography.'[5] He dismissed his own in about five lines. But the Clark family story in Paisley was very remarkable. Paisley, today a suburb of Glasgow, was effectively a company town of the cotton industry, and was dominated by the Clark family. After Clark's great-great-great-great-grandfather William Clark, a farmer at Dykebar, died in 1753, his widow had moved with her children to nearby Paisley, where her son James (1747–1829) started a business as a weaver's furnisher and heddle twine manufacturer. The shortages of imports arising from the Napoleonic blockade stimulated the development of a new English cotton that was as smooth as silk, and Clark's son, another James (1783–1865), laid the foundations of the family fortune with the invention of the cotton spool. With his brothers he built the enormous factory that established Paisley as a world leader in manufacturing cotton thread. Paisley grew into a town of consequence, with grand public buildings presented by the Clarks and their commercial rivals, the Coats family: the town hall (Clark), infirmary (Clark), and art gallery and library (Coats) as well as schools and churches. By what Kenneth described as 'the not very exacting standards of the time' the Clarks were conscientious employers, and their philanthropy probably conditioned his belief that humanitarianism was the greatest discovery of the nineteenth century.[6]

In 1896 the family sold out to J&P Coats for the enormous sum of £2,585,913 (about £2.5 billion today). This fortune was divided between four family members, including Kenneth Mackenzie Clark (1868–1932), who was to become the father of Kenneth. Clark senior had been brought up in Paisley, and left school in Greenock at fourteen; according to his son he had a very good brain, although it was untrained and undisciplined. He was sent to Australia and New Zealand, and adored both, and on his return at the age of twenty-two he took up a position as a director of the family business. After two years it became evident that his love of sport and the bottle was distracting him; he was effectively sacked, and from that moment onwards devoted himself entirely to pleasure. His main occupation became building and racing yachts on the Clyde, naming three of them *Katoomba*, after the chief town of the Blue Mountains in New South Wales (his racing yacht was named *Kariad*). The family, as his son later explained, 'were big frogs in the small pool of Clyde yacht racing'. All through his life, Clark senior never cut his links with Paisley, and was always generous with charitable subscriptions: he was fondly remembered as the 'news-boys' friend', providing them with an annual outing and dinner.[7] He also never lost his Ayrshire accent.

Clark paints a rollicking portrait of his father as an independent-minded, self-indulgent 'roaring boy'. Attracted to women, he drank too much and delayed marriage until the age of thirty-five, when his choice fell upon Alice McArthur, a puritanical cousin who made it her unsuccessful mission to save him from his alcoholic excesses. Before she married, Alice had been living with her Quaker mother in Godalming, 'so different to the rowdy boozy world of Clyde yacht racing'.[8] 'Two more different people than my father and mother can hardly be imagined. He was convivial, natural, totally unself-conscious; she was shy, inhibited, and prone to self-deception. They were united by two qualities, intelligence and a total absence of snobbery'.[9]

Clark's father was a big man with a drooping moustache, who was burdened by no inhibitions and knew no boundaries. Clark was fond of his father but alarmed by him, and embarrassed by his drunkenness and bad behaviour. He found his mother by contrast cold and sharp, although he was aware that he had painted a particularly unfeeling portrait of her in his autobiography: 'I have been worried that the allusions to her in Vol 1 were incomplete. Her life was ruined by being in the wrong box. At the end of her life she reverted to being a shrewd, frugal Quakerish lady, living in a bedsitter. That suited her much better than [the family's Suffolk home]

Sudbourne, and she became quite peaceful.'[10] He claimed that she never held him as a child, which several photographs show to be untrue. She remains, however, a shadowy and rather mournful figure who only came into her own as a grandmother. Unfortunately, no letters survive from her until her son was eighteen – by which time she had belatedly discovered his genius.

'Like so many remarkable men he was the only son of two entirely opposite and incompatible parents,' Clark wrote in his obituary of Cyril Connolly, and he certainly saw himself in these terms.[11] Yet despite everything, his parents made a successful marriage, and remained devoted to each other. Theirs was an extraordinarily peripatetic existence. The Edwardian era is often portrayed as an earthly paradise for the rich, and no doubt it was to those who welcomed an uninterrupted social life. The Clarks, however, had no social ambitions, and were too eccentric to belong with comfort to any fixed society. They adopted the conventional habit of the rich and moved from house to house, but for them it was a stratagem to avoid rather than to meet polite society. Alice Clark found herself mistress of a house in Grosvenor Square, a large rented house in Perthshire, an even larger house and estate in Suffolk, two yachts, and soon an additional house at Cap Martin in the south of France. Their life became a progress dictated by the sporting calendar, but to the young Clark 'my home was Sudbourne Hall, about a mile from Orford in Suffolk'.[12] One remarkable aspect of Clark's childhood is how very well documented it was by good photographs. His father employed a professional photographer to take numerous pictures of all aspects of their life – Sudbourne Hall, the yachts, the shooting parties, and young Kenneth in many poses and costumes. All these are preserved at Saltwood, and suggest that Clark's parents were not as indifferent as he maintained.

Named after his grandfather, Kenneth McKenzie Clark was born at 32 Grosvenor Square in London on 13 July 1903. He was delivered by Caesarean section, which in those days meant that he would remain an only child. A year later his father acquired the eleven-thousand-acre Sudbourne estate for £237,500, with a mortgage of £75,000.[13] From what followed we may deduce that the purchase was made with his son in mind, and the expectation that the boy would grow up to enjoy the pleasures of a rich man's sporting estate. This was in fact as far as Clark senior's dynastic ambitions would ever go: Kenneth once came into his father's study at Sudbourne and found two men in black coats and striped trousers offering Clark senior the chance to buy a peerage – one of them was the notorious

Maundy Gregory, Lloyd George's chief agent in the sale of honours – 'Wouldn't you like this little chap to succeed you?' The response was 'Go to hell,' and the men drove off.[14] This encounter also tells us that the Clarks were in all probability supporters of the Liberal Party.

Even by expansive Edwardian standards the Sudbourne estate was large; it included a model farm and several well-ordered villages. The house was elegant but rather stark, 'one of Wyatt's typical East Anglian jobs, a large square brick box, with a frigid, neo-classical interior'.[15] It was built in 1784 for the first Marquess of Hertford, and had devolved on his colourful descendants, the triumvirate of art collectors who created the Wallace Collection. The eponymous Richard Wallace, the illegitimate Hertford heir, mainly used Sudbourne for its shooting, and on one occasion entertained the Prince of Wales, the future King Edward VII, there. Clark senior bought the estate in 1904 for the shooting, but found the house cold and uncomfortable, and consequently ordered a makeover. He and Alice went abroad, and returned to their newly minted 'Jacobethan' interior in richly carved walnut, which was probably a more suitable setting for their furnishings and paintings. Young Kenneth thought it was all in very poor taste, although he found the renovations more friendly than Wyatt's original interiors.

Clark's parents had few connections with the local social life of the county set. One of these was the Suffolk Show, at which his father would show his pigs and his prize collection of Suffolk Punch draught horses. These beautiful animals had their own special stables at Sudbourne, and would be brought out every Sunday morning and paraded on the lawn in front of the house before trotting home 'as complacent as Morris dancers'.[16] The main stables at the side of the house were refitted to hold the collection of motor cars: a Rolls-Royce, two Delaunay-Bellevilles and a Panhard, 'a quiet, insinuating electric car which had been intended for use in London'.

Clark senior was a well-intentioned if unconventional landlord, who built a cottage hospital in nearby Orford and allowed Coronation sports at the hall in 1911. His main preoccupation, however, was the pheasant shoot from October until the end of January; the Sudbourne shoot was one of very high numbers and low-flying birds. At first the young Clark enjoyed the shooting parties because they brought female visitors to the house, whom he would persuade to come to his bedroom for a beauty parade of their dresses, which he would judge with care and precision, evincing the first signs of the emerging aesthete. Then at the age of ten

Clark had a gun placed into his hands, and we have the recollection of Phyllis Ellis, a young girl on the estate, that 'Young Kenneth used to get very upset when all these birds were brought in – pheasants and ducks. They looked so beautiful in their winter plumage … He didn't like shooting – which, of course, annoyed his father.'[17] Sometimes as many as a thousand birds a day were shot, which sickened young Kenneth. He gave up shooting as early as he could – Phyllis tells us that after a time 'he would never go out with the shooting parties'.[18] Since this sport was the main point of Sudbourne, young Clark's reaction was particularly distressing to his father, and this is the earliest external evidence that Kenneth was not going to be a conventional boy of his background. Apart from the shoot, Sudbourne boasted a private cricket pitch and a fourteen-hole golf course, complete with a professional. Clark's father was too impatient to play a proper round of golf, but in his irresponsible way would encourage visitors to try to hit a ball over the house, causing the inevitable broken windows, which delighted him and pained his son. Phyllis Ellis reported that Alice Clark 'when alone would play golf on the private 14-hole course with the gamekeeper's wife'. She cuts a rather lonely figure.

One day when Clark was six his mother came to the nursery and caught his German governess scolding him. The governess was sent away the next morning and replaced by a Highland Scots woman, Miss Lamont, thereafter always known as 'Lam'. Lam was the daughter of a minister from Skye, but was not at all dour; she was a great giggler, with a naughty sense of humour, and above all she was affectionate and full of unsentimental goodness. Clark adored her, and for the first time he encountered uncritical love. 'The arrival of Lam,' he wrote, 'was the first of several pieces of human good fortune which have befallen me in my life.'[19] He always claimed that Lam saved him: 'At last I had someone whom I could love and depend on, and who even seemed to share my interests.'[20] Lam became his protector and companion. This remarkable woman spoke four languages, never married, and ended up, thanks to Clark's recommendation, as the housekeeper at Chequers, where she once remarked on the similarity between Clark senior and Mr Churchill.

At the end of January, when the shooting season was over, the Clark household would move by *wagon-lit* to the south of France, where one of the pleasure yachts would have sailed from the Clyde to await them in the harbour at Monte Carlo. His father loved the casino, but his mother found Monaco too socially demanding, and preferred the quieter pleasures of nearby Menton. One day a French woman who had joined them for lunch

on the *Katoomba* expressed the wish to own a yacht of such beauty. Clark senior saw his chance, and named an enormous price, which to everyone's surprise she accepted. The Clarks left their yacht the following day, and with the money Clark senior acquired a parcel of land near Menton on Cap Martin, where he employed the Danish architect Hans-Georg Tersling to build – using Scottish labour – a sturdy wedding cake of a villa in which the family would stay for three months of every year. Clark senior would gamble all day at the tables, where according to his son he had extraordinary luck that would fund extravagant purchases.* The Menton casino also put on early-evening shows for children, with conjurors, jugglers, acrobats, comedians and stuntmen, and through these entertainers the young Clark developed a desire to become an actor; he loved showing off his newly learned skills to his rather bored mother and her friends. In France, his mother's only occupation seems to have been directing the head gardener, who returned during the summer months to his native Pitlochry.

Clark claimed to have had no childhood friends on the Riviera, but Isobel Somerville, the daughter of the English vicar at Menton, remembers playing rounders with him; she also recalls his passion for parsley sandwiches. She was captivated by Lam, with her compassion, her sense of the ridiculous and her exhortations to her charge – 'Kenneth, don't be silly.' She remembers Lam bringing 'her fabulously rich employers to Menton, each in turn. When she went to the Churchills, because we got no gossip whatever out of her, we changed her name into "Damn-clam-Lam".'[21]

Perhaps the first indication of Clark's remarkable gift for engaging the affection of distinguished friends and mentors is his improbable attachment to the Empress Eugénie, the elderly widow of Napoleon III, a neighbour who would allow him to accompany her as she took her morning walks. Otherwise the rather sedate life of the Riviera was punctuated for the small boy with carnivals and flower festivals which brought colour and a welcome vulgarity.

When his parents left Menton in April for a cure at Carlsbad or Vichy, young Clark would be sent back to Sudbourne – which was a mixed pleas-

* Clark senior bought the Imperial Hotel in Menton with his winnings. On another occasion he acquired a golf course at Sospel and built a large, ugly hotel on it, also designed by Tersling, which he later gave to his son. Curiously, the art historian R. Langton Douglas and Sotheby's chairman Geoffrey Hobson were partners in the golf course. (Information from the late Anthony Hobson.)

ure. With his parents away he found himself looked after by resentful servants, whom he accused in his memoirs of taking out their malice on him by serving him rotten food.*

But there were also enormous compensations to life at Sudbourne. His favourite room was the library, the heart of the house, still filled with books left by the previous owner. Clark learned to read late, from an illustrated manual called *Reading Without Tears* in which each letter was represented by a pictogram. He read all the standard Edwardian children's classics, but claimed that one series of books 'influenced my character more than anything I have read since'. This was the illustrated adventures of 'Golliwogg' by Florence and Bertha Upton.[22] Golliwogg, as Clark explained, lives on terms of perfect happiness with five girls. He always treats them with the greatest courtesy, and they share his adventures. Their role is to admire him, and when things go wrong they rescue and console him. 'He was for me an example of chivalry far more persuasive than the unconvincing Knights of the Arthurian legend,' wrote Clark, who added the frank admission, 'I identify myself with him completely and have never quite ceased to do so.'[23] Indeed, he was to spend the second half of his life enjoying carefully managed relationships with a number of women at the same time, and their role would be to appreciate and console him in a not dissimilar fashion.

Meanwhile in his nursery the solitary Clark enjoyed constructing elaborate Classical buildings with his bricks, and putting on performances with his circus figures *à la Menton*. 'When my parents departed for Cap Martin and Vichy, I was left to my own devices,' he wrote. 'I was an only child and should have felt lonely, but in fact I do not remember suffering any inconvenience from solitude. On the contrary, I remember with fear and loathing the rare occasions when some well-wishing grown-up arranged for me to meet companions of my own age.'[24] When other children did appear he found that he had little in common with them. Nor did he expect them to share his interests, thus nurturing a personal exceptionalism from an early age. He rejoiced when they left, and 'returned with relief to my bears, my bricks, or at a later date, my billiard table'.[25] All his life he would be pleased when guests had departed, and he believed that

* His friend Joan Drogheda wrote to complain about this passage in his memoirs, stating that most servants did not treat children in the way he claimed, nor were they resentful of their employers, and that he had 'struck the wrong note'. Letter from Lady Drogheda, 19 February 1972 (Tate 8812/1/4/36).

his early solitude 'made me absolutely incapable of any collective activity. I cannot belong to a group.'[26] He tended to exaggerate this point: in fact he was to demonstrate an unending capacity for collegiate activity by serving on numerous committees throughout his career, from the war onwards. His solitary childhood did make him shy – except with grown-ups – but it also helped to develop his sensitive perception of works of art.

Perhaps a greater enemy than loneliness to a solitary child might have been boredom. But Clark was at pains to dispel any such notion: 'my days were all pleasure. Most children suffer from boredom, but I do not remember a dull moment at Sudbourne. I loved the Suffolk country, the heaths and sandpits, the great oaks in Sudbourne wood, the wide river at Iken.'[27] Equally, he could write: 'in family life the enemy of happiness is not oppression, but boredom, and against this the unfortunate parents are almost powerless'.[28] All his life Clark was frightened of boredom – an important consideration in his attitude to other people. To most observers he displayed a very low boredom threshold; he was always allergic to bores, and was terrified of becoming one himself in his lectures or television programmes.

The large eighteenth-century Sudbourne Hall was opulent, and its estate well-tended, but down the road was romantic Iken on the Alde estuary, with its isolated thatched Saxon church of St Botolph. Clark would be taken there by horse and cart to go shrimping, and it was to remain a magical spot for him: 'I found that the delicate music of the Suffolk coast, with its woods straggling into sandy commons, its lonely marshes and estuaries full of small boats, still had more charm for me than the great brass bands of natural scenery, the Alps or the Dolomites.'[29] It was here, in a cove on the edge of the River Alde, that Clark was painted by Charles Sims, the first artist he befriended. He had already had his portrait painted by Sir John Lavery in the manner of Velázquez (which he described, using Maurice Bowra's favourite term of praise, as 'by no means bad'). Clark thought the Sims portrait lacked freshness, but the choice of setting on the Alde estuary is important. He would return there all his life, and at nearby Aldeburgh on the coast he would write his best books. When in later years he formed a close friendship with Benjamin Britten and Peter Pears, he became an early champion of the Aldeburgh Festival and helped establish its reputation.

In London the family had given up the house in Grosvenor Square where young Clark had been born, and rented a flat in Berkeley Square. 'We never stayed in London for long,' wrote Clark, 'because my mother

thought, and rightly, that my father would get into trouble; but I enjoyed these visits because it meant going to the theatre.'[30] He was taken to see all the famous Edwardian actors: Squire Bancroft, Gerald du Maurier, and his favourite, Charles Hawtrey. His mother may have watched her husband like a hawk in London, but he was allowed to take young Kenneth to the music hall; Clark senior kept boxes at the Empire and the Alhambra theatres. As a result the young Clark stored a repertoire of music-hall songs in his head, which would emerge in later life to the surprise of his friends.*

In 1910 Lam took Clark to see the great exhibition of Japanese art at White City. It was one of the most formative moments of his childhood. There he saw life-sized dioramas representing various scenes and settings of Japan, but it was the screens that made the greatest impression, 'with paintings of flowers of such ravishing beauty that I was not only struck dumb with delight, I felt that I had entered a new world'.[31] He realised that something had happened to him. This aesthetic awakening marked the birth of his 'freak aptitude'. The following Christmas his grandmother gave him a picture book of the Louvre, which was his first introduction to the Old Masters. The images fascinated him, and he found himself similarly enchanted. However, when he showed her his favourite plate, Titian's *Concert Champêtre* (then attributed to Giorgione), her only comment was, 'Oh dear, it's very nude' – which was probably the first time he encountered the word.

In fact, paintings surrounded the young Clark at Sudbourne. His father was a voracious buyer of pictures of the Highland cattle variety, although occasionally he bought something more interesting, such as Millais' *Murthley Moss*, a Corot or a Barbizon School landscape. In general, however, he enjoyed the high polish and sentimentality of Jozef Israëls' *Pancake Day*, Rosa Bonheur's *Highland Cattle* and William Orchardson's *Story of a Life*. This was what his son called 'a coarse diet for a growing aesthete', but he came to believe that those who had grown up with too much good taste were less capable in later life of a catholic response to works of art. 'It is no accident,' he wrote about Ruskin, 'that the three or four Englishmen whose appreciation of art has been strong enough and perceptive enough to penetrate the normal callosity of their countrymen – Hazlitt, Ruskin, Roger Fry – have all come from philistine, puritanical

* It would also provide a mutual interest with Val Parnell and Lew Grade when Clark was chairman of ITV. Their background was in music hall and variety.

homes. To be brought up in an atmosphere of good taste is to have the hunger for art satisfied at too early an age, and to think of it as a pleasant amenity rather than an urgent need.'[32]

Clark senior enjoyed the company of artists. No doubt they appealed to him as living outside the conventions of the day, and he befriended several, including Sims and Orchardson. He encouraged his son's interest in them, and the boy's ambitions did indeed change from acting to painting. His father even allowed him to rehang the smaller pictures at Sudbourne on a regular basis, developing a skill that would one day help to make the National Gallery in London one of the most carefully hung picture galleries in the world. And on young Clark's twelfth birthday his father, presumably remembering his son's rapturous tales of his visit with Lam to White City, gave Kenneth a scrapbook, put together around 1830 by a Japanese collector, containing drawings and prints from the circle of Hokusai; a wonderful treasure which he still owned at the end of his life, and one that fed young Clark's growing passion.

Each summer the family would make the long train journey to Ross-shire for the fishing. They would spend a night at the North British Hotel in Edinburgh, where his father would invariably get very drunk and have to be fetched by his son from a sofa in the main lounge and helped upstairs muttering, 'It's a hard road for an old dog.' Young Clark hated the holidays in the Scottish Highlands, and his heart sank at the thought of the thread-bare comforts the house there offered. He described the country around Loch Ewe as 'endless bogs, not an acre of cultivated land, persistent rain, followed by swarms of midges'.[33]

The British habit of sending their offspring away to boarding school at the age of seven or eight, which Clark abhorred (but repeated with his own children), was, he believed, 'maintained solely in order that parents could get their children out of the house'.[34] His parents' choice of preparatory school was Wixenford, a fashionable school in Hampshire. Like most schools of its type, Wixenford was faintly ridiculous, and Clark probably made the place sound even more ridiculous than it actually was, with shades of Llanabba Castle, the school from Evelyn Waugh's *Decline and Fall*. Wixenford was a feeder for Eton, and in Clark's description expended more effort on entertaining parents than educating children. It was housed in mock-Tudor buildings and had a very pretty garden, 'leading to an avenue of pleached limes, under which, it was alleged, school meals were served in the summer term'.[35] Lord Curzon was an alumnus, and the pupils

were the children of the upper classes and of American and South African millionaires.

By the standards of the time Wixenford was an easy-going and benign establishment, whose staff Clark characterised as a 'pathetic group of misfits and boozy cynics'. The only master with whom he had any kind of rapport was the art master, G.L. Thompson – known as 'Tompy' – who introduced him to the drawing methods of the Paris art schools of the 1850s. Wixenford encouraged the boys to put on theatrical productions and write for the school magazines, and Clark did both. He staged a revue incorporating all his favourite music-hall songs. Harold Acton, the future leader of the Oxford aesthetes, was a contemporary at Wixenford. He edited a magazine, and it was probably for him that Clark produced his first literary effort, an article entitled 'Milk and Biscuits' (which referred to those breaks added to the school's curriculum, so Clark argued, in order to please the parents). Acton in his memoirs remembered Clark as a mature prodigy, 'walking with benign assurance in our midst, an embryo archbishop or Cabinet Minister', and mischievously added, 'Since those days he seems to have grown much younger.'[36] Wixenford provided one revelation for Clark. The 'school dance was the first time I had met girls and I was enchanted beyond words, not by anything tangible, but the aura of femininity. *Incipit vita nova*.'*[37] For good and ill, this enchantment would remain with him for the rest of his life. He enjoyed his days at Wixenford, and was described in his leaving report as 'a jolly boy' – a description that would be beaten out of him at Winchester.

When Clark looked back on his childhood world of Edwardian England he described it as a vulgar, disgraceful, overfed, godless social order, but admitted that he had enjoyed it. He also allowed that the period was a golden age of creativity: 'Well it always seems to me that there was a great deal to be said for living between 1900 and 1914, because it wasn't simply the age of the Edwardian plutocrat; it was also the age of the Fabians, of extremely intelligent people like Shaw and Wells. It was the age of the Russian Ballet. It was the age of Proust. It was the age of Picasso, Braque and Matisse. In fact almost everything I enjoy in what is called modern civilisation was in fact evolved before 1916. I do think the 1914 war was the great turning point in European civilisation.'[38] When he came to tell the story of *Civilisation* on television he ended his account in 1914.

* 'Thus begins a new life.'

3

Winchester

Winchester helped to open for me the doors of perception.

KENNETH CLARK, *Another Part of the Wood*[1]

Winchester was a curious choice of public school for Clark's parents, and is perhaps best understood in negative terms: it was not Eton or Harrow. Clark senior had a horror of the nobility, who – as he liked to point out – only ever wrote to ask him for something. He did not want his boy turning into a snob, and he and Alice would no doubt have felt uncomfortable at speech days – had they ever bothered to attend. The idea of sending Kenneth to Winchester almost certainly came from Wixenford. Even in an establishment so academically lax, it was recognised that the boy was exceptionally promising. His sponsor in the entry book at Winchester is given as P.H. Morton, Wixenford's headmaster. Kenneth was the only boy in his year to go to Winchester.

Winchester is one of the great schools of England, with a distinctive and cerebral reputation. Founded in 1382 by William of Wykeham, Bishop of Winchester, as a school for poor scholars, it maintained a standard of academic excellence that was daunting to all but the cleverest boys. Clark painted a miserable picture of the school in his early years there, but pointed out that 'All intellectuals complain about their schooldays. This is ridiculous.'[2] He believed that they tended 'to regard bullying and injustice as a personal attack on themselves, instead of the invariable condition of growing up in any society'.[3] Ridiculous or not, Clark certainly took bullying personally. An additional privation was the effect of arriving at the school in the middle of World War I, which meant little heat and very poor food. Clark, who all his life was mildly epicurean, suffered accordingly. He also missed the soothing feminine influences of Lam.

Like all English public schools, Winchester had its peculiar rites and customs, including a vernacular language called 'notions'. It was an academic hothouse, with a dual emphasis on studying the Classics and sporting achievements. When Clark was later honoured by the school in the *Ad Portas* ceremony, its highest honour, he said, 'Winchester was once famed for the uniformity of her sons: a uniform excellence, no doubt, but one obtained at the expense of individual fulfilment.' This was to be one of several hindrances he felt at Winchester, since his trajectory was not to follow the conventional Classics route to scholarly recognition. He chose instead to walk an individual path through the study of art and its history. Arriving from Wixenford poor in Latin and without Greek, he was under-rated during his early years at Winchester until Montague John Rendall, the school's unconventional headmaster, recognised his singularity.

The second problem Clark faced was his total unpreparedness for the tribal cruelties inflicted by older boys on younger ones. As a mollycoddled only child who had never experienced sibling rough-and-tumble, nor yet learned teenage cunning, the thirteen-year-old Clark was to experience probably the greatest trauma of his life in his first week at Winchester. He tells the story with some emotion in his autobiography. On the school train he addressed a handsome senior boy, who ignored him. The boy turned out to be the head prefect of his house, and on arrival at the school Clark was summoned to the library, where he was instructed to 'Sport an arse' – i.e. bend over – and received several painful strokes of a cane for his bumptious behaviour in speaking to an elder. The prefect's children were later to become close friends of Clark's children, but he never revealed the story to them.

Tony Keswick,[4] who became Clark's closest friend at Winchester, recalled that first day at the school. The new boys for the 1917 spring term had arrived on an early train, been abandoned and got over their tears. He and Clark were beginning tentatively to make friends when the main school train arrived. There was a tremendous cacophony of voices, at which point 'a river, an avalanche of boys poured in'. Clark turned to Keswick and said, 'This is dreadful, isn't it?' Keswick agreed, and later said, 'It's the most vivid memory I have of him.'[5] Clark's torments were only just beginning. On the second evening Clark encountered a prefect who was an artist, and rashly offered an opinion on his work. 'Bloody little new man. Think you know all about art. Sport an arse.' In addition to these beatings, Clark found himself regularly cleaning fourteen pairs of prefects' shoes. 'In the twinkling of an eye,' as he put it, 'the jolly boy from Wixenford

became a silent, solitary, inward-turning but still imperfect Wykehamist.'[6] The traumas of his first week at Winchester gave him a bruise from which he never fully recovered, and a lifelong horror of upper-class tribalism.

The school was divided into ten 'houses' of about thirty boys each, and Clark was placed in the house of Herbert Aris, known as 'the Hake', with whom he had no understanding or sympathy. Houses were remarkably individual, and took their character from the nature of the housemaster. Aris was Clark's housemaster for three years, until 1920, when he retired on his wife's money to a country estate and his place was taken by Horace Jackson, 'the Jacker'. The house still stands as it did in Clark's day; a line of small brick houses at 69 Kingsgate Street, pleasant cottage architecture with internal panelling. Aris – whose motto appears to have been 'Go hard, go hard' – wanted to make a man of Clark, who describes in his autobiography how Aris encouraged him to learn boxing, and exclaimed, 'I want to see that big head knocked about.'[7] After a few weeks he asked Clark how he was getting on. 'I am enjoying it sir.' Aris was furious: 'I don't want you to enjoy it, I want you to get hurt.' Clark wrote a witty dialogue entitled 'The Housemaster' reproducing this scene. It is the earliest surviving manuscript in the Saltwood archive, and it suggests a more humorous gloss, with Clark responding '(penitently & repressing tears – or is it laughter! – with difficulty) So sorry sir.'

Clark's portrait of Aris in his autobiography was of a small-minded sadist, but he records Mrs Aris as charming. Their son, John Aris, later wrote to Clark remembering his mother lending him a book on Ruskin (which Clark acknowledged had a crucial influence on his life) and allowing him to play her piano. He added, 'You might be right about my father as a schoolmaster, though your contemporaries would not all agree ... He was not unkind but he was a man of rather simple austerity, and I believe he was then preoccupied with those who went from Winchester to France [i.e. to war]. I hope you have not misjudged him.'[8]

Clark's second housemaster, 'the Jacker', was something of a Winchester legend. A school manuscript describes him as 'a ferocious little man who didn't suffer fools – wounded in the war, he became an ardent militarist but he collected china and knew about woodcuts. He had many unlikeable qualities and was not by nature affectionate. It was said he was only interested in athletes.'[9] Despite their obvious differences, Clark thought he treated him very fairly. Jackson hated conceit. When someone towards the end of Clark's time at the school asked him what he was going to do afterwards, Clark answered, 'Help Mr Berenson to produce a new edition of

The Drawings of the Florentine Painters.' Jackson, whom he had not observed, remarked 'Bloody little prig.'[10] He was not the last to voice this sentiment. Equally often quoted, though probably misinterpreted, was the Jacker's remark when sitting between Clark and Keswick, whose father was a leading Hong Kong nabob, 'Never, never again will I have the son of a businessman in my House.'[11] In fact there were many such children in the house, and as Jackson's obituary stated, 'he could crack a joke, maybe with an edge to it'.

Like most clever and sensitive boys at school, Clark found refuges. The most important was 'the drawing school' or art room. On his third day he called on the art master, Mr Macdonald – 'a kindly, agreeable person but the laziest man I have ever known'. Winchester frowned upon extra-curricular activities, and Macdonald did not have many pupils, so it was probably with mixed feelings that he eyed the eager young student. Fortunately, Clark admired two prints by the Japanese artist Utamaro on the wall, and Macdonald invited him to 'come next Sunday, I have some more in those drawers'. Clark devoured the astonishing collection of prints by Utamaro, Hokusai and Kunyoshi – later, he was always to have Japanese prints in his own art collection. He had already resolved that he was going to be an artist, and this decision informed the rest of his time at Winchester. His Sunday afternoons with Mr Macdonald 'were among the happiest and most formative in my life. They confirmed my belief that nothing could destroy me as long as I could enjoy works of art.'[12]

Macdonald taught Clark to draw plaster casts of sculpture – a training, as he ruefully observed, that would be more useful to him later as an art historian – and each year he duly won the school drawing prize. The kind Mrs Aris showed him copies of *The Studio*, the bible of the Aesthetic Movement, and it was there that he encountered the work of Aubrey Beardsley, who together with the illustrator Charles Keene was the main influence on his drawing. Years later it was these two artists that Clark chose to lecture about at the Aldeburgh Festival. Several drawings survive in the Tate archive in the modish naughty nineties style of Beardsley, occasionally signed 'KCM', mostly male nude studies. Others show the cross-hatching manner of Keene. It was Mr Macdonald who introduced him to one of his later gods: 'I remember vividly the first moment at which my drawing master at school pulled out of a cupboard some photographs of Piero della Francesca's frescoes at Arezzo, then seldom reproduced in any book. Even upside down, as they emerged, I felt a shock of recognition.'[13]

Apart from the art room, Clark's other refuge was the school library. This had practically no art books except Richard Muther's monograph on Goya.[14] But it did contain the set of volumes that were to have the greatest influence on his life, *The Collected Works of John Ruskin* in the edition edited by Cook and Wedderburn (1903–12). 'I expected them to be about art. Instead they were about glaciers, and clouds, plants and crystals, political economy and morals.'[15] If the works of Roger Fry and Clive Bell were more contemporary and easier to read, the Ruskin volumes ignited a slow-burning flame that would last all his life. They profoundly influenced not just the way he looked at and described works of art, but also his political and social attitudes. Among his own books, Clark's favourite was to be his selection of the Victorian writer's work, *Ruskin Today*. Almost as important was his discovery of Walter Pater,* his writings on art and his story in *Imaginary Portraits* of the nihilistic young patrician 'Sebastian Van Storck', in whose 'refusal to do or be any definite thing I recognised a revelation of my own state of mind'.[16] Clark's unhappiness at school and rejection of the sporting life at Sudbourne fed these melancholic feelings. He was to be prone to *ennui* all his life, and in later years only action and work would enable him to overcome his fear of boredom.

At home during the holidays, the teenage Kenneth Clark was a withdrawn figure. To the annoyance of his father, he still refused to go out shooting. Phyllis Ellis described him at Sudbourne during this period: 'They also had a pianola in the billiard room. When young Kenneth came back from school, on holiday, we used to go through the pianola rolls. And he'd take me out in a boat on the lake. It was extraordinary, a boy of fourteen spending his time with a four-year-old girl, but he was always different from other people and perhaps, like me, a lonely child. He wasn't very happy at that time.'[17]

It was a great disappointment to his father that Kenneth was not interested in the shoot, and this, combined with the upheavals of the war, called into question the future of the estate. No doubt Clark's mother also longed to be free of the burden of organising house parties, and his father decided to put Sudbourne on the market in 1917. We can only imagine the distress felt by Clark's father at selling what he had spent so long creating. He almost sold the property to Walter Boynton, a timber-man who offered

* 'I read Walter Pater at Winchester but for some reason left this out of the autobiography, a disgraceful omission.' (BBC, 'Interview with Basil Taylor', 8 October 1974, British Library National Sound Archive, Disc 196.)

£170,000 but was unable to pay. The estate was therefore auctioned the following year in parcels, but most lots failed to find buyers. It was a disastrous time to sell, with a quarter of all English estates being for sale. Finally, in 1921, the industrialist Joseph Watson, shortly to become the first Baron Manton, stepped in and bought it with a reduced acreage for £86,000, representing a massive loss for the Clark family.*

The Clarks moved to Bath, where they remained for most of Kenneth's schooldays. His father would spend all day at the club playing bridge and billiards, but Kenneth could never fathom what his mother did, apart from visit antique shops. He became very fond of the city, and was unexpectedly to spend a school term there.† Perhaps surprisingly, he was a good sportsman – an improbably skilful bowler for the cricket team, and he even won a running prize. One day after a long run he was taken ill with pneumonia. So serious was his condition that he was removed from the school for a term. He was already showing signs of the hypochondria that dogged him for the rest of his life. Always liking to project himself as an autodidact, he described being ill as 'the only time at which I learnt anything of lasting value.'[18] He passed his days reading and playing Chopin on his pianola, and was later to view this period as crucial to his development: 'My mind was in a plastic condition, and for the last time I was able to remember a good deal of what I read.'[19] He was devouring English poetry of the seventeenth century, particularly Vaughan and Milton; Chinese poetry of the ninth century in Arthur Waley's translations; Ibsen, who taught him the complexities of human motivation; Samuel Butler, a different kind of scepticism; and of course Ruskin, 'whose *Unto This Last* was the most important book I ever read'. He also did most of his novel-reading at this period, enjoying the works of Anatole France, Joseph Conrad and Thomas Hardy.

The end of the war produced one extraordinary benefit without which no aesthetic education of the period was complete – the arrival in England of Diaghilev's Ballets Russes. 'It was an intoxication,' Clark wrote, 'even stronger than Beardsley.'[20] The sight of works such as *Scheherazade* and *The Firebird* was an escape from the dreary parochialism of school into a dream world. Who it was that took Clark to see the Ballets Russes is a

* Information supplied by the Orford Museum. Today Sudbourne Hall is gone, but the drive, converted stables, model farm and village remain. The trappings of Edwardian wealth are still evident, and the vast empty walled gardens, the cricket pitch and surviving outbuildings speak of the former scale of the establishment.

† In the 1960s Clark would become one of its leading defenders against developers.

mystery, but it may have been Victor 'Prendy' Prendergast, a slightly older boy in the same house. Clark described him as 'a great influence on my life at Winchester. He was a dyed in the wool aesthete and a Yellow Book character.'[21] They shared a mutual interest not only in ballet but also in modern art. Prendy must have been a sympathetic figure, but Clark lost sight of him at Oxford, and the Winchester old boys' register simply says he 'travelled and did literary work'.

If the Ballets Russes gave Clark his first taste of international modernism, this education continued at the modest London gallery that put on the first one-man show in England of just about every major European avant-garde artist, the Leicester Galleries. It was in these unpretentious surroundings, under the gentle guidance of its director Oliver Brown,[22] that Clark discovered the joys of collecting, at this time usually drawings under £5. When he was sixteen a godfather gave him £100 with which to buy a picture, and he was struck by an oil of a primitive-looking boy by an artist he had never heard of, Modigliani. He reserved it, but at the last minute – trying to imagine it hanging alongside his parents' Barbizon works – his courage failed him and he cancelled the purchase. As a testament to its quality, today it hangs in the Tate Gallery.

The man who more than any other was responsible for the transformation of Clark and his growing confidence at Winchester was the towering, eccentric, quixotic headmaster, Montague John Rendall. He was a Harrovian bachelor who devoted his life to the school, and whose old age was spent catching up on what old boys were doing from the newspapers. He is one of the greatest and most striking headmasters of his era, in the class of J.F. Roxburgh, the founder of Stowe. Monty Rendall responded to originality and cleverness in boys, and was the first person outside the family circle fully to recognise Clark's potential. Clark always spoke of him later with affection, claiming 'he saved me'.

What was Rendall like? Clark thought he combined the muscular Christianity of Charles Kingsley with the aestheticism of the pre-Raphaelites. He was something of an actor, both grave and absurd, who affected a shaggy Edwardian moustache and always wore a tie unknotted but dragged through a key ring. One contemporary described him: 'Monty was so marvellously, so intoxicatingly, so memorably, so splendidly funny … he came from a generation who had the courage to dramatise itself.'[23] Chivalry was the cardinal virtue for Rendall, and he commissioned a medievalising triptych in praise of it, which he bequeathed to the school. He believed, wrote Clark, in 'that mixture of learning, courtesy and fair

play, which seemed to him the ideal of a gentleman either in Mantua or Winchester College'.[24] To Clark, as to many Wykehamists, Monty Rendall was always the loveable, inspiring teacher who introduced him to Italian art.*

Rendall set up a study centre at Winchester with images of Italian drawings and paintings. He produced detailed and beautiful wall charts of the painters of northern Italy – Florence, Umbria and Siena – in which he referred to Clark's future mentor Bernard Berenson. His rooms were full of Italian art and Italianate contemporary art. He even created an Italian garden in front of the headmaster's house, cheekily known to the boys as 'Monte Fiasco'. Above all Rendall was an inspired lecturer, and Clark had his eyes opened to the wonders of Giotto, Fra Angelico, Pisanello, Botticelli and Bellini, all presented with the kind of humorous asides that he was later to employ himself. The lectures were a mixture of learning from Berenson, Roger Fry and Herbert Horne, but Rendall had bicycled around Italy and actually seen all the works of art he described, so his lectures had a directness that spoke to the young Clark. Every year Rendall would give his most memorable lecture, on St Francis of Assisi. Fifty years later, when Clark made the third episode of *Civilisation* and spoke of the saint, many old Wykehamists – and he acknowledged that they were right – heard echoes of Rendall. It was these lectures and exhibitions at Winchester that predisposed Clark to work with Berenson. When he was leaving the school Rendall gave him a copy of Berenson's *A Sienese Painter of the Franciscan Legend*.[25]

There was another important way in which Rendall influenced Clark. He would invite a dozen of the more interesting boys to join a society known as 'SROGUS', which stood for Shakespeare Reading Orpheus Glee United Society. They met on Saturday evenings, wearing dinner jackets, in the headmaster's house, where Clark found himself alongside two future socialist grandees, Hugh Gaitskell and Richard Crossman. These readings cemented his lifelong taste for Shakespeare and the theatre, which one day would lead him to play a significant role in the formation of the National Theatre. The parts he asked to read show an interest in character: Justice Shallow, the porter in Macbeth, and Caliban.[26]

* In 1951 Clark funded the reinstallation in Thurbern's Chantry chapel of four beautiful stained-glass windows from 1393 showing the tree of Jesse, in memory of Rendall. The cost was in excess of £5,000, an enormous sum at the time. See letter to L.H. Lamb, 27 July 1973 (Winchester P6/135).

'The beauty of the buildings of Winchester penetrated my spirit,' Clark later wrote, and they inspired his lifelong love of architecture. He was bowled over by the cathedral: 'nothing had prepared me for such a sequence of contrasting styles, each beautiful in itself, and yet palpably harmonious'.[27] He later referred to it as the building he had in his mind during the war when he was put in charge of Home Publicity, and was formulating the values for which the country was fighting.[28] Clark sketched the ruins of the Romanesque arches in the south transept – he was already aware of Turner – and was encouraged by the greatest architectural draughtsman of the day, Muirhead Bone, a kindly Scotsman who visited Winchester and would later play an important role in Clark's life on the War Artists' Advisory Committee. He also admired the fabric of the school itself, the Gothic chantry and its cloisters, and even the nineteenth-century buildings by William Butterfield. There is no doubt that Clark's love of architecture was ignited at school, and from this later emerged his book *The Gothic Revival* and his acquisition of Saltwood Castle. It extended beyond the stones: 'No Wykehamist can forget that Keats lived there while he was writing the Ode to Autumn, and walked every day through the meads to St. Cross: so his poem and letters are mixed up with the most vivid memories of natural beauty.'[29] During the 1960s he was to campaign to save the water meadows.

Did Clark make any school friendships? Tony Keswick, who later became an important patron of Henry Moore, remembered his kindness when he had nothing to put up in his 'toy'.* Clark said, 'Don't worry, I have an envelope full of drawings, help yourself,' and pulled out drawings by Augustus John and William Orpen, which as Keswick recounted, 'being the dear fellow that he was', he was allowed to keep for 'the rest of my career at Winchester'.[30] It was in his last year that Clark encountered a fair-haired boy who was three years younger than himself. They met in Gilbert's second-hand bookshop off the Cathedral Close, which 'became a potting shed for my mental growth', where John Sparrow† mentioned that he had just discovered a copy of a lost book, John Donne's *Devotions*.[31] Their friendship was based on a shared interest in seventeenth-century literature; Clark became Sparrow's mentor, and the relationship endured. Clark would later inscribe books for him as 'my

* The Winchester term for the wooden partitioned area allowed to each boy.

† Sparrow (1906–92), the future Warden of All Souls, was to be a lifelong friend.

oldest friend', and Clark, Sparrow and Maurice Bowra would form a lifelong friendship triangle.

Clark's academic progress was steady but not outstanding by Winchester standards, and he eventually became a house prefect. We can follow the improvements in his reports over a two-year period, 1921–22:

'Fair report ... Mustn't shirk the dull part of work'

'Coming on in character'

'Lack of concentration: must take being a prefect seriously'

'Plenty of intellectual interests but does not let them prevent his ordinary work'

'Useful prefect'

'Must keep art as a hobby and keep a sense of proportion'

'Brilliant report'

Contrary to the impression given in his autobiography, by 1921, his penultimate year at the school, Clark was regaining the confidence so dented by his first year. He became a conspicuous school intellectual, giving art history lectures and vigorously debating international affairs and post-war politics. We begin to observe the future leader of the arts in Britain finding his feet. He gave a lecture about 'Wall Decorations' from Byzantium to Puvis de Chavannes – *The Wykehamist* reported that his 'style was free, but somewhat spoilt by the frequency of artist jargon'. The greatest surprise, however, to those who have read his own accounts of his obscurity and shyness at school, is the debates. On 8 November 1921 he opened a debate to speak in favour of benevolent despots, and reflected that there 'might be found perhaps some educated Dukes ... but that there were practically no educated charwomen'. In March 1922 *The Wykehamist* tells us Clark informed the chamber that 'To argue was great fun ... and concluded on a magnificently journalistic note by enquiring if there was anything more pleasant than to really squash (ugh!) your opponent.'[32]

Clark had come a long way since the miserable first week at the school. It was now his turn to terrify juniors, though he never did so physically or cruelly. One said, 'My attitude towards him is, I think, best expressed in the simple word "fear". He was impatient of stupidity, humbug and conceit ... his demeanour was one of urbane ferocity.'[33] Clark was in fact undergoing several changes at this time. He was coming to the gradual realisation that his talents lay not in his rather derivative drawings, but in writing and the use of his intellect. He was struck by Matthew Arnold's dictum

that if an Englishman can both write and paint, he should write, for writing is the national form of expression. A few of Clark's early writings survive, including a story entitled 'Historical Vignettes: Wonston, 80 A.D.', 'written at school for the Library master 1921'. This is a whimsical, rather Shavian dialogue between a wise savage Briton and his foreman, a sophisticated Roman centurion, about the virtues and graces of civilisation.[34] What finally cemented Clark's belief that his future lay with the pen rather than the brush was winning a scholarship to Trinity College, Oxford, in 1922. He liked to pretend that everyone at Winchester was astonished, and nobody more than his housemaster, the Jacker, but the evidence suggests otherwise. The idea suited Clark's view of himself as an autodidact outside the mainstream.

Kenneth Clark was thought later in life to embody certain characteristics that it used to be claimed were Wykehamical: he was astringent of mind, ferociously disciplined, and occasionally chilly. When he was interviewed for a school magazine in 1974, he reflected, 'It always surprises me when I hear people talk of Wykehamists as a special breed, because you simply cannot group them all together: I was there with David Eccles, Hugh Gaitskell, Cecil King, Dick Crossman, Douglas Jay – possibly the only real Wykehamist among them – John Sparrow and Denis [sic] Lowson;* they were a very mixed lot.' Winchester produced more than the usual number of socialist intellectuals, but the only one of that list who was to become a close friend of Clark was John Sparrow, who emerged as the tease of the left. Dick Crossman characterised the typical Wykehamist as a 'blend of intellectual arrogance and conventional good manners'.[35] Winchester may not have had the Whig insouciance and Athenian elegance of Eton, but it had a high seriousness of purpose and an intellectual distinction that has produced generations of ambassadors, permanent secretaries, heads of Oxbridge colleges and field marshals. The school encouraged a social conscience, often revealed in public service, and apart from the specific benefits of Rendall, this remained its strongest influence on Clark's life.

The charm of Golly and his Dutch dolls, who formed such an integral part of his private world, and the affectionate support of Lam may have been rudely interrupted by the male rituals of Winchester, but if the school

* Lord Eccles, Tory politician and Arts Minister; Hugh Gaitskell, Labour leader and Chancellor; Cecil King, newspaper publisher; Richard Crossman, Labour politician and diarist; Douglas Jay, Labour politician; Sir Denys Lowson, much-censured City tycoon.

destroyed the innocent dreams of the solitary boy, it brightened his quick-silver mind and opened it to the possibilities of Italian art, English theatre and poetry, which were to be the sustenance of his life. Every Winchester boy has a note on his file – called 'Leaves' – that gives an indication of what happened after he left the school. Clark's is wonderfully schoolmasterish: 'Did not get a first in history at Oxford, probably too much drawn off to art: turned to art criticism.'

4

Oxford

The most valuable thing about college life is the infection of ideas which takes place during those years. It is like a rapid series of inoculations. People who have not been to college catch ideas late in life and are made ill by them.

KENNETH CLARK to Wesley Hartley,
19 February 1959[1]

In October 1922 Kenneth Clark entered Trinity College with an honorary scholarship, ready to enjoy what he later called the *hors d'oeuvres* of life. The attractions of Oxford in the 1920s have often been described; the city still breathed from its towers the last enchantments of the Middle Ages, and the suburbs barely encroached on its borders. Clark was part of the famous generation of Oxford undergraduates who came up confident in the jingle

> Après la guerre,
> There'll be a good time everywhere.

And yet in that brilliant and colourful gallery which included Harold Acton, Evelyn Waugh, Graham Greene and Anthony Powell, Clark hardly registers at all. By his own account the reason was his shyness, but he was never likely to be part of the aesthetes' set which congregated around Christ Church, with its homosexual clubs and flamboyant behaviour. Clark's own college, Trinity, was small, not especially distinguished, and had a hearty and sporting reputation. A recent president,[2] eyeing the alumni portraits in the President's Lodge, observed that on one wall were all those who had won the colonies, and on the opposite wall were all those who had lost them. If history chiefly remembers Oxford in the twen-

ties for the antics of a few conspicuous undergraduates, it has forgotten that most were ordinary beer-drinking, pipe-smoking sportsmen, and it was these who would generally have confronted Clark in his own college. Clark was faced with the same problem he had had at Winchester of fitting in, and his 'first feelings at Oxford were of loneliness and a lack of direction'.[3] He never joined the Oxford Union or any of the conventional clubs where alliances were forged. Nevertheless, he was to make most of the friendships that carried him through life at the university.

Clark was rescued from loneliness by the pink-faced dean of Balliol, F.F. Urquhart, always known as 'Sligger'. He was a medievalist who as a young man nearly became a Jesuit and remained a devout Catholic, the first don of that persuasion in the university since the seventeenth century. Sligger – who reminded some of a prim maiden aunt – never wrote a book. Instead he made it his life's work to bring undergraduates together. He kept open house – without alcohol – for serious-minded undergraduates each evening, and you were as likely to meet minor royalty as budding poets in his rooms. For Clark these occasions were 'a reservoir of kindness and tolerance and I went there most gratefully'.[4]

It was in Sligger's rooms that Clark met two Etonian scholars destined to be among his closest university friends – Bobby Longden at Trinity and Cyril Connolly at Balliol. Longden, 'that rare and irresistible combination, an intelligent extrovert',[5] was a red-headed Apollo whose gaiety and charm captivated Clark. Connolly he described as 'without doubt the most gifted undergraduate of his generation' – he was certainly the best-read, well versed in French poetry, Silver Latin and the Church Fathers. For his part, Connolly described Clark as 'a polished hawk-god in obsidian', but their relationship was complicated by Connolly's melancholic temperament, possessiveness over Longden, and Clark's didactic nature.* Connolly was a gifted letter-writer, and wrote Clark a series of letters which he described as 'erudite, original, observant and so perfectly phrased that they could have been published as they stood'.[6]

But the man who blew away Clark's shyness and gave him the courage to be himself was Maurice Bowra, later Warden of Wadham. Bowra, an Oxford titan who had a profound influence on many of Clark's generation

* 'I see mainly Bobbie and Piers with a good deal of Roger and Maurice and a bit of K. Clark – who is usually bearable for the first three weeks.' Letter from Cyril Connolly to Noel Blakiston, 25 January 1925 (Connolly, *A Romantic Friendship: The Letters of Cyril Connolly to Noel Blakiston*).

and later, was the nodal figure of that liberal generation of intellectuals and educators that Noel Annan called 'Our Age'.[7] Bowra had served in the trenches during World War I, and gained a lasting dislike of officialdom. Isaiah Berlin said of him, 'he was emotionally with the poachers, even when he officially crossed over to the gamekeepers'.[8] His chief weapon was wit, which he used to disinhibit young men with what he called his 'Trumpets, and kettledrums, and the outrageous cannon'.[9] All Clark's priggish fears and inhibitions were blown to smithereens under a barrage of bravura teasing. Bowra enjoyed being outrageous and shocking the prim – he was at the centre of a homosexual-leaning world he referred to as 'the immoral front', 'the homintern' or 'the 69th International'. He loathed prigs and cold fish, and it is greatly to his credit that he was able to see beneath Clark's shyness, especially as Clark remained entirely heterosexual in his tastes.

Part of Bowra's technique was to draw undergraduates out about their parents – 'What does Major Connolly think of *L'Après-midi d'un Faune*?'[10] In Clark's case he invented a mythical personality for his father, outrageous and funny, which 'lifted from my shoulders a load of shame and resentment'. Bowra had a booming voice, and came out with truths that no one else would dare speak. To his friends he was the most affectionate and warm-hearted man, but woe betide his enemies. In his autobiography he described Clark at Oxford: 'In exhilarated moments he would sing snatches of Opera; he liked good food and drink, and knew about them … he had a keen sense of absurdity, told excellent stories of strange characters whom he had met, and was always ready to laugh at himself. This essential gaiety was at war with his appearance and manner.'[11] Bowra's wide culture spanned ancient and modern, and he extended Clark's range of authors: the poetry of Yeats, Rilke and Edith Sitwell, the works of Turgenev. Clark later admitted that 'I use a great many expressions, intonations and inflexions I derive from Maurice.'[12] They also shared socialist politics. Clark would often refer to Bowra as his greatest friend, and they would spend Christmas together until old age. Clark would always be what later became known as a 'Bowrista'.

If Clark's literary education took place mainly in Maurice Bowra's rooms, there was also the matter of his undergraduate course, or History Schools. The Oxford practice of producing a weekly essay, he later thought, 'leads to a certain amount of facility in condensing and arranging ideas … it teaches one to write of everything at a certain length … about the length of a newspaper article, and so this bad habit continues in after life … I

suffer from it very much.'[13] Clark liked to give the false impression that he took a relaxed view of his studies, and as he laconically observed to Connolly, 'If anyone will not take the trouble to read history, Maurois and Lytton Strachey are amusing enough.'[14] In fact his reading at this time was deep, and his learning struck his contemporaries. His college tutor at Trinity was a booby, a hangover from Gibbon's Oxford who was invariably indisposed, but Clark did have two great teachers, the economist F.W. Ogilvie and the economic historian G.N. Clark – the latter 'taught me the little about historical method that I know'.* His borrowings from the college library, such as Ranke's *History of the Popes*, occasionally fore-shadow later references. He claimed that he only went to lectures in the hope of sitting next to a pretty undergraduate named Alix Kilroy (later Dame Alix Meynell), but as usual he was devising his own course of stud-ies, and had begun the reading that would enable him one day to make *Civilisation*. When he came up to Oxford he had already read Carlyle's *Past and Present* and Michelet's *History of France*. At the university he started reading economic history with Tawney's *Religion and the Rise of Capitalism*, the bible of the Labour Party and the book that crystallised the socialism that Ruskin had first stirred in him. Clark has described how at Winchester social questions were far from his mind, and when a debate was organised with the local working men's club, 'they seemed to belong to a different species and we regarded them as figures of fun'.[15]

The change in Clark's outlook was gradual, and there is no doubt that the main influence was reading Ruskin's *Unto This Last*, a book that also made a deep impression on Gandhi. What was it about Ruskin that stirred Clark? Ruskin revealed a unique combination of artistic and moral sensi-bility. His perceptions on art and nature were often contradictory and unexpected, but were based on unrivalled power of observation and expressed in luminous prose. He was a preacher who believed that art, beauty and morality were indivisible, and that ugliness was wicked. Henry James observed of Ruskin's approach to art that it was as if an assize court was in perpetual session governed by Draconic legislation. Clark perfectly well saw the many inconsistencies in Ruskin's position, but nevertheless was captivated by his credo that beauty was everyone's birthright. He was never to adopt a moral position about art and beauty, but what he took from Ruskin was not only his descriptive power but the belief that art

* G.N. Clark was interested in the seventeenth-century Netherlands, and there are echoes of his influence in *Civilisation* episode 8, *The Light of Experience*.

should belong to all. The counterpoint to Ruskin was the Swiss Jacob Burckhardt,[16] whom Clark believed was the most intelligent and best-equipped of art historians: 'where Burckhardt is calm and detached, Ruskin is excited and engaged; where Burckhardt is sceptical, Ruskin credulous, where Burckhardt is sure-footed and economical, Ruskin plunges into one extravagant irrelevance after another'.[17]

Clark's other Victorian household god was Walter Pater, who preached the gospel of aestheticism. Pater's famous 'Conclusion' to his book on the Renaissance exhorted Oxford youth 'to burn always with a hard gemlike flame, to maintain this ecstasy, [that] is success in life'. Clark certainly understood that a passion for art made him spiritually indestructible, but Pater to him was much more than a brilliant stylist. He later made the case that Pater was a philosopher of sorts: 'the aim of his best works was to suggest ways of achieving the ideal life'.[18] There would be many echoes of Pater in Clark's own work, particularly *Leonardo* and the unfinished *Motives*.

If Clark thought that the infection of ideas was the most useful education at Oxford, he was lucky in having another education which would determine the course of his life. On arrival at the university he had gone in search of artistic company, first at the Dramatic Society and then at the Uffizi Society, but came to the conclusion that 'it would have been difficult to find more than three or four people' in Oxford interested in art.[19] Any examination of student magazines and exhibitions of the time reveals this statement to be untrue, but Clark wanted nothing to do with the aesthetes' herd, and was rarely seen at undergraduate parties. Instead he went in search of art itself. He began to inspect, systematically, the collection of drawings at the Ashmolean Museum, one of the greatest assemblages in the world, under the guidance of the Keeper of Fine Art, C.F. Bell.[20] Small and slightly hunched, Charles Bell was as different from booming Bowra as can be imagined. If Bowra liked to fire the big guns – Socrates, St Paul and Tolstoy – Bell's interests were narrower and more parochial, English watercolours and Italian plaquettes. He was a man of taste who ran his department as a grand private collection. Prickly and possessive, Bell almost certainly fell in love with Clark, who played Charles Victor de Bonstetten to his Thomas Gray.*

C.F. Bell was to have a profound influence on Clark's life in three ways: he introduced him to Bernard Berenson; he suggested the subject of his

* Towards the end of his life the poet Thomas Gray (1716–71) fell in love with the young Swiss aristocrat Bonstetten, who lived near his lodgings in Cambridge.

first book; and he allowed him free run of the drawings by Michelangelo and Raphael in the Ashmolean. He gave Clark a copy of J.C. Robinson's 1870 catalogue of the drawings, and instructed him to annotate it, which was 'the finest training for the eye that any young man could have had'.[21] Clark always professed that Bell, more than anybody else, was responsible for his education in art, by forcing him to look at drawings. Bell also took Clark to visit private collections such as that of Dyson Perrins,* where he could inspect the Gorleston Psalter. But all this came at a heavy price: Bell wrote Clark long letters that he felt incapable of answering adequately. Later the relationship was to sour, and Bell became Clark's most vociferous critic both in private and in public.

If Clark was still more at ease with older men, he did make some effort with his contemporaries at his own college, and to be part of university life. He joined the Gryphon Club, the Trinity paper reading club, and soon became its secretary – he appears in a 1925 club photograph. Bobby Longden and John Sutro[22] were also members, and Clark attended the annual dinners. He also wrote lively art reviews for the university periodicals the *Cherwell* and the *Oxford Outlook*.[23] He was still sporty, and enjoyed playing tennis and golf.[24] However, there were two distinctive features of Clark at Oxford that drew him away from university life: he owned a motor car, and as Bowra observed, 'he cultivated young women when there were few about, but kept them from his friends, since they did not yet form part of the Oxford scene and he was not sure how they would be received'.[25] Where women were concerned, Clark was already starting to compartmentalise his life.

What sort of impression did Clark make on his contemporaries? He spent his first year at Trinity in the New Building, designed in the Jacobethan style of 1885 by T.G. Jackson. Colin Anderson[26] was on the same staircase: 'As you got up to his floor, it was not Shangri-La exactly, but it was detached from the world': the furniture had been changed, the pictures were real paintings (including a ravishing Corot), and the room was strewn with beautiful objects. Clark had an up-to-date gramophone

* Perrins was a distinguished books and manuscripts collector. Years later, when Clark was at the Ministry of Information, he wrote to Perrins, who lived near Malvern, stating that if London was bombed the ministry would be evacuated to Malvern, and asking if in that event he could be billeted at Perrins' house, where 'I would be less likely than some other evacuees to do violence to your early printed books and pictures.' Apart from giving away confidential information, the request was highly irregular. Letter to Dyson Perrins, 17 May 1940 (Tate 8812/1/1/6).

on which he played Bartók, Mozart and Beethoven – all his visitors were struck by his enormous record collection, in which he was helped by Eddie Sackville-West, an aristocratic musicologist with a *fin-de-siècle* disposition.[27] 'He was cocooned in a civilisation of his own up there,' noted Anderson, adding, 'he took very little part in the life of the college'.[28] At some point Clark's rooms suffered the attentions of college hearties, and were wrecked in a manner not unusual for an aesthetically-minded undergraduate to suffer.*

Anthony Powell remembered Clark at Oxford as 'intensely ambitious, quite ruthless … he was a ready bat for a brilliant career … he was one of those persons with whom one never knew whether he would be quite genial or behave as if he had never set eyes on one before'.[29] Peter Quennell, the most admired undergraduate poet in the university, described this as Clark's 'Curzonian superiority'. One contemporary who became a close friend for life was the Cambridge medieval historian David Knowles. Sligger Urquhart owned a chalet in the Savoy Alps, to which he would take reading parties, and he invited Clark alongside Knowles in the summer of 1924. Clark did not enjoy these Spartan visits any more than he enjoyed holidays with his parents in Scotland. Knowles' impression was that he was 'incredibly learned, fastidious, almost cold'.[30]

During that summer Clark turned twenty-one, and for the first time we have surviving letters to and from his parents which provide a window into his home life. His father paid for him to receive a newspaper, but Clark had to admit, 'I am afraid my "Times" has not been a success. There is no time to read it and for that matter very little of interest. It goes straight into the waste paper basket.'[31] This surprising lack of interest in newspapers was to endure all his life.

Around the time Clark first went up to Oxford his parents moved from Bath to Bournemouth, which was thought to be healthier. They bought a large, featureless villa, 'The Toft', which is a hotel today. Despite considerable losses from his properties, boats and (as we shall presently see) industrial investments, Clark's father was still able to afford to buy the

* See a letter of protest from Josslyn Hennessy (3 February 1975) about a curious incident when Clark turned on him at a Beefsteak Club lunch after Hennessy had mentioned their first meeting at Oxford: 'For you said with what, in contrast to your previous manner, struck me as studied politeness, "Now that you remind me of it, I remember it perfectly," adding after a pause, "That was the time that you were one of the gang who wrecked my room."' (Tate 8812/1/4/36.)

Ardnamurchan peninsula on the west coast of Scotland, consisting of seventy-five thousand barren acres of land and a large, gloomy lodge at Shielbridge. Clark went there out of duty, and began a lifelong habit of going for long solitary walks. During these walks he would often soliloquise, and it was to this that he attributed his later ease at lecturing. Through force of habit Clark senior kept a boat on Loch Sunart, which brought one unexpected benefit for his son – the numinous pleasures of the nearby abbey of Iona. This was always to remain a sacred place for him, to be compared with Delphi, Delos and Avila, where he felt the vibrations of the past; emanations that he communicated in the first episode of *Civilisation*.

Clark described the Oxford summer term to his mother as 'a charming vision of white trousers, river-picnics, long shadows in the parks, bathers in the stripling Thames'.[32] His parents were already complaining about the vagueness of his future plans, and distressed that he chose to spend the long vacation improving his French rather than with them at Shielbridge. He wrote a rather sanctimonious letter to his mother from the Hyde Park Hotel by way of justification: 'I cannot pretend that it is going to be any fun being by myself in France. But as I have explained before … and as we have to impress upon the Labour Government (which I shall one day adorn) the vacations were intended to provide time for quiet, independent work and the study of foreign languages. One's schools depend entirely upon the amount of work done in one's last long vac.'[33] Perhaps this letter reveals more about his mother's newly formed ambitions for him. She appears to have belatedly discovered her son's brilliance, and wanted him to become prime minister, or at least a diplomat. Clark spent most of the summer vacation at St Avertin on the Loire, under a tough but brilliant French teacher, 'Madame', whom he both loved and loathed. He placed photos of objects from the V&A in his room, and enjoyed the local golf course when he had time off. His father recommended that he should fall in love with a pretty French girl.[34]

Normally Clark would have left Oxford after graduation at the end of his third year in June 1925, but he decided to stay on for a further year. He informed his mother that he might catalogue Michael Sadler's collection of modern pictures[35] or study one of the great Italian painters, but the project that he actually adopted for his fourth year was suggested by Charles Bell in the week before his final examinations. It was as unexpected as it was original: 'Write a book on the Gothic Revival.' Bell had

become interested in the topic as librarian of the Oxford Architectural Society. It was an inspired idea. Here was a subject that surrounded Clark at Oxford, and played to his interest in Ruskin. Moreover, 'these monsters, these unsightly wrecks stranded upon the mud flat of Victorian taste' required explanation.[36] As Clark said, the Gothic Revival was seen as a sort of national misfortune – like the weather – and he was expected to write something satirical in the manner of Lytton Strachey. He described how undergraduates and young dons would break off their afternoon walk to go and have a good laugh at the quadrangle of Keble, which it was universally believed was designed by Ruskin rather than Butterfield.

With so many distractions, Clark was doubtful about the likelihood of his achieving a first in his finals. He wrote to his mother, 'you must prepare for a steady second' – which was in fact what he received. He was sanguine about the result, claiming to believe that 'I have not got a first-class mind' – but nobody at the time or since has accepted that explanation. Sligger Urquhart reminded him that John Henry Newman and Mark Pattison[37] both got seconds, and Clark reminded himself of Ruskin's honorary fourth. A consoling Bowra wrote: 'I am so sorry about the schools. I am afraid it will mean your family driving you into the business and that would be terrible. Otherwise it has no importance as experts always get seconds and journalists usually get firsts ... nobody else will think the worse of you for not being officially regarded as a master of a subject which bores you to death.'[38] It certainly made no difference to Clark's career, and if it dented his confidence nobody noticed – but it may have curbed his conceit. He undoubtedly had a powerful belief in his own superior gifts, but this was an early indication that these might not lie in a purely academic sphere. The failure to achieve a first may have had a greater influence on his outlook than was apparent at the time, and he eventually became impatient with scholarship for its own sake.

At Oxford Clark had addressed himself most effectively to senior members of the university – he had made a deep impression on older men, all bachelors; but he was now about to exercise his *Wunderkind* charm on somebody as attached to feminine company as himself.

5

Florence, and Love

I come now to the turning point in my life.

KENNETH CLARK, *Aesthete's Progress*[1]

It was an invitation to go to Italy in the summer of 1925 with Charles Bell that was to determine Clark's future. He later wrote, 'the idea annoyed my parents "Still going about with school-masters", but I went'.[2] The trip took place at the height of Bell's infatuation with Clark, and would slowly lead to their disengagement, for in his innocence Bell was to introduce his pupil to another, far more compelling, mentor, whose range and surroundings would captivate him. This seminal encounter would define Clark's taste and set the trajectory of his career. But it was a grateful pupil who arrived with his distinguished master in Italy for the first time. They stopped at Bologna, where Bell was enough of a Victorian to have a reverence for a school of painting that had suffered an eclipse of taste. It was his eloquent defence, and the knowledge that these great paintings by Guido Reni and the Carracci had been considered as the summit of excellence in the eighteenth century, that forced Clark to make the effort to see their merit, though he never came to love them. As a result he was to be an early encourager of Denis Mahon and the *seicento* revival of the 1950s.[3]

From Bologna they moved to Florence, where they were to stay with the formidable and immensely grand Janet Ross. She had been a great beauty – and allegedly the muse of several Victorian novelists – and now lived alone in the hills above the city, managing her farm. Her villa, Poggio Gherardo, was large, gaunt and uncomfortable. She sat in the middle of a room stuffed with portrait drawings by Watts, and photographs of Tennyson and other Victorian worthies. Whatever first impression she might have made on Clark was dampened by the fact that Bell had fallen very ill on the journey and needed to be supported to bed on arrival. Clark

therefore dined alone with this 'well known terrifier', fortified by her *aperi-tivo di casa*, made from a secret Medici recipe. It was early the next morn-ing on the terrace, observing Mrs Ross supervising her *contadini*, that Clark first 'felt that yearning for the long tradition of Mediterranean life, unbroken, in spite of disasters, for over two thousand years that has fasci-nated northern man since Goethe – *dahin, dahin*'.[4]

The highlight of the journey was to be a visit to Bernard Berenson, usually referred to and addressed by his friends as 'BB', at I Tatti, his famous villa near Settignano. Bell held a baleful view of Berenson – 'He's really only a kind of charlatan, and all that business of attribution is pure guess-work' – but to Clark, he was already an idol. Clark's autobiography is inaccurate about the detail of this most significant meeting, and dram-atises the action into one lunch. The facts are as Berenson's wife Mary wrote to I Tatti's librarian Nicky Mariano on 12 September: 'Mrs Ross, Charlie Bell and a handsome Oxford boy were coming to dinner but Charlie is ill and only aunt Janet and the boy are coming.' The following day: 'The boy turned out to be a perfect dear. B.B. was enraptured by his intelligence and culture. This morning we walked over to Poggio Gherardo to see Bell and he was worse, and said he was particularly sorry because of his young friend. So I said let him come over to lunch ... the chief thing was that B.B. after more talk with him invited him to come and work under himself for two or three years and the young man was enraptured. It all depends on his father who wants him to be a lawyer. He is very rich.'[5]

Clark wrote a long letter to his father that corroborates Mary Berenson's version of events: 'Aunt Janet and I dined at the Berensons'. I had seen the great man before and had not liked him much. He is very small with tiny wrists and hands, has a large but well proportioned head and a perfect pointed beard. He is always exquisitely dressed and has rather odd ... nervous gestures. Intellectually he is far and away the most impressive person I have ever met. His house is amazing; having made masses of money by his books it is perfectly furnished, contains the finest private collection of early Italian pictures anywhere and beautiful Chinese things; he also has the best library of art books in existence all arranged in three enormous rooms.' Berenson talked exclusively to Clark over dinner: 'I liked him much better. The next day the Berensons both came up to see Bell and say "good-bye", as they were leaving for Munich in the afternoon. They asked me to go and have lunch with them.'[6]

Clark's autobiography does not mention the dinner, but describes this lunch as the first meeting: the guests were assembled, when 'At the last,

perfectly chosen moment [Berenson] entered, small, beautifully dressed, a carnation in his button-hole. There was an awestruck silence.' In this account, Clark took a great dislike to Berenson because of the conceit and vituperation that formed a large part of his conversation. After lunch they moved to the *limonaia* for coffee, and the great man summoned Clark to come and sit next to him. This was evidently successful, because as Mary was beckoning her husband over to the car to leave he turned to Clark and said, '"I'm very impulsive, my dear boy, and I have only known you for a few minutes, but I would like you to come and work with me to help me prepare a new edition of my *Florentine Drawings*. Please let me know." He thereupon jumped nimbly into the palpitating vehicle and drove away.'[7]

Berenson's offer aroused considerable emotions in Clark. This was the realisation of his Winchester dream, and the greatest prize for any young man with his interests, but he felt sure his parents would object. He was not even certain that he would enjoy I Tatti, or BB's personality. Broaching the subject with his father, he put the offer in rather different terms: 'I want a secretary; would you care for the job? ... please assure your father ... that I am not going to make you into an art critic. I am going to give you the chance of seeing people and places that you would not otherwise have seen.' Clark told his father that 'the prospect simply stupefied me', adding, 'I think I should be mad to refuse it. But it depends on what you think.'[8] He had of course already made up his mind, as is clear from a letter he wrote to his mother shortly afterwards.

Clark and Bell remained at Poggio Gherardo for several more weeks. Bell planned Clark's sightseeing in Florence from his sickbed. He was first directed to the Bargello, and Florentine sculpture was to be the main theme of his first week, as Bell saw this as the foundation of *quattrocento* art in the city. 'Can't I go to the Uffizi?' became Clark's constant refrain. 'No, not yet, today you must go to Santa Maria Novella ...' Finally he was given permission, but he found it a dismal experience until he came upon Piero della Francesca's portraits of the Duke and Duchess of Urbino. Piero's *Baptism* was already his favourite painting in the London National Gallery, 'but nothing prepared me for the brilliance and sparkle of the Urbino diptych. I fell to my knees.'[9] Clark was often to react with nervous tension to works of art. He could be reduced to tears or shaking knees by poignant situations, overcome by a kind of afflatus of emotion or inspiration. Anthony Powell linked this to his belief that he was going to die of paralysis before the age of thirty, and his recurrent agonies at feeling he was wasting his life.[10]

After two weeks of sightseeing in the Val d'Arno, Clark was despatched with a protégé of Mary Berenson to southern Tuscany and Umbria, still under Bell's instruction. By the time he returned to Florence, 'I felt as if I had lived in Italy all my life. The echoing corridors of Poggio Gherardo were no longer alarming; the coarse damp sheets were like my daily bread; the idea of a bath before dinner ridiculous. In a few days I had to leave and my only thought was how to get back.'[11] As he wrote to his mother: 'What an extraordinary holiday it has been! I have had rather a debauch of loitering among beautiful things and quite look forward to getting down to hard work again.'[12] On the way home he mentioned Berenson's offer to Bell, who commented, 'You wouldn't like it, you know. You'd hear nothing but abuse of your friends. They are like crows picking over the bones of everybody's reputation.'[13]

Clark's parents – reluctant to see their only child leave Britain – strongly objected to him giving up his fourth year at Oxford. He therefore wrote to Berenson offering to come to I Tatti at the end of the academic year – with a trial month in January – although he realised that this might jeopardise the offer.[14] Mary Berenson, who managed her husband's commitments, wrote back accepting the arrangement and agreeing that Clark should improve his Italian and German language skills in the meantime.

On his return to Oxford Clark settled down to work on *The Gothic Revival*. His final year at the university, from October 1925 to June 1926, is a rather shadowy affair, and marked by a return of his hypochondria. He lived out of college, in rooms in Beaumont Street, and rarely went in for meals, except on Sunday evenings when Oxford's restaurants were closed. He was by now president of the Gryphon Club, and in February 1926 he read a paper about Ruskin in which he described 'the continual struggle that went on in Ruskin's mind to make his likes and dislikes agree with his theories of art'.[15] His motivation in giving the paper – as he explained to Mary Berenson – was to help clarify his ideas on Ruskin's relationship with the Gothic revivalists. Clark told her that although he was depressed about Oxford the work on the book was going well, and he already had more material than he could use.

One of the pleasures of working on *The Gothic Revival* was that it brought him enduring friendship with one of the most original undergraduates in the university, John Betjeman. They met at Maurice Bowra's, and as Clark later told Betjeman's biographer, 'as a young man he cast himself in the role of the nineteenth-century man. He loved life and he loved jokes, and he laughed more than anybody else I knew. His discovery

of the merits of the Gothic Revival coincided with mine and went a little further. He had the merit of seeing through fashionable styles.'[16] Clark and Betjeman remained friends for life.

Clark occasionally returned to his parents' house in Bournemouth. One evening in November 1925 when he happened to be staying at The Toft, his father appeared – 'I shall never forget his face' – holding a newspaper with the headline 'WELSH DAM DISASTER, Whole Village Washed Away'. Clark senior had invested a considerable part of his fortune in an aluminium plant powered by water from a large dam near the village of Dolgarrog. The dam, woefully inadequate to its task, had burst, destroying the village with the loss of sixteen lives. Clark's father had only been there once, but he recognised his responsibilities, and covered the resulting compensation claims. To his embarrassment, young Clark was put on the company's board, but it never recovered and the plant was sold shortly afterwards at a loss. Clark senior reckoned that he had lost over a million pounds. This was probably half his fortune, but there were still sufficient funds to ensure that no immediate consequences were felt by the family. Clark spent what must have been a melancholy Christmas with his parents in Bournemouth, and then headed back to the pleasures of Italy.

The 'trial' three weeks at I Tatti in January were an evident success. Clark wrote to Mary Berenson that they were 'the most delightful I can remember. Walking in the hills, shuffling Bellinis in the library or simply browsing amongst the books were all a great joy to me; and above all to be with people who understand … my enthusiasms, was a new and enchanting experience.'[17] Mary's brother, the *belle lettrist* Logan Pearsall Smith, was staying, and wrote to their sister Alys (the ex-wife of Bertrand Russell): 'It is just like a little court here with favourites … Clark is the new great favourite now and he seems to deserve his favour – his knowledge and his reading and his power of expressing himself are certainly prodigious for his age. He likes it here immensely, loves the good talk and appreciates the humour of the situation and his own to the full, and being rich and popular and independent, he is not much concerned as to what happens. I have just left him sitting with the B.B.'s over a portfolio of photographs, emitting opinions about them which they seem to listen to with respect.'[18] On the other hand, Nicky Mariano, BB's librarian and mistress, who was adored by all, especially Mary, found Clark 'rather standoffish and cutting in his remarks, also not free of conceit for one so young. But soon I real-

ised that much of this was a mask for shyness.'[19] She also observed that
Logan had, without even realising it, fallen in love with him. It is a meas-
ure of Clark's inscrutability that nobody at I Tatti was certain where his
sexual tastes lay.

Logan lived at St Leonard's Terrace in London, where he was known as
'the Sage of Chelsea'. His life was devoted to literary pursuits, malicious
gossip and polishing sentences for his collections of maxims. Like Walter
Pater, he played with words until 'they glowed like jewels upon his pages'.[20]
He was always searching for the ideal literary apprentice, and threw a fly
over Clark: 'I don't want to force an unwelcome correspondence on you,
but I shall always be glad to hear from you, and will answer with due
promptness. Only the notion of my teaching you to write seems more and
more absurd, since you write so well already.'[21] Clark replied offering
passages from three of his favourite authors for Logan's *Treasury of English
Prose*: Samuel Johnson, Walter Pater and Lytton Strachey. Clark was to
remain fond of Logan, but it was BB to whom he was apprenticed. He
offered Cyril Connolly instead, which was an unexpected success.

That spring Clark frequently wrote to Mary Berenson about forthcom-
ing arrangements: questions about a summer visit to Germany to learn the
language, the type of camera he should bring to I Tatti for photographing
paintings on their trips to obscure churches, and most surprisingly, 'If you
think my car would be useful to me during August & September – as well
it may be, if I am visiting out of the way towns – then perhaps it may be
possible to find some lodgings for my chauffeur. It sounds preposterous
that anyone of my age should have a chauffeur at all, but he will be able to
valet to me when I am on my own; and I am afraid I cannot drive far
without one, as I am a fool with the inwards [sic] of cars and when they
break I am lost.'[22] The chauffeur makes only sporadic appearances, and was
not a permanent fixture. Clark wrote to Mary from the Golf Hotel at
Sospel near Menton, which his father had built but was now bored with.
He handed the hotel to his son, who claims to have 'much enjoyed the
drama and complications of hotel management', but it is difficult to gauge
exactly what this means, as the only example he cites is a guest stealing all
the eggs and then throwing them at the night porter, the Swiss manager
and himself.[23] A more useful addition to his life was a place to stay in
London. His parents had taken a serviced flat in St Ermin's Hotel, a large
Edwardian wedding cake in the middle of Westminster. From here Clark
would venture out to the Burlington Fine Arts Club, which he had joined,
where people were already beginning to speak about him as the coming

man in the art world.* This was where the grand world of Edwardian connoisseurs, collectors and scholars gathered, and it was a natural home for Clark to gravitate towards. He also entered the fringes of the Bloomsbury group thanks to his friendship with Roger Fry. These two worlds of Edwardian connoisseurship and Cambridge intellectuals were to be assimilated, and eventually rejected, by Clark.

Clark's interests were never exclusively with the Old Masters. Roger Fry completed what the Leicester Galleries had begun, opening his eyes to Post-Impressionist French and contemporary art. Charles Bell had personally prevented this prophet of modern art from becoming Slade Professor of Fine Art at Oxford – 'The old spider did it,' Fry would say with glee – but for Clark 'he was the most bewitching lecturer I have ever heard'. His lectures on Cézanne and Poussin at Queen's Hall, often filled with two thousand people, succeeded in making Post-Impressionism acceptable to the British elite. Clark later pronounced that if taste was changed by one man, it was changed by Fry. It was said of him that, like T.S. Eliot, he drew a new map by presenting Post-Impressionism to London. E.M. Forster thought that Fry changed culture from being principally a social asset – he addressed new audiences, and encouraged them to enjoy art. This was something Clark inherited.[24]

Clark had read Fry's *Vision and Design* (1920) at Winchester, and was more impressed by the intellectual rigour of Fry's analysis than by Fry's friend Clive Bell's doctrine of 'significant form'. Fry was a painter who was searching to understand the anatomical structure of compositions. The essence of his ideas was to write about works of art in terms of their form rather than their subject-matter – a method suitable for discussing Cézanne, but inadequate for Rembrandt. Clark was soon to outgrow this approach, which played down historical, literary and iconographical interpretations.[25] However, one aspect of Fry's critical writing which was clearly influential on Clark was his tendency to draw visual analogies between works of quite different epochs and cultures. Clark would apply this to great effect in all his books and lectures. Fry was also a delightful companion, and when Clark bought one of his strangely dead paintings, they became close friends. Clark probably enjoyed talking about art with Fry more than with anybody else in his life, and once confessed, 'I doubt if I

* Founded in 1866, the Burlington Fine Arts Club was where connoisseurs and art collectors gathered and mounted exhibitions. Its premises were originally opposite Burlington House (hence the name) in Piccadilly, and in Clark's day at Savile Row.

have ever felt clever again since Roger died.' In addition, Fry introduced him to Bloomsbury, which led to his friendship with Vanessa Bell and Duncan Grant. We owe it largely to Fry that Clark championed modern art when he was the director of the National Gallery.

Women had played only a background role in Clark's adult life to date, but that was about to change dramatically. In June he wrote to his mother: 'I stopped at Newbury to pick up Gordon Waterfield and his young lady,' the first reference to his future wife, Jane Martin.[26] Clark did not have one particular girlfriend at the time, although there are frequent references to an 'Eileen' in letters home, and also to Sybil Dawson, of whom he later wrote, 'everybody expected that I would marry her, but she was too materially minded'.[27] Sybil's father was the King's physician, and as a doctor's daughter she did not approve of Clark senior's drinking, as she tactlessly told his son.[28] There were other girlfriends, and it is perhaps surprising that Clark had no grand passion before Jane Martin, the Oxford graduate fiancée of his friend Gordon Waterfield. Jane was a friendly, unpretentious girl, and attractive in a vivacious way. Men had flocked around her at Oxford, where she had read History, admiring her high spirits and natural elegance. Gordon Waterfield was also a dashing figure, whose father was a painter and whose mother, Lina, was a niece of Janet Ross. His fees at Oxford were paid by an uncle in the cotton business (who was interested to hear of his friendship with a member of the Clark family). At some point in the summer of 1926 Waterfield was sent to Egypt to learn about the cotton trade, and unwisely entrusted his fiancée to Clark's care. Clark began to send her letters, and to perform small services on her behalf, such as acquiring tweeds for her. He consoled himself that Newbury, where she had taken a position as a teacher at a school, Downe House, was 'only 25 miles from Oxford'.

When Clark left Oxford in June, he was perhaps already in love with Jane; he had certainly ceased to admire Sybil. He spent the early summer with his parents in Scotland, which 'was the happiest month I've ever spent … it is wonderful that the awful Sybil didn't cloud it'.[29] Back in London, he prepared for a visit to Germany, and in August he and Connolly went down to Logan's house by the sea in Hampshire, where again he was happy: 'We all worked on the lawn most of the day, Logan at an essay on Pater, Cyril selecting passages from Jeremy Taylor, I reading all Hazlitt's art criticism. In the afternoon we sailed on the Hamble and in the evening we bathed. Logan's blithe and mellow charm engulfed us … I

find him tremendously stimulating and I come away feeling I must write on almost every subject.'[30]

At the end of August Clark left for Germany, where he would stay over a month, learning the language, visiting the important art galleries and spending evenings at the opera. In those days German was the principal language of art history, and Berenson had underlined its indispensability if Clark was to read Riegl, Wölfflin and the other great art historians in the original.* He headed for Dresden, which was an interesting choice. Before World War II it was one of the loveliest cities in Europe, and its art collections were superb; moreover, it was small enough to be digestible. He lodged with a family who spoke little English, and he felt lonely: 'Yesterday I found the strain of never speaking English and having no human relations with anyone rather unpleasant, I was seized with the melancholy. However, I've shaken it off by dint of hard work. "If you are solitary be not idle" were Johnson's last words to Bozzy, when Bozzy went on his European tour.'[31]

He was shaken out of his *ennui* by a visit from his friend Leigh Ashton. 'Don't expect a letter for three days,' he warned his mother, 'as it is impossible to write when one is with Leigh. He keeps one on the run all day.' Clark had first met Ashton at Winchester, when he was already on the staff of the V&A, which he would one day direct. He was a flamboyant showman who had a creative rather than a scholarly mind, and like Clark he possessed a vast appetite for works of art. Together they toured Germany, and made subsequent trips to visit collections in Paris and Brussels. The greatest revelation in Germany for Clark was his discovery of the Baroque and Rococo, and he confessed that he was 'so bowled over by Nymphenburg that forty years later I gave it too much prominence in the ninth programme of *Civilisation*'.[32]

In the last letter he wrote to his mother from Dresden, he broke some important news: 'I return to England, then … I must go down to Oxford to see Charles [Bell] and my tailor; also to Newbury to see Jane … as you know Jane and I are completely devoted to one another and I must see as much of her as I can. When you wrote that I was not in the least in love with her, I didn't contradict you … However I have been in love with her

* Alois Riegl (1858–1905), Austrian art historian whose masterpiece *Spät-Romische Kunst-Industrie* was to greatly influence Clark. Heinrich Wölfflin (1864–1945), Swiss art historian who taught in Germany, writing major books concerned with form and style in Renaissance and Baroque art.

for about two years now, and extraordinary as it seems she has with me …
I think that unless anything unforeseen occurs we shall eventually get
married. I have no gift for falling in love and am not likely to do so again.
Nor am I ever likely to find anyone with whom I have so much in common.'
For whatever reason, he had convinced himself that his father would be
against the liaison, and told his mother: 'He must realise that I am, unfor-
tunately very different to him; bachelor joys, parties and late nights and
good fellows have no charm for me. I am the least "clubbable" of men and
if I am not with intimate friends or at home I am alone; and I hate being
alone. Try and impress on him that Jane would be a companion to me …
My dear, I look forward to seeing you again more than I ever remember. I
have enjoyed Dresden, on the whole, but I was not cut out for an exile.'[33] It
is significant that Clark's love for Jane had grown under conditions of
distance. He was away much of the time; and Jane was already engaged –
both factors that protected him from the pressures of expectation. Besides,
having promised Waterfield to look after Jane, Clark had every justifica-
tion for offering her his companionship and support. Perhaps this ambi-
guity also kept him from feeling self-conscious about their deepening
relationship.

The first question everybody asked in those days, when caste meant so
much, was, who is Jane Martin? She was an Irish girl, born Elizabeth
(always known as 'Betty' in the family) Martin, who changed her Christian
name at Oxford. She was brought up in middle-class Dublin. Her father,
Robert Martin, was a feckless businessman who never stopped showing
off. Clark called him an 'incredible old fake'. On the other hand, Jane's
mother, Dr Emily Dickson, who was ten years older than her husband, was
a distinguished surgeon who gave up her practice on marriage. There were
four boys in the family,[34] and Jane had a tomboy side when she was young.
Her parents eventually separated: her roguish father went to South Africa
to run the Durban Cricket Club,* and her long-suffering mother to
Tunbridge Wells, where economic necessity forced her back into medical
practice – Clark seldom saw her smile. Jane was sent to school in England
at Malvern Girls' School, from where she went to Somerville, Oxford. She

* 'Jane's father was a very charming man, but completely idle. Jane was fond of him and
indulged him, but he was a non-stop talker, which became rather a bore to us all.
Fortunately she found a way of sending him off to South Africa where he became secre-
tary of the bowls club in Durban, and no doubt could always find a wretched listener.'
Clark to Meryle Secrest, 27 August 1973 (I Tatti).

was naturally elegant and inclined to break the rules, both of which made her popular. Her academic career was undistinguished; she obtained a third class degree after retakes. Apart from her obvious and slightly gamine charm, Clark and she were both outsiders who would 'invent' themselves as a couple. Her father advised her always to subordinate her interests to her husband.

Clark's engagement to Jane entailed having to write an awkward letter to Gordon Waterfield in Egypt. He sent it from St Ermin's Hotel. According to Clark's account, Waterfield took the news philosophically, but a curious incident suggests otherwise. It happened almost at the end of Jane's life, during her long and unhappy final illness, when Waterfield came to live at Hythe in Kent, close by the Clarks' last home at Saltwood. One day, in conversation with Clark's daughter Colette, Waterfield pulled out of his top pocket the letter that her father had written half a century before. It was on four sides of paper, a smooth, self-justifying document which Clark had concluded with: 'in the end you will find that this is better for everybody'. It is clear that Jane's abandonment still caused Waterfield pain, as he turned to Colette and said with feeling, 'If only she had stayed with me, she would have never have got into this state.'[35]

6

BB

*[Berenson] wanted to respond to works of art as part
of an overall experience of life, and he hoped to describe
this experience, in all its complexity, as the unifying
element in the history of man's spirit.*

KENNETH CLARK, 'Aesthete's Progress'[1]

The story of Kenneth Clark's relationship with BB is one of enduring love
and ambivalence. 'The character of Mr Berenson,' as he once wrote, 'was
like the sharp ridge of a mountain running from east to west. If you stood
on the south side it was fascinating and, in his own words, life-enhancing.
If you went onto the north side there were aspects that made one very
uneasy.'[2] Clark generally experienced the south side of the mountain, but
at the time of his arrival at I Tatti Berenson was at the peak of his influence
in the art world, and success had made him bombastic and opinionated;
the north side often loomed. The fundamental difficulty was that Clark's
presence at I Tatti was based on a misunderstanding. Berenson viewed
Clark as an assistant who would undertake the revision work on *Florentine
Drawings*, a project that was as necessary as it was daunting. But Clark,
who was unlikely to be anybody's assistant for long – as Mary Berenson
soon realised – saw himself as a collaborator.

Berenson's remarkable story has often been told. Born in 1865 to a
Jewish family in Lithuania and brought up in Boston, he was an autodidact
whose education took place in the public library and at Boston and
Harvard Universities. His early interests were in Oriental languages and
literature. It was not until he went to Italy that he changed direction
and began his lifelong study of Renaissance artists. Berenson fell in love
with Italy, and poor as he was, travelled from one dusty village church to
another in pursuit of his work. It was in a café in Bergamo that he had his

famous epiphany to dedicate himself to connoisseurship, with 'no thought of a reward ... we must not stop till we are sure that every Lotto is a Lotto, every Cariani a Cariani'; he conceived his life as a sacred mission.

Connoisseurship has taken some hard knocks since Berenson's time – indeed, partly because of the financial rewards it brought him – but it has always been necessary to know who painted what, and this was especially so in the undeveloped field in which Berenson began to operate. He was building on the foundations of Crowe and Cavalcaselle,[3] and above all Giovanni Morelli, who had begun an analysis of the 'handwriting' of Italian artists. Morelli had studied comparative anatomy in Germany, and began to apply a similar scientific method of classification to the study of painting, through attention to details such as hands and drapery, in what critics called the 'ear and toenail school'. Berenson became the most famous practitioner of this approach, although he emerged as a singular kind of art historian. While British writers such as Walter Pater might describe works of art in literary terms, and Germans might attempt to analyse them, Berenson used his encyclopaedic knowledge to create accurate 'lists' of the corpus of Italian Renaissance artists. With the publication of these lists, and the influential introductory essays that went with them, Berenson's opinion became almost Holy Writ amongst dealers and collectors. Their appearance coincided with the unprecedented exodus of art from Europe to America, and Berenson's imprimatur was considered the most likely to be accurate in a field of speculative guesswork.

In 1900 Berenson had married Mary Costelloe, who came from a Philadelphia Quaker background. With what Clark called her 'Chaucerian common sense', Mary considered nothing more important than a home, stability and outward signs of success. Where her husband was exquisite, secretive and cerebral, Mary was large, impulsive, trusting and energetic. Clark described them together: 'Mr Berenson was small and nimble and the sight of them walking together in the hills reminded me of a solicitous mahout directing the steps of an elephant.'[4] Mary always needed money, initially to enlarge I Tatti and later to subsidise her children by a previous marriage. She strongly encouraged BB to use his talents commercially, although neither of them could have foreseen how lucrative this would become. The retainers and commissions he earned from art dealers, especially the ebullient Joseph Duveen,[5] for authenticating paintings made BB a rich man. Duveen was the most successful of all art dealers, by dint of his access not only to the sellers in Europe, but more importantly the buyers in America, which gave him a paramount position in that

extraordinary transfer of art across the Atlantic – facilitated by Berenson's passport.

The most visible manifestation of the Berensons' new affluence was the development of the gardens and the library at I Tatti. The interior of the villa still contains large, beautiful white rooms with touches of damask that set off BB's extraordinary collection of Renaissance paintings. The house remains comfortable rather than luxurious, a perfect retreat for a humanist scholar. At the heart of the house, and its main point, was the sombre library which some thought was BB's finest achievement; it is one of the best collections of art history books anywhere. Eventually I Tatti became as famous as its owner – the two became synonymous – and as Clark wrote: 'There are many more spectacular villas in Italy but none have played a greater role in the cultural life of Europe – and the United States – for over half a century'.[6]

The Berensons enjoyed a princely *train de vie* at I Tatti, with the support of a large staff. Every day distinguished or merely rich visitors would be invited up for lunch, while those of lesser importance came for tea. The responsibility for the guests would rest with Nicky Mariano, whom Clark described as 'one of the most universally beloved people in the world'. Nicky – 'half Neapolitan and half Baltic baron' – had originally been hired as BB's librarian and secretary. Many people fell in love with her, but she reserved herself for the Berensons, and never lost their adoration. She was the living embodiment of Berenson's favourite phrase, 'life enhancing'. Clark once said that the most genuine thing about BB was his love for Nicky. She oiled the wheels of life at I Tatti while Mr and Mrs Berenson pursued emotionally chaotic lives in different directions.

Mary especially liked clever young Englishmen; before Clark arrived, her sister Alys Russell had already introduced Lytton Strachey, Maynard Keynes and Geoffrey Scott to the Berensons. Scott was the author of *The Architecture of Humanism* (which was already a major influence on Clark's temporarily set-aside book on the Gothic Revival), and was to become a central figure in the Anglo-American Florentine world. Mary fell in love with this *homme fatale*, who became entrusted with much of the architectural work at I Tatti, while his partner, the architect Cecil Pinsent, oversaw the design of the formal garden. This contained box hedges and pebble mosaics, with cypress walks and ilex groves beyond. Both men were party to many of Mary's fanciful schemes – often accomplished in BB's absence, and the cause of Jehovah-like rages. Added to this *ménage* was Mary's brother Logan, who had his own room at I Tatti and remained a sardonic

observer. Logan's occasional funny stories would be dismissed by BB with, 'Dear me, what a smutty old clown Logan is becoming.' Another key member of the court was Umberto Morra,[7] a scholarly young literary friend whose anti-fascist views made him especially welcome, and who was to become a lifelong friend of Clark, and almost a son to Berenson. Finally, visitors included BB's numerous girlfriends, the most significant of whom was the exotic siren who ran the Morgan Library in New York, Belle da Costa Greene. BB would write to her with the same frequency with which Clark would later write to his own girlfriends.

The dependency on art dealers that underpinned the economics of I Tatti is generally credited with having distracted Berenson from writing 'the great book'. He left behind some brilliant fragmentary writings, including propositions about the nature of our responses to works of art with his 'tactile values', but the 'lists' with their introductory essays, especially *The Drawings of the Florentine Painters*, remain his most important art historical legacy. According to Clark's view, Berenson's disillusionment with his life choices was very evident by the 1920s, and he spoke surprisingly rarely about art. Clark wondered if distaste for the means of earning a living had not in some way put Berenson off the Italian Renaissance, for he studied – and talked about – almost everything else. His conversation at meals was customarily a monologue on history or literature. Typically, he might summarise the decline of Classical art, the rise of the Persian epic, the early history of the Scythians, and offer a warning about the evils of fascism. But it was on his afternoon walks, without a grand audience to show off to, that Berenson was at his best. Then he would talk about nature with a sensitivity which reminded Clark that underneath he possessed the soul of a poet, who had lost his way.

Why did Berenson take Clark on? A handsome, clever Oxford acolyte was always welcome, but there was a specific task in mind. As Clark put it, 'During these years collectors, dealers and students of art history were all clamouring for revised lists, and I don't see how Mr Berenson could have refused them.'[8] The 'lists' were by now very out of date, and a standing reproach to BB's own revisions and reputation; someone was needed to do the groundwork. The revised lists and the accompanying text would be much less fun to compile than the originals – no pilgrimages to fragrant valleys north of Bergamo, but instead a mass of dubious photographs: 'Those photographs!' said Clark. 'They were like a plague of flies which descended on I Tatti, driving everybody mad.'[9] Berenson proposed that Clark simply go and browse in the library, but the practical Mary set him

to work on Giovanni Bellini. Soon, however, he abandoned browsing and started in earnest on the revision of *Drawings of the Florentine Painters*. Graduating from the I Tatti library to the Gabinetto dei Disegni of the Uffizi, he found dozens of drawings not in the 'lists', but when he took his notes back to BB 'he was not much interested. He had done his work fifty years ago, and did not want to be reminded of it.'*

Clark fitted well into I Tatti. BB found him 'thorough and painstaking', and 'genial and loveable always consumed with intellectual passion'.[10] Mary wrote to her family: 'It is quite moving to see how Kenneth admires B.B. Nothing is lost on that boy, he is so marvellously cultivated that he can follow intelligently almost every path that B.B. opens.'[11] Clark did everything he could to be useful. I Tatti was much more than an education in art for him. Florence became an emotional centre for the rest of his life, and BB a father figure. At I Tatti Clark found for the first time a family and a community to which he felt he belonged. Many years later he wrote rather wistfully to Janet Stone, 'Celly† rang from Litton Cheney[12] and said "we are a little community", which gave me a pang, I would so much love to be a part of it. Perhaps I was part of the community of I Tatti, but never since.'[13] Charles Bell had been right to warn of the virulence Berenson expressed at every meal about friends and colleagues, especially Roger Fry, but Clark found this merely tiresome.

Soon after his arrival at I Tatti, Clark accompanied the Berensons with Nicky on a tour of Italian galleries. There were several adventures: in Milan he encountered Diaghilev; in Treviglio he was arrested for stealing a church treasure; in Brescia BB's shawl was stolen and returned after a priestly appeal from the pulpit; and in Padua they were entertained, to BB's pleasure, by 'a very great lady', the Countess Papafava. The local museums could be a trial, with their talkative curators and endless galleries of second-rate pictures. Clark probably sympathised with Mary's frustration as BB spent hours poring over unattributable paintings of the late Middle Ages that added no value to their enterprise. However, the trip was

* Clark, 'Aesthete's Progress' (John Murray Archive). Caroline Elam points out that this statement is very questionable – apart from the faulty chronology (this was 1926, and BB didn't start until the 1890s) – and perhaps reflects Clark's old-age view of the matter. BB had invested so much of his scholarly capital in the project that it is unlikely that he was not interested.

† Clark's daughter Colette.

aesthetically important for Clark. He began to glimpse BB's early fascination with the unpredictable Lotto, and was awed by 'the intolerable confidence of Titian'. But it was Giotto in Padua that made the most lasting impression. Confronted with the greatest storyteller in Italian art, Clark saw the pitiful limitations of 'significant form' and 'tactile values'.* In Parma, looking at Correggio, Clark describes 'another moment of vision which was to lie dormant in my imagination … a realisation of the ecstasy of martyrdom, which came to me before Correggio's picture of S. Placidus and S. Flavia. It was the moment I became capable of writing the chapter on the Counter-Reformation in *Civilisation*.'[14]

Mary Berenson mysteriously left the party to disappear back to I Tatti. On their return the reason became apparent. She felt that the unpretentious architecture of I Tatti needed something more assertive, and had instructed Cecil Pinsent in BB's absence to install a central clock on the garden façade. Berenson's invariable reaction to Mary's follies was to faint, take to his bed and demand their removal, but it was usually too late. Her elevated clock is still there, and much admired.

All the inhabitants of I Tatti were puzzled by Clark's romantic life – or the seeming lack of it. Mary had hoped he might marry one of her granddaughters, BB that he would find a great lady in Florence, but the suspicion dawned on the household that they had misunderstood his proclivities, and that Clark was drawn to boys. Mary, with her usual naïve optimism, decided that he should move out of I Tatti to share a house with the obviously gay Cecil Pinsent. 'Driven into a corner by this bizarre proposition,' Clark relates that 'I had no alternative but to come out with the truth, "Mary, I want to get married."'[15] This announcement, made in December, pleased nobody, as it would change the fragile dynamic of the I Tatti court. It was the end of the apprenticeship as the Berensons had conceived it, with Clark as the solicitous, ever-available bachelor.

Clark claims that after this conversation with Mary he wired Jane, asking her to marry him and proposing a date, 10 January 1927 – which suggests that they already had an understanding on the subject. She immediately wired back her acceptance. Mary, with her strong sense of family, set about finding a house that would be suitable for them when they returned together as a married couple. Clark wrote to John Sparrow announcing his arrival in England, but made no reference to the wedding.

* Two fashionable concepts at the time, the first offered by Berenson and the second by Clive Bell, to explain the aesthetic value of works of art.

This was characteristic of his peculiar attitude to the event: 'I shall be living at St Ermins for a few weeks trying to finish the Gothic Revival. Probably Jane will be living with me, but you must try not to mind that. I have a morbid dread of living alone out here.'[16] He left I Tatti after Christmas, and all that BB said when he went to say goodbye was 'I don't mind.' But he did, and he felt that Clark had betrayed him.

Clark had disengaged from C.F. Bell to work at I Tatti, and by marrying Jane he had taken the first step towards independence from Berenson. Although he came to have doubts about BB, Clark was always clear about his debt to him. He said it best in the *Sunday Times* piece he wrote on Berenson's death: 'His fear of pedantry made him unwilling to give the generations of young men who frequented I Tatti any sort of formal instruction. But I think we were his pupils: for at almost every meal, and on those unforgettable walks, our eyes were opened and our minds were filled. At first we might resent the hard knocks administered to local gods. But as we came to realise that neither Oxford nor Bloomsbury nor Cambridge Mass. had established the ultimate boundaries of civilisation, we found ourselves entering a larger inheritance. We were educated as few young men since the Renaissance ... for we learned to think of civilised life as catholic and apostolic ... and we came to believe that love of art is only a part of the love of life. I owe him more than I can say and probably much more than I know.'[17]

Clark's wedding was one of the oddest events he ever described. After leaving I Tatti, instead of going home to see his fiancée or help with arrangements, he went to Rome. The closest he got to a stag night was his last dinner in Rome, in the company of Lytton Strachey, the orientalist Arthur Waley and his partner the dancer and critic Beryl de Zoete. He arrived in London on the eve of the wedding, organised by Jane's mother, who had been supplied with his draconian instructions: no wedding dress, no bridesmaids, no reception and no church. He wanted the ceremony to take place in a register office, but Jane and her mother insisted on a church. It is perfectly possible that Clark had never actually been to a wedding before. The dismal event took place at St Peter's church in Eaton Square. Clark gave as his occupation 'art critic', the one thing he had assured his father he would not become. His former travelling companion Leigh Ashton was best man, and the few guests – consisting mostly of Clark family servants – dispersed after the service. The bride and groom had lunch alone with his parents at the gloomy St Ermin's Hotel.

Clark described the event to Mary Berenson: 'We were married in a hideous church – not even Gothic Revival. But it only took fourteen minutes, so I can't grumble. Everyone seemed satisfied except the pew opener who refused to believe that two such drab and youthful people could be bride and bridegroom. No organ, no champagne and only half-a-dozen handshakes: I call that a success.'[18]

Whatever was he doing? Clark claims that it was his mother's Quakerish fear of ritual that overcame him, but why did Jane – who loved all the things he denied her on her wedding day – put up with this? There is no clear answer. Clark could certainly be selfish, as Mary Berenson divined, and Jane was probably still in awe of his family.

After a few days spent at the St Ermin's flat (which his parents had given them as a wedding present) the newly married couple took the Florence section of the Rome Express to begin their new life.* Mary had arranged a home for them to rent at the Chiostro di San Martino, near I Tatti, which had a plaque in their bedroom to the effect that St Andrew the Scot had died there in 682. Adjoining the property was an attractive church in the manner of Brunelleschi. They inherited an experienced staff, and this would be the background to one of the happiest periods of their marriage. For Jane it was a time of learning about art under a natural teacher, and she entered her new world with the same gusto that she had displayed at Oxford.

But there was an alarming rite of passage to be faced, the thought of which made Clark feel ill: 'less than a mile away loomed two ogres' castles, I Tatti and Poggio Gherardo'. Would they be kind to Jane and accept her? Mary Berenson wrote to her husband from Bern with a report from her sister Alys in London: 'she likes Kenneth's Jane who is neither dressy nor smart … I think our policy is to make the best of it, while it lasts, and not speak against either of them. What we say will inevitably come round to them … I hope we can be good friends to him, even if we don't get what we too hastily imagined we should get.'[19]

The first visit was to Poggio Gherardo. It could hardly have gone worse. Aunt Janet was no doubt prejudiced against Jane for breaking off her engagement with her great-nephew Gordon Waterfield, even though his family had never thought her good enough. 'The old dragon in her best Ouida form, would not speak to Jane at all,'[20] and Clark decided to leave

* According to this letter (Cumming (ed.), *My Dear BB*, p.12), Clark was planning to take Jane to Sospel. A less romantic place could hardly be imagined.

the house rather than have a row, an early example of his habit of running away from confrontation.

Initially, the visit to I Tatti went no better. BB put Jane next to himself at lunch, and then proceeded to talk across her in Italian and German, two languages she did not understand. The fact that this was normal behaviour for Berenson was lost on Jane, who was understandably upset and never entirely got over it, even if she concealed her feelings well. What saved the situation was Clark telling BB the story of her reception by Aunt Janet. This stirred some chivalrous emotion in him (and perhaps some guilt), because he 'put on a tail coat and silk top hat and went up to Poggio Gherardo to administer an official rebuke'.[21] Clark wrote untruthfully to Mary about the visit: 'Most charming of all was B.B. Jane finds, as I do, that he is not in the least awe inspiring, and that however much one may admire his wonderful intellectual qualities, he is essentially friendly and lovable.'[22] Mary later reported the I Tatti view of Jane to Alys: 'She has absolutely *nothing to say* although she is very sweet and always *looks* interested.'[23]

Clark thought the early days at Chiostro di San Martino were their happiest. He was engaged in interesting work, and enjoyed showing Jane all the sights of Florence, 'skipping from picture to picture, from chapel to chapel, in a frenzy of excitement'. Friends came to stay, and were taken up to be presented at I Tatti, firstly John Sparrow and Maurice Bowra. Bowra was a failure, as there was only room for one magus in that court. Cyril Connolly was better received, but his description of Berenson was ambivalent: 'He talks the whole time and drowns everybody else, and though he has enormous and universal knowledge and is excessively stimulating, half his remarks are preposterously conceited and the other half entirely insincere.'[24] He left an equally good account of staying with the Clarks: 'K is rather easier with Jane added though a bit dogmatic and garrulous before the set of sun. It is a passably nice house with a passably nice view and a good chef and I like the life with its daily drive to some church or gallery or neighbouring town and the Berenson menage looming over like the Big House to the agent's cottage.'[25]

The Clarks took the opportunity of being in Italy to go travelling. They visited Venice for the first time. Charles Bell had advised arriving by the slow boat from Padua so they 'saw Venice rising out of the sea as Ruskin and Whistler had seen it'. Clark shared his impressions with Connolly: 'it is certainly a moving though it can hardly be an intimate experience. It seemed to us barely credible, like New York.' Equally vivid would be their

drive home through France: 'It was a great delight to be out of Italy and we saw many wonderful things. I think Vezelay unsurpassed, don't you? And Autun very little less good.'[26] These were later to be two important locations of the third programme of *Civilisation*.

But before that, the cataloguing, measuring and checking of *Florentine Drawings* continued, and although Clark was beginning to find the work laborious, he was enjoying the life. One day he mentioned to Jane that he would drop *The Gothic Revival*. She was shocked at the suggestion, and told him he mustn't give up at this point. There is no doubt that she saved the book, and she became his typist and his first critical reader. Jane always had a great respect for the printed word, and spent much of their later life trying to persuade her husband to write more books rather than make TV programmes. They arranged to spend the summer in Oxford so that he could finish the book.

While Clark was at Oxford, BB came to England and they visited the Ashmolean Museum together. Clark wrote to Charles Bell from St Ermin's to say how sorry they were to have missed him, and described his first impression of the Royal Collection: 'Today we have been to Buckingham Palace. It is just what one would expect – like a bad station hotel and the pictures abominably hung. We had the Titian landscape down and it is a very wonderful romantic thing – surely one of a series; if the others could only be found! The Duccio, of course, you know well. There are many other attractive Italian things but the Rembrandts are wonderful; and what a Claude – and Rubens!'[27]

In August Jane and Clark went to Shielbridge, which she disliked as much as he did. Their daughter Colette later said that her mother regarded it as 'the un-chicest place on earth', and never returned. Although Scots himself, Clark always found his countrymen rather hard to take.* That autumn it became apparent that Jane was pregnant, and she went to stay with her mother in Tunbridge Wells, while Clark travelled to Paris. He wrote to her setting out their finances: 'Most beloved wife … My bank balance is certainly good … £600 in deposit for the spring which will pay

* Years later he told Janet Stone: 'The Scots are really *odious*, so noisy and tactless, no sense of privacy. They grasp one with one hand and point over emphatically with the other, and shout in one's ear. I loathe them – but I love Edinburgh, and I recognize that their lack of restraint is partly due to warm-heartedness.' Letter to Janet Stone, 9 August 1955 (Bodleian Library).

for the car and the baby (I put them in order of expense). By April I shall have got another £500 from Coats.'* In the same letter he described his visits to the art dealers, and echoed Berenson's ambivalent view of Picasso: 'I became very disconsolate till I reached Rosenberg. He really has some fine things ... £10,000 for each of his big Picassos and £9,000 for his Douanier Rousseau. They *are* good things. The Picassos are abstract designs but really very fine as such. *Pout!* He says he will not sell his 25 finest Picassos at *any* price because they will soon become so much more valuable. O that I may live to see what happens when this craze ends. What fools they will look! What fun it will be! The pictures are not only dear ... yet alas, there is something in his work ... I think of you all the time, and sometimes it comes in waves and leaves me breathless still. K.'

The desire for their child to be born in England precipitated the gradual closure of the I Tatti chapter of Clark's life. It stumbled on until early 1929, when Mary wrote to Alys: 'K would like to get out of it and B.B. would like him to, but none of us ... dare to put in our oars. B.B. feels sure that K cannot help him, as he needs careful scholarship and not pretty writing ... K had said to me that he loathed the pettifogging business of correcting notes and numbers ... But all he wants out of it is, I fear, whatever kudos he will get from the association. He has an ungenerous self-centred nature, and B.B. needs devotion.'[28] She was essentially right: if Clark was going to do any pettifogging scholarly work, he would prefer to do it on his own account. Clark, however, looked back with profound gratitude at his time spent at I Tatti. As he later wrote to BB, 'the greatest debt is emancipation from various intellectual fashions of the time. If I had never gone to I Tatti I should certainly have been bound apprentice to Bloomsbury – or perhaps never moved beyond Oxford.'[29]

The remarkable thing about the Berenson–Clark relationship is that it not only endured but deepened once the shackles of *Florentine Drawings* were removed, and they were on more equal terms. Berenson recognised that Clark had administrative and writing skills that he personally did not possess, and suggested that he had 'a certain faculty for seeing things vertically instead of horizontally', adding, 'that is what you should cultivate.'[30] He watched the progress of Clark's career as an admiring schoolmaster might a slightly wayward pupil. If Clark craved BB's blessing, the older man asked for, and never felt he received, affection and love in return. In

* Clark was to depend on shares from the family cotton business, Coats, all his life. Letter to Jane, 10 November 1927 (Saltwood).

1937 he wrote what he called 'a cry for the goodwill, and cordial confidence that I miss to a degree that amounts at times to real unhappiness'.[31] All Clark could answer was that he 'came from an undemonstrative family and my feelings are as stiff as an unused limb'.[32] He confessed to his friend John Walker that he was never entirely at ease with Berenson, and towards the end of his life he became critical of his commercial shenanigans. BB, for his part, on a walk one day with one of his pupils, Willy Mostyn-Owen, stopped 'and turned to me and said regretfully "I love K, but, you know, I am not sure if I like him."'[33]

Berenson's imprint remained all over Clark. He was always to see things in terms of their origins, which he learned from BB. They both harboured lifelong ambitions to write 'the great book', which by their own lights neither achieved. They both adored women and cultivated sentimental attachments, occasionally even pursuing the same prey. Later in life Clark would spend the evenings as Berenson did, writing to his current amours. Saltwood in the eyes of many was Clark's own I Tatti – when his son Alan was first taken up to Settignano and saw the familiar combination of Renaissance pictures and bronzes with Eastern works of art, he exclaimed, 'Now at last I understand Papa.'[34] Both Clark and Berenson had a love–hate relationship with their own tribe, and both believed (probably wrongly) that they had steered away from their true path – in Clark's case pure scholarship. Their differences were as striking as their similarities. Clark devoted much of his life to administering the arts, mostly *pro bono* committee work. Berenson had no such compulsion, although he left I Tatti with its art collections and library to Harvard for use by scholars. He never gave a public lecture in his life, whereas this became the lifeblood of Clark's reputation. Berenson once prophetically said that Clark would not be able to resist the wish to become '*un grand vulgarisateur*'.[35] What he would have made of *Civilisation* nobody can say – yet by his range and his example he was in many ways responsible for it.

7

The Gothic Revival

'Blessed are those who have taste,' said Nietzsche,
'even although it be bad taste.'

Quoted by KENNETH CLARK in *The Gothic Revival*[1]

Kenneth Clark's first book, *The Gothic Revival*, was completed on almost exactly the same day that his first child was born, 13 April 1928. Jane had been taken to hospital the night before, and at first all seemed well. However, it turned out to be a difficult birth on account of the baby's enormous head, and Jane suffered accordingly. Clark made light of the matter when he wrote to Mary Berenson: 'I believe she is much better today, though still stiff & weak. As for the baby, no one seems to bother about it, so I presume it is perfectly normal. It seemed to me abnormally ugly, but people with more experience assure me that it's beautiful. School of Baldovinetti, anyway, and very close to the one in the André picture.'[2]

The baby was christened Alan Kenneth Mackenzie Clark, and to everyone's amusement 'hiccoughed gently while we gave solemn promises that he would shun the flesh.'[3] Alan certainly never heeded this undertaking. His godparents were two of Clark's Oxford friends, Bobby Longden and Tom Boase,[4] the latter a curious choice who does not even rate an entry in Clark's autobiography. He and Boase had met at Sligger Urquhart's chalet, and perhaps Boase's mild, uncompetitive character – Maurice Bowra later ridiculed him as 'a man who has no public virtue and no private parts' – made him an acceptable choice of godfather to Jane, who may have been alarmed by the alternatives.

The boy was taken back to St Ermin's Hotel. It was not until the following year that the Clarks bought their first house, at 56 Tufton Street in Westminster. This joyless dwelling, paid for by Clark's father,

was furnished with many of the heavy left-over pieces of furniture and pictures from Sudbourne. Clark wrote with his usual breeziness to the Berensons: 'This house is very much to my taste. The decorations are quite unadventurous, and of a kind most unpopular just now – mahogany furniture & large gold picture frames of the kind called Edwardian. But I grew up among such surroundings & would not be comfortable in the shiny rooms now fashionable ... Jane is very well, despite a great deal of work and worry ... Our first experiment in servants was a failure, the cook refusing to attempt an omelette, owing to the complicated nature of the dish.'[5] Jane had their bedroom redecorated with William Morris wallpaper – this was to become a feature of all their future houses – and Kenneth commissioned the then comparatively unknown Bernard Leach to make tiles for a fireplace. He hung his drawings in the study and bragged to the Berensons, 'They include an enchanting Correggio & a ravishing Beccafumi which I managed to snatch out of the teeth of the dealers here. Soon I shall believe I own Leonardos & Michelangelos.'[6] Despite having a setting for their things, neither of the Clarks liked what he later referred to as 'a nasty little house in Westminster', and within a year it was sold.

The Gothic Revival was published the following year by Constable, a firm recommended by Logan Pearsall Smith.[7] Its genesis was the result of C.F. Bell compiling material on the subject for a study of the ethics of the Revival. He had a habit of collecting notes which he would sometimes hand over to a favoured pupil, and had offered the idea, along with his notes, to Clark for presentation as a B.Litt. to enable him to spend a fourth year at Oxford. The university was still overcrowded owing to the after-effects of the war, and the board of studies required reassurance that Clark would stay the course. Bell, who had volunteered to act as his supervisor, duly told the board that Clark was a serious student and would not default.[8] Part of his later bitterness about Clark arose from the feeling that he had cavalierly tossed the B.Litt. to one side, thus causing him embarrassment with the board and 'concealing the circumstances in which [the book] was in the first instance undertaken'.[9] Bell's weariness with Clark is well expressed in a letter to Berenson: 'I have my own causes of complaint against K; but I am quite sure that my genuine admiration for him – the sort of admiration which can only be felt by an elderly mediocrity for a young being from whom so much is to be hoped – and his gratitude to me (as exaggerated as it is) for suggesting lines of thought ... I have lost more friends through marriage than through

death.'* Despite Bell's spiky possessiveness, Clark tried to maintain a cordial relationship and dedicated the book to Bell, who made an unsuccessful request to the publisher to have the dedication removed from later editions.

Very little had appeared on the subject since Charles Eastlake's *The History of the Gothic Revival* in 1872, and Clark thought that this was because the movement 'produced so little on which our eyes can rest without pain'.[10] His Introduction was an apologia for writing about the topic at all, and this ambivalence runs throughout the book. When he set out to write *The Gothic Revival* he was infected by what he called 'Stracheyan irony', and his approach to the subject was one of amused tolerance. It should be pointed out that he had no architectural training of either a practical or a historical kind. The truth is that he knew so little when he started, and learned so much in the course of writing, that he was 'unconsciously persuaded by what [he] set out to deride'.[11] Unfortunately, at the very moment that he began to see real merit in the buildings of the movement, he lost his nerve. Yet the book is not so much about architecture as what he called the 'ideals and motives' of the Gothic Revival – it is subtitled *An Essay in the History of Taste*. Clark set out to explain in literary and psychological terms the source of the movement and its development towards an ethical and moral purpose. The book was conceived as a literary work, which Clark believed suited the subject, pointing out that 'every change in form [is] accompanied by a change in literature which helps the writer in his difficult task of translating shapes into words'.[12]

The Gothic Revival opens with chapters on literary and antiquarian influences on the eighteenth century: ruins and Rococo from the capricious Strawberry Hill to the fallen legend of Fonthill Abbey. Clark later judged these chapters dull, as he had not yet shaken off the B.Litt. thesis manner. The second, more complex, half of the book deals with the battle of styles and the polemical controversies that followed. It was in his unravelling of the complexities of 'Ecclesiology',[13] and his account of the two towering apologists of the Revival, Ruskin and Pugin, that everybody agreed that the book was brilliant. Clark had started out with a baleful view of Pugin. In the course of his researches he asked the Keeper of Prints

* Letter from C.F. Bell to Mary Berenson, 2 June 1927 (I Tatti). An undated letter (c.1927) to Berenson provides Bell's view of Jane Clark: 'I wish he had made a better marriage. I do not like his wife, she is sly and insincere.' He did, however, like to emphasise Jane's role in saving, typing and reading *The Gothic Revival*, perhaps as a way of underlining her husband's fickleness.

and Drawings at the V&A about some Pugin drawings: 'I am ashamed to trouble you over works so devoid of merit. But Pugin, whatever he was as an artist, is an overwhelmingly important figure in the history of taste. He is, as it were, a Haydon who succeeded – unfortunately for us. We mayn't like the Gothic revival churches which confront us at every bend in the road. But it is worth trying to find out why our fathers did.'[14] But he gradually came under Pugin's spell, and realised that even if his works were sometimes disappointing he was a genius of sorts. Later he was to write: 'There are lots of errors in the Gothic Revival, and even more omissions, but … the real point of the book is the discovery of Pugin.'*

Anybody who looks at Clark's book for a description of the movement's great buildings – Barry and Pugin's Houses of Parliament apart – or for an account of its great architects will be disappointed. Gilbert Scott features as a rather cynical, commercial figure whose merits Clark did not at that time sufficiently recognise.† As for Butterfield, Waterhouse, Burges and Street, they are barely mentioned. It was only as he was completing the book that the quality of their work dawned on Clark, as he later admitted when it was republished: 'I was not sufficiently sure of my ground. I felt fairly certain that Street was a great architect but could not say why.'[15]

As mentioned earlier, Clark had been much influenced by Geoffrey Scott's *The Architecture of Humanism*, a then fashionable book which attempted to expose Victorian architectural fallacies under the headings 'Romantic', 'Mechanical', 'Ethical' and 'Biological'.[16] Clark applied Scott's fallacies to the interpretation of his own subject, and posited a false antithesis between Pugin and Scott. This was pointed out in an otherwise admiring review by the architect Harry Goodhart-Rendel, the most sensitive and knowledgeable contemporary interpreter of Victorian architecture. His 1924 lecture at the RIBA had been a stepping stone towards understanding the movement, and Clark referred to him as 'the father of us all'. He gently took Clark to task for believing that there is a rule of taste.[17]

Despite its limitations, *The Gothic Revival* was a successful, pioneering and much-admired book, not least for the elegance of its prose, and is still read with pleasure today. The brilliant young critic John Summerson

* Letter to G.M. Young, 29 June 1949 (Tate 8812/1/2/7235). Clark erroneously believed that Pugin was entirely forgotten, and was unaware that Hermann Muthesius had written about him in *Die neuere Kirchliche Baukunst in England* (1900).

† 'One great difference between Gilbert Scott and ourselves: he believed that he built very good Gothic, we that he built very bad.' (Clark, *The Gothic Revival*, p.182.)

described it as 'a small, exquisite and entirely delightful book',[18] and the architect Stephen Dykes Bower called it 'a very good book', but regretted its failure to deal with the main architects: 'the missing quarter is the most important. Mr Clark has gained the ramparts; and had his courage mounted with the occasion, he might have stormed the citadel'.[19] The *TLS* was equally admiring: 'Mr Clark's insistence on the scenic value of the Revival is one of the acutest points in the book. It allows him to try in the court of the picturesque works that would suffer if brought before a strictly architectural tribunal'.[20] What these reviews reveal is how timely the book was. Today it can be seen as part of the neo-Victorianism of the 1920s: John Betjeman, Osbert Lancaster, and Christopher Hussey's important book on *The Picturesque* published in 1927, and perhaps even a distant relative of the whimsical Victorian revival of Harold Acton and Evelyn Waugh.

When the publisher Michael Sadleir[21] proposed a new edition of *The Gothic Revival* in 1949, Clark reopened the book after a twenty-year interval and responded, 'I expected to find the history inaccurate, the entertainment out of date, the criticism relatively sound. But it is the criticism which has worn least well'.[22] It was republished in 1950, and the *TLS* ran a leader welcoming it, but pointing out its inherent contradictions. Clark did not change the text, which he felt was a period piece, but added some self-lacerating footnotes, two of which will give a flavour:

> Text: King's College Chapel is not completely successful and would be less so if it were a church and stood alone.
> Clark 1949 footnote: *I forget now why I thought it grand to be so critical of King's College chapel.*

> Text: The result is a series of erosions and excrescences, breaking the line of our streets, wasting valuable ground space, and totally disregarding the chief problem of modern civil architecture.
> Clark 1949 footnote: *This is the stupidest and most pretentious sentence in the book. I knew little enough about 'modern civil architecture', but if I had stopped to think for a second would have realised that the beauty of all towns depends on the 'waste of valuable ground space'; and I had not to go further than Oxford High Street to see what beauty a street can derive from its line being broken by erosions and excrescences.*

Clark's autobiography states that 'having delivered the book to a publisher … I was free to turn back to my true centre, Italian art', and implies that

he went straight to Leonardo da Vinci.[23] But in fact he contemplated and toyed with a number of very ambitious projects which reflect his continuing admiration for Austrian and German art history and his desire to emulate Riegl and Wölfflin. He described one to his mother: 'My imagination is fired by the great subject which I have long been starting and I now definitely approach – The Classical Revival.'[24] He was still nominally collecting material for Berenson, and tried out one suggestion on his mentor: 'Of course work for the Florentine Drawings cannot consume all my time … Many plans have occurred to me, the most ambitious and the one which seems to me most worth doing is some study of the conflict between classicism & baroque which seems to have absorbed the Italian spirit during the late 16th & early 17th century. I should like to put Raphael & Michelangelo into two slots at the top and see them come out Poussin and Rubens at the bottom … Do you think it is worth attempting?'[25]

The project he outlined never developed, although he was later to show a parallel interest in the conflict between Neoclassicism and the Romantic Movement. However, there was another idea that was to tease Clark for the next fifty years. A notebook in his archive, dated 1928, reveals the beginning of a lifelong obsession with what he believed would be his 'great book', to which he frequently returned: *Motives*. The cryptic note reads: 'write a Study in the History of Ornament tracing the change of character in various well known motives. By taking the history of one motive, one is able to concentrate on changes of form. The ornaments must have had at least three incarnations – Classical, Medieval & Renaissance … & Oriental, Baroque & Modern. Collect subjects beginning with: 1. Mermaids 2. Greek masters [?] 3. Horses & chariots etc.'[26] The project, which owed much to Riegl, was an attempt to interpret design as a revelation of a state of mind, and changes of style, as for example that from the Classical to the early medieval, not as a decadence but as a change of will.[27] By examining a recurrent theme he hoped it would be possible to express the unity of form and subject – the essence of a work of art. Clark returned to *Motives* at various points of his life, notably when he was Slade Professor, but confessed in his autobiography that 'I had neither the intelligence nor the staying power to achieve such an ambition, but it has haunted me ever since, and although I have not written my "great book" I know what kind of book it ought to have been.'[28] *Motives* was even to become one of his principal arguments against making *Civilisation*.[29]

* * *

In May 1929 Berenson finally decided to drop any pretence about his rela-
tions with Clark. He wrote from Baalbek in Lebanon: 'I think I must let
you know after having thought it over as well as I know how, I have decided
that we had better give up our plan of collaborating on the new edition of
the Florentine Drawings … I shall need not a collaborator but an assistant
… It would be absurd to expect you to leave house and wife and child and
friends to devil for a cantankerous old man … I want you to believe, dear
Kenneth, that it is to save our friendship that I am giving up our working
together.'[30] Once he had recovered from the initial upset, Clark would have
realised that Berenson was right. Besides, he was about to embark on a
great adventure in the London art world, and one of which BB would not
approve.

The Italian Exhibition

What a horrible affair the whole thing is! I wonder if ...
Italian friendship is worth the risk?

LORD BALNIEL to Kenneth Clark[1]

On 18 December 1929 there sailed into the East India Docks in East London the greatest cargo of art ever brought to Britain's shores. The priceless hoard of over three hundred works – paintings, sculpture and drawings – was placed in the hold of a single boat, the *Leonardo da Vinci*, which made its way from Genoa through winter storms off the coast of Brittany to London. With it came Kenneth Clark's first great opportunity in the London art world: his involvement in the extraordinary exhibition of Italian art that opened at the Royal Academy on 1 January 1930.

The exhibition's aims were shamelessly political – it was an attempt by Mussolini to promote *italianita*, or what Francis Haskell, in his entertaining account of the saga, described as 'Botticelli in the service of Fascism'.[2] With enthusiastic support from Il Duce, the loaned works of art were of a quality and importance inconceivable outside a fascist state. They included virtually every major painting that was judged safe to make the journey from Italy to London: Masaccio's *Crucifixion*, Botticelli's *Birth of Venus*, Giorgione's *Tempesta*, Titian's *Portrait of an Englishman*, and the pair of portraits that had brought Clark to his knees in the Uffizi, Piero della Francesca's *Duke and Duchess of Urbino*. The irresponsibility of consigning so many of the world's art treasures to such risks was widely condemned at the time. 'Naturally,' wrote Clark, 'all right thinking lovers of art were horrified by this piece of vandalism – none more so than Mr Berenson.'[3] So why did Clark become one of the principal organisers of the exhibition? It was an irresistible opportunity to catalogue some of the greatest paintings in the world that no ambitious young man could forgo.

The idea of the exhibition had in fact been born in Britain. During the previous decade a series of successful London exhibitions, each with a different national theme, had been held at the Royal Academy: Spanish paintings, Flemish art, and Dutch art. The last two were not actually organised by the Academy, which levied a rental fee for the use of its galleries. These promising precedents gave Lady Chamberlain, the formidable wife of the Foreign Secretary, Austen Chamberlain, the idea for an even more ambitious exhibition of Italian art. She and her husband were enthusiastic Italophiles, and it was her vision, energy and connections that brought the exhibition into being. It came, however, at a shocking cost in strained relationships between the two countries.

All started reasonably well. Lady Chamberlain and the collector Sir Robert Witt[4] put together a committee in the second half of 1927, which elected her as chair. The historical range of the exhibition was agreed to be 1300–1900, mostly paintings, but also drawings, sculpture, manuscripts and ceramics. Loans – all chosen by a London selection committee – were sought from museums and private collections across Europe, but well over half would come from Italy. At the Italian end, Ettore Modigliani was appointed to organise the exhibition. His qualifications were excellent: director of the Brera Museum for twenty years, and Soprintendente delle Belle Arti of Lombardy – but his distinction was lost on Clark, whose aversion to bores got the better of him. He described Modigliani as 'a ridiculous figure by any standards and must have risen to high office by sheer volubility. He never stopped talking for a second, and hard-pressed officials must have given him anything he wanted just to get rid of him.'[5] Haskell, from an examination of Modigliani's life, thought this was an unfair caricature.

The support of Mussolini was crucial to realising the high ambitions of the organisers, which, Modigliani hoped, would *épater* the English and show that despite recent history, Italy was still a great lady.[6] Mussolini wanted to impress Austen Chamberlain, and brought enormous pressure to bear on reluctant Italian lenders, whether public or private, to accede to British requests. He personally intervened with the Poldi Pezzoli Museum in Milan for the loan of Pollaiuolo's *Portrait of a Lady*, which in the event became the exhibition poster. But the Italian leader finally lost his patience when Lady Chamberlain refused to take no for an answer over Titian's *Sacred and Profane Love* in the Villa Borghese. The British Ambassador in Rome informed her: 'It appears that Mussolini is thoroughly fed up with the question of the pictures and can't bear any mention of them.'[7] Any

good the exhibition might have done for Anglo–Italian relations was soon wiped out by the Abyssinia crisis.

The main problems for Lady Chamberlain and her committee, however, were domestic: the London art world was a political minefield. Roger Fry, one of the moving spirits of the exhibition, had for years been in a feud with Berenson (mostly over the *Burlington Magazine*, which Fry had edited), who was against it. Key figures on the committee, Robert Witt and Lord Lee of Fareham,[8] were regarded with contempt and dislike by their colleagues. Nor was Berenson alone in resisting the exhibition: Clark's other mentor, C.F. Bell, was fiercely against it. Not only did he think it irresponsible, but he had no wish to denude his newly arranged museum. Lady Chamberlain appealed unsuccessfully over his head to the Vice-Chancellor of Oxford University, and eventually a Tiepolo oil sketch was coaxed out of the Ashmolean. The Royal Academy, however, turned out to be by far the greatest obstacle. The organising committee was outraged when it demanded 50 per cent of all profits as well as a gallery hire fee. This turned into a long and bitter row. Then, to add to the committee's woes, the National Gallery refused to lend any of its paintings; but at least it provided what Clark referred to – *de haut en bas* – as 'an industrious official' named W.G. Constable to arrange the exhibition. The various hostilities gathered pace, so that by the time Clark was appointed to assist with the catalogue he described the situation as 'like a battlefield at nightfall. The principal combatants were exhausted and had retired to their own quarters, surrounded by their attendants; but their enmities continued unabated.'[9]

Clark's appointment by the committee to assist Constable was a sensible choice. He had the practical experience and prestige of having worked with Berenson, he had just enough knowledge of Italian collections, and, perhaps most important of all, was 'a new member of their circle who was not influenced by their old feuds'. The young man had a novelty value, and all the competing parties thought he was on their side. Clark had a chameleon aspect to his character which always enabled him to play with opposing factions, and this becomes very evident later in his career with his dealings with politicians from all sides. In practical terms his appointment to the Italian exhibition meant three things: he would sit on the selection committee, he would catalogue the pictures that came from outside Italy,[10] and finally he would be allowed to hang the exhibition. Very little is known about which members of the committee selected the paintings, or indeed what the exhibition looked like. Constable, with

whom Clark got on well, gave him a free hand. Clark wrote to Umberto Morra: 'As you may have heard I was inveigled onto the Italian Exhibition committee and I bitterly regret it. Besides annoying BB and causing some resentment among those of my elders and betters who are not on, it has meant a lot of co-operative work. It has however had an excellent result. It has pleased my parents who find it a recognizable form of success, and will acquiesce more quietly in my future inactivity.'[11]

Contrary to the impression he gave Morra, Clark was enjoying himself very much. Hanging paintings was his favourite activity, and to be given the opportunity to hang six hundred of the finest Italian pictures in the world was all he could ever hope for. He deliberately left Botticelli's *Birth of Venus* until last, and – having gathered everybody to watch – had the painting hauled up from the basement, enjoying the *coup de théâtre* as she slowly rose into the gallery. His main responsibility, the catalogue, he described as 'by a long chalk, the worst catalogue of a great exhibition ever printed'.[12] He blamed himself: 'I simply did not know enough.' He was momentarily overlooking the fact that at least five people had a hand in the catalogue entries. Haskell thought that retrospective guilt at his involvement in a piece of fascist propaganda so coloured Clark's judgement that he was misleadingly dismissive about his own capabilities, as well as those of his colleagues. Two of these colleagues were to become friends, one of them lifelong.

Clark always maintained that for him the best thing to come out of the Italian exhibition was his friendship with David, then Lord Balniel, later the Earl of Crawford. Balniel came from an ancient Scots family that had produced generations of cultivated art collectors and bibliophiles. The family art collection contained Renaissance paintings and works of art assembled by Ruskin's mentor, Lord Lindsay. Clark shared with his father a slight horror of aristocracy, but made an exception for David Balniel, who devoted much of his life to *pro bono* public service in the arts. Their paths were to remain entwined. At the time of the Italian exhibition, Clark thought that Balniel knew far more about the subject than he did.

The other friendship Clark gained through the exhibition was with 'that fascinating character, Charles Ricketts'.[13] Ricketts, the quintessence of the 1890s, was an apostle of beauty, an all-round artist, stage designer, illustrator and art collector. When visitors later compared the Saltwood Castle art collection to I Tatti, they might just as accurately have referred to the eclectic splendour of that assembled by Charles Ricketts and his friend Charles Shannon. It was a marriage of love and taste – Japanese prints,

early antiquities, drawings and paintings. 'Can one ever be too precious?' Ricketts once asked Clark, whose response was, 'Quite right.' Clark was always to have a soft spot for art collectors, and would put up with their eccentricities and egoism if they genuinely loved art. He was to write warmly of characters such as 'Bogey' Harris and Herbert Horne in his memoirs.[14]

The Italian exhibition was a fabulous success with the public. There were 540,000 visitors, and the press was enthusiastic. As a result Clark enjoyed his first taste of social cachet with London hostesses who were hoping for an invitation to a Sunday-morning private view. This also marked the beginning of his lecturing career – he gave his first talk, on Botticelli, at the Chelsea home of St John Hornby.[15] With his childhood love of acting and his teenage habit of soliloquy, lecturing came very naturally to Clark. But he was painfully aware that it encouraged 'all the evasions and half-truths that I had learnt to practise in my weekly essays at Oxford'. He often wondered if it would have been better had he never taken this direction – in which he would be so spectacularly successful – reflecting that 'the practice of lecturing not only ended my ambition to be a scholar (this might never have succeeded as I am too easily bored) but prevented me from examining problems of style and history with sufficient care'.[16] Paradoxically, he was soon to start work on his greatest scholarly achievement.

While organising the Italian exhibition, Clark heard a lecture in Rome that was to have a profound influence on his life and work. Given by a man he described as 'without doubt the most original thinker on art-history of our time', Aby Warburg,[17] it was delivered in German at the Bibliotheca Hertziana. Warburg liked to address one person when lecturing, and Clark was flattered that he 'directed the whole lecture at me'. It lasted two hours, and by the end of it Clark had glimpsed an entirely new approach to looking at works of art. In his words, 'instead of thinking of works of art as life-enhancing representations he [Warburg] thought of them as symbols, and he believed that the art historian should concern himself with the origin, meaning and transmission of symbolic images'.[18] This was very far from the formalism of Roger Fry and the connoisseurship of BB. Clark later said: 'His whole approach was entirely new to me, my knowledge of the German language was incomplete, and at the end of three hours I felt I had been riding in an intellectual Grand National. But it changed my life and I am eternally grateful.'[19]

Clark was deeply impressed by the possibilities this iconographical approach offered. It was particularly relevant for the interpretation of Renaissance art, with its dual freight of Christian and Classical symbolism. He began to ask very different questions in front of works of art. Until this point he had been preoccupied with the Berensonian questions of connoisseurship: when and where was this picture painted, and by whom? He now started to think more about the function of a work of art: why was it painted, what does it represent, in what circumstances was it painted, and above all, what does it mean? He later claimed that the chapter on 'Pathos' in his most admired book, *The Nude*, is 'entirely Warburgian'. But in the end aesthetics were too important for Clark ever to be an ardent student of iconography, and the elucidation of detailed symbolism came to bore him.

Clark's approach to art history was a synthetic and evolutionary affair, containing many elements, beginning with the poetic and descriptive literary inheritance of Hazlitt, Pater and Ruskin. He could already see the limitations of Roger Fry's analysis of design (or formalism), but we can still detect this influence when he came to write his book on Piero della Francesca. The residual artist in Clark was focused – in a rather French way – on the creative process, and why artists did things in a particular way. Years later he was to tell one correspondent: 'If my work has any value this is because I write from the point of view of an artist, and not as an academic'.[20] He did not give up connoisseurship, and went on playing what he called 'the attributions game' – this was to cause him much trouble in future at the National Gallery. He was never to spend much time in archives, and once claimed that in the field of Renaissance art 'the study of archives has made relatively little progress since the 1870s ... and if these heroes of the first age of accumulation are seldom remembered today, except by the writers of footnotes, it is because posterity draws a distinction ... between architecture and a ton of bricks'.[21] This attitude would raise eyebrows within the profession.

The most unexpected element of Clark's art history came from books he read in German – what he described as the historical interpretation of form and composition by Wölfflin, and Riegl's study of the art-will.[22] They brought a rigour and an analytical approach to Clark's work that is seen to best advantage in *The Nude*. German art history freed Clark from the world of Edwardian connoisseurs and Bloomsbury. Finally, there was his new-found Warburgian interest in symbols and subject-matter; but he was sometimes critical of this approach if taken to extremes, where the crudest

woodcut might be as valuable to study as a Raphael painting. He distrusted philosophical and metaphysical approaches to art history, and always steered clear of dogma, quoting Giovanni Morelli, who 'loved to tease the professors who, "preferring abstract theories to practical examination are wont to look at a picture as if it were a mirror in which they see nothing but the reflection of their own minds"'.[23] Clark told a teenagers' radio programme that the qualities of a good art historian are 'imagination, sympathy, responding to works of art, knowing how to use documents and telling the truth'.[24]

While in Rome, Clark had one other unforgettable experience: a sight of the strange, rarely seen, very late Michelangelo frescoes in the Cappella Paolina in the Vatican. These represent the *Martyrdom of St Peter* and the *Conversion of St Paul*, and reduced Clark to an uncomprehending loss of words. Jane broke the silence: 'They are tragic.' The sight of these frescoes haunted Clark for the rest of his life, and they became the centrepiece for his 1970 Rede Lecture, 'The Artist Grows Old'.

Clark was starting to spread his wings across the art world even before the Italian exhibition. When a group of art historians that included Herbert Read, W.G. Constable and Roger Hinks suggested a History of Art Society to publish original books on the subject in English, Clark was proposed as the secretary. But, as he wrote to his mother, they all had different aims: 'Constable is for scholarship, Read for philosophy, I for history,' adding, 'Personally I see no public that will swallow any chaff of German scholarship … I had a taste of pure scholarship last night, when I attended a meeting of the Society of Antiquaries, and it will do me for years. I would rather go to church.'[25] In fact, Clark himself was about to face the limitations of British interest in intellectual German art history when he gave two lectures at London University on his heroes, Riegl and Wölfflin. It was a chastening experience, as he told BB: 'They cost me infinite pains & were complete failures: only twenty people in a vast hall & of the twenty 15 were elderly ladies recruited by Jane. They neither heard nor understood a word, & my chairman greeted me at the end with the words "You don't really think Riegl a serious writer, do you." So ended the first effort to spread the gospel in Great Britain.'[26]

With the Italian exhibition behind him and the abandonment of *Florentine Drawings*, Clark needed a new project. 'I was prevented from dispersing my faculties,' he wrote, 'by [an] offer from the newly appointed librarian at Windsor Castle.'[27] Owen Morshead was an unusual courtier

– scholarly, funny and affectionate, he was much admired by George V because he had won both a DSO and an MC in the war. He had been impressed by Clark on his visits to the library to inspect the drawings ('he has an austere quality of mind', he told a friend[28]), and took an avuncular interest in his career. He had proposed the librarianship of the House of Lords to Clark, suggesting, 'I think your wings <u>must</u> have to be clipped a bit.'[29] Now Morshead offered Clark the chance to catalogue the extraordinary collection of Leonardo drawings in the Royal Collection. As Clark wrote: 'This was one of the most important assignments that could be given to a scholar, and it is almost incredible that it should be handed to an unknown amateur of 25 with no standing. Owen Morshead took a big risk.' 'But,' he added, 'I think it came off.'[30]

Clark published his first article on Leonardo, an essay in *Life and Letters*, in 1929.[31] This has two characteristics of all his later writings on the subject: the importance of understanding the wider intellectual interests of the man, and the necessity to demythologise him. He started work at Windsor the following year, and his catalogue took three years to complete. The mammoth task of researching and cataloguing six hundred drawings by the most diverse of all Renaissance artists should not be underestimated. There was virtually nothing to help him except a few unfinished nineteenth-century notes. It has never been established how the Leonardo drawings came to be at Windsor, but they were in the collection of Thomas Howard, Earl of Arundel, in the early seventeenth century, and by the end of that century are recorded in the Royal Collection.

Clark's catalogue was eventually published in 1935 by the Cambridge University Press, in a lavish edition for which Clark was paid fifty guineas. The Leonardo catalogue has always been his most admired work amongst the scholarly community. For the Leonardo specialist Martin Kemp, it set 'the British standard for such publications', within an attributional framework that has 'stood up to sustained examination incredibly well'.[32] Whenever critics have wanted to question Clark's standing as a serious art historian, his defenders have always pointed to the Windsor catalogue as evidence of his ability to produce impressive scholarship on one of the most complex and difficult assault courses the discipline can offer. Clark himself modestly called it 'my only claim to be considered a scholar'.

Meanwhile, the Clarks were so miserable in their Westminster house that they travelled as much as possible. They visited the hotel at Sospel, which was failing as a business but was still a source of pleasure to share with

their friends Maurice Bowra and John Sparrow. They even began house-hunting around Sudbourne, but Clark's parents made it clear that they would only buy them a house near London. A solution presented itself when the Clarks were invited for lunch by the British Museum drawings scholar A.E. Popham at Twickenham, beside the river. The house was 'full of reflected light and children', and its charms persuaded them to look along the Thames in West London – which was also convenient for Windsor Castle. They found a beautiful Georgian house called Old Palace Place, on the site of the Tudor palace of Sheen, on Richmond Green. Clark wrote to his father, 'I think I might get it and all the fixtures and a few optional oddments for £12,000 … I am so glad you liked the look of the house and I must tell you that I am truly grateful for your offering to give it to me. I know you say it is only reasonable to give me the money now rather than later, but not all fathers are reasonable with their son especially when their sons have done so little to deserve it. We should be very proud indeed to live in such a fine house.'[33]

For the first time the Clarks possessed a house where they could proudly receive visitors and entertain. They knocked through two first-floor rooms to create a long drawing room, with seven tall windows, in which they could display their growing art collection. They hung the walls with old red silk, and at one end placed the lion of their collection, 'a large heavy portrait by Tintoretto'. With the passage of time Clark came to feel this grand purchase was a mistake, and that the picture really belonged in a gallery. In future he was always to make a distinction between a 'gallery' picture and a 'private' one, and he eventually sold his Tintoretto.[34] He had already formed a group of drawings, many of them acquired from the Fairfax Murray estate in Florence, and these were placed in the downstairs sitting room, where French windows opened onto the garden. Many of these drawings were to remain with Clark all his life, and were on his walls when he died. His favourite was Samuel Palmer's Cornfield by Moonlight with the Evening Star, bought from the sale of the artist's son at Christie's in 1928, which was later credited with influencing Graham Sutherland.

The Clarks were delighted with their new house. Jane wrote to Bowra, 'your room is ready', and Clark told his mother, 'Even in the foggy weather Richmond is delightful … Lam stayed with us and took Alan for long walks.'[35] They started giving ambitious dinner parties. Clark described one of them to his mother: 'Our grand party was pretty good fun – less for me than for Jane who sat next to the PM [Ramsay MacDonald[36]] and got a lot out of him. I think you would like him, especially if you talked to him

about France … about France he rivals my Father.'[37] It was not only the great that they received. The young John Pope-Hennessy, then a schoolboy at Downside, has left an account of a visit: 'When I rang the bell at the Old Palace, the door was opened by a young man of extraordinary charm, confidence and suavity … he showed me his drawings. Would I like him to tell me who did them, he asked, or would I prefer to form my own impressions? I said I had rather be told … I felt then (and for some years afterwards) that he was everything that I aspired to be.'[38]

Clark was enjoying his work, and a routine soon established itself. Each day he would catch a train from Richmond station to Windsor, where he worked in the library till lunchtime. He would have a snack in a teashop and then take the train home, 'my pockets stuffed with notes'.[39] He expected this peaceful and happy existence to last for many years, until one day 'I received a telephone call from a character named Brigadier Sir Harold Hartley asking if he could call on me. It boded no good, and sure enough he came to invite me to become Keeper of the department of Fine Art in the Ashmolean Museum, Oxford.'[40]

9

The Ashmolean

*You certainly would be in clover to be in such
a toy-shop for grown-ups.*

BERNARD BERENSON to Kenneth Clark,
10 June 1931[1]

The circumstances of C.F. Bell's forced resignation from his position as
Keeper of Fine Art at the Ashmolean Museum by the university authori-
ties are unclear. Certainly he ran his department as a private fiefdom, and
was frequently obstructive to both students and collectors. Lord Lee of
Fareham was treated with such disdain by Bell that he switched the bequest
of his art collection from Oxford to London.* As early as 1928, Clark had
written to Berenson suggesting that Bell was 'thinking seriously of retir-
ing. So his great life's work of preventing people seeing the drawings in the
Ashmolean may be ruined. Much as I love him, it will be a good thing for
Oxford and students generally when a more liberal spirit rules the
Ashmolean.'[2] It was, however, not for another three years that Clark found
himself turning to BB for advice: 'I have been offered Charlie Bell's post at
the Ashmolean. I did not stand for it, partly because a friend of mine
named Ashton was standing, but apparently he and all the other candi-
dates have been turned down and they have come to me in despair ... I am
very much tempted, though it means leaving our lovely house and garden,
which really distresses me, as well as costing several thousand pounds.
Please forgive my bothering you, and let me know what you think.'[3]

The Ashmolean is the oldest public museum in Britain. It was given to
the university by Elias Ashmole in 1683 as a collection of curiosities, and

* The other side of the story was that Lee's promised bequest was conditional on his own
attributions being maintained, which Bell would not accept.

has grown far beyond the founder's imagining. In 1908 the museum was amalgamated with the University Gallery and went from strength to strength, augmented by gifts and bequests, many of them princely. The Ashmolean is a scholar's museum, 'a collection of collections' with a complex history of amalgamations and transformations. In Clark's time it was divided into two: an archaeological department with its own keeper, and a fine art department with outstanding Western and Oriental art, and – as we have seen – a particular strength in drawings. It was this keepership that Clark was offered. His department also housed the glorious Fox-Strangways collection of early Italian pictures, including Uccello's *The Hunt in the Forest*.

BB answered shrewdly: 'It is a most flattering offer. You certainly would be in clover to be in such a toy-shop for grown-ups … You would at the same time take a high rank among the dignitaries of a great university where so recently you were a mere boy … The advantages are so real, so splendid, & so alluring that you would – perhaps – do well to seize them. On the other hand the post will fix you down in the world of collectors, curators, dons … My dear Kenneth you still are so young that I venture yet once again – but positively for the last time – to ask you to reconsider what you are doing.'[4] Despite BB's plea, Clark accepted the position, explaining to him that it was 'partly that I should have, as you say, so many lovely toys to play with, and partly that it really gets me out of the Burlington world'[5] – by which he meant the London art world exemplified by the *Burlington Magazine*, Burlington House and the Burlington Fine Arts Club. He had seen this world at ugly close quarters during the Italian exhibition.

Clark's appointment to the Keepership of Fine Art at the Ashmolean was in some ways more astonishing than his National Gallery directorship, which was to come three years later. Oxford was a conservative place, where age and rank took precedence, and he was still only twenty-seven. Nothing is known about the reason for his appointment. It was welcomed by Bell – with whom Clark had not yet had his final break: 'I don't think I ever could have felt so happy and contented. It is far better than being followed by a son … for even in moments of the most soaring fantasy I never could imagine myself producing a son with your intellect and sympathetic temperament.'[6] At this stage Bell preferred to see the appointment as the result of his own patronage, writing acidly to the University Registrar: 'I cannot help reflecting that it is fortunate for the Museum that

the new Keeper happens to be an old Friend and Pupil of my own, so that the transfer of the duties will be as smooth and the interruption of business as slight as we can possibly make them by mutual give and take. Certainly the Visitors [i.e. the museum's trustees] have no reason to congratulate themselves for having brought about this happy coincidence.'[7]

Clark gave his reasons for accepting the post as 'vanity and filial piety'. As he later told an interviewer: 'I thought it would be nice for my parents to be able to say that their boy was doing something. Actually, they were faintly distressed, because it meant that I had less time to play bridge with them.'[8] With his usual sense of loss and regret, in his memoirs he described the appointment as 'the turning point of my life, and I am certain that I took the wrong turning'.[9] He believed that by accepting the museum post, 'administration would prevent me from writing the great books that I already had in mind'.[10] The divided man is a recurring theme of Clark's life; the constant dance between seeking the contemplative life when in the throes of action, and gladly accepting the return to action when he achieved it. It is doubtful if he would ever have been contented with one or other life – he needed the stimulus of both.

Letters of congratulation poured in to the new keeper.[11] Sydney Cockerell,[12] the director of the Ashmolean's sister museum, the Fitzwilliam in Cambridge, expressed the hope that they would be brothers in arms rather than jealous rivals. Ellis Waterhouse* wrote an enthusiastic letter, as did Maurice Bowra. The director of the National Gallery, Augustus Daniel, wrote to console Clark on having 'just got a good house that suits you and to have to scrap it and start afresh'. The architect Lord Gerald Wellesley took the same line, but added, 'what fun you will have among those thousands of drawings'. The collector Paul Oppé prophesied: 'I take it for granted that before long you will take on the National Gallery, a period at the Ashmolean will be the most useful preparation.'

Clark's immediate concern was to be allowed to finish work on the Windsor drawings, and to find a new assistant keeper who would make this possible. The trustees of the Ashmolean indulged him on both points. Bell, who left Clark twenty-one pages of closely written advice on all

* One of the keepers at the National Gallery just before Clark's time. He was considered by Clark to be the ablest of them, and he went on to have a distinguished career as director of the Barber Institute in Birmingham and as a writer on Italian and British painting.

aspects of the collection, ended his notes by encouraging him to appoint his own assistant. Sir Charles Holroyd put forward Teddy Croft-Murray and Ellis Waterhouse, two exceptionally clever young art historians, but as E.T. Leeds wrote to Clark, 'As you say, brilliancy is not wanted. A capacity for steady work, which doesn't shirk drudgery at times, is much more essential.'[13] The candidate he chose, I.G. Robertson, was later upset by Clark's description of him as one who, 'whatever his shortcomings as a scholar, was a wizard with old ladies'.[14]

The next priority was to find a new home. Clark wrote to Berenson, 'We are determined not to live in or too near Oxford & become involved in University Society – which means that grave of so many valuable abilities, University politics.'[15] They rented what he described as a featureless modern house with twenty acres and a good view over the Thames valley at Shotover Cleve for £15 a year.[16] Rather surprisingly, Clark wrote, 'on the whole we prefer it to Richmond, where we had bored ourselves with our own boasting. This house is nothing to boast about.'[17] Jane was by all accounts upset to be leaving Old Palace Place, which was rented out. Alys Russell was more enthusiastic, and called the new house 'a delightful white Italian villa with a lovely tame and wild garden'.[18]

One of the chief glories of the fine arts department at the Ashmolean is generally hidden – its drawings. These cannot be permanently displayed, but Clark was determined to show more of the rest of the collection. He started by rehanging the paintings, and was revelling in his new life, as he told BB: 'We have had a busy but an agreeable Autumn. I have enjoyed playing about in my toy shop, which really looks very pretty now. And I am delighted to find how little there is to do. Even though I have rehung the whole gallery I have had plenty of spare time. Most of this has been spent on my Leonardo Catalogue which is now almost finished … Charlie Bell is not returned to Oxford. I don't believe he ever will, as he couldn't bear to see the mess I was making.'[19]

The main problem Clark faced was a lack of gallery space. Soon after his arrival he wrote, 'unless some extension of the galleries is achieved, it will be absolutely impossible for the University to accept any gifts, bequests, or loans for oil paintings'.[20] A second problem was to find funding – during his tenure the keeper's office was run on a shoestring: in 1931 his entire department budget, including purchases, was £1,400. In order to pay for a new gallery to be built, Clark offered to advance the amount required to the university anonymously, which it was glad to accept. His

plans for the partial rebuilding of the museum caused the destruction of Bell's life work, the Fortnum Gallery; this was another black mark as far as Bell was concerned, and the final breach was near at hand. He vented his frustration with Clark to Berenson: 'I am afraid I shall never really *like* him or his wife … not because I am jealous or covetous, if I know myself in the least, but I have an instinctive turning away from the facile.'[21] To John Pope-Hennessy, an undergraduate at Oxford, Bell went even further: 'I stood behind Kenneth Clark on the platform of a bus this morning and could have pushed him off.'[22]

Clark made some very fine purchases for the museum, starting with two important works by Samuel Palmer, *Self Portrait* and the artist's first major oil, *Repose of the Holy Family*. But his boldest acquisition came in his second year. Piero di Cosimo's *Forest Fire* had been in the Italian exhibition, loaned from the collection of Prince Paul of Yugoslavia. Having no purchase grant, Clark paid for the picture with £3,000 of his own money, and then appealed to the National Art Collections Fund, which reimbursed the entire price.[23] He was later to describe it in his book *Landscape Into Art* as 'the first landscape in Italian painting in which man is of no importance'.[24] As Pope-Hennessy said at Clark's memorial service, 'How many undergraduates' imaginations must have been kindled by that painting since it was acquired?' It remains, with Uccello's *Hunt in the Forest*, the museum's most popular painting.

In addition, Clark acquired a *Virgin and Child* from the workshop of Botticelli that once belonged to Ruskin, and a purchase well ahead of its time – an elaborate Burges cupboard of which he wrote, 'though not acceptable to present-day taste it will always remain an important document'.[25] However, his favourite acquisition was not a painting but a 'ravishing' ivory of *Venus and Cupid* by Georg Petel, which may have been owned by Rubens. He also persuaded Lord Duveen to lend a *Resurrection* then attributed to Andrea del Castagno.[26]

Clark's tenure at the Ashmolean is still regarded as important. It could not be claimed that he was in any way populist, which might not have been particularly appropriate to a scholarly university collection, but 'he will be remembered for the brief period between August 1931 and December 1933 when, with his characteristic mixture of arrogance and energy, he transformed both the collections and their display'.[27]

One of the obligations of the keepership, which Bell had ignored, was the giving of lectures. Clark enjoyed this task. He also invited Roger Fry to talk on Cézanne, although sadly no record of his lectures survives. Given

Fry's recent rejection as Slade Professor, this invitation was seen as provocative in some quarters – especially by Bell. Clark described the visit to Berenson: 'We had Fry down to lecture in Oxford (in the face of bitter opposition) and he developed violent influenza which the doctor feared would turn to pneumonia. He was staying with us. We had to send away Alan and call in two nurses … we were fully prepared for him not to recover. However he did, in a fortnight. And no sooner had he left us than Jane had a motoring accident. She ran into a lamp post, when driving her small car, at such a speed that she upset the lamp post, and overturned the car. The car was smashed to atoms and it is a miracle that she came out alive.'[28]

The Clarks entertained a good deal at their new house, and according to Alys Russell kept a staff of ten. Isaiah Berlin recalled to Clark's daughter Colette, 'I used to be invited to marvellous evenings at Shotover, and there met gifted and delightful people by all of whom I was dazzled and some of whom were sympathetic.'[29] Jane was a perfect Oxford wife, entertaining Clark's friends and being charming to the elderly university grandees. In that world she cut a very striking figure. Edward Croft-Murray described her driving her car up to the main entrance of the Ashmolean and appearing in a round white hat and riding breeches, 'looking frightfully smart'.[30] Jane, however, was always more complicated than she appeared to be, and anybody who knew her well soon realised that she could adopt several very different personalities. She had a destructive side which became more apparent later in life, with frequent temper tantrums and a growing dependency on alcohol. The first manifestation of these rages took place one night at Shotover, when she made such a violent scene that Clark had to leave the house. He spent the night walking the streets of Oxford wondering whether he had made a terrible mistake in marrying her.[31] This was the beginning of a pattern of difficult behaviour. It was widely believed later that Jane's erratic temper was a response to Clark's infidelities (which had not yet begun), and no doubt they were a stimulant, but the Shotover episode suggests that long before there was any evidence of her husband's affairs, her personality was unstable.

Clark's ambitious book projects – other than the Windsor catalogue – had by now stalled, and he found a collaborator for what he referred to as 'a history of classicism in European art'. Roger Hinks was a highly intellectual art historian whom Clark later described as 'the rudest man in the world and *very* clever'.[32] (Hinks was later to take the blame for the contro-

versial cleaning of the Elgin marbles at the British Museum.) Clark char-acterised the plan – with echoes of Riegl and Wölfflin – as 'our Antike-Mittelalter-Renaissance project'. This was almost certainly *Motives* by another description. Hinks asked Clark to subsidise three years' research, but Clark's funds were fully stretched in advancing the money for the new gallery at the Ashmolean. In the meantime, Owen Morshead was already beginning to plot Clark's next move, writing in confidence to advise him that Charles Collins Baker would soon retire as Surveyor of the King's Pictures.[33] Ellis Waterhouse was generally considered the front-runner to replace him, but it is evident that Morshead preferred Clark.[34] In the event Collins Baker took a great deal longer to retire than Morshead expected, but it was a marker for the future.

During the autumn of 1932 it was family matters that took up most of Clark's energies. Jane was pregnant again, this time with twins, and his father's health had finally collapsed through cirrhosis of the liver. Clark had visited him in August at Shielbridge, where his father mistook him for his own brother, Norman, who had died thirty-two years before. Clark told Jane that he 'spoke much of his death and disturbed my mother terri-bly'.[35] By October, the time of the expected birth, his father was dying. Clark went north to be with him, rushing back to the nursing home in London for the arrival of the twins on 9 October, then returning once more to Scotland to be with his father at the end.

Clark's father lived to hear of the birth of the twins. 'That's good,' he said, 'but there'll never be another ...' He meant to say 'Alan', but *in extremis* muttered 'Roddy', the name of his ghillie. They were his last words. He died on 19 October, aged sixty-four. The widowed Alice Clark was inconsolable and, no longer able to repress the feelings she had bottled up for so long, became hysterical. As her son (who hated scenes more than anything) was to point out, her life's work was over. She had been left the Scottish estate, and now she relied on Kenneth to make all arrangements for her. The net value of his father's personal estate in England was £100,780, and in Scotland £414,830, which included Ardnamurchan and no doubt his Coats shares. He left his son the income from £100,000 in trust, and his personal effects. Clark already had an income of £2,000 a year from Coats shares that his father had given him.[36] While he was never as rich as people believed him to be, it is possible that Clark could have maintained his lifestyle (including the acquisition of works of art) on this income, combined with his salary and his father's

bequest. He was also soon to receive further capital funds from his mother's share. The only contemporary reference to his father's will comes in a letter from C.F. Bell to Berenson in the sneering tone that he now adopted when referring to his old pupil: 'I have heard nothing direct of the K. Claques but he is announcing that he has inherited 5 houses and no money.'[37]

The arrival of the twins caused a minor sensation. Clark went to lunch on the day of their birth with the hostess Lady Cunard.[38] Feeling understandably elated, he bounced into the room announcing, 'Emerald, we've just had twins.' 'Oh Kenneth,' she replied, 'how wicked of you to bring more people into this world.' The architect Edwin Lutyens enquired, 'Boys or girls?' 'A boy and a girl,' Clark answered triumphantly, to receive the response, 'Always means two fathers ...'[39]

The twins were named Colin and Colette – a conceit that Colin later thought reflected a rare lapse of taste on his parents' part – and would be known in the family as 'Col' and 'Celly' (pronounced 'Kelly'). They were christened in Clark's old college chapel at Trinity, and the choice of godparents reflected old and new friendships. Colin MacArthur Clark was given the novelist Edith Wharton, Nicky Mariano, Owen Morshead and the Oxford Classical scholar Roger Mynors. The last proved so negligent that he was later replaced by the composer William Walton. Colette Elizabeth Dixon Clark was assigned Maurice Bowra, John Sparrow and also Nicky Mariano (who was thus godmother to both children). The only person who did not greet the arrival of the twins with pleasure was their brother Alan. Having previously been the sole object of adoration, he had no intention of allowing attention to be diverted. He yelled and screamed, and 'if he scratched his leg he had to say it had been cut off'.[40]

Perhaps the most surprising of the godparents was the seventy-year-old Edith Wharton. Clark had met her at I Tatti, where at first she had ignored him, as she sometimes did upon meeting new people. But once *The Gothic Revival* had been published, she bestowed her friendship upon him. Maybe, as Clark suggests in his memoirs, she recognised a fellow craftsman. He was an admirer of her novels, although he found it difficult to reconcile their pessimism with her fundamentally warm-hearted personality. Soon the Clarks were regular guests at her pretty villa at Hyères in the south of France, where, as he later told her biographer, Edith was a terrible fidget: 'She couldn't bear anyone to sit down without a little table beside him, and I used to say that "little tables" should be her telegraphic

address.'[41] Clark hated writing letters, but he always took especial care when he wrote to Edith Wharton.*

In December 1933 the Clarks went to Paris for a break. They spent most of their time at the Louvre, and Clark wrote to Wharton, 'what an inexhaustible old junk shop it is'. He referred to Jane's purchases at Lanvin, but was much more animated by a haul of his own: 'I must tell you as it is really rather exciting ... it consists of 60 Cézanne drawings and watercolours discovered by Cézanne fils, and sold for an incredibly small sum ... I had the first pick out of 120, and I think all of them have a good deal of interest.' They comprised drawings of Madame Cézanne and the artist, and a series of watercolours of still life, landscape and composition studies which 'really provide a new basis for understanding Cézanne'.[42] Clark found them in Paul Guillaume's shop just after Cézanne's son had brought them in. He paid £250 for over fifty drawings, and they were to become the backbone of his art collection. When John Pope-Hennessy visited Shotover, he described it as filled with Cézanne watercolours, Vanessa Bells and Duncan Grants.[43] Over the years Clark would give away quite a few of the watercolours to Henry Moore and other friends.

There was one other older figure besides Edith Wharton whom the Clarks befriended. This was Lord Lee of Fareham, who proved rather more useful to them – and much more controversial. A collector who had been on the committee of the Italian exhibition, in which connection Clark described him as 'the most detested figure of the museum world',[44] he loved making 'discoveries', and believed all his geese were swans. As an art-world operator Lord Lee was tactless and overbearing, but he was also partly responsible for the founding of the Courtauld Institute, the introduction of the Warburg Institute to London,† and presenting Chequers to the nation for the use of the prime minister. A frustrated politician, he turned his energies and high-handed interventionism to the art world, where he made friends and enemies in equal numbers. Yet Lee achieved great things, and gained the confidence of austere men like Samuel Courtauld. He had an adorable American wife whose money he used to fund his art collecting; Clark described her as 'an angel'. The couple took

* She died only a few years later, in 1937, and left her godson Colin her library. Clark purloined it, and Colin received no benefit from it until his father's death.

† It was on the suggestion of Clark that Lee went into action when the Institute and its important library in Hamburg were in danger (see *Another Part of the Wood*, pp.207–8).

up the Clarks, whom Lee described in his autobiography as 'our most inti-
mate – almost our only – friends in the younger generation.'[45] Clark's
daughter Colette thought that 'Uncle Arthur', as Lee was known in the
Clark household, 'fell in love with my mother like everyone else. My father
was always very grateful and charming to him but didn't trust him. He was
always scornful about Lee's art collection.'[46]

There can be little doubt that both men realised how useful they could
be to one another. During most of the period that Clark was at the
Ashmolean, Lee was chairman of the National Gallery, where he was on
very poor terms with the director, Augustus Daniel. Daniel was probably
the most inactive director the gallery had ever appointed, and Lee dreamed
of replacing him with Clark. As Clark explained to his own biographer, 'I
think he was genuinely fond of me, but also hoped that I would be his
stooge.'[47]

Clark's final Oxford triumph was the opening of the new gallery. It was
named after Mrs Weldon, the north Oxford benefactress who had
presented the museum with Claude's *Ascanius and the Stag*, together with
a Watteau and a Chardin. The Weldon Room was a top-lit gallery created
by E. Stanley Hall to house English and French pictures of the eighteenth
century, and designed to blend with Charles Cockerell's original architec-
ture. There was a grand opening to which, the *Oxford Times* reported,
practically the whole of the university turned out. The newspaper also
revealed that the anonymous donor who had come forward to create the
extension four years before the university felt it could raise the money was
Kenneth Clark himself.[48] It fell to Lord Halifax, the Chancellor of Oxford
University, to make a speech in which he described Clark as 'a man young
in years but ageless in his love and knowledge of the arts.'[49]

Clark left the Ashmolean at the end of December 1933, to take up his
new appointment at the National Gallery in London on 1 January 1934.
Owen Morshead sent him Christmas greetings from Windsor, wishing
him success in his new position: 'Happy & Glorious, Not too uproarious,
God save our K.'

10

Appointment and Trustees

*So in the intervals of being a manager of a large
department store I shall have to be a professional
entertainer to the landed and official classes.*

KENNETH CLARK to Bernard Berenson,
5 February 1934[1]

The announcement that Kenneth Clark would be the next director of the
National Gallery was gazetted in *The Times* on 2 September 1933. Although
he was only thirty years old, his appointment was greeted with relief and
optimism. David Balniel summed up the feeling: 'This is an excellent
appointment in contrast to both the previous directors. He has youth,
enthusiasm, tact and discretion, and more all-round knowledge than
anyone else in England. A brilliant mind, lots of money, plenty of friends
and ambition. He will do well.'[2] Balniel's father Lord Crawford, however,
was less impressed, and recorded his opinion of Clark as 'a very arrogant
little chap, but clever as a monkey', who fancied himself 'well able to
distribute official patronage'.[3] Both views would have validity during the
tumultuous years that followed.

The National Gallery had been almost ungovernable over the previous
decade, with a continuous simmering row between the trustees and the
staff. This was partly because the constitution that governed it had so often
been adapted to suit special circumstances. Under the infamous 'Rosebery
Minute' of 1894, powers of acquisition had largely passed from the direc-
tor to the trustees. The trustees had become high-handed, treating the
curators as mere functionaries to carry out their wishes. Clark's predeces-
sor, Augustus Daniel (a caretaker appointment), had done as little as
possible, and suffered under what he described as 'the tyranny and malig-
nancy of the Board'. His successor was expected to be the gallery's deputy

director, Clark's former colleague on the Italian exhibition, W.G. Constable, but Lord Lee had persuaded him to take over the newly established Courtauld Institute of Art Historical Studies. Constable hoped he would be able to do both jobs when the time came. Lord Lee's term as chairman came to its end in 1933, and he was replaced by the debonair Sir Philip Sassoon.[4] Lee had certainly manoeuvred to achieve Clark's appointment, in part to secure his own reappointment as a trustee. Although some thought Clark was too young, there was a consensus on the board that as an exceptionally bright young man who spoke their patrician language, he could bridge the division between the trustees and the staff. Both sides greeted the appointment warmly, believing Clark to be on their side. As he told BB, he was appointed for his 'conciliatory disposition', and it 'would be the act of a mugwump to refuse'.[5]

Clark also believed himself to be too young, but when he received the telegram from the Prime Minister, Ramsay MacDonald, he was flattered. A letter from 10 Downing Street confirmed the appointment, offering him the post for five years, starting on 1 January 1934 with a salary of between £1,200 and £1,500. The letter pointed out (misleadingly) that previous directors had also been on the board of trustees, but 'the Commission on Museums and Galleries recommended that that practice should be ended, as it has been the cause of some friction which has been experienced with the administration of the Gallery'.[6] Clark accepted this apparent erosion of his new position, confident that his powers of persuasion were of greater importance.

The letters of congratulation struck a cautious note, identifying the trustees as a potential source of trouble ahead. Leigh Ashton wrote from the V&A: 'You will, of course, have a difficult time, but you know your own mind and you must always remember that if you choose you can put your hat on your head and walk out.'[7] Ashton believed that the most likely problems would come from Philip Sassoon, who could be charming but then on a whim could become 'a thorny problem'. He hoped Jane would charm Sassoon with 'her admirable powers'. Isaiah Berlin wrote on a more positive note: 'the activity of choosing and buying and arranging pictures when one's life is devoted to them is as near to Paradise as I can conceive'. But he, like the others, thought Clark's troubles would stem from the trustees. Anthony Blunt summed it up: 'May you have plenty of fun with the Trustees – that, I imagine, will be the most disagreeable part of your duties.' Lord Duveen sent a telegram of 'Heartiest congratulations', misspelling Clark's surname with a final 'e'; Vanessa Bell and Duncan

Grant hoped he would remove the glass that covered every picture in the gallery; and Monty Rendall observed that he was the first Wykehamist to hold the position. Interestingly, that wise old bird Sydney Cockerell, the director of the Fitzwilliam Museum at Cambridge, struck a different note from the rest: 'it appears to me that the Trustees have been maligned and that they are as gentle and tractable as cooing doves'. The gallery staff believed that Clark, a professional art historian like themselves, would fight their corner and not be overawed by the trustees. As with the Italian exhibition, everybody assumed he was on their side. The keeper, Harold Isherwood Kay,[8] who was to play such a malevolent part in Clark's time at the gallery, wrote: 'Your promised advent, if you will not mind my saying so, is the best news of the year.'[9] The only place where the appointment was regarded with less enthusiasm was Windsor Castle, where Clark was already marked down for a future post.

Just before Clark took up his new position he visited Spain for the first time, because, as he told Edith Wharton, 'I really cannot direct the National Gallery unless I have seen the Prado. I shan't attempt to see Spain – I shall simply go straight to the Prado, and back, after one large orgy.'[10] He confided to her, with regard to his appointment, that BB 'will be furious … he will say that I will be wholly corrupted, and I will never be able to drink the pure water of scholarship again. Perhaps he is right, but there are no scholars in my family – they were all company directors, and one can't hope to swim against the tide of heredity for ever.'[11]

Clark's predecessor, Daniel, advised him to come in on 1 January, when the gallery would be open and all the staff there to greet him: 'You will have no difficulty I am sure. Walk straight into your room and ask the Keeper to tell you if there is anything urgent. You will have letters on your desk.'[12] Clark duly appeared on New Year's Day, and noted in his diary: 'First day at the NG. Deep fog, train late. Tour with Glasgow; not very bright but willing to try innovations … on the whole exciting and agreeable.'[13] Waiting on his desk was a minute written by Daniel on 31 December 1933, in which he offered the following advice: 1. He should lay down his own requirements, i.e. if he wanted to see letters, and whether inspection visits should be referred to him first. 2. To use the firms of Morrill and Holder for picture cleaning. After various other specific matters, Daniel recommended 'the folder … containing the Blue Paper, with the Rosebery Minute and other resolutions of the Board passed from time to time. I consider that an understanding of this is of great importance in the conduct of the Board.'[14]

Clark put himself up at the Burlington Hotel in Cork Street until he could find a permanent home in central London. The early days were an unalloyed pleasure: the trustees and the keepers made him feel welcome, and surprisingly, owing to Daniel's inaction, the gallery had considerable unspent funds available for acquisitions. As he wrote to Edith Wharton: 'Everyone is being very kind to us and making my work as easy as possible and I am forced to conclude that either my predecessors were unresponsive or I am in for a catastrophic change.'[15] Over the next few days he was able to find time to lunch with Lady Horner[16] and the interior decorator and society hostess Sibyl Colefax. BB enquired to Jane, 'I wonder how Kenneth is inserting himself into his new charge, how he is filling it with his own personality and whether it is still softly and cosily upholstered, or whether already showing the points of the Nuremberg Virgin.* Not that I hope, altho' one can scarcely expect roses, roses all the way and never a stab at all. If only Kenneth had the leisure to keep a detailed diary!'[17]

Clark's cryptic appointments diary records that on 3 January his new chairman, Sir Philip Sassoon, came to visit. The exotic Sassoon, whose family were of Baghdad Jewish origins, was a Tory MP and Under-Secretary of State for Air. Clark described him as 'a kind of Haroun al Raschid figure, entertaining with oriental magnificence in three large houses, endlessly kind to his friends, witty, mercurial, and ultimately mysterious'.[18] The two men immediately formed a rapport, and Sassoon was to be Clark's final patron: 'For seven years Philip played the same dominating part in my life that Maurice Bowra had played at Oxford.'[19] He entertained the world of power politics, mostly but not exclusively Tory, at Port Lympne, his rather curious home in Kent, and Trent Park, his country house in Hertfordshire which was by comparison the epitome of Georgian good taste. His own collecting interests revolved around eighteenth-century conversation pieces, whose popularity he did much to revive. When David Crawford joined the National Gallery board in 1935 he judged Sassoon to be 'an admirable chairman, fair, amusing, brisk'.[20]

The other trustees were scarcely less colourful. By far the most troublesome was the art dealer Joe Duveen, who had been ennobled in 1933 after his munificent gift of a new gallery to the Tate, and had a dominating position in the international art market, to a degree difficult to imagine today. Lord Duveen had made a very successful career playing the *grand seigneur* in America and the buffoon in England, for it was difficult to

* The torture device better known as the iron maiden.

resist his ebullient personality. Lords Lee and d'Abernon had secured his appointment as a trustee; both had made advantageous art deals with him. Clark once observed: 'It has been well said of the late Lord Duveen that he had got the better of every art dealer in the world except that great syndicate of art dealers, the House of Lords.'[21] His position on the board was to cause Clark trouble from the start, for while being naturally generous and socially irresistible, Duveen was also amoral. He was not only incapable of keeping board meeting confidences, but frequently acted on information gleaned from them. Conflicts of interest arose with almost every meeting. Duveen's supporter Lord d'Abernon was a former diplomat and *marchand amateur*, whose invariable and almost inaudible contribution to the debates on acquiring pictures was 'Offer half.'

The most elegant trustee was Evan Charteris, a *beau monde* figure who was the gallery's liaison officer with, and later chairman of, the Tate – in those days still a satellite of the National Gallery, which controlled its purchase grant. The most improbable trustee was the Prince of Wales, who attended meetings infrequently, as he was not allowed to smoke. A problem arose when the Prince of Wales became King Edward VIII in January 1936; as monarch he could not sit on the board. It was suggested that he should sit as Earl of Chester, but in the event he resigned. The most useful trustee was Samuel Courtauld,[22] who was not only to lend the best of his incomparable collection of modern French paintings to the gallery, but had also given £50,000 in 1924 to establish a fund to purchase such works. Perhaps the most surprising thing about this great and good man was the degree to which he was in thrall to Arthur Lee, who established the institute that bears Courtauld's name. In 1935 Clark's friend David Balniel also became a trustee, and was to prove a staunch ally.

Gallery board meetings took place once a month at 2.30 p.m. The trustees would usually be invited for lunch beforehand at Philip Sassoon's London mansion on Park Lane, where they would be served off gold plate. The meetings involved housekeeping, with much time spent on old chestnuts such as the cleaning of pictures, but the main item on the agenda was usually the scrutiny of paintings that had been, or might be, offered for sale. During the 1920s the purchase grant had reached £7,000. It was reduced to nothing after the Crash, climbed back to £3,500 in 1935, and reached £5,000 in 1936. In addition Clark had £7,000 of endowment fund income he could call upon, but even so, this was only enough to buy one good picture a year. The National Art Collections Fund was his saviour in most cases. After a period of inactivity under Daniel, a surprisingly large

surplus had accumulated, and as Clark wrote to BB before taking up his appointment: 'the trustees are all longing to spend money, and will much dislike it if I try to deprive them of their legitimate excitement. If they can be persuaded to spend it on framing and decoration all will be well, but heaven preserve me from flashy acquisitions.'[23]

Clark established an excellent relationship with the board. Sassoon was delighted with his new protégé, and Lord Duveen could soon write, 'now that such perfect harmony exists at the meetings, every minute is a joyous one. This is of course since you arrived.'[24] Naturally, each trustee tended to push his own area of interest: Sassoon invariably urged the purchase of Zoffany, and Courtauld of Impressionists. Whatever criticism can be levelled at Clark's purchases, he had no *parti pris*, apart from a distaste for what he called 'the dealer's view of British art' – the grand full-length portraits that were still fashionable and that dominated the items on offer. He was keen to acquire more good nineteenth-century French paintings to make up a deficiency in the Impressionists collection, but was aware that these were viewed by the trustees as 'a Dealer's boom'. Fortunately Courtauld came to his rescue, lending Manet's *Un Bar aux Folies-Bergère* and Cézanne's *La Montagne Sainte-Victoire*, the first work by the artist in the gallery. Clark also persuaded the Tate to return Renoir's *Les Parapluies*. He felt that his first achievement at the gallery was to hang a room of French nineteenth-century art that was worthy of the place.

'Buying pictures,' as Clark often observed, 'was the chief reward of being at the National Gallery. It was still possible to buy great works of art in the 1930s.'[25] As soon as he arrived he had started to think about purchases, and he was determined that these should be important. Already under discussion were two Velázquezes from the Frere Collection, including *The Immaculate Conception* – but they got away. It was to take another forty years for that painting finally to reach the gallery walls. By the trustees' meeting in March, which was his third, Clark was already recommending Constable's full-scale oil sketch *Hadleigh Castle*, and seven panels of *The Life of St Francis* by the Sienese artist Sassetta. His appreciation of full-size Constable sketches was ahead of its time, and he needed Sassoon's support to get it past the trustees. In the same meeting, Lord Lee was offering *The Family of Sir Peter Lely* from his own collection, which was turned down.[26]

The seven Sassetta panels constituted a special drama of their own that demonstrated everything that was wrong with having Duveen on the board. These bewitching panels (the eighth is at Chantilly) formed the

artist's San Sepolcro altarpiece, which had been created for a convent that was suppressed during the Napoleonic era. The centrepiece depicting *St Francis in Glory* was already very familiar to Clark, as it was in the Berensons' collection at I Tatti. The panels had been offered to the National Gallery by an American millionaire named Clarence Mackay, who had acquired them from Duveen. When it became clear that Mackay was unable to pay for them, Duveen set up the fiction that Mackay wished to sell them. Clark offered £35,000, half the price Mackay had been supposed to pay (and also the price at which they appeared in Duveen's accounts). By bribing Mackay's butler, Duveen ensured that Mackay never received Clark's offer, a fact Duveen cheerfully admitted to the trustees. Eventually a compromise was reached at £42,000, with a press release stating that the panels had been acquired 'through the good services of Lord Duveen'. As so often happened, it was the National Art Collections Fund that enabled the money to be raised.

Occasionally Duveen's interventions worked to the gallery's advantage. Hogarth's vivacious *Graham Children*, which Clark called 'the perfect poster', was sent to the gallery by its owner, Lord Normanton, 'to allow the Board to consider this picture at its next meeting'. The painting was then mysteriously withdrawn, and purchased by Duveen behind the backs of the trustees. When confronted by Philip Sassoon, he relented and presented the picture as a gift to the gallery. Clark was exasperated by such behaviour, but gratified to receive 'perhaps the most beautiful large painting by Hogarth in existence'.[27]

Clark wanted to avoid making too many pretty purchases – a natural tendency of the trustees – and in July he made a courageous purchase against considerable opposition, Bosch's *Christ Mocked with the Crown of Thorns*. As he wrote to Isherwood Kay, 'The Bosch was not popular but was supported by Courtauld, Witt and Gore; Duveen keeping up a ground base of "My God! What a picture." The result was we offered 300,000 lire, which to my great surprise has been accepted.' He added significantly, 'I get no support from Pouncey and Davies who detest it.' Philip Pouncey and Martin Davies were two clever young curators whose respective interests were Italian and Netherlandish art; the first example of a disagreement with Clark from that quarter.

Clark would normally enliven board meetings with a lantern show, a *tour d'horizon* of what was available on the London market. As he told Isherwood Kay, 'England is still far and away the best place in which to form a collection of any paintings, including Italian.'[28] Occasionally he and

the trustees would buy a painting they did not strictly need, such as the Rubens landscape *The Watering Place*. The gallery was already rich in paintings by Rubens, but this work from the Duke of Buccleuch's collection was so glorious that they found it irresistible. The country houses were still the greatest repository of paintings, and long before Clark's time what the gallery referred to as the list of 'paramount' paintings – those for which every effort to acquire should be made if they became available. The owners were sometimes named after their pictures, hence 'the Earl of Raphael' for Lord Ellesmere and 'the Marquess of Reynolds' for Lord Lansdowne. This list was kept secret,[29] which Clark thought was a mistake: 'we were strictly enjoined not to tell the owners. As a result at least three of the pictures were sold secretly overseas before the present act came in.'[30] The most grievous loss was Holbein's *Henry VIII*, sold to the German-Hungarian collector Baron Thyssen by his friend Lord Spencer without the gallery being offered the chance to buy it.

Clark was acutely aware of the gallery's weakness in the German school, and this was something that could not be remedied through the art trade in London. In a particularly bold move, he travelled to St Florian's monastery in Austria to try to secure the important Altdorfer *Passion* and *St Sebastian* series for the gallery – without success. Good German paintings were hard to find, but he did manage to acquire the Dürer variant, *Virgin with Iris*. In 1935 he went with Jane to Russia to see the Hermitage Museum, at a time when the Soviet Union's desire for foreign currency was driving the authorities quietly to sell off art works. The gallery had come within an ace of buying Tiepolo's *Feast of Cleopatra* under Clark's predecessor, but then backed out of the deal, which may have made it harder for Clark to negotiate with the Soviets. He identified two pictures he would like for the gallery, Giorgione's *Judith* and Rembrandt's *Prodigal Son*, but had to inform his trustees that there was no chance of buying anything from the Hermitage at present.

January 1936 was a golden month for acquisition, when the gallery succeeded in securing Constable's *Hadleigh Castle*, the glorious Buccleuch Rubens, and the painting Clark was proudest of finding, Ingres' *Portrait of Madame Moitessier*. He had travelled to Paris to see an earlier likeness of the same sitter wearing a black dress at Paul Rosenberg's gallery, and while there he picked up intelligence that the later, much finer, portrait might be available. He did not hesitate, and earned a plaudit from BB: 'Let me congratulate you on the Ingres you have just purchased. How redolent of Raphael …'[31] Clark was to describe this portrait lovingly in his TV essay

on Ingres in *Romantic versus Classic Art*: 'impassive in her extravagant finery, she reminds one of some sacred figure carried in procession'.[32] He recounted the reaction of the trustees to this splurge of acquisitions to Lord d'Abernon: 'After the first shock of imagining themselves penniless, they were persuaded by the beauty of the pictures'.[33]

Acquiring the Ingres was one of Clark's finest achievements at the gallery, but even that had its critics – and from a direction whence more trouble would stir in future. Sir Gerald Kelly, president of the Royal Academy, wrote to Clark that 'she isn't everyone's seven course dinner. (It is ridiculous to use the phrase "cup of tea" in connection with the stately Mme. Moitessier.)'[34] Sometimes Clark was unable to get his way with the trustees. 'The only time,' he once told an audience, 'I ever observed agreement between the staff and the trustees of the National Gallery was when I proposed (as I fairly frequently did in thirteen years) the purchase of a Delacroix. They were agreed that he was a tiresome, second-rate painter, and none of his pictures were bought'.[35]

Clark had got off to an excellent start as director, but the work was fatiguing, and his health was never strong. As he wrote to Edith Wharton: 'I work from 9.30 to 5.30 without a minute's pause. Then I come home and write lectures till dinner. At the end of it I am good for nothing. However I do feel that the work is rewarding ... though I have seen some claws which may soon be turned on me'.[36] Over Christmas 1934 he collapsed, and was taken to hospital with a strained heart. Owen Morshead sent a memo to Queen Mary describing the problem: 'His heart had shifted two inches out of its place owing to the fatigue of the muscles which hold it in position'.[37] Wharton invited him to convalesce in the south of France, but Jane took him to Brighton instead, where together they explored the antique shops. Clark recovered, and would enjoy another eighteen months of productive and reasonably smooth running at the gallery before the claws to which he had referred became troublesome.

11

By Royal Command

My colleagues, even the friendliest of them,
thought that I was a place-hunter.

KENNETH CLARK, *Another Part of the Woods*

The visit of King George V and Queen Mary to the National Gallery described at the opening of this book was the result of two years of lobbying on the part of Owen Morshead. Once it was known that Charles Collins Baker was going to retire as Surveyor of the King's Pictures, various candidates had been considered. The King and Queen's daughter Princess Mary, the Princess Royal, promoted the candidature of the ubiquitous Finnish art historian and arch-monarchist Tancred Borenius, who had helped her husband, the Earl of Harewood, assemble his collection of Old Master paintings. The trouble with 'Tankie', as Morshead liked to refer to him, was that he was tainted by a too-close involvement with the art trade. Morshead crucially got the support of Queen Mary, who – as he reported to Clark – had told him, 'I know the King wants nothing so much as to feel he has his own pictures under his own man – someone whom he can order about, to whom he can say what he wants done, without feeling that he has to go and ask the permission of the National Gallery officials in the disposition of his own things.'[1] Clark had been at the Ashmolean at the time, although frequently in and out of Windsor completing his Leonardo catalogue. The idea appears to have attracted Clark, because Morshead wrote to Queen Mary recommending him for questions of attribution and cleaning, while suggesting that the rest of the work might be done by an administrator – an idea which evidently came from Clark.[2] In Morshead's view Clark was not only the best, but the only, man for the job.

The King had expressed a desire that someone should tell him when to clean his pictures. This worried Clark, as he felt inexperienced in what he

called 'the cleaning side', and he withdrew his candidature. Morshead then received a note from the King's private secretary, Lord Wigram: 'The King and Queen have read your letter to Cromer* about Kenneth Clark. Their Majesties think that the latter is probably a modest retiring young man, who would be quite capable of filling the appointment, and taking all the responsibility.'[3] The King and Queen also expressed a desire to meet Clark. Morshead in turn wrote to Clark: 'You would I am sure find them most sympathetic people, and reasonable: I think you could perfectly well do the two jobs for five years.'[4] The matter then had to be left in abeyance, as Collins Baker continued in his post for another year, so it came as a shock at Windsor when Clark accepted the position at the National Gallery. Owen Morshead reported the Queen saying that 'the news of your appointment had temporarily stunned herself and the Monarch.'[5] At this point the King and Queen decided to make their extraordinary trip down to Trafalgar Square on a Sunday morning in March. In Clark's words: 'I refused the royal job, so the King came to the National Gallery to persuade me.'[6]

Lord Wigram wrote to Philip Sassoon, as chairman of the trustees, announcing that the King and Queen would make 'a short visit of about half an hour to the National Gallery, at 12 noon on Sunday, 25 March. Their Majesties would like the Director to be there ...' They tactfully indicated that the trustees should not change their existing appointments, and that they did not wish invitations to be extended to them as a body.[7] Given that this was the first visit by a reigning monarch to the gallery, it was a considerable matter to leave the trustees out of the picture. Clark made a cryptic diary account of the visit: 'Motor up to London to take King and Queen round NG. I start with Q[ueen]. very stiff and full of formal questions. After the first room take on K[ing]. who is much jollier. Loudly proclaimed that Turner was mad. Very much consoled by [Frith's] Derby Day where we traced all the incidents, but regretted that the race was not visible. Wanted to put his stick through Cézanne. Q. clearly felt that K. and I were not serious enough but thawed a bit. K. enjoyed view from steps and went off through cheering crowd.'[8] The degree to which Clark perjured himself in artistic terms discussing Cézanne and Turner with the monarch can only be imagined, but it is clear that the two men had contrived to enjoy themselves.

Morshead's debrief to Clark after the visit is characteristically direct: 'The Queen said to me this morning: "We were both greatly taken with Mr

* Rowland Baring, second Earl Cromer, the Lord Chamberlain of the Royal Household.

Clark; he seems just the very person we should like so very much to have … the King is most anxious to secure Mr Clark if only it can be arranged" … I went along the passage to see the King … the conversation took this turn:– K. "Well, I met your friend Clark the other day; he took me over the N.G., and we had a long time together. I must frankly say it's a long time since I met any young man who took my fancy so much; in fact I don't know when I've taken to anyone more completely – the more I saw of him the more I thought 'that's just exactly what I had always hoped to get' … And I liked his little wife too so much … I came away enchanted after a delightful afternoon." Well well.'[9]

Apart from the understandable fear of not having the time to do both jobs, Clark was anxious about the reaction of the National Gallery trustees. All this was swept aside at Windsor, and Morshead reassured Queen Mary that pressure was being put on Clark to accept: 'I felt that if he knew the degree to which the King's personal desires were involved the issue might present itself in a different light.'[10] Clark went to the trustees and obtained their consent; with this kind of pressure being exerted by the King and Queen he had no choice but to accept the position.

It was the sheer scale of the Royal Collection that was so daunting – seven thousand paintings, as opposed to a mere two thousand at the National Gallery. Nevertheless, on 3 July 1934 Clark was gazetted as Surveyor of the King's Pictures. Reactions to the appointment were mixed. Berenson wrote laconically: 'I am doubly glad as I shall feel free to ask you for photos & information about said pictures.'[11] But others felt affronted by such pluralism in one so young, believing it to be a sign of Clark's ambition.[12] Apart from the envy the appointment caused, he also felt he lacked Borenius's enthusiasm for pedigrees and portraiture: at Windsor, royal iconography came well above aesthetics. However, as a later Surveyor put it, 'the important point about Kenneth Clark at the Royal Collection was the fact that somebody of that calibre was there at all. It set off the train of modern times with great scholars looking after the collection.'[13]

Clark settled into the job of Surveyor with characteristic efficiency. Few monarchs have had so little aesthetic appreciation – postage stamps apart – as George V. Despite this, Clark became very fond of the King, and found his gruff naval manner concealed a kind and fatherly patron. The Queen was a different matter, and took a close interest in the Royal Collection. Years later Clark told his biographer, 'As a matter of fact I enjoyed it hugely: staying at Windsor was the best thing in the world. One was left free all day and had the use of a royal car. The old King took a

great fancy to Jane and changed the "placement" in order to have her next to him'.[14] Clark also enjoyed 'very good grub' at Windsor. His main task, as he saw it, was to follow the King's instructions and implement a programme of restoration and cleaning of the paintings. As he wrote to the Lord Chamberlain, 'the Collection has been very much let down in the last hundred years'.[15] He presented lists of pictures that needed conservation, but invariably provided estimates of the cost – without consulting the restorers – that were far too low, which caused endless trouble with palace officials.[16] Typical was the case of the huge Van der Goes altarpiece loaned to Edinburgh, that cost two and a half times Clark's original estimate for repairs – which he was forced to explain to the Lord Chamberlain's Office.

With the King's death in January 1936, Clark had new masters at Windsor. There was a hiatus during the Abdication period, so it was not until May the following year that King George VI and Queen Elizabeth were crowned. Clark had already identified the Duchess of York – as the Queen then was – as a potential ally before the abdication of her brother-in-law. After she wrote Clark a flattering letter about his lecture on English landscape painting he sent her *The Gothic Revival*, recommending the chapter on Pugin, 'who was a fascinating character'. They had recently been to an exhibition together, and Clark added that 'so few people seem to enjoy pictures: they look at them stodgily, or critically – or acquisitively; seldom with real enthusiasm'.[17] He enjoyed writing to her about the places he visited. On a tour of Eastern Europe he told her that 'the most fascinating place we saw was Cracow. It is incredibly mediaeval, squalid & superstitious, with a ghetto full of magnificent old Jews with fur caps & long curly beards: in fact a population of living Rembrandts'.[18]

The flavour of Clark's life in the build-up to the coronation, and his impressions of the new King and Queen, were conveyed in a letter to Edith Wharton: 'I am engaged in a last wild round up before going to Vienna and Budapest next Thursday. We are opening a new gallery, collecting new loans and acquisitions, fighting the Treasury, choosing the great seal etc. every minute of the day. On top of it I have to spend two days at Windsor with the Monarch advising him about his pictures – interminably standing and grinning. This is particularly bitter because it keeps me away from my beloved "Bellers" [his new rented house in the country] which we enjoy more and more every visit ... Jane has been laid low with a horrible attack of flu which almost became jaundice. She suffered agonies of depression ... I found the new King and Queen very pleasant – she just above the

average country house type, he just below it.'[19] Clark was to become an ardent fan of the Queen, but he never changed his mind about the King.

On the day of the coronation, the Clarks were in their seats in Westminster Abbey by 8 a.m., three hours before the arrival of the King. Jane wore a white court brocade dress, with a long white velvet Schiaparelli cloak and a tiara.[20] 'The coronation,' Clark wrote to his mother, 'was far the most moving and magnificent performance I have ever seen. We had very good seats, almost the best in the Abbey [he enclosed a diagram] ... The whole performance was beyond [the theatrical impresarios] Reinhardt and Cochran partly because it took place in the Abbey, partly because it cost £1 million, but chiefly because the leading actors and actresses really looked the part ... I must say too, that I felt the real significance of the coronation in a way I couldn't have believed. The sight of all these different races, of these representatives of every corner of the earth united by this single ideal has converted me to Imperialism.'[21]

Clark's first instinct in the new reign was to resign. He was worried that the new King would want to rehang everything, and despite this being his favourite occupation, that he would not have enough time. Morshead talked him out of it, and he soon found that he was far more useful than he had been under the previous regime. First, there was the question of new state portraits, for which Clark recommended Sir Gerald Kelly. He was expected to be in attendance for visits of foreign heads of state, such as the French President Albert Lebrun in March 1939, to show them the treasures. He also found himself an unofficial adviser for the Order of Merit, which – with the exception of the Garter – is the most distinguished award for high achievement at the monarch's disposal. When his opinion was invited on Edwin Lutyens versus Giles Gilbert Scott for the OM, he replied without a moment's hesitation 'Lutyens', who despite being at the nadir of critical fortune was in Clark's opinion greater than all his rival architects.[22] Later he was consulted about musicians, intellectuals and even scientists, pushing the claims of Maynard Keynes and the physiologist Edgar Adrian.[23]

Clark had been right in identifying the new Queen as a potential patron of the arts. She began by asking his advice on the rehanging of her sitting room at Windsor. Matters moved on from there, as Jane's diary reveals: 'K has enjoyed Windsor espec two long walks with Queen ... they want to get in touch with modern life in as many aspects as poss but go slow so as not to hurt people's feelings.' She also noted that her husband was 'shocked at how little K&Q do. She gets up at 11. Hardly anyone at Windsor and just

as dreary in the evenings as under King G and QM, but at least latter went
to bed earlier. He likes the Q *v much*.'[24] Clark's position was unusual, as an
intellectual who had the ear of the Queen and was as close to her as
anybody outside the family in the new reign.

To Clark's delight, the Queen started to assemble a small but distinctive
collection of contemporary British paintings. Most of her acquisitions
were made post-war, but in 1938 she purchased the portrait of Bernard
Shaw by Augustus John entitled *When Homer Nods*. Clark wrote her an
enthusiastic letter: 'May I say how extremely valuable to all of us who care
for the arts is Your Majesty's decision to buy the work of living painters. It
is not too much to say that it will have an important effect on British art
in general … you will make them [the painters] feel that they are not
working for a small clique but for the centre of the national life.'[25] He
formed a warm and productive relationship with the Queen, who wrote to
him: 'It is so important that the monarchy should be kept in touch with
the trend & life of modern, as well as ancient Art, and I hope that you will
advise & help us along those lines?'[26] Clark took the hint, and over the
coming years would write to her, 'May I take this opportunity of telling
Your Majesty about several other things which are happening in the arts.'[27]
He arranged visits for the young Princesses to the National Gallery, and
became a fixture of social life at Windsor. The Queen had her own taste,
but the advice proffered by Clark, and later by the chairman of the Tate,
Jasper Ridley, was a great stimulation to her interest in this field.

It was building work at Hampton Court which enabled Clark to have
what he called 'the glorious opportunity of rehanging the pictures' there.
He had previously written to BB: 'I have always hated palaces as a tourist
& I hate them even more as a servant. The exception is Hampton Court,
which is of course really a public gallery, tho' as badly run as if it were
private … There are an immense number of pictures tucked away …
which … few can have seen since you first went there – chiefly Bassanos,
of course, but a few interesting sub Titianesque Venetians.'[28] Clark believed
that his predecessor had treated the place too much like a public gallery
and not enough as a palace. He was fortunate that Philip Sassoon was at
the Office of Works at the time, and persuaded Lord Duveen to pay for the
redecoration of the state rooms with red and gold brocade. The result was
that a very moribund palace came back to life, and Clark's rehang was
much admired.

However much Clark enjoyed his role as artistic *chevalier servant* to the
Queen, he found the courtiers and palace administrators tiresome and

generally ignorant. As he told Gerald Kelly, 'I was amused by your refer-
ences to the life of the courtier. It is interesting to find how educated
people, when they are in a position of a servant, take on the servant's
mentality with its touchiness, jealousy, etc. Having been attached to the
Court myself for about six years, I now begin to think of the domestic
servant with more understanding.'[29] Clark's impatience with courts, and
the life they sustained, was to emerge again in *Civilisation*, when he spoke
of their 'odious pomposity'. Although he gave high marks to the courts of
Urbino and Mantua, he virtually left Versailles out of the series. When he
made *Royal Palaces* (1966), which was the first time television cameras
were allowed into Windsor and Buckingham Palace, his tone offended the
Queen and Prince Philip, who found him 'sarcastic' – an incomprehensi-
ble judgement by today's standards. Up until then Clark had been
welcomed at state banquets, and described one of them to Janet Stone:
'The state banquet last night was really beautiful – gold is undoubtedly
life-enhancing, and I have never seen so much. All the waiters covered
with it, all the plates and cutlery made of it, all the walls lined with it. Into
the middle of this over-civilised display came the Black Watch Pipers –
making this deafening, but to me intoxicating noise. I wept with joy greatly
to the scandal of my neighbour … I had an agonising ten minutes with the
Q – she was tired and longing to get away.'[30]

At the very end of his life Clark suggested to his publisher a new book
of essays: 'I thought of calling this volume "Afterthoughts" and it would
include an essay on royalty – a very amusing subject on which I am
expert.'[31] Apart from the various members of the British royal family, he
became well acquainted with Prince Paul, the Regent of Yugoslavia, and
the King of Sweden. Despite his qualms and the later temporary fallout
over *Royal Palaces*, Clark was a very successful courtier. Apart from being
a conscientious curator, he recognised the unifying power of monarchy,
which was to become so important during the coming war. Both Kenneth
Clark and the royal family were about to embrace paternalistic populism.

12

The Great Clark Boom

We have lots of friends and know the King and Queen
and lots of famous people ... we are very well off
and very happy ... also a dog called Tor.

Diary of COLETTE CLARK (aged six)

'I now come to the strangest period in our lives: what can only be described as the Great Clark Boom. It lasted from about 1932 till 1939, and was as mysterious as a boom in Australian gold shares.'[1] In fact there is little mystery about the matter. At a very young age Clark held a commanding position in the art world that required him to circulate in what used to be called society, and Jane was a natural and beautiful hostess. The Clarks were ambitious, young and attractive, and found themselves fashionable. Cyril Connolly, looking back on his Oxford generation, reflected how little politics had impinged on it and how unworldly was his generation, of whom 'The most realistic, such as Mr Evelyn Waugh and Mr Kenneth Clark, were the first to grasp how entirely the kind of life they liked depended on close co-operation with the governing classes.'[2]

Clark portrayed himself and Jane as 'Innocents in Clover' (a description which might have been truer of Roger Fry in his shabby suits). The Clarks acquired a grand and elegant London house, where they entertained everybody from the King and Queen downwards. As Clark's first author-ised biographer Fram Dinshaw observed, 'the point about the Clark boom was that it was the link between society and art'.[3] They were an integral part of the more literate end of the *beau monde*, and the two worlds met at their house – although the Clarks succeeded, in their own minds at least, in maintaining a detachment from the social vortex through his writing and their friendship with artists. For the remainder of his life the latter group was to ground Clark in the values he most believed in.

The backdrop of the Great Clark Boom was a large house at 30 Portland Place, between Oxford Circus and Regent's Park, on which they took a lease from the Howard de Walden estate. It was like an embassy in scale, with Adam-style reception rooms and a grand entrance hall. Early in 1934 Clark commissioned the fashionable architect Lord Gerald Wellesley to make a report on the house. Wellesley was impressed, and thought the first-floor drawing rooms extremely pretty; he designed modish bookcases for the downstairs library in which the Clarks usually sat and received visitors. The house is surprisingly undocumented. Most accounts focus on the art collection and the elegant curtains, some in yellow silk – others were designed by Duncan Grant (with a pattern of Apollo pursuing Daphne in creamy pinks, terracotta, beige and brown).[4] Marion Dorn, the American designer who also acted as the children's art teacher, created many of the textiles and carpets. The large Adamesque dining room on the ground floor contained a big Matisse painting, *L'Atelier*, which Clark acquired from the Gargoyle Club.[5]

The 1930s was the main decade of growth for Clark's art collection, and by 1937 the young art historian Ben Nicolson wrote in his diary: 'On to K Clarks at Portland Place. Talked to Jane about Giorgione whilst K interviewed [Robin] Ironside [for the position of assistant to the director of the Tate][6] upstairs. They showed me the new Cézannes and Renoirs, the collection is now almost as superb as Victor Rothschild's, and these two wonderful Seurats to cap it all ... The Clarks were so charming I wished they were great friends.'[7]

Clark always claimed that he was not an art collector in any systematic sense. He once asked himself, why do men collect? He decided that it was like asking why we fall in love, since the reasons were as various. He reduced collectors to two essential types: those who are bewitched by bright objects, and those who want to put them in a series. He belonged in the first category, and most of his purchasing was opportunistic. No doubt having empty walls to fill was a motivation, and during the Portland Place era Clark acquired some of his most important paintings: four Cézanne landscape oils, including *Château Noir* from Vollard in Paris. He bought Seurat's *Le Bec du Hoc*,[8] which was later to influence Henry Moore's two-piece *Reclining Figure* (1959) when the sculptor saw it in the Clark collection. Clark paid £3,500 for the Seurat, which so pleased the owner that she added a second painting by the artist for free, the beautiful *Sous Bois*.[9] Clark's favourite picture was his Renoir, *La Baigneuse Blonde*, which was always given pride of place in his various houses. He would refer to her

as 'my blond bombshell', and had himself photographed standing in front of her. Clark even included this naked bather – who was in fact the artist's wife – in his book *The Nude*, in which he compares her to Raphael's *Galatea* and Titian's *Venus Anadyomene*, adding that she 'gives us the illusion that we are looking through some magic glass at one of the lost masterpieces extolled by Pliny'.[10] One of his most charming and unexpected purchases from this period was *The Saltonstall Family*, an enormous early-seventeenth-century family portrait that hung on the stairs at Portland Place and is now at Tate Britain. Yet if Clark's ambitions had moved up several notches since his collecting days at Richmond, he was only just beginning to patronise contemporary British artists in a serious way.

Jane commanded a small army of staff to keep Portland Place running. Her chief assistant in the early days was the secretary, Elizabeth Arnold, who like all Jane's assistants found her an exacting but generous mistress – she would give her Schiaparelli dresses. There were seven domestic staff including the chauffeur, and if the Clarks' son Colin is to be believed, three more for the children. 'We lived in a smaller building,' he wrote, 'tacked onto the back connected by a green baize door where we had a nanny, a maid and a cook.'[11] When in London the children did not see very much of their parents until bedtime, when Kenneth and Jane would appear – usually dressed to go out for dinner – to say goodnight. They saw far more of them in the country, at a house in Kent provided by Philip Sassoon.

Almost as soon as Clark was appointed to the National Gallery, Sassoon began to invite them down to his extraordinary creation at Port Lympne. The house was designed by Herbert Baker in the Cape colonial style, and the garden, which was planned by Philip Tilden, had something of Hadrian's Villa about it. The interiors were an eccentric jumble of rooms decorated by Josep Maria Sert, John Singer Sargent and Rex Whistler, all converging around a Moorish courtyard. Clark thought the house faintly ridiculous – '*Sassoon à son goût*,' as Osbert Sitwell quipped – but he admired the architectural gardens, which contained the longest and deepest herbaceous borders. Clark enjoyed the exoticism of his host, whom he found amusing and intoxicating. Sassoon, who was a bachelor, was regarded as a social barometer, and entertained what Clark described variously as 'unstuffy, new world society' and 'the unorthodox Tory fringe'.* And yet, as if he were back at his first day at Winchester or Oxford, Clark

* One personality Clark met at Lympne was T.E. Lawrence (of Arabia), who he described as 'scrubby, donnish, or rather school master-ish'. Diary, 20 March 1934 (I Tatti).

claimed that 'none of them gave me a kind word or, indeed, spoke to me at all', and he refers to the 'contemptuous young wives of viscounts'. Such occasional bouts of self-pity can be discounted in this case, as Sassoon declared himself 'crackers about Clark' and offered him a charming house, Bellevue, on his estate for the weekends. He was also befriended by Philip's sister Sybil Cholmondeley, but found his cousin Hannah Gubbay unprepossessing.* At one house party in 1934, Clark found himself a fellow guest of Winston Churchill, who as an amateur painter sought Clark's advice and invited him down to Chartwell. What struck Clark most about Churchill was 'a side of his character that appealed to me strongly, and which appeared frequently in his conversation: the element of the naughty boy'.[12] All his life Clark was to have a soft spot for men who reminded him of his father.

'Bellers', the house Sassoon rented to the Clark family, is a low eighteenth-century brick house which in those days had ravishing views over Romney Marsh. Sassoon had asked Philip Tilden to make some alterations to it while he was working on the big house. These resulted in the creation of one grand interior room and the placing of flanking colonnades on the garden front. The Clark children adored the house. Sassoon was a hero to the boys, and Port Lympne occupied a special place in their family mythology. Alan called it his favourite place in Kent, and later he wistfully recalled how he would 'sit on the terrace drinking tea *limone*, and indescribably thin cucumber sandwiches before being sent back to Bellers. Can still look through the glass door at that marbled Moorish interior, black and white floors and arched ceilings.'[13] Sassoon had a private airfield half a mile to the north of Bellevue, from which he would take Alan and Colin up in his plane to buzz 'Bellers'. Sometimes the Clarks would be flown to his other house, Trent Park in Hertfordshire, where their father recalled 'the children were astonished by a platoon of footmen with red cummerbunds'.[14]

Clark expressed his pleasure in Bellevue to Edith Wharton: 'I write in my new study with a view across Romney Marsh almost as far as Rye … so enchanted to have a house in the country again.'[15] They could invite their friends for the weekend – Maurice Bowra, the Graham Sutherlands – and for the children this was to prove the happiest time of their childhood. When the art historian Ben Nicolson was about to join the National

* The two women were both remarkable. Sybil Cholmondeley became a brilliant châtelaine of Houghton Hall, Norfolk, and a musical patroness. Hannah Gubbay was a collector of porcelain; her collection is housed at Clandon Park in Surrey (National Trust).

Gallery as an honorary attaché, he paid a visit to Bellevue: 'Drove over [from Sissinghurst] to lunch alone with K Clark at Lympne. He has taken Philip Sassoon's little house next to the entrance to the aerodrome. It is simply sweet and Clark has of course done it up beautifully with Duncans [Grant] and [André] Masson water colours and Graham Sutherland for whom he has a great admiration ... It was all heavenly but I was a little bit frightened of him and he still insists on calling me Nicolson.'*

If Bellevue was a retreat from London cares, Portland Place was a stage on which the Clarks performed. At their grand dinners they brought together socialites, artists and writers. Clark later wrote rather condescendingly: 'I have been told by several society people that this was the first time that they had met artists, and were surprised how "civilised" they were.'[16] When he asked himself why the socialites, with whom he and Jane had so little in common, came to Portland Place, he thought it was 'perhaps to enjoy the vivacious and intelligent company of my wife'.[17] For Jane was the key to the Great Clark Boom; she was at least an equal partner, as their daughter Colette explained: 'For the first 20 years of their marriage they were known as Jane and K ... everybody was paying court to her and Papa was almost the dear old professor in the background actually.'[18] Left to his own devices, Clark would not have pursued such a grand social life. Their friend Lord Drogheda underlines this in his memoirs, believing that Jane did much 'to promote his talents and aid his self-confidence'. He describes her large blue eyes and very dark hair, and her generous and considerate nature. 'Without her influence his career path would have been different, and less I think in the public eye. Together they were a formidable combination.'[19] Jane devoted her considerable talents to the service of her husband; she read and commented on his work before it was published, she invited the guests, and protected him from unwanted attentions. Those who knew her at Oxford were fascinated by the transition from the amusing, penniless girl they had known into the grand figure they now encountered. Peter Quennell wrote: 'I sometimes found it difficult to recognise her as the smart & fashionably dressed great lady whom she afterwards became.'[20]

* Ben Nicolson, diary, 29 December 1936 (private collection, copy at *Burlington Magazine*). Clark later explained to Nicolson his fondness for using surnames: 'No: Lady C is impossible. So is Sir K. Try Jane & K, or if the latter sticks in your throat the Doric surname unadorned, a form I like to use.' Letter to Ben Nicolson, 3 February 1938 (private collection, copy at *Burlington Magazine*).

Jane's elegance and dress sense were much admired. She favoured the house of Schiaparelli, and wore its gowns to great effect, along with jewellery specially designed for her by the sculptor Alexander Calder. Guests found her bewitching, and according to Colin, when in the presence of great men 'she would open her eyes very wide and gaze at them with genuine admiration'.[21] She might indeed sometimes hero-worship, but Jane could also be sharp. To a dinner guest who had murmured about possessing some yellow Sèvres she is said to have coolly responded, 'Yes, but you're rich.'[22] Entertaining was very much her forte. Without Jane, Clark would have been quite happy to have remained – in Max Beerbohm's great division of mankind – a guest. People wanted to be invited to Portland Place: it was chic. To the diarist and socialite 'Chips' Channon, who complained that they had never asked him to dinner, Jane smiled sweetly and said, 'But Chips, we don't know anyone grand enough to invite with you.'[23] Jane was naturally extravagant where her husband was frugal (except in buying art). She would send everybody she met, from her hairdresser to the royals, expensive presents. It was part of her generous and warm personality.

The Clarks were in demand and invited everywhere. As Maurice Bowra, in a parody of a popular church hymn, wrote: 'Jane and Sir K is all around I see.' They were enjoying what Logan Pearsall Smith used to call a 'swimgloat'. Jane's diary entry for 9 April 1937 is typical: 'We lunch with the Kents, Belgrave Square. I sit between [Gerald] Chichester and Ivor [Churchill] …'[24] The Clarks may have had the intellectuals' horror of the landed gentry, whom they considered bores and philistines, but it was necessary for the director of the National Gallery to make an exception for the inheritors of the great art collections. They would stay at Drumlanrig Castle and Chatsworth with the Dukes of Buccleuch and Devonshire, and the Clark archive preserves press cuttings of a house party at Chatsworth for the Princess Royal to which they were invited.[25] In his *homme du peuple* moments Clark liked to give the impression that this was a passing phase: 'With the approach of war the grand people returned to their country houses and the artists remained our friends.'[26] This was not the whole story, as he remained close friends for life with such great châtelaines as Molly Buccleuch and Sybil Cholmondeley.

If the Clarks did not generally like the upper classes, their son Colin believed that 'they didn't like the middle class any better. "How dreadfully bourgeois" was one of their favourite ways of dismissing something.'[27] Clark's fastidiousness would occasionally emerge: after a Mediterranean cruise he wrote to Edith Wharton: 'There was not one person on board

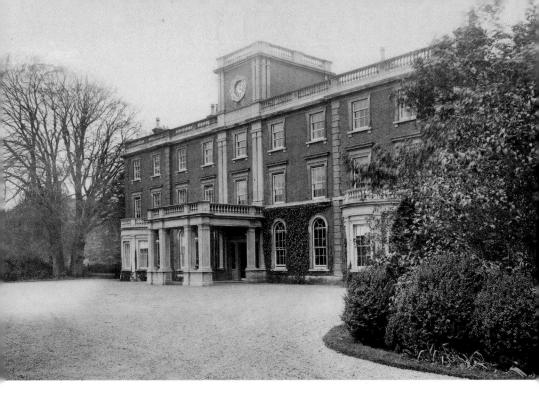

Childhood home: Sudbourne Hall, Suffolk, built by James Wyatt for the first Marquess of Hertford in 1784 and remodelled for Clark's father.

Clark's raffish and boozy father.

Clark enjoying solitude at Iken, Suffolk, on the Alde estuary.

Lam, the Scottish governess whose affection and companionship 'saved' the young Clark.

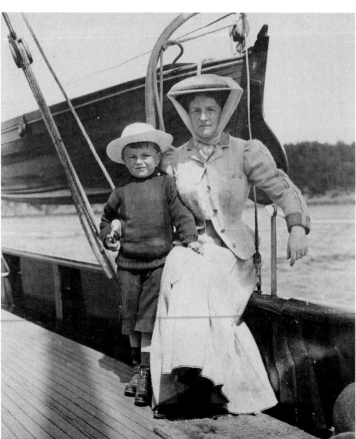

Clark and his mother in a rare moment of demonstrative affection on one of the family yachts.

Clark's suffocating mentor, C.F. Bell, keeper of the Fine Art Department at the Ashmolean Museum, Oxford.

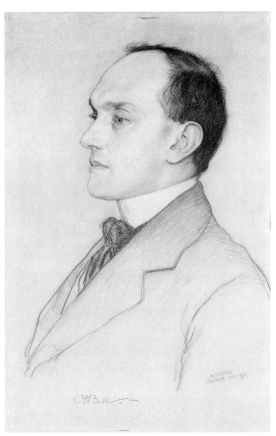

Maurice Bowra, Warden of Wadham College. The great disinhibitor.

Oxford, 1925: the Gryphon Club. Clark is middle row, right. His close friend Bobby Longden, the future headmaster of Wellington School, is two to his left.

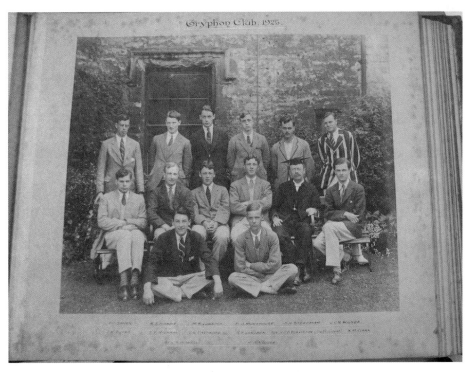

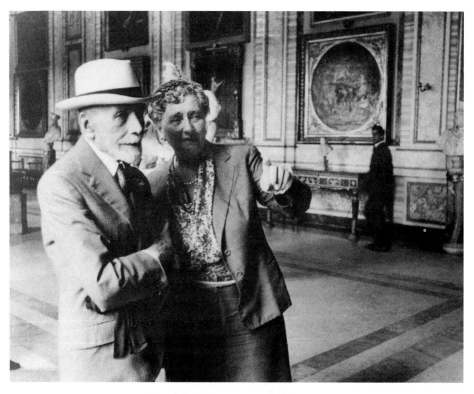

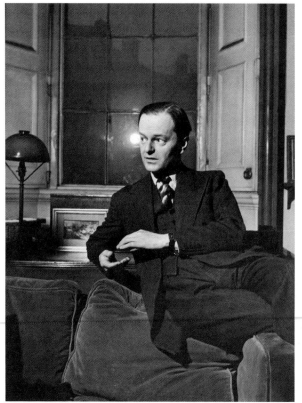

Bernard Berenson with his
mistress, I Tatti's librarian
Nicky Mariano. Clark
described her as 'one of the
most universally beloved
people in the world'.

Jane, the love of Clark's life.
They married in 1927.

The young director of the
National Gallery.

25 March 1934. Clark bidding farewell to King George V and Queen Mary after they had come to recruit him as Surveyor of the King's Pictures – the first visit by a monarch to the National Gallery.

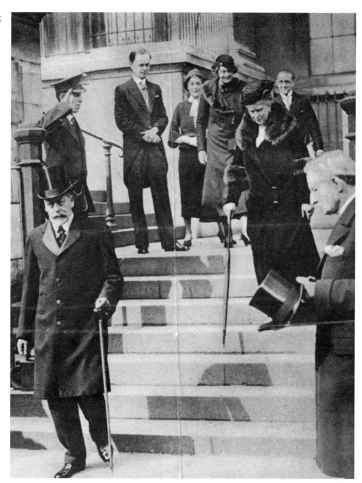

'Bellers' – Bellevue, on Philip Sassoon's Port Lympne estate – where the Clark children were happiest.

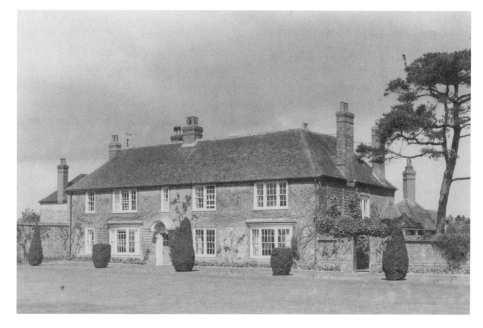

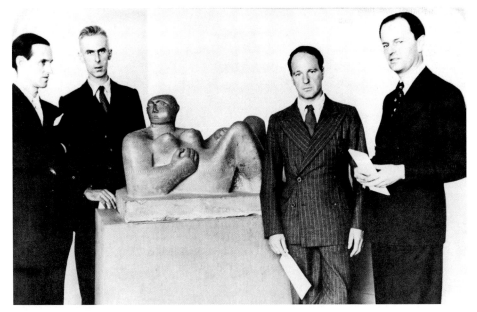

Graham Sutherland, John Piper, Henry Moore – Clark the patron with his artists.

John Piper at his Chiltern farmhouse, Fawley Bottom, named 'Fawley Bum' by John Betjeman.

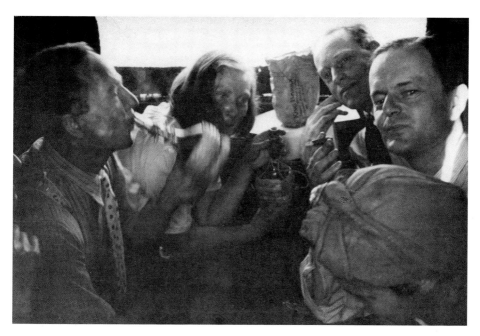

Clark (right) enjoys a bibulous train journey to Leeds with Henry Moore, Myfanwy Piper and Colin Anderson.

Clark's son Alan and daughter Colette, with Tor. Photograph by Douglas Glass.

Upton, Gloucestershire, where Jane was left with the children during the war.

Van Dyck stuck under a bridge, heading for the Manod Caves, where the pictures from the National Gallery would be stored for the duration of the war.

who spoke English with an educated accent, and in most cases the lack of polish went deeper than pronunciation.'[28] But for Clark there was one group who could do no wrong: the artists. His patience with them exceeded anything possible in the other compartments of his life. The painter Graham Bell came to live on the top floor of Portland Place; Duncan Grant and Vanessa Bell, Ted McKnight Kauffer and Marion Dorn, and the Graham Sutherlands were all regular dinner guests. Indeed, the two artist couples who would become the Clarks' closest friends, John and Myfanwy Piper, and Henry and Irina Moore, had no interest at all in grand social life, but accepted their friendship with gratitude and affection. Colin later wrote: 'The sweet kind gentle artists were a complete contrast to our parents' usual circle of friends. None of those socially important people would ever have taken any notice of children.'[29]

Anthony Powell claimed that the Clarks were famously ruthless on their way up in society. Those who replied late to invitations were told that their places had already been filled.[30] His automaton-like, often terrifying, efficiency gave Clark a bad name in some circles, and he frequently caused offence. It would be difficult to exaggerate how busy he was during the 1930s, travelling, lecturing, writing, entertaining, as well as fulfilling two important jobs, with the result that he could be off-hand and impatient. Occasionally this was misleading: when Ben Nicolson went up to him at a private view at the National Gallery to find out about his internship, 'K refuses to shake hands or address one word to me. This distressed me for the rest of the evening because I thought probably it meant that I had been refused for the NG. I cannot put on any other interpretation of his extraordinary behaviour.'[31] This was followed by a letter from Clark: 'I am so sorry I didn't have a chance of speaking to you at our Gulbenkian party on Wednesday. I was being torn in pieces by the most ferocious bores who always victimize one on an occasion like that. If I could have spoken to you I should have said how much I hoped you would be able to come here as honorary attaché next January.'[32] St John (Bobby) Gore used to tell a story of being invited to a white-tie dinner at Portland Place at which Ben Nicolson was a fellow guest. Notoriously dishevelled, Nicolson arrived late, having struggled into a *black* tie. As he was shown into the room, Gore noticed Clark slip out, to return minutes later having changed into his dinner jacket with a black tie. He cited this as an example of Clark's impeccable manners.[33]

The Clarks were taken up by two of the great hostesses of the 1930s, Sibyl Colefax and Emerald Cunard. Lady Colefax lived at Argyll House on

the King's Road, dubbed the 'Lions' Corner House'. There she introduced the Clarks as 'my young people' to the likes of H.G. Wells, Max Beerbohm and the influential American political commentator Walter Lippmann. They were only supplanted in this role after she ran into Clark one day lunching with a ravishingly beautiful woman at Wheeler's – always his favourite restaurant. With an impish tease, Clark failed to introduce Vivien Leigh (then married to Laurence Olivier). Sibyl rang up later to enquire who his companion was. Ten days later the Clarks were invited to meet the Oliviers at Argyll House, and were greeted with, 'Have you met my young people?'

Emerald Cunard mixed music, literature and politics at her lunches in Grosvenor Square, 'a rallying point for most of London society' where the conversation was quick-witted and 'brilliant'; it glided from subject to subject in an exchange of epigrams and *bons mots*. Clark felt that this was a diet of *hors d'oeuvres*, and preferred to linger over a subject, 'to the fury of the other guests; but Emerald forgave me'.[34] Something of this slick brilliance, however, did enter Clark's bloodstream. Many found his gift for summary to be glib, especially when it was witty. A little of it crept into his lecture style – what the German émigré architectural historian Nikolaus Pevsner,[35] brought up in a more rigorous school of art history, described as 'thrown away to the flippancies of the amateur'.[36] For Clark, terror of bores was only exceeded by the fear of becoming one.

With the ascension to the throne of George VI and Queen Elizabeth, the Clarks reached the zenith of their influence. In early 1939 the royal couple came to luncheon at Portland Place. Jane wrote to BB about the visit: 'He is difficult to rouse but she is charming … they liked the magpie mixture in the house … she had never seen a Cezanne before, and thought them v.g. … the King gazed at the large early Matisse but was too polite to say anything.'[37] Alan recalled the visit years later: 'I remember once George VI came to lunch and I was produced in my short trousers and satin shirt, and he was very splendid and he offered me some ice cream, which was extremely good as I was never allowed ice cream because my mother had this puritan side, believing one shouldn't indulge in the pleasures of the flesh. So that made me a Royalist forever.'[38]

When Clark came to make the last episode of *Civilisation*, he told his audience, 'One mustn't overrate the culture of what used to be called the "top people" before the wars. They had charming manners, but they were ignorant as swans.'[39] This prompted a protest from one American listener, whom Clark answered as follows: 'My remark about society people being

as ignorant as swans was based on fairly extensive experience in the 1930s. If I may give one example: I went to Glyndebourne to see *The Magic Flute* and found myself sitting next to Lady Diana Cooper, who was the queen of society for 50 years. Half way through she said to me in a loud voice, "What is this incredible nonsense?" I replied, "I will tell you in the interval." She said she had remembered hearing about it from Tommy Beecham. I said to her, "What on earth made you come?" She replied "To see darling Oliver's (Messel) sets, of course." Does this convince you?'[40] This uncharacteristically ungallant letter reflects, as much as anything else, Clark's ambivalence about Diana Cooper.[41] If one part of Clark was in society, the other half of him despised it, an example of Graham Sutherland's characterisation of him as the divided man. As he later wrote, 'I had a front row seat at Vanity Fair, but a back row seat in Bartholomew Fair might have done me more good.'[42] His increasing sense of mission, and the coming of war, were to be his escape route.

Towards the end of the 1930s Clark embarked on a new course that would characterise the rest of his life: he started being unfaithful to his wife. Jane noted in her diary 'a sudden change in K's attitude' – evidence, she believed, that her husband was having an affair. She took to her bed and confided to her diary, 'decide no use floundering in a sea of surprise, must try and forget and then see what happens, but this is difficult.'[43] Often Clark would merely have lunch with beautiful, unobtainable women such as Vivien Leigh,* and have passing dalliances with those around him. One such affair was with his and Jane's elegant secretary Elizabeth Arnold, who after a brief sojourn working for the Duke and Duchess of Windsor was to follow Clark to the Ministry of Information. On one occasion Jane came home and found her husband in an embrace with 'Stempy' – Elizabeth Stemp, the very pretty maid at Portland Place.

But at the end of the 1930s the story changes. Clark fell in love with Edith Russell-Roberts, the sister of the choreographer Frederick Ashton. Many years later he was to write to his then *amour*, Janet Stone: 'I have been IN love only twice – once with Jane, and once with Freddie's sister, little Edith who was so gentle with me in 1939, when Jane was being bloody.'[44] Edith was small, neat and fair, with a warm and sentimental

* Leigh was acting in George Bernard Shaw's *The Doctor's Dilemma* at the Haymarket, and on matinee days she would drop in between performances. Clark's friendship with her began in 1939.

character, but according to Colette Clark not as clever as her brother – 'an adorable sweet hopeless little goose'.[45] She was married to a choleric naval officer, Douglas Russell-Roberts, who was frequently away, during which times Clark and Edith would meet at her house in Lennox Garden Mews. There are two undated letters from her at I Tatti: 'My darling heart, I feel a lovelorn lass this evening …' and 'Last night at long last a divine sunset, awakening all my longings for you, and all the happiness that I feel in your presence …' Clark evidently told Jane about his feelings for Edith; she was baffled, and hoped he would get over it. He even gave Edith a Henry Moore drawing. Edith was later to claim that Clark was 'the love of my life who taught me everything I know'.[46] Contrary to what Clark later wrote, he was certainly to fall in love on many more than two occasions.

Jane idolised her husband; she had oriented her life in every way to serve his needs, so the revelation that he was less than perfect was a hard shock. In those days it was far from unusual for couples of their class to take lovers after ten years or so of marriage – the Berenson household was not untypical – but Jane bitterly resented the change. She was already prone to tantrums when she and Clark were alone, and took refuge in alcohol and prescription drugs in an attempt to control her temper. How much these tantrums were aggravated by Clark's behaviour is not clear: Colette believes that they were a part of her mother's character, with or without the provocation of his affairs. Jane discovered a fashionable Harley Street doctor, Bedford Russell, who gave her a nasal spray containing morphine and cocaine, and from then on she would reappear after a puff, puff, puff 'in a beautiful haze'.[47] Her husband meekly accepted her outbursts as the price for his misdemeanours, but the more she tormented him, the more he sought solace elsewhere. But on only one occasion was the marriage actually in crisis. Neither of them ever seriously contemplated divorce – they believed in marriage, and had established mutual bonds that went too deep to separate.

13

Running the Gallery

Stand close around ye artist set
Old masters sometimes will forget
With dear K to your shores conveyed
The pictures that they never made.

CYRIL CONNOLLY[1]

Kenneth Clark was the first director of the National Gallery to become a household name. Although his tenure there was marked by controversy, it nonetheless constituted eleven years of steady achievement in which the gallery moved from being a very inward-looking organisation towards a far greater engagement with the needs of the visiting public. Many of the previous directors had been artists who sought to improve the appreciation of painting in Britain, but Clark was an unlikely populist with a Ruskinian desire to open the nation's eyes to works of art. Indeed, the predecessor with whom he most identified was Charles Holmes (director 1916–28), who like Clark was interested in contemporary art, held fund-raising concerts at the gallery, and wrote an accessible book on Rembrandt. Holmes brought the gallery into the twentieth century by acquiring modern French pictures (for the Tate with the Courtauld Fund), including three works by Van Gogh (*Sunflowers* among them). Clark once refused to alter an erroneous attribution, explaining: 'My motive for not changing the label is simply that my predecessor, Sir Charles Holmes, has always behaved most generously towards me and would no doubt regard it as a personal insult if I were to do so.'[2] What separated Clark from his predecessors was the way he grasped the extraordinary opportunity offered by World War II to turn the gallery into (in the words of the *Observer*) 'far more genuinely a national possession than ever before'.[3] But long before the war began, he initiated a modernising agenda that was to delight some and appal others.

Inevitably, Clark's priority on arriving at the gallery was to rehang the pictures. He always felt that the institution was fortunate in having been created before museum buildings became grandiose. Its galleries had human proportions despite Victorian enlargements. But at the same time it lacked the variety of room sizes necessary to hang both the Venetian pictures, for which it was well suited, and the small Dutch cabinet pictures, for which it was not suited. Clark never believed that it worked to have the best of all periods and schools jostling together, nor to introduce sculpture and furniture 'to give the illusion that pictures were in something resembling their original settings'.[4] He enjoyed a crowded picture hang, but regarded it as a self-indulgence.

Although Holmes had started the process of decluttering the galleries, Clark's rehanging was close to the spirit of the gallery today, keeping the schools apart in a hang that was uncrowded compared with those of his Victorian predecessors, but rich by comparison with later museum hangs of the 1960s, when greater emphasis was placed on the individual paintings. Ultimately he thought pictures should 'look at home and show us all they have to show without interruption or distortion'.[5] Clark believed picture hangs could not be planned on paper, and that paintings must be placed next to each other to see if they sang together or clashed. There is no doubt that he had a flair for hanging pictures, and his arrangements were much admired. John Pope-Hennessy later wrote that 'the Gallery looked beautiful while he was there',[6] and Helen Anrep wrote to Clark: 'It's a completely new Gallery ... the whole place seems full of a new gaiety and fragrance.'[7] He took great trouble choosing the background colours, telling the keeper Harold Isherwood Kay, 'At present my chief preoccupation is with the colour for Room 1. I have managed to get a grey which seems far kinder to the Pieros than the present colour ... I should like to have a set of paints and about twenty boards ... and then spend several weeks making experiments by myself.'[8] All this was done with virtually no consultation with his curatorial staff, whose resentment was, for the time being, carefully concealed.

Lighting was next on Clark's list. He felt that unvarying artificial light was unpleasant and deadened the pictures, but that top lighting was wrong for Dutch paintings, which benefited from being side-lit – a conundrum he eventually solved by opening three rooms downstairs as side-lit cabinets for the Netherlandish cabinet pictures. The very late introduction to the gallery of electric light in 1934 meant that opening hours could be extended for three nights a week to allow the working public to enjoy the

paintings after office hours, till 8 p.m. Electric light also made glamorous evening events possible all the year round. As Clark wrote to Jane, 'At 6.30 I went to the gallery. I saw the revised lighting. It is enormously improved: in fact I can truly boast of it, and I think the party will be a huge success. The PM is coming: it will be a new experience for him to enter the National Gallery. We are also getting the Yorks, and all the ambassadors and all the cabinet ministers.'[9]

When Clark took up his appointment at the gallery, all the pictures were glazed. This was a response to London's polluted atmosphere and, to a much lesser extent, to memories of the vandalism of the *Rokeby Venus*, which had been slashed by a Suffragette in 1914. The argument over glazing raged at meetings of the trustees from the day Clark arrived. He was personally against glass because of the reflection it produced. The matter came into focus again when Duveen presented Hogarth's *The Graham Children* on condition that the picture remained unglazed. In October 1935 the board discussed glazing in detail, and although Sir Robert Witt pointed out that 'protection from Sulphur may be obtained by adopting the American system of conditioning the air', it reluctantly accepted the need for 'glasses', as they were called. Clark had already discussed the idea of air conditioning – or 'air washing', as he referred to it – with the Office of Works, but insufficient money was available to equip even half the gallery. Queen Mary became involved, and 'laid it down as a rule that, apart from the improvement in appearance, glasses in London were an absolute necessity'.[10] Air conditioning was introduced only after the war, and the glass was then removed from the paintings.

The National Gallery – at the insistence of the Treasury – charged the public for admission two days a week, a practice which Clark urged the trustees to abolish (entrance charges were eventually dropped during the war). Another of his earliest acts was to appoint a PR firm to give advice on attracting more visitors and to examine their needs and preferences. The new evening openings were advertised in Underground stations, and became the subject of the first gallery press view. Public lectures were reduced in length from two hours to one, and a series of new publications were designed as hand guides rather than catalogues. Clark argued for a room to be set aside in which women could sit and rest, but failed to achieve this – there seems to have been a perpetual fear on the part of the trustees that tramps might take advantage of the gallery's facilities. Sometimes the board's minutes verge on the comic, such as one headed 'The Nuisance caused by singing Welsh Miners', who apparently

pestered 'nervous provincial or colonial' visitors as they entered or left the gallery.[11] Clark had an important ally in David Ormsby-Gore,[12] First Commissioner of Works, who told him, 'As to my own part I am always ready to do anything you personally like – neither less, nor more.'[13] Ormsby-Gore was to smooth many bumpy paths in future, including pushing the Overseas Loans Bill through the House of Commons *sub silentio* – which made exhibitions abroad possible, including the 1938 Paris exhibition of British art.

Clark's populism is perhaps best remembered for the early opening on FA Cup final day in 1938. A gallery minute reads: 'The provincial supporters of the Finalists … up early for the day in London, might have an opportunity of seeing some famous exhibitions instead of wandering about the streets.' It was agreed to open the gallery at 8 a.m.: 279 visitors were recorded before 10 a.m., and 3,602 for the whole day.[14] Neil MacGregor, a later gallery director, called this 'a dazzling populist touch, and it doesn't matter whether anyone ever did come to see the pictures. The fact that he thought of it, did it and announced it is just the kind of populist brilliance that did a great deal to put the gallery right at the heart of the nation's affection.'[15]

Clark saw the potential of the media for bringing his work to the attention of the nation, and MacGregor believes he was uniquely gifted as a director in the way he was able to handle and excite the press. He gave interviews about the gallery – the *Daily Mirror* ran a profile in a series called 'Under 40': at number four, 'The man who may be called Britain's art chief is a spruce, pleasant young organiser of 33, with a nice taste in ties, cool, business-like eyes, determined chin and an air that suggests Lombard Street rather than Trafalgar Square.'[16] His strategy saw results: between 1934 and 1939 there was an increase of 100,000 visitors. However, this flair for publicity – which would land Clark an important wartime job – went strongly against the grain of the conservative gallery staff.

Of enormous significance for Clark's future, a heading in the minutes for 13 April 1937 reads 'Television'. He had just visited Alexandra Palace, the early home of the BBC's television broadcasts, and was clearly intrigued by the new medium's potential for popularising the gallery, 'if ever it attained the necessary degree of proficiency'. However, the first question was whether filming involved any danger to the pictures. Clark saw that the intense light that was required created great local heat, but felt that though television's present image-quality was feeble in the extreme, the gallery should stay in touch with developments. Eight months later he

made his first TV broadcast from Alexandra Palace, on Florentine painting.[17]

Clark is usually given credit for starting up the National Gallery photographic department. As Neil MacGregor told the author: 'When I joined the National Gallery, there were two contradictory legends about K; the first was that he was seen as contemptuous of the staff (probably untrue, but that is the legend) and arrogantly overconfident. He was also, however, revered for setting up the photographic department, which produced the first high-quality detailed photographs of any museum, certainly in Europe. It became the only source of high-quality photographs for textbooks, and put the National Gallery at the centre of art history studies. It also enabled the public to get closer to the pictures, and this was always K's ambition.'[18] In fact Clark did not set up the photographic department, but he greatly extended it, and found a brilliant way of using it that was both scholarly and populist.

In 1938 Clark published *One Hundred Details from Pictures in the National Gallery*, a book that provided a delightful parlour game of guessing who the details were by, often with surprising answers. He had taken the idea from his friend Yukio Yashiro's study of Botticelli, which used photographic details – although as he commented, it was odd that nobody had thought of the idea before: it was an inevitable result of the Morellian method. Ruskin had published detailed illustrations of his own drawings and photographs of buildings.[19] Clark sent complimentary copies of the book to half the grand houses of England. It elicited praise from Logan Pearsall Smith, who wrote on Christmas Day that it 'makes my Xmas, usually a dreary day, almost a merry Xmas'. Winston Churchill sent a telegram of thanks, and Sydney Cockerell called it 'the cheapest and most exciting six shillings worth I ever saw. The selection is unassailable.'[20] *Details* was reviewed admiringly by Roger Hinks in *The Listener*, who rightly felt that 'the point of this selection lies, then, quite as much in the opposition of one detail to another as in the choice of the details themselves.'[21] The critic Eric Newton thought that Clark's notes about the plates were casual but brilliant.[22] It is extraordinary how quickly the use of details caught on: Skira was one publisher which immediately began to introduce them into its architectural books. Clark's book was reissued by the gallery in 1990 and 2008.

One thing that Clark did set up (from the profits of the sale of postcards) was the gallery's scientific department, for x-ray examination and analysis of paintings. This was under the care of a Cambridge radiologist

named Ian Rawlins, 'a kind, good, man, but one of the most relentless bores I have ever encountered, who fussed interminably over the most trivial details'.[23] The information revealed by x-rays and infra-red radiography transformed decision-making over picture-cleaning, the subject that would provide Clark's first public trial as director. When he approached the question of whether or not to clean, he admitted, 'the primary question is aesthetic: will the picture look more beautiful restored or unrestored?' – but he believed that science should assist the decision.[24] In the comfortable remoteness of old age, he was able to write: 'I do not regard cleaning controversies as of any importance. They are epidemics which take place about every twenty-five years.'[25] The National Gallery was certainly no stranger to them – in 1853 a government inquiry into the gallery had paid special attention to the practice, so this was not a matter to be taken lightly. Clark used two principal restorers, W.A. Holder and Helmut Ruhemann: 'I thought that different types of pictures needed cleaning by different characters. Mr Holder was an instinctive cleaner, who touched the canvas with the gentleness of a game-keeper picking up a baby partridge. Ruhemann was, of course, far more skilful and more scientific.'[26]

The first salvo in the 'cleaning wars' was a letter from the secretary of the Royal Academy that Clark read out at a trustees' meeting. It stated that a member of the RA proposed to ask public questions concerning the National Gallery's cleaning policy.[27] Clark was rattled, and wrote an exasperated letter to the RA's president, Sir Gerald Kelly: 'The quarrels which for some years had rendered the Gallery notorious have completely disappeared ... now it seems that all our hopes are about to be shattered ... [I] may be forced to resign, a press campaign against the Gallery may be instituted ... once more the Gallery is to be dragged into the public eye as the scene of humiliating differences of opinion.'[28] Part of the problem was that the Academicians thought that an artist should run the gallery (as indeed had usually been the case), rather than an art historian, and they actually enjoyed spats. The painting that aroused their feelings was the Velázquez portrait of Philip II, the so-called 'Silver Philip', that had just received the attentions of Ruhemann. The *Daily Telegraph* had been stirring up controversy by inviting well-known artists to voice their opinions on the subject. Critics included Alfred Munnings, William Nicholson and Frank Brangwyn, who preferred to view Old Masters through the golden glow of discoloured varnish, and even threatened the establishment of a Society for the Protection of Old Masters. A lot of ink was spilled on the

matter of whether 'glazes' or varnish had been removed from the Velázquez. Clark defended the gallery on the letters page of *The Times*,[29] and Sir William Rothenstein wrote to express approval of 'the Silver Philip', but advised in future bringing in two or three prominent artists for 'sharing the blame'.[30] Clark, however, preferred to rely on the science: 'tastes differ, and therefore we are less open to attack on this score. Technical matters should be capable of proof, and if controversy should ever arise, as I fear it eventually will, we should be able to prove that no harm has been done.'[31] The matter rumbled on for over a year.[32]

On the way home one evening in the summer of 1936, Clark saw a newspaper hoarding announcing 'National Gallery Grave Scandal'. He had not the faintest idea what this could be, but probably imagined that it was the Academicians making mischief again. In fact the matter was much more serious – and a complete surprise, as he explained to Lord Crawford: 'My holiday was delayed for two most disagreeable days by the discovery that our accountant had been systematically robbing the till for some years. He had taken over £300 – hence the muddle in the accounts. I hardly knew him, but always thought him rather odd, but [the keeper Isherwood] Kay (and of course Collins Baker) always swore by him as a model of reliability. Apparently he had been drinking for some time. We have all the usual accompaniments – loaded revolver, scenes, confessions, screaming wife etc. Coming the day after the Gulbenkian party it showed the range of activities a director of the gallery may be called upon to undertake.'[33]

Since Clark was the gallery's director, he was technically responsible for the accounts – as Isherwood Kay gleefully pointed out. Clark felt exposed, as he had been travelling a great deal, leaving the day-to-day business to Kay. He wrote to Jane in Cannes: 'Had to go to the Treasury about tomorrow's interview with the ... accounts committee which promises to be *most* disagreeable. Little Kay is wholly to blame but I must try to protect him.'[34] The following day he reported: 'Most disagreeable day. The interview with the public accounts committee took two and a half hours, during the great part of which I was violently attacked ... It was a most humiliating experience and has left me a good deal shaken.'[35] He was widely expected to offer his resignation, but thanks to solid support from his trustees he survived the crisis. The accountant was sent to prison for six months and the gallery staff were censured. The sum of money involved was £1,267.

* * *

If much of Clark's work required him to be an administrator, answering letters and attending meetings, part of his role which he found much more enjoyable was the cultivation of art collectors. With a small annual purchase grant that could not compete with those of the gallery's American rivals, he realised that one way of displaying great paintings he could not afford to buy was through loans – which with luck might even one day turn into bequests. As a collector himself, Clark was sympathetic to the breed, but reflected that they were often less than perfect human beings: 'Three great collectors – Dr. Barnes, Sir William Burrell and Mr Gulbenkian – were my frequent companions before the war, and I recognised that they were terrible characters. They were ruthless ... But let no one say they did not love art. They did.'[36] Dr Barnes we will meet in the next chapter; William Burrell was equally reluctant to allow anyone to see his collection. It contained forty pictures by Degas and many magnificent tapestries and carpets, all kept at Hatton Castle, a baronial pile in Scotland. Clark gained his trust – no mean feat with 'a man so singularly devoid of human feelings' – and soon they were discussing the future of the Burrell collection. One of Burrell's difficult conditions was for a personal museum to be built in a smokeless zone near a large city. Clark was therefore quite pleased to find a site in Hampstead, opposite Jack Straw's Castle, which he almost persuaded the London County Council to help finance. Negotiations foundered, however, on who was going to pay for the site and the building, the spectre of death duties, and finally the coming of war.[37]

These last two problems would also bedevil the plans of by far the most formidable of the trio. Calouste Gulbenkian was the most feared operator at the heart of the international oil business. Of Armenian origins, educated in England, he lived in Paris, but the Middle East was the source of his fortune. He once told Clark that his father advised him when he was young, '"Calouste, do not look up; look down," so I looked down and I found oil.' In 1920 he had negotiated a 5 per cent share in the newly discovered oilfields of Mesopotamia (modern-day Syria and Iraq). This gave him the sobriquet 'Mr 5 Per Cent' and an income of several million dollars a year, which he spent the rest of his life protecting. Gulbenkian was intensely suspicious – 'Always on the bridge, Mr Clark' – and his constant refrain was 'Check, check, check.' As a collector he was a man of extraordinary discrimination, with a divided heart: one part lay in eighteenth-century France, the other in the arts of Islam. What united his works of art, be they Persian manuscripts, Mughal carpets or French bookbindings, was a desire to see the designs of nature transmuted into

art – he was the creator of several beautiful gardens. Gulbenkian's paintings were by any standards superb, and included several masterpieces whose acquisition he had personally negotiated with the Russian government between 1928 and 1930, including the *Portrait of Hélène Fourment* by Rubens, and Rembrandt's *Pallas Athene*. He had a particular *penchant* for Guardi's views of Venice. His collection of the decorative arts was also of the highest standard: furniture by Cressent, silver by Germain – but even they were overshadowed by the textiles, from Lahore and Bursa. The collection had – and still has – the rare distinction of bringing Eastern and Western elements to sit comfortably together.

Gulbenkian housed his collection in a fortified residence on the Avenue d'Iéna in Paris. He rarely admitted strangers to see what he called 'my children' – when asked why he so rarely showed his treasures, he famously replied that Orientals didn't unveil the women in the harem. Clark was invited to inspect the collection, probably in 1935, and took Jane to Paris with him. While they were waiting for their host, she sensibly warned her husband that everything they said would be relayed to him. Clark was at his best in such situations, when he could charm his interlocutor with his wit, knowledge and intelligence. He was impressed by the quality of Gulbenkian's paintings and French furniture, and even more enchanted by the Persian roof garden.

A few weeks later the telephone rang in his office: 'This is Mr Gulbenkian. Would you like to take some of my pictures on loan at the National Gallery?' Clark said he would, and when asked how many, suggested forty. A measure of how confident he felt in his authority may be gauged by his response to Gulbenkian's query, 'You do not ask your trustees?' Clark thought that was unnecessary, and cannily left the selection of the pictures to their lender: 'I have perfect confidence that you will send the best.' Gulbenkian wrote to express his desire that his works of art 'should have happy surroundings and procure public enjoyment. No one will understand me better than yourself and for this I am grateful.'[38] The first batch of fourteen paintings was discussed at the next trustees' meeting, at which Clark told the board of his acceptance of the loan under circumstances that did not allow for proper consultation. Since the pictures on offer included the *Pallas Athene* and the *Hélène Fourment*, the trustees acquiesced, just as Clark had predicted they would.

Clark initially hung the group of Gulbenkian paintings together – as he told Samuel Courtauld, in order to make more of a *réclame*.[39] *The Times* welcomed the loan, but in such terms that Clark felt compelled to write: 'I

should like to lay more stress on Mr. Gulbenkian's generosity in lending us his pictures. To part with his greatest treasures, to see them exposed to all the risks of travel and a change of climate, involved a great sacrifice and should have earned more explicit gratitude.'[40] It would not have been lost on Gulbenkian that he had a champion at Trafalgar Square, and Clark was extremely anxious that all the gallery staff should understand the importance of this new lender. He wrote to Isherwood Kay from his holiday: 'We ought to do everything we can to please Gulbenkian. I write to him once a week – and usually in answer to a long letter from him.'[41] Trust between the two men reached such a pitch that the collector began to rely on Clark's judgement for all his purchases, having first 'double checked to make sure that I was not being influenced by the vendor'.[42] Over the next few years Clark was consulted on a wide variety of art, from Masaccio and majolica to Picasso, whose work Gulbenkian did not like: 'I have been told by Rosenberg that you nearly fainted when you saw the Picassos … I regret that my education has not gone so far as to understand even the elementary side of this peculiar art.'[43]

It was some months after the initial loan that Gulbenkian raised the matter that must have been uppermost in Clark's mind: the question of the future of the collection. Surprisingly, the National Gallery negotiations for the Gulbenkian collection encompassed not just the paintings but also the superb decorative arts (about which it possessed no expertise), with the endowment of Gulbenkian's entire fortune. This would at one stroke have made the National the richest gallery on earth, and was the greatest prize that any museum could receive. To the trustees the opportunity presented by their young director was dazzling. At the June meeting in 1937 Clark reported Gulbenkian's intention to leave everything to Britain, to be housed in a separate building attached to the National Gallery, and 'demanded' authority to continue negotiations concerning land hitherto earmarked for an extension to the north. The solution he put forward was ingenious: an annexe on then-vacant ground (roughly where the northern wing is now located), accessible from its own entrance in St Martin's Street and also from the gallery. The decorative arts would be housed on the ground floor and the paintings on the first floor, connected via a bridge to the rest of the gallery. Clark was congratulated on the skill with which he had dealt with the matter. Gulbenkian seems to have been well pleased with the idea, and the conversation moved on to architects.

By January 1938 Gulbenkian was looking forward to seeing the plans of Clark's architects, but these evidently did not satisfy him, for a year later

he was urging Clark to look at the architect of the American consulate in Paris – 'the best example of the architecture of modern times I have seen. I have no confidence in any other architects.'[44] Gulbenkian's favoured architect was William Adams Delano, who worked in the conservative *Beaux Arts* style favoured by American millionaires. Clark wrote to Delano explaining the requirement for five or six galleries on two floors, each about forty by fifty feet. But now he had not only Gulbenkian to deal with; he also had to persuade the Office of Works to allow him to change its plans for the site, which also involved the National Portrait Gallery. Using an outside architect was another hurdle Clark had to overcome, and he was left to undertake all the negotiations between Delano and the Office of Works. A large architect's model was eventually produced, which was somehow shipped across from America in 1940 during the Battle of the Atlantic. The model, which was later discarded, showed a ponderous building in the 5th Avenue millionaire manner.

The main obstacle to the plan that was being hatched between Clark and his benefactor was the problem of where and how Gulbenkian's will could be managed to allow his entire estate to bypass both his family and taxes. As early as 1937 Clark was seeking advice from the legal adviser to the British Embassy in Paris about the difference between 'domicile' and 'residence', and the implications of making an English will.[45] This last matter was central to Gulbenkian's concerns; he did not want to pay British death duties, but was equally opposed to a French will, which would have forcibly given a third of his estate to his family, 'a thought' that according to Clark 'greatly distressed him'.[46] These were fairly insuperable barriers, but there was also another, less predictable, problem. As Clark explained to Lord Balniel, by now chairman of the trustees: 'There seems to be no doubt that he [Gulbenkian] is going to go through with his benefaction in the course of the next year if we can agree to his terms. He has authorised me to spend another £2,000 on plans and models and when these are to his liking he will draw up a legal and what he insists on calling a "moral" scheme for the gift. The cost of the building has been estimated at about £150,000. I think it will be rather more but this does not seem to deter him in the least. The only thing that worries him is that we cannot offer him a big enough garden, and if the scheme does not come off it will be solely because of his horticultural obsession.'[47]

The letters between Clark and Gulbenkian are businesslike, mostly about specific works of art, usually paintings, and always formal in their manner of address. In a typical early example, Clark is suggesting the

publication of a short catalogue of the pictures and alerting Gulbenkian to a Bellini from Charles I's collection that was for sale on the London market. As he became more confident in the relationship, Clark would draw Gulbenkian's attention to items on which the National Gallery had passed, such as a Rubens of the Archduke Albert and a Terborch portrait of a woman.[48] Finally Clark turned to him to buy items that the gallery would like to own but could not afford, in the hope that they would one day join the rest of Gulbenkian's 'children' at Trafalgar Square.

One of the collections that was always on the radar of the director of the National Gallery was the Cook collection, held at Doughty House on Richmond Hill. It was a late-nineteenth-century collection, full of masterpieces including important Renaissance paintings and Rembrandt's beguiling *Portrait of Titus*. Sir Herbert Cook died in 1939, and Gulbenkian, never one to miss a chance, wrote to ask Clark whether anything would be sold. Clark had a clear conflict of interest with the National Gallery as he described the collection, and in particular the *Titus* portrait, to his benefactor, but he thought that nothing would happen immediately.[49] Gulbenkian was unconvinced: 'I think the matter will require your urgent attention in order that we should not miss such a fine opportunity.'[50] Later in the month Clark took Gulbenkian down to Richmond, and shortly afterwards they made an offer through the Cook family's lawyer for Rembrandt's *Portrait of a Small Boy* [*Titus*] and Benozzo Gozzoli's *Madonna and Child with Angels*. The Cook trustees prevaricated, and matters rumbled on through the war, but Gulbenkian never managed to secure them.* The continuing story of Gulbenkian belongs to another chapter.

The Cook executors and trustees were to prove a thorn in Clark's flesh. Several of the Cook paintings, including a most desirable Van Eyck, a Fra Angelico and Filippo Lippi team effort, and Titian's *La Schiavona*, were on the gallery's list of paramount paintings. The Cook family had always enjoyed close links with Trafalgar Square, and various promises were believed to have been made with regard to the future – to which the executors of the collection, whose priorities were different, felt under no obligation. 'They are Shits,' wrote Lord Crawford in a rare outburst,[51] and Sir Robert Witt of the National Art Collections Fund complained that 'the greed of a degenerate Baronet has done us down!' Having no purchase

* Clark bought the Benozzo Gozzoli for the National Gallery in 1945. The Rembrandt was the subject of a notorious auction sale in 1965, when it was bought by Norton Simon.

funds available, Clark even proposed to Lord Crawford selling 'a few of our redundant pictures? It will create a most appalling row, however as Mr Gulbenkian says – "The dogs howl, the caravan passes" – and the great thing is that we should secure the Fra Filippo and the Van Eyck.'[52] He went to the Treasury to see if it would advance the money, but by then war had broken out and it was impossible to expect any government largesse – or to call upon Gulbenkian. The Van Eyck and the Lippi were eventually sold abroad;* however, the Titian was presented to the gallery by the family in 1942. Clark had had more luck with the Duke of Buccleuch, who in 1938 offered another irresistible painting, Rembrandt's portrait of his wife, *Saskia*, which Clark was able to acquire for the gallery for £28,000.

At the end of 1937 the question arose of Lord Duveen's reappointment to the board for a further term. The gallery chairman at the time, Samuel Courtauld, was opposed, as was another trustee, Lord Bearsted. Clark agreed with them, believing that the reappointment would be a disaster. Furthermore, Gulbenkian had attached a condition to any gift that there should be no dealer on the trustee board. But Duveen had strong supporters in Sassoon, d'Abernon and Charteris, who told Clark, 'Surely the policy of hitting a gift horse in the mouth with a crowbar is not only a little brutal but extremely unwise.' As a group they had more political cunning than their opponents. What happened next is a matter of some doubt. Clark left an account in his autobiography, and also placed an account in the files of the *Burlington Magazine*: 'When the vacancy occurred I asked permission to see [the Prime Minister] Mr. Chamberlain. I am not likely to forget the interview, which took place in the Cabinet room: Mr. Chamberlain on the opposite side of the green baize table looking like a starved and hungry vulture. On my stating my purpose he said, "It is too late, I have promised Sassoon and Charteris and I have already informed Duveen that he has been re-appointed." I asked permission to state my case at greater length. At the end of ten minutes Mr. Chamberlain said, "You have convinced me; I will ring up Duveen (who was in America) and revoke the appointment": which he very courageously did.'[53] The problem with this account is that the records show that it was Lord Balniel and Courtauld who saw the Prime Minister, and not Clark.[54] Whether or not his account was a second-

* In 1939 they were offered to the gallery for £150,000 and £60,000 respectively – prices so high that Clark believed the family were deliberately seeking a refusal by the gallery in order to sell abroad.

hand one (which seems likely), Duveen's friends assumed that his inter-
vention had carried the day. Sassoon was furious, and wouldn't speak to
Clark for three months, while Charteris calmly told Clark, 'You do not
know what harm you have done.'[55] When he came to write his autobiogra-
phy Clark looked back on his own position as 'a piece of priggish nonsense',
but his change of mind was influenced by the fact that Duveen died a year
later of cancer.

One of Clark's responsibilities was the Tate Gallery, which at that time was
still an uneasy dependency of Trafalgar Square. Paintings for the Tate were
offered to the National Gallery board meetings, as the Tate had no
purchase grant of its own. The main point of contention was the custom-
ary division of paintings, and at what point, and by what criteria, paintings
should pass from the Tate to the National Gallery.* The feeling at Trafalgar
Square was that the Tate was too weak to deserve to keep the finest
pictures, a position that caused resentment, but Clark bent over backwards
in his efforts to be fair to the Tate, for which he had great sympathy.[56]
Much depended on the relationship between the two directors, and fortu-
nately Clark got on well with the painter James Bolivar Manson, who
directed the Tate. Manson was a charmer with a twinkle, whose acquisitive
vision Clark thought was limited to pictures 'more or less in the style of
himself and his friends'.[57] He kept Picasso out of the Tate, and refused the
Stoop collection[58] for the same reason. Herbert Read's *Art Now*, published
in 1933, had offered a view of European avant-garde art which made the
Tate appear hopelessly insular and behind the times.

But Manson's most obvious disadvantage was his drinking. The chair-
man, Evan Charteris, had a soft spot for his errant director, and would
deploy all his powers of advocacy to rescue him from scrapes. 'Evan had
decided to champion the Tate gallery,' Clark told Jane, adding that Philip
Sassoon complained: 'My dear, if you even *hint* to Evan that Manson's ever
drunk anything but *milk* he flies into a rage!'[59] Manson finally went too far
at the opening of the British exhibition at the Louvre in 1938. Clark organ-
ised this exhibition, hoping to escape the dealers' view of British art and
do justice to such artists as Samuel Palmer and William Blake. He thought
it contained 'the best collection of British painting ever assembled', with

* The National Gallery contains the nation's collection of Old Master paintings, whereas
the Tate held exclusively British paintings and what were deemed as modern works of
art. This was generally defined with a cut-off around 1900, but was never exact.

three living artists – Walter Sickert, Augustus John and Ruskin Steer. Manson's downfall came at the opening banquet at the Hôtel George V. Clark always enjoyed the story, not least because the French press attributed Manson's behaviour to the young director of the National Gallery: 'Quite early in the meal ominous farmyard noises came from one of the small tables where Manson was seated ... By the second course these had been succeeded by remarkably life-like and penetrating "cock-a-doodle-do's" at which point Manson set out on his peregrinations.'[60] He went off in search of more to drink, and on the way leered at the delicate wife of the British Ambassador, 'I'll show you something that isn't in the Tate Gallery ...'[61]

After Manson's inevitable departure, John Rothenstein was appointed as his successor. He was to become one of the Tate's most successful directors. Clark wrote to him to express 'relief to have a reasonable being at the Tate who does not envisage the relations of the Tate and the National Gallery as a continual guerrilla warfare'.[62] Rothenstein found Clark decisive and knowledgeable, and wrote that their seven years as colleagues had 'never, so far as I recall, been flawed by the smallest disharmony', which was quite a feat.[63] Clark told Rothenstein when he was appointed, 'You have in Evan an admirable Chairman. But when you see his face assume a dreamy, far-away look, take care.'[64] Evan Charteris had by this time become thoroughly disenchanted with Clark, no doubt partly as a result of the Duveen affair, but also because Clark was turning into a controversial figure amongst his colleagues. Lord Crawford's diary records the two prevailing views about Clark at the beginning of 1938: 'Evan was full of complaints about Kenneth Clark, "the young dictator has faults, and doesn't know how to behave, puts people's backs up and makes unnecessary enemies"; but to me his virtues far outweigh his faults. His energy, drive, imagination and brilliant mental gifts are all at the service of the Gallery and he has done more there already than has been done for generations.'[65] But unfortunately Clark had played directly into the hands of his detractors, as we shall see.

14

Lecturing and *Leonardo*

*Leonardo is the Hamlet of art history whom each
of us must recreate for himself.*

KENNETH CLARK, *Leonardo da Vinci*

With Clark's arrival at the National Gallery, his ability to find the time to
write scholarly books was drastically curtailed. His ambitious plans for
works on Classical art, motives and symbols were all put on hold. However,
lecturing was still possible and desirable for any public figure in the arts.
Throughout the 1930s he gave scores of talks, some impromptu and others
polished for publication. The appearance of Clark's Windsor Leonardo
drawings catalogue in 1935 established his scholarly credentials, and the
book received considerable applause. The *Times Literary Supplement*
devoted a leading article to a review praising Clark's 'quiet precision'.[1] It
admired his wide knowledge, but also his practical sense in distinguishing
the master from the pupils by the simple explanation that, since Leonardo
was left-handed, the diagonal strokes of his drawings always run down
from left to right.[2] The enthusiastic response of his young protégé John
Pope-Hennessy particularly pleased Clark: 'There is nothing nicer than to
be praised by people younger than oneself. The old become slack and
maudlin ... but the young are always ferocious.'[3]

Many of the reviewers expressed the hope that Clark would use the
knowledge he had gained at Windsor to write a shorter general life of the
artist, a point not lost on him. When he was invited to give the prestigious
Ryerson Lectures at Yale, he chose as his subject Leonardo da Vinci's
development as an artist. The lecture series had the additional benefit of
taking him to America for the first time. Clark was to blow hot and cold
about the USA over the next twenty years, but he was very enthusiastic
about his first trip.[4]

The Clarks' arrival in the United States in 1936 made headlines owing to a press interview in which he remarked that the recent Depression had hit only bad art. While fashionable portrait painters were without work, he said, the good artists went on selling; he added the doubtful proposition that 'good paintings fetch much less money than bad paintings, you know'.[5] He also expressed a strong desire to see all the great collections of nineteenth-century French paintings in America, and in that he almost succeeded. The Clarks took a suite on the twenty-eighth floor of the Waldorf Towers Hotel in New York, which to his delight appeared to be two (sic) thousand leagues under the sea – he 'would not have been surprised if a large fish had bumped its nose against our window'.[6]

America in the 1930s was the place to see French Impressionist paintings, as European museums were still catching up. Clark and Jane visited the collection of the banker Chester Dale, which 'proved, what I already knew, that the love of art was in no way related to culture or refinement of manners'.[7] But the undoubted climax of their trip was a visit to the collecting maverick Dr Albert C. Barnes in Philadelphia. Barnes was a genuine doctor of medicine who had made a fortune from an antiseptic called Argyrol. On the face of it, Clark represented everything that Barnes disliked: museums, art history, and the establishment he was determined to snub. As Clark later put it, some collectors acquired art to get a foothold in society, but 'Dr Barnes enjoyed the refined pleasure of keeping people out'.[8] Clark, however, always had a soft spot for monsters, and recognised that there was an element of spoof to the collector, who appeared dressed as though for St Tropez. Whatever Barnes's morals, and the appalling methods he had used to separate widows from their paintings, Clark felt that his passionate love and knowledge of painting made him supportable, and they got on well. Clark was particularly impressed by Barnes's huge groups of works by Cézanne and Renoir.

Joe Duveen took care of the Clarks' New York arrangements, and lent them a secretary – partly in order to monitor their activities, which did not bother them at all. They visited his celebrated 5th Avenue gallery, where pictures were hastily changed on each circuit of the six showrooms. In one room they saw a spirited Baroque marble *Virgin and Child* that Clark admired. It was of no interest to Duveen, as he could not sell it as a Bernini, so he sold it to the Clarks for a tiny sum. The sculpture still makes a splendid impression at the head of a passage at Saltwood.[9] Duveen threw a dinner party for the Clarks at which men in creaking shirts and white tie accompanied ladies so weighed down with jewellery that, according to

Clark, they laid pieces on the table. The evening was mentioned in the diary of the painter Adolfo Müller-Ury, who records that many of the great names in American art collecting were present – Samuel Kress, Jules Bache, Nelson Rockefeller and Robert Lehman, among others – so Clark was able at one swoop to meet almost everybody of importance in the upper echelons of New York society.[10]

The lectures on Leonardo at Yale were well received, and it was agreed to publish them as a book, with three additional chapters. This was to establish the pattern for most of Clark's best-known books: lectures written up, supplemented and polished for publication. University publishing houses are notoriously slow, as Clark must have known, but when two years had passed he wrote a petulant letter ruling out any involvement of Yale University Press as a publisher for *Leonardo*, accusing it of 'seriously injuring the success of publication by delay', with the result that he had 'finally decided not to publish it'.[11] He was obliged to use Yale under the terms of the Ryerson Lectures contract, and the effect at the publisher was one of great surprise. The book appeared the following year, published by Cambridge University Press.

Clark's book on Leonardo was at every level a success. It is one of a tiny handful of art history books that are read by non-specialists, and it has rarely been out of print since its publication in 1939. In searching for models for *Leonardo da Vinci*, Herbert Horne's book on Botticelli is sometimes cited, and Clark regarded it as 'undoubtedly the best book on any single painter'. Horne's work, however, was a luxury book, and very different in intention. The art historian Hugh Honour thought that Clark's book was 'a model biography of an artist and humanist – he got it absolutely right – he invented the form. Horne is too precise and archaeological to be an influence.'[12]

The first thing that everybody noticed about *Leonardo da Vinci* was how beautifully it was written, with well-chosen references to Goethe, Pater, Valéry and Freud. For anybody writing about Leonardo, Walter Pater's famous essay remained the poetic benchmark. While Clark wished his readers to be stirred by beauty, he didn't attempt *fin de siècle* flights of description, but occasional Paterian touches do appear. Here is Clark describing some drawings: 'beside prosaic horses ... are wild ethereal horses, with nervous heads thrown back. They are the spies and outriders of Leonardo's imagination entering the world of conventional Florentine art.'[13] As the Leonardo scholar Martin Kemp wrote, Clark 'believed in the interpretative power of literary description, in a manner with which we

are now relatively unfamiliar'.[14] Kemp believed that the main virtue of Clark's approach was to intuit the nature of Leonardo's vision as a whole – 'the remaking of nature through the art of painting. Thus every picture becomes a kind of multiple "proof" that he has truly understood the relationship between the causes and effects in all visual phenomena'.[15]

Clark was not blinded by the Victorian cult of a superhuman Leonardo. He was anxious to create a non-mythical artist: 'We must admit that the early pictures are less good than we should expect them to be. Only one of them, the Liechtenstein portrait [of Ginevra de' Benci[16]] is a wholly successful work of art.' However, for Clark Leonardo was the standing refutation of the comfortable belief that all great men are simple. No more complex and mysterious a character ever existed, and any attempt at simplification would run contrary to the whole direction of his mind. The Windsor drawings of *The Deluge*, for instance, he thought were 'more complex than anything in European art. They are so far from the Classical tradition that our first term of comparison might be one of the great Chinese paintings of cloud and storm, for example the Dragon Scroll in the Boston Museum'.[17] He happily quotes King Lear in this connection: 'Blow, winds, and crack your cheeks! Rage! Blow! You cataracts and hurricanoes, spout.'

The Gordian knot of Leonardo scholarship is the dating of the two versions of *The Virgin of the Rocks* in Paris and London. This is a subject of unusual interest, because we can see the development of Leonardo's style and ideas through two of his major works. Initially Clark accepted the conventional view that the Paris picture was commissioned in 1483 for the Confraternity of the Immaculate Conception of San Francesco Grande in Milan, and therefore came first. His eyes told him that with its soft, warmer tones, the Paris version is perfectly finished in Leonardo's early style, whereas the London version is in his later style. But then Clark allowed himself to be persuaded by an eccentric article published in 1937 by Martin Davies, 'whose thorough and inflexible examination of the documents' convinced him that he was mistaken, and that it was the London version that was commissioned in 1483. Modern scholarship favours the earlier view, and the probability that the Paris version was sold to a third party after a dispute over money with the Confraternity in the early 1490s. The London version may have been a replacement, begun around the same time for the Confraternity but not finished until 1508, when the final payment was made.[18] Years later, in refusing to write a two-hundred-word article for *Picture Post* about the London *Virgin of the*

Rocks, Clark responded wearily: 'As to the relation of the picture to the Louvre Madonna, the subject has become so hopelessly involved that two hundred thousand words would be nearer the mark.'[19]

When he came to the *Mona Lisa*, Clark tells us, 'the surface has the delicacy of a new-laid egg'. With Pater's description ringing in his ears,* he reminds us that anything he writes will be poor and shallow by comparison. He makes the point that in essence the Mona Lisa smile is a Gothic smile, the smile of the queens and saints at Rheims or Naumburg. He was to return to the *Mona Lisa* on several occasions over the next forty years. One of the best lectures of his late years was a radio talk in which he calls her the 'submarine goddess of the Louvre', describes the painting as an *objet de culte* akin to the riddle of the sphinx, and compares the problem of the identity of the *Mona Lisa* to Shakespeare's dark lady, the embodiment of the mysterious, a *femme fatale*.[20]

Leonardo da Vinci remains arguably the most readable introduction to the subject. Roger Mynors called it 'an archipelago book – the tops of buried mountains', and Vita Sackville-West wrote to Clark: 'I have delighted in your style, both your form of expression, and the combination of an imaginative approach with true authority and scholarship. The expert is so apt to grow dry!'[21] Raymond Mortimer in the *New Statesman* said that Clark 'reminds us that it is possible to combine erudition with elegance'.[22] Berenson wrote to Clark that it was 'the most rational yet sensitive interpretation of a great genius I have come across … What a blessed contrast to the Talmudic Hegelian writings … turned out by the Germano phonies of Central Europe.'[23] The most thought-provoking commentary on Clark and his subject, however, had to wait until his death, when Michael Levey wrote a particularly penetrating obituary in the *Proceedings of the British Academy* in which he referred to *Leonardo*, suggesting that 'the suavity, stylishness, aloofness, and elusiveness of the artist found echoes in the personality of his biographer'.[24]

Clark's articles and lectures from the 1930s have not worn as well as the books. In his autobiography he remarked that 'looking through them I am agreeably surprised to see how bad they are. The intervening years have

* In *The Renaissance* (1893), Pater famously wrote of the *Mona Lisa*: 'She is older than the rocks among which she sits; like the vampire, she has been dead many times, and learned the secrets of the grave; and has been a diver in deep seas, and keeps their fallen day about her; and trafficked for strange webs with Eastern merchants.'

not been entirely lost.'[25] It was not until the post-war period that he gained the reputation of being the best lecturer in England. Nikolaus Pevsner was infuriated by a Clark lecture on Leonardo: 'I detect a lot of work on the originals – but the tenor of it is an arrogance for which I could box his ears, "Leonardo shouldn't have done this", "That was a waste of time", and then his rather *blasé* jokes in between to make the students laugh.'[26]

The range of Clark's writings was already wide: he wrote several pieces of the 'Art and Democracy' and 'Is Art Necessary?' type. They still read quite well today, and are more lucid than most expositions of this kind. Interestingly, he reviewed the 1936 Royal Academy exhibition of Chinese painting under the title 'Chinese Painting as it Appears to an Authority on European Painting'.[27] He is faintly patronising about the conformity and lack of excitement in Chinese painting, which he found limited in both means and aim. He returned to the theme a few years later in a much more carefully-thought-out piece, 'An Englishman Looks at Chinese Painting', coinciding with the Aid China exhibition at the Wallace Collection.[28] In this lecture Clark sees compelling echoes of British artists and art collecting in China, observing the main interest of both cultures in landscape painting and a shared passion for illustrators. They were both 'gentleman cultures'.

Clark did not only address the metropolitan elite, but felt that it was important to give lectures in the regions, as he told Clive Bell: 'Of course I don't go lecturing in Manchester for the sake of fame or fortune – in fact I am never paid, I go from a vague feeling that it encourages people to take an interest in the National Gallery and in painting generally … I daresay this is all a delusion – a sort of pathetic fallacy.'[29] He was particularly keen to get pictures out of the National Gallery basement, and promoted the renewal of a loan scheme for regional museums. While he found the response disappointing, nevertheless seventeen of them accepted paintings.[30] Clark actually became the adviser to Southampton City Art Gallery, where he is credited with creating one of the most interesting of all regional collections. His policy there was to acquire good paintings regardless of who the artist might be, which led to the purchase of original masterpieces such as Sofonisba Anguissola's *Portrait of the Artist's Sister Disguised as a Nun*. His visits to the regions were to be of enormous importance in the future, not only for his wartime thinking about the arts and who they were for, but also, crucially, in his approach to the foundation of Independent Television in the 1950s, which was regionally based.

* * *

Clark's broader influence across British intellectual life, and the committee work which would so characterise his later career, were already becoming apparent in the 1930s. Sometimes he used his authority with boards to assist a colleague such as the Marxist art historian Frederick Antal, whose work he described as 'of great value as it proceeds from a wider knowledge of the conditions under which works of art are produced than any other scholar known to me possesses'.[31] In 1934 he joined the newly formed Royal Mail Advisory Committee with the Shell art patron Jack Beddington,[32] which commissioned Barnett Freedman to design the George V Silver Jubilee stamps, among the most interesting British stamps ever made. It was presumably Clark who persuaded the King to accept the series' proto-Festival of Britain design. Clark was invited on to the Spoken English Committee of the BBC, and in 1937 wrote at length on 'the decadence of language', adding that 'the work of the Committee has always interested me profoundly'.[33] In the same year he joined the Public Relations Committee of the embryonic National Theatre, the beginning of a thirty-five-year relationship in which he would play an unexpectedly significant role. A happier story, of equal longevity, was his joining the Mint Advisory Committee in 1936, an important year owing to the requirement of new designs for coinage, medals and seals for the new reign. He enjoyed his time on this committee, which met in the Tapestry Room of St James's Palace, finally severing his link with it in 1975.

In working on Leonardo, Clark became fascinated by that *uomo universale* Leon Battista Alberti, in whose written works he detected an influence on Leonardo. Alberti was the hero of one of Clark's early gods, Jacob Burckhardt, in his book on the Renaissance.[34] He was a daunting subject because of the range of his activities – architect, artist, humanist philosopher, poet, and more – whose motto Clark might have adopted: 'A man can do all things if he will.' Alberti had no loyalties and no religion, and this chimed with Clark. The difficulty in writing about his range of interests appealed to Clark, whose reading took him into some very unexpected corners. Above all, he saw Alberti as the quintessential early Renaissance man, and was pleased to be entering more fully into that period of art, where he felt most at home. For almost a decade he worked on Alberti, believing that he would be the subject of his next scholarly book. But the war intervened, and like most of Clark's unfinished books it became a quarry for lectures and other studies. He gave a lecture on Alberti's book on the theory of painting, which he regarded as 'the first

time that his influence on Leonardo's *Treatise on Painting* is firmly established'.[35] In his autobiography Clark wrote: 'Alberti, in spite of his multifarious talents and splendid profile, turns out to be a slightly unsympathetic character'.[36] 'However,' as he told Jane, 'it has got him out of my system and has taken (more) time to write than Carlyle's Frederick the Great, the Idylls of the King and similar mistakes of direction'.[37] Even so, he never entirely got Alberti 'out of his system'. Thirty years later he was still writing lectures on 'The Universal Man',[38] inspired by Alberti, and found much in him to enthuse about in *Civilisation*.

15

Director versus Staff

*The currency of museum staff is knowledge, not vision,
and at the Gallery the staff could not acclimatise themselves
to a director who addressed Leon Battista Alberti and
Philip Sassoon on equal terms.*

JOHN POPE-HENNESSY, at Kenneth Clark's memorial service[1]

In April 1939 the National Gallery hosted a glamorous reception for a thousand guests – at which there was neither food, drink nor music, according to the *Evening Standard* (although the next day the *Daily Telegraph* reported that the Clarks had given a dinner party for thirty people beforehand at Portland Place). But all was not well at the gallery. Clark had many detractors, both inside and out, who were biding their time and waiting for him to make a mistake. Throughout the 1930s he was travelling frequently to exhibitions and museums, keeping in touch via bulletins from his keeper, Harold Isherwood Kay. There was barely a month when he was not at Hyères staying with Edith Wharton, visiting an exhibition in Brussels, seeing dealers in Paris (where he always stayed at the Crillon), looking at drawings in Bayonne, recovering from a bout of illness in Biarritz or visiting Prince Paul in Belgrade.

Even Clark's detractors must have been surprised by the scale of the opportunity that presented itself when in July 1937 he convened a special board meeting at which he reported the capricious purchase of 'four Venetian pictures'. He had rushed the sale through – without adequate consultation with his curatorial staff – at £14,000, twice that year's annual purchase grant. The year before, he had confessed to an audience: 'Every time I enter a picture dealer's I feel confident that I am going to discover at least a Raphael or possibly a Giorgione – and almost certainly the latter.'[2] Now he seems to have believed that this moment had arrived.

The pictures were four panels that Clark had encountered in the Viennese apartment of 'an entertaining but equivocal expert on Venetian sculpture named Planiscig'.[3] He told his board that they might or might not be by Giorgione, but they were 'as near as we were likely to come to the sound of Giorgione's music'. The trustees were as bewitched as Clark, and Sir Robert Witt of the National Art Collections Fund offered to present the pictures to the gallery on the condition that they should be labelled as by Giorgione. As the gallery's future director Nicholas Penny put it: 'When senior potentates permit themselves to be tamed by golden youth, they like the world to know how golden he is.'[4] In the minutes of the October board meeting the panels had duly become attributed to Giorgione. When the curator Neil MacLaren protested at the purchase, Clark replied, 'Perhaps you are deaf to that particular music.'[5] Clark asked the Warburg Institute to unravel the paintings' iconography, and a young scholar who had newly arrived in England from Austria, Ernst Gombrich,[6] identified the subjects from the second Eclogue of Tebaldeo. Clark told Samuel Courtauld that 'this does not add anything to the beauty of the pictures but it will no doubt weigh heavily with the public who as Canova said "see with their ears"'.[7]

Clark wrote to the then dying Edith Wharton: 'Most thrilling purchase for the gallery: Nothing less than four pictures by Giorgione. They are completely unknown or else we should not have been able to afford them.'[8] To Berenson he was hardly less guarded: 'Personally, I think these little pictures are of supreme beauty, the purest expression of humanist or pantheist poetry I have ever seen in painting, and I find it difficult to resist the belief that they are by the painter of the Tempesta in an earlier phase.'[9] When he was finally able to send BB photos he added, 'For some reason they defy the camera, and you cannot judge the beauty of the pictures until you see the originals. I am sure you will like them: they are full of poetry. Of course I do not expect you to think or say that they are by Giorgione. When my Trustees bought them I told them that they must do so purely because of their beauty and that there would never be agreement or certainty as to their authorship. They accepted this very well but rather unfortunately have insisted on the pictures being published as Giorgione. It does not greatly matter as they certainly are all that the ordinary educated man means by that name … if Giorgione didn't paint them I have no idea who did. Perhaps one can say that they have the spirit of Giorgione without the letter.'[10] Berenson was non-committal, but confessed that he could not see that the panels had much to do with Giorgione.[11]

Clark's enemies in the art world now saw their chance. It was his old friend Tancred Borenius who fired the first shot, in *The Times* on 21 October 1937, denying the Giorgione attribution and pushing the claims of Palma Vecchio instead. Clark wrote a woefully inadequate justification for the *Burlington Magazine* which did nothing to persuade the sceptics.[12] In what must have been a particularly wounding letter, his old mentor C.F. Bell then wrote to *The Times*: 'Snobbery in Art: The Giorgione Panels … These little paintings are scarcely suitable acquisitions for the National Gallery. At the root of the matter lies the snobbery of assessing the importance and value of pictures by the renown of their real or reputed authors.' He went on to assert that the panels were really no more than decorative furniture: 'it has been generally agreed that the proper place for such things is in the furniture courts of the Victoria and Albert Museum. That surely is also the place for these most charming little *sportelli* …'[13] Clark responded: 'It is curious that Mr. Bell should have chosen this purchase as an example of snobbery. Here were four pictures, with no pedigree, no provenance, no name, nothing to recommend them except their beauty.'[14]

By December the row over the attribution, orchestrated by Borenius, was in full swing. In the same month Lord Balniel was appointed chairman of the trustees, and it would be his first task to deal with the growing clamour. The press and the trustees were in fact less concerned about the attribution than about a damaging rumour that the panels had been offered to a collector eighteen months earlier for only £10,000, which Clark told the board was erroneous. In December the *Daily Telegraph* reported that Dr G.M. Richter, an expert on Giorgione, ascribed them to Previtali,[15] an attribution which the four panels still bear today. This was actually first proposed by one of Clark's own junior curators, Philip Pouncey, who did not want to contradict the director publicly. A small ray of hope for Clark came with the discovery of the provenance, which as he told an old school friend was 'the best which any Giorgione could have, no less than the old Manfrin collection which also contained the Tempesta'.[16] But this turned out to be false.

The criticisms did not abate, and in January 1938 the row over 'the four Venetian pictures' was still dominating board meetings. The new chairman conceded that it was not without grounds. They *had* paid too much for the panels, but he took responsibility (no doubt to shield Clark) for having advised the trustees that there was a chance they might be by Giorgione. The trustees sincerely hoped the controversy would go away, but they would, if necessary, reaffirm their confidence in Clark as director.

Clark was fortunate that the other subject that dominated the gallery meetings was Mr Gulbenkian – a source from which Clark derived much trustee capital. By February the matter of the panels had reached the House of Commons, with a question put down, and Prime Minister Neville Chamberlain even came to look at them for himself. Fortunately he liked them, and was impressed by Clark's article, which he had taken to read at Chequers.

Clark later recalled the period to Janet Stone: 'I remember when I was being attacked over the "Giorgione" panels I felt quite hysterical – all kinds of people I hardly knew wrote me abusive letters. Of course they didn't care about the "Giorgiones" – they were attacking my too-rapid rise to fame. The worst part was that I was entirely in the wrong.'[17] He could console himself that his nineteenth-century predecessor Charles Eastlake had had similar problems with a non-Holbein, and Clark believed that 'nearly all the attacks were influenced by jealousy'. He had blundered through a mixture of haste, overconfidence, and a failure to consult his staff properly. But he had acted in a similar fashion recently to secure the Gulbenkian loan, and no doubt thought he could pull off a second coup. Nicholas Penny intriguingly suggests that he may have been viewing the four panels through the slightly gauche pictorial spectacles of Bloomsbury.[18] They have remained mostly in the National Gallery basement ever since, less for their downgraded state than for the memory of an ugly episode in the gallery's history. With a show of some defiance, in 1949 Clark would use them to illustrate the Giorgionesque theme in *Landscape Into Art*.[19]

It is time to consider Clark's colleagues at the National Gallery. He made two excellent curatorial appointments: Philip Pouncey and Neil MacLaren. Pouncey joined in 1934 as an assistant keeper, and was to become the most widely respected specialist in Italian paintings and drawings in Britain. He generally got on well with Clark, but had been offended at not being properly consulted over the 'Giorgione' panels, and later became irritated by Clark's slighting of Ian Rawlins, the gallery's scientist. MacLaren, who joined the gallery the year after Pouncey, was an authority on Dutch and Spanish paintings, and not unlike Clark in his refusal to suffer fools. It is not recorded what he thought of Clark, but neither he nor Pouncey shared Clark's desire to communicate with the public, and it is unlikely that they regarded his connoisseurship very highly. One day Clark wittily told Pouncey that he felt 'MacLaren possesses a superiority simplex' – something many believed was truer of Clark himself.[20]

Among his happier achievements at the gallery, Clark helped the careers of three talented young art historians whom he made honorary attachés: Ben Nicolson, who later became editor of the *Burlington Magazine*; Denis Mahon, who would be largely responsible for the revival of the appreciation of *seicento* paintings in Britain; and John Pope-Hennessy, who was to serve as director of both the V&A and the British Museum.

Clark had been a mentor to Denis Mahon since his Ashmolean days, although when Mahon applied unsuccessfully for a curatorial post Clark told the board that 'his temperament might be a hindrance to his fitting into institutional life'. Mahon however remained profoundly grateful to Clark, and years later wrote him a moving letter setting out his debt to him.*

In 1936 Clark urged the trustees to accept John Pope-Hennessy as an honorary attaché without salary. The only obstacle to this was Pope-Hennessy's military father, who was opposed to the idea. Clark invited the General to meet him at the gallery, a plan almost wrecked by Clark uncharacteristically failing to make a note of the visit, so that he was out when his visitor arrived. Despite this, Pope-Hennessy did come to work at the gallery, and left an unflattering account of his senior colleagues: 'The academic staff was small, inward-looking, and with one exception, un-talented. The exception was Philip Pouncey ... The Keeper was a nonentity named Isherwood Kay, who had once written a book on the watercolour painter Cotman, and the deputy keeper a prissy, thin-faced figure called Martin Davies, with whom I found it difficult at that time to keep my temper.'[21] It was these last two who were to be the cause of a great deal of trouble for Kenneth Clark.

Clark's problem with his two senior keepers, Harold Isherwood Kay and Martin Davies, was essentially a power struggle exacerbated by his style of leadership. The gallery staff regarded themselves as public servants, and thought Clark was behaving as if he was above all that. He was young, rich, a pluralist, and they were offended by his lack of interest in

* 'I think this is the occasion to mention two of my debts of gratitude to you when I was just starting to take an interest in art history. First, it was from your advice to read Wölfflin that I date the origins of the entirely fresh approach so necessary in this country for anyone proposing to take the Seicento seriously. Secondly, when I did so, you were always more than tolerant of the eccentricity, and never condescended to it. That meant a great deal in those days, you know!' (1960, Tate 8812/1/3/1801–1850.)

their activities. The curators were already conditioned to be alert to condescension from the trustees, and they merely transferred their frustrations onto the director, whose sympathies they felt were with the trustees rather than with the gallery staff.

The Giorgione scandal let the genie out of the bottle. Clark's friend John Walker, who would become director of the National Gallery in Washington DC, looked back on how 'His staff reacted like small children and sent him to Coventry. They would not listen to him or speak to him and kept their offices locked. Things got so bad that he called the staff together and asked what they thought the function of the director should be.'[22] The brunt of this problem fell on the new chairman, Lord Balniel, who kept very careful notes of all his interviews with Isherwood Kay and Davies. Isherwood Kay initially approached Balniel to complain that 'he had difficulties shared by the rest of the staff, in his relationship with the director: "They were not consulted by the Director, nor had his confidence ... They did not know what was happening, and, instead of being treated as junior partners in a firm, were looked down upon as the porters and servants."'[23] However, Isherwood Kay was careful to add that Clark was not in any way discourteous to them.

The first part of the problem was Clark's policy, which Isherwood Kay told Lord Balniel 'seemed to be to popularise the Gallery, whereas the prestige of the Gallery could only be enhanced by its becoming an institute of scholarship'. Isherwood Kay strongly believed that scholarly concern should come first, 'and publicity and popularising of the Gallery should take second place'. He gave the example of Martin Davies being 'forced to write a short "popular" introduction to a new Gallery handbook. Davies had done so but "without his heart being in the job". He – and all the staff except the Director – felt that this was work he should not have been asked to undertake, that one of the lecturers or a journalist should have done it, that it was derogatory to a scholar etc.'[24]

The second part of the problem was the definition of the roles of director and keeper. Among the papers in the Clark archive is a six-page letter to Lord Duveen in which he explains the ambiguities of the gallery's constitution: 'The constitution of the National Gallery is like the British constitution: it has grown up gradually as the result of various traditions and adjustments, and on many important points it is almost impossible to find out how or where our constitution is defined.'[25] Isherwood Kay and Martin Davies both believed that Clark was 'trying to whittle down the Keeper's office'. Astonishingly, Isherwood Kay thought the director had 'no

part in the day to day running of the Gallery, and it was not even necessary for him to attend at the Gallery'.[26] When Balniel suggested to Isherwood Kay that he had formed a false impression of his duties and his constitutional relation to the director, he replied that he had been basing his position on the (long redundant) Treasury minute of 1855, which was a response to Charles Eastlake's desire to be away searching for paintings in Italy. Davies shared Isherwood Kay's view, and Clark wrote to Balniel: 'I am fascinated by his account of the Director's functions. What an ideal job! I am almost sorry that the never-to-be-forgotten Treasury minute of 1855 is not still in operation.'[27]

Isherwood Kay then admitted to Balniel that he was in a 'state of great mental confusion, and unable to collect his thoughts', and that he had begun to focus upon trivialities, 'provoked by an irritation too small in itself to be recounted in a letter'.[28] He announced his desire to leave the gallery and to apply for the vacant directorship of the Tate, which became an escape route for dissatisfied staff. Martin Davies told Balniel that if Isherwood Kay was appointed to the Tate he would like to go as well, and described the atmosphere at the National Gallery as 'poisonous'.[29] Balniel concluded that 'Clark had completely upset the Gallery staff: but he was admittedly dealing with fools and neurotics, who were hopelessly in the wrong themselves: but Clark ought to have been able to smooth matters over … He is so nearly the perfect director that one deeply regrets his failings: but they are there, and apparent for all to see. Still I like him and find him an ideal companion.'[30] Clark wrote to him: 'I am terribly sorry that the Gallery is causing you so much bother and unpleasantness. I do apologise most humbly for my part in it.'[31] He imparted his misery to his mother: 'As for the Gallery, I am very disillusioned. Attacks come from all sides, within and without … My staff are more miserable than ever. However I must cling on and see if I can wipe the floor with them all.'[32]

Martin Davies was a far more formidable foe than Isherwood Kay. In his office he had a large filing cabinet with a drawer marked 'Clark', which was designed to unnerve the director. He was an unquestionably fine scholar, responsible for setting new and very high standards for the cataloguing of the National Gallery's collection, but as a personality he was very dry bones: a colleague recalled that 'the only strong emotion he experienced was hatred – intense and lasting hatred – of Kenneth Clark'.[33] Davies was unmarried, and his entire social life was based at the Reform Club, where he lunched and dined almost every day. Christopher Brown, a colleague at the gallery, offered the following observations of Davies: 'his

catalogues were a model for many subsequently produced by the world's greatest collections of Old Master paintings. He had a profound loathing of Kenneth Clark which was, I think, based on two points of difference. Firstly ... the director should, in Martin's view, represent the views of the staff to the trustees. He thought that Clark was too close to the trustees and, because of what Davies thought to be his foolish social climbing, disinclined to offend them by representing a contrary view. Secondly, he thought Clark a slapdash scholar, and it was just such poor scholarship that he had set his face against in his gallery catalogues ... [Davies] was said by one of our NG colleagues to have come from "a long line of unmarried vicars", and indeed it was hard to conjure up great enthusiasm from him – even about the work of Rogier van der Weyden, on whom he published his only monograph. Returning with the enthusiasm of youth to the gallery, having just seen Rogier's *Last Judgement* in Beaune, I told him how exciting I had found the experience. "It is, of course, substantially damaged," was all I got in reply. He was also forgetful, and famously took the King of Norway on an official visit around the National Gallery wearing his carpet slippers.[34] Davies could however be kind to young scholars, who recall a sardonic wit.

Clark believed that Davies was neurotic, a natural misanthrope, and wrote to his chairman: 'The whole thing has been a great blow to me, because I know I must be in some way to blame – not in what I have done, but in a certain absence of true cordiality in my dealings with Davies.'[35] He hoped that Davies 'would be willing to try and work with me without further upsets ... If things [do not improve] perhaps Davies might be reminded that I am Director, not he, and if I take special pains to placate him he must take even greater ones to please me.'[36] He added, 'Unbalanced as Davies is, I do not think he can be quite so far gone as to wish to throw up a good job in the Gallery simply out of personal dislike of me.' Despite Davies' lasting dislike, he and Clark were able to make an accommodation with each other during the war, and Clark went on to write about him without rancour – but not without some satire – in his memoirs. Martin Davies became director of the National Gallery in 1968.

Clark found little solace at home from his troubles at the gallery. Jane showed him no sympathy. 'However bad the rows were,' he told Colette, 'nothing was so bad as having to defend myself to your mother at the time.' Even if Jane did not actually take his opponents' side, he still had to justify himself to her, and she was very cross and sceptical.[37] But Clark did receive one consolation: in December 1937 there arrived a letter from 10 Downing

Street offering him a knighthood. When his name appeared in the New Year's honours list he received over a hundred letters of congratulation. Monty Rendall was among the first to applaud his old pupil, and most of the art world followed suit. Some (like Roger Hinks) took the opportunity to commiserate with Clark over the attacks on the National Gallery. The Duke of Buccleuch added to his note: 'I see you have also been under heavy fire recently, and I trust you are still unscathed.'[38] Clark thanked everybody for their letters: typical was his letter to the diplomat Victor Mallet: 'A KCB seems wholly inappropriate to my age and character, but as it is given to the office and not to its holder I am not unduly disturbed.'[39] Jane observed, 'we are called Sir K and Lady for the first time and feel rather bashful'.[40]

Harold Isherwood Kay died in October 1938, which alleviated some of Clark's troubles, and opened a vacancy. He wrote to Balniel: 'I would rather be landed with the reprobate but agreeable older man than ... the type of colourless pipsqueak which is already too well represented in the Gallery.'[41] The successor whom he favoured was William Gibson, already on the gallery staff. Gibson was duly appointed, and this ushered in a long period of peace in director–staff relations. As Clark wrote to Ben Nicolson: 'The Gallery is very pleasant now that we have a new keeper. Kay was an innocent creature, but steeped in the Collins Baker tradition. I wish you could have been here under the more liberal regime of Gibson. M[artin] Davies is quiet and sad, but his friends tell me that he thrives on misery and that even if I were able to alleviate his unhappiness (which I am not) it would be unkind to do so.'[42] By 1939 Clark had more pressing problems on his hands, for it had fallen to him to safeguard the nation's pictures against the approach of war.

16

The Listener and the Artists

My ideal patron does not simply buy pictures at exhibition,
he helps give the artist his direction.

KENNETH CLARK interviewed in *The Listener*,
22 February 1940[1]

During the mid-1960s Clark proclaimed that art was in an infinitely better place than it had been at any time since 1936.[2] He did not choose that date at random: with the death of Roger Fry two years earlier, people had started wondering where English art was heading. Some thought Fry's Francophile hegemony had left English art in ruins, and that perhaps there might no longer be a place for a national style. Writing the Preface to Fry's posthumous *Last Lectures* (1939), Clark asserted that since 1936 'feelings about life and art have changed'. But it was not so much that art changed in that period – Clark himself had changed. He had engaged with a new group of young artists: Henry Moore, Graham Sutherland, John Piper and Victor Pasmore.

Clark's interest in contemporary art had gradually increased, mostly under the influence of Roger Fry. Even at the age of twenty-six, before his Ashmolean appointment, he had been in discussion about lending support to contemporary British artists, although the idea went nowhere at the time.* However, he continued to buy and commission works by Vanessa

* Clark was in discussion with R.R. Tatlock and the painter Alfred Thornton over an idea for a new exhibiting society of contemporary artists. He offered a 'subvention' and to finance any future show, but Thornton got cold feet at the thought that such a scheme would cut across two existing groups, the New English Art Club and the London Group. Robert Rattray Tatlock (1889–1954) was a critic and the editor of the *Burlington Magazine*. See letter Alfred Thornton to D.S. MacColl, 15 September 1929 (Glasgow University, Ms MacColl T63).

Bell and Duncan Grant, including a large set of forty-eight colourful ceramic plates of Famous Ladies. 'As usual with commissions,' wrote Clark, 'it turned out differently to what we had expected' – instead of repeated ornamental designs 'these are in effect forty-eight unique paintings by Duncan and Vanessa.'[3] In addition, both artists painted moderately successful portraits of Jane (who was photographed, with far more interesting results, by Man Ray in Paris). But from the early 1930s Clark began to look for a way out of Bloomsbury, and puzzled about the direction of contemporary painting; at that time he believed abstraction was a blind alley, a position he may have inherited from Berenson. Then in 1935 he embroiled himself in a controversy which had the opposite effect of his intentions – far from revealing him as a thoughtful examiner of contemporary art, it caused him to be seen as a mild reactionary.

It took place in the pages of *The Listener*, the esteemed highbrow magazine of the BBC. Clark opened an article entitled 'The Future of Painting' with the provocative, if not startling, statement: 'The art of painting has become not so much difficult as impossible,' and then asked why this should be so. After a swipe at the Royal Academy ('a sort of pathetic charm ... a period piece'), he dismissed the latter-day Impressionists, and suggested that the 'post-war movement in the arts, with its belief in violence and superstition, has been essentially German'. But his real quarry was what he called 'the advanced school of painters', as promoted by Herbert Read.[4] He noted their reliance on theory, with 'an extreme opposition to everybody who does not think as they do', and classed them under two headings, *cubists* and *super-realists* (Surrealists). He expressed the belief that abstract art had 'the fatal defect of purity', and that the whole Cubist movement 'has revealed the poverty of human invention when forced to spin a web from its own guts'. He objected to the tendency to identify new schools of art with new structures of society, and used a simile which has caused critics to snigger ever since: 'To claim one's style is the style of the future is like claiming to be the Duchess of Devonshire – quite useless unless one has the consent of the Duke; and whatever shape society is going to take it is not going to be ruled by people who like cubist or super-realist painting.' He then opined that 'Good visual art is not an invariable accompaniment of civilised life ... there have been slack periods,' and cited Italian painting at the end of the sixteenth century and long, mediocre intervals in Egyptian, Indian and Mesopotamian art. He ended by suggesting that no new style would emerge out of a preoccupation with art for its own sake: 'it can only arise from a new interest in

subject matter. We need a new myth in which the symbols are inherently pictorial.'[5]

Herbert Read rose to the challenge.[6] As the champion of international modernism, this uneasy friend of Clark's took the occasion of reviewing the painter Ben Nicholson's show at the Lefevre Gallery in *The Listener* to provide an example of an abstract artist 'who [according to Clark] has now contracted spiritual beri-beri and is about to die of exhaustion'. Read confidently defended 'the artist's reality underlying appearances', and used the analogy of music to defend abstraction. Curiously, although he never fully appreciated Nicholson's work, Clark had recently acquired one of his abstract white reliefs for his own collection. *The Listener* correspondence pages attracted contributions from Roland Penrose,[7] who defended Surrealism, and most savagely from Douglas Cooper defending Cubism.[8] Always possessive about Cubism, on which subject he was a leading expert, Cooper was a formidable opponent who from now on marked Clark down as an enemy: 'the contemporary vision exists, and no amount of disapprobation from Clark can kill it'. Touchy, outrageous and fearless, he relentlessly enjoyed baiting establishment targets like Kenneth Clark. When Edith Sitwell was being attacked by the critic Geoffrey Grigson (who also enjoyed baiting Clark), Clark told her, 'There is a gent in the world of painting called Cooper who is as bad – almost a replica. I wish someone could be found to deal with him as effectively.'[9] Even at the end of his life, Clark mused sardonically to a friend, 'I wonder which paper will be enterprising enough to get Douglas Cooper to write my obituary.'[10]

Clark's final contribution to *The Listener* controversy was an exhibition review entitled 'The Art of Rouault',[11] in which he lamented that (from the correspondence both for and against his views), 'when I see how my article has been misinterpreted I am almost sorry that I wrote it. My attempt to view the future of painting with some detachment has been turned into an attack on modern art. I have been made the hired assassin of the Colonel Blimps of criticism.' He pointed out that in his bedroom 'hangs the work of Picasso, Braque, Henry Moore and Mr Nicholson himself', but then spoiled the point by characterising Nicholson's works 'less as cosmic symbols than as tasteful pieces of decoration' – which brought forth an inevitable protest from the artist.[12] Many in the art world saw Clark's attempt to pontificate about modern art as ridiculous. Charles Collins Baker, Clark's predecessor at Windsor, told the Tate keeper Douglas MacColl: 'K. Clark, as I read him in the Listener, exasperates me: not only by his damn superiority, which wants a well planted kick in the pants, but

even more by his calm omniscience about things he really knows nothing about.'[13]

Herbert Read had at one point implied that Clark, in his denial of abstraction, would be forced to betray his generation and live in 'a world without art'. Clark thought the situation was not quite so desperate, and pointed out the healthy state of architecture, photography, textiles, printing and posters. The year before he had made a speech at the opening of an exhibition of the admirable posters designed by artists to advertise Shell petrol, in which he linked the decline of art to the decline of patronage.[14] Clark always believed that it took two people to make a picture: one to commission it, and one to carry it out. Where were today's patrons? Not for the last time, he himself would turn out to be the answer to his own question.

Clark had been aware of the work of one of the emerging artists for several years, but it took time for him to see the complete picture: 'Much as I loved them,' he later wrote, 'I realised that Duncan and Vanessa, and the whole Bloomsbury movement, was a local, not to say provincial, phenomenon. But in [1928] I saw in a gallery kept by an erratic amateur named Dorothy Warren a number of drawings and some pieces of sculpture which were emphatically *not* provincial. They were by a man named Henry Moore ... nearly all the drawings were sold, but I managed to acquire one which I thought would be acceptable to my parents and it became the foundation of a fairly large collection.'[15] He wrote in his autobiography: 'I had recognised that something extraordinary and completely unexpected had happened in English art.'

Whether Clark really had the *coup de foudre* he later claimed is open to debate. But over the next few years he was to buy several more of Moore's drawings, and a friendship slowly blossomed. In the early days he appreciated Moore's drawings more than the sculptures, which according to Graham Sutherland's wife Kathy he compared to hot-water bottles. Part of the problem was the very oddity of Moore's existence, as Clark explained when the artist was eighty: 'Henry Moore is a great English sculptor. That is an extraordinary, almost an incredible, statement, because, although the English have a genius for lyric poetry ... they have been notably deficient in plastic sense.'[16] During the war, Clark neatly expressed his feelings about Moore's greatness in writing to the King's private secretary, Sir Alan Lascelles, recommending the artist for the OM: 'In my opinion, and that of many good judges, he is the greatest artist of his generation, not only in England but anywhere else ... There is a largeness and nobility about all

he does which puts him in a different class from a capable sculptor like [Eric] Gill.'[17]

Clark would famously hold a dictum – often repeated – about Henry Moore, that if it were necessary to send an ambassador of the human race to Mars, he would undoubtedly be his first choice. The equable miner's son from Castleford and the privileged young director of the National Gallery did not become friends until 1937. According to Jane's diary, the Clarks went to Moore's Hampstead house one Saturday in December of that year, and early in the new year Clark went over from Bellevue to see Moore at Burcroft in Kent. Although Clark was five years younger than the sculptor, Moore was anxious about the visit, which had smacked of the grand patron inspecting the artist's studio. He wanted his assistant Bernard Meadows to put on a demonstration of carving, but Meadows was too nervous.[18] The visit was a success, however, and Clark saw the embryonic elmwood *Reclining Figure*, being carved for the Russian architect Berthold Lubetkin. This piece is often seen as Moore's early masterpiece, and when Lubetkin had to relinquish the commission, Clark cabled Alfred Barr at MoMA in New York, suggesting a price of £300. Clark knew that no British museum at that date would take it, but as Barr was unable to inspect it, he did not buy it either. Clark later wondered why he did not acquire it himself, except for the fact that he had nowhere to put it.

He did better the following year. Another Russian architect, Serge Chermayeff, had returned Moore's *Recumbent Figure*. Fortunately, Clark was that year's buyer for the Contemporary Arts Society, a remarkable body that bought extremely well, covering the role of the National Art Collections Fund for contemporary art. Clark acquired the sculpture on behalf of the Society, but the problem was to persuade the Tate trustees to accept it from them. James Bolivar Manson had always said that Henry Moore would only enter the Tate over his dead body, but with a new director in John Rothenstein, the board voted by a majority to accept the work. Moore sought Clark's advice on how much to charge, and not wishing to appear greedy, suggested coming down to £250, but Clark urged him to accept £300, which was the final price. Moore appreciated having so powerful and knowledgeable a friend, and he would write and tell Clark what he was doing. He was impressed by the way Clark could summon references from the past and make comparisons with the Old Masters, a habit he himself would follow.

The early letters from Moore to Clark during the late 1930s are respectful rather than intimate, and always begin 'Dear Sir Kenneth' until 1940. A

deeper friendship developed during the war, when their paths crossed
more often. An important ingredient was Moore's admiration and affection
for Jane, the necessary corrective to her husband: 'K can sometimes put a
glass screen between himself and someone he doesn't want to be with. No,
never with me. It's probably a protection … But Jane was so kind and
warm-hearted and outgoing. She had the human touch.'[19] When Clark was
asked if he had influenced Moore's work in any way, he thought not at all.
When Moore was asked the same question he replied, 'Not enough to
change one's course, no. But one knows what an expert he is and one does
take notice of people whose opinions one values.'[20] It would be truer to say
that both men were to have an enormous impact on each other's lives. The
friendship, on Clark's side, was to be among the most important in his life,
rivalling even that with Maurice Bowra. Forty-five years later the
wheelchair-bound Henry Moore would throw the first sod at Clark's
funeral.

When Clark wrote his memoirs he believed that he first met Graham
Sutherland at the opening of the Shell posters exhibition in 1934, but else-
where he wrote that it was at an exhibition of china at Harrods, while
others dispute both accounts.* What is clear is that he immediately recog-
nised a new talent in English painting: 'Ever since Oxford I had been
hoping to find an English painter of my own generation whose work I
could admire without reserve.'[21] In Sutherland, Clark had found an artist
in the tradition of Blake, Samuel Palmer and Turner, who showed him 'a
way out of the virtuous fog of Bloomsbury art'. He found Sutherland 'a
fascinating contrast to our Bloomsbury friends – a quiet dandy, highly
intelligent and completely independent. We immediately bought all the
pictures he had brought with him to show us … Both he and his pretty
wife enjoyed society, and in return were much admired by the social
figures who met them with us. If artists were really like that, well, it might
be possible to invite them to one's house.'[22] For Sutherland, it was an aston-
ishing turn of fortune: 'I was seeing the high life. Kenneth Clark had real
charisma. I thought he was elegant, a Renaissance prince. But I was also
frightened of him because he didn't suffer fools gladly.'[23]

Apart from purchasing as many of Sutherland's paintings as he could,
Clark also introduced him to an international dealer who had a gallery in

* The typographer Oliver Simon was sure that he had taken the artist to Portland Place,
where they met for the first time. Simon resented the notion that Clark had 'discovered'
Sutherland (see Grigson, *Recollections*, p.162).

London, Rosenberg and Helft, where the painter was to have an exhibition in 1938 with an Introduction written by Clark. Sutherland was very grateful to Clark for arranging this: 'a complete surprise to me, since the idea seemed so far beyond the bounds of possibility. Thank you a thousand times.'[24] Clark had actually recommended a joint show of Moore and Sutherland, and wrote to Henry warning him, 'there is a luxurious atmosphere about the gallery which rather annoys me.'[25] Moore was however already committed to the Mayor Gallery, and could not oblige. Kathy Sutherland, whom Clark described as like a geisha (a very feisty geisha, as he was to discover), went to see Clark at the National Gallery to ask if he would lend them some money so Graham could give up teaching. Clark replied, 'No I won't, it ruins a friendship. But I will guarantee you an overdraft.'[26] He did in fact also lend them the down-payment on their future house in Kent. When Gertrude Stein wrote to Clark to promote the mediocre talents of Francis Rose, he avoided offering an opinion but proposed, 'I hope you will come and see our pictures … there is one young English painter called Graham Sutherland I think is outstandingly good.'[27] Years later, looking back over his career, Sutherland told Clark that 'one can almost say that not only were the "seed beds" prepared by you, but that the "seedlings" were nursed.'[28]

If the Sutherlands were beautiful and *soigné*, John and Myfanwy Piper were loveable and chaotic. They lived in a farmhouse in an empty valley near Henley, Fawley Bottom ('Fawley Bum'), where the ingredients of life were so entrancing that Clark thought the mixture of books, laughter, conversation and Myfanwy's cooking made it 'the perfect antidote to London'. They would sing Revivalist hymns after dinner with John on the piano; it was a place where Clark, coming from the grandeur of Portland Place, recognised the authentic values of decent lives devoted to art and literature. He first met the Pipers when the sculptor Alexander 'Sandy' Calder brought them to tea at Portland Place in around 1938. John Piper was in a transitional phase, just emerging from abstraction and heading towards topography, architecture and landscape. Myfanwy had edited *Axis* magazine and was an apologist for abstraction, so it cannot have surprised Clark that she challenged his negative views on the subject – 'being awfully schoolgirlish and brash about the whole thing', as she recalled.[29] Myfanwy remembered that 'the whole set up was pretty grand. K was rather stately and very nice and I felt rather naughty for going for him.'[30] She was if anything even more remarkable than her husband: a highly intelligent earth mother and an Oxford swimming Blue who would later write libretti

for Benjamin Britten. She and Clark were to enjoy an *amitié amoureuse*, and she was one of the few women apart from Jane who could tell him off.

The year after their visit to Portland Place, Clark acquired John Piper's *Dead Resort Kemptown* for the Contemporary Arts Society, a semi-abstract architectural painting that resembles the artist's *Brighton Aquatints*. It was Piper's first sale to an institution, and it went some way to lifting his reputation alongside those of Sutherland and Moore.[31] That October John Betjeman wrote enthusiastically to Clark about Piper's work: 'He can do Gothic Revival or genuine Norman or the most complicated Geometric Tracery with equal facility, he gets all the texture of lichened stone and no niggliness and lovely deep recessions.'[32] As Clark recognised, both Betjeman and Piper had made a similar discovery in the byways of English churches and topography. The Bloomsbury world had been Francophile in its preferences, and in Sutherland and Piper, Clark had found two artists who had deep English roots. In the words of one cultural historian, he thought it 'increasingly important that art should be allowed to claim national allegiance and artists be encouraged to acknowledge their Englishness'.[33]

The mantle of Roger Fry and the pervasive post-Cézanne influence was taken up by Graham Bell and the Euston Road Group, of whom Clark wrote: 'This group [Fry], so to say, bequeathed to me.'[34] Bell was given a room at Portland Place, and he, William Coldstream, Claude Rogers and Victor Pasmore were to be supported by Clark, although (Pasmore apart) not with quite the same enthusiasm as he supported Moore, Sutherland and Piper. He funded the first prospectus of the Euston Road Group, and when they produced a pamphlet, 'A Plan for Artists', asking for ten patrons to guarantee a bank overdraft, Clark was the first to sign up, and persuaded Sam Courtauld to follow suit. Apart from commissioning paintings, Clark set up a trust fund to provide stipends to artists which supported, among others, Bell, Coldstream and above all Pasmore.[35] Bell later put on record: 'Your generosity in cash to Bill and me was more than we could have hoped: but your support of me when I had hardly a picture to my name was beyond that – an extraordinary act of faith.'[36]

Clark and Pasmore first met under surprising circumstances. One day at the National Gallery, Clark was rehanging a Turner which he had reframed in a silvery frame which did not work, when 'a young man with bright black eyes came up to me and said "I don't know who you are, but whoever you are you've no taste." I agreed and the frame was hastily removed.'[37] As Clark recognised, Pasmore was the most talented of the

Group, and supporting him was probably the most useful of all his acts of patronage. It enabled the artist to leave his desk job at the London County Council and turn professional. As a result Clark owned at least twenty of his pictures, the cream of his early work, many of which he later gave to museums so that Pasmore's paintings would be better-known.[38]

In the second half of the decade Clark had established a degree of 'ownership' of these two groups of artists – the Moore, Piper, Sutherland axis and the Euston Road Group. He believed he had identified the authentic voice of England, its landscape, poetry and weather, in contemporary idiom. Herbert Read led the dissenters, as he told Ben Nicholson and Barbara Hepworth: 'Sir Clark is very busy. But don't place too much hope on him. I was present at a lunch the other day at which he gave it as his opinion – that abstract art, functional architecture "and all that sort of thing" was dead, & a damned good job too ... We are in for a revival of "the picture with a story". Nice clean healthy nature, the Coldstream Guards forming fours behind their Fuhrer ... all we represent & have fought for is threatened by the most appalling reaction.'[39] Read was right to be worried, for over the coming six years of war – camouflage apart – there would not be much work for abstractionists, while representational and narrative painting would never be so widely enjoyed by the general public, and Clark was to be its ringmaster.

17

Packing Up: 'Bury Them in the Bowels of the Earth'

Bury them in the Bowels of the Earth,
but not a picture shall leave this Island.

WINSTON CHURCHILL to Kenneth Clark,
June 1940[1]

The Great Clark Boom came to a natural close with the death of Sir Philip Sassoon on 3 June 1939. Jane's diary recorded: 'Philip is dead. Stunned by the news. Dear Philip who was fairy prince, godmother and magic carpet to all of us.' Two days later she reported that Philip's ashes had been scattered over Trent from his aeroplane.[2] With Sassoon's death the decade of parties and pleasure at Port Lympne was over, and it marks the beginning of the next period of Clark's life and the imminent war. Clark was to accept the opportunities offered by the war, and use them brilliantly. The story has several interlocking episodes: the removal of the National Gallery's paintings to safe storage in Wales, the setting-up of the War Artists' Scheme, his work at the Ministry of Information both as head of Home Publicity and head of the Film Division, and his role on committees which were to have such an impact on the arts in post-war Britain. Clark was to emerge from the war a very different figure from the one who entered it, no longer the remote dictator of legend but a more collegiate figure who had put the National Gallery at the heart of what might be called London's cultural resistance to Hitler.

Clark's preparations for World War II began long before Sassoon's death. It was obvious that if hostilities did break out they would almost certainly involve bombing raids, and the National Gallery would be very vulnerable. Following the example of the Spanish Civil War, most people in Britain imagined that aerial bombardment would cause instant obliteration, and H.G. Wells's book turned into a film, *The Shape of Things to Come*, encour-

aged this notion. 'Air raid precautions' first appear in the gallery minutes in May 1937, and the gallery began by adapting all the frames so that both the glass and the pictures could be taken out from the front at a moment's notice, leaving the frame hanging on the wall. Clark gave a BBC Empire Broadcast on the story of the evacuation in which he told his audience that 'although I grumbled a good deal about the cost and trouble at the time, I am now very thankful because some altarpieces which it used to take a whole day to get out of their frames can now be got down in five or six minutes'.[3] An unexpected benefit of such planning occurred one day while Clark was rummaging around in the basement of the gallery, looking for safe places to store pictures, and came across twenty rolls of grimy canvas. Curious as to what they might be, he called for a brush, soap and water, and got on his knees to scrub the darkened surface, only stopping when he realised they were thirty-four previously unseen late Turners. They went on show at the Tate in February 1939, and became, as Clark later wrote, 'among the most admired Turners in the Tate gallery'.[4]

The question of finding storage space for the National Gallery in the event of war proved more difficult than expected: country houses had big enough rooms, but seldom had big enough doors, not to mention the question of fire protection and warders. Martin Davies made a tour of potential houses and compiled a characteristically acerbic report, a typical entry reading: 'Owner is nice, ruled by his wife, a tartar, anxious to have NG pictures instead of refugees or worse'.[5] Clark had the inestimable luck of having on his staff Ian Rawlins, who as well as being a meticulous scientific adviser was a railway enthusiast who knew his Bradshaw. Clark would often later be introduced as the man who saved the nation's pictures in wartime, but as he pointed out, that honour really belonged to Rawlins, aided by Martin Davies. They settled on a number of Welsh locations, which included University Hall in Bangor, Penrhyn Castle and the National Library at Aberystwyth. The prolonged to-ing and fro-ing of Neville Chamberlain's diplomacy gave the gallery a chance to practise the evacuation, so that when war was imminent all the pictures were removed in ten days. Some 1,800 pictures, all those designated for evacuation, had left London the day before war was declared. They were conveyed in special containers by a dedicated train travelling at twenty miles per hour, and thence by lorry. Many people, including Clark's mother, wondered whether it was all worth it, but he told her: 'And is all this evacuation necessary? … On the whole I think it is. After his Russian Pact Hitler must have a complete victory or he is done for … I *think* the Russian alliance will turn out to be a great mistake'.[6]

Clark actually rather enjoyed the move, seeing 'pictures in all kind of unexpected lights and surroundings ... Many pictures which I have known for years have only come to life for me for the first time during these last days when I have seen them being wheeled in and out of shafts of sunlight, and finally buried in the darkness of a railway container.'[7] The gallery would make the most of its removal to Wales: the time would be usefully spent in cataloguing and cleaning pictures under almost perfect conditions, not possible in peacetime. As Lord Balniel told Clark: 'One of the advantages of the war appears to be that we will get a lot of pictures put in order for very little money.'[8] Holder and Ruhemann were established in Wales with a studio and paid £5 per week, although the latter had not yet received his naturalisation papers, and so could not technically be employed by the government. Clark's former antagonist Martin Davies was perfectly suited to the scholarly quiet of Bangor, as Clark told Jane: 'Davies is in very good form reading the Italian classics and working indefatigably ... there are a good many decisions for me to take ... so my time is well spent. And as before I must confess I am enjoying Bangor ... the surrounding country is sublime. I usually profess indifference to hills, but at the moment I feel like the Psalmist.'[9]

It soon became clear, however, that the pictures were no safer in their new homes than in London. German bombers could easily reach Wales, and in the case of Penrhyn Castle, Martin Davies reported that 'the owner is celebrating the war by being fairly constantly drunk'. The trustees considered sending all the pictures to Canada (Lord Lee advocated this), and this was followed by an offer from the American government to give sanctuary to the collection. This proposal troubled Clark, as he confided to Balniel: 'Jane is passionately opposed to it. I don't know why she and Mary should be right but I must confess there is a good deal to be said against it, not only the risk, but also that ... the Americans would always claim that they had saved the National Gallery for us.'[10] When pressure was put on Clark to export the pictures, he went above his trustees directly to Winston Churchill, who scribbled on the memorandum in red ink the famous words at the head of this chapter.* Rawlins, as usual, came up with the answer; an abandoned slate quarry with a series of enormous cham-

* At the time Clark wrote: 'The Prime Minister's actual words were "Hide them in caves and cellars, but not one picture shall leave this island."' See Bosman, *The National Gallery in Wartime*, p.31, and also letter from Downing Street, 1 June 1940 (reproduced p.16), which calls into question Clark's more picturesque account in his memoirs.

bers known as the Manod Caves in a remote valley near Blaenau Ffestiniog, in north Wales. The Office of Works was able to build the necessary dry, well-lit and air-conditioned storerooms, in which the National Gallery's paintings would be remarkably stable and well looked after for the duration. All this was achieved in six months.

The problem was to get the large pictures from the railway up the six miles of steep, narrow mountain road to Manod. Clark was there to supervise. Entrances had been enlarged, roads hollowed out under bridges and every detail considered, but the case containing the two largest pictures, van Dyck's *Charles I on Horseback* and Sebastiano del Piombo's *Raising of Lazarus*, became jammed under a bridge – Rawlins had miscalculated by half an inch. 'We all stood silent,' said Clark, who with his mind stored with historical references 'was reminded of the moment in Ranke's History of the Popes, when the ropes lifting the obelisk in St. Peter's Square began to fray. The crowd had been sworn to silence, but one sailor from Bordighera could not restrain himself, "Aqua alle tende"* he shouted. Silence was broken. "Let the air out of the tyres" we all said in chorus. It was done and grinding under, scraping over, the huge packing case passed through.'[11] While the Manod Caves were being prepared and the pictures moved there, Clark, with an eye on history, had a film record made by Paramount of this unusual operation, a process repeated at the end of the war with their return to Trafalgar Square.

Clark thought the experience of visiting Manod was Wagnerian: the romantic isolation, the long tunnels, the buried treasure and the two talismanic rocks, known as 'the dragons', that guarded the caves.[12] It was one thing for the men left to look after the pictures to be at Bangor, but Clark was concerned about morale at the isolated caves, as he told the gallery keeper, William Gibson: 'we must envisage a time when the men will be snowed up, sometimes for several days on end, and provide them with such simple comforts as a wireless set, a library of cheap books, first-aid sets etc'.[13] In fact the arrangements were to be remarkably successful; the guardians were not insensible of the advantages of spending the war in Wales. Holder worked 'uncomplainingly throughout the war' restoring pictures, and Martin Davies, who was in charge of the installation, toiled away at his catalogues, which as Clark acknowledged, 'by their thoroughness, no less than their austerity, raised the standard of cataloguing in

* 'Water for the ropes.'

every country'.[14] Clark enjoyed going to north Wales – less to inspect the pictures, which he found difficult to enjoy in these surroundings, than to escape the war and enjoy the breathtaking scenery: in old age he found that he still dreamed about those Welsh valleys. Sometimes he took Jane with him, and they stayed either at Portmeirion, Clough Williams-Ellis's picturesque recreation of a north Italian port, or with Christabel Aberconway at Bodnant, which Jane thought the ugliest house she had ever seen.

It was not just the National Gallery that needed packing up. The Clarks decided that they had to give up both Bellevue and Portland Place. Apart from the loss of Philip Sassoon, Bellevue was far too close to any likely invasion spot, and would be in the front line of aerial warfare. 'Uncle Arthur' Lee persuaded the Clarks to move to Gloucestershire to be close to him at Old Quarries, his Regency house near Avening. They found a pretty artisan Baroque country house to rent, called Upton, close to Tetbury. It was here that Jane and the children would spend most of the war. The house was in very poor condition, but it had a striking double-height salon with pilasters, and a library.

Clark had always known that Portland Place and all it represented was a luxury that they could not afford. He had been preparing Jane for some time – two years earlier he had warned her: 'under normal conditions our way of life, quite apart from picture buying, is a little beyond our income'.[15] The tax year 1939–40 is one of the very few for which there is a surviving record of the family finances. Before tax, Clark had a large income of £13,324, of which £10,400 was from stocks and shares, and £950 from property rental (including Old Palace Place). His net income of £6,600 was over £1,000 down on the previous year, owing to higher taxation.[16]

Disposing of Portland Place was never going to be easy with war imminent, and an improbable saga developed. Herbert Read, Clark's antagonist in the *Listener* controversy, had a surprising habit of consulting Clark,[17] and in 1939 he decided to leave his post at the *Burlington Magazine* in order to help Peggy Guggenheim set up a museum of modern art in London to rival New York's MoMA. Read wrote to Clark asking about a suitable location and to discuss the general policy of the museum.[18] In May 1939 he wrote again to say that Mrs Guggenheim and himself would like Clark to be a trustee (the other was to be Roland Penrose). He also mentioned that he had not found a home for the museum yet, and was looking for a floor in a modern building.[19]

Peggy Guggenheim takes up the story in her memoirs: 'One day Mr Read phoned me to say that he had been offered the ideal spot for the museum. It was Sir Kenneth Clark's house in Portland Place ... Lady Clark showed me all over her beautiful house. It really was the perfect place ... even though it was not modern. Lady Clark, who had been a gym teacher,* was particularly pleased with the air raid shelter she had made in the basement ... We actually took the house, but as the lawyers were away on holiday I never signed the lease, and when war was declared, I had no legal obligation toward Sir Kenneth Clark. He, however, thought I had a moral one, and ... he suggested that I give the indemnity to a committee he had formed for artists in distress, to which he had by then sacrificed his house. Mr Read considered Sir Kenneth Clark was richer than I.'[20]

Read had alerted Clark to the probability that with the declaration of war Peggy Guggenheim would not take his house, but offered him a very different view of the situation from that he reported to her: 'I agree that you have a case for compensation and I will urge this view as strongly as possible.'[21] Clark was extremely put out, believing that this might be his only chance in the present circumstances of selling the thirty years left on the house's lease. He rarely became angry, except when he felt he had in some way been cheated. Nor did his sense of injustice end at that: 'The landlords, in order to swindle us, pretended that the house could not be let to anything but a private person; we eventually sold the house for about £6000 and they immediately let it to Lawleys the glass manufacturers.'[22] Clark later admitted that Portland Place 'would in fact have been totally unsuitable' for the London Guggenheim museum, and in the event the pictures went to New York before finally coming triumphantly to rest in Venice.[23] The war lost London the chance to have both the Gulbenkian and the Guggenheim collections.

On 14 June 1939 there was one last great event at Portland Place, when a dinner was given for the American journalist Walter Lippmann, whom Clark described as 'the greatest listener of the age'. The other guests were Winston Churchill, Lady Colefax, Harold Nicolson and Mr and Mrs Julian Huxley. There can be little doubt that the motivation for the dinner was political, for Lippmann to hear Churchill speak about the dangers faced by Europe, and to challenge American isolationism, a subject about which Clark felt strongly. Clark, although left-leaning, had no political affilia-

* This was a mischievous misunderstanding – Jane had taken gym classes, but she was never a gym teacher.

tions, and as so often in his life 'the leading figures on both sides talked to us ... assuming that we must be on their side'. In fact, Clark at this time was 'unequivocally on the side of Mr Churchill', having seen at first hand during his lonely Dresden days the destructive direction being taken by Germany. He had read *Mein Kampf*, and although he liked Neville Chamberlain, observed 'a disastrous *fond* of naivety' in his character. Clark believed that only Churchill, with his sweep of historical imagination, could see the future as it might be presented in 1939. Many years later, in a BBC interview (about Berenson), Clark admitted, 'I have never been frightened of anyone except Churchill.' When the interviewer challenged this and questioned whether Churchill was an intellectual, Clark forcefully responded, 'Don't be taken in, he was a man of a wonderful and very powerful mind.'[24]

During the dinner Lippmann raised the notorious statement recently made by the American Ambassador to London, Joseph Kennedy, that Britain would be 'licked' in the forthcoming war. Harold Nicolson left a florid account of what happened next: 'Winston is stirred by this defeatism into a magnificent oration. He sits hunched there, waving his whisky and soda to mark his periods, stubbing his cigar with the other hand ... describing the trials ahead and concluding "Yet these trials and disasters, I ask you to believe, Mr Lippmann, will but serve to steel the resolution of the British people and to enhance our will for victory. No, the Ambassador should not have spoken so, Mr Lippmann, he should not have said that dreadful word ... Nor should I die happy in the great struggle which I see before me, were I not convinced that if we in this dear, dear island succumb to the ferocity and might of our enemies, over there in your distant and immune continent the torch of liberty will burn untarnished and (I should trust and hope) undismayed." We then change the subject and speak about the Giant Panda.'[25]

Clark in his memoirs complains that Nicolson 'could not resist shampooing' his account of the dinner.[26] In fact there are four accounts of it: Nicolson's, that in Clark's memoirs, Jane's diary, and one by Lippmann (who made extensive notes which form a memo he wrote later that evening[27]) – and they all agree with Clark that the evening witnessed 'the most brilliant display of Mr Churchill's conversational powers'.[28] The final touching moment of the evening came as Churchill was leaving at around 1.30 a.m.: 'He went out into a deserted Portland Place, the pavement glistening with heavy rain ... and told his chauffeur to take him to Westerham [Chartwell]. "Good heavens" said Jane "you're not going all that way?"

"Yes my dear, I only come to London to sock the Government or to dine with you.'"*

Once they had moved out of Portland Place, Clark wrote to his mother, who was living in Cheltenham: 'I have been a very neglectful son, but these last few days have been in some ways more exhausting than the actual evacuation. All the stimulating bustle is over and instead there is the dreary routine … I am staying at Garland's Hotel in Suffolk St. It is very shabby and the only bath is on the half landing; but I find it good enough, and preferable to a Grand Babylon. I can dress and be at the Gallery in 5 minutes, so that you needn't worry about air raids … London is looking very strange and rather beautiful at night. It really *is* dark so that one bumps into pedestrians.'[29]

It was in a café in the Charing Cross Road that Clark heard Chamberlain's 'tired old voice announcing the declaration of war'. He walked aimlessly through the West End, and melancholy thoughts were stirred at the bottom of Waterloo Place, gazing at the dull office buildings of Edwardian London, which 'took on a grandeur and fatefulness that I had never felt before', while even the vulgar illuminations of Piccadilly Circus 'achieved a kind of pathos'. Melancholy gave way to mutability as 'the banal thought passed through my mind that even if they were not destroyed by bombs that night they would before long be deserted and crumble to the ground. It gave me a curious feeling of elation. The social system of which these featureless blocks were an emanation was a worn-out monster founded on exploitation, bewildered by a bad conscience. It would be better to start afresh.'[30] He was jolted out of these reflections by the appearance of an air-raid warden.

After the last painting left the National Gallery, there was a deep silence in the large empty spaces. They looked strange and unreal with all the vacated picture frames, and it seemed as if they would remain like that for the duration. At the end of August 1939 the National Gallery was handed over to the Office of Works, and was expected shortly to be taken over by the government. As it happened, the government had no plan or idea what to do with the building, and Clark was surprised and grateful to be left his office. The first months of the war he later described as a sort of penitential rite, with emergency orders requiring that all the pleasures of civilised life

* Clark, *Another Part of the Wood* (p.273). It should be remembered that Churchill was not yet Prime Minister.

were closed down – no art, no concerts, no theatre and no cinema – and he began to feel what he called a hunger of the spirit. It was three weeks into this void that Myra Hess appeared in Clark's office with a proposal that would transform the wartime position of the National Gallery.

18

The National Gallery at War

*A defiant outpost of culture right in the middle of
a bombed and shattered metropolis.*

HERBERT READ (1941)

The historian of the National Gallery warns us that we should approach 'war-time folk memories gingerly, nervously aware of the important role the Gallery played in raising morale'.[1] Bound up as it is with national myths of the Blitz and Churchill's 'finest hour', the story of a defiant gallery at the heart of the capital, keeping alight the flame of high culture, is indeed moving – and sometimes in danger of being sentimentalised. It certainly presents a paradox, in that the gallery achieved a higher level of popularity with the public when it was emptied of its treasures. Nor had any of the components of its new success been planned: not the concerts, the Picture of the Month, the hub for war artists, nor the exhibitions of art and post-war planning that were to give the place such a central importance in wartime London. With brilliant pragmatism, Clark in each case simply identified new opportunities as they arose and seized them, for the circumstances of war perfectly suited his activist outlook and his readiness to take quick decisions. As he told James Lees-Milne on the station platform at Bookham in Surrey, during a visit to Polesden Lacey: 'to accomplish anything today a man must be resolute and ruthless, and must act and think afterwards'.[2] Clark believed that art and culture were central to the very values that Britain was fighting to defend, and that they should therefore be marshalled to articulate those values. In short, he wanted art not only to raise morale, but to show the public what they were fighting for. As Michael Levey observed, it was through the war that 'Clark's eyes were opened to the power of art, in its widest sense, over supposedly ordinary people.'[3]

Conscious that the civil service was scheduled to take over the National Gallery's buildings, Clark had devised no plans for their use. But when it became apparent that the government had no idea what to do with them, he seized a new proposal that chanced to come his way, and expanded it into something of an institution. London had only just evacuated its children, closed down its entertainments and newly draped itself in blackout curtains when into his office stepped the large and much-loved international concert pianist, Myra Hess. Only the previous weekend Hess had been speaking of her desire to bring music to the capital, in response to which a friend had suggested the National Gallery as a venue. Although neither of them really believed in the possibility, Hess wasted no time in introducing herself to Clark, cautiously proposing the idea of a concert every three weeks. 'No,' Clark responded. 'Every day!' The most surprising part of the story is that government departments 'in their strange, stiff way behaved well' and authorised these now famous concerts to go ahead. When the gallery trustees offered no objection, the first was scheduled for 10 October, only five weeks after the outbreak of war.

The first concert was publicised on the BBC, and advertisements were placed in newspapers; all profits were to go to the Musicians' Benevolent Fund. The main problem was finding enough chairs, and five hundred were eventually procured, some of which were still arriving as the audience gathered. It was expected that perhaps two hundred people might come, but in the event a thousand people formed a patient queue – office boys, servicemen and women in uniform, and civilians with their gas-masks. Everyone was to be charged a shilling, and when the first person presented a half-crown coin (two shillings and sixpence) there was no change. Eight hundred people were crammed into the gallery, far exceeding the Home Office limit on numbers in public places; the rest, to Clark's great sadness, had to be turned away.

Both Clark and Hess had agreed that the concerts should be primarily of German music. The opening concert began with Scarlatti, Bach, Beethoven, Schubert, Chopin and Brahms. Clark wrote of it: 'The first concert was given by Miss Hess herself, and the moment when she played the opening bars of Beethoven's "Appassionata" will always remain for me one of the great experiences of my life. It was an assurance that all our sufferings were not in vain.'[4] Hess was fearful that her German name might give rise to booing, but she became in every way the heroine of the hour – her radiant smile (which sometimes reminded people of Queen Elizabeth) and presence won every audience over. For her encore she

chose Bach's *Jesu, Joy of Man's Desiring*, which was to become her signature tune.

The success of the concerts took everyone by surprise. On 6 February 1940, when Hess played Bach, the audience totalled 1,280. The BBC was slow to spot an opportunity, its first broadcast being of the one hundredth National Gallery concert; but then, at the beginning of the war the Corporation had not understood the mood of the nation, and believed that people wanted nothing but light music. To Clark, the concerts 'were the first sign that we were recovering from a sort of numbness which overcame our sensibilities for a week or two after the war was declared; and they remain proof that although we are at war we do not want an unrelieved diet of hearty songs and patriotic imbecilities'.[5] What the concerts also proved was that at moments of national crisis, as Clark correctly perceived, there was a hunger for culture – and this manifested itself in a call for music, literature and art. One of the concert-goers was the novelist E.M. Forster, whose mind wandered to the gallery interior. He thought that 'the Renaissance decorations of the building, a little complacent in peacetime, are indescribably moving today, they inspire nobility, hopefulness, calm'.[6]

The musicians, who called Hess 'Auntie', were paid five guineas each, whether they were famous or merely students. They pitted their playing against military bands in Trafalgar Square, bell-ringing from St Martin-in-the-Fields (soon silenced), and during the worst period of the Blitz they performed in icy conditions with blue fingers. The gallery took several direct hits, but the concerts continued regardless, merely being relocated from the Barry Rooms under the dome to the basement. Once, when a delayed-action bomb fell on the gallery, nearby South Africa House offered its library as an alternative venue, and a boy stood outside the gallery redirecting the audience. No doubt encouraged by Clark, the Queen came to an early concert, and returned on several occasions, sometimes with the two Princesses and once with the King. Writing the day after a concert attended by the Queen, Hess described it as 'the happiest and certainly the prettiest day of my life'.[7]

The most memorable concert was held on New Year's Day 1940, when Clark himself conducted Leopold Mozart's Toy Symphony (then believed to be by Haydn). He had no experience of conducting an orchestra whatsoever, and next to none of playing an instrument; but perhaps something of his childhood exhibitionism returned to carry him through. He took advice from Sir Thomas Beecham, who went carefully through the score

with him, although the performers did not take the matter nearly as seriously. This brought out the priggish side of Clark when, at an uproarious rehearsal in which famous musicians were larking about, Clark was heard to repeat, 'Now children!' As he told the *Daily Express*: 'All I have to do is to see that the cuckoos and trumpets and the rest of the noise come in at the right places.' On the day a thousand people turned up, determined to enjoy the fun. Myra Hess and her fellow pianist Irene Scharrer played on bird warblers, toy trumpets and sixpenny drums; Joyce Grenfell performed the part of a nightingale on a metal whistle. This was probably the most enjoyed of all the concerts, raising gales of laughter every time the stars tried their instruments – indeed, they could barely play for laughing themselves. The press called it 'a great lark', *The Times* saying that Clark conducted 'in the spirit of Leonardo' – or as one critic put it less kindly: 'The musicians didn't need a conductor but he kept time with them beautifully.' One of the nicest letters Clark received as a result of this promising debut was from his old governess Lam, who was now the housekeeper at Chequers. She herself had once played the piano part of the Toy Symphony: 'the papers were really cheerful – for me at least – this morning and I feel I must congratulate you on your success as a Conductor'.[8]

The concerts were designed to last exactly an hour, to fit the office workers' standard lunch break, and 1,700 sandwiches a day (regarded as the best in London) were provided by an energetic socialite, Lady Gator, and her crew of smart ladies. Clark wrote to Bernard Berenson: 'We get audiences of up to 1,000 almost every day – people of all sorts who are prepared to give up their lunch in order to escape for a short time out of the ugliness and disorder of the present moment.'[9] He was exaggerating a little, as the average audience was nearer five hundred – although eight hundred was not unusual. His secretary at the National Gallery, Nancy Thomas,[10] spoke for many when she said that 'the concerts were a tremendous feature of London life. It was one of the very few things that was happening and they were lovely.' On 19 November 1943 the half-millionth audience member was declared – a sailor who was about to return to his ship from shore leave. Overall the Musicians' Benevolent Fund received £12,000 (although there was a hitch when it was discovered that Ronald Jones, the treasurer of the concert committee, had been taking money from the funds and putting in IOUs).

So much a part of the British wartime scene did the National Gallery concerts become that films made for America and the colonies represented them as part of the war effort, notably in *Listen to Britain*, produced

by Ian Dalrymple for the Crown Film Unit. Like other such films, this was folksy in tone, showing children dancing, tanks rolling through pictur-esque villages and musicians in uniform at a battered National Gallery playing Mozart – with, in the background, exhibitions of war artists and a shot of Clark sitting next to the Queen and grinning. Other scenes showed the large, echoing galleries with their empty frames powerfully evoking the pictures now far away; the gallery had become a symbol of national defiance.

During the working week Clark stayed in London, but at weekends he would join Jane at the Hare and Hounds in Westonbirt, Gloucestershire, where they were having to camp out. Upton House was still in very poor shape, and the builders had been called away – as Clark told Berenson, 'it was being entirely done up inside and when the war came was uninhabit-able. Owing to the shortage of men and materials it has taken two months before we can even sleep there, and I don't suppose it will be in decent order before Christmas. Poor Jane has had to spend her time chivvying workmen and imagining that I was having a very eventful, exciting life at the centre of things in London. Actually I am kept so busy that I see prac-tically no one and hear no news.'[11] But Jane was right in believing that Clark had been having a much nicer time than her, as he admitted to his mother: 'I dined alone with the Queen, the Duchess of Kent and an old friend, Malcolm Bullock. It was the first private party the Q had given since the war began and she was as excited as a child ... I don't see how one can go higher than that in the hall-porter world. We sat talking till almost midnight.'[12]

Meanwhile, back in Gloucestershire, Jane was having to look after the children for the first time, which she found tiresome; such proximity brought out the worst in her. She demanded total obedience from them, and responded to their noise and disorder with angry shouting. Romantically, she had imagined that she could settle quietly in the country and enjoy growing vegetables, but in reality she was miserable, and missed the glamour and sociability of London. In November, when Portland Place had finally gone, the Clarks decided to rent a large but snug flat at 5 Gray's Inn Square, where Jane could come and see her husband.

The business of the National Gallery did not entirely close down during wartime. Trustees' meetings continued, although with less frequency, and pictures occasionally came up for acquisition. In 1940 Lord Balniel's father died, in consequence of which he became the Earl of Crawford and faced

considerable death duties; the following year he offered his Rembrandt *Portrait of Margaretha Trip* to the gallery. This presented two problems: firstly, he correctly insisted on resigning his trusteeship and chairmanship, as these conflicted with his position as vendor; secondly, the gallery already held another portrait of Margaretha Trip – and by the same artist. Clark's usual resource, the National Art Collections Fund, led by Sir Robert Witt, initially declined to contribute – it had given £8,000 three years earlier for Rembrandt's *Saskia*. Clark asked the trustees if he could therefore offer the portrait to Mr Gulbenkian to buy it for them. In the event, the NACF did contribute the funds (made easier by tax remission), and the gallery acquired its second Trip portrait for £20,000. But before he committed to the purchase Clark took the precaution of writing to the Earl of Radnor, stating that the gallery was about to make a purchase that would use up its funds for many years to come; he wanted to reassure himself that Radnor had no plans to sell his Holbein *Portrait of Erasmus* or the Velázquez *Portrait of Juan de Pareja*.[13]

Although Clark was delighted with the Rembrandt acquisition, it came at the very heavy price of his friend David Crawford's resignation from the gallery board. 'Looking back on your chairmanship,' Clark wrote, 'I am distressed to think how what should have been the most perfect two years of my time at the gallery was continuously interrupted by outside troubles – first the Giorgiones, then the rows with Kay and Davies, then Kay's death and then all the bother of ARP and the threat of war.'[14]

The Rembrandt story was to have, however, one happy consequence. The eminent archaeologist Sir Mortimer Wheeler wrote to *The Times* suggesting that the gallery should put its new prize on exhibition. Clark responded that in view of the hunger 'which many of us feel for the sight of a great painting', the trustees were going to put the Rembrandt on show for a month, and furthermore they were 'also considering the suggestion that one picture from the Gallery should be exhibited every week in this way'.[15] Thus began the talismanic 'Picture of the Month', which became such a major part of the gallery's wartime legend.[16] To excite popular interest in the idea, Clark told an interviewer: 'I asked people to send me a postcard with the names of some of the pictures they would most like to see again.' Michelangelo's *Entombment* and Piero's *Nativity* were the most requested, although Clark considered these too precious to put at risk. In fact nearly all the requests he received were for Italian pictures, which he interpreted as a 'longing for the sense of order and the noble types of humanity which the great Renaissance painters show'.[17] Because the keep-

ers were generally reluctant to accept the idea, it was agreed that Martin Davies should have the last word on which paintings would or would not be allowed up from Wales. Together Davies and Clark settled on pictures which showed the depth of human experience. Among those selected to make the journey were Tintoretto's *St George and the Dragon*, with its nationalistic undertone; Constable's *Hay Wain*, with its expression of British values; Bellini's *Agony in the Garden*, a study of self-sacrifice; and Titian's *Noli me Tangere*. The intensity of the viewer's encounter with the Picture of the Month hanging on its own in the gallery was expressed by Albert Irvin RA, who said, 'You didn't half look at it, you ravished it.' Even Clark's wicked fairy, Tancred Borenius, applauded, describing the 'beehive-like' activity around each picture. Over six hundred people a day would visit; 36,826 came to see Velázquez's *Rokeby Venus*, and slightly fewer saw Botticelli's *Venus and Mars*.

The Crawford Rembrandt was not the only wartime offering to the trustees. As well as the gift of the Cook Titian, in July 1943 Clark announced to the board that the Duke of Rutland had offered his Poussin *Seven Sacraments* series – which Clark recommended against, on grounds of their condition and their inferiority to the Sutherland series.* Only poverty and the hope of acquiring the Sutherland series (today on loan to the National Gallery of Scotland) make such a refusal comprehensible. However, even this had a happy outcome, because when Lord Radnor offered his – arguably superior – Poussin *Worship of the Golden Calf* in 1945, Clark was able to make a half-hearted offer to buy it for £10,000 against its valuation of £15,000 – and to everyone's surprise this was accepted.

Clark's royal duties had been wound down with the coming of war. He had sent most of the Royal Collection to Wales for safekeeping, but there was simply too much for it all to go. Hampton Court, which was felt to be reasonably safe from the Blitz, was hung for the duration with pictures that were normally held in store, and Clark considered the result 'exceedingly attractive and although the pictures exhibited are not as famous or as valuable as the ones we have taken away, they certainly constitute the most imposing collection of Old Masters at present on exhibition'.[18] As Surveyor of the King's Pictures, one of Clark's main concerns was the safety of the Raphael cartoons (which with the Leonardo drawings are the greatest

* Poussin painted two series of the *Seven Sacraments*, in 1637–40 and 1644–48. The latter was owned by the Duke of Sutherland.

treasures of the Royal Collection), on loan to the V&A. They were too large to move, and had therefore been marooned at the museum. Sir Eric Maclagan, the director, recommended building a brick fortress around them topped by steel girders, but Clark insisted instead on the construction of tall, narrow doors so they could be slid out in case of fire: to illustrate his point he even made a sketch. His precaution turned out to be very necessary, for the museum took a direct hit in November 1940.[19] In the event, the greatest threat to the cartoons' safety was a plan to create an RAF training school in the building, with cooking and washing facilities for two thousand men adjacent to where they were stored – a scheme that was dropped under protest.

One of the many unexpected outcomes of the war was the boost it brought to contemporary British artists, for with all the valuable art sent away, galleries and dealers had nothing else to show. The National Gallery led the way: during the war Clark staged thirty-four exhibitions, with a strong accent on war artists and modern art. One group of exhibitions happened as a result of Clark's chance encounter at Coventry railway station in 1939 with a forceful young contemporary art dealer, Lillian Browse, who wanted to stage loan exhibitions of modern British painting at the National Gallery; the story reveals Clark at his best and worst. He invited Browse to travel with him, and she related that 'I had to tell him I was travelling "hard", to which he disarmingly and with feigned apology replied that he was travelling first but that I should not mind for he would pay the difference.'[20] Fortified by this encounter, Browse 'went to see him in his impressive, sombre office at Trafalgar Square. Alas, this was a very different Sir Kenneth to the one I had met in Coventry. Without giving any reason, he summarily dismissed my proposal.' He was later persuaded to change his mind, and told Browse that she could put on an exhibition at the gallery, adding that he was far too busy to do much himself, which 'prompted me to ask him what time he got up in the morning. "Eight o'clock." I suggested he rise an hour earlier. I doubt whether anyone had ever asked him such an impertinent question, but it must have amused him for when Queen Elizabeth came to visit our exhibition I heard him telling her what I had said.'[21]

Clark was frequently irritated by Browse's relentless determination; on one occasion she found herself on a crossed telephone line and overheard him describing her as 'quite intolerable'. However, he recognised the quality of her exhibitions, beginning with 'British Painting Since Whistler' (1940), and followed in 1942 by a combined retrospective of William

Nicholson and Jack Yeats (the motivation for exhibiting the latter being partly that of strengthening relations with Ireland). Clark himself wrote the Introduction, in which he compared the fastidious work of Nicholson with the essays of Max Beerbohm.

A cryptic diary entry of Clark's for 5 January 1943 reads: '1.30 Connaught, de Gaulle.' This lunch came about because Clark had organised an exhibition of French art at the National Gallery, and de Gaulle's Gallic pride had been hurt when he had not been invited to open it: he wrote to complain. Clark had written to Stephen Spender the year before: 'I do not like the idea of speeches at the opening of exhibitions and I hate making them. The idea of compiling another string of false and facile generalisations about art, the war, Russia, etc., makes me feel sick.'[22] His reply to de Gaulle is lost, but it must have been more mollifying, because the General invited him to lunch, at which Clark was surprised to discover an intellectual in the manner of Henri Bergson.[23] In spite of his professed aversion to them, Clark made many opening speeches at this time, particularly in connection with a new initiative to use artists to record the disappearing landscape.

Clark was one of the instigators of 'Recording Britain', an initiative that brought three more exhibitions to the gallery. Funded by the Pilgrim Trust and set up to employ mostly watercolour artists on the home front, it recorded the sort of scenes and landscapes that were particularly vulnerable to war, and visualised the world that the British were fighting to defend. The scheme resulted in the commissioning of over 1,600 works, many of them elegiac in character, by artists including Russell Flint, John Piper and Barbara Jones; Graham Bell's painting of *Brunswick Square* (1940) was a typical example. Even the arch-modernist Herbert Read approved, and wrote: 'these drawings may serve to remind us of the real fight – the fight against all commercial vandalism and insensitive neglect'.[24] By far the most famous paintings exhibited (if not commissioned) under the Recording Britain scheme were Piper's set of watercolours of Windsor Castle, the story of which is told in Chapter 20.

Although Clark believed that paintings achieved a dimension that was beyond photography, with the coming of the Blitz it was obvious that something urgent had to be done to make an objective record of vulnerable buildings, both for historical purposes and in case reconstruction became necessary; he gave a speech at the Royal Institute of British Architects to this end in November 1940. This was the catalyst in bringing into being the National Buildings Record, the aim of which was that all

buildings of national value that were at risk of destruction by enemy action should be photographed and measured. Clark was immediately put on the management committee; through his position at the Ministry of Information (discussed in the next chapter) he could issue the necessary permits. He had told the RIBA audience that 'Police and Military will respect a permit, the public will not and local people will stone or knock down people taking photographs.' A fraction of the resulting photographs were exhibited at the National Gallery in 1944, and were received by Londoners as poignant reminders of what had already gone. As Harold Nicolson wrote in the *Spectator*, 'a visit to the National Gallery … will convince anyone of the true value of the work being done' by this scheme, 'namely an illustrated catalogue of all our national treasures'.[25] And after the war it did indeed prove to be instrumental in the reconstruction of damaged historic buildings.

When the gallery was not exhibiting young British artists, Clark was keen that it should champion designs for the rebuilding and planning of Britain after the war. In February 1943 Alan Lascelles wrote in his diary: 'I went to the National Gallery to hear [the economist and social reformer] Sir W. Beveridge open an exhibition of designs for post-war housing, organised by the Royal Institution of British Architects … Kenneth Clark wound up with a neat speech in which he said that the architecture of the Middle Ages had been inspired by man's faith in God, that of the Renaissance by their faith in the majesty of the human intellect, while that of the coming age would necessarily have a more utilitarian motive, and we must therefore be prepared for some sacrifice of aesthetic considerations.'[26]

In 1944 Jill Craigie directed *Out of Chaos*, a documentary that centred on the National Gallery and featured Clark as one of its leading presenters. Her film welded the appreciation of modern art with the story of the gallery at war, and mixed interviews with artists and vox pop. It was an innovative approach that set a new pattern for presenting art programmes. It also showed exhibitions of amateur art all over the country, and captured the Home Secretary Herbert Morrison saying, 'I hope that this bond between the artist and the man in the street will outlast the war.' *Out of Chaos* was a pioneering venture as an art documentary, and Clark had made his selection of British painters and used the opportunity to support a female director, unusual then and thereafter.

* * *

The gallery was hit nine times during the war, and particularly badly on 12 October 1940, when Hampton's furniture store next door (where the Sainsbury Wing is today) was completely destroyed; the concerts had to be moved. There were some lucky escapes, but when an unexploded bomb fell on the gallery in October 1940 a full-scale row developed between Clark and Major General Taylor of the Bomb Disposal Unit, whom Clark thought behaved inefficiently and dangerously. The Unit had inspected the bomb, shown it to the gallery staff (which was against all regulations), then gone off for lunch – whereupon it exploded, destroying two galleries. The keeper Willie Gibson complained to Taylor, and told Clark and Courtauld that he had never received 'a more insolent and scandalous reply to legitimate criticism'.[27] Clark was never in sympathy with the rigid military mind, and angrily told Gibson, 'General Taylor's letter is typical of what one would suffer under a military dictatorship.'[28] With gaping holes all over the building, Clark and Gibson increased the number of night warders from two to three, and in addition arranged for two day staff to sleep overnight at the gallery.

Perhaps more serious was a call that Clark received from the supervisor of the Manod caves: 'It's a crisis, it's a crisis. Come at once.' Air conditioning and a change in temperature had caused large pieces of slate to collapse, and the spectre presented itself of the gallery's pictures being buried under an avalanche. Steel scaffolding solved that particular problem, and there were no further falls.

One of Clark's perennial concerns at the gallery was his benefactor Calouste Gulbenkian. At the outbreak of war Gulbenkian had stayed in Paris, attaching himself to the Iranian Embassy, which gave him diplomatic status. This meant that his treasures were not carted off to Berlin, but by remaining in Vichy France he had technically rendered himself an 'enemy alien' of Britain. His many enemies used this as an excuse to cut off his famous 5 per cent revenues from the Iraq oilfields. Clark did his best to intercede with the British Treasury, but he could do nothing about the loss of revenue that had resulted. After many vicissitudes Gulbenkian went to live at the Hotel Aviz in Lisbon, where one day he was even arrested while rivals attempted to find evidence to incriminate him. He survived all these machinations but nurtured a growing grudge against Britain, and there was little Clark could do but unsuccessfully speak up on his behalf to Foreign Secretary Anthony Eden and Maynard Keynes.

Despite these frustrations, Gulbenkian went on believing in their project at the National Gallery. Throughout the war – communicating

with Clark via a diplomatic bag – he made enquiries about paintings for sale: 'I shall be very grateful if you find time to let me know when there are any extremely fine pictures which you would like to add to our "family".'[29] Clark had no luck – he went on hoping for the Cook Rembrandt, *Titus*, and mentioned the possibility of pictures from the Crawford collection; he even suggested that Lord Spencer might sell some of his incomparable collection of portraits by Reynolds. At one point he was all set to buy Constable's *White Horse* at auction, but the National Gallery of Scotland stepped in and the painting was withdrawn. In the meantime William Adams Delano, the architect of the proposed Gulbenkian wing, could not get his fee, and told Clark in 1942, 'You must be a confirmed optimist if you still have faith that your benefactor will come true.'[30] The following year, however, Gulbenkian wrote Clark a long, reassuring letter, saying that their plan was still on track, and even that he intended to lend more items after the war.[31]

But there were alarming rumours going around. James Lees-Milne recorded in his diary an encounter at the Travellers' Club with the British Consul in Lisbon: 'He told me that Gulbenkian, now living in Lisbon was being slighted by the British Embassy and society because although a British subject, he was evading income tax. Consequently Gulbenkian had hinted to the Consul that he might after all not leave his pictures and collections, now in England to this country. Did I know Kenneth Clark? And would I do something?'[32] The matter was still at this stage rescuable; the *dénouement* was not to come until the war was over.

19

The Ministry of Information

*It was a perfectly useless body, and the war would have
been in no way affected if it had been dissolved and
only the censorship retained.*

KENNETH CLARK, quoted in Ian McLaine,
Ministry of Morale[1]

Once the National Gallery pictures were safely despatched, like most men
of his age Clark wondered what he should do for the war effort. 'For
anyone with my background,' he wrote, 'there was an obvious source of
employment, the so-called Ministry of Information'[2] – the British equiva-
lent of a propaganda ministry. This cobbled-together institution was
housed in the monolithic 1930s Senate House of London University, and
was from the beginning an uneasy mixture of clever amateurs and (occa-
sionally resentful) civil servants whom other ministries were prepared to
release. Harold Nicolson's first impression was that 'all the lunatics flock to
the MoI like bees around ale'. Clark's time at the ministry was quite short
– about eighteen months – and he later liked to denigrate his efforts there.
During its early days the MoI was indeed ineffective through a mixture of
poor leadership, inappropriate personnel and confusion of purpose, but
Clark's verdict that it was a useless body is unduly harsh. It was always
going to be harder running such a ministry at a time when all the news
was bad.[3]

Clark's first attempt at getting a job was almost a caricature of wartime
recruitment – a chance meeting in a gentlemen's club which he described
to Jane: 'This is to say that I met at the Beefsteak a nice anthropologist
called Lord Raglan who is in the M of I as deputy chief censor, and he has
arranged for me to go round there this evening … I have just been to the
M of I but without much success. A pleasant man took the line of "you're

far too big a man to get a job through the ordinary channels, you should write to Perth etc."[4] He dutifully wrote to Lord Perth, who held high office at the ministry, but as he told Jane: 'I hastened to the Gallery, but alas no word of a job not even an acknowledgement of my letters. I begin to learn what it must feel like to be unemployed. There is only the usual pile of letters from artists all assuming I can get them jobs.'

Clark believed that of the two of them, Jane was more employable: 'I have only luxury talents.'[5] He wrote half in despair to Lord Lloyd at the British Council: 'I can get together a panel of the best advertising experts in England. It seems that the Ministry of Information are not interested in persuading people through their eyes.'[6] At this point 'Uncle Arthur' Lee sprang into action and wrote directly to the Minister of Information, Lord Macmillan (who had been at school with Clark's father at Greenock). Lee described Clark as 'one of the ablest young men of my acquaintance … he is a man of great and natural administrative and business ability … [whose] ardent spirit will simply lure him into one of the fighting services.'[7] As a civil servant Clark had been exempted from the armed forces, and although he dreaded the idea of 'going back to school' he did contemplate the Royal Naval Voluntary Reserve, as Jane recorded, 'if he could get a commission, failing that a minesweeper, which gives one lots of time for reading.'[8] In the event, the Ministry of Information accepted Clark, and he began work there on 27 December 1939. He was thirty-six years of age.

Founded on the day war broke out, the MoI was originally given five functions: the release of official news; censorship of the press, films and radio; maintaining morale; creating publicity campaigns for other government departments; and propaganda in connection with both enemies and allies. Harold Nicolson, who was the junior minister at the ministry, kept a diary of the period which opens a window into Clark's life there. Nicolson thought the MoI was 'too decent, educated and intellectual to follow Goebbels.'[9] Unlike existing ministries, which had evolved over many years, the MoI's structure had to be invented, and it was from the start over-complicated and subject to continuous change, which is as confusing to the historian as it was to the public at the time, not to mention those who worked there. A great deal of energy was expended in the early days on purpose, definition, function and procedure. Clark's surviving MoI memos show how exercised he was by the competing claims of different branches of the ministry, and the problem of whether individual committees were 'deliberative', 'executive', 'coordinating' or 'informative'.[10] He served under

three ministers, none of whom was very successful in the post: Lord Macmillan, who had recruited him; Sir John Reith,[11] appointed in January 1940 (with whom Clark got on well); and from May 1940 Duff Cooper,[12] a Tory with whose views Clark was rarely in sympathy. This succession of ministers prompted the ditty:

> Hush, hush, chuckle who dares,
> Another new Minister's fallen downstairs.

The ministry puzzled people, appearing as it did to be overstaffed, very expensive to run and bringing few discernible benefits. It was determined not to become a Ministry of Entertainment, but it certainly became the butt of many jokes – 'the Ministry of Aggravation', or 'Minnie', as John Betjeman and others who worked there referred to it. Despite his later denigration, Clark took his time there very seriously; as he wrote in the month of his appointment, 'this war is not a war of man-power, but to a great extent a war of morale'.[13] He held positions of considerable influence, mostly chairing committees which changed name and purpose with bewildering speed, reflecting the uncomfortable character of that period.

To Clark's surprise, and everybody else's, he was put in charge of the Film Division. The *canard* put about by Clark himself that this was because of a confusion over his being an expert in 'pictures' is very unlikely, although in keeping with the amateur reputation of the ministry. It seems far more probable that his administrative ability, his perceived understanding of 'creative types' and his left-of-centre political views were the real reasons. His predecessor, Sir Joseph Ball, had been a political appointment from the Conservative Party; there was a feeling of inertia about Ball, and the film world had received him with hostility. Clark was seen by contrast as effective, young and dynamic.

Sir John Reith, the father of the BBC, arrived very shortly after Clark, and the combination was initially thought to be positive. Reith, referred to by Churchill, who loathed him, as 'that Wuthering Height', immediately interrogated Clark about his religious beliefs (Clark must have stretched casuistry to its limits), and concluded with, 'You have an independent income ... that's bad.' Clark responded by pointing out that so did William Morris, Ruskin and the fathers of British socialism, to which Reith retorted, 'It's all right for you but it's no good for me. I can't get you to obey me so easily.'[14] Reith, like so many older men, took to Clark at once, and was determined to promote him, which Clark managed to resist at first.

Clark's friends were delighted but not surprised by his appointment to the Film Division. Henry Moore thought that film 'is easily the most powerful reflective medium for propaganda of all'.[15] Lord Bearsted was less sure, telling Balniel: 'I fear he may not be capable of dealing with the tough gang who run the film industry'.[16] Clark wrote to his mother about his new job: 'I am encouraged by the support of my colleagues – far more than I got in the gallery, although I am so much less qualified for the work … we are going to pay for some quite important productions and last Tuesday I persuaded the Treasury to allot me the formidable sum of £770,000 … my great difficulty is to find a number of good stories which will carry my propaganda messages … I believe I am much attacked in trade papers but as I never look at them it doesn't matter … Every day makes me a more committed socialist. Bureaucracy may be full of evils, but nothing could be worse than the present system, where private profit is the controlling factor … However I mustn't turn this letter into a Ruskinian tract'.[17]

Despite his lack of experience, Clark was cautiously welcomed into the industry. He gave an interview with *Kinematograph Weekly*[18] in which he offered the conventional view that 'no film is good propaganda unless it is good entertainment … the greatest of the anti-German agents is Donald Duck. The whole ethics of Disney's work is that, while being superb entertainment, he portrays the popular hatred of regimentation' – but then added the unfortunate remark: 'if we lose the war let the non-British and Jewish elements in the industry realise what would happen to them under totalitarian control'. The remark was reported by the *Daily Herald*, which wondered why Clark had been appointed at all, reminding him that ten thousand unemployed British film technicians were still waiting for work.[19]

The Film Division of the MoI both paid for the making of films and encouraged production companies to make the kind that were needed. Clark realised that these fell into two types: full-length entertainments, which only worked if the public did not recognise them as propaganda; and the short two-to-five-minute films that preceded them, which today would be called advertisements. Clark's main claim to success in running the Film Division was to bring the leaders of the film industry into a closer cooperation. This seems perfectly plausible, although when he took over there were already several films in production, with titles such as *Convoy*, *Contraband*, *Freedom Radio* and *Gestapo*. He confessed to a colleague: 'I am not in favour of propaganda films which show the wickedness of the

Germans. It is very difficult to do this without also showing their efficiency and apparent invincibility.'[20]

In February 1940 we find Clark inspecting the set of a U-boat for a film called *All Hands*, one of three being made on the 'Careless Talk' theme in production under Michael Balcon, starring John Mills and Dorothy Hyson. He gave an interview to Dilys Powell at the *Sunday Times* describing the Film Division's two favourite themes: 'What Britain is Fighting For' and 'How Britain Fights'. He believed that the first was best expressed by features showing humanity in national character, as in Alfred Hitchcock's *The Lady Vanishes* (and later in the celebrated Olivier *Henry V*, which was approved during Clark's tenure). The second was usually best expressed in short films, and occasionally in longer documentaries such as Michael Balcon's *Convoy*.[21]

Clark enjoyed the film world and its characters. He started including actors and directors in his dinner parties, as Harold Nicolson noted: 'Dine with Kenneth Clark. Willy Maugham, Mrs Winston Churchill and Leslie Howard are there. We have an agreeable dinner and talk mostly about films.'[22] But there was one particular director for whom Clark was to have a very soft spot. Gabriel Pascal appeared at the MoI without an appointment on a busy day, sat himself down and proceeded to outline all the films he would make for Clark. As Clark confessed, 'to say that Pascal was a liar would be an absurd under-statement. He was a sort of Baron Munchausen, who never opened his mouth without telling some obviously untrue story.'[23] Clark was delighted by this short, thick-set, shameless Hungarian imposter who had somehow persuaded Bernard Shaw to give him the film rights to his plays. Gabby Pascal appeared like a whirlwind in Clark family life, delighting the children with his fabulous stories. He would bombard Clark with telegrams from Canada (which he thought would be the perfect place to make patriotic films), full of brave promises and exhorting Clark to send over the best actors. A typical telegram reads: 'This is Programme of six pictures for first year stop. Have all finances together to have studio ready in six weeks.'[24] There is no evidence that anything they did together ever came to much, but Pascal joined Clark's gallery of grotesques. As Clark's son Colin wrote: 'My father loved people like Gabby Pascal. Perhaps he was frightened of turning into his mother who had been so disapproving and so prim, and every now and then needed an injection of his boisterous and badly behaved father.'[25]

During the early part of the war Clark was besieged by artists clamouring for jobs, and also by some writers. His old friend John Betjeman had

written in desperation after Clark had given him bad news over a job: 'I bear no grudge … but for the sake of W. Butterfield, J.L. Pearson and Burges* do your best for yours, John Betjeman.'[26] Clark then had a 'brain-wave while shaving', and rather quixotically brought Betjeman into the ministry as a deputy in his own division. But as Clark told Betjeman's biographer, 'Can you imagine John being at home in the MoI? … I got him into the MoI and thought we could find something for him to do, but we didn't. He was under me and we had some good laughs. Every now and then I got him to write an introduction or some piece of some sort. Which he did very well.'[27] Clark explained, 'I wanted his flexibility and originality of mind and also his charm – because, essentially, ours was a public relations role.'[28]

Almost Betjeman's first job was to be sent to meet one of Britain's great film moguls, Sir Sidney Bernstein, in his office in Golden Square. The only mystery in this story is why Clark, who greatly enjoyed such people, left the meeting to Betjeman. 'What,' Betjeman asked Bernstein, 'should the government be doing about film and propaganda?' Bernstein simply opened a drawer and produced a prepared document, which suggests that Clark had already been in touch: 'British Film Production and Propaganda by Film'.[29] This emphasised the importance of entertainment, and also of the newsreel – which in fact accorded with Clark's views. Clark offered Bernstein a desk at the MoI, which he refused to accept as long as 'the appeaser' Chamberlain was prime minister; he only changed his mind when Churchill came to power. In the event, Bernstein was particularly helpful in persuading the industry to screen government films and gather audience feedback. He would reappear later in Clark's life, when Clark was setting up Independent Television.

In February 1940 the German propaganda machine paid Clark the compliment of caricaturing him in a broadcast from Bremen.[30] It reported that 'the Films Dictator of Ministry of Misinformation, Sir Kenneth Clark' had informed the press that he wanted to arrange a film of the '*Altmark* incident', in which 299 British prisoners of war being transported through Norwegian waters in a German ship had been rescued by HMS *Cossack*. The German broadcast claimed that Clark, who 'a generation ago would not have been admitted to a single self-respecting club', had tried and failed to hire Charles Laughton for the project. However, no film was ever

* The Victorian architects William Butterfield, John Loughborough Pearson and William Burges.

made (or probably ever planned) of the incident that made famous the phrase 'The navy's here!'

Clark reflected on his time at the Film Division in a November 1940 lecture at the Royal Institution entitled 'The Film as a Means of Propaganda.'[31] He cited *Miss Grant Goes to the Door* (the counterpart to the ministry leaflet 'If the Invader Comes', which had been produced during the Battle of Britain in anticipation of invasion) as an example of a bad short film. In the film a maiden lady steals a German parachutist's gun and shoots him. The conventional stage trick which enabled Miss Grant to take a gun from a trained soldier, Clark thought, was unrealistic in the extreme. Newsreel, he told his audience, had been made difficult by the reluctance of the services to grant facilities to film crews. He went on to applaud (with as much horror as admiration) the German propaganda film *Baptism of Fire*, an account of the invasion of Poland, and declared that the two British films of which he was proudest were *London Can Take It*, which was to have such an effect on public opinion in America, and *Britain at Bay*, narrated by J.B. Priestley. Clark had by now shifted his position on one point – that propaganda films were no good if they did not have entertainment value. He now believed that they must be of the highest quality, have form and movement, and that above all they must hold the audience's attention.

More trying times at the MoI arrived with Colonel Norman Scorgie, appointed as deputy director-general in order to impose discipline on the ramshackle organisation. Scorgie was a martinet who was not in fact a soldier at all, but a civil servant drafted across from the Stationery Office. He took the rank of colonel, and immediately made his feelings about his new charges known by putting up prep-school-type notices telling them they were 'slack' and should 'pull their socks up' and 'all pull together'. This was too much for Betjeman, who was in the lift one day when he identified Scorgie (whom he had never met). He turned to the almost deaf liftman, saying in a stage whisper, 'I say, have you seen anything of this fellow *Scroggie*? They tell me that he's not really *pulling his weight*.' The inevitable consequence was that Scorgie appeared in Clark's office: 'The egregious Colonel Scorgie instructed me to get rid of him, he said he's half baked and I said he's very clever: If he has one idea a month that no one else in this beastly building has in a whole year, he's worth keeping.'[32]

But it was a chance conversation with Betjeman one day that Clark always claimed (with tongue half in cheek) was his most lasting achievement at the MoI: 'Knowing that he shared my tastes I said "John you must

go up to the canteen. A most ravishing girl has just appeared there – clear brown complexion, dark eyes, wearing a white overall – she's called Miss Joan Hunter Dunn."' Unfortunately there are several claimants for the honour of being the midwife of the only great poem to come out of the MoI.* Betjeman was given a brief stay of execution before taking up a position as press attaché in Dublin.

Sir John Reith finally got his way, and promoted Clark in April 1940 to Controller of Home Publicity, assuming charge of several further divisions. His job at the Film Division was taken by his old friend from Shell, Jack Beddington.[33] Clark's new position was one of considerable power, but – as he himself ruefully pointed out – he became the object of 'everyone with a scheme for saving the country, reforming the world, or, more modestly, spending vast sums of money on advertising campaigns'.[34] Whatever their cause, they all sang the same song: 'All we want is a blessing.' The main part of his new job, however, operated through the numerous daily committees he chaired, or merely attended. Some, like the Dunkirk Emergency Committee, were convened in response to a particular crisis, and were temporary. But among all the permanent committees the two most important, which met most days, were the Policy Committee, attended by the ministers and senior members of the ministry staff, and the Planning Committee, chaired by Clark, which usually immediately followed it, and was convened to put policy into action. A typical Planning Committee agenda might examine the desirability of warning the public that German bombers were bound to get through; the countering of defeatism by an 'Anger Campaign'; a campaign to bring home what England means; 'Life Under German Rule'; and 'Victory is Possible'.

One of the first things Clark did in his new role was to produce a report on home morale: 'In retrospect the only interesting feature was the amount of evidence that came in on how low morale in England was, much lower than anybody had ever dared to say. But there was obviously nothing that we could do about it, except to hope that by some miracle we could win a few battles.'[35] Crisis followed crisis; we can follow, for instance, events

* In their memoirs, both Clark and the fashion writer Ernestine Carter (wife of the bibliographer and diplomat John Carter) claimed to have introduced Betjeman to Joan Hunter Dunn. Their accounts are not entirely incompatible. Clark first mentioned her name to Betjeman, but the actual introduction, according to Miss Hunter Dunn, was by Michael Bonavia, who summoned her to his room to meet the poet (see Hillier, *New Fame, New Love*, p.180). The cash register she used is preserved in Senate House by the Institute of English Studies, University of London.

surrounding Dunkirk through Harold Nicolson's diary, in which he describes how Clark was summoned to Walter Monckton's office at the MoI, where General Macfarlane told them that the British army in France was surrounded at Dunkirk, and the problem was how to communicate this to the public. Blame the French? The Belgians? The politicians?[36] In the event the work of the MoI's Emergency Dunkirk Committee was taken over by the cabinet, and Clark went to Downing Street to discuss the planned rescue mission. The evacuation of the troops from France using the 'little ships' was a brilliant publicity coup – certainly the greatest of the war up to that point. How far Dunkirk was an MoI success, and the extent of Clark's involvement, are unclear, as the responsibility was taken over by the cabinet; but it seems likely that the celebrated BBC 'little ships' appeal did not emerge from the MoI.[37]

Clark grasped that the public needed to be satisfied that the war could be won, and that Britain was hitting back. Posters, pamphlets, films, campaigns and speeches were the stock-in-trade of the MoI Planning Committee. A poster of Churchill with a background of Hurricane fighter planes and Cruiser tanks was an instant success, and at the behest of Churchill himself, the ministry undertook a campaign in 1940 warning against the dangers of rumour. Although it doubted that this would be successful, the MoI had no option but to comply, and Clark was put in charge. He consulted an advertising agency about the proposed phrase 'Silent Column', and prepared a poster, radio and press work, but the whole thing became the butt of public jokes. In fact, so many campaigns were inflicted on the British people by the MoI that Aneurin Bevan asked in Parliament: 'Is the Minister aware that the impression is now universal that if the Germans do not manage to bomb us to death, the Ministry of Information will bore us to death?'

It is not always clear which campaigns and slogans can be attributed to Clark. The best evidence lies in surviving memos from him, for instance those concerning the poster campaign 'This is What We are Fighting For'.[38] Years later, in a speech to the National Trust, Clark explained this in elegiac terms: 'Every time we had a new minister or director-general, which was almost once a month, he used to summon us together and say with the air of someone who had a brilliant new idea, "We must decide what we are fighting for!" It was a difficult question. We all knew what we were fighting against. But what were we fighting *for*? Democracy? Parliamentary institutions? They didn't sound very inspiring to me, and many of the civilisations which I admired most had got on well enough without them. My

mind, on these occasions, was a blank. But in my mind's eye I had a clear vision of a small English town – halfway between a town and a village – Tetbury or Long Melford. There it all was: the church, the three pubs, the inexplicable bend in the road, the house with the stone gate where the old lady lived … I used to think "That is what we are fighting for." The thought of the Germans marching in there … made me very angry.'[39]

Harold Nicolson gives us a vivid picture of Clark, the imperishable aesthete, in his office at the MoI: 'I go into KC's room for something and there lying on its pillow with eyes upstaring is the most beautiful marble head. For the moment I assume that it is Greek until I look at the hair and lips which are clearly Canova. It is a bust of the Duc de Reichstadt which K had picked up in a junk shop … I do so admire K's infinite variety. He does not like being here really and wld be far happier going back to the Nat-Gallery and vaguely doing high-brow war service. Yet he works like a nigger here merely because he loathes Hitler so much.'[40]

Duff Cooper, a friend of Churchill, was appointed Minster of Information in May 1940. He and Clark never saw eye to eye, and Cooper proposed to appoint the Conservative politician Lord Davidson to take over the Home Front Section of the ministry – effectively over Clark. Davidson had already made his opinion clear to Nicolson that 'Kenneth Clark and I are too intellectual to get a real nation-wide appeal and that it ought to be in the hands of professional advertisers'.[41] Clark was philosophical, as Nicolson noted: 'this will be difficult especially as I doubt whether Kenneth Clark will consent to remain under such conditions. [Clark] is very nice about it all and rather agrees that publicity of the nature we shall now require needs a bull rather than a china collector and that Davidson is probably the best bounder we can get.'[42] Jane told their friend Lord Crawford, 'Alas K has no control of Duff and dislikes him. He is a coarse fellow,' and again: 'Duff is trying to sack K and put Lord Davidson in his place.' According to Jane, Cooper thought the MoI 'too leftist'.[43] But Davidson was in fact appointed under Clark.

September 1940 brought the Blitz. The main concern at the MoI was, once more, home morale; they wondered whether it could be sustained in the light of the worsening situation overseas. Nicolson described Clark's anxieties: 'K confided his misery over the destruction of so many beautiful things. He felt that more bombing of cities, the capture of Egypt and a German peace offer would put the popular press against continuing the war and the MoI.'[44] Clark described what he saw in the West End of London to Lord Crawford: 'From Ministry of Information written from the cellar

during a raid. Apart from the human problem, the destruction is very painful. St. James, Piccadilly, the Clubs, Carlton House Terrace, Kensington Palace all struck last night, the first demolished. Every night sees the end of some fine building – also, I must admit, of a lot of bad ones.'[45]

One night in early 1941 when they both happened to be there, the Clarks' new flat at Gray's Inn Square was destroyed. They were blown out of bed, but fortunately not harmed. After this Clark slept either in the basement of the MoI or occasionally at the Russell Hotel nearby. His air-raid misery was not over, as Nicolson recorded: 'Kenneth Clark appeared at the Policy Committee in blue flannel coat and striped trousers. He has lost his all in a fire at the Russell Hotel.'[46] This confined Clark to the MoI basement at night, where the cartoonist and architectural historian Osbert Lancaster was a fellow occupant. Lancaster described the dormitory as 'wonderfully bizarre': 'There picking his way delicately, albeit somewhat bad temperedly, one may observe Sir Kenneth Clark with a seventeenth-century folio under one arm and a set of pale blue *crepe de chine* sheets over the other searching where he may lay his head.'[47]

Clark painted an equally vivid picture of his life to Jane, safely at Upton, in September 1940. He described sleeping on a camp bed at the MoI and having dinner most evenings with John Betjeman and the Chinese scholar Arthur Waley at a nearby restaurant at 7 p.m. because the raids started, with German punctuality, between 8.15 and 9 o'clock: 'The military think invasion next week a 10 to 1 chance. The PM still thinks it even chances. I am working hard on posters … Also I am trying to think of ways of preventing class bitterness which is the natural reflex of the East End being bombed. The papers and wireless are silly about this unless one watches them all the time … Goodnight my dear love. I know you will hate feeling so isolated, but you must try to think that I am in the navy. I will write often. The children must think of me as in the fighting forces and not worry. Your devoted husband, K.'[48] Clark's last comment was hardly calculated to set his children's minds at ease, and is a curious sidelight on the way he wished them to perceive him.

Clark was heavily involved in planning for the anticipated German invasion of Britain, chairing all the meetings concerning 'Publicity about Invasion' and 'How We are to Prepare the Public for Invasion'.[49] The answer was a leaflet, 'If the Invader Comes'. 'I wrote this useless document,' he claimed, but so did Nicolson, and probably like so much committee work it was the result of several hands. Clark thought that what the public would want was not so much words of comfort but of command; however, as he

pointed out, 'the difficulty was to think up enough technical instructions'.[50] The first draft, entitled 'If the Germans Invade Great Britain', contained seven rules telling the public what to do and what not to do: stay put, do not believe rumours, do not give the Germans anything, etc. The document is covered with corrections in Clark's handwriting.[51]

Part of German propaganda was to foster the idea that the burden of war was falling upon Britain's working people, a point Clark had touched on in his letter to Jane. The MoI was seriously considering a campaign to point out that wealthier people were also playing their part, and Clark wrote a memorandum on the subject: 'I am afraid I think it would be very dangerous for us to support any propaganda on behalf of the wealthier classes … If we are caught out putting their case there would be a fearful rumpus.' He felt that 'A certain amount of patting on the back for workers is desirable, if a form can be found free of patronage'.[52] Another of his concerns was the image of the USA in Britain – the sceptical public needed to be shown that America was a nation of friends, and eager to help, but it was perceived, Clark thought, 'as being a country of luxury, lawlessness, unbridled capitalism, strikes and delays'. He believed the public needed to know that the average American was 'a kindly, simple, honourable character', that the US was not a country of rampant private capitalism and that it was on our side.[53]

One of the most interesting aspects of Clark's war was his prescient appreciation of the importance of post-war planning. As early as 1940 he was persuading Edward Hulton, the owner of *Picture Post*, to devote a special number to 'The Britain We Hope to Build When the War is Over'. Julian Huxley was brought in as editor, and the forty-page special issue was published on 4 January 1941, with pieces by Maxwell Fry on planning; A.D. Lindsay, Master of Balliol, on education; J.B. Priestley on culture and recreation; and Huxley himself on 'Health for All'. It might have been – and arguably was – the blueprint for post-war Britain.

The same month, the ministry asked Clark to prepare a memorandum on whether Germany was immutably wicked. His paper was entitled 'It's the Same Old Hun'. The most striking thing about it is his opinion that, in contrast to the situation in 1914–18, 'all the best elements of German culture and science … are outside Germany and supporting us'.[54] Clark, as we shall see, was much involved with helping to settle many German refugees, notably the scholars of the Warburg Institute from Hamburg.

Clark was by his own account frequently off to see Churchill, and he describes the consequences of one visit: 'I chanced to be lunching at

Downing St when the Air Chief Marshal said to me (very indiscreetly), "that old leaning tower of yours is going to take a beating". I said "Do you mean that you are going to bomb Pisa?" He nodded and I got hold of the bombing unit that was going to do the job and showed them how they could bomb Pisa station without going near the cathedral or baptistery.'[55] He later told his secretary, Catherine Porteous, 'I wish I could have known in advance about Dresden,' but he conceded that by that stage of the war Bomber Command had become so bloody-minded that they would not have listened. According to his memoirs, Clark undertook a mission on behalf of Churchill to see the Irish Taoiseach, Éamon de Valera, in 1941 to discuss the Irish ports. Quite why the Prime Minister would send Clark on this major diplomatic mission, and why it came under the MoI, is a mystery, but he went, with Jane. Given Ireland's isolationist policy, de Valera was never likely to grant the British the use of Irish ports, but the meeting was a success at a human level, and Clark found him sympathetic – 'like a priest for whom the idea of progress has no meaning. No doubt that is why I liked him.'[56] While they were in Dublin they saw John Betjeman, who told John and Myfanwy Piper, 'K and Jane came over here – thank God for them, they worked very hard with the Irish and created the most wonderful impression and talked to Dev for two hours.'[57] In all probability Clark was invited to Ireland by Betjeman to lecture, and it was he who arranged the meeting with de Valera (at which Dev himself may have brought up the subject of the ports), which Clark then reported back to Churchill.

By mid-1941 Clark had two powerful enemies at the MoI in Colonel Scorgie and Duff Cooper, and he realised that his useful time there was over. In July he made a serious gaffe, telling the Home Defence Executive that the MoI had no control over the BBC. The BBC's neglect of MoI directives had been a running sore, but the matter was taken seriously. In December 1940 the ministry's director-general, Walter Monckton, was forced to step in and tell the Privy Council Office that 'Sir Kenneth Clark is unlikely to remain much longer in the Ministry.'[58] In fact Clark had already tendered his resignation. Harold Nicolson saw him afterwards: 'Lunch with Kenneth Clark at the Travellers. He has resigned from the MoI and is glad about it. Or not wholly glad. He says that it is like leaving a Transatlantic liner. One is glad to be home yet one says goodbye to the ship with some sadness.'[59]

Cooper himself was fired the same month (May 1941), and under his successor Brendan Bracken the MoI became a more respected institution.

As Clark put it, 'I belonged to the old, amateurish, ineffective, music-hall-joke Ministry, and had long been an unnecessary member of that ramshackle body.'[60] After the war Duff Cooper, reflecting on his lack of success, declared, 'there is no place in the British scheme of government for a Ministry of Information'. Clark would probably have agreed, but the later successes of the MoI were built on the troubled foundations of those early years. They mirror Britain's war effort. The frustration Clark felt there, which so soured his view of the MoI, was that of an activist mired by bureaucracy. The ministry did, however, give him the chance to develop and run his greatest legacy of the conflict, the War Artists' Scheme.

20

Artists at War

*I hate all forms of organisation and think them particularly
tiresome when applied to artists and men of letters but
something of this sort is necessary now.*

KENNETH CLARK to John Betjeman, 20 September 1939[1]

In the first empty week of the war Clark had gone into action on behalf of
living artists. As he explained, 'I thought it would be a good thing to have
a record of the war by artists for two reasons: one that they could give
some feeling of events which a mere camera could not do, and secondly
that it might be a means of keeping artists out of active service.'[2] Or as Jane
put it more bluntly: 'to save our friends.'[3] It is surprising that Clark felt this
was his responsibility; one might have expected the director of the Tate or
the president of the Royal Academy to take such an initiative, not the
director of the National Gallery. It is a measure of his personal identifica-
tion with contemporary art that he should be the instigator of the scheme.

In August 1939 Clark made a proposal to the Ministry of Information
recommending the formation of a body roughly comparable to one which
Canada had set up during World War I. One of his earliest exposures to
modern painting was the War Artists exhibition in 1917 (including work
by Wyndham Lewis and William Roberts), and the connection had made
a lasting impression on him. He also went to see the Treasury: 'Early in the
war everybody was in a helpful and somewhat excitable condition, and I
did not have to prepare the ground for my scheme. It was accepted imme-
diately.'[4] His scheme started out at the Ministry of Labour, but was soon
passed back to the MoI, on the grounds that war pictures were classified
as publicity. That Clark was to attain high office in the MoI was a blessing
– and the scheme certainly became more difficult to maintain after he left
the ministry.

Clark at once began to form a committee and to prepare a list of artists for its consideration. He later told Augustus John how that autumn he received about twenty-five letters a day from artists asking if he could help them; he somehow found time to answer them all, and was always at pains to point out – somewhat disingenuously – that it was not *he* who was compiling the list, but a committee of which he was a member. The artist Paul Nash attempted to set up a rival 'self-constituted' committee – which irritated Clark, as he told John Betjeman: 'I wish that Nash would go on painting and repress his insatiable appetite for organisation.'[5] Clark easily outmanoeuvred Nash, and on 23 November 1939, when the war was not yet twelve weeks old, a meeting of the newly formed War Artists' Advisory Committee (WAAC) was held at the National Gallery under Clark's chairmanship. It was carefully constructed: Muirhead Bone, Clark's old friend and 'a most sweet character', who had been part of the World War I scheme; Percy Jowett of the Royal College of Art; E.M. O'Rourke Dickey to act as secretary; and a representative of each of the armed services. The Admiralty and the War Office had already conceived plans of their own, but were reluctantly marshalled under Clark's umbrella in an uneasy compromise whereby each service could request certain artists that it favoured. The Royal Academy posed its usual problem for Clark, but he decided that it would be better to have it inside the tent than complaining on the outside: the keeper, Walter Russell, accepted a place on the committee.[6]

By the beginning of 1940 there were over two hundred artists on the list. Clark anticipated that they would be used in three ways: to paint camouflage, to devise propaganda, and to create a record of the war itself. It was the last that he was interested in; he was always dubious about the value of propaganda art, which he saw as unhealthy for the artist, because likely 'to coarsen his style and degrade his vision.'[7] Although many artists signed up for camouflage, others saw it as a lower form of life – as Edward Bawden told Clark: 'The difference between being a camouflage officer & being given the opportunity of recording war scenes, is simply between making myself an efficient & conscientious servant & being allowed to rise on the wings of my profession.'[8] Clark would have agreed, but at this stage it was simply a question of keeping the artists out of the armed services and giving them work. Most found that with the coming of war, commissions had dried up, so this was a lifeline.

Clark certainly saw the scheme as a chance to articulate national values and beliefs at a time when they were most needed; he argued that there

was 'no use in fighting to preserve free functioning of intelligence and sensibility, if we abandon the arts in the process'.[9] No doubt he also hoped that the scheme would educate and improve public taste. Above all it was a way of ennobling the mundane tasks of war and engaging the interest of ordinary people by allowing them to see themselves through art. For this, recognisable subject-matter and a degree of clarity in execution were crucial, and so abstraction was ruled out. Moreover, the criterion of acceptance could not be aesthetic quality alone. For instance, Clark recognised the merit of David Bomberg's drawings, but considered 'his work looks artificial and done for effect, which is the last thing that we want our war records to be. I would rather they were a little dull and naïve'.[10] As he wrote to Cecil Day-Lewis: 'Thank you for Laura Knight's Introduction, which in its hearty, gym-mistress style I rather like. Like her painting it has the courage of its own commonplaceness'.[11] Commonplace or not, Knight's painting of a munitions worker, *Ruby Loftus Screwing a Breech Ring* (1943), caught the public imagination and became one of the most popular images of the war.* At its most basic, War Artist work was reportage of one kind or another, and whether good or bad it attained a documentary value. But as Clark often repeated, such paintings would also show posterity what the war *felt* like. In his October 1939 article in *The Listener*, 'The Artist in Wartime', an early apologia for the scheme, he wrote: 'There are certain things in life so serious that only a poet can tell the truth about them.' Henry Moore's shelter drawings were to prove the truth of that assertion.

Not the least interesting aspect of the WAAC was that it established a framework for state support of the visual arts. A distinction was made between salaried artists, whose war works belonged to the committee, and 'artists working on commission', whose work was bought by the committee only if they liked it. There were thirty-six salaried artists, six of whom might be seconded to the Admiralty, eleven to the army, seven to the Air Ministry, etc., and for the most part they were given honorary ranks. Fees were generally not problematic, although Paul Nash was an exception: Clark had to write him a long explanatory letter on behalf of the committee offering him fifteen guineas for a drawing, and twenty-five or fifty for an oil painting, depending on size.[12] During the fiscal year 1939–40 the

* This was largely to do with the inspiring subject, a twenty-one-year-old young woman at the ordnance factory at Monmouth, who had been bombed out of London and acquired extraordinary skills at making components.

WAAC received £5,000 for purchasing works of art. In the following year this was raised to £8,000, and despite the Treasury's doubts, the year after that to £14,000.[13] Clark's departure from the MoI in May 1941 made the situation more precarious, and the finances were never as certain again: the scheme's administration was moved to the National Gallery in 1943, and the MoI continued to dispense a reduced grant, with growing reluctance.

Matching artists with appropriate subjects often turned out to be a matter of trial and error. John Piper was a case in point. Piper had not even asked to be a War Artist, and had signed up for the RAF, but no doubt Clark talked him out of this. Initially, on the basis that Piper liked seaside subjects, Clark suggested he might prefer a job with the Admiralty. In the event he was sent to paint the Bristol Air Raid Control Rooms, which did not bring out the best in him. In October 1940, when Clark must have been one of the busiest men in England, he intervened and recommended that Piper go and paint the recently damaged church at Newport Pagnell in Buckinghamshire. Piper excelled at this kind of subject-matter, and while he was there he received a telephone call with instructions to go immediately to Coventry, where the notorious night raid of 14–15 November had just taken place and the cathedral was in ruins. Whether Clark was behind this call is not clear, but it certainly resulted in the artist's most powerful war work.

Even better known than Piper's paintings of Coventry Cathedral are his views of Windsor Castle painted in late 1941. These were not part of the WAAC scheme, but the result of the Queen visiting a 'Recording Britain' exhibition at the National Gallery. As Jane told Lord Crawford: 'K has persuaded HM to commission John Piper to do 15 watercolours of Windsor (for £150) like the Sandby series which should be interesting?'[14] Both Clark and Owen Morshead thought the castle should be recorded in case it was bombed. Morshead wanted something topographical, in the manner of Paul Sandby's graceful eighteenth-century watercolours, and did not like Piper's dark and dramatic interpretation. Clark was anxious about the Queen's reaction, but after initial doubts – and presumably persuaded by Clark's advocacy – she became very fond of the set. When the King was shown the drawings he famously turned to the artist and said, 'You don't seem to have much luck with the weather, Mr Piper.' The story of the commission brought forth one of John Betjeman's most delightful fantasies, a series of ten pen-and-ink drawings which he sent in a personal letter to the Pipers, showing Clark as 'a great magician who

lived in a beautiful office surrounded by Cézannes, pointillists, pens, abstracts, soft carpets and all manner of lovely things. This magician had a magic wand. Many a down-and-out artist came and slumped into one of his comfortable chairs and he had only to wave his wand and the artist's dream was realized.'[15] Such was the way Clark was viewed by most, if not all, of the artistic community.

Probably the artist whose reputation was most enhanced by the war was Henry Moore. Clark had failed to recruit him as a salaried War Artist; not only had Moore seen too much of war in 1914–18, but as a sculptor it was difficult to see how he could contribute. Clark then tried to persuade Moore and his wife Irina to move to Gloucestershire, but they could not be dislodged from London. This turned out to be fortunate, for one night in the early weeks of the Blitz the artist unexpectedly stumbled on his most celebrated subject, the underground shelters. The sight of people sleeping on the platforms of the London Underground made him think of the rows huddled together in African slave ships, and discreetly he began to sketch. He took his first batch of drawings down to Upton one weekend to show Clark. Jane enthused to David Crawford: 'Henry Moore and wife have just been staying with us and he has brought such lovely drawings of people in shelters, really magnificent, that K bought the lot for £50 for his war artists committee.'[16] In his memoirs Clark wrote that these sketches 'always will be considered the greatest works of art inspired by the war',[17] and he was finally able to convince Moore that he could be a useful War Artist. Moore was to give one of his shelter sketch-books to Jane; eventually the Clarks passed this on to the British Museum. After the success of the shelter drawings the WAAC proposed that Moore,

who was a coalminer's son, should tackle a series of drawings down the pits. 'It wasn't a bad idea,' Clark thought, 'but for some reason the spectacle didn't move him.'[18] One of the problems of such subject-matter was that there was nothing recognisably of the war about it. Moore thought little of the drawings that resulted, but Clark disagreed, and even acquired one.

Graham Sutherland was the artist of whom Clark saw most during the war, because Sutherland and Kathy went to live with Jane and the children at Upton for two years. Douglas Cooper, one of the artist's biographers, thought proximity to Clark was important in extending Sutherland's cultural horizons. Clark believed that the war gave what he called the artist's 'mood of heightened emotion' a much wider appeal, and vastly increased his range. 'Before the war,' he wrote, 'Sutherland's vision was so personal that few people could see nature through his eyes.'[19] The artist's views of London bomb damage (and also of Cornish tin mines) are among the most admired products of the WAAC. Sutherland once described his first impression of the City after a raid: 'the silence, the absolute dead silence, except every now and again a thin tinkle of falling glass … everywhere there was a terrible stench.'[20]

A great deal of Clark's time was spent trying to release artists from the armed services, typically Carel Weight from the Royal Armoured Corps, and Mervyn Peake from 'washing dishes'.[21] Clark believed Peake would make a brilliant propaganda artist, but had difficulty in getting him accepted by the WAAC. The most difficult case, however, was Victor Pasmore. Pasmore, a conscientious objector, had quixotically started military training at Sandhurst out of loathing of Nazism. Clark was therefore surprised when he appeared one day in his office at the National Gallery. It emerged that the artist had walked out, and was 'absent without leave'. Clark could not prevent him being sent to prison, but wrote a note stating that he was 'one of the most completely sincere people I have ever met … in my view his first duty to society is to paint. I would not say that about many artists, perhaps there are only half a dozen …'[22] Pasmore was never a War Artist, partly because as a 'pure painter' his subject-matter did not qualify, and partly because his principles would not allow him to accept the concept. He settled in 1942 in Hammersmith Terrace, whence he wrote Clark begging letters describing the minutiae of his finances and the difficulty of finding buyers for his paintings. Clark appears at his most patient in his dealings with Pasmore; he guaranteed his overdraft, and acquired virtually all his best work from this period.

Clark's patience with all artists is particularly evident when one looks at the correspondence he received. Those who – like Graham Bell – had a lot of time on their hands would write anything between five and ten pages a month telling Clark about their war work, and seem not to have been troubled by the lack of replies. One of the longest and warmest correspondences was with David Jones (who was not a War Artist), who, referring to the need for a new Ruskin, thought 'we perhaps have [one] in Kenneth Clark'.[23] Clark owned three of Jones's works, and when Jones asked if he could extend El Greco's *Christ and the Money Changers* as Picture of the Month for an extra week, Clark duly obliged. Jones's verdict on Clark was: 'Kenneth is a funny chap, a funny chap …'[24] Clark was to support him financially, putting £25 anonymously in Jones's bank account each year from 1944 onwards, rising to £150 a year in the 1950s.

Clark struggled to do his best for artists who were deemed unsuitable on grounds of style or subject-matter. Maynard Keynes asked him to help Ivon Hitchens, but as Clark wrote, 'I am afraid a letter from me saying that he is a good painter would not make much impression on the Ministry of Labour. I have managed to get some painters of his age deferred because they were doing commissions for the War Artists Committee, but his style makes it impossible to give him any official work, unless some enlightened person would commission him to decorate canteens.'[25] He duly wrote the necessary letters to help Hitchens. A number of artists turned against Clark when their work was rejected. Typical was C.R.W. Nevinson, who used to refer to him as 'Kenneth Napoleon Clark', and in 1940 wrote, 'it would be better to be gassed by the enemy than breathe in a hot house atmosphere of museum cranks and didactic favouritism'.[26] Perhaps the most poignant omission from the WAAC was Rex Whistler, who was killed on active service in Normandy in 1944. Clark later claimed that Whistler had not wanted to be a War Artist, but there is no evidence that he was ever approached, and one suspects that Clark did not like his work except as a stage designer.* Although the scheme did protect the lives of War Artists there were some losses: Eric Ravilious, who died on an RAF

* See letter to Henry Lewes, 10 May 1969 (Tate 8812/1/4/55). Whistler's name was on a reserve list, with 'No' marked against it. The artist's brother and biographer, Laurence, wrote to Clark to ask if he was ever considered; his response was one of dissembling and surprise (2 December 1982, Tate 8812/1/4/444). But Clark spoke of Whistler's death as 'a real disaster for the English stage' (lecture, 'Ballet Decors', late 1940s?, Tate 8812/2/2/76–77).

rescue mission in Iceland; Albert Richards, who was killed by a mine in Belgium; and Thomas Hennell, who may have been murdered by nationalists in Borneo.

Among the more troublesome artists for Clark was Paul Nash. Early in the war he wrote to Clark that he wanted to paint 'Monsters', by which he meant tanks, aeroplanes (particularly), submarines, etc. 'This is the War of the Machines,' he declared, 'and they have taken on human and animal appearance.'[27] He was supremely suited to paint the machines of war, and his *Battle of Britain* (1941) is one of the best paintings of the whole scheme. But Nash constantly badgered Clark about the RAF bigwigs who failed to appreciate him, and about money: 'I do earnestly pray you will be able to arrange that I get a monthly cheque, as my present position demands a regular wage of some sort.'[28] Then the Air Ministry refused to renew Nash's contract because they felt he was inaccurate in his depictions of aircraft. Clark wrote to the ministry, telling them in unusually strong terms how foolish they were, but as he pointed out to Nash, there were a number of senior members (led by Air Commodore Peake) who yearned for the Royal Academy style. Nash would write to Clark for reassurance: 'I am always left with a feeling of failure; that is why I want to hear other people's opinions' – which Clark would give as tactfully as possible: 'it [Nash's painting *Defence of Albion*] will come in for a lot of criticism because you have altered the proportions of the aircraft. People are used to artists changing the proportions of landscape ... but there is something sacred about the nicely calculated proportions of an aircraft ... however you have certainly succeeded in pleasing me.'[29] This was not always the case, however – when Nash produced the semi-abstract *Battle of Germany* (1944) Clark had to admit: 'I can only tell you truthfully my own feeling in front of it, which is apologetic bewilderment and incomprehension.'[30]

Unquestionably the most difficult of all was Wyndham Lewis, a veteran artist of the First World War who was living in Canada. Lewis approached Clark via Henry Moore, offering to paint Canada's industrial war effort. Clark enthusiastically agreed, whereupon Lewis started to dictate terms. He rejected the offered one hundred guineas, demanding a fee of £300, paid in advance, in order that he might be able to afford to return to England. Wartime currency restrictions made it extraordinarily difficult to send money abroad, and the WAAC never paid for works that it could not first inspect, but Clark broke all the rules to accommodate Lewis, and the committee sent half the sum he demanded. Lewis set to work – with many interruptions – at the Anaconda Brass works. A year later he claimed

his painting was completed, and secured the other half of the payment, but no picture materialised. He refused to send it – ignoring the fact that it was now the property of the WAAC – and thoroughly enjoyed teasing Clark and the committee, complaining to T.S. Eliot, Augustus John and anyone who would listen that he was being persecuted by Clark, who was not only an 'art dictator' but representative of all that was most evil in the bureaucratic system exploiting artists like himself. Lewis, who relished enmity, became fixated with Clark: 'I have a natural dislike of being patronised by sleek gentlemen for whom the Fine Arts is a fine lucrative official assignment, and the road up to the social summits for the clever climber.'[31] Clark resigned himself to not receiving the painting: 'I fear that we have been simply swindled,' he scribbled over a letter on the subject. The committee briefly got possession of *A Canadian War Factory* in 1946, but Lewis took it back for further work, and it only entered the Tate after his death in 1957.

It was not only his detractors who tested Clark's patience. In May 1941 John Betjeman wrote from Dublin to tell him about the work of a young woman, 'twenty seven, red haird [sic] and awkward and not cognisant of any modern artists', called Miss Nano Reid. He enthused about her landscapes, and at a time when Clark was still at the MoI with hardly a moment to himself, urged: 'if you could get for me a London gallery ... will you act as agent and let me send the pictures to you? Now for heaven's sake do come over ... Love to Miss Arnold ... Sean O'betjeman.'[32] Clark rashly wrote back: 'Send me over some of Miss Nano Reid's watercolours and I will guarantee to get them exhibited, either at the Redfern or the Leicester Galleries.'[33] Nano Reid was, according to Betjeman, beside herself with excitement, but Clark was less enthused when he saw her watercolours, 'some of which are rather inconclusive' – but for the sake of Betjeman and Anglo–Irish relations he persevered. The exhibition was a predictable failure, and Betjeman pushed his luck further by asking if Clark could send the watercolours back to the artist, whether any had been sold, whether any notices had appeared, and whether the pictures should be transferred to another gallery. The answer was a polite no to everything. When the Redfern Gallery was unable to get a permit to return the pictures to Dublin it dumped them on Clark, who had to call in favours and have them returned via the diplomatic bag, commenting: 'the whole affair has done more harm than good'.[34]

Clark was determined to exhibit the paintings of the WAAC as soon as possible in order to engage the public's interest. They were mostly shown

at the National Gallery, starting from July 1940, but nine smaller exhibi-
tions were also mounted and sent to 140 towns and villages around Britain,
to be displayed wherever possible. Attendance figures were impressive:
five hundred a day in Bath, eight hundred a day in Braintree. Clark and his
committee often conceived the exhibitions along the lines of 'The Battle of
the Workshops', 'The Battle of the Air', 'The Battle of the Seas', etc. Preparing
them was a chance to assess the hoard amassed, and Clark recognised its
weakness in a letter to Frank Pick in 1941: 'all bits and pieces; too many
sketches and not enough major works'.[35] He bemoaned the preponderance
of air-raid-damage subjects, 'which no artist can resist'.[36] The following
year he wrote a thoughtful review of one of his own National Gallery exhi-
bitions, in which he asserted that 'English painting is becoming a great
deal more English ... a certain strangeness, and an almost dreamlike
intensity'.[37] He admired Stanley Spencer's triptych of *Burners in a Clyde
Shipbuilding Yard*, which he thought was the best of the first batch of war
paintings, and observed that the gift of humorous illustration in the tradi-
tion of Gillray and Rowlandson was alive and well in Edward Ardizzone's
genial depictions of 'fat W.A.A.F's, boozy and over-enthusiastic Home
Guards'. Only portrait painting disappointed, with half a cheer for Eric
Kennington, William Dring and Henry Lamb.

The most ambitious undertaking by the WAAC was the sending of an
exhibition of 110 paintings, 'Britain at War', to MoMA in New York in the
spring of 1941. The motivation was political, with the hope in those
pre-Pearl Harbor days that the USA would be stirred into supporting the
British war effort. Clark opened the exhibition from London by radio
broadcast. Harold Nicolson told the story in his diary: 'Before midnight I
am picked up by Kenneth Clark and we go to the BBC ... Jane comes with
us. As usual she looks as smart and neat as a new pin. It is rather a curious
experience. K and I sit opposite each other and have earphones then we
hear that we are linked up to New York and Kenneth starts doing his piece.
He is opening the exhibition of British War Artists in the Museum of
Modern Art in New York.'[38] The exhibition was a huge success with New
Yorkers – three thousand visitors on the opening day alone – and moved
on to Baltimore and then Ottawa. The following year there was even a
suggestion that the War Artists' pictures should be sent to Russia, an idea
that foundered because of transport difficulties, among other problems.

The WAAC scheme continued until the very end of the war. This came
with its terrible revelation: the opening of the German concentration
camps made a macabre set of subjects for Mary Kessell. She arrived at

Bergen-Belsen on 9 August 1945 and stayed there for three weeks, making visits also to Hamburg, Hanover, Kiel, Berlin and Potsdam. As moved by the despairing German population as she was by Belsen itself, she wrote a number of stricken letters to Clark from Berlin: 'No words can describe this place. Every poet & artist & thinker should come and see it – and feel it. This white silence after chaos, so silent – one can hear the crickets singing. And the smell – of thousands dead – and creeping groups with bundles & nothingness for miles – but ruins.'[39]

When the War Artists scheme was finally wound up, it was estimated that the entire project had cost the Treasury £96,000 for six thousand works of art. It had given full-time employment to thirty-six male artists and one female,* and short-term contracts to a hundred others. It had also purchased works submitted by an additional 264 artists, both amateur and professional. The scheme's final act was the distribution of the pieces among museums and galleries around Britain and the Commonwealth. The lion's share went to the Tate and the Imperial War Museum.

What was Clark's final assessment of the WAAC's achievements? He had to admit that no new artists had come forward – except Albert Richards – and he had never expected masterpieces to emerge, but he felt that the results were very satisfactory. Above all, he was pleased that the gulf between artists and the public had been bridged. Quite early in the war he took part in a BBC *Brains Trust* in which he expressed it best: 'Artists before the war … were painting for themselves with subjects the public couldn't understand, they lacked subjects. The war has given the artists a subject, something they feel deeply about. War does not create artists, but it has enabled the best artists to get in touch with a much bigger public.'[40] His hope was that the War Artists collection might form the basis for a fuller artistic appreciation after the war. In this he would be partly disappointed, as once the war was over the public lost its appetite for painting. But the state had shown that patronage of living artists could be an important component of national life, and this would unexpectedly continue through the birth of the Arts Council.

* This was Evelyn Dunbar, who was assigned to the MoI in 1943–44, with the expectation that she would specialise in 'agricultural and women's subjects'.

21

The Home Front

*Before the war Jane and I had seldom been separated from
one another by more than a day or two. Now I was cut off from
her for weeks at a time. Naturally I got into trouble of a kind
which I need neither specify nor describe.*

KENNETH CLARK, *The Other Half*

While Clark was one of the busiest men in London during the war, chairing committees and organising artists, Jane was frustrated at Upton. He would write to her several times a week, and was careful to give the impression that he was having a miserable time. Upton was a very attractive country house, but it involved a lot of work for Jane, who was having to run the household with a much reduced staff, and also found herself responsible for the children for the first time. It is difficult to escape the conclusion that she got very little pleasure from family life. As Clark told his mother, Jane 'is so much more highly strung than she will admit'.[1] When Alan chose his *Desert Island Discs* on BBC Radio 4 in 1995 he described his mother as 'a terrible lip-curler ... she was often very cruel. I didn't have any standard to compare her by until I sat around a cabinet table with Mrs Thatcher and then I saw again a woman being as cruel'.[2] Yet she could change in an instant. When their father was away she could be angelic to the children, especially to Colin, whom she perceived as needing special protection. She had a difficult relationship with Colin's twin, Colette, at whom she often shouted, 'You are a spoilt, stupid, selfish girl and I wish you were dead.' When Clark was at home her screaming was often directed at him until somebody else appeared, when all would be serene and she would be the adoring wife once more. One day at Upton she got into such a rage that Clark took refuge with his mother at Cheltenham. For a man whose most

fervent prayer was for a quiet life, it is remarkable how unsuccessful he was at achieving it. People often wondered why he accepted Jane's behaviour so meekly – it was perhaps a mixture of old-fashioned values, love and guilt.

At the age of eight – as was usual in those days – the children were packed off to prep school at Cheltenham, which was conveniently near Upton.[3] It was also where Clark's mother lived, and whatever her short-comings as a mother she was better suited to the role of grandmother, although as Colette recalled, 'Granny was very Quaker with quite a sharp tongue.' There is no doubt that Granny Martin was the more selfless of the two grandmothers; she offered herself for medical war work before she died in 1944.

After a bomb fell near Granny Clark's house she went to live with the *ménage* at Upton. Here she joined the newly arrived Graham Sutherlands, which led to a running confusion between 'Gran' and 'Gram'. The other long-term war guest was Clark's old Oxford friend Eddie Sackville-West, and these arrivals improved matters for Jane, who had some distraction and help with the organisation of the house. As she told David Crawford, 'Eddie plays us the gramophone and we forget the war for moments. He is the perfect guest and has taken complete charge down here and runs everything for me!'[4] At Christmas 1940 Jane noted in her diary: 'Graham gave K Palmer etching and he gave G Palmer drawing! K gives me lovely agate box and Colette an exquisite necklace of small Italian cameos. Maurice [Bowra] and Eddie are also staying.' But she was to change her mind about Eddie Sackville-West: '[Graham] and Katherine leave us on Friday, tho' they will be back for Xmas … they have lived with us for over a year and we are *very sorry* they are going … Alas I can't say the same of poor Ed – we just don't feel the house is our own any more … E quite intolerable … follows one all over the house even when I am seeing the cook.'[5] The cook, Mrs Nelson, was nothing if not exotic. In her youth she had been on the stage in Paris, and had been a friend of the can-can dancer Jane Avril. With dyed red hair and the remains of beauty, she claimed her daughter had been fathered by the composer Edward Elgar.[6]

A graphic picture of Upton during the Clarks' time there is provided by Clark's sometime collaborator Roger Hinks: 'The house itself is almost grotesquely filled full of pictures: positively encrusted, like the Casino Pio,[7] as K remarked. Apart from the Clark collection, Upton houses distin-guished evacuees like Emerald Cunard's Manets, which she inherited from

George Moore, and a whole troop of Bogey [Harris]'s[8] Sienese primitives, all the way up the bedroom stairs. My bathroom contains a nude by Duncan Grant, a landscape by Tchelitchew, a Henry Moore, and no fewer than three Graham Sutherlands.'[9]

In 1941 the Sutherlands returned to Kent, where they eventually bought the White House at Trottiscliffe, Clark guaranteeing their mortgage. Jane was keen to get more help with the housework at Upton, and wrote to Mrs Massey's Agency at 100 Baker Street to find 'a second Housemaid', pointing out that the area was considered safe.[10] Henry Moore and other friends came down to stay whenever they could. Bobby Longden, now headmaster of Wellington, visited, and afterwards wrote a six-page letter trying to persuade Jane to send Alan, his godson, to Wellington rather than Eton. Bobby was killed shortly afterwards by a stray bomb that fell on the school. This prompted Jane to write to David Crawford: 'I always meant to ask you if you would mind being a deus ex machina if we were both killed? The guardians for the children (there are separate financial trustees!) are Tom Boase and William Walton with Eddie [Sackville-West] as a substitute if anything happened to either of them.'[11]

The composer William Walton had in fact just become Jane's lover. On New Year's Day 1941 she confided to her diary: 'Elizabeth [Arnold – Clark's pre-war secretary] is in love with K and W with me.'[12] While Clark was in London, Walton would come down to Gloucestershire, as Jane's diary reveals: 'Willie and I play marriages with children and Grannie C[lark] … and Willie plays me the Ravel "Daphnis and Chloe" he has just given me.'[13] Clark had managed to get Walton exemption from active service by attaching him to the Crown Film Unit. Walton's affair with Jane was probably a relief to her husband, as it made her less tense, and provided him with room for manoeuvre. One evening when Jane was out with Walton, Clark took Colette to Verdi's opera *Falstaff*. At one point she asked about the meaning of a certain aria. 'Jealousy,' said her father – 'something I do not suffer from in the least.'[14] Colette thought that 'Willy Walton was very good for her as he was so full of Yorkshire common sense and worldliness. My mother would proclaim, "I know about life," to which Papa would retort, "I know nothing about life and I am hoping to get through life without knowing about it."' Jane's affair with Walton continued for a decade, and some even thought they would run off together.* His

* This is unlikely, not least because Lady Wimborne, Walton's other mistress and his patroness, was against such a move.

letters to her are short and passionate, written on letter cards (a sort of folded postcard without a picture), inviting her to come up to London for the day for assignations at the Paddington Hotel: 'I adore you and are [sic] obsessed by you.' There is a pile of them at Saltwood that Jane put in an envelope marked 'J.C. To be burnt unread.'

For holidays the family would go to Portmeirion, which was conveniently close to Manod. This colourful architectural fantasy of an Italian fishing port served them well, and their times there were carefree and happy for the children, who enjoyed bathing and climbing. The family were becoming noisy, as Clark told his mother: 'Family talk is fairly ferocious – sometimes deafening. Being an only child I cannot accustom myself to these boisterous arguments which I am unable to distinguish from real quarrels.'[15] Catriona Anderson, daughter of Clark's Oxford friend Colin, remembered those holidays: 'We went to Portmeirion when I was six or seven. I found K very daunting. He had this way of looking at you expecting you to say something clever. Jane was more human … K had absolutely no small talk. I don't remember him swimming. He was very detached and took my father over to see the Manod Caves.'[16] Clark's relationship with his own children had generally been emotionally distant, but at Portmeirion when Jane was away they began to see a different man. He developed a warm and admiring relationship with Colette, which may have caused further resentment to a jealous Jane. Curiously, the only occasion on which the children ever saw their father lose his temper with their mother was on a visit to Portmeirion. They had a train to catch, and Clark, who was always extremely punctual, became irritated by Jane's tardiness and diva-like behaviour. Finally, to everyone's astonishment – and particularly Jane's – he exploded and told her to come at once. She went like a lamb.

The children were turning into teenagers. After Alan had gone to Eton, Clark reported to his mother, with extraordinary percipience, that 'he has a good head and should do well if he can find any occupation to bring out his qualities. I think he would do well in politics if he weren't – by profound conviction – a fascist. That will never do in this country, tho' the rest of the world may ultimately require it.'[17] Clark never explained why they chose Eton for the boys, but probably his choice, like his father's before him, was negative – in this case that it was *not* his old school, Winchester. Colette was sent to Cheltenham Ladies' College, where she rose to become head girl. After one visit to see her there, Clark confided to John Piper, 'I can't

think why girls who are the age of Shakespeare's heroines are all so hideous.'[18]

Apart from the Lees, the Gloucestershire neighbour they saw the most of was a rich industrialist named Hiram Winterbotham, a bachelor with intellectual tastes who may have fallen in love with Alan (and who later put him on the board of St Thomas's Hospital). Whenever Clark needed to do some serious work, he would borrow Hiram's house and see nobody. But by 1943 things were turning sour in relation to Upton. Apart from the extreme possessiveness of Uncle Arthur, who drove Jane mad when Clark was in London, the owners of the house were sending solicitors' letters about the arrival of evacuees, and were trying to make the Clarks take full responsibility for the damage, wear and tear caused by up to sixty occupants. The house had been requisitioned by the Women's Land Army, and the Clarks' things were bundled into three rooms. They finally gave up the lease, deciding to spend more time in London, where Jane had found interesting war work.

Jane had been invited – probably at her husband's suggestion – to take charge of the decoration of 'British Restaurants', canteens that sprang up during the war in parish halls and other public places to feed a hungry population. She commissioned murals from friends like Duncan Grant, Vanessa Bell and John Piper. Clark lent pictures to the scheme (twenty-two to the East Ham branch alone),[19] and everybody agreed that Jane showed formidable energy and zeal in her organisation. Her other occupation was to run the Churchill Club, for culturally minded American GIs, housed at Ashburnham House, Westminster, to which she persuaded friends like Edith Sitwell and T.S. Eliot to come and speak. Sitwell had become a close friend of the Clarks, and Kenneth was to be a great champion of her poetry and a faithful correspondent.[20] He himself gave a number of lectures at the Churchill Club, including an 'Introduction to Sculpture' and 'Looking at Drawings', but he felt that his effort 'was a failure – not sufficiently up to date. Americans are intelligent about anything on the front page – otherwise ignorant as pigs, and embarrassed at anything dowdy.'[21] T.S. Eliot was more upbeat, writing to Jane: 'The Churchill club creates a new comradeship for the future informed by the Majesty of the past.'[22]

After the loss of their flat in Gray's Inn Square, when in London the Clarks put themselves up at Claridge's Hotel, where they enjoyed making requests to the string quartet that played in the foyer. Social life continued, and hostesses still gave pared-down dinners. Harold Nicolson saw Clark

at dinner with Sibyl Colefax, where he claimed that all she could offer her guests was biscuits and sherry. Clark would attend Edith Sitwell's eccentric lunches at the Sesame Club, at which Dylan Thomas was often a fellow guest.[23] Other sightings of Clark at this time were by James Pope-Hennessy, who called him 'the emu K. Clark',[24] and James Lees-Milne, who described hearing him lecture: 'superhuman learning worn with ease … he makes me feel like a nurserymaid addressed by royalty'.[25] Lees-Milne spent a day with Clark sorting out the pictures at Polesden Lacey in Surrey, and left a vivid portrait of him: 'he impresses me as being extremely intelligent and capable, very ambitious and energetic. He has the missionary drive … of Lloyd George. He dresses like a dapper footman on his half-day off. He is immaculate, spruce and correct in blue topcoat, gloves and blue Homburg hat.'[26]

Of all their friends, the Clarks worried most about the Berensons stranded in Italy. BB's position as a Jew in a country now allied to Germany was profoundly dangerous, and his refusal to leave the country was a matter of courage and love. He did eventually go into hiding, but essentially his faith in his adopted country was justified: by staying out of sight he was left untouched, and so was I Tatti. Clark had hoped that Berenson might come to England, and at the outbreak of war wrote to him: 'So if you can get permission for Nicky to leave I think I can promise to find you a small house where you would be comfortable, and I can guarantee that you will not be put to any inconveniences other than those inseparable from our climate. It would be best of all if we could find a house for you somewhere near our own so you could use our Library, such as it is, and Edith's … You can well imagine that there are a great many German refugees for whom I am partly responsible and so far none of them seems to have suffered the least inconvenience.'[27]

Refugees indeed took up a great deal of Clark's time, and he referred to 'the great new British sport of passing the refugee'.[28] In August 1940, fifteen interned artists, including Kurt Schwitters, wrote to Clark asking if he could help them, and he pleaded their case with a judge and with the minister responsible at the Home Department, Osbert Peake.[29] Helen Roeder of the Artists' Refugee Committee expressed her gratitude on behalf of the refugees: 'You can have no idea what a relief it is to meet someone who can pick up a telephone and suggest leaders to people like the Times. Please go on making them sit up and take notice – they need it.'[30] Clark frequently got involved in the cases of individuals, such as the

Hungarian Michelangelo scholar Johannes Wilde;* Sebastian Isepp, a Viennese Jewish restorer at the National Gallery; and the Austrian painter Oskar Kokoschka, of whom he wrote to the Chief Constable of Cornwall: 'Quite apart from being anti-Nazi, I should think that he is far too dreamy and undependable for the Nazis to use as an agent.'[31]

The Warburg Institute presented a special problem, because most of its staff were German and Austrian refugees. Clark believed that the war was being fought to save institutions like the Warburg. This distinguished body, dedicated to the study of the Classical tradition and its subject-matter as the embodiment of impulses in art and history, had moved to London in 1933–34. Clark was an ardent supporter, comparing their mission to the Benedictine ideal of learning: 'nothing more monastic than their corpus of Platonic studies could be imagined'.[32] Fritz Saxl, the first London director, depended on Samuel Courtauld for financial support and on Clark for the influence he could bring to bear, especially in the early days of the war, when several members of staff were sent to internment camps.[33] Saxl would write to Clark, often on a monthly basis. When the institute came close to relocating to America, he drafted a letter to Clark stating that: 'it is more important than ever that the Institute's work goes on, and goes on in London. Every fool can go to America.'[34] When money was running out in 1943 he turned to Clark once more, and although some of Clark's replies are missing, the continuation of the Warburg in London is due in the first instance to Saxl's determination, and secondly to the support he received from Clark.

After giving up Upton, the Clarks moved briefly to Dorking, Surrey, and then in January 1942 bought the freehold of a pretty, cottagey house in Hampstead, named Capo di Monte, for £6,500. The house was far too small for their needs, and the stairs were too narrow for most of their furniture, which had to be winched up through the first-floor windows. As Jane recorded in her diary: 'Chaos at Capo ... [servants] arrive from Upton with 6 hens, Tor [the dog] and the canaries and are v sniffy about

* Wilde (1891–1970), of the Kunsthistorisches Museum in Vienna, was a Renaissance specialist. His wife was Jewish, which forced his exile from Austria, and he settled in England at the beginning of the war. Clark offered him £5 a week to go to Aberystwyth to help with work on National Gallery catalogues, but was not able to prevent him from being deported to Canada. After the war Wilde became Deputy Director of the Courtauld Institute from 1948 to 1958, and would frequently invite Clark to lecture there.

the house.'[35] Clark wrote to Roger Hinks with the same story: 'Yes, we have practically bought a very small house on the top of Hampstead Heath with the appropriate name of *Capo di Monte*. It is far too small to take a tenth of our pictures, books and objects for which I despair of ever affording a house big enough to accommodate.'[36] At first he adored the house: 'I am more than a little in love with Capo,' he told a friend, and its remoteness gave him an excuse to refuse dinner invitations. A year later, however, they were looking longingly at a Georgian beauty across the road, Upper Terrace House, a large detached house with a spacious garden behind a high wall. In April 1943 Clark had an offer of £20,000 for it turned down, but his next offer was accepted, and this would be their only home for the next decade.*

Upper Terrace was big enough to accommodate Clark's art collection and library, and the garden delighted Jane. The house had been altered by the architect Oliver Hill, 'who did a number of stunts on the interior', particularly with 'a staircase in the Odeon style'.[37] Clark asked Albert Richardson to rectify the worst of them. Unfortunately, the following February a fire broke out while Clark's mother was alone in the house. On his return he found most of his books damaged, while a Dosso Dossi, a Bourdon, a Corot and several other pictures had been destroyed. Jane told David Crawford, 'Till now with no floor it has not been possible to know how many books can be cleaned and rebound and how many are total loss … I fear all the gramophone records are too warped to use. The Samuel Palmer was protected by glass and has survived so has the Constable letter. The Bellini I had taken to A Lee the day before as the raids had been so noisy.'[38] The only irreplaceable loss was a collection of letters from Cyril Connolly dating from Oxford days. We get a glimpse of Clark the shrewd businessman in his negotiations with the insurers. He refused to sign any acceptance form from them until every last piece was agreed, including the door with false books, the cost of renting somewhere else to live (six weeks for the children at Portmeirion at a guinea a day per head), etc. There is no doubt that when he chose, Clark could be a difficult customer. In April 1943, organising a dinner at the Savoy, he wrote beforehand to

* He sold the remaining lease of 30 Portland Place in 1944. See letter from Clark to the estate agents John D. Wood, 4 May 1944: 'I will accept Mr. Lawley's offer of £7,000 subject to the proviso that I have nothing to do with the Howard de Walden Estate, the L.C.C., the War Damage claims or anything else connected with the property which could involve me in trouble or expense.' (Tate 8812/1/1/3451–3500.)

renegotiate the price (mentioning on the way the presence at the occasion of Lady Churchill and several cabinet ministers), and again afterwards about the bullying behaviour of the head waiter, who it seems had been rude to Jane.[39]

Clark continued to maintain a vigorous private life. Although he was a ladies' man, not all women liked him – Mary Crawford, wife of David, for one, thought he was pretentious and irritatingly intellectually superior. His publisher Jock Murray's wife Diana was another who intensely disliked his habit of talking over her head to somebody he regarded as more interesting. Clark always preferred lunching with women, whether or not they were lovers. Berenson well described his position: 'So my kind of person turns to women, surrounds himself with women, appeals to women, not in the first place and perhaps not at all for reasons of sex, no matter how deodorized, alembicated and transubstantiated, but for the one deciding reason that women … are more receptive, more appreciative and consequently more stimulating.'[40] Clark would have agreed with every word. He favoured the Étoile, and later Wheeler's fish restaurant, where he might take Vivien Leigh (who was not a lover) or Margaret Douglas Home, who worked in the publications department at the gallery (and may have been). Sometimes he would have lunch at one of his clubs, typically the Travellers', from where he would write to his girlfriends, asking them to use the address as a safe place to send letters without Jane intercepting them.

By now Clark had fallen seriously in love. Early in the war, in answer to an enquiry seeking a deserving artist to receive some materials, he suggested: 'most of the impoverished young artists I know have been called up, but there is a young woman of considerable talent who, I think, would be glad of the paints and canvases. She is named Miss Mary Kessell, 12 Queen Street, Bath, and comes to London periodically.'[41] The following year he was describing her work as 'most original, full of grace, vitality and dramatic invention'.[42] She and Clark fell deeply in love. Colette, to whom Mary was to become a surrogate mother, told the author: 'Col and I adored Mary Kessell, an artist *par excellence*, warm, wore exotic, fantastic clothes, smocks, with ribbons in her hair. She had two houses, one in the little square beneath Upper Terrace which Papa had bought her.[43] She frequently came to Upper Terrace. Col and I once went to see Mary on Downshire Hill and Papa's car was outside but we still went in. She was absolutely enchanting.'[44] The relationship was tender, but full of reverberations. An early letter from Mary, addressed to the National Gallery and marked

'Personal', sets the tone: 'Try & see me if you can – I am feeling so utterly alone this week end … I want to see you very much. Your Mary.'[45]

The following year she was still yearning for more of Clark's time: 'If I am very important in your life – try to make me feel it again. Make me feel that you will sometimes avoid plans – for my sake – or if it's going to be too difficult – or if anything else is more worth while than I am to you – tell me now. I don't know what has happened – but something surely has which has made me feel my whole existence is a farce – and unworthwhile. Your life has fitted in with mine as an artist – I am an artist by your love – that's the best way I can put it – I love you dearly – & I can't go on – until I feel my foot on a rock again. Your Mary.'[46] We do not have his replies, but when they did spend time together she could write with joy: 'What a most perfect unforgettable evening. Quite one of the most lovely we have ever had. There is no one else in the world for me. You know, when I put my arms around you – I feel whole … God means us for one another.'[47]

Of all Clark's lady friends, Myfanwy Piper was the most intelligent, wise and level-headed. She too complained of how little time they were able to spend together: 'for years I have suffered from not seeing enough of you at a time and now it grows worse but I think of our – must I call it associ-ation, there seems to be no other word, with nothing but delight. Never let any of our arrangements become a burden to you my dear.'[48] She would come up for the day from Henley and have lunch with Clark, and he would unburden his woes upon her. In all probability, theirs remained an *amitié amoureuse*. The Clarks would enjoy going to stay with the Pipers at Fawley Bottom, as he told his mother: 'managed to go down to the Pipers for the day … it was heavenly down there. I love them, I am always perfectly happy in their company.'[49] John Piper does not appear to have been jealous of the friendship – he was more irritated by Clark's assertion of artistic omnipotence, and enjoyed being mildly facetious about him behind his back. When Clark felt depressed it was to Myfanwy that he turned: 'it is really tragic that you are so much depressed. Much as I would like to think my dear that it is your fault for not being sterner and rougher I'm coming to the conclusion that you really are an angel … I think your only hope is to force yourself to be less vulnerable – it is against your nature I know to be indifferent – even to a goldfish … You know how much I believed, not only in your critical powers but in your creative powers, which are the ones that will be suffocated if you can't develop the artist's armoury of egotism … I love you more and more my dearest. K. May you be happy Myfanwy.'[50]

22

The Best for the Most

*A little island of civilisation surrounded by burning churches –
that was how the arts seemed in England during the war.*

STEPHEN SPENDER, *World Within World* (1951)

When James Lees-Milne referred to Clark's 'sense of mission' he was artic-
ulating his Ruskinian desire to touch people's lives with the power of art.
The enormous success of the War Artists' Advisory Committee was at the
heart of this, and the National Gallery kept the flame of a populist high
culture burning throughout the war. The credit was largely given to Clark.
'Just how much culture would we have had without Sir Kenneth Clark?'
asked Cyril Connolly in *Horizon*.[1] But there were other arrows in Clark's
quiver which would be aimed towards the future. Increasingly he thought
about Britain after the war, and how art and design could improve people's
lives. He was not Utopian about this, and rejected giving a lecture for
UNESCO of 'the marching-together-towards-a-better-land variety'.[2] He
believed in the inspiration that art gives to the individual soul, and that
access to good art is what matters. Central to this was a socialist viewpoint
and the idea that the state could, with some reservations, support the arts.
He had no doubts about his own role in this future.

When the critic Eric Newton interviewed Clark about patronage and
the state, he was optimistic about the idea, depending on the ability of the
individuals allowed to choose the art, and provided they were left alone,
without interference. He added with jocular smugness: 'The Government
make a good choice of their individuals because they have chosen me!'[3]
He believed that major private patronage of artists was over, and correctly
predicted that the post-war world, at least in Britain, would be one of
specialist collectors. In this chapter we shall see some of the initiatives in
which Clark was involved, and some of the influences that shaped his

thinking. It tells of the transformation from 'Clark the dictator' to the man everybody wanted on their committee. In 1940 he still believed that the only useful committees consisted of one person of decided views and a lot of 'yes-men'. The war modified that view, for this era (and its aftermath) was a period in which the committee took on an almost mystical importance. Clark's strong belief in public service meant that he rarely refused to serve.

The limits of Clark's populism were evident in a 1941 letter to *The Times* under the heading 'The Eclipse of the Highbrow', in which he took issue with a leader that had drawn attention to the fact that many of the most talented writers and painters have been appreciated by only a few people. This provoked a number of letters, including one from the poet Stephen Spender claiming to speak for the 'middle-brows'. Clark responded: 'Sir – The whoops of joy which accompany the hunting of the highbrow have distracted many of your correspondents from the purpose of my original letter … I am pleased that the responsibility for understanding works of art, and interpreting them to the average man, must rest with a small minority. In the end a few great works may win popular approval, though not always popular understanding (not many people understand Dante, for example), but in most cases this approval has been made possible by the penetration and faith of a few people who have recognized an artist's merit in spite of the unfamiliarity of his style.'[4] This received a cheer from E.M. Forster in his essay 'Art for Art's Sake', in which he said: 'Sir Kenneth Clark, who was at that time director of our National Gallery, commented on this pernicious doctrine in a letter which cannot be too often quoted. "The poet and the artist," wrote Clark, "are important precisely because they are not average men: because in sensibility, intelligence, and power of invention they far exceed the average."'[5]

Despite a difficult relationship with the BBC while he was at the MoI, Clark had continuous access to the airwaves. A notebook at the Tate lists around twenty wartime broadcasts on subjects as diverse as 'The English Weather', 'John Ruskin' and 'Films and Evacuation of National Collections'. He advised the BBC on a series of twelve talks under the title *Art and the Public*, with contributions from Eric Newton and his old Royal Academy adversary Gerald Kelly. Clark excelled in discussion programmes, and was invited to appear on the most prestigious of all radio programmes at the time, *Any Questions?*, subsequently renamed *The Brains Trust*. This was an unexpectedly successful wartime innovation in which five panellists (three permanent and two irregular) answered questions sent in by

the public on philosophy, art and science. Audiences reached up to ten million. Clark joined as an irregular member in 1941, and was accurately described by the host, Donald McCullough, as one of the most efficient links between the state effort and the artistic mind in the country. The permanent members were Professor C.E.M. Joad, Julian Huxley and (in Clark's view) a 'genial imposter' called Commander A.B. Campbell, whose presence Clark initially thought was a stroke of genius, though he later changed his mind and tried to have him dropped.* Clark was paid twenty guineas a performance, and made what was considered to be 'a brilliant first appearance'.[6] The programmes became Clark's workshop for ideas as to how the arts could be used to improve national life. He made one particular personal revelation: that his favourite picture in the National Gallery was Piero's *Nativity*. One young listener was Michael Gill, the future producer of *Civilisation*. He was dazzled by the intellectual energy and the wit, 'but I did not like Clark … youthfully I judged him a cold, self-satisfied man'.[7]

Perhaps Clark's most intriguing broadcast with the BBC was a radio play. *Gestapo in England* – reported in the *Radio Times* as being 'from a story by Sir Kenneth Clark and Graham Greene' – was aired at 9.35 p.m. on 7 August 1942. The play was set in a public school to which a London secondary school has been evacuated, in which class differences, evident at first, melt away under a common purpose. It was written to demonstrate 'what might happen here if Germany won the war', but no script or recording has surfaced. Clark in his memoirs records that in his MoI days Graham Greene wrote an excellent film script about 'the Gestapo in England', and we must assume that this was an adaptation.† In May 1942 Clark accepted an invitation from Roy Plomley to choose his *Desert Island Discs*, but then changed his mind on account of a wartime clause that would not allow the broadcast of any words in Italian or German: 'an imbecile regulation' (precluding most opera), as he wrote in protest to Harold Nicolson.[8] He was never to do the programme, even after the

* 'It seems rather paradoxical that one member of a body that should be devoted to the spreading of light gives his whole time to the bolstering of superstition'. Draft letter to Harold Nicolson, 23 April 1942 (Tate 8812/1/1/30).

† Clark and Greene were not close friends; the only letter in the Clark Archive from Greene is c.1950, when the novelist and his wife were taking a holiday on the Isle of Wight and wanted to see the Winterhalter portraits at Osborne House. Could Clark help? Unfortunately not (Tate 8812/1/2/2601–2651).

success of *Civilisation*. Whatever his failings, bearing grudges was not one of them, so it seems likely that it was Plomley who decided never to ask him again.

The most lasting of all wartime arts initiatives was the formation of the Council for the Encouragement of Music and the Arts (CEMA), the embryonic Arts Council. It is important to remember that before the war England had no state opera or theatre, no subsidised orchestras, and no government expenditure on living artists. During the war the state began to undertake patronage of the performing arts, thanks to a vision and a telephone call.[9] The vision was that of Lord De La Warr, the president of the Board of Education, who had what Clark described as 'Venetian visions of a post-war Lord Mayor's show on the Thames in which the Board of Education led the Arts in triumph from Whitehall to Greenwich in magnificent barges and gondolas: orchestras, madrigal singers, Shakespeare from the Old Vic, ballet from Sadler's Wells, shining canvases from the Royal Academy, folk dancers from village greens – in fact Merrie England'.[10] As a foretaste of the end result, this was – the Royal Academy apart – not far from the mark. The telephone call was to the chairman of the Pilgrim Trust,* Lord Macmillan, who also happened to be Minister of Information, asking for £5,000 to realise the idea. Was he interested? He was indeed, but for his own reasons. For Macmillan, this was the answer to a minister's prayer – a way of employing actors, musicians and singers as national troubadours to entertain weary Britons and prop up national morale, for which he felt responsible. 'Supply and demand kissed,' as Clark put it. He attended the first meeting, held at the MoI, at which the idea was lifted from the banks of the Thames to fall like a golden rain of good intentions over the whole country. The budget rose to £25,000, which the Treasury then matched, and matters developed rapidly.

A board was set up, dominated initially by two remarkable Welshmen, Dr Thomas Jones and W.E. (Bill) Williams; the latter – whose day job was with Penguin Books – was to play a significant part in Clark's life. Williams had run the 'Arts for the People' scheme for the British Institute of Adult Education, which had sent small exhibitions into villages and towns. Clark had been closely involved in the scheme and its offshoots – he introduced

* The Pilgrim Trust was the gift of Edward Harkness, an American millionaire who in 1930 gave £2 million to help preserve 'the Britishness of Britain, land, architecture, artefacts and society'.

one of the exhibitions with the arresting phrase: 'One of the chief obstacles to a more widespread appreciation of art is the idea that art is cissy, and that the artist is a kind of Pekinese dog.'[11]

The conundrum that concerned CEMA in its early days was 'Raise or spread?' – the tension between local need and metropolitan excellence.* Clark stood for the latter, but Thomas Jones said, 'I am making it a condition that they play and sing in the dreary Dagenhams of the country.'[12] The economist Maynard Keynes succeeded Lord Macmillan as chairman of CEMA in 1942, just at the moment when the Pilgrim Trust's initial grant came to an end, and it was he, with his knowledge of how to operate the levers of Whitehall, who persuaded the Treasury to continue the burden beyond the war. By 1944, Clark believed that the Labour Party might win the next general election, and considered inviting two senior Labour politicians, Ernest Bevin and Herbert Morrison, to dinner in order to secure state support for the arts.[13] In Maynard Keynes, Clark had an ally for excellence – 'he was not the man for wandering minstrels and amateur theatricals' – but he thought that Keynes used his brilliance too unsparingly: 'he never dimmed his headlights'.[14] It was Ivor Brown, the *Observer* drama critic, who when he joined CEMA's board coined the slogan 'The best for the most', which papered over the professional-versus-amateur argument.

The historian of the Arts Council has commented that 'If Keynes was to create the machine of the Arts Council, Kenneth Clark was its grease … the primal committee man of the war. It was he who translated the practices and retrieved the opinions of one committee after another.'[15] Clark was unusual in his range of interests, capable of offering informed views on theatre and music, but his main role was to chair the distinguished Arts Panel, which included Samuel Courtauld, Duncan Grant, Henry Moore, John Rothenstein – and, conspicuously, no Royal Academicians. When Keynes died in 1946, Clark expected to succeed him as chairman, and was disappointed not to be offered the post. It went instead to a sound City man, Sir Ernest Pooley, who had no interest in the arts but was not going to rock the boat. Pooley's refrain was, 'I am not such a fool as I look, you know.' He did one thing that Clark certainly thought was foolish – sacking the admirable secretary of the Arts Council, Mary Glasgow. Clark, feeling

* The 1941 CEMA report states that in two years its art exhibitions attracted more than half a million visitors, the plays performed under its auspices were seen by a million and a half people, and a staggering eight thousand concerts were put on. It was the first time there had been a mass audience for drama, music and song in Britain.

the need for a change, resigned from chairing the Arts Panel, but was to return as chairman of the whole organisation in 1953.

If exhibitions were the principal means of disseminating art during the war, thanks to the genius of Allen Lane, publishing was not far behind. The WAAC had given the publishing rights of War Artists to the Oxford University Press, no doubt for reasons of prestige. Pre-war art books were large, luxury items, but Lane, the founder of Penguin Books, had a vision of doing for modern British artists what the company already did for authors, by providing inexpensive and widely available editions of their works. He and Bill Williams turned to Clark to suggest an editor, and Clark responded: 'I was very much excited by your proposal of doing Penguin monographs on painters, and I could not help thinking how I would enjoy editing the series myself.' He pointed out how busy he was, and that his name was a red rag to a bull in some quarters of the art world.[16] Lane, however, was not going to give up the chance of the Clark name, and delegated most of the work to a competent young editor, Eunice Frost. She would chivvy the authors, negotiate with the painters, deal with the owners of the paintings, and generally steer the books into print. Lane offered Clark £50 for each new title commissioned, which Clark protested was too much, given that most of the work was done by Miss Frost.

The first in the highly successful series to be published was Geoffrey Grigson on Henry Moore in 1944, and this was followed by eighteen more books over the next fifteen years, including Raymond Mortimer on Duncan Grant, Herbert Read on Paul Nash, and Edward Sackville-West on Graham Sutherland. Print runs were as high as forty thousand. Myfanwy Piper suggested Betjeman to write about her husband John, and Clark asked her to write about Frances Hodgkins – 'She is delighted to be regarded as authoress by the noble Lord,' John Piper mischievously told Betjeman. Clark argued with Herbert Read about the inclusion of Ben Nicholson; he gave way, but told that volume's author Jim Ede, 'I must warn you that I cannot have a preponderance of white squares and circles among the illus-trations, as I cannot understand them.'[17] He was against the inclusion of two foreigners, Klee and Braque, which he finally used as an excuse to withdraw from his role: 'the old scheme seemed to me valuable because it helped people to understand painters whose work they could buy'. However, he thought the experience had been a good one, and when he resigned in 1946 he told Lane that it had done 'a great service to modern painting'. Interestingly, when Nikolaus Pevsner proposed the scholarly Pelican

History of Art series, Clark thought it a mistake, telling Bill Williams, 'We are departing from our chosen function of cheap accessibility.'[18]

Clark's interest in post-war design led him to join the nascent Council of Industrial Design in 1944 and to chair its Design Committee. The Council, which aimed 'to promote by all practicable means the improvement of design in the products of British industry',[19] was established by the Board of Trade to increase exports, and had both a commercial and an aesthetic purpose. It promoted the kind of simple modernistic design that Clark later described – not entirely flatteringly – in his ATV programme *What is Good Taste?* (see page 283). Clark was only a half-believer. On 12 January 1945 he attended the Council's inaugural meeting, at which he hoped it might be able to influence the designs of the new pound note and the new firemen's helmets. He even wrote to the chairman of BOAC about the fitting out of planes.

In 1946 the Council put on an exhibition at the V&A, 'Britain Can Make It', which the wags dubbed 'Britain Can't Make It!'. The members of the selection committee were only too aware of the conflict between themselves, the metropolitan elite, and the northern manufacturers, a tension not dissimilar to that Clark would encounter at the Arts Council. When he resigned from chairing the Design Committee he enclosed a quote from Ruskin: 'Efforts having origin only in the hope of enriching ourselves by the sales of our productions are assuredly condemned to dishonourable failure ... because that peculiar art-skill can never be developed with a view to profit. The right fulfilment of national power in art depends always on the direction of its aim by the experience of ages.'[20] The meaning is that good taste and design will not be advanced exclusively by the profit motive, a discouraging message for those he left behind at the Council. Clark also instinctively fought against a pure, clean and functional view of modern design, and insisted that art must also include invention, mystery and passion.*

In 1942 Clark had gone on behalf of the British Council to lecture in Sweden, and was impressed by the country in several ways. There was a strong political component to the visit, which it was hoped would help to

* See 'Art & Democracy', manuscript published in 1945 in *Cornhill Magazine*, July issue (Tate 8812/2/2/42). See also a 1949 lecture on 'Taste' (author's collection): 'But functionalist propaganda has been so specious and relentless that the doctrine of salvation through exclusion is still to be found in the persuasive leaflets of the Council of Industrial Design and similar bodies.'

keep the neutral Swedes out of the Nazi embrace. On his return Clark told the press that Britain's greatest assets in Sweden were the Prime Minister, whose photo seemed to adorn every home, and the RAF. He generally found the country pro-British, but subject to German propaganda. He would enthuse on *The Brains Trust* about the Swedes' high standard of living and design, and told one correspondent that 'in working conditions, housing and everything of that sort they are far superior to any other part of Europe. But the people are growing almost uneasy at having solved their material problems so well', and were wondering 'how to satisfy the needs of the spirit'.[21] He was sufficiently inspired to outline a Ruskinian tract entitled 'To Hell with Materialism', which would have addressed the balance between material comfort and the satisfaction of the spirit.[22]

In fact Clark's tour of Sweden had been very difficult. At first his transport could not be organised, so his departure was delayed by two weeks. When he finally arrived he found that the British Council had mislaid his slides, and he therefore had to rewrite his lectures according to what was available from the National Museum in Stockholm – which, as the lecture was about British art, was very limiting. He had a punishing schedule of sixteen lectures, travelling, cocktail parties and large dinners accompanied by interminable speeches. A British Embassy report on the visit concluded: 'The lecture tour was unquestionably a very great success in spite of the delays … Sir Kenneth has an imperturbable temperament which enabled him to meet all these mishaps unruffled, and the kind of iron constitution which is necessary to carry through such a programme … it has been reported from Uppsala that there is quite a Kenneth Clark craze as if he had been a popular film star.' The writer reported that Crown Prince Gustaf Adolf invited Clark to lunch, and personally conducted him around the royal palace for two hours. They also spent a whole day driving out to see old churches together: 'At a time when the royal family is very careful not to associate publicly with foreigners such hospitality is so exceptional as to be worth recording.'[23] Clark was to return to Sweden in 1944 and deepen his friendship with the Crown Prince, who was also a friend of Berenson.

After the liberation of Paris in 1944, Clark visited the city with John Rothenstein, the Tate director, under the misapprehension that there would be rich pickings. They believed that American art dealers were scooping up bargains, but in fact the art market was booming, and nothing was cheap. They flew in a bomber in October, and Rothenstein described how 'In the pellucid air, silent at midday, just freed, Paris was a

spectacle to linger long in memory.' Lacking transport and a working tele-
phone, they trudged the length and breadth of the city on a fruitless quest
for art. Clark visited his friend Georges Salles, now head of the Louvre, but
the highlight of the trip was a meeting with Picasso at the apartment of the
artist's patron and friend Madame Cuttoli, where Clark showed Picasso a
book on Henry Moore: 'He sat for the rest of the meal, turning the pages
like an old monkey that had got hold of a tin he can't open.'[24] The following
day Clark paid a visit to Picasso's studio, and described the successive
layers of people to be negotiated before arriving at the large upstairs studio,
furnished only with two green park benches. Clark was never an unequiv-
ocal admirer of Picasso, and saw some of 'the worst landscapes I have ever
seen', but also some beautiful drawings of Cupid and Psyche. The original
purpose of the trip, to acquire art, was a failure, and the only thing Clark
brought back to London was a wodge of notepaper from the Hôtel de
Crillon bearing the insignia of the German High Command, which he
thought would amuse his children to use for writing letters to their friends.
On his return to London he wrote a review of the Paris art scene for the
New Statesman in which – Picasso apart – he described the soil as tempo-
rarily exhausted, with nothing much coming up.[25]

'The end came suddenly,' was how Clark remembered the close of the war.
As soon as peace was declared he brought the National Gallery's pictures
back from Wales and filled three undamaged rooms. The King and Queen
came to reopen the gallery, and Louis MacNeice wrote his poem 'The
National Gallery' about the paintings' return:

> Aye; the Kings are back from their caves in the Welsh hills,
> Refreshed by darkness, armed with colour, sleight-of-hand and
> imponderables,
> Armed with Uccello's lances, with beer-mugs, dragons' tongues, peacocks'
> eyes, bangles and spangles and flounces and frills.

Clark had already decided that he was not the man to put the gallery back
on its feet after the war, and resigned his position. The National Gallery
had had 'a good war' – damaged but not irreparable, it had kept the flame
of high culture alight under difficult conditions. Clark had also had a good
war, and had more than recovered from his weakened position *vis à vis* the
staff and the 'Giorgione' controversy. He thought it was the right moment
to leave, telling the editor of the *Spectator*: 'I have resigned from the

Gallery in order to read, ruminate and occasionally write.'[26] He wanted to concentrate on writing books and lecturing. He was also worn out by the hostility from the art world. Myfanwy Piper wrote to him: 'My paper tells me that you have resigned from the N.G. I look for a great flowering my dear and pray hard that you may have the strength of mind to be a little selfish.'[27] Berenson, by now back at I Tatti, wrote: 'Rumours reach me that you already have resigned the N.G. I congratulate you. You will now be able to devote yourself to tasks more worthy of your gifts and I look forward to the results.'[28] Clark gave a final wireless broadcast, on the return of the paintings from Wales; this appears to have been particularly successful, with many strangers writing to express their appreciation.

Clark had one last task to undertake for the gallery, which was to go to Portugal and try to secure the Gulbenkian collection. Gulbenkian invited the whole family out to Lisbon, a welcome holiday away from war-torn Britain, and requested that they bring with them four boxes of Shredded Wheat breakfast cereal, which was difficult to obtain in Lisbon. Colette recalled: 'We arrived at the Aviz Hotel and very unusually Mr G was in the hall to greet us which was a great honour. He was like a little owl. We loved this holiday as we had good food and fruit which we had been denied for so long and Portugal was full of colour and Mediterranean life, from which we had been so starved.'[29] But as far as Gulbenkian was concerned, the National Gallery had become a less attractive option for the future of his collection, as he had a deep sense of injustice about the way he had been treated by Britain during the war. If Clark had stayed at the gallery it is possible that this might have tipped the balance – but unlikely, given the tax problems of leaving Gulbenkian's estate in Britain. As it happened, Clark's successor, Philip Hendy, was not sympathetic to Gulbenkian's constant enquiries about whether his 'children' were being properly cared for, when he had more pressing problems of reinstating the gallery. Gulbenkian wrote a melancholy letter to Clark: 'It strikes me that Mr Hendy is not very keen about my pictures in the Gallery. As you know I am very sensitive and I may be all wrong. If I am not, it will sooner or later be very unpleasant, and I shall therefore have to consider what other steps I ought to take so that my dear "children" should in no way remain in sufferance.'[30] Clark would continue to act for Gulbenkian after he left Trafalgar Square, and made several trips to Portugal; these served to convince him that Lisbon was a better location for the collection, where it would always be the main attraction.

* * *

At the same time that Clark resigned from the gallery, he also gave up his post at Windsor. During the war he had appointed Ben Nicolson as his deputy, but the King and Queen were not impressed by Nicolson's shambolic manner. Clark therefore pressed the claims of a sharper candidate, 'Major Blunt', as Anthony Blunt was then described. Owen Morshead told Clark, 'I like A. Blunt. He's the goods.'[31] The Royal Collection had thrown up one last surprise. Clark was astonished to read one day in *The Times* about an exhibition of the King's pictures to be held at the Royal Academy. The Lord Chamberlain was also in the dark, and asked Clark for an explanation. He replied that he suspected – correctly – that the Academy had gone behind their backs to the Treasurer of the Royal Household. It was a traditional right of the Royal Academy to approach the King through this route, but Clark thought the situation 'improper and highly discourteous.'[32] He was furious, and rightly concluded that the Academy wished to run the exhibition without the intervention of any art historians or court officials, although – as he told Eric Maclagan at the V&A – 'they find their members are both too lazy and too ignorant to do so, and they are waiting to find a way out of this difficulty'.[33] As it happened, the resulting exhibition (staged while Buckingham Palace was being redecorated) was a huge success, especially with the King. Morshead wrote to Clark: 'You likey Exhibition? It's almost the first time I've ever known my Employer pleased – for He is ever more prone to carp than praise.'[34]

Clark attended his last trustees' meeting at the National Gallery on 13 December 1945, and a generous minute records regret at his departure, gratitude and appreciation for his services and skills, and wishes him 'good fortune wherever his path may lead'. John Pope-Hennessy was one of the many who wrote to him: 'May I say how really sorry I am that you are leaving the Gallery? Everyone who is interested in pictures owes an immense debt to your work there, and I can imagine no successor whose record over a comparable period will prove to have been at once so progressive and so sound.'[35]

Most commentators agree that Clark was a brilliant wartime director, but his peacetime record – despite great achievements and additions to the gallery – has always been overshadowed by the 'Giorgione' episode and his difficulties with the staff. Views on his directorship will always be coloured by views on the man. When he asked himself whether he had been a good director he answered, 'Not very, but better than my predecessors in this century.'[36] But for many, Owen Morshead summed up the feeling at the time: 'a deepfelt sigh at your departure from the National Gallery. I can

hardly bear to contemplate it, my very dear friend ... CUJUS DULCIS
MEMORIA IN HIS LOCIS SPIRAT ET HABITAT* if that makes sense. It is
very true in sentiment, dear K. You have made those bones live for count-
less thousands of people, who feel the pulse of a living organism the
moment they enter the premises – whether for music or pictures.'[37] Clark
had strongly supported the appointment of Hendy as his successor, but
soon became disillusioned, first over Gulbenkian and then by differences
over cleaning pictures.

Clark meant to concentrate on his writing, but would that be enough for
him? Mary Glasgow of the Arts Council later wrote a memoir in which she
left the most perceptive assessment of Clark at this time: 'He always
seemed to me to be two people, each fighting the other. He is intellectually
a giant, with a well-stocked mind and administrative powers to match. He
ought to have taken a leading part in the affairs of the country at large, let
alone the cultural ones. Yet whenever he has approached the centre of
things, as when, early in the war, he went to the Ministry of Information,
he has shied away, saying to himself something like, "All this is dust and
ashes; I must devote myself to things of the mind." Then he would retire,
to think, write and contemplate; until the pendulum swung back and he
would say; "What am I doing in a vacuum? I must go back into the arena."
I think he has suffered all his life from not being himself a creative artist,
knowing so much while never producing original work or painting or
sculpture.'[38] After Clark said goodbye to the National Gallery to concen-
trate on writing, the tension between the *vita activa* and the *vita contem-
plativa* was to become ever more evident over the next forty years.

There was one last terrible shock for Clark at the end of the war – the
dropping of the atom bomb on Hiroshima 'filled me with despair about
the future of mankind from which I have never wholly recovered.'[39] He
realised that this was the end of humanist science, and it imbued him with
the pessimism, as well as the horror of machines and computers as instru-
ments of power, that were to make themselves felt in *Civilisation*.

* 'Whose sweet memory breathes and dwells on in this space'.

23

Writing and Lecturing

*For some unknown reason my mind worked better from
1945 to 1955 than it had ever done before.*

KENNETH CLARK, *The Other Half*[1]

Clark had given up a high-profile position, but during the next decade he
was never to be out of the limelight. With his appointment as Slade
Professor of Fine Art at Oxford, and the publication of two of his finest
books, *Landscape Into Art* and *Piero della Francesca*, this was to be one of
the most productive periods of his life. Moreover, during this time he
established himself as the country's most sought-after lecturer. As the art
historian Hugh Honour put it: 'One can't think of the 1940s and 50s with-
out him. He made people think that you could write about art without
being pedantic.'[2] Clark himself did not interpret this as a shift away from
the public sphere; rather he saw lecturing as a renunciation of scholarship,
telling one critic, 'I only changed from scholarship to lecturing in 1946,
when I was made Slade Professor.'[3] He could never understand how,
whereas literary criticism could attract a wide general readership – he
used to cite Robert Gittings on Keats – no equivalent existed for books on
art: he would assert that art historians only published their books to
impress each other.

Clark was not alone in his Oxford generation to address himself to a
broader public, a path also followed by John Betjeman and Cyril Connolly.
John Rothenstein witnessed the change in Clark's outlook: 'Scholarship for
scholarship's sake – did he not once compare it to knitting – has held
diminishing attraction, while his urge to share his knowledge and experi-
ence with a very wide public has correspondingly increased.'[4] Rothenstein
attributed this to the influence of Ruskin, which is undoubtedly accurate,
but there were other factors at play. The war years had shown that a

broader public could be made receptive to art, and Clark had come to enjoy his power to open people's eyes. The July 1945 general election had delivered the socialist government that he had hoped for, and a new educative enthusiasm was now sweeping the country. This was a period of relative stability and calm in his own life; as Colette put it: 'At Upper Terrace he was at his happiest and most fun. He was released from the National Gallery and Mama was still sane.'[5]

However, post-war British socialism turned out to have its limitations, as Clark observed to Berenson: 'It seems incredible that anyone can exist except in service of the state – like Tang China, or business in America. This makes it all the more necessary to fight a rearguard action on behalf of the individual.'[6] Having himself just left the comfortable umbrella of the state – he had never had to pay for his own office and secretary before – Clark was now anxious about his income, and in 1945 he became involved in talks with a building firm, Prebuilt Constructions Ltd, about a possible directorship, to promote the design possibilities of a new material called 'Plimmer'. For Clark, the main attraction was an office at 44a Dover Street in which he could store books and receive visitors in the West End.* Given that Clark was still advising him on works of art, he suggested that Gulbenkian might pay for a secretary, but was firmly rebuffed, 'as it may create complications for both of us.'[7] However, his financial anxieties were soon resolved. He was called to his mother's deathbed in Cheltenham, where he was surprised to find himself so moved: 'She spoke to me with a love and understanding she had never shown before. What mysterious inhibition had prevented her from talking to me like this before?'[8] In addition, Alice Clark left her son her remaining shares in Coats, worth some £66,316.

The Slade Professorship at Oxford which Clark held for three years, from 1946 to 1948, was probably the most rewarding position he ever occupied. He was lecturing in apostolic succession to the founder of the series, John Ruskin, whose declared mission had been so much Clark's own: 'To make our English youth care somewhat for the arts.' Accordingly, Clark's opening lecture was entitled 'The First Slade Professor: Ruskin in Oxford' – a difficult subject, and a considerable act of *pietas*, since by the time Ruskin assumed this role he had in fact begun to lose his powers.[9] The Slade Professorship gave Clark licence to develop whatever subjects

* By 1948 the firm needed the office space, and Clark felt he had not done enough for them, so he repaid £300 for two years of back rent.

took his fancy, and the resulting lectures were to become the bedrock of nearly all his subsequent art historical essays; indeed, the first year was dominated by a series of lectures on landscape painting that he later reconfigured into one of his finest books, *Landscape Into Art*.

At that time the University of Oxford did not teach art history, and Clark's Slade Lectures, which were open to all, created intense excitement. With their growing popularity his audience swelled from twenty-five to five hundred, necessitating a move from the Taylorian Institution, and eventually bringing him to lecture at the Oxford Playhouse, the public theatre opposite the Ashmolean Museum. The historian Hugh Trevor-Roper observed that Clark had made art lectures in Oxford fashionable with the *beau monde*; certainly Jane's hats were a special attraction of their own. Clark established a routine of always taking her with him and delivering the lecture on a Monday at 5 p.m., then staying overnight with Maurice Bowra at Wadham. The following day he might go to the Ashmolean to show drawings to pupils (having first asked the keeper to put out the relevant works), or he might be found at his old college, Trinity, which lent him a room in which to see students. He later said: 'I never thought of myself as a teacher. The Slade Professorship was exactly right for me going down once a week.'[10] It gave him the perfect degree of engagement, and just as importantly, disengagement.

His second series of lectures, in 1947–48, dealt with the Renaissance, and included 'Brunelleschi', 'Donatello', 'Masaccio', 'Alberti and Uccello', 'Piero della Francesca' and 'Mantegna'. The third year he moved on to 'Raphael', 'The Young Michelangelo' and 'The End of Humanism'. In the Michaelmas term of 1948 he explored Rembrandt (whom he pronounced 'Rumbrundt'), and he believed these lectures to be his finest: Berenson had always maintained that Rembrandt was the artist Clark understood best. He then started to explore the dance between Classicism and Romanticism that culminated in the work of Ingres and Delacroix, a subject he was to revisit for his television essays later published under the title *The Romantic Rebellion* (1973). The last series was given to Leonardo and to Venetian art; he finished it with 'Art and Photography'* and, unusually for the Slade, a lecture about a living artist, 'Henry Moore'. Some lectures did not quite

* Clark enjoyed talking about photography, and gave the Centenary Lecture to the Royal Photographic Society, entitled "The Relations of Photography and Painting', in which he posed the question, 'Is photography an art?' His answer was: 'Yes but an incomplete one. It is to a large extent a purveyor of raw material.'

come off: 'Error in Art' was a not particularly successful attempt at explaining aesthetics and why certain works of art fail. Nor would Clark have claimed to be providing fresh scholarship, although he took the trouble to keep abreast of new developments – 'They will mean that I can overcome the first difficulty of teaching, which is to start one step ahead of one's pupils';[11] for instance, he requested proofs of Oskar Fischel's new book on Raphael. His audiences were so delighted with everything they heard that few noticed his lack of sympathy for the Northern Renaissance, or the eighteenth century, 'that winter of the imagination'.

There was certainly a magic in Clark's lecturing; everybody testified to his eloquence and urbanity. The Warburg director Gertrud Bing called him 'the Toscanini of the *diapositives*', and Stephen Spender told Clark that the 'lucidity and certainty with which you speak gives one a sense of the greatness of the art'.[12] He was never theatrical, but knew when to bring the audience into the freemasonry of the profession – for instance, drawing people's attention to the only area in Giorgione's *Castelfranco Madonna* that has never been repainted. But the point of the lectures had been, as Clark put it, to open windows for the students. One young attendee who – largely in response – started writing about art was the historian of the Renaissance John Hale.[13] Another young member of his audience was John Hayes, who went on to become director of the National Portrait Gallery, and dedicated his book on Graham Sutherland to Clark, who 'when Slade Professor at Oxford first made me aware of the history of art'.

When Clark was asked to suggest his successor as Slade Professor he made the imaginative proposal of John Betjeman – but only for a year: 'He soon gets tired of a job and then is apt to exploit a vein of paradox which has made him popular but would appeal disastrously to undergraduates.'[14] After Tom Boase, who was on the Slade committee, vetoed the idea, Clark advocated the architectural historian John Summerson, who had to wait eight years to be appointed.

The main legacy of the Slade Lectures was the publication of *Landscape Into Art* by John Murray in 1949, and thenceforth the firm, under Clark's good friend Jock Murray, was to remain his principal publisher. Jock was the quintessential 'gentleman publisher', operating from his august premises in Albemarle Street with their famous Byron room and relics. An immensely likeable man whom Clark once described as 'sepia toned like the subject of a Fox Talbot photograph', Jock's priorities were literary and commercial in equal measure; although he was not really an art publisher at all, he served Clark well for the rest of his life. Clark found the Slade

Lectures unusually difficult to turn into a book, and Jock would anxiously enquire for news of the typescript, adding, 'I hope that a slave-driver can keep the friendship of his victim.' Rosalys Torr of the Courtauld assisted Clark with the collection of images, an onerous task as every photograph and slide had to be sourced, requested and paid for individually. The greatest problem, however, was the title of the book. Nobody liked Clark's suggestion of *Landscape Into Art*, and no fewer than sixteen variations were considered. Jane favoured a long title in the eighteenth-century style – 'An Inquiry into the Principles of Landscape Painting'. Colin Anderson advised Clark to stick to his guns: 'I'm rather inclined towards "risking" your title because it is attached to your name. I wouldn't advise it for an unknown.'[15] The American co-publishers, however, refused it, calling it a 'trick' title, and using *Landscape Painting* instead. Clark always maintained that this was why the book sold over thirty thousand copies in the UK and only three hundred in the US.[16] He invited Graham Sutherland to design the cover. The cost made Murray anxious, as it entailed five printings, but – as Clark put it – 'It will certainly be the most striking wrapper of the year.' He dedicated the book to Maurice Bowra.

Traditionally, books on landscape painting had been strictly organised by either school or chronology, but *Landscape Into Art* offered a different and original approach that struck a happy balance between the two. Clark arranged his subject thematically across the centuries: 'The Landscape of Facts', 'Landscape of Fantasy', 'Ideal Landscape', 'The Natural Vision', 'The Northern Lights' and 'The Return to Order'. He covered artists from van Eyck to Cézanne, showing how 'in spite of Classical traditions and the unanimous opposition of theorists, landscape painting became an independent art'. It was a book in the best English literary tradition of art history, but was also informed by Clark's wide reading and interest in German art history, a synthesis that was a peculiar Clark invention (and that would be repeated with even more interesting results in *The Nude*). John Walker, writing in the *Burlington Magazine*, described Clark as belonging 'among the analytical and interpretive critics who have been the glory of art history from Sir Joshua Reynolds to Roger Fry. Theirs is a different tradition from that which has determined the metaphysical approach of the Germans, or the rhetorical style of the Italians, or the epigrammatic incantations so popular in France, or the sociological studies of the Marxists, or the fashionable allegories of the iconographers. Their approach is empirical ... and motivated by love of the actual works of art.'[17] However, *Landscape Into Art* did not convince everybody. James

Lees-Milne recorded that John Pope-Hennessy was condescending about the book, 'which while admitting the excellent style, he thinks twists facts to bear out the author's preconceived theories on the progression of the subject throughout the ages'.[18] Foreign art historians felt that it grossly underestimated German artists such as Caspar David Friedrich, and considered it too English in its bias. Clark writes with a special frisson about Constable and Turner, and even the French artist Nicolas Poussin is aligned with the English poet John Milton – Clark found in both 'the same early delight in pagan richness … the same strenuous and didactic middle period, and the same old age of renunciation and remoteness, giving a new depth of poetic vision'.[19]

Landscape Into Art ended on a curious note, which Clark would later revisit in the final episode of *Civilisation* – the faint optimism of a pessimist who has been profoundly depressed by the horrors of recent history: 'As an old-fashioned individualist I believe that all the science and bureaucracy in the world, all the atom bombs and concentration camps, will not entirely destroy the human spirit; and the spirit will always succeed in giving itself a visible shape.'[20] The adverb is the killer.

Punctilious readers sent in about two dozen minor corrections, mostly spelling mistakes, because as Clark confessed to Murray (and as all his secretaries were surprised to discover), 'the trouble is that I cannot spell in any language'.[21] The most wounding criticism came from Clive Bell, who took Clark to task for admiring Turner; but most readers agreed with Berenson that the book was a delight. It has remained in print ever since, and is still read by specialists and non-specialists alike.

Clark had never been in such high demand as a lecturer, and although he tried to satisfy the requests from Bangor to Hull, he had to turn most of them down. Some lectures, such as the story of the Warburg Institute, he gave over the radio.[22] In London his lectures attracted grand ladies, as John Pope-Hennessy observed: 'When he talked at the Royal Institution on Alberti or Piero della Francesca, a line of smartly dressed ladies would be found walking up Albemarle Street, and inside the lecture theatre voices were lowered as Emerald Cunard and Sibyl Colefax and Hannah Gubbay were shown to their seats in the front row.'[23] Turner became a more frequent subject, and Clark's theme was always the same: that Ruskin and the Victorians had wrongly preferred the early work, and it is in the later paintings that Turner speaks most directly to us. He conceded, however, that Turner could be very bad, and once said: 'a piece cut out of one of his

academic pictures framed in a maple veneer and hung in a county hotel would, I am sure, pass unnoticed by any member of this audience'.[24] He also once told Ernst Gombrich that the English 'are such a literary people that the best way of persuading them to take an interest in a picture is to find that it has its origins in a poem'.[25] One of the most original and admired lectures he ever delivered was the 1954 Romanes Lecture in Oxford, 'Moments of Vision', which identified moments of intensified physical perception in art as in poetry.* It demonstrated his ability to entwine art and literature, although he himself was not sure whether it would come off, telling a friend beforehand that the lecture 'remains dubious – not at all my best, but I think I shall squeeze through, on account of the quotations'.[26] The lecture brought together Blake, Newman, Yeats, Wordsworth, Rembrandt, Coleridge and Ruskin.†

In 1951 Clark published *Piero della Francesca*. It was one of his few books that did not start out as a series of lectures, and from a literary point of view he believed it to be his finest. He certainly found it his most satisfying. It opens with an explanation as to why Piero became so talismanic to the twentieth century: 'his rediscovery is part of the new classicism of which Cézanne and Seurat were the living manifestations'. Roger Fry had turned Piero into a proto-Modernist, and he had been celebrated by major literary figures such as Aldous Huxley and T.S. Eliot; although there was 'a brilliant but eccentric masterpiece' on him in Italian by Roberto Longhi, there was very little in English.[27] Clark's book was commissioned by Dr Bela Horovitz, the founder of the Phaidon Press. He contacted Clark, who had written a highly critical review of a book that Phaidon had published, inviting him to show how it should be done. Horovitz, whom Clark called the Duveen of publishing, had never heard of Piero, but agreed to Clark's terms to rephotograph the frescoes in Arezzo. *Piero della Francesca* was not intended to be a full scholarly monograph, but a guide to the appreciation of Piero's work. Clark was fully aware of its limitations – as he told

* Later published in an elegant limited edition by John Murray (1973), with wood engravings by Reynolds Stone and printed in his typeface 'Janet'. The title is taken from Thomas Hardy.

† Cambridge was not neglected: in 1949 Clark delivered the Henry Sidgwick Memorial Lecture there, 'The Limits of Classicism', examining the tension of Classical and sensuous creativity. This talk contained a Clarkian gem: 'The classicists of the eighteenth century made their sums come out by looking up their answers at the end. Seurat and Matisse have made them come out by sheer hard work and a true intellectual process.' (Henry Sidgwick Memorial Lecture, 7 May 1949, reprinted in *Cambridge Review*.)

Horovitz, 'a proper learned work would have to be twice as long, and include many questions of authenticity which are not discussed'.[28] He had also not spent enough time researching in Florence, and by one of those terrible coincidences that happen not infrequently to those who write books, it emerged that a Professor Salmi of Florence University was also planning a book on the artist, based on the documentation in Florentine archives. Clark was discomfited about his rival, and turned to Colette one day: 'Can you believe it? No book on Piero for ages and suddenly two books coming out in the same week.' His fears were groundless, as Salmi never published his monograph on Piero.[29]

Clark's *Piero della Francesca* has been described as 'an extended version of a Fry lecture', and indeed Roger Fry's book *Giovanni Bellini* (1899) is a plausible model.[30] If Fry's formalism was his starting point, Clark also demonstrated a deep engagement with the subject-matter, and as he told Carel Weight: 'I think it is nice and solid, and I am prepared to throw it at the head of anyone in the Warburg Institute who says I am a dilettante.'[31] The book, dedicated to Henry Moore, was well received. However, given the complexity of Piero scholarship (for example, the difficulty of inter-preting the three foreground figures in Piero's *The Flagellation of Christ*), it was never going to find easy agreement among scholars. The most pene-trating review was in the *Burlington Magazine* by Ernst Gombrich, who raised questions on the grounds of iconography and chronology.[32] He enjoyed the passages of beautiful writing, which he thought 'might well find their way into anthologies of poetic prose', and compared the endeav-our to Pater's work on Giorgione. But he took serious issue with Clark for seeing pagan as well as Christian elements in Piero, and in an intellectual somersault even provided a Jungian framework through which, by collec-tive memory, this might be plausible – only to reject it. To those unfamiliar with such complexities, the book was much admired. Maurice Bowra told Clark: 'I tried to delude myself by saying that it must be much easier to write about pictures than about poetry, that [it is] just because you have mastered the subject and sunk yourself in it that you produce it all easily and clearly for us.'[33]

Clark planned a number of books that were never written. He toyed with the idea of a study of English art, but decided that there was not enough scholarly groundwork already in place. He signed up to write *The Art and Architecture of the Quattrocento* for the Pelican History of Art series edited by Nikolaus Pevsner and published by Allen Lane, but after nine months' work confessed that he was ill-suited to the task, and begged

to be let off.[34] Also with Allen Lane he planned an anthology of the writings of Ruskin, which he hoped would interest a new generation; but the project was postponed, and instead he wrote an Introduction to Ruskin's autobiography, *Praeterita*, for Rupert Hart-Davis. Clark always maintained that for anybody embarking on reading Ruskin, *Praeterita* was the best place to start, and many younger people would have echoed Edith Sitwell, who wrote in thanks for her copy: 'I, for one, owe Ruskin entirely to you.' There is an undated letter (circa 1948) to Jock Murray in the Clark Archive with a list of four proposed books of essays, mostly worked-up lectures (a well-known form of literary suicide, as Clark well knew): 'Studies in the Renaissance', 'Studies in English Art', 'Studies in Aesthetics', 'Literary Studies' – and a postscript, 'perhaps also a long book on the Nude'.[35] This was the germ of what was to become his most important book.

One of the constant puzzles about Clark's life was how he accommodated the sheer number of requests for help that he received. It is no wonder that he began to dread the postman, for he was besieged with letters (often at great length, with attached photographs) seeking advice on jobs, careers, selling pictures, creating art, buying art, writing novels about art, restoration, courses about art history, etc. All received courteous replies, although occasionally a note of exasperation creeps in: 'So perhaps the only advice I can give you is to compare the work of Orpen, de Laszlo and [Frank] Salisbury with that of Titian, Velasquez and Gainsborough and if after some time you cannot see any great difference between them, there is really no more to be done.'[36] Sometimes the writers are surprising: in 1952 he received an unsolicited letter from a young Henry Kissinger, then editor of the first issue of *Confluence*, a Harvard University magazine, inviting Clark's views and contributions. It received this response: 'I started to read it with considerable scepticism because it deals with the sort of abstract topics which usually promote nothing but hot air, but your writers are prepared to face the facts.' But Clark concludes: 'I have no ideas worth printing.'[37] However, when the subject in hand appealed to him, he might write a long scholarly review for a journal such as the *Burlington Magazine*. Anita Brookner remembered Clark 'with affection … because unlike many scholars he disdained adversarial positions'.[38] He would shrink from writing a bad review, as he told the editor of the *Burlington* when declining to review a new edition of Longhi's *Piero della Francesca*, because 'I am ashamed to say I cannot be bothered in involving myself in a row.'[39] When the literary editor of the *Sunday Times* asked him to review Arnold

Hauser's Marxist *Social History of Art*, Clark wrote back: 'Reading it is like correcting a vast number of examination papers by conscientious students. You must send it to somebody with an appetite for estimable half truths; he should not be hard to find.'[40]

Committees took up most of Clark's week. He once turned down an invitation to join an exhibition selection committee with the words, 'I consider it most unfortunate that one individual should hold so many responsible positions.'[41] But more often than not his sense of obligation got the better of him. It was not ambition, as he explained to Berenson: 'We lead a quiet and happy life, Jane gardening, I writing my Oxford lectures, which continue to draw large crowds. We have become socially lazy – partly because in these times and in this socialist country entertaining of any kind involves very hard work: and partly because we are like a satisfied power.'[42] But iron discipline in his approach to work, fear of boredom, strong self-belief, and above all a sense of public duty, led him to continue to accept new positions. These included the British Committee on the Preservation and Restitution of Works of Art, the Governing Council of Bath Academy of Art, the Home House Trust (i.e. the Courtauld), the Council for the Festival of Britain, and the Royal Fine Art Commission, which offered advice on the design of bridges, new buildings, memorials and town planning. Clark took them all very seriously, and was never going to be a silent presence. In 1948 he joined the Council for the Festival of Britain, but the meetings were so often cancelled that he wrote a strong letter to the chairman, General Lord Ismay, deeply concerned that decisions were being taken without the committee's knowledge for which its members would be held responsible, and expressing the grave doubts about the organisation of the Festival that were being voiced by sensible people.[43]

More rewarding was Clark's involvement with the Henry Moore exhibition at the Musée de l'Art Moderne in Paris in 1949. Like many Englishmen he regarded France as the benchmark of cultural standards – when on one occasion he was invited to say what defined good English artists he responded, 'Let us say painters whose work one could show to an intelligent Frenchman without any sense of embarrassment.' The opportunity to show Henry Moore provided such a chance, but things had gone badly during the setting-up of the exhibition. The sculptures were awkwardly arranged, and Clark found the artist dejected. Kenneth Clark was certainly the only Englishman who could override the organisers, pick up the telephone and request an *équipe* from the Louvre to help him rearrange the exhibition. Georges Salles sent a team round within the hour,

and Clark reported to Berenson: 'We are here for the opening of our friend Henry Moore's official exhibition. The French are a good deal disturbed by the thought of an English sculptor achieving such eminence, and were not all wholly co-operative. This gave me the pleasure of exercising my old metier and arranging the show with my own hands.'[44] Moore for one believed that Clark had saved the day.

It is perhaps at this point worth giving a brief review of Clark's ambivalent attitude towards contemporary architecture. He always said that there were two questions he most dreaded being asked: recommending a portrait painter or an architect, because he had never found a satisfactory answer to either. Post-war planning forced him to think about the subject of architecture in a more practical way, but – as he told one correspondent who sought his opinion on new buildings for Oxford in 1949 – 'Personally I am an architectural Blimp. I do not like functionalism on principle, and I particularly dislike it in Oxford … I have grown to have a very gloomy view of architecture in this country.'[45] A decade earlier he had offered Giles Gilbert Scott's Battersea Power Station as his favourite modern building in London.[46] He also admired Scott's Liverpool Cathedral, but considered Basil Spence's celebrated Coventry Cathedral to be 'reasonable, contented, mediocre, in a second rate and democratic new world'.[47] Clark sat on the Royal Fine Art Commission, where as he ruefully said all they did was tell architects to remove ornament, because, to his way of thinking, after 'the debauches of the nineteenth century our architects have such indigestion that they are condemned to a diet of Ryvita and Vichy water'.[48] He found the Commission a confusing body, uncertain 'whether it ought to be maintaining high standards of taste or making the best of the inevitable bad job'.[49] He did in fact admire the work of some contemporary 1940s architects: Maxwell Fry, Charles Holden and Edwin Lutyens in the UK, Frank Lloyd Wright in the US, Alvar Aalto in Finland, Nils Einar Eriksson in Sweden (specifically his concert hall in Gothenburg). He even admired Le Corbusier's flats in Paris.* But when London's Festival Hall was

* See letter to John Killick, 7 April 1943 (Tate 8812/1/1/24). But two days later Clark wrote to Miss M.E. Lloyd: 'Unfortunately, I disagree with almost all your views. I detest straight lines and right-angles as much as did Baudelaire and Blake. I believe that abstractions are cruel and wicked things which imprison the spirit of man; and as for Corbusier with his homage to Louis XIV – words fail me. However, I find it stimulating to read anything with which I am so violently in disagreement' (9 April 1943, Tate 8812/1/1/27).

completed in 1951 he likened it to 'a cheap radio set'.[50] During the 1960s Clark would still be struggling to keep an open mind about Modernism in his television programmes with the architectural critic Reyner Banham, although his heart was with Betjeman, who was by now badgering him for an honour for the church architect and Gothic Revivalist Ninian Comper. Clark's interest steadily shifted towards conservation, and although he would never have the high profile of Betjeman in that field, he saw it as vital to protect what was left of Britain's cities after the ravages of both the Luftwaffe and post-war planning.

24

Upper Terrace

*This house represents a desperate rear-guard action.
Under the influence of the prevailing moral ideas England
has had to destroy one of the most perfect of all English
works of art, the great house.*

KENNETH CLARK in *Art et Style* magazine (April 1947)[1]

Clark was immensely proud of Upper Terrace House, and it was some-
thing of an achievement to make it so comfortable in war-torn London
when builders and materials were hard to find. Life in Hampstead,
however, was wonderfully insulated, and it is difficult to find much
evidence of post-war austerity in the lives of the Clark family. Clark once
introduced a book on art collectors with the recollection: 'I remember that
in the threadbare, unheated, half-starved atmosphere of post-war England,
a visit to the Wallace Collection was better than a hot bath.'[2]

Social life gradually resumed its pre-war rhythm, and dinner parties
were once again arranged. James Lees-Milne was a guest: 'To dine with the
Kenneth Clarks. Admirable hosts … Talked a lot with Jane Clark who is
very easy. Her husband's gracious manner – I don't think he cares for men
one bit – frightens me. Yet he arouses my fervent admiration. He is a sort
of Jupiter in intellect.'[3] Lees-Milne pondered this dichotomy, and
concluded that Clark 'lacked the fine human instincts that make people
sociable and beloved'.[4] Cynthia Jebb, a society hostess, had a similar
complaint about the Clarks: 'They are a strange pair, and there is some-
thing curiously inhuman and unreal about them'[5] – but she thought that
Clark became a much nicer person without Jane. Post-war London lacked
the cosmopolitan ease of the Sassoon era, and the Clarks found themselves
curiously placed socially – too intellectual for café society, and too rich for
most intellectuals. Typical of the intellectuals was Alan Bowness, who

lived five minutes away in Hampstead: 'Everybody knew the gossip – she drinks, he has mistresses.'[6] And yet to young visitors Upper Terrace House presented a dazzling and attractive family, overflowing with energy, against a backdrop of great beauty. Clark was always especially kind to young people, even if they found him remote.

Lord Crawford's son Robin was a frequent visitor to Upper Terrace, and remembered: 'Everyone was called Larry, Vivien or Margot, although I had no idea who they all were. The house was beautiful in itself, and I was struck by the vitality of the household … K would take me down to the pub at Holly Hill in Hampstead.'[7] Although nearly all visitors found Jane easier than her husband, most young friends of the children became aware of her fearsome temper. Caryl Hubbard, a friend of Colette's who became an art dealer and occasional researcher for Clark, found the household 'extremely talkative, they laughed and interrupted each other, full of interesting and amusing family banter'.[8] The children were growing up, and everybody could see that Colette had an easy, direct relationship with her father, whereas her twin Colin was frightened of him.* All the children went to Oxford (Colette winning a scholarship), but Colin had done National Service in the RAF beforehand, and found it hard to settle. Jane fretted about him, writing anxiously but inaccurately to John Sparrow, 'he has no real friends at Oxford – only riff raff'.[9] Clark, no doubt badgered by Jane, went down to see Col, and revealed the rather conventional ambition for him that if he got a second in his finals, the family firm, Coats, would take him on. In the event he went to work for Laurence Olivier – the result may be seen in the film *My Week with Marilyn*.[10] As for Alan, his father described him to Berenson as 'though in some ways the least sympathetic member of the family he is also the ablest, parents included'.[11]

Jane's charm was as potent as ever, but all her relationships were imbued with drama. Everybody was an ally or an enemy. She became emotionally involved not only with people in distress, but with everyone she met – from her grand guests to the restaurant coat girl. The exception was her brother Kenneth's large boisterous family, who would arrive from New Zealand, filling the house with cries of 'Aunt Betty!' which set her teeth on edge.†

* There is an undated letter from Clark to Myfanwy Piper describing hers as 'the only writing I am glad to see (except Alan's & Celly's)'. He never had much time for Colin (Tate 200410/1/1793).

† Her daughter-in-law, Alan's wife Jane, remembers a similar scene at Saltwood when Clark asked with a mischievous grin, 'Would Aunt Betty like some more tea?'

Jane was never strong, and she began to have mysterious illnesses. She underwent a major operation in 1951 that Colette believed 'was probably to do with the womb. She never stopped having operations but their reason was never explained or discussed.'[12] Clark confessed to the Berensons: 'She has not been well, and I am a good deal worried about her – she has grown into a sort of tragic figure without in fact being associated with any tragedy – a sort of Muse without a role. Still, I suppose it is sufficiently tragic to feel ill and nervous three quarters of the time.'[13] Despite this, Jane still attracted admirers – in particular, René Massigli, the French Ambassador, a correct, mustachioed figure whom Clark described as 'a perfect type of Frenchman, intelligent and warm-hearted'. One of Alan's Oxford girlfriends, Ethne Rudd, recalled arriving at Upper Terrace House, opening a door, and 'there was Lady Clark in a passionate embrace with M. Massigli'. Jane told Ethne, 'You go and wash your hands,' while the Ambassador pretended not to speak English.[14] Henry Moore remained a stout friend and admirer of Jane, but nobody has ever been certain whether or not they had an affair.

Each day a hire service provided a car to wait outside Upper Terrace which would be available all day to take Jane to her hairdresser in Dover Street or her husband to his meetings. Jane issued 'Lady Clark at Home' cards for Mondays from 5.30 to 7 during May, June and July. She was always an elegant hostess, as Betjeman observed, thanking her for a dinner: 'My most vivid recollection … is of you on those Oliver Hill stairs with that Tartan shawl over the black dress, the black sleeves showing, the watered grey silk flowing out, your black head and huge Irish eyes. It was really a lovely picture.'[15] When Colette had her nineteenth birthday in 1951, her parents put up a tent in the enormous garden and gave a dance which Jane described to Colin Anderson: 'I think it was a success – we were lucky in the weather … new friends were made, i.e. the Duchess of Kent danced with Lucian Freud.'* The other great events at Upper Terrace were the fashion shows after Jane became the president of the Society of London Fashion Designers, a great compliment to her energy and chic. These attracted visits from the Queen Mother and Princess Margaret. Jane always had a tendency to be star-struck: a letter she wrote to Colin Anderson from a family holiday at Aldeburgh breezily refers to Henry Moore, Graham Sutherland, Frederick Ashton, Sidney Nolan, Ninette de

* Postcard from Jane to Colin Anderson, 8 July 1951 (private collection). The Clarks supported Lucian Freud from their Art Fund, bought his early work and gave him a bank guarantee for £500 in 1951.

Valois, Benjamin Britten, E.M. Forster, and only at the end mentions the twins.[16]

To Clark it was always the artists who were most welcome at Upper Terrace. When Barnett Freedman had been ill, Clark suggested that he come and sit in the garden on a bank holiday, and even offered to arrange a car to collect him. The sceptical Hampstead locals enjoyed musing over Clark's largesse to artists. Geoffrey Grigson tells the story of the typographer Oliver Simon attempting at a dinner party to discover Clark's real preference between two of his artist friends: 'Would Clark talk more about Pipers or about Sutherlands? Which wife, Piper's or Sutherland's, would be the more frequently mentioned? Before the Hampstead evening began Oliver filled a trouser pocket with pebbles from his garden path. Every time John's pictures and John's wife were mentioned by Clark, Oliver transferred a pebble to one coat pocket, every time Clark's talk was of Sutherland's pictures and Sutherland's wife a pebble was transferred to the other coat pocket; after which only a count was necessary to settle the preferences and stoke the jealousy.'[17]

Most people agreed that the setting and art collection of Upper Terrace House were perfect. Colin pointed out that 'in matters of taste my parents were surprisingly old-fashioned. Their houses were decorated in the style of the Ashmolean museum in Oxford.'[18] There is some truth to this, and the house contained one or two examples of almost every kind of artefact from all periods from the Egyptians onwards, with an unusual preponderance of sculpture. Clark always said that his collection represented a compromise between taste and opportunity. He owned far more pictures than he could possibly hang, and enjoyed moving things round. An article in the French magazine *Art et Style* provides a useful snapshot of the collection as it was arranged in 1947. The hall set the pace, with Degas's *Woman Washing* over a Renaissance chest. The library featured one of the Samuel Palmers and Bellini's *Madonna and Child*. The drawing room, furnished with Sheraton satinwood furniture, contained 'the tutelary goddess of the house', Renoir's *Baigneuse Blonde*, together with Cézanne's *Château Noir* and Seurat's *Le Bec du Hoc*. Other photographs show Renaissance ceramics and bronzes, drawings by Turner, Gainsborough and Tiepolo, and a miniature of Valerio Belli by Raphael. It was an epicurean collection formed for pleasure, an I Tatti with Impressionist paintings.

Clark shifted things about and hung them according to visual compatibility: 'there must be some bond of sentiment or of form or colour'. There

were a few antiquarian elements, including the extraordinary group of 150 medieval miniatures from the collection of James Dennistoun that Clark had first seen at Auckland Castle.[19] He had a taste for artists' copies, and acquired some curiosities: Cézanne copying Delacroix, Degas copying Cariani, and Duncan Grant after Zurbarán. He owned a genuine Zurbarán, a beautiful still life, *Cup of Water and a Rose*, that hung in an archway of the drawing room beside a figure study by William Etty. There were some exotic juxtapositions: the enormous seventeenth-century provincial Saltonstall family portrait was flanked by two giant porcelain pagodas made for the Brighton Pavilion. Clark also had eight drawings by Constable, part of a large group of mostly English and Italian Old Master drawings. One, which he bought at the Oppenheimer sale, he hoped was by Michelangelo, and Johannes Wilde almost accepted it, but today it is believed to be by a follower.[20] After the spectacular French paintings, it was the contemporary works by Moore and Sutherland that made the most impact on visitors. Clark once told a correspondent that 'the merits of our collection are rather like those of the best English films: the supporting cast is about as good as the stars, and it did not cost much to make'.[21]

The Clarks enjoyed sharing their collection, whether with visitors to Upper Terrace or through loans to exhibitions. Students from the Central School of Art and the Coal Board Art Circle were typical of the groups he showed around the house. The loans, however, got completely out of hand. Throughout the 1940s at any one time there were anything up to 150 works away; they became impossible to track, and damage inevitably occurred. The Henry Moore drawings and shelter sketchbook were particularly sought-after. Jane explained their motivation for lending: 'Kenneth never refuses to lend pictures by living artists if the artist wishes them to be shown.'[22]

But by the end of the decade the Clarks were forced to have a card printed, explaining that over the past few years they had made over a thousand loans, and could not lend any more. They made a generous gift instead of works by living artists to the Contemporary Art Society. This was the body for which Clark had bought the Henry Moore *Recumbent Figure* before the war. Alan Bowness thought that 'the CAS might not have survived World War II had it not been for the presence of the young and energetic Kenneth Clark'.[23] In 1946 the Clarks invited Denis Matthews of the CAS, along with Sir Edward Marsh and Sir Jasper Ridley, to come to Upper Terrace House to make the selection from pictures brought up from the cellars. The gift, made without any conditions, initially consisted of

seventy-five works by thirty-four artists, with important groups by Grant, Kessell, Piper and Sutherland.[24] They were distributed to over thirty regional galleries in Britain, and also, interestingly, to Australia and South Africa. This donation was supplemented by another smaller gift in 1951. To Clark's annoyance it later turned out that few of these pictures could be traced.

By the 1950s, the collection had reached its peak. There would be only one major addition after this, a late Turner seascape,[25] but several depletions through sales. The Marlborough Gallery was circling, and frequently approached Clark to lend his Seurat *Le Bec du Hoc* and the Renoir. It persuaded him to sell the Seurat for £15,000. This was stopped for export, and eventually went to the Tate in 1952. The Turner, sometimes called *Folkestone*, would remain with Clark for the rest of his life, and became his favourite. It perfectly demonstrates all that he liked in the artist's late style.

One underestimated part of Clark's collection was the library. He had been a book collector since Winchester, and enjoyed nothing more than browsing in second-hand bookshops. In 1937 he became a member of the Roxburghe Club, the world's premier bibliophile club. In time-honoured fashion, he invited the members to Hampstead to inspect his library, which was strong in sixteenth- and seventeenth-century Italian books and French eighteenth-century illustrated volumes.* Some of these reflected his professional interest in Alberti and Leonardo, but others – like the *Bizzarie* of Giovanbatista Braccelli (1624) – were unusual curiosities. He was to leave about a hundred of his most important books to the Morgan Library in New York, on the grounds that most cultural benefactions tended to be from America to Britain, and he wished to redress the balance.†

During the 1940s and 1950s Clark's private life became very complex, as the world of Golly and his adoring ladies became a reality. The most tragic story was that of Mary Kessell, whose hopes were always to be dashed: 'I had so hoped, that when the Peace came – you'd ring me up – & somehow include me in whatever you were doing. It's a lonely time anyway – & we met through the war ... I am a sort of back door person coming to see the children – or have a drink before dinner ... I am never coming inside your

* Clark planned to present the club with an edition of Turner's Paris sketchbook that he owned, but he never finished writing the Introduction.

† He toyed with leaving the more valuable books to Winchester, but changed his mind.

house again – either to see you – or the children … unless you can change all this. This I do mean.'[26] Clark visited her as often as he could, and an uneasy truce was reached with Jane. He provided Mary with an introduction to Berenson when she was visiting Florence, which was an enormous success. Clark had made his own joyful return to I Tatti in 1947, writing afterwards to BB: 'Our visit to I Tatti was one of the great experiences of my life and I cannot tell you how moving it was to find you so well and so calm in the midst of that hortus conclusus of civilization. We shall never forget the kindness and affection with which you received us. It was particularly good of you to give up a morning … and to pour out your wisdom to us in such abundance.'[27] Mary's visit came three years later, and not for the last time BB fell for one of Clark's girlfriends (the actress Irene Worth was another). He was enchanted by her: 'I greatly enjoyed Mary Kessell. Such candour, naturalness and intelligence all combined, and so much warmth. How I wish she was living here!'[28]

Mary was invited back to I Tatti on several occasions, on one of which Clark happened to visit at the same time, and Jane found out. Clark always swore that this was a coincidence – which may well have been true – but for Jane it was the last straw. For the first and only time in her life she seriously threatened to leave him, unless he stopped seeing Mary. Clark was forced to sit down and write to Mary. His letter is missing, but not her reply: 'Words can never tell you how terrible your news was to me. Well you know from my letters how unhappy I have been feeling & this is the last bitter blow – but I do understand … If I have made [Jane] sad I am sorry … I shall always love you … dear lover that was, write to me and keep in touch with me as my patron I beg of you. & tell me where to write to you sometimes. This will be the last time I shall speak of my love: but all the best I can do is yours.'[29] Her subsequent life was not a happy one – her heart was broken – and she became an alcoholic. As Clark once ruefully observed, 'All the ladies I love take to the bottle.' When Mary died in 1977 her last words were, 'Will I see K in the next?'[30]

Clark had in fact been trying to disengage from Mary after she became briefly engaged to the bibliographer Theodore Besterman in the late 1940s. At the beginning of 1949 he had met another artist whose quiet still life and landscape paintings he greatly admired. Mary Potter was a very private person, highly intelligent and a famously good listener, who in 1951 went to live at Aldeburgh, where her life would eventually entwine (after her divorce) with those of Benjamin Britten and Peter Pears. Clark made the first move: 'It is terribly difficult, in middle age, to make new

friends, but I should like to go on trying. So if I may I shall ring you up …
next week and hope that we can arrange a meal together. Yours sincerely
K. Clark.'[31] Their friendship blossomed, and a year later Clark would write:
'Darling Mary, you are, without exception, the most loveable human being
I have ever met. You are the perfect friend, and I am eternally, and unde-
servedly fortunate in that you let me call you that. Much, much love, K.'[32]
Mary Potter was to be a stalwart and uncomplicated friend to Clark for the
rest of his life.

Clark had a neglected child's yearning for love that would never be
satisfied, however many women loved him. Sex seems not to have been the
main motivation: he enjoyed writing to his girlfriends and basking in their
admiration. When Colin asked him about one lady friend he responded,
'Don't like her – too lecherous.'[33] Perhaps there was also a subconscious
search for his childhood governess Lam and the uncritical love she showed
him.* John Piper shrewdly observed that Clark used women to protect
himself from women. Certainly Jane felt a greater safety in numbers. Fram
Dinshaw has observed that Clark's girlfriends were divided between grand
society ladies, with whom his liaisons were flirtatious, and artistic women
with whom he had affairs. In the first category were Joan Drogheda,
Morna Anderson, Princess Kathleen Schwarzenberg,† and later Jayne
Wrightsman.

Morna Anderson, the wife of his Oxford friend Colin, and the Clarks'
neighbour in Hampstead, is something of a mystery, as her letters do not
survive. But Clark's letters to her are among the most unbuttoned that he
ever wrote. Morna knew about Mary Kessell, and understood Clark's
anguish on that point. Just before he embarked on a trip he saw Morna,
and brooded about their encounter: 'Never in my life has a short meeting
produced such a bomb-shell – indeed I think I would have come to believe
that it was a dream, if you hadn't also written your letter – which I carry
everywhere to give me strength. I cannot tell you what you have done for
me. The relief of knowing that there was somebody who understood and
sympathised is so great that I feel completely transformed. Of course I
can't believe, quite, all that you said – and yet I have such faith in your
judgement that I know there must be something in it. My dear, I am eter-
nally grateful to you for the courage and for the affection which prompted

* To Clark's great sorrow, Lam died in 1954.

† Wife of the Austrian Ambassador to London, Prince Johannes Schwarzenberg. Evelyn
Waugh in his *Diaries* describes her as 'very elegant' and her husband as a 'pipsqueak'.

it. And since lids have come off, let me for once have the satisfaction of telling you, what you know well, that I love you, and have for years, and always shall. There: I shall not refer to it again, but I am glad to have said it the once ... What a heavenly earth ... and I have recaptured a happiness which I thought had gone forever.'[34] It is likely that Clark's relationship with Morna was sentimental rather than physical, as a second letter hints: 'It is strange to love you as much as I do and in the way I do, and yet keep up our happy relationship – and I daresay many people wouldn't believe in it. I must say it sometimes makes me restless. But there it is! I value it more than anything and am grateful ... Much, much love, my dear, K.'[35] Clark always retained the affection and respect of the Andersons, and this seems to have been a passing phase. He once told Colette that all the women he was in love with began with 'M': 'Morna, Myfanwy, Mary and Mummy'. And he was undoubtedly fascinating to women – the writer Barbara Skelton, who met him in the 1950s, described him as 'a cross between Edmund Wilson, Bernard Berenson and Rudolph Valentino'.

In 1947, John and Myfanwy Piper asked Clark to be godfather to their youngest daughter, Suzanna. A fellow godparent was Janet Stone, wife of the wood engraver Reynolds Stone. Janet was the daughter of a Bishop of Lichfield, and might have become a professional singer, but devoted her life to bringing up her and Reynolds' four children in their romantic old rectory at Litton Cheney in Dorset. Always beautifully poised, she dressed in Victorian clothes and presented a striking spectacle. Myfanwy had described her to Clark as looking like a beauty of the court of Queen Elizabeth I, and added, 'I think you will get along.'[36] That proved to be an understatement, and it is through his letters to her over the next thirty years that we can follow Clark's innermost thoughts and beliefs. It was Janet who made the first move, dropping him a note: 'Dear Sir Kenneth Clarke [sic]. Reynolds and I were in London the other day and would very much have liked to see you. Can we be allowed your telephone number and address, and are you ever free at lunch time? Yours, Janet Stone.'[37] This was to turn into the great love affair of the second half of his life.

25

Town and Country

Everyone who tries to spread the appreciation of the arts finds himself swaying between hope and despair.

KENNETH CLARK in *The Wykehamist*, 27 July 1953

In the late 1940s and throughout the 1950s, Clark was at the zenith of his influence, the committee man *par excellence*. As he complained to Berenson: 'It seems like the best part of a year spent entirely in meetings and public works. Arts Councils, Commissions … Conferences with the Ministry of Works, the Fine Arts Commission and Covent Garden – every day, morning and afternoon.'* This period of Clark's life was to be defined by his pivotal roles in the creation of the Royal Opera House, the extraordinary success of setting up Independent Television, his writing *The Nude* and his chairmanship of the Arts Council. In refusing Ben Nicolson's request that he should become a director of the *Burlington Magazine*, he replied: 'It is true that the duties are not onerous, but that is true of all the other things I am connected with. They all involve only a very few meetings a year but, cumulatively, they weigh me down so that I can with difficulty give ½ an hour a day to writing or reading … I do want in the next ten years to get out of myself anything that is to be got.'[1] Yet from the perspective of his family, his most important activity at this time was his purchase of Saltwood Castle. This was to be the centre of his existence for the rest of his life, and the place he loved more than any other. It allowed

* Letter to Berenson, 5 November 1951 (Cumming (ed.), *My Dear BB*, p.354). Clark found the Royal Fine Art Commission, which scrutinised new buildings, to be a confused body, uncertain 'whether it ought to be maintaining high standards of taste or making the best of the inevitable bad job'. See letter to Betjeman, 20 December 1951 (Tate 8812/1/3/328).

him an escape from his life of action, just as committees gave him an escape from *ennui* and family.

At the end of each decade Clark had always felt itchy feet, and the 1940s were no exception. The problem with Upper Terrace was that his books had long outgrown the library, and as it was by the front door, he had nowhere to retire for peace and quiet. He found it easier to write in his Bentley parked down the lane. Hampstead was also becoming a frustrating place to get in and out of if you were a fanatical time-keeper, as Clark certainly was.

Like so many wealthy city-dwellers, he found his dream rural home in the pages of *Country Life*. Saltwood Castle intrigued him from the photographs, revealing a medieval complex of which he had never even heard, despite the fact that it was only four miles from Lympne in Kent. Much of the building dated from the twelfth and fourteenth centuries, and it was, by tradition, the castle from which the knights rode to murder Thomas Becket in 1170. Saltwood had belonged to the Archbishops of Canterbury until the dissolution of the monasteries in the sixteenth century. Its capricious owner, Lady Conway, put it on the market in 1948 but then withdrew it.* Clark had only viewed the castle from across the valley, but fell in love with its Gothic battlements and Tennysonian air. Lady Conway died in 1953, and coincidentally the Clarks found themselves stranded in Folkestone on account of a French railway strike. They decided to take a closer look, drove up unannounced (according to Clark's unreliable account) and met Lady Conway's companion, Miss Baird, who told them the castle was very expensive, to which Clark cheerfully responded, 'Oh that's all right.' The sight of the living quarters in the gate tower, the enormous grass inner bailey courtyard, and on one side the great hall (beautifully restored by Lady Conway with Philip Tilden as architect), left no doubt in the Clarks' minds that this was a most magical place. They were eventually able to buy the castle for £15,000, and the contents for a further £13,000. Clark took out a mortgage until he sold Upper Terrace for £27,250, almost exactly the amount required for both; at the same time he also sold Old Palace Place in Richmond, which had been rented for £7,500. The castle's contents were of the tapestried, pewter and Gothic statue variety that formed the fashionable medieval castle taste of the 1930s, and the

* The earliest correspondence is on 13 April 1948, with the estate agents Knight, Frank & Rutley writing that Lady Conway was prepared to sell Saltwood with less land and with or without the furnishings.

Clarks weeded out about half of them. (They held an auction of the remaining contents from a marquee in December 1953. It raised £8,520.[2]) To keep a bolthole in London, they acquired a small apartment – or 'set' as they are called – at Albany, the Regency courtyard off Piccadilly that has provided a collegial London retreat for so many grand literary and artistic figures.

It is easy to understand what drew the Clarks to Saltwood (which the family affectionately dubbed 'Salters'). The castle is intensely romantic, and although close to the small town of Hythe – only a quarter of a mile as the crow flies – it is separated by woods, ravines, high walls and centuries of seclusion. It is a place of Gothic tracery, jackdaws and picturesque ruins. While the outer walls are complete, much of the internal building is ruinous. The gate tower contains the main living area, but the centrepiece is the great hall, which is on the scale of the hall of an Oxford college. Clark turned this noble space into his library, commissioning a Hythe joinery company to fit magnificent oak bookshelves. It was in the great hall that he hung the Lavery full-length portrait of himself as a child, along with a number of Old Master paintings – the overmantel was a large Spanish Baroque painting by Antonio del Castillo of *Tobias and the Angel*. Penelope Betjeman thought the library should be inscribed with the Persian couplet on the Diwan-I-Khas in Delhi: 'If there is a Paradise on earth/It is this, it is this, it is this.'* Just off the hall was the study where Clark worked, with Gothic windows, sofa, tapestry and desk – although he actually wrote from a chair in the window with a pad on his knee. It survives today as he left it, the comfortable study of a humanist scholar in which, as Clark might have put it, Erasmus would have felt at home.

The gate tower, or main house, was decorated in an eclectic manner, with the contents of Upper Terrace and the addition of oak tables and tapestries. John Berger, the iconoclastic critic with whom Clark had a curious relationship (personally warm yet publicly suffused with generational antagonism),[3] described Saltwood and its contents in his novel *A Painter of Our Time* (1958). Berger characterised the collection as 'certainly impressive, but not because it had been acquired with anything so vulgar as untold wealth. It was impressive because it reflected the discerning, intelligent, catholic taste of a man who had a wide knowledge of European art and enough money to buy about a quarter of what he

* Letter from Penelope Betjeman to Clark, undated, 'Feast of Ss Perpetua and Felicity' (Tate 8812/1/3/310–350). The couplet comes from the Persian poet Amir Khusrau, and graces several buildings in India.

wanted.'* This was certainly true, and Clark's collecting had already gone into reverse. Saltwood was to prove a hungry devourer of cash, and given a choice between selling the shares on which his income depended or objects from his art collection, Clark always preferred to sell art. The Marlborough Gallery was on hand for discreet sales – Cézanne's *Le Château Noir* went for £35,000 in 1958, and the following year Clark wrote to Janet Stone: 'I had to give up my precious Renoir. She went on Monday and I suppose will never return. I had foreseen this ever since I first saw Salters, and recognised in a flash that I would have to choose between them.'[4] At least he still had his Turner seascape with which to console himself. He received £150,000 for the Renoir, from which he gave each of the children a cheque for £20,000.

The pride of Saltwood was the Turner, although Clark had nearly bought the painting for someone else. On resigning from the National Gallery he had been invited to become the paintings adviser to the Felton Bequest, which provided most of the purchasing funds of the Melbourne Museum, the National Gallery of Victoria. He had accepted the post as a means of staying in touch with the art market, and enjoyed spending the £15,000 annual budget. However, it often led to conflicts and dilemmas, as he revealed to Colin Agnew: 'I shall certainly take the Murillo, either for Melbourne or for myself: not that I have anywhere to place it, but it is too good to let go.'[5] Clark recommended that Melbourne should acquire diverse works to be exhibited according to century rather than school – not unlike the Ashmolean, with paintings displayed alongside tapestries and missals of the same period.[6] He advised on about twenty paintings, mostly Old Masters, of which the most significant was Poussin's *Crossing of the Red Sea*,[7] and the most beautiful a Bonnard nude, formerly from his own collection. Not all his acquisitions were appreciated: 'The only purchase of mine that offended my committee was a Landseer. Landseer was then out of fashion and I was able to buy his masterpiece for a very small sum. But my friends in Melbourne were distressed – I had hurt their feelings.'[8] His guiding principle was to buy a small number of masterpieces and – *pace* the Landseer – not be tempted by bargains.

* Clark's secretary, Audrey Scales, told the author: 'Berger sent a copy of his book to Clark, who wrote a letter to Berger (dictated to me) thanking him for sending it: "Naturally I did not enjoy the chapter about me." KC did not ignore Berger's gratuitous rudeness, but he did not retaliate or noticeably take offence, at least not at the time. However, it must have been hurtful.'

By 1948 the director of the Melbourne Museum, Daryl Lindsay, and the Professor of Fine Arts at Melbourne University, Joseph Burke, were urging him to come out to Australia to see the collection for himself. As the latter put it: 'I cannot emphasise too strongly the influence a visit from you would have, and particularly the encouragement it would give to the small band of really good modern artists and lovers of modern art.'[9] Clark went, out of a mixture of curiosity and adventure, and no doubt welcoming a break from all his responsibilities. As it happened, Colin Anderson, by now chairman of P&O, was taking his wife Morna to Australia that December on the maiden voyage of the SS *Orcades*, so Clark joined them. Unfortunately Anderson fell ill early in the voyage, and he and Morna disembarked in the Mediterranean – which left Clark alone, and exposed to his own weaknesses. He had written to Jane from on board: 'I am so proud when I can make you happy, and I hope at the beginning of every year that I will do better, and won't have my *silly fits*. I really think I have learned to recognise them and contain them better, and if I come back from this expedition they will be inexcusable. So let us hope that I shall become less tiresome. I am, my darling, your adoring husband, K.'[10]

There can be little doubt that 'silly fits' refers to women rather than temper, but despite these good intentions Clark started an affair on board with Barbara Desborough, an Australian friend of Morna's whom Anderson later described as 'an intriguing but also rather infuriating woman with red hair and freckles'.[11] Colin Clark mentions the matter in his memoirs: 'I know that he had got seriously involved with an Australian lady and that my mother was quite frightened that she would lose him. If she welcomed him home with all his children, she reasoned, he would remember his responsibilities and stay.'[12] On his return Jane would be waiting at Southampton with Alan and the twins. Barbara Desborough subsequently left her husband and children and came to London to devote herself to Clark, who had to recruit the help of the Andersons to keep her at bay. He would be named in the Desboroughs' divorce proceedings, which found their way into the Australian press – a considerable scandal by the standards of the day.

Clark liked Australia, as he told Berenson: 'As you will have learnt from Jane, I enjoyed Australia far more than I had expected to do. I find it hard to explain why without seeming patronizing, but the brilliant climate seems to have had a magical effect on the Anglo Saxons, removing their inhibitions and hypocrisies. Of course they are very naïve – hardly out of

the pioneering stage – but they are a gifted people, only held back by lazi-ness.'[13] He found Melbourne a little staid and conventional compared to Sydney, tactfully telling the *Melbourne Sun*: 'I know of no other place where one can live so completely in the 19th century … Sydney is more reckless than Melbourne … Perth was like a film by René Clair … quite isolated from the world, peaceful and lovely moving in slow, harmonious tempo.'[14] He was fêted wherever he went: the press mogul Sir Keith Murdoch, chairman of the museum, gave a dinner for him on his third night in Melbourne, there were lectures, lunches at Government House, trips to 'big timber country', dinners, social events, and all the usual aspects of a state visit. The most important lecture he gave was 'The Idea of a Great Gallery', delivered in Melbourne, in which he set out his guiding principles for the museum.[15] By far the most popular item housed there was the stuffed remains of the celebrated racehorse Phar Lap. Clark outlined the need for a balance between popular art (Highland cattle/Impressionists) and art that stretches us, 'and the gradual creation of a new store of values based on the contemplation of the greatest works of the past'; he cited two works in the museum, Turner's *Red Rigi* and the Poussin *Crossing of the Red Sea*.

Clark travelled around Australia, and was enchanted by the natural world, especially the luminosity of the landscape – everything so light, with no forest darkness.[16] He was particularly pleased by a sighting, for which he had got up especially early, of a duck-billed platypus – 'this was worth the whole trip'. Among the places he visited was Adelaide, where he became an early admirer of Aboriginal art: 'No one had observed that these poor, harmless, stone age people had been sensitive artists.'[17] While in Adelaide he rehung the gallery, and he was invited to scout pictures for it, but turned down any suggestion of a fee. The sums of money were small, and for that reason Clark was all the prouder of what he managed to acquire: a large John Piper Welsh landscape watercolour at a cost of forty guineas, Pasmore's *Flower Barrow* (£350),[18] William Nicholson's *House in Snow* (£275), Gwen John's *Girl with a Cat* (£260) and Lucian Freud's *The Boy with a White Scarf* (£75), as well as works from the Barbizon school and Old Master paintings.[19]

The most lasting personal benefit of Clark's visit to Australia was the lifelong friendship he forged with the artist Sidney Nolan. It was Joseph Burke who alerted Clark to Nolan's work, taking him to an exhibition at which Clark was deeply impressed by Nolan's *Abandoned Mine*, which he immediately bought: 'a straightforward painting of the Australian

countryside ... without any mythical ingredients, except a disconsolate-looking sundowner'.[20] The next day they drove out together to meet Nolan in a Sydney suburb;[21] the encounter increased Clark's admiration, and he wrote that he felt 'confident that he had stumbled on a genius'.[22] Nolan was initially a bit fazed by Clark, with his English talk about his paintings being 'corking good', but did not doubt his enthusiasm. Clark offered to arrange an exhibition in London, and wrote to Oliver Brown at the Leicester Galleries, although it was in fact the Redfern Gallery that was to take the artist up. He bought three more of Nolan's paintings, and wondered how they would look under a northern sky. When they arrived, the answer – delighting Nolan – was 'a bit queer, which proves how very like Australia they are'.[23] This friendship would endure (despite Nolan's wife Cynthia's violent disapproval of Clark's womanising), and Nolan was the last major contemporary artist that Clark was to befriend and champion. There was one other artist whose work Clark acquired in Australia: Russell Drysdale, a natural choice for Clark, as his work was influenced by Moore and Sutherland.

Clark's visit to Australia and his purchases, although modest, had a galvanising effect on the artistic community there; as Burke wrote to him, 'One can travel by the stars, but one also needs a compass and perhaps more than anyone you have provided that for painters.'[24] Clark later described the arrival of the Australian school of contemporary painting as 'one of those blessed events which help to free the arts from the iron grip of historical determinism'.[25]

Clark always proclaimed that, apart from his family, he had no loyalties except to the Royal Opera House, Covent Garden. This was the committee that gave him the most pleasure both in terms of what it instigated, and from its increasingly impressive results: Covent Garden turned into the home of one of the great opera and ballet companies of the world. Clark's support had begun with Sadler's Wells Ballet in the 1930s, and by 1940 he was guaranteeing the company to the tune of £500 a year.[26] At the end of the war the question arose of the future of the Covent Garden theatre, which was being used as a dance hall. The music publishers Boosey & Hawkes had acquired a short lease, and in the absence of CEMA's chairman Maynard Keynes, who was attending the post-war economic conference at Bretton Woods, called on Clark in his role as vice-chairman. They asked if CEMA might support a season of opera at the theatre, but, with echoes of his response to Myra Hess at the National Gallery he said, 'No; we will take

on Covent Garden altogether.'* Clark's decisive action, followed by strong advocacy to the Treasury from Keynes, transformed the fortunes of Covent Garden and led to the creation of the Royal Ballet and Royal Opera Companies. A trust was established, with Keynes as chairman and Clark as a prominent member (he would later become vice-chairman).

The Royal Ballet was a relatively simple matter to bring to life: the new board persuaded Ninette de Valois and the Sadler's Wells Company to change its name and to make Covent Garden its home. De Valois became a close friend to Clark, to whom she would always bitterly complain that the Royal Ballet was treated like a poor relation of the opera company.† Its opening night on 20 February 1946 was Oliver Messel's production of *Sleeping Beauty*, with Margot Fonteyn and Robert Helpmann performing in front of the King and Queen. The only thing that marred the occasion was that as the curtain rose, Keynes was taken ill – he was to die two months later.

After a faltering start, the vastly more expensive Royal Opera Company eventually took off, heralding a golden era of British opera, with important work coming from Vaughan Williams, Benjamin Britten, Michael Tippett and Lennox Berkeley. Clark's personal taste in opera was catholic: he loved Mozart and Verdi – he would start his children on the former so as not to spoil their ear – and Britten. Not sharing Jane's passion for the Norwegian soprano Kirsten Flagstad singing Isolde, he discovered a chaise longue at the back of the royal box which he told his secretary was the ideal place to recline and listen to Wagner.[27]

The immediate problem was finding someone to run Covent Garden, and Clark put forward David Webster to become the general administrator. They had met in Liverpool, where Webster, who ran the city's philharmonic orchestra, had impressed Clark with his knowledge and energy. Other names were mentioned, but it was the advocacy of Kenneth Clark that mattered, for in Leslie Boosey's words, 'Everyone listened to him.'[28]

* Clark, *The Other Half* (p.131). Boosey & Hawkes received a promise of financial backing from the Treasury and took a short lease on the building. Behind the scenes, negotiations were going on which resulted in the government acquiring a fifty-year lease of the property and renting it to a newly created Covent Garden Opera Trust. (See Lord Drogheda, *Double Harness: Memoirs*.)

† At her eightieth birthday party in 1978 Clark proposed her health; he told Colette his speech was a *pensée d'escalier* in which he described how she turned ugly ducklings into swans.

Webster was appointed, and had a long if not always smooth run until 1970. Clark also introduced Lord Drogheda, the managing director of the *Financial Times*, as secretary to the board – probably at Jane's behest. Drogheda, who was later to become chairman, described Clark as 'that extraordinary polymath, who had first introduced me to the scene'.[29] Clark resigned from the board of Covent Garden when in 1953 he was invited by the Conservative Chancellor of the Exchequer, Rab Butler, to become chairman of the Arts Council, a job he was never to enjoy. He remained close to Covent Garden, not least because his daughter Colette was asked to create its reference library. The board was so impressed by her that she became one of the directors shortly afterwards.

It is not entirely clear why Clark took the Arts Council job, unless out of a weary sense of public duty – but at least it provided him with a splendid office in St James's Square for meetings, and an excuse to come up to London during the week.* After his participation in CEMA's heroic foundation years with Keynes, a return to the Arts Council was always going to be somewhat mundane. The Council's operations had settled into a pattern of making inadequate grants and coping with disappointed supplicants. It was divided into semi-independent baronies in art, music, literature and drama; there was even a modest budget for acquiring works of art. Clark was privately ambivalent about the whole premise of the Arts Council. He believed such bodies should exist to help and give access to the public (without it there could be no Covent Garden), but that 'what it can't do by spending money is create artists. God does that. And I think that although schemes of the kind that set out to help the creative side are very worthy, very honourable, I think they're trying to do something which is almost impossible'.[30] In an indiscreet moment he confided to Janet Stone: 'Behind it all one felt the corrupting effect of subsidies. There were moments when I felt that it would be quite a good thing to cut the whole grant and see what would happen.'[31] He even told his successor: 'Everybody says we should have double. If we did, it would only be wasted.'[32] He knew that the government could only refrain from interfer-

* The Arts Council provided Clark with a car (a black Rover) and driver, and a beautiful office in the former library on the ground floor of the headquarters at No. 4 St James's Square. Clark could thank himself for that, as he had been instrumental in the choice of the building in 1947, and persuaded its former owners, the Astor family, to lend fittings: 'I do think that it is very important that our nearest equivalent to a Ministry of Fine Arts should be housed in a beautiful building.' Letter to Lady Astor, 8 December 1947 (Tate 8812/1/2/351–400).

ence if the Council remained poor, although this gave its meetings a nega-
tive and despondent character. Despite his (generally suppressed) doubts,
Clark found himself having to lobby an even less enthusiastic Conservative
government for more money – the annual grant of £575,000 had remained
static for five years. When he went to put the case to the Prime Minister,
Harold Macmillan, he was reportedly kept waiting for hours before the
Prime Minister greeted him with: 'Good evening, Clark, now what's this
trouble with your Arts Society?'[33]

Clark had been appointed to bring his enormous prestige to the organ-
isation, which had already settled into its own rhythm. Contrary to his
expectations, he was not required to be executive. His first surprise was to
discover that the role of the chairman had been severely curtailed since the
days of Keynes; the Council was now run by his old friend from Penguin
Books, Sir William 'Bill' Williams, the secretary-general, and there was
nothing Clark could do about it. Williams told him, 'I am the Captain of
this ship. You are the Admiral. I pipe you aboard with full honours. But I
run the ship, you see.' Denis Forman, who was director of the British Film
Institute at the time, remembered Williams as a 'curt, big, bluff organiser,
like a football manager in the field of culture, socially orientated rather
than arts orientated'.[34] Others called him a powerful *éminence rouge*. Clark
might chair the meetings, but Williams controlled their agendas and
minutes. Colette recalled: 'Bill Williams was in love with my mother but
they did not have an affair. Father was a bit sneery about him – he was very
left-wing and idealistic. He was warm-hearted but steely. They had many
gibes between them. Williams was a tough egg and used to get drunk.'*

Clark was popular with the staff, who were all aware of his difficult
position; nonetheless, although insisting 'I like to be bothered,' he
remained aloof. He was much appreciated by the secretaries who served
him at the Council, first Catherine Porteous and then Audrey Scales, who
replaced Porteous when she became pregnant. Scales described Clark as
'appreciative, courteous and kind. I enjoyed his "throw away" remarks …
He had a very quick mind and I admired his honesty. He was not at all
egotistical.'[35] She recalled how in the late afternoon Clark would have a fire

* (Interview with the author.) Curiously, the year before Clark went to the Arts Council
he had proposed Williams for the Travellers' Club, and when it was evident that he would
be blackballed, Clark resigned: 'If he is an unsuitable member … I am most certainly an
unsuitable member myself.' Letter to R.P. McDouall, 29 February 1952 (Tate
8812/1/2/6544).

lit in his book-lined office and retire to an armchair to smoke a cheroot and read and write.[36]

Catherine Porteous described the Arts Council as 'riven with feuds, arts weren't talking to drama, etc. Everybody knew about the power struggle between K and Sir W, but K knew everybody and therefore exercised more influence. It was a deeply eccentric place, with a lady in the basement doing astrology, but there was a quiet sense of mission. It was left-ish and on a mission to bring art to the people. I found myself measuring and making costumes for Opera for All. There was a touch of inspired amateurism about the place.'[37]

Clark devoted most of his time to organising a series of small, low-key exhibitions for which he wrote the introductions, and which were mounted in the former dining room at St James's Square: 'Edward Lear', 'Ruskin Drawings', 'Turner', 'Charles Keene', 'Graham Sutherland' and 'Reynolds Stone'. The Arts Council's role in showing art gradually mutated into supporting more ambitious exhibitions, such as 'The Romantic Movement' (1959) at the Tate; for this Clark wrote the introduction, which is a foretaste of two of his *Civilisation* episodes – *The Fallacies of Hope* and *The Worship of Nature*, with their emphasis on Turner and Constable but underplaying German Romanticism, with the exception of Goethe. The great era of Arts Council exhibitions lay in the future, after Clark had left.

One of the compensations of Clark's position was being able to entertain all the grandees of the art world in elegant surroundings. At the end of 1954 the Clarks' friends the Massiglis were recalled to France, and Clark and Jane used this as an excuse to throw a grand farewell dinner for them, inviting the cream of the creative world. Harold Nicolson recorded the occasion: 'Viti and I dine at The Arts Council where Kenneth and Jane Clark throw a huge party of 60 for the Massiglis ... The heads of all the professions are there. Tom Eliot for literature, the Oliviers for the theatre, Margot Fonteyn for the ballet, William Walton for music, Graham Sutherland for art, and Lord and Lady Waverley for the Port of London Authority. It is well done and a success.'[38] Raymond Mortimer went even further in his bread-and-butter letter: 'Nobody else could have mustered such a gallery: it should be immortalised in one of those engravings the Victorians went in for ... a party such as has never, I imagine, been given for any other Ambassador.'[39]

In 1960 Clark's term at the Arts Council came to an end, and although there was an attempt to make him stay he was too disillusioned by the

organisation. He confided to Janet Stone: 'such a dim and stagnant affair … it is like trying to revive the use of canals.'[40] Bill Williams wrote a warm farewell letter: 'The A.C. had the luck to have you in the chair during what I am sure has been the trickiest years of its adolescence … there is a melancholy air about the Camp.'[41] Clark had brought his considerable prestige to the Arts Council, but apart from a few exhibitions it is unlikely that he made much of a difference, as he knew only too well. He could not decide whether this was his fault or theirs, and told Janet: 'I think there is a general feeling that I should have done better – and so I should. Or is it simply that I don't like institutions and in the end institutions don't like me? I think the latter has a lot to do with it, for I remember feeling the same when I left the NG.'[42]

Clark may have felt frustrated by almost every aspect of the Arts Council, but it had provided him with the means of escape from Jane at Saltwood. Mary Glasgow was right in her analysis that he meandered between the desire to retreat with relief to his Montaigne's tower at Saltwood, only to obey with alacrity the next summons to London. As he once admitted: 'there is evidently a low side to my nature which loves action and big decisions.'[43] Of all his major positions, however, the Arts Council was the one from which he came away with least to show. Part of the trouble was that, while Williams shut him out, Clark himself was also distracted by his chairmanship of the Independent Television Authority (see Chapter 27) and by the writing of *The Nude*, both of which required all his intellectual powers.

The exhibitionist side of Clark was always there, but concealed under shyness. He maintained that he was the least clubbable of men, yet he belonged at different times to at least seven clubs: the Travellers', the Beefsteak, the Athenaeum, St James's, Brooks's, the Dilettanti, and the bibliophile Roxburghe Club. Like most Englishmen of his class and time he used clubs as a convenient place to meet friends for lunch in the West End of London, but he had a horror of being at the bar and 'joining in'. He belonged to distinguished academic bodies such as the British Academy (of which he was vice-president in 1958–59), but took no part in their proceedings. Denis Forman, on the other hand, observing Clark in the showbiz world, rated him as 'a good conversationalist with a knack of bringing conversation around to his subjects – he wanted to be the star – he absolutely loved clubs'.[44] Clark was to use all his clubbable skills over the next three years to establish Independent Television and somehow find time to write his best book, *The Nude*.

26

The Naked and the Nude

*He has written much that is elegant and attractive; this I
must pass over, but one thing it would be improper to omit
– a difficult and tricky task, which he has successfully
accomplished: his persuasive reasoning has taught us
how to distinguish the naked from the nude.*

THE CAMBRIDGE UNIVERSITY ORATOR,
on the occasion of the presentation to
Clark of an honorary Doctor of
Letters degree, 9 June 1966

Of all his books, Clark was proudest of *The Nude*, describing it as 'without question my best book, full of ideas and information, simplifying its complex subject without deformation, and in places almost eloquent'.[1] It was his most original work, developing the synthesis that he had pioneered in *Landscape Into Art* but bringing it to bear on a far more ambitious subject. Clark believed that *The Nude* stretched him to the very limits of his abilities; however, he felt inspired, and if there is one book that epitomises his approach to art history, it is this. *Civilisation* was to reach a much larger audience and make a greater impact, but Clark's reputation as an art historian largely rests here. He wrote *The Nude* in the two places that – Saltwood apart – he loved most, I Tatti and Aldeburgh, and he dedicated it to Bernard Berenson, whose intellectual range informs its background. However, from a practical perspective *The Nude* was the result of Clark's tentative but growing love affair with America (to which he referred as that 'kind, crude, competitive continent'[2]), and from now on all his major projects were to have an American component.

Clark went to America almost every year during the 1950s, to lecture in either Philadelphia, Washington or New York (where he spoke at MoMA and the Frick).* Most of these talks were reruns of old favourites, and he was reluctant to go 'off piste', as he told the Washington National Gallery's director David Finley when he visited Philadelphia: 'I have no message for the world, and if I had, I certainly could not spout it from the platform in ten minutes. It would be much better if they had engaged Danny Kaye.'[3] Clark always enjoyed New York: he found it exhilarating, and compared it to being in the Alps. His friendships there, however, were still at an early stage, and it was not until the 1960s that he settled into his routine of staying with Ronnie and Marietta Tree at 123 East 79th Street, lunching with the hostess Nin Ryan and being fêted by the collectors Charles and Jayne Wrightsman.[4] Washington he knew better, because it was smaller – although this had its disadvantages, as he told Berenson: 'In spite of many kind friends there, I must confess that I am dreading it. I can't face the mixture of heartiness and competition. One has the feeling that culture is a sinking ship in which everyone is trying to get a seat in the last boat; and quite prepared to stab their neighbour in the back in order to get there. However, this may be bracing after the quiet apathy of our home town.'[5] Despite his doubts, Clark came to adore Washington, whose social life he eventually found the most rewarding in America. He and Jane (who usually went with him) were drawn into the Georgetown circle of Democratic politicians, lawyers and journalists, 'who were in the thick of affairs at a vital moment in the world's history'. Cultivated, intelligent men like Dean Acheson, Joe Alsop, Walter Lippmann and Felix Frankfurter all lived within a stone's throw of each other, and would see the Clarks most evenings at dinner.[6]

The art world in Washington was dominated by the collectors Mrs Robert Woods-Bliss and Duncan and Marjorie Phillips, with whom the Clarks often stayed. The Phillipses had acquired Clark's great Matisse *Studio, Quai St Michel*, and had amassed an astonishing collection of mostly nineteenth-century French paintings, including Renoir's masterpiece *The Boating Party*. It was John Walker, Clark's erstwhile replacement as assistant to BB and now chief curator at the National Gallery of Art in Washington, who suggested that Clark should give the prestigious Mellon

* He arranged these trips through the travel department of Fortnum & Mason, usually flying with BOAC, booking sleepers, but occasionally travelling first class on the *Queen Mary*.

Lectures there in 1953. Clark's first choice of subject was a reworking of his Oxford lectures on Humanism, but Berenson persuaded him to write something fresh. When Clark proposed his new subject to Walker in October 1950 as 'The Nude: A Study of Ideal Art', he realised that it might arouse facetious comment, and in those still prudish days thought it would be advisable to withhold the title of the lectures.[7] But Walker responded: 'We all like your proposed subject for the Mellon lectures. In fact I doubt whether we will ever have a more appealing one!'[8] It was a well-paid assignment, offering Clark $7,500 plus $2,500 expenses, but this included publication rights. He insisted on retaining the UK rights (which turned out to be a canny move), for the honourable reason that he had originally conceived the subject as a book for Jock Murray.[9] After the difficulties he had encountered with *Landscape Into Art*, he preferred in any case to write *The Nude* as a book and then condense it into the six lectures required for Washington.[10] An interesting light is shed on his experience of writing the book by a letter he wrote to Mary Potter while working on it: 'It is a great burden to be on one's own, as you are. It deprives one of all the compromises, which are really props. One has to go for perfection. I should probably never write a word, if I hadn't to do it under difficulties. As it is, I am keeping up my 1,000 per day.'[11]

Clark's choice of subject was inspired. Given the importance of the nude in Western art, the literature on it was surprisingly small; the only general studies were both in German, and one of them was Marxist. As Clark explained: 'Since Jacob Burckhardt no responsible art historian would have attempted to cover both antique and post-medieval art ... The dwindling appreciation of antique art during the last 50 years has greatly impoverished our understanding of art in general; and professional writers on Classical archaeology, microscopically re-examining the scanty evidence, have not helped us to understand why it was that for 400 years artists and amateurs shed tears of admiration for works which arouse no tremor of emotion in us.'[12]

Clark's decision to tackle a subject so rooted in antiquity seems reasonable enough today, but at a time when (thanks in part to Roger Fry) Greek and Roman art were at the nadir of fashion and had become the preserve of specialists and archaeologists, such an undertaking was brave, and perhaps almost foolhardy for a non-specialist. As he admitted to Jock Murray: 'To tell the truth, I think the subject is a little beyond me, but I am committed now and I must do my best.'[13] Clark had conceived the idea at I Tatti, and returned there to make use of its

library.* He described his visit to Mary Potter: 'I am now in the stage when work is going well and I dread leaving. For a few days I couldn't settle down, and got rather nervous. Then I had an idea of how to treat my vast subject, and I haven't looked back. It has given me a wonderful … feeling like a religious conversion, which would be dangerous and a bore if it were to last – but it won't … You ask me about my life here. I usually write till 10.30. Then I go into Florence and take notes in the galleries or churches, lunch, visit more galleries and return at 4.0 – sleep till 5.0 and then work till dinner at 8.0. I lunch and dine alone, but as I lunch in Florence it isn't as dull as it sounds.'[14]

This 'religious' feeling was to follow him to Aldeburgh, where he went to finish the book, staying at the Wentworth Hotel overlooking the sea. The hotel is architecturally commonplace but loveable – like the town – and Clark often took the family there as an alternative to Portmeirion. In fact he reached such a pitch of confidence that he wrote the hotel manager a remarkably detailed letter suggesting a long list of good everyday wines to be put on the *carte du vin* – even supplying the vintage, price and the shipper.[15] Clark loved Aldeburgh, 'which ever since my childhood has had the effect of sharpening my mind … I remember that after writing the passage on Rubens I began to tremble, and had to leave my hotel bedroom and walk along the seafront. I make no claim to be an inspired writer but I know what inspiration feels like.'† He specially revisited the Athens museum, but then in 1953 had to put his manuscript aside to deliver the Washington lectures, confessing to John Walker: 'My chief feeling about the lectures is one of curiosity; I have been thinking about the subject so long that I have no idea what they will seem like to other people.'[16]

Clark had been right about the title; in prudish 1950s America the lectures were announced without a subject, relying on the prestige of the lecturer and the series to draw its audience. He wrote cautiously to BB: 'If

* Letter to Edith Sitwell, 10 November 1950 (Harry Ransom Center, University of Texas, Sitwell Collection): 'I was a month alone in Florence, and was rewarded for my solitude by an idea for a book which is exactly what I have been waiting for. It is about the use in art of the human body as a symbol of various states – embodiments and the like, Apollo, Venus, Hercules … if I think of it now it puts me out of patience with all the hack jobs I have to do for my American visit.'

† He once told the biologist Julian Huxley: 'I cannot begin to explain the history of art without accepting the concept of inspiration, and this is even more troublesome for the rational art historian than mutation is for the biologist.' Letter to Huxley, 19 March 1959 (Fondren Library, Rice University).

it turns out to be any good I should dearly love to dedicate it to you, for nothing else I am likely to write will contain more that I have learnt from you. But I mustn't land you with a failure – so let me see how it goes in Washington, and if it is well received (by me!).'[17] The lectures were in fact very well received in Washington – Walter Lippmann attended, and told Clark, 'I have a growing impression that this book is going to land you ultimately among the philosophers.'[18] Clark later said, 'I have never spoken to a more intelligent audience, and I should like to have given every member of the audience a copy of [the] book as a token of gratitude as soon as the course was over.'[19] They would have to wait three years for the book, with its many additions and notes, to appear. When it did come out in 1956 it became, by the standards of art history, a bestseller. Gertrud Bing, the director of the Warburg Institute, wrote Clark an admiring letter: 'I felt as if I were being taken on a long walk through the galleries of Europe, engaged in an unhurried conversation, arguing, questioning, testing my own impressions against yours.'[20]

By far the most important aspect of *The Nude* was its reassessment of Greek and Roman art for an audience increasingly attuned to anti-Classical modern art and African masks. It opens with the memorable, if somewhat misleading, sentence: 'The English language, with its elaborate generosity, distinguishes between the naked and the nude.' The book identifies the naked as the Gothic nude of the north, which Clark calls 'the alternative convention', for although it includes major artists such as Rembrandt, this is not the main subject of the book. Instead *The Nude* sets out to explore the survival of ideal and heroic forms, and gives names to these – 'Apollo', 'Venus', 'Energy', 'Pathos' and 'Ecstasy'; and along the way it takes in all that is most expressive in Western art, from the *kouroi* of ancient Greece to the work of Matisse and Henry Moore. Clark explains the idea of the nude as a Greek invention – which, when he later visited the Cairo museum, he realised had been an oversimplified notion;[21] he admitted that he had viewed the ancient world from the point of view of a student of Italian Renaissance art: 'I saw Graeco-Roman art through the eyes of Raphael and Michelangelo.'[22] This continuity, however, was also the strength of the book, a successful attempt to reinterpret the art of the Classical world to a general audience, providing illuminating reassessments of those masterpieces of antiquity, the *Apollo Belvedere*, the *Venus de Milo* and the *Laocoön*, by bringing the reader to see their ancient power sometimes through the Renaissance works of art they had inspired. Thus the book explains Classical art's various reinventions into medieval,

Renaissance and Baroque forms, and achieves a fine balance between exploring individual works of art and engaging with their broader cultural context.

For many it was the passages on Michelangelo that electrified the whole book. His is the dominant personality that fills the chapters on 'Energy' and 'Pathos', and Clark tells us that 'Before the *Crucifixion* of Michelangelo we remember the nude is, after all, the most serious of all subjects in art.' Clark was never a conventional believer in the Christian faith, but when he contemplates these Michelangelo drawings he tells us, 'we reach a realm of the spirit where analysis is inappropriate and critical language inadequate. We can only be grateful for a second to catch a glimpse of the *nobilissima visione*. For a second those great mysteries of our faith, the Incarnation and the Redemption, are made clear to us by an image of the naked human body.'[23] This essentially emotional response was not confined to Michelangelo. The artist whose reputation was probably most enhanced by *The Nude* was Rubens, about whom Clark writes with freshness and love. He describes the artist's depictions of 'golden hair and swelling bosoms' as 'hymns of thanksgiving for abundance', and claimed that 'Rubens did for the female nude what Michelangelo had done for the male.'

The Nude was the most successful of Clark's syntheses. Some considered that his account of the alternative convention – the nude of the Gothic north – represented an uneasy grouping of disparate parts, with Cranach's saucy nudes placed alongside Rembrandt's *Bathsheba*, but most of Clark's readers found his imaginative connection of the ancient with the modern both exhilarating and revelatory. As Ben Nicolson wrote in his review: 'This most un-German of writers, has absorbed German scholarship, and enriched his perceptions in the process.'[24] The book is unthinkable without its debt to the historical interpretation of form and composition by Clark's German hero Wölfflin, and the influence of Aby Warburg. Gertrud Bing, who worked closely with Warburg, told Clark, 'he saw like you images as the embodiments of impulses, coined in the workshop of Classical antiquity and capable of being discovered in such apparently divergent products as the Nereids and Michelangelo's Risen Christ.'[25] To Bing, the seemingly opposite approaches of Warburg and Walter Pater had found their natural meeting point in *The Nude*.

The immediate response to the book was almost universally positive, although some readers took issue with the weakness of the oversimplified medieval sections, and debated whether nudes should or should not be

received as erotic (Clark had been of the opinion that they should, however remote the feeling). The praise that mattered most to him came from Berenson: 'Let me congratulate you on surpassing even yourself in "the Nude". Much as I always have expected from you, this achievement goes beyond expectation. You unfurl the subject to its vastest horizons and fill it with details so perfectly communicated, such precise epithets, such illuminating evocative phrases, such rhythmic sentences, that it is a delight to read and read and read. I admire your scholarship and the way you have assimilated it. Wonderful your analysis of the Apollonian nude. You end by constructing a schema of common characteristics regarding the figure work. No province or representation that you fail to illumine.'[26] Maurice Bowra wrote with his usual enthusiasm: 'the writing, as always with you, gave me unending pleasure – the right words, the varied movements of the sentences, the quiet surprises, the imaginative outbursts – I like them all very much. Of course you will be accused of being lush.'[27] Robert Graves even penned a witty poem, 'The Naked and the Nude', which appeared in the *New Yorker*.

The backlash would come in the 1960s, when critics such as John Berger examined how the concept of the nude in European art masked the true nature of women as individual human beings, transforming them into ideal types and sexual stereotypes. This cry has been echoed by feminist art historians, many of whom view Clark as the embodiment of a patriarchal establishment.[28] Notwithstanding such dissenters, the work remains Clark's most impressive art historical achievement.[29]

The success of *The Nude* was followed by the failure of *Motives*, the unfinished 'great book' to which Clark kept returning. This was a development of the project he had attempted with Roger Hinks in Ashmolean days, the successor to Riegl's *Spät-Römische Kunst-Industrie*, intended to interpret design as a revelation of a state of mind. The origin of *Motives* was Walter Pater's fusion of form with subject, and those recurrent themes which, when the cultural impulse was with them, produced great works of art.[30] When Oxford reappointed Clark as Slade Professor in 1961, he tried to articulate his ideas to a sympathetic audience: 'A motive may lie about for centuries in the scrapheap of ordinary perception … It is picked up when some artist perceives that it can be used to embody a necessary idea, i.e., the Virgin and child.' The lectures dealt with 'Encounters' (visitations and annunciations), 'The Pillar and the Trunk' (standing man, medieval art, Piero della Francesca), 'Recumbent Man', 'The Ecstatic Spiral and Struggle'

(Hercules and the lion, Rubens and Stubbs), and 'Private Motives' (Leonardo and Turner). The Oxford audience was baffled, and Clark realised that the subject – which never quite got going – was a mistake: 'I am not quite up to the intellectual effort needed. It is like something that I can see but can't quite touch.'[31] He was never happy dealing with abstractions, and the lectures lacked both the unifying conception of *The Nude* and its brilliant engagement with the works of art. Clark was tenaciously to cling on to this mirage, almost vetoing *Civilisation* because of it (as was Jane's wish); as late as 1974, he still clung to the belief that 'it will be my best book.'[32]

While Clark had some powerful admirers, like Gombrich, his relationship with his fellow art historians was often prickly.* Part of this was a hangover from the National Gallery years. When he went to a party at the British Museum in 1967 he found 'all my former colleagues, many of whom I hadn't seen for fifteen years, looking extremely old, and discontented. They loathed the sight of me – I felt myself plunged into a pool of malicious animal magnetism.'[33] But he himself was often derogatory about the profession. In the course of preparing *Motives*, he described to Janet Stone a visit to the Warburg Institute, 'to do a little research. But, alas, it depresses me beyond words – all those dim wraith-like figures in corners of the book stores silently turning the pages of books on iconography seem like ghosts in a Hades of futility. I can see no life-principle in their labours, and I cannot even use their conclusions, because if they ever do publish anything they have forgotten what they are looking for.'[34] The Courtauld Institute, the leading powerhouse of British art history, provided an impressively wide range of scholarship, from medievalists to modernists as well as architectural historians. Its staff was increasingly divided about Clark. The pupils of Johannes Wilde were taught to revere him, but the modernists did not regard him as a professional art historian – especially after he started making television programmes.† Anthony Blunt, the Courtauld's

* 'Over the years, Clark has engendered a certain, often latent, hostility in art historical circles' (*Burlington Magazine* leader, June 1969). Of Gombrich, Clark always said: 'I am nothing compared to Gombrich. He is everything, I am very little.' See Paul Johnson, *Brief Lives* (p.68).

† This view is confirmed by Alan Bowness and the late Brian Sewell. According to Neil MacGregor, the Courtauld evidently took the same view of Michael Levey when he started making television programmes. Jennifer Fletcher, on the other hand, as a pupil of Wilde remembers that Clark's name was always mentioned with respect.

director from 1947 to 1974, would invite him to lecture – mostly on extra-curricular subjects such as Aubrey Beardsley – and while personally scrupulously polite to Clark, he quite enjoyed his pupils' irreverence about him.* Numerous anecdotes arose, tinged with malice, typically of Clark arriving to give lectures, parking his Bentley outside, and grandly announcing that he would leave at 12.30 to have lunch with Lady Aberconway, whether or not he had finished. It is certainly true that he would never take questions after a lecture.

Clark's subjective brand of art history was increasingly out of step with more sociological approaches to the subject, but there was a younger generation of scholars who admired him, as he found when he went to a party at Murray's: 'I enjoyed myself and was cheered up to find that scholars of the Haskell/Jaffé age were sympathetic, and seemed anxious for me to publish my lectures.'[35]

If the profession was divided between the admiring and the faintly sneering, to outsiders Kenneth Clark represented art history. It was to him that educators and publishers turned, proffering manuscripts and soliciting opinions on fellowships. Clark greatly admired Erwin Panofsky, the German émigré Princeton art historian of symbols and iconography, of whom he wrote that he was 'undoubtedly a very remarkable writer on art. He represents the reaction against the points of view of Berenson and Fry, that is to say, he does not want to know who painted a picture and does not ask whether it is beautiful or why ... he brings amazing learning and ingenuity. He is often obscure with the Talmudic obscurity now fashionable with Jewish American scholars but one always learns from him.'[36] Edgar Wind, famous since writing the art book *Pagan Mysteries of the Renaissance* (1958), which became something of a cult in the 1960s, was the subject of frequent enquiries to Clark from academics at Oxford and Cambridge, who were uncertain whether he was a genius or a charlatan. To Noel Annan, Clark wrote: 'he is perhaps the most brilliant lecturer on art alive and, while he is talking one is persuaded of the most fantastic hypotheses ... the kind of scholar to whom the term "brilliant" rather than "sound" is usually applied'.[37]

Clark showed some admiration (although little sympathy) for Marxist art history, as he warned one practitioner, Frederick Antal: 'I think there is a great danger in your method, especially for young people who apply it

* For his part, Clark liked Blunt and hugely admired his work on Poussin. He was shattered by the exposure in 1979 of Blunt's treachery.

without learning. Ultimately it tends to a denial of values and to an exaltation of mediocre artists, simply because they always provide more convenient illustrations ... however this does not prevent me from recognising the marvellous learning of your book [*Florentine Painting and its Social Background* (1948)] and the clarity with which you approach social problems.'[38] More problematic was the 'determinist' view of history that Marx had propagated, and many non-Marxists had embraced as a prevailing orthodoxy. Clark addressed this in his lecture 'Apologia of an Art Historian': 'In the last forty years our outlook on art history, as on all history, has swung round from free will to determinism.' He offered the example of Rembrandt, observing, 'that he should have appeared when he did was an accident; that he should have appeared at all was a necessity. That is the nearest I can go to solving the problem of free will and determinism, as it is presented in the history of art.'[39] In fact determinism went against one of Clark's strongest beliefs, that of the God-given genius of great artists. In another lecture, 'Is the Artist Ever Free?', he was more explicit: 'The history of art is not at all like a stream. If any natural analogy is to be used (and none will be exact) it is more like a series of harvests some of which are self-sown, so that the crop gets progressively poorer; and some of which are sown afresh, and the seed is individual genius.'[40] This was the view he promulgated when he came to make *Civilisation*.

'In 1958 when I was still threshing around among my *Motives*, I was invited by *The Sunday Times* to do a series of articles on single pictures.'[41] These were to be the origin of Clark's book *Looking at Pictures* (1960), in which he played to his strengths by describing paintings with love, insight and astute observation. He had once said that the intuitive impact of a picture lasts as long as you can smell an orange; he wished to take the reader beyond that first sensation. 'Art is not a lollipop or even a glass of Kümmel. The meaning of a great work of art, or the little of it that we can understand, must be related to our own life in such a way as to increase our energy of spirit. Looking at pictures requires active participation, and, in the early stages, a certain amount of discipline.' His choice of painters was instructive, including Botticelli, Raphael, Titian, Rembrandt, Velázquez, Vermeer, Watteau, Delacroix, Goya, Turner, Constable and Seurat. Here we are reminded of the child Clark, admiring the highlights of the Louvre. His aim was simple, as he once wrote in another connection: 'It seems to me that the chief aim of the art historian is to give the reader some idea of why great artists are great.'[42] *Looking at Pictures*

included two works in the V&A (Constable's sketch for *The Leaping Horse* and Raphael's cartoon of *The Miraculous Draught of Fish*), and one bright morning while working with his secretary at Albany Clark looked outside and announced to her that he had to go immediately to the V&A to look at the Raphael cartoons – 'The light will be just right.'[43]

Of all his books, Clark had the softest spot for his anthology of Ruskin's writings, *Ruskin Today*, published by Murray in 1964. He had been planning such a work for over thirty years as an act of *pietas*, but also out of a desire to rekindle interest in Ruskin at a time when his unwanted works filled the top shelves of second-hand bookshops. Clark found the task of rereading all of Ruskin daunting, as he told Janet Stone: 'Dear me, what a lot of rubbish he wrote – in his youth false logic, in middle age ranting sermons, and in old age distracted grumbling. Yet every now and then insight, courage, and marvellous power of language.'[44] The resulting anthology was much admired, and Clark successfully brought Ruskin to a new generation who otherwise had no idea how to approach the vast corpus of this strange Victorian prophet, moralist and art critic.[45] His Introduction is masterly – perhaps the best short essay ever written about Ruskin. Clark said to Colette, 'You don't have to read Ruskin now, I have done it for you.'[46]

It was Clark's relationship with Jayne Wrightsman that led to the invitation to New York to deliver the first series of Wrightsman Lectures at the Met under the auspices of New York University. He chose as his subject 'Rembrandt and the Italian Renaissance', combining two of his main interests. The resulting book was published in 1966, and has usually been respectfully passed over. The Dutch specialists felt Clark was poaching on their territory, and noted his reliance on the great Rembrandt scholar Frits Lugt,[47] while the general public found the book a little ponderous, with too much hunting for sources. Clark was aware of this, and told Janet Stone: 'It's all right – not like the Nude or Piero, alas. Too much art-history, and I suppose my wits aren't as bright.'[48] It was probably Clark's least successful major work. As Professor Christopher Brown points out, *Rembrandt and the Italian Renaissance* is in the end a profoundly misleading title: Rembrandt never went to Italy, and was in certain ways anti-Italian.[49] While the connections Clark made were ingenious and often original, for a book that he himself described as attempting to study the creative process, its reception fell slightly flat.[50] He received the usual praise from laymen; the professionals were less kind, but Clark (who was inordinately

proud of the book) brushed off their criticisms as being 'more attacks on the image of me'.[51]

In the same letter to Janet Stone he set out his quandary over what to do next, and his belief that his powers were diminishing: 'I am haunted by the number of books I still have to write, and only six years to go.* And the favourable reception of Rembrandt by everyone except the critics has naturally encouraged me to go on with Motives and with the collected papers. I really don't know what to think.' Fortunately the BBC would solve the problem by inviting him to write a thirteen-episode television series on Western civilisation.

* Clark had persuaded himself that his working life would be over at the age of seventy.

27

Inventing Independent Television:
'A Vital Vulgarity'

I am like an architect who has built a fine town,
and now sees it inhabited by Yahoos.

KENNETH CLARK to Bernard Berenson,
3 September 1955[1]

In a career full of the unexpected, perhaps the most improbable of all the job offers that Kenneth Clark received was that of the chairmanship of the Independent Television Authority in 1954. He was being asked to set up 'the people's television channel' when he did not even own a television. True, he had taken a close interest in the development of the medium, but on the face of it he was a most unlikely person to run the commercial television authority: a grand mandarin in charge of what many perceived as a vulgar American import. Why did he accept it? He had more than enough to occupy himself, even though he was bored at the Arts Council. Besides, the job was extraordinarily risky. There were strong elements in both of the main political parties against commercial television, and initially the contracting companies struggled to make profits. But lurking below the polished surface, there was enough of Clark's father in his make-up for Clark to take the chance – it was almost an anti-establishment gesture. His appointment took everybody by surprise. John Russell of the *Sunday Times* later likened him to an Afghan hound that had been harnessed to a brewer's dray and would do himself an injury.[2]

Although the notion of commercial television was rejected by many in both the Labour Party and the ruling Conservative Party, it was also supported in equal measure by both. Most intellectuals despised television because they thought it caused people to read less; however, everybody agreed that the BBC monopoly had served Britain well. The BBC had gained extraordinary prestige as a broadcaster of high principle,

whereas American television was thought to exemplify all the vulgarities of commercial dumbing down. It was the Conservative Party's natural dislike of monopolies that gradually won backbench support for the idea of Independent Television, although the fear remained among the Labour opposition that it would become the voice of commercial interests and big business.[3] MPs on both sides wanted reassurance that any advertising would conform to British rather than American standards.* But it was the programme content that worried critics most. When the Television Bill was published in March 1954 it outlined, in order to appease them, that the new authority would not only receive a government loan of up to £1 million to cover initial capital costs, but that, at the suggestion of the Archbishop of Canterbury, a further £750,000 from public funds would also be available as an annual grant for ten years, in order that more serious programmes should be made. It was this as much as anything else that persuaded Clark to accept the role of chairman. Although no Tory, he too disliked monopolies: 'I am opposed to any kind of monopoly. I believe that it leads to self-satisfaction and even to a certain amount of injustice.'† Above all, his characteristic sense of mission led him to seize the new medium and its opportunities. As Fram Dinshaw observed, 'he very quickly realised that television was going to change unimaginably the kind and quality of information that was available to ordinary people'.[4] Clark himself later said in an interview: 'Television gives people what they want. It is not keeping people from reading, they are not reading anyway. It gives us a sense of one world, news and nature, it has enlarged our range.'[5]

The chairmanship was in the gift of the Postmaster General Lord De La Warr – an anomalous figure: a socialist hereditary peer serving in a Tory government. He appointed Clark in order to assuage the critics; he knew that he would appear acceptable to the Tories – he was a friend of Anthony Eden and Rab Butler – but was politically left-leaning, and would not allow the newly formed authority to be taken over by Tory interests. This was particularly important because De La Warr had appointed a Tory business-

* The appearance of a chimpanzee called 'J. Fred Muggs' in a commercial which interrupted the US television broadcast of Queen Elizabeth II's coronation was thought by one Labour politician to be particularly tasteless. See Sendall, *Independent Television in Britain, Vol. I: Origin and Foundation 1946–1962* (p.15).

† *Look* magazine, 7 September 1971. In an interview with Mark Amory in 1974 Clark said: 'The BBC had got a complete monopoly, like the early Puritan Church in America.'

man, Sir Charles Colston, as vice-chairman.* Equally important, Clark's appointment would calm what Clark referred to as Athenaeum Club circles, who hoped that he might keep the barbarians at bay. He did not entirely succeed in this, as he told the Townswomen's Guild at the Albert Hall in 1970: 'When I became chairman of the Independent Television Authority, I was booed in the Athenaeum – very quietly, but unmistakeably booed. There was a good reason for this demonstration. On a given evening fifty thousand people can read fifty thousand different books. But they can look at only one or two television programmes.'[6] Clark's name was a badge of respectability which ensured a quality threshold.

Although he was the establishment safe man, the announcement surprised everybody, including David Attenborough, who later became controller of BBC2: 'It was a great shock when Clark took the chairman job. To us at the BBC, ITV was the Devil – low and commercial to the Reithian outlook – so when K sanctified it we were very surprised, but he had an appetite for public service.'[7] Denis Forman suggested that 'nobody thought it would work. I did not support it – he was a rich dandy – he was not in electronics or entertainment. The engineers ran television, it was created by them and they owned it until 1960. People were both sceptical and delighted by Clark's appointment – he knew nothing about television.'[8] Clark's friends were equally surprised and appalled, but he rather enjoyed that.

He explained his decision to accept the job to Janet Stone: 'I couldn't resist the temptation of seeing what could be done with it. However one may dislike television, it is the way in which people's minds are going to be formed, and I am still sufficiently Victorian to feel that if one is offered the opportunity of contributing to such a colossal task one oughtn't to refuse it … we start from nothing. I have to organise the whole set up – staff, offices – everything … what a strange, unexpected change of fortune!'[9] He was right: the Authority initially had nothing except an inexperienced board, and during the first year its meetings took place at the Arts Council.†

In October 1954 Clark went to the United States to find out as much as he could about the operation of commercial television there, meeting

* Colston was a fundraiser for the Conservative Party, and resigned shortly afterwards. Sir Ronald Matthews took his place, and things worked harmoniously thereafter.

† Clark's salary was set at £3,000 per annum. The only board member who knew anything about the subject was the film critic Dilys Powell.

senior officers and technicians at CBS and NBC. He enjoyed the process
of setting up the Authority with its eventual staff of fifty, but nothing could
be achieved until the appointment of a director-general. Clark amusingly
described how the Treasury tried to fob him off with various retired
members of the armed services, including nine admirals and seventeen
generals – but he already knew who he wanted: Bob, later Sir Robert,
Fraser, with whom he had worked at the MoI, where he had been a very
successful head of publications. Clark persuaded him to put in for the job,
and later recalled how he had to 'push his name past my exhausted
colleagues at one sitting' before they could investigate Fraser's socialist
record.[10]

Bob Fraser turned out to be a brilliant appointment. An Australian
who had originally come to London to sit under Harold Laski at the
London School of Economics, he had become a leader writer for the
Daily Herald and had stood as a Labour parliamentary candidate. As
Colette commented: 'Bob Fraser was a bit off-centre, being Aussie, and
like David Webster at the opera got on very well with my father.'[11] Fraser
was a professional communicator, and he and Clark were to be the prime
movers in the establishment of the ITA. Bernard Sendall, Fraser's senior
civil servant and later the historian of Independent Television, was in no
doubt that these two men in that first year – 'there was never to be another
year like it' – made excellent decisions, with the able assistance of their
board, and established the shape and structure of Independent Television
for a quarter of a century.[12] But Clark and Fraser's extremely warm and
cooperative relationship would be severely tested by the trials of the
coming year.

The first problem was one of design. What kind of franchises should be
offered to the competing companies applying for licences? Regionalism
became so well established as the basis of Independent Television during
its first decades that today we take it for granted, but it was a far from
obvious approach in 1954. Many models from overseas were examined:
should the companies be given a 'horizontal' slot, i.e. one company
producing all the morning programmes, another the women's programmes,
a third the children's programmes, a fourth the news programmes and a
fifth the entertainment programmes? Or should the design be 'vertical', so
that there was a Monday-to-Friday company and a Saturday-to-Sunday
company – which could perhaps be rotated? As Fraser noted, these would
be 'cages in which we would be caught forever'. What was eventually
created was a regional federal system, clearly differentiated from the BBC,

which in those days was entirely metropolitan and had no presence in the regions.

On 14 October 1954 the ITA initially chose to have three regions – London, Midlands and Northern, with one or two companies appointed to each station to operate a 'competitive optional network'. Much trouble was taken to introduce competition between the contractors. Clark wrote an important memorandum on the subject: 'Although I want the system to be vertical in *control*, I want to see it largely horizontal *in operation*, in the *movement of programmes* – that is, I want a network connection technically capable of giving an unlimited introduction of programmes from any one region into either of the others. I want London to be in full competition with the Midlands in selling programmes to the Northern, Midlands with Northern in selling to London etc.'[13] But as Bernard Sendall pointed out, the reality of what later came to be called the 'carve up' never conformed to this vision of a state of perfect competition, and tendencies to regional monopolies in Independent Television soon began to emerge.[14] 'Vertical control – horizontal competition', however, became the mantra.

The role of the ITA was threefold, constructing and operating the transmission stations to be used by the network, awarding franchises for the making of programmes to commercial broadcasters, and regulating programme content. It would have a landlord–tenant relationship with the contractors. One of the ITA board's anxieties was putting the news in the hands of commercial companies, and some advocated handing it over to Reuters. Clark opposed this, and always claimed that it was his contribution to insist on a separate channel to handle news for all the companies; but as the historian of ITV cautions us: 'This story of the origins of Independent Television News affords no corroboration of any individual claims to parentage.'[15]

In the second half of 1954 the Authority invited applications from programme contractors. Clark's initial fear was that ITV would fall into the hands of the Conservative press, something he perceived as 'disastrous for the future of Independent television'.[16] Twenty-five applications were received, and four companies were chosen, to give as far as possible similar value in terms of air time and population coverage. The most controversial application was from the Kemsley Newspaper Group (which included the *Sunday Times*), causing Herbert Morrison to ask in Parliament if the government was giving preference to its friends.[17] However, Morrison was not looking at the whole picture: one of the successful companies was run by Sidney Bernstein of Granada, who was a fully-paid-up member of the

Labour Party. But this episode was a reminder of the fragility of ITV, and the fact that Labour had given a warning that the Television Act of 1954 might well be repealed after the next election. The City financiers were very sceptical, and in the first year profitability eluded the contracting companies. In August 1955 Clark and the ITA moved into grand offices at 14 Prince's Gate, the former London residence of J.P. Morgan and afterwards for a time the American Embassy residence.

All doubts were put to one side for the launch of Independent Television at a magnificent banquet at the Guildhall on 22 September 1955. At 7.15 p.m. the first transmission began, and millions of viewers watched the arrival of the five hundred guests in white tie. The guests enjoyed a dinner of smoked salmon, turtle soup, lobster chablis, roast grouse and peach Melba. Speeches were made by the Lord Mayor of London, the Postmaster General, and finally Clark, who announced that hitherto television had been controlled by a single public corporation, but that 'ten minutes ago that weapon was placed in the hand of companies who are hardly controlled at all'. He added, 'The ITA is an experiment in the art of government – an attempt to solve one of the chief problems of democracy: how to combine a maximum of freedom with an ultimate direction.' It was the first time Kenneth Clark was seen by a mass public, and they heard him speak in a clipped, measured accent.* He was followed by the first ever British television advertisement, for Gibbs SR toothpaste.†

The problems that Clark and Fraser faced during their first year were perfectly expressed by John Spencer Wills, chairman of Associated-Rediffusion: 'Never in all the thirty-five years I have been in the business have I come across a case in which the task of the entrepreneur has been made more difficult. A limited security of tenure from the Conservative government, a threat of extinction from the Labour opposition, an excessively high annual payment to the ITA, an obligation to put on "minority" programmes of small advertising value, a host of restrictions imposed by

* Clark's speech was, however, overshadowed by the death of Grace Archer in the long-running radio serial *The Archers*: 'The following morning there was far more comment – along with far more leaders – in the press about Grace's death than there were about the Guildhall speech.' Asa Briggs, *The BBC: The First Fifty Years* (p.259).

† The companies were allowed to broadcast a maximum of eight hours of television per day between 9 a.m. and 11 p.m., with an off period between 6 and 7 p.m., known as the 'toddlers' truce', to allow parents to get children off to bed. On Sundays there was to be no transmission between 6.15 and 7.30 p.m., to protect Evensong.

Statute and by licence, threats of additional competition from the BBC – all these must daunt the wildest optimist.'[18] During the first year, the problems that beset Clark over the birth of ITV were immense: the complex problems of transmitters and masts, the non-profitability of the companies,[19] and their inevitable power struggles with the Authority. Clark described it to Janet Stone: 'Pandemonium at ITV ... several writs threatened and one actually served ... I consoled myself by thinking that for once I qualified for a beatitude – I mean "Blessed are the peacemakers."'[20] He got no sympathy at Saltwood: 'culminating in J[ane] saying last night ... that she sympathised with the Programme Contractors, that the ITA were just a lot of governessy civil servants, that we didn't know what we were doing ... I can face any attacks from *outside*, but not from within. How well Ibsen understood this situation.'[21]

The nadir of ITV's early crises was reached with the resignation of the charismatic news chief at Independent Television News, Aidan Crawley, and his deputy. Morale sank to its lowest, and Clark agreed to be interviewed on the evening news bulletin. This was Robin Day's first important interview, and – despite his astonishment that Clark had agreed to appear – it is clear from the chapter 'Personal Milestone' in his book *Day by Day* (1975) that Day regarded it as a turning point in his career: 'Though Sir Kenneth Clark avoided giving direct answers to some of these questions, the interview drew from him several important declarations of ITA policy. He defended the amount of entertainment on ITV: "You must capture an audience first of all. When you are established and secure you can gradually build up to a higher level."'* Clark's appearance did something to raise morale at ITN. However, by the end of 1956 ITV was starting to win the ratings war with programmes such as the talent contest *Opportunity Knocks*. An upturn in advertising revenue followed. The contractors entered a more confident and prosperous phase, and the dawn of the era which Roy Thomson, who owned the Scottish station, famously described as 'just like having a permit to print your own money'.

Clark struck up a warm relationship with the company bosses, including some of the most famous entertainment moguls of the time. He already knew Sidney Bernstein at Granada from MoI days, and he formed a particularly fruitful friendship with the colourful duo at Associated

* Robin Day, *Day by Day* (pp.178–82): 'What I think gave the interview its interest was that the chairman of an organisation was being publicly cross-examined about his duties by one of his employees. This was unusual, if not unique.'

Television, Val Parnell and Lew Grade. As he told a BBC director: 'I must confess that I like the people I have to deal with – I suppose I was helped by my non-academic (and non-military) background, which made me feel more at home with Val Parnell and Lew Grade than I often did/do with my colleagues in the museum world.'[22] In a later interview he went further: 'I get on best with showbiz people. They are larger than life and always doing absolutely unexpected and incredible things. They are monsters, total egomaniacs – far more appealing to an old sinner like me.'[23] No doubt they reminded him of his naughty father. Lew Grade – who could be shameless – greatly respected Clark, and described how one day Clark said to him, '"Lew, you will never get away with that," so I turned to him and said, "K, what do I have to do to get away with it?" He told me and I did it.'[24]

Clark would divide his week between his two impressive offices, at the Arts Council in St James's Square and ITA in Prince's Gate. When he met the contractors he was usually by far the youngest person in the room, but he was able to hold his own intellectually. Denis Forman, despite his initial doubts, came to regard him as 'a successful chairman with a strong analytical mind – he could chair a meeting. However, he was not interested in the economics or technical aspects. Clark was better on general matters, i.e. religious views. He cultivated an attitude which told you that he had a superior mind.'[25] In fact, the most surprising things revealed by the ITA archives of the time are the level of detail and the technical nature of so many of Clark's interventions, and his ability to dictate long, detailed memos about so many aspects of the organisation: engineering, legal, admin and finance and the programme sections.[26] While the vast majority of memos are by Bob Fraser, Clark clearly grasped enough of every aspect of the industry, from regional news questions to masts and transmitters. The last were to be a particularly vexing, expensive and time-consuming problem.*

Once financial stability was established in the network, Clark began to worry more about the 'higher level' he had spoken about to Robin Day. Quality control of the programmes was, after all, the principal reason he had been appointed in the first place. But did the ITA actually have the powers to influence programme planners and creators to keep up quality?

* See Bournemouth ITA Archive (Box 254). Clark even asked one of the technicians how long it would take him to properly understand the technical questions concerning masts and transmitters. The answer was discouraging: if he did nothing else, three years would be the minimum.

As Clark put it: 'The Act, on this point, is as ambiguous as the Elizabethan prayer-book, and it is really for the Authority to interpret its ruling.' But he was nervous that 'any attempt we made at an extended interference in programmes would be resented as unwarranted and unfair ... an appeal decision would go against us'.[27]

Although Clark expected that ITV would display what he called 'a vital vulgarity', he was appalled by the low quality of output, as he told a lecture audience: 'And to watch a whole day's television right through, as I have had to do, is a really terrible experience and leaves one asking the old question, is it lack of talent, or commercial exploitation or a correct assessment of public taste that is responsible for this avalanche of vulgarity? Probably a combination of all three.'[28] Part of the problem was a built-in parochialism. Hollywood films and well-made American programmes like *I Love Lucy* were popular, but there was a statutory requirement that 80 per cent of programmes transmitted were to be of 'British origin and British performance'.

The last year of Clark's term at the ITA was dominated by his attempt to try to hold the government to its promise of £750,000 for quality programmes. He protested to Lord De La Warr's successor as Postmaster General, Dr Charles Hill – whom Clark found sly and slippery: 'The appointment of the Chairman of the Arts Council as Chairman of the ITA clearly implied the government's intention to maintain standards and balance. The present programmes are often extremely embarrassing but, as you know, I have defended them because I have always assumed that the means of improving them would be forthcoming.'[29] The matter was all the more galling as the Exchequer was holding the full £750,000 in readiness. Clark would accept even a token payment as a foot in the door. Dr Hill asked for concrete proposals for how the money would be spent, which the ITA felt was its business. The areas Clark and Fraser initially identified were religion, royal occasions, children and news,[30] and this broadened to discussion programmes and classical music. Clark set out a detailed memorandum of the types of series he envisaged: 'Window on England', 'Window on the World', 'Person to Person' (great scientists, wise men, athletes, etc.), an arts programme 'under some general title such as "Omnibus" rotating within it a great play one week, an opera the next, then music and so on'.[31] Elsewhere he made a plea for Shakespeare, while recognising that the plays would have to be cut to work on television.

As the months passed, the '£750,000 gift horse that bolted', or 'the grant that never was', as it became known, came no closer to reality. Clark wrote

in a melancholy mood to Janet Stone: 'I think I had better go. I am really *very* sad, not only because I was proud to be entrusted with such important work, but because I love action and I now see myself condemned to moulder.'[32] He decided to leave, and sent copies of his resignation letter to the Lord Chancellor, Lord Kilmuir and the Lord Privy Seal, Rab Butler. Hill, who was on holiday at Sandwich Bay, thought this was all a storm in a teacup, and was rather cross to have Butler on the telephone asking what was to be done. Clark agreed to defer his resignation until Hill returned from holiday. His gloom did not lift, as he told Janet: 'My semi-detachment from ITA has brought home to me how awful 9/10 of it is, and like the widow in Peter Grimes I go round singing to myself "This is no place for me".'[33] Colette remarked that this phrase was almost an anthem for Clark when depressed. Hill persuaded Clark to continue holding off his resignation while he saw what he could do.

In November 1956 – by which time Britain was engulfed in the Suez Crisis – Clark went off to attend a UNESCO conference in India. He enjoyed India but hated the conference, as he told Janet: 'Really absurd and futile … 750 people simply wasting their time and their country's money. I suppose the church councils of the 15th Century were something of this kind – all meaningless abstractions and appeals to precedent so complex that no one can dispute them.'[34] He was appalled by the Suez fiasco, and felt embarrassed to be in India representing Britain: 'I simply couldn't hold up my head. But then I reflected that now above all was the time to go, to show that there was something more permanent in England than this disgusting re-ignition of 19th Century jingoism. Of course if the Govt. falls, I shall have to stay [at ITA] – but incredibly enough I don't now believe that it will.'*

However, while he was travelling around India, the ITA was offered a token £100,000 by the government. Without any reference to the ITA the four (by now profitable) programme companies collectively issued a statement declaring that they were turning down the offer, believing that it implied they could not stand on their own feet. Clark was furious, stating that the companies had made the ITA look foolish and were usurping its authority – the grant was none of their business, but represented a gesture

* Letter to Janet Stone, 1 November 1956 (Bodleian Library). Clark later said of Anthony Eden (who was an old friend): 'Suez was really a blessing in disguise, because, revolting as it was, it allowed the Tories to get rid of our worst prime minister since Lord North.' Letter to Janet Stone, 12 April 1964.

of confidence in the Authority and an important point of principle. His meeting with the programme companies on 14 December was stormy, and he did not mince his words. He felt the most important thing was the precedent for payment of a grant in future years. The money was duly collected and the crisis passed.

Clark came to the end of his term in August 1957, and was slightly miffed not to be invited to renew his contract. Notwithstanding the 'bolting horse' episode, he was regarded as having been an outstanding success. Even Charles Hill wrote in his memoirs: 'What he proved by the undoubted courage and wisdom he brought to an appallingly difficult task was that a cultivated mind does not necessarily exclude a capacity for administration. Independent Television owes a very great deal to Kenneth Clark.'[35] Clark knew that he had succeeded, as he told Berenson: 'My television years are over. I was a great success and beloved by all! An experience I never had in the art world.'[36] However, he was to devastate his former colleagues by his appearance at the Pilkington Committee on Broadcasting in 1960, at which he argued against the introduction of more channels and longer broadcasting hours on the grounds that they would unleash a torrent of rubbish. He regarded over-production as 'much the most serious danger to television'.[37]

The historian of Independent Television, Bernard Sendall, who had worked closely with Clark, shrewdly summed up his time at the ITA: 'Kenneth Clark was a kind of Jekyll and Hyde in television affairs. There was the Jekyll who launched ITV and saw it through its initial difficulties with brilliant success. He was tolerant and considerate and displayed infinite resource. He withdrew after three years, to the universal disappointment of his ITV friends. He states that he was not asked to stay on and hated leaving. There was the Hyde who subsequently presented disparaging and destructive evidence to the Pilkington Committee. He was an aesthete and an individual, and yet in his dealings with the whole range of Independent Television, from the tycoons to the bureaucrats, he showed no hint of condescension.'[38]

Clark was given a lavish leaving party, to which all his friends from the companies came. One had a particular mission that night. For some time Lew Grade had been asking Clark to make arts programmes for ATV, as he later recalled: '"Kenneth, I would like you to do an arts piece on the great artists of the world." He said, "You can't talk to me about me doing any programmes while I am still Chairman of the ITA." The day he was due to retire there was a big party for him. I knew at 12 o'clock he would

terminate as Chairman and I kept looking at my watch. At one minute past twelve I went up to him and asked if he would do my programme. He said yes.'[39] Although Clark had already made several programmes, this was the true beginning of arguably his most successful career – as a presenter of the arts on television.

28

The Early Television Programmes

Since my first programmes I have never thought of the
camera for a second. I have felt that I was talking
to a friend, or more often soliloquising.

KENNETH CLARK, *The Other Half*[1]

Shortly after his resignation as chairman of the ITA, Clark took part in a
BBC panel discussion about the future of television with Jacob Bronowski,
who would one day present *The Ascent of Man*, the scientist's answer to
Civilisation.[2] Clark offered the opinion that television would not influence
art, but was culturally important in itself. Both he and Bronowski, however,
were hard-pressed to think of examples that might demonstrate this.
Nobody at that time could have foreseen that the two men were the answer
to their own question. Clark and his interlocutor were to produce the two
series that would define how culture could be conveyed on television, and
make a contribution to culture itself. However, before Clark made
Civilisation he presented or took part in nearly sixty programmes, which
helped to establish a cultural agenda on British television.[3] For a decade,
presenting television lectures was his main occupation.

Clark once gave his Arts Council colleague Alan Bowness a piece of
advice: 'If you want to do television you must dedicate yourself to it.'[4] His
early programmes are a curiosity today. Through them we can follow the
technical improvements in the medium that took place during the 1960s,
and his own growing ease with the camera. The studio-bound limitations
of his earliest black-and-white efforts – in which he is effectively delivering
a Slade Lecture on camera – are gradually replaced by the on-location
sophistication and colour of *Royal Palaces*. Clark and television were
growing up together, and he was learning how to charm an audience. He
was never to be a television 'personality' in the sense of John Betjeman or

A.J.P. Taylor – Clark was a populariser without being populist. But in a world of only two channels he often achieved higher audiences for his ATV programmes than he later did with the vastly more influential *Civilisation*.

Lew Grade gave Clark a very clear instruction: he wanted him to tell people about art in the same way that Clark spoke to him on the subject, which he found mesmerising. Denis Forman thought that 'although Lew was the most philistine of moguls, he was a simple man who recognised something that worked'.[5] Val Parnell and Lew Grade's company, ATV, which had the franchise for the weekend in London and weekdays in the Midlands, had emerged from show business. Clark's contract was as a consultant on programme planning, for which he was paid £2,500 a year. In addition he was expected to make between ten and fifteen films, for each of which he would receive an extra £200.[6]

ATV also provided him with a £53 television set; when asked what he watched, he said, 'I enjoy plays about detectives and policemen.' His problem was how to compete with these popular dramas. He planned a series entitled *Is Art Necessary?*, a natural development from his wartime BBC radio series *Art and the Public*. ATV put out a press release describing how Clark 'and distinguished experts will approach a wide range of cultural subjects with an adventurous spirit'. They were also to 'sharply illuminate conflicts of opinion'. Titles in preparation (they always posed a question, but not all were adopted) were: *Is Opera Absurd?*, *Is Art Necessary in Public?*, *Need We Talk?*, *Isn't he Beautiful?*, and one about contemporary architecture, *Is Your Cornice Necessary?* As Clark explained to Benjamin Britten when inviting him to talk about opera: 'The form of each programme is to take an art which can be made interesting by television, and begin by accepting, perhaps caricaturing, the philistine view about it, and then gradually winning people round to recognising that it is important after all.'[7]

The first programme to be made, *Isn't he Beautiful?* (1958), directed by Leonard Brett, opens with Colin Clark's enormous dog Plato, a Great Dane,[8] and a voice-over repeating, 'Isn't he beautiful?' It develops into a very stiff panel discussion, with a horse-breeder and a dog-breeder who calls Clark 'sir'. Clark described it as 'one of the worst programmes ever put on'.[9] Things improved with his intriguing second ATV film, which has only survived in fragmentary form, *Encounters in the Dark*, in which Clark and Henry Moore visit the British Museum after closing time in winter, flashing their torches at Assyrian sculpture and Egyptian heads. Clark was on home ground, and 'several people have said to me that I seemed much

more at ease in the British Museum film than talking direct to camera'.[10] So when he planned the next film, *Should Every Picture Tell a Story?*, he stuck to the same format – this time interviewing Somerset Maugham in the south of France about Victorian art, and his new acquaintance John Berger about the subject-matter of Picasso's *Guernica*. As he told the producer, Quentin Lawrence, 'the vitality of this programme would depend on Berger and myself getting into some sort of argument'[11] – which they did in a very polite way, discussing whether *Guernica* was a piece of popular art. Clark thought not.

The man who taught Clark to speak directly to camera was Michael Redington, who became his favourite producer. Redington, a genial and modest man, was an actor by trade who started at the Old Vic. He first became aware of Clark when an oversize bunch of flowers was delivered there for Laurence Olivier and Vivien Leigh.* When Redington joined ATV in 1955 he pioneered religious programmes for the so-called 'toddlers' truce', when transmission was interrupted so that mothers could get their children off to bed. His job in charge of Clark's programmes, he explained, 'was to put K at ease. My acting experience was very useful and I wanted to make K a bit of an actor himself'.[12] The first film they made together was *What is Good Taste?*[13] Clark by now maintained that all efforts to improve taste were a mistake – the moment you tell somebody what to do, it is no longer their taste. He had come a long way since *The Gothic Revival*, when he had believed that there was a rule of taste. What made this film memorable was the ploy of Clark examining a so-called 'good taste' room and a 'bad taste' room, the latter including a hideously bad-taste sideboard from a hotel in Shrewsbury, 'so monstrous as to be amiable'. He smoked a small cigar as he moved between the 'bad taste' room, with flying ducks and heavily patterned wallpaper, and into an all-white, modernist 'good taste' room. Clark's sympathies lay with the former, which he thought showed more humanity. *What is Good Taste?* was watched by three million viewers; it was the first of the series to be considered successful. Redington said, 'People loved *What is Good Taste?* And from then on I think we caught the right note.'[14]

Clark rapidly realised that good arts television had three ground rules: every word must be scripted in advance; viewers require information, not

* In 1950 the Clarks gave Olivier a walking cane. They had a tendency to shower genius with expensive presents and flowers: Margot Fonteyn, Kathleen Ferrier, Benjamin Britten, T.S. Eliot and others – but Jane was naturally generous to everybody.

ideas; and the commentary must be clear, economical and energetic. The early programmes were usually live transmissions, so it was essential to plan every detail in advance. Redington and Clark adopted a regular way of working together: 'K would write the scripts and give me a list of pictures in his tiny handwriting, which we would then have to find from around the world, and blow them up for the studio. He would always start with the pictures and then write the scripts to the pictures.'[15] After that Clark would ask his secretary, Audrey Scales, 'to transfer the scripts to postcards, although he would try and learn them by heart. Irene Worth coached him a bit and he would walk along the seafront at Hythe practising and consolidating his lines.'[16] On transmission night, ATV would send a car to take Clark to the converted studios at either the Wood Green Empire or the Hackney Empire (Val Parnell had come up through variety, and the early ATV television studios were old music halls). Redington remembers: 'We would go through a practice run with K and then leave for dinner, usually at a station hotel [station hotels were usually good places to eat in 1960s Britain], St Pancras, Liverpool Street or Euston, depending which studio. K would always say, "I have ordered the wine," in a very debonair fashion, then a car would take us all back to the studio for transmission at 10.30 p.m. There was always a very good atmosphere in the studio and K had a teleprompter. He was extremely professional and very rarely fluffed a line. At the end I would throw up my hands and say, "Well done! K Clark has done it again!"'[17] Clark formed a very good rapport with the film crews, as Redington attested: 'We never had any trouble with him and he was always at ease. We knew nothing of his private life.'[18]

The *Is Art Necessary?* series came to an end in 1959 with a particularly awkward programme, *What is Sculpture?* Clark felt something was wrong with the programmes, and called a meeting at his office in St James's Square. He told Redington: 'They're not working, are they? What we want to do is tell stories, that's what people like, isn't it, a narrative.' The solution was a new series entitled *Five Revolutionary Painters*, featuring Goya, Bruegel, Caravaggio, Rembrandt and Van Gogh. It proved to be a very successful format, and looking back Clark described the effect of the programmes to Ben Nicolson: 'I remember how all the porters at Charing Cross used to talk to me about them, and [the publisher] Alan Dent was astonished to encounter a conversation about *Caravaggio* in a pub in Covent Garden.'[19] Clark enjoyed the attention: 'I like being a film star.'[20] The *News Chronicle* thought that *Five Revolutionary Painters* were the best programmes Clark

had made, but noted his awkward pose – 'a steady unblinking profile like one of Peter Scott's marine iguanas'.[21] If Redington and Clark were stung by this criticism they certainly acted on it, because in 1960 they made the programme which is a milestone among Clark's television appearances.

The 1960 Picasso exhibition at the Tate Gallery was hugely anticipated by a London still uncertain what to make of the artist. Clark persuaded the Tate to let ATV film the exhibition in the very short interval between hanging and opening. There were many critics who knew more about Picasso than Clark, but his was a reassuring presence to viewers, particularly as he was only a half-believer. The man who had told them about Rembrandt could be trusted on Picasso. The film could not be shot live, as Clark and the crew were only allowed into the exhibition at six in the morning on Sunday (for a Monday-evening transmission), and they had to be out of the gallery by 1 o'clock for the public. It was Clark's best performance to date, full of energy and vim. As he looked at *Les Demoiselles d'Avignon* he exclaimed: 'Now we are off! Modern painting has begun.' He was fascinated, but not entirely convinced, by *Les Demoiselles*, and had the courage to say so, characterising the artist as 'an entertainer and incomparable clown'. He generally preferred Picasso's abstract pictures to his representational paintings, and referred to each change of style as an 'eruption'. He described Picasso's love–hate relationship with the human form, in which hate got the upper hand – 'It is doubtful how far an art form will go based on hate' – and spoke of the 'shocking reality of Picasso's abstractions'. He regretted the lack of drawing and sculpture in the exhibition, and admired Picasso's 'throb of creative power'. The film is a *tour de force* of memory and coordinated movement: walking and talking under pressure of time from room to room without stumbling over the carefully composed script. The choreography between words, body movement and objects is mastered. As Fram Dinshaw remembered: 'The early TV programmes are imbued with condescension. The change comes when he takes the viewer round the Picasso exhibition and is himself for the first time.'[22]

Clark, however, was worried that he was getting stale, and told Bob Heller,* a senior executive at ATV, 'it is certain that my talks on art will exhaust themselves fairly soon and that the viewer will want a fresh face and a new approach'.[23] Clark's solution once again was to change the subject – this time to architecture. He suggested that 'as the BBC has

* Heller was an American who went from CBS to Granada, and then to ATV. He always wanted social commentary – Clark would say, 'There's Bob's social comment.'

specialised in savages, black people, and animals, could they do a series on Cities, not just picturesque ones like Rio but a new Russian town?'[24] The idea developed into his making three programmes with the architectural critic and apologist for modernist architecture, Reyner Banham.* Clark was disappointed by most modern architecture, and as time went by he became an increasingly vocal conservationist, but in 1960 he was still trying to come to terms with modernism and relate it to the great buildings of the past.

He was on surer ground when he proposed making a series on *Great Temples of the World*: San Marco in Venice, Chartres Cathedral and Karnak. Bob Heller responded with a resounding yes, and added percipiently, 'you are unmatched as an interpreter of civilisations from the monuments and the objects'.[25] It took four years before this series went into production, and – to Clark's chagrin – Michael Redington was not available to produce it. He described filming *San Marco* at night: 'My producer is an amiable gorilla, very slow and stupid, who occasionally has thoughts which he wrestles with like Laocoon while his camera crew stand round in undisguised impatience. The cameraman is excellent, and with him alone I would have done the job in two days'.[26] The writer J.R. Ackerley happened to watch *San Marco*, and pronounced it 'sheer magic', but others thought the *Chartres* programme more successful, because Clark loved the place so much.[27] *Karnak* was the most comical, because although some of the shots were done on location by local cameramen, most of the script was delivered by Clark in a London studio, wearing a white golfing hat with an enormous photograph of the pyramids of Giza behind. The general verdict was 'hokey as hell'.

In 1965, *Contrast* magazine voted Clark's art lectures the most memorable and significant programmes on television, ahead of *World in Action* and *Coronation Street*. This was a vote of critics rather than the public, but Clark was by now, unassailably, the leading TV art historian. Everybody wanted him to talk about contemporary art, but he said that needed colour – which had not yet reached British television – and recommended that Bryan Robertson of the Whitechapel Gallery should be brought in, as a younger man more in touch with contemporary art. The BBC went on

* Clark's secretary Catherine Porteous notes that when young people sent him their PhD theses, Clark would sometimes mischievously respond that he was not knowledgeable enough to make helpful observations, but was sure that Reyner Banham would be most interested.

trying to reclaim Clark,* and in 1965 a project came up that involved both it and ITV. Two very presentable producers, David Windlesham and Tony de Lotbinière, had been appointed to work with Lord Cobbold, the Lord Chamberlain, to make a film about the royal palaces. This was a very considerable coup. Never before had television cameras been allowed into the palaces, and an important precedent was being set. The Queen had to approve all the arrangements. Jackie Kennedy had already taken television cameras into the White House, and during the early 1960s there had been growing pressure on the royal household to do something similar. The first discussions took place between the Lord Chamberlain and Lord Hill of Luton for the ITA, but it would have to be a joint BBC/ITV production (as had been the funeral of Winston Churchill in January 1965). All the palaces would be made available for filming when the Queen was away: Buckingham Palace, Brighton Pavilion, Windsor Castle, Holyrood and Hampton Court. Clark was the obvious choice as presenter, and nobody else appears to have been considered, although in retrospect Clark himself felt the arch-royal historian Sir Arthur Bryant should have been chosen.

Clark was initially offered a derisory £100 per week for fourteen weeks' work (four weeks' preliminary work, six weeks' shooting and four weeks' editing). He rejected this, and negotiated a £4,600 package which included his £2,500 annual consultant's fee to ATV, plus £2,000 for the programmes and £100 for a book.[28] He was unenthusiastic about the project – it was a return to a world he had left behind – and never really gave it enough time, as he told Janet Stone: 'Endless bother over Royal Palaces on TV. I don't want to do it, but it is very difficult to get out of it when everyone asks me, and my company say it will give them great credit etc. I am longing to get back to *Motives*, which I have glanced at, and think could be my best effort.'[29]

The script in places reflected Clark's state of mind: 'Charles II didn't care about anything, as long as he was not bothered.' But Clark, with his experience of life at Windsor, was concerned about the palace officials. The Lord Chamberlain's office did request the script for scrutiny, if not actual censorship, which Clark thought might be imposed.[30] Clark told Lord

* In 1965 the BBC was already suggesting 'an ambitious series of visits to some of the Treasure Houses, Galleries, Museums, Palaces and Cathedrals of Eastern and Western Europe. We want this to be the "Grand Tour" of someone who can interpret their significance and dilate on their contents.' See letter to Clark from W.G. Duncalf, 13 January 1965 (Tate 8812/1/4/55).

Crawford, 'The Lord Chamberlain's office are longing to find fault with it, and are in a rage because I have refused to submit the script.'[31] But when the Queen asked to see the film in an early cut, in time to make alterations, this could not be ignored. (In the event this screening took place too late for any meaningful changes to be made.) Clark had become used to a rather jaunty presenting style at ATV, full of asides which brought his subjects to life. How could he get through *Royal Palaces* without an ounce of irony? As he confided to Janet: 'I worry a lot about my Royal Palaces. Every time I see the people it is clear that what they really want is a sort of Arthur Bryant script, and I can't do it. I still feel that I may give it up – it is so much *not* my line.'[32]

The making of *Royal Palaces* was, however, important for the future. The production quality was much higher than normal television, as the programme was shot on colour 35mm like a feature film, although it was broadcast in black and white. Many of the techniques of outside broadcasting and lighting that would be crucial to *Civilisation* were pioneered on *Royal Palaces*, and some of the crew were to work on both productions, notably the cameramen 'Tubby' Englander and Ken Macmillan, with whom Clark established a particularly warm relationship.[33] Macmillan describes the scene: '*Royal Palaces* was my first job and involved a lot of technically rather tricky moments. It was the first time anybody filmed at the palace and we were allowed to park our cars in the central courtyard because the monarch was away. K was very practised at talking and walking and good at timing. A real professional. K appeared in only a limited number of shots because the lighting in the palaces was poor and we needed extended exposures, which were far too slow for human movement and speech.'[34]

The programme opened with Clark on the balcony of Buckingham Palace. He then turned his back and went inside, the camera accompanying him into the rooms behind the façade. Clark's script was lively and generally enthusiastic, but adopted an aesthetic criterion rather than a historical one – occasionally damning with faint praise. When it was completed, the Queen was booked in for a screening at Buckingham Palace at 6 p.m. on 19 October 1966, with the Duke of Edinburgh, Lord Cobbold and various palace officials, as well as the two producers. Clark takes up the story to Janet: 'All did *not* go well when I showed it to the monarch. She was *furious*, and would have liked to stop it, but couldn't find a pretext for doing so – not a single disrespectful word or sentiment (except that Henry VIII was fat!). All she could say was "it's so sarcastic" – which means devoid of the slop and unction to which she is conditioned.

She didn't say a word about the photography which is excellent and wouldn't speak to my poor producer. The courtiers were confused. I had foreseen all this but in a way it's remarkable that my lack of enthusiasm for the monarchy should have oozed through my extremely respectable (and very dull) script.'[35]

Clark saw Cecil Beaton shortly afterwards, and told him that the Queen swept out of the room, followed by her embarrassed courtiers. Prince Philip lingered behind, and asked Clark, 'How do you *know* the people guzzled at the palace banquets?' To which he answered, 'Because half the population was undernourished. Few had good meals. This was the occasion for a tuck-in.'[36] The only member of the royal family who showed any interest in the film was Prince Charles.

The producer wrote to Clark the following day, commiserating: 'It must have been for you a disheartening and wounding reaction to the film last night: although perhaps one that you had anticipated.'[37] The Queen's private secretary, Sir Michael Adeane, tried to put a positive face on the matter: 'Actually I think that the Queen and Prince Philip liked it a lot but as the object of the session was to criticise they criticised and I think that this is a sign of great interest in the subject.'[38] There is no question that *Royal Palaces* was a disappointment to the Queen and Prince Philip. They had been used to complete deference on the airwaves from the BBC, and no doubt believed that on the first occasion on which they opened the palaces to the cameras they might expect it. Looking at *Royal Palaces* today, it is hard to see what all the fuss was about, but to a monarch used to the honeyed tones of Richard Dimbleby, Clark appeared facetious and critical. The criticism is virtually inaudible to a modern audience which is now acclimatised to a historical treatment of the Queen's forebears.

To the world beyond the palace, the programme was a great success. Cecil Beaton summed up the general view: 'It was interesting, with, for once, a running commentary by someone with a first-class brain and an extraordinary knowledge ... he brought greatness to the subject ... he talked of kings and queens as real people in history. He criticised from a very lofty plane some of the works of art in the palaces and although giving credit where it was due, was probably a little condescending about the position of Zoffany.'[39] *Royal Palaces* was by far the most important heritage programme shown on British television to date. Its sophistication and technical advances pointed the way to *Civilisation*, but more importantly, Clark's relaxed and *soigné* performance made it inevitable that he would be the presenter of such a series. The BBC had claimed back their man.

29

Saltwood: The Private Man

*Like all civilised men they kept their
life in separate compartments.*

KENNETH CLARK, *The Three Faces of France: Manet* (ATV)

Life at Saltwood provided many of the ingredients of an idyll. The castle was both comfortable and romantic, and gave the Clarks what they most desired: privacy, peace, a garden for Jane and the magnificent library for Kenneth. He wrote excitedly to Janet Stone: 'I am *longing* for you to see [Saltwood], for no photos or engravings do it justice. It is really more a piece of landscape than a house, and takes on the character of the weather.'[1] The seventy-mile distance from London gave them a degree of separation, but visitors were not put off, arriving for lunch at Sandling station two miles away. As Clark told Berenson: 'All goes well as long as I can be at Saltwood from Friday to Monday – without that I degenerate. My whole aim is not to have guests. I love seeing friends, but for meals only: if I feel that they are keeping me from my work or the garden my love turns instantly to loathing.'[2] It was a question of running a tight timetable and not allowing visitors to interfere with the day's work. We can follow Clark's life at Saltwood in intimate detail through the letters he wrote to Janet Stone.

Clark always ran his life to a very ordered schedule.[3] He would work from six to eight in his dressing gown, on his books and lectures. Breakfast was laid out on a tray in the kitchen by the staff, and then Clark would inspect the 'day diary' by the back door to see if anyone was coming for lunch, and view the menu. He would disappear after breakfast to work in his study off the great hall – where there was no telephone – until 10.30 a.m., when he would return to the 'house' to give dictation to his Saltwood secretary and then phone his London secretary at Albany. He would then

go back to his study to work in his chair in the window. Cheques and less agreeable mail would be dealt with at the big desk. At 12.45 he would walk briskly across the bailey lawn to pre-lunch drinks in the panelled library (confusingly, although this room, which served as the Clarks' sitting room, contained a bookcase, the library was actually housed in the great hall). Guests were invited promptly at this hour – if they were late Jane was understanding, but as the librarian/archivist Margaret Slythe commented, 'for K, it often seemed as if he had been personally insulted'.[4] Depending on the interest and importance of the guests, coffee would be served either at the table (if he wanted them to leave) or in the library. Very rarely guests would be considered 'cake-worthy' and invited to look around the castle (without their host) and have tea at 3.45 before being shown the door. The Clarks always had a siesta after lunch. Another hour's work would follow, until drinks at around 6.30 p.m. If Jane was in a mellow mood, Clark would spend the time before dinner writing personal letters – usually to his girlfriends – and would leave several envelopes to be stamped and posted the following day.

The staff at Saltwood consisted of Mr and Mrs Emberson, factotum and cook. The butler was Mr Cloake, whose wife was the parlourmaid. Isa Mackay looked after the linen cupboard, and there were various housemaids, making altogether eight indoor staff. Out of doors there were three gardeners. Maintaining this household meant the Clarks were living well beyond their income, which they had to supplement with the sale of paintings. Clark was continuously anxious about money, as he told Janet: 'What a bore it is that one can't just forget about money – set a course and live by it as one can when piloting an aeroplane. However, I suppose that each age has its own way of distorting one's equanimity, and in the 19th century I should have been continually harassed by doubts about the Trinity.'* With the Labour government's introduction in 1966 of supertax – as immortalised by the Beatles' song 'Taxman' – Clark was forced to reduce the number of indoor staff, and he and Jane were looked after by an Italian couple: Maria the cook and her husband Pasquale, who acted as butler, chauffeur and valet. They shared most of the housekeeping duties, and would return home each summer for a few weeks, which left the Clarks bereft, as neither had any cooking skills. Jane's interest lay in the garden she had created

* Letter to Janet Stone, 5 May 1955 (Bodleian Library): 'A very depressing interview with my financial advisor. I had been far too careless, and if it wasn't for my pictures I should be BROKE.'

within the castle walls, with long herbaceous borders useful for the house flower arrangements. She was very knowledgeable about plants, often placing them in an original manner, and inspected the garden every day, usually with Cradduck, the head gardener, who lived in the lodge.

After lunch on Monday the car would be packed up with flowers, food and clean linen, and in the early days the Clarks would be driven to London. As traffic conditions deteriorated they resorted to the train, either from Folkestone or from Sandling station, where they were treated like royalty because Jane, who knew everybody by name, tipped them all so lavishly. Jane gradually spent more time at Saltwood, and Clark would go up to London alone, which probably suited him. He would return on Thursday, in time for tea. As Colin wrote: 'My father, who would usually spend part of the week with his mistresses, would be in a jolly mood, pottering about and uncorking bottles of wine.'[5]

The Clarks enjoyed entertaining old friends at the weekend: the Moores, Pipers and Sutherlands, Margot Fonteyn, the Oliviers, Spenders, Andersons, Droghedas, and Yehudi Menuhin. Some guests, like E.M. Forster and David Knowles,* were modest and unassuming, while others, like Penelope Betjeman, talked too much, Clark thought: 'At meals etc she is too dominating a personality – I believe saintly, and like all saints an exhibitionist and unwashed. I doubt if she ever has a bath, or removes the lower layer of her clothes … I really rather liked her.'[6] When Alan invited the military historian and savant Basil Liddell Hart to stay, Clark observed: 'he is obviously in the habit of being heard with respect and it wasn't easy to persuade J[ane] that she should let him talk uninterruptedly.'[7]

They began to ask attractive younger couples, such as Colette's friends Caryl and John Hubbard. Caryl often did research for Clark, who admired her husband's paintings. New names start to appear in the visitors' book, notably Burnet Pavitt, a wealthy bachelor who was on the Covent Garden board, became a regular visitor and would be best man at Clark's second marriage. The Queen Mother spent the night of 28–29 June 1957 at Saltwood before crossing the Channel to unveil the Dunkirk memorial:

* 'Morgan Forster was *adorable*. We loved every minute of his visit, he could have stayed for weeks and we should have been glad. He is the only moral force I have encountered since Bishop Gore.' Letter to Janet Stone, 24 February 1960 (Bodleian Library). Of David Knowles' visit, Clark wrote: 'a great and holy man, but so unassuming that one finds oneself doing all the talking and pushing him around.' Letter to Janet Stone, 7 August 1962 (Bodleian Library).

she came with a large retinue of staff including her private secretary, lady-in-waiting, valet, lady's maid and chauffeur. The Clarks had engaged Julian Bream to give a short lute recital after dinner, but for some reason this never took place.

Neighbours were very rarely encountered at Saltwood, except Colette's friends John and Anya Sainsbury,[8] who had built a modernist bungalow nearby, and were already forming a distinguished art collection. Clark rather enjoyed visits to a local major, 'who was an azalea grower and had a veranda from which he would inspect his garden like a company of soldiers'.[9] Not all their guests were impressed by a visit to Saltwood. John Mallet, the son of Clark's friend Victor, the former Ambassador to Sweden, found 'Lady Clark could hardly have been more vulgarly unwelcoming ... perhaps the trouble was that she had hoped for a long spell of genius-talk with Aldous Huxley, who was stretched lankily in a chair in the sitting-room when we arrived ... Sir Kenneth showed us his library and was attentive to us, and one would have said kind, had not the total effect of his attentions left one feeling a little chilled. He has a marvellous brain, hard, brilliant and cold as a diamond.'[10]

Very few of Clark's professional colleagues were invited for the week-end, an exception being the future director of the National Gallery Michael Levey, and his novelist wife Brigid Brophy. Their arrival alarmed Clark: 'I rather dreaded his wife, who is said to be a figure who crunches up the skulls of middle-aged men of letters. She showed no sign of this, but was no doubt taking notes for future use.'[11] John Hubbard described a weekend at Saltwood as 'full of jokes and stories – not particularly intellectual'.[12] On Saturday afternoon guests were likely to be taken for a visit to Canterbury Cathedral, or Romney Marsh with its ancient churches, or Hythe with its Napoleonic canal. Clark enjoyed walking – Jane never got further than the edge of the estate – part of the incentive being the dogs, Plato the Great Dane and star of *Isn't he Beautiful?*, 'a noble character but not very clever', and Emma the Dachshund, a highly intelligent and convivial animal. Clark adored them both, and wrote movingly about their intuitions and deaths in his memoirs.[13] Visitors to Saltwood were kept busy all weekend, and as Margaret Slythe observed, 'most went home exhausted, both phys-ically and intellectually'.[14] Clark was certainly pleased when they had left, and reminded Janet of a well-worn family tale: 'You remember the story of the late-staying guest, who had been to the lavatory, and as he emerged heard me saying to our old dog, "isn't it wonderful, they've all gone." Well, they have.'[15]

Clark was ambivalent about Christmas at Saltwood. On the positive side, it meant the arrival of Maurice Bowra and John Sparrow, but it also brought out Clark's inner puritan: 'five days of guzzling and drinking, and guests sitting *doing nothing* but smoke and jaw. I loathe it.' John Sparrow was an easy guest, 'unlike Maurice who never opens a book'.[16] Clark described Bowra one Christmas: 'He settled down to his usual talking marathon … at least 16 hours at a stretch. As Irene [Worth] was in New York, Robin Ironside had to bear the brunt of it and played up marvellously. I must say that Maurice was really adorable – so warm hearted as well as clever.'[17] John Sainsbury was fascinated watching the three old friends together: 'John, Maurice and K were very intimate and spoke in a private language.' Colin tells how they would get out *The Oxford Dictionary of Quotations* and challenge each other to say who wrote what and when. They would occasionally insert statements from Clark's books to see if anybody identified them: '"The great religious art of the world is deeply involved with the female principle." "Goodness, what nonsense! Who can have said that?" "Kenneth Clark …"'[18] The main risk of Christmas week, however, was the chance of the rows that were always too apt to break out whenever the Clark family were gathered in one place.

Although the Clarks wanted nothing to do with the county set – shades of Clark's parents in Suffolk here – he was prepared to involve himself in local causes, particularly when church repairs were involved. The village cricket pitch was on the edge of the property, and he told the club's secretary: 'I value my connection with the Club and would be very glad to attend your next annual general meeting.'[19] They lent the castle for local cancer charity evenings, and Clark gave his support to various Canterbury Cathedral appeals.[20] He would lend his name to church fund-raising, offer to write to grant-giving bodies, give a lecture or occasionally send a small cheque. When the Saltwood parish church asked for money he agreed to pay for a new altar, using a local carpenter. He was very cautious about his good causes, and as taxation eroded his disposable income he confined his giving to artists and the preservation of buildings: the Anglo-Italian historian and grandee Harold Acton was shocked when Clark refused to support an appeal for the British Institute in Florence. Although princely in his generosity to artists, Clark was by nature very thrifty – as his staff would discover. He once described himself as 'when alone mean and punctual as any old maid in a lodging house'.[21] People certainly thought Clark was richer than he was, but when they visited Saltwood that was

understandable – his money was all on the walls. Besides, he had a very expensive family, constantly in need of cash.

The Clark children had grown up with very distinctive personalities. Alan and Colin demonstrated sibling rivalry to an extraordinary degree, but both boys were rather frightened of their parents. Alan always maintained that Colin had a psychological need to be conned, and on occasion took advantage of Colin's hopelessness with money himself. During the 1950s they were in their 'cars and girls' phase. Both had a weakness for expensive marques, and although Jane was the first to force their father into writing a cheque when they were in trouble, in general her mantra was: 'Don't give the boys any money, they will only spend it on cars.'[22] Alan was frequently what his parents called *rébarbatif*, and made his views known in strong terms, whatever the subject. He enjoyed bringing his girlfriends to meet his famous parents at Saltwood – one of them, Pam Hart, remembered trying to cut a fresh salmon on the sideboard at Saltwood through the bone, to which Clark said, 'That's a bold stroke, my dear.'[23] In one of his letters Berenson asked Clark about the children: 'I want news of each member of your family, particularly of the "problem-child" Alan. He fascinates me.'[24]

Clark indeed had important news to give BB about Alan, who was now twenty-nine years of age: 'My dear BB I wonder if you have heard that our Alan is getting married. The whole episode is characteristic of his oddity. [Alan had fallen in love with Jane Beuttler, a fourteen-year-old girl who lived near him in Rye.] After a time the parents became alarmed, & took her away to Malta (her father is a Colonel in the Army) where, in classic style, they destroyed Alan's letters to their daughter, and hers to him. However, when she came back they were equally devoted to each other, and soon after her 16th birthday Alan came to us and said that he wanted us to meet someone whom he wanted to marry. The first we had heard of her, of course. Fortunately she turned out to be most attractive – charming to look at and with none of the silliness or self-consciousness of most young girls. So we spurred him on, and her parents consented, and the marriage takes place on the 31st of this month. It seems to me no more chancy than any other marriage. Alan is capable of great devotion, and will really try to look after his little shrimp.'[25] The bride's parents, after a long pause, had finally agreed to the wedding, realising, as her father put it to Clark, 'You might as well try to stop Arab nationalism,' a remark he much enjoyed.[26] The reception took place at the Arts Council in St James's Square. Clark became very fond of his daughter-in-law. He told Janet that

Alan was 'a strange mixture of childishness and maturity. Lots of brains, and lots of prejudice ... little Jane is like a crisp little bird – a dipper or something of the sort. She has lots of sense and misses nothing.'[27]

Clark was surprised, exasperated and amused by Alan, who he realised had much of his own boisterous father in him. Colin on the other hand was a gentler character, although just as predatory as his brother with women. Where Alan would settle down to become a military historian and later a politician, Colin's career in the film business was more fractured. Denis Forman, who gave him a job at Granada, described him thus: 'Col had all the family charm – underrated by the family – but he was too rich. However, he worked beautifully for me. Col had a very sweet disposition, a little effeminate with no fire in his belly. He was not a good producer as he wasn't tough enough. Col was afraid of K – he would duck a phone call or writing a letter.'[28] Colin was in perpetual financial crisis, and would eventually pluck up the courage to approach his father, who would look very grave and listen carefully and then think for a while: 'Yes, Col that is bad ... that is very bad.' And then he would go back to writing on his knee, but at this point Jane would intervene and come bursting in with, 'Colin needs a cheque K.' He hated writing cheques, but he could refuse Jane nothing.[29] Colin had always been Jane's favourite, and was protected as such, but he also had the capacity to destabilise her, as his father knew only too well: 'Col called in on the way to France and that always ends in tears literally, for hours. He is such a dear, but his Mama is too fond of him, and grows hysterical from 12 hours before he is due to arrive.'[30]

Clark's ambivalence about his younger son (and absence of parental support) emerged when Colin fell in love with and wanted to marry the rising ballet star Violette Verdy.[31] Clark told Janet: 'At first sight a typical well-brought up French girl, but on further acquaintance very intelligent and perceptive. I quite see why her friends in New York are furiously saying that she is too good for Col.'[32] As the day neared, his premonitions got worse: 'Oh dear I do pray that all goes well – I wouldn't be in Violette's shoes for all the tea in China.'[33] The wedding took place at Saltwood parish church – where there was a scuffle between the two organists over the wedding march – followed by a grand reception at the castle. It was the first time the castle's resources had been extended. 'Everybody seemed happy,' Clark commented, 'but I was not.'[34] His worst fears came to pass, and the marriage came to a rapid end. Colin was to marry twice again: the first time, for over a decade, to Faith Wright, the half-sister of his best friend Tim Rathbone;[35] and the second to Helena Siu Kwan, who survived him.

Colin's twin Colette had a successful career as a director of the Royal Opera House. She was the only one of the children that Clark loved unreservedly; his affection was reciprocated, but this carried an inevitable price with Jane. She and Colette could not get on with each other at all until 1967, when Colette gave birth out of wedlock to a son, Sam, by the painter Tony Fry. This was a brave choice at a time when illegitimacy still carried a social stigma, and the Clark parents, for all their liberalism, subscribed to such conventions. But after the initial shock they gave her their full support, as she told her godfather, Maurice Bowra: 'The old Clarks behaved better than I have ever known them – totally understand all my feelings, believed I had made the right decisions. Mama even took the thought of telling the servants completely in her stride.'[36]

The Clarks' London apartment at B5 Albany was on the second floor, and consisted of four rooms: hall, sitting room with double doors to the bedroom, and a tiny lavatory with three Constable drawings in it.[37] It was far from luxurious – the kitchen and bathroom were the same room. The bath had a hinged lid which came down to make a workspace for the cook, Joan Dawson, who would come in about once a week: 'I started with the oldest gas stove you have ever seen,' and sometimes 'Sir Kenneth would be shaving at one end of the kitchen while I was scraping potatoes at the other end.'[38] Mrs Dawson adored her boss: 'He had the most charming manners imaginable. Jane was also charming but less reliable and her manners became more charming as she became drunker. He would very much enjoy talking to me about the art in the flat. When you watch *Civilisation* that was exactly what he was like.'

Clark made most of the arrangements, and Mrs Dawson still has the menu book with the names of the guests, and what they ate: Cecil Beaton with Francis Watson, director of the Wallace Collection (pheasant pâté, grilled sole parsley butter, salad fennel and butter, lemon sorbet), Duncan Grant (prawn Sicilian, kidneys Lorraine, strawberry sorbet), and the Duchess of Westminster (eggs Mimosa, escalope with cream beans, peas, new potatoes, green salad, raspberry sorbet). She recalls: 'Lady Clark would bring the principal guest into the kitchen to say thank you. Sometimes they were absolutely charming, like Sir Ralph Richardson, who concealed a £20 tip. Others, like the American Ambassador, Walter Annenberg, looked bored beyond belief and were astonished to be taken into such a lowly kitchen merely to meet the cook. Sidney Nolan once sent a painting of a cyclamen as a thank-you

after lunch and Sir Kenneth said, "I think this belongs to both of us," and put it up in the kitchen.'[39]

Gill Ross came to work for Clark at Albany in 1960. 'There was an advertisement in the personal column of *The Times* that Sir Kenneth Clark was looking for a PA. No salary was mentioned but there were 120 replies. K was by nature very tight with money. I worked on *Landscape Into Art* and only really got paid by the TV company when it was turned into a programme, as I was the researcher. K said, "When I put letters on that bed, I don't want you to answer them." They were all begging letters, of which there were dozens. Jane was always interfering, and she did exactly what suited Jane.'[40] Clark was forgiving when things went wrong: 'I once lost the manuscript for a lecture (K always wrote by hand), and he was very kind about it, but he had to rewrite the whole thing.'[41]

When not lunching at home Clark would go out to a restaurant, at which he would choose his guests' food: Wheeler's in Jermyn Street, Overton's in St James's, the Brompton Grill in Knightsbridge or the Ivy near Covent Garden. Dover sole was his preferred main course, and he never chose expensive wine. Henry Moore's daughter Mary recalled: 'Henry and K would meet every week if they were in London at the Café Royal Grill Room, where they always had a corner table. Afterwards they might view a saleroom, and once bought a Kuba mask after lunch.'[42] In the evenings when in London Clark occasionally went to a music hall, a hang-over from childhood, and was known to go to the Victoria Palace to watch the Crazy Gang. He rarely enjoyed official dinners or dinner parties, but usually accepted invitations to foreign embassies, despite the attendant risks – Jane fell off every embassy chair in London, occasions known to the family as her 'tumbling'.

Jane, meanwhile, was bored, lonely and spoilt. She had no female friends, and her admirers had moved on; she presents an increasingly sad picture. Apart from the garden at Saltwood she had few interests beyond her husband's work, of which she was both proud and censorious. She worshipped and tormented him in equal measure. Both Clarks were hypo-chondriacs, and consequently many of their letters concern health. In 1952 Jane became very ill with one of her unspecified problems, and spent a long time recovering at a convent nursing home. Clark always knew that for him, 'action is the healthiest drug, and I dread the various forms of melancholia which accompany inaction'. Although he was only fifty-three, he told Janet in March 1957: 'The trouble is that I know I have jumped

down from one ledge to another – for growing old is a series of jumps – how I wish I had known you two ledges higher.'[43] Jane was only too aware that she had many rivals, but how far did she know that her aggression was driving her husband away? No doubt her behaviour was aggravated by his affairs, but she behaved in a similar fashion towards her children. Clark poured out his troubles to Janet: 'Family affairs still rather uneasy owing to J's appetite for tragic scenes, which has been stirred up lately and so is prepared to seek nourishment anywhere.'[44] He had both work and girl-friends for consolation, but Jane had nothing except alcohol; it was an unhappy reminder of his father's fate.

The presence of the children usually made Jane even worse: 'In fact it was the first time for years that all five of us have been together for a few days without some sort of flaming row blowing up – always started by Jane, who seems to feel a psychological hunger for such manifestations.'[45] Only when she had a few drinks inside her did Jane calm down and become sweet; she would carry her 'cough medicine' in her handbag. Colin makes the point that 'My father never failed to support my mother, never. He was always worried about her, when he was away filming he rang her, wrote to her every day. He was completely obsessed with keeping her in as good a shape as he possibly could'[46] – although he was not above giving her a drink so as to be able to get on with his work. He liked a strong whisky himself in the evening, and realised that to take Jane off alcohol would mean abstention for them both.

Clark was certainly gallant towards Jane when she fell off chairs in public, and various medical excuses would be offered. Many were surprised and impressed by his patience, but she had invested her life in his great-ness, and she would use whatever hold she could over him. Jane was unpredictable – John Mallet wrote of the 'total worship (nauseating to outsiders like ourselves) he gets from his wife',[47] but the next minute she would be encouraging a young museum official to disagree with her husband: 'That's right, don't let him get away with it.'[48] She had a tendency to show off – Alan Pryce-Jones recalled once meeting her in the forecourt of Albany when she was about to go to Sweden, and offering her a friend to look up: 'Oh,' said Jane, 'do give us a letter. We should love to meet some ordinary people. We never see anybody in Sweden but the King.'* Clark

* Alan Pryce-Jones, *The Bonus of Laughter* (p.187). This was a recurring theme: Jane once told the decorator Nicky Haslam, apropos of nothing: 'The last time I was reading the Bible was to the King of Sweden' (*Financial Times*, 5 June 2014).

continued to nurse tender feelings towards her, and quoted Thomas Browne: 'Then I think of my poor Jane "as for this world I count it not as an inn, but as a hospital, and a place not to live but to die in".'[49]

Outside the family, the dominating figure in Clark's life during the 1950s and 60s was Janet Stone. The letters they exchanged are like no others that he wrote; they have the candour and freshness of new love, but through them we also follow his marital torments and professional anxieties. For Clark they were a safety valve through which he let off steam – or as Janet herself put it, 'I was his sink.' She allowed him to be himself, and he would confess to her: 'Your dear letter found me in the depths of gloom – you mustn't think I am anything but a weak, selfish, fraud. I spend my life breaking promises and letting people down – often out of sheer inertia.'[50] The letters are also the first time that he wrote substantially about himself, a first draft at autobiography.

Did Clark love Janet? No doubt he believed it when he wrote that he did, although he was never blind to her eccentricities: 'Janet is really a bit of a goose,' he would tell his secretary Catherine Porteous. She was amusing, original, and something of a lion-hunter, who enjoyed having artistic giants like Benjamin Britten and Iris Murdoch to stay at Litton Cheney. Her letters to him are charming accounts of her daily happenings, often written in the form of a diary with interspersions of 'darling, O MY DARLING I do love you so'. Clark would flatter Janet, a little smugly, by comparing her letters to those of the celebrated seventeenth-century correspondent Lady Dorothy Temple, but a chilling aspect of the story is that he did not always bother to read them – Catherine Porteous found a large box of them unopened at Albany after his death.[51]

This did not deter Clark from writing: 'I think a lot of our feelings for one another – what Henry James would have called our predicament. There is no doubt at all what has happened, the only question is, what will happen – and then I agree with you that nothing can take away a profound sympathy which we felt (I think) from the first moment.'[52] What Janet probably never understood until it was too late was Clark's 'system' of keeping several lady friends going at once – the fulfilment of Golly. Crucially, it provided the safety in numbers which was so important for both his protection and that of Jane. The relationship with Janet worked in precisely the manner that had evolved: letters and a monthly meeting in London. It is questionable whether Clark ever had any real intention of changing this routine, as time would reveal.

Clark would ask Janet to write to Albany, where Jane was less likely to intercept letters.* Telephone calls were also monitored: 'There is so much I can't say that in the end I say nothing. For years all telephone calls at Hampstead were listened in to (it isn't so easy at Salters where we have a different system) so that I got into the way of being very cagey to everyone.'[53] When in 1956 Clark went for the first time to stay (alone) with Janet and Reynolds Stone in Dorset, he was enchanted by their old rectory and the life it sustained: 'It was as the Italians say "quattro passi nelle nuvole"†... I had a feeling I thought never to experience again. First love plus happy childhood.'[54] He recognised at Litton Cheney the same civilised values of lives dedicated to art that he found with the Pipers at Fawley Bottom. Reynolds Stone was the supreme wood engraver of his generation, and the house was a temple to all the things he and Janet held dear – printing presses, poetry, art, music and a romantic wild garden. Did Reynolds mind the liaison between Janet and Clark? He was a loveable, intensely shy man, wrapped up in his obsessions, and he was pleased for her that she had found such a brilliant admirer.[55]

What of Clark's other girlfriends? Colette maintained, 'My father was a compulsive charmer; he was very put out if women did not fall in love with him.' He would take his ladies to first nights at the theatre or opera and to exhibition openings, as well as to see works of art in galleries; one remembers, 'He worked really hard at special treats and his pleasure was to see us hang on his every word.'[56] There were a great many who did, and they all offered him something slightly different. Perhaps on Janet's account, Myfanwy Piper eventually went off Clark, who noticed without undue concern: 'A happy visit. John entirely unchanged. Myf no longer anxious to please – or at any rate to please me – which is a trifle less nice for me, but she is a dear all the same.'[57] The relationship would suffer a further knock when Myfanwy wrote a play, *The Seducer*, based on a novel by Kierkegaard, which Clark didn't like. She wrote him an angry but affectionate letter which had little effect, as he told Janet: 'She wouldn't have liked it any better if I said this is boring nonsense, which is actually what I thought.'[58] Clark continued to correspond with Mary Potter over

* Clark's secretary Audrey Scales recalled to the author: 'Every Monday morning a small square white envelope with neat italic handwriting in black ink marked "Personal" would arrive, addressed to KC, and I would place it on his desk, unopened.'

† Slightly misquoted: '*Quatro passi fra le nuvole*' (four steps in the clouds) – also the title of a 1942 Italian film.

Aldeburgh happenings, and in keeping with his dictum that all his girl-
friends' names began with 'M', during his Arts Council period he had an
affair with a London University lecturer, Maria Shirley, whom the art
historian Giles Waterfield remembers as 'an engaging maiden lady'. The
actress Irene Worth was another faithful adorer, but their association
became too much for her, and a period of estrangement followed.

Clark was playing with fire when he indulged in a romantic friendship
with Jayne Wrightsman. She and her very watchful multi-millionaire
husband Charles were the main benefactors of the Metropolitan Museum
in New York. She was clever, very pretty, and one of the queens of New
York society; he was a forceful oil executive, and together they collected
art at the highest level, from Vermeer to David. Clark met Jayne
(according to her recollection) at I Tatti in the late 1950s,[59] and was
smitten at once. She displayed an extraordinary curiosity about the arts,
and nothing escaped her. 'Jayne Wrightsman was a great love,' thought
Catherine Porteous, 'and K fancied her very much. One day he said,
"Charles is very jealous of me, and not without reason." On another
occasion he said to me that "Jayne Wrightsman and I stood in front of
the *Polish Rider* at the Frick and I never felt so close to anybody as at that
moment."'[60] Colette had heard her father mention Jayne casually as 'a
little old lady', and was quite unprepared for the glamorous figure she
encountered by accident on the steps of Albany. His love was reciprocated,
judging from a set of postcards Jayne wrote at about the time Clark was
giving the Wrightsman Lectures in 1965. One refers to every obstacle
being in their way.[61] Clark's feelings for Jayne probably presented the
greatest threat to his marriage since Mary Kessell, but good sense was to
prevail. By 1968 he could confide roguishly to Janet: 'Every spare minute
was taken up by the famous Wrightsmans. Thank heaven they only come
once a year and they have to be treated like Royalty. I must say they have
been very kind to me. Poor old Charles isn't nice at all, but Jayne is
adorable. Seventeen years ago she was the prettiest thing in the world
and he was an old man. Now he is in the pink, and she looks as if she
were dying ... don't worry – we only meet once a year and Charles never
lets her out of his sight.'[62]

Clark also had a discreet affair with Margaret Slythe, the unpaid archi-
vist/librarian for twenty years at Saltwood, and otherwise a tutor librarian
at Bournemouth College of Art. She became very fond of both Clarks, and
found herself 'complicit in supporting them at a number of different
levels.'[63]

Clark once told a journalist that he had received sweetness and forgiveness from all except one of his lady friends. The exception was probably the Hythe interior designer and art dealer Elizabeth Kirwan-Taylor. An opinionated, glamorous redhead who enjoyed literary company and claimed friendship with Vita Sackville-West and Noël Coward, she was divorced with four grown-up children, and believed that Clark would marry her; she was not inclined to go quietly when he failed to.[64]

There is no doubt that Clark got himself into an extraordinary mess with his declarations and promises. It is true that such affairs within marriage were handled with greater urbanity in those days, and did not customarily lead to divorce. That was certainly never Clark's intention. He enjoyed these *alliances* precisely because he was married, and in a sense safe. Sex no doubt played its part, but it is unlikely to have been the motivating force. Clark liked to write to his girlfriends, and to meet them only occasionally. Writing letters in this context meant a great deal to him; it gave a sense of reality to what might otherwise have been a mere passing fancy. Colin summed it up: 'What my father really loved was to have an intimate dinner with an intelligent, beautiful lady ... But sometimes it did lead him into indiscretions and because he was a writer he wrote letters which he later regretted. He once told me, "I can't go for walks alone in the countryside, I've just got too many of those letters hanging around in my head." He was unable to forget the fact that he had been so indiscreet and so often, and with so many people, sometimes on the same evening.'

Apart from writing letters to his girlfriends, Clark's greatest relaxation was reading. 'I am not a novel reader,' he once told an audience. 'Perhaps the habit of reading history has led to the feeling that I must check every statement to see if it is true.'* Under pressure from Janet he tried the novels of her friend Iris Murdoch: 'After my adventure in reading I. Murdoch, I am now trying Durrell Alexandria Quartet; not my sort of book.'[65] Colette was puzzled by his reading: 'At some stage Papa must have read a few books. I never saw him work or read. One day I was reading *War and Peace* and he turned to me and asked, "Is it any good?"' She was surprised to discover that he had never read it, although he later called Tolstoy's novels 'marvels of sustained imagination'.[66] Colette remembered, 'He had

* Talk on Edith Wharton to PEN Club, 12 July 1978. See also letter to Leonard Cutts, 10 June 1950: 'I am afraid I am not a novel reader. In fact I have not read one for years' (Tate 8812/1/4/6).

read Anatole France, but on the whole my mother had read much more.'[67] Secretaries recall his fondness for detective novels and whodunnits when travelling or waiting. But Clark's preferred reading was poetry, the Early Church Fathers and history. When he made a radio programme about his literary tastes, *With Great Pleasure*, he described the seventeenth century – from Donne to Dryden – as his favourite period of poetry.[68] He presented readings from Herbert, Cowley and Vaughan, and also included pieces from Homer, Wyatt, Wordsworth, Keats and Burns. He ended with poets he knew: Yeats, Edith Sitwell, and Arthur Waley's translations of Po Chu-i. When he asked John Betjeman which of his poems he should use, Betjeman wrote back that all his poems were terrible, and enclosed a piece of prose entitled 'Winter at Home'.[69]

Clark's reading of the Church Fathers is unexpected, and raises the question of his faith, or lack of it. His parents were not churchgoers, and his introduction to the Church of England at prep school and Winchester left no obvious imprint apart from the aesthetic pleasures of ritual. At Oxford Sligger Urquhart was a devout Roman Catholic, but the influence of Maurice Bowra was much stronger. Bowra was an unbeliever who accepted the outward trappings of the Church of England and the frame-work of a Christian community, useful for rites marking the passage of life. Although Clark took his cue from Bowra, he felt that something was miss-ing: 'I cannot get it into my head that the C of E is not concerned with God, but with good fellowship, cricket, flowers etc. My lecture was full of references to the Passion, the liturgy and so forth, which made everyone wince. The trouble is that my notions of religion are derived either from the medieval saints or the 17th century preachers, and I don't realise how things have changed.'[70]

Perhaps more important, at various stages in his life Clark was touched – or so he believed – by the divine. The most notable example of this was an experience at San Lorenzo in Florence: 'for a few minutes my whole being was radiated by a kind of heavenly joy, far more intense than anything I had known before. This state of mind lasted for several months, and wonderful though it was, it posed an awkward problem in terms of action.'[71] He knew that his life was far from blameless, and felt unworthy of receiving this flood of grace. While he was sure that he had 'felt the finger of God', it did not make him a believer, but 'it still helps me to understand the joys of the saints'.[72] He was particularly sensitive to certain 'holy places': Sanchi, Delphi, Iona and Assisi – he would celebrate the sense of the numinous of the last two in *Civilisation*.

Clark's position was not unlike that of Walter Pater, of whom he wrote: 'although he passed through a phase of positive atheism, [he] was constantly brooding on the mystery, both doctrinal and historical, of the Christian religion'.[73] Clark had a nebulous respect for the idea of the immortal soul, and believed in God-given genius – but whose God? His position was closest to the Deism of the Enlightenment, and a belief in nature and natural law, although he felt the attempts by Teilhard de Chardin to link the two were 'subtle but incomprehensible'.[74] He told Janet – the daughter of an Anglican bishop: 'I am not a Christian because I cannot accept the doctrine of the Atonement, even symbolically … I am not a moralist – and have been a man of frivolous and irregular life – so I cannot get in on the John Reith–[Malcolm] Muggeridge ticket … there is no such thing as primitive ie pre-Pauline Christianity. It is no more than a personal selection from the Gospels, leaving out all the unpleasant, ie Judaic parts. As you see Theology (and drugs) are my chief preoccupation.'[75]

His feelings may be gauged by his conditions for the renewal of his annual £50 covenant to Saltwood parish church: 'I do not wish any of this money to be used for Missions abroad, and I am particularly opposed to the Parish Korean Mission.'[76] However, he liked to sit and contemplate in an old church, and claimed to have crossed the road and entered St James's Piccadilly every day when he was in London.[77] In the evenings he would read theology or the lives of the saints: a book on St Teresa of Avila or the Everyman Thomas Aquinas. He wasn't always impressed, as he told Janet: 'Have just finished reading the Penguin *Acts of the Apostles*. Paul that tireless, terrible, heroic, horrible little dynamo. What was he like – a mixture of Montgomery and Beaverbrook, but harder headed in spite of being so emotional.'[78]

If Clark's religious attitudes were puzzling, his political beliefs are probably clearer to us today than they were to his contemporaries. Everybody, as we have seen, always thought he was on their side, and he usually played his cards close to his chest (except over matters of principle like Suez). His Ruskinian heart lay with socialism, but his head was happy to collude with a Conservative establishment over, for instance, Independent Television. He was careful not to antagonise the Tories, and entertained many of their grandees: Churchill, Anthony Eden, and Rab Butler. Very few socialist politicians had reached the Clarks' table since Ramsay MacDonald. When he ran into his old school friend Hugh Gaitskell, by then leader of the Labour Party, he told Janet: 'Little Hugh has grown rather heavier looking

– far more of a cavalier than a roundhead. But he remains more one of us than other politicians. Whether or not that will be a good thing for the country I don't know.'[79]

There is a letter from Isaiah Berlin about Turgenev which neatly describes Clark's position: 'He spent his entire time apologising to everybody and explaining to the right why he was slightly left-wing and to the left why he was not quite right-wing.'[80] Clark's socialism was Wykehamical and *à la carte*; he remained all his life an elitist and a believer in wealth. His socialism was motivated by his veneration for Ruskin, and to a lesser extent by a mistrust of the Tory establishment. He evinced no special sympathy for the working class, but a fierce belief that 'art is not the prerogative of nobs and snobs, but the right of every man'.[81] Professionally, he usually favoured left-of-centre technocrats like David Webster and Bob Fraser. He always voted for the Labour Party in elections (Jane remained a Tory), and when Edward Heath won a surprise victory for the Conservatives in 1970 he told Janet, 'I am absolutely shattered by the result of the election … I never realised how strong my Labour sympathies were till I went down to breakfast this morning. Of course everybody else here is jubilant! They will soon be wringing their hands!'[82]

However he voted, Clark was never at home in either political establishment; he wished to maintain his independence, and the right to be a Cavalier among Roundheads and a Roundhead among Cavaliers. When he joined the House of Lords in 1969, appointed by the Labour Prime Minister Harold Wilson, he sat on the non-party cross benches.

30

Public Man: The 1960s

I fear we are lost – not economically, but mentally bankrupt.
We listen only to the negative and destructive – Sartre, Beckett,
Pinter etc and if anyone is positive he sounds disgustingly smug
… of course every age has thought that things were going to
pot, but this time they jolly well are.

KENNETH CLARK to Janet Stone, 1 July 1967

Clark celebrated the birth of the sixties in an improbable fashion, as he told Janet Stone: 'I did such a ridiculous thing last night. I was asked to do an interview on the last day of the year etc on a TV programme which I had never seen. I thought we would just be sitting around like sick sheep – but the producer had the bright idea of situating us in a *nightclub* (at least I suppose it was a nightclub, as I have never seen one). There I sat surrounded by jiving sluts and a comic barman, and two pop singers and a jazz band, and finally had an interview with a character called Lady Lewisham,* who never stopped talking. I enjoyed the absurdity of the situation immensely – in fact got the giggles. Jane said, quite truly, that it was disgusting, vulgar and undignified.'[1]

During the 1960s Clark found himself increasingly siding with the forces of reaction. The Queen had invested him as a Companion of Honour in 1959, the highest award for achievement in public life after the Order of Merit.† However, the world that Clark had come to represent and

* Later to be better known as Raine, Countess Spencer – the stepmother of Diana, Princess of Wales.

† Edith Sitwell wrote, 'Companion of Honour is the best name for you, the exact name,' and Reynolds Stone thought it 'sounds to me the most romantic of honours, and suggests long and intimate conversations with Royalty!'

the values of the culture he so fervently projected were to be challenged throughout the decade, with its generational upheavals. It was an extraordinary piece of luck that towards the end of the sixties he was afforded the opportunity to make, in *Civilisation*, an eloquent defence of everything he stood for; but until that series transformed his life the decade was to be a depressing time. His ATV programmes had never been more popular, yet he felt his powers were waning, and he was still unable to grasp his 'great book'. As he told Janet: 'Sleeping so badly. I used to sleep like a mole, but now I worry, and, absurd as it seems, think of all the mistakes I have made in my life, especially the people I have let down. They go round and round in my head. Every day I plan to do more work, and then a thousand things happen. Really what is wanted is more energy and will power.'[2] He also found that he was becoming less responsive to works of art – feeling tired and guilty about the work to be done, he wrote to Janet from Rome: 'I had the miserable feeling of not reacting to things I know to be beautiful!'[3]

As if to increase Clark's sense of loss, the man who, Maurice Bowra apart, had been the greatest influence on his life died in October 1959. Clark wrote a piece for the *Sunday Times* in which he tried to convey what Bernard Berenson had represented to Anglo-Saxon intellectual life and for him personally. It was a heartfelt tribute, which drew praise from some unexpected quarters, including Sydney Cockerell and Hugh Trevor-Roper.* Despite the warmth of this paean, Clark was beginning to change his ground about his old mentor. John Walker records Clark telling him: 'After 1938 I believed myself to be on comfortable and affectionate terms with B.B., and after the war he behaved to me with the utmost kindness and sympathy. It was only later on that I discovered to my surprise that B.B. did not really like me. A friend of mine who looked up my name in the index of [BB's published post-war diaries] Sunset and Twilight, said to me: "Heavens! How Mr Berenson disliked you!" It was a great shock, and it proves how sweet he was that he never let me feel it when I was in his company.'[4] There can be no doubt that Clark would have been hurt by the revelation. For most of his life he had closed his mind to much that was questionable about Berenson – the early unkindness to Jane, the habit of vituperation about all his friends, and his questionable association with

* 'A few bouquets from unexpected quarters – Sydney Cockerell, Gerald Kelly, Hugh Trevor-Roper!!! All people I never see, and except for old Cockerell don't much like.' Letter, 11 November 1959 (Tate 8812/1/3/3252–3300). Trevor-Roper hailed the piece as 'by far the best thing I have read on him'.

Duveen. Berenson's death released these buried feelings, and in future accounts Clark admitted a great deal more ambiguity in his descriptions of the man.

His friendship with Henry Moore, however, remained as strong as ever.* In the summer of 1961 Clark gave an exhibition of his own, by now considerable, collection of Moore's work at the Scottish National Gallery of Modern Art; it included nineteen sculptures – mostly bronzes – and forty-eight drawings. As for the Pipers, although their friendship endured, Clark did not admire John's later work: 'I didn't at all like the large oils. Since the Welsh things there has been a curious lack of reality about his work – which isn't a matter of realism, but of inner knowledge and conviction.'[5] He enthusiastically embraced Graham Sutherland's artistic change of direction in painting portraits, and maintained that it was he who recommended Sutherland to paint the ill-fated Churchill portrait that was reportedly destroyed on the orders of Lady Churchill.[6] However, when Sutherland painted Clark's own portrait in 1963–64 it led to a cooling in relations. Sutherland painted Clark in profile, like a Renaissance medal, based on the Piero della Francesca *Portrait of Federico da Montefeltro*. Clark was a bad sitter, and was unhappy with the result, which he thought made him look like a snooty dictator. But this was not the main problem: to Jane's annoyance Kathy Sutherland asked for Graham's standard fee. Colin described the spat: 'My mother had definitely attracted Graham's eye in her youth, and she had always disliked Kathy underneath the surface. She now wrote to her in considerable rage, offering only half the sum which had been asked. Kathy, who probably did not like my mother much either, accepted, but made it clear that this would not include any of Graham's sketches for the portrait.'[7] Relations were only ever partially patched up.

Clark's appreciation of modern art in the 1960s was, like so much about the man, a contradictory affair. His fundamental belief that abstraction was a blind alley inhibited his proper appreciation of the art of the day. For Clark, abstract art had developed too quickly, and through a succession of

* Moore was always at the top of Clark's holiday postcard list. Clark enjoyed sending and keeping postcards: 'In a collection of postcards you have, in the cheapest and handiest form, what Mr. Malraux has called an imaginary museum, which you can arrange and discard at your pleasure.' Talk given at the Royal Albert Hall to the National Federation of Women's Institutes, 30 May 1962, to help save the RA Leonardo cartoon for the National Gallery.

only a few men of genius: Picasso, Braque, Kandinsky, Malevich, and then the pure abstractions of Mondrian – so it was all over by 1925. Now, to his own surprise, he became fascinated by the post-war New York School. On a visit to Venice in 1950 he saw a notice for the exhibition of an American artist of whom he had never heard: 'I went in, and for two minutes was bewildered,' he later wrote of this first encounter with the work of Jackson Pollock, 'then suddenly I became aware of an energy and a vitality that had almost faded out of European art. France, to which all earnest lovers of modern art had for so long turned their eyes, was exhausted; a new school had arisen where we had not expected to find it, the USA.'[8] Clark certainly thought that Pollock's early death in a car accident in 1956 was one of the great disasters for art in his time. When he tried to decide where Pollock fitted into the pattern of twentieth-century art, he saw it like this: Mondrian had been a classic artist who closed the door to abstraction, but painters of the New York School reacted against this and produced Jackson Pollock, a great romantic spirit. Pollock intended to appeal to our feelings, and released us, so Clark thought, from the somewhat sterile classicism to which the Cubists had led us. He would refer to Pollock as a 'Dionysiac' painter.[9]

Perhaps even more surprising than Clark's admiration for Pollock was his reaction to Mark Rothko. He found him a charming, if rather sentimental, artist,[10] but believed that his use of colour had extended the genre: 'Only in the realm of pure sensation, that is to say in the realm of colour, have some painters, notably Rothko, made an advance on the founders of pure abstraction.'[11] Clark believed that Mondrian, Pollock and Rothko had also exhausted their genre, and that a return to nature was needed, a concern for human figures and their natural setting. He was fond of quoting his friend Victor Pasmore: 'We don't know what we are doing or what we should be doing.'

Clark became a friend of the New York School artist Robert Motherwell, and they would lunch together at Albany. One day Clark mentioned that he had met the American colour-field painter Barnett Newman, whom he described as 'just like a cobbler, an old cobbler'.[12] The man largely responsible for introducing the New York School to London was Clark's friend and protégé Bryan Robertson of the Whitechapel Gallery in London's East End. Clark hugely admired him, describing him as 'the most gifted gallery director (next to Sir John Pope-Hennessy) who has been produced in England since the war'; the Whitechapel Gallery he described as the place where 'everybody who cared for art had to go',[13] and whenever he was

invited to explain contemporary art on television, he would always recommend Robertson instead. Michael Gill, the soon-to-be producer of *Civilisation*, remembers observing Clark at the Whitechapel during a Robert Rauschenberg exhibition: 'When Clark swept through with the actress, Irene Worth, he delivered brilliant, perceptive and, I thought, ultimately condescending opinions on each complex image in turn.'[14]

Clark had no such sympathy with Pop Art: 'I think Pop Art is nonsense – a fifty year old hang-over from Duchamp and Dada, plus some contemporary hokey iconography. But I have seen pictures by Roy Lichtenstein that were powerfully designed and even imaginative.'[15] Jane gives an amusing description of a visit to Andy Warhol's Factory in 1964: 'In the morning we went to the Jewish Museum & saw a very good exhibition of a very modern (but not pop) artist [sic] by an artist called Johns – very impressive quality of paint and drawing. But in the afternoon to a pop artist's studio – exactly like a Pinter play. K was so upset he had a sneezing fit! Andy Warhol the name. It has no relation to art – he paints rows and rows of boxes Heinz soup boxes etc exactly like the containers and meant to be – he has an exhibition next week! We then cheered ourselves up by going to the Frick.'[16] For Clark, both abstraction and Pop Art were a fall from the grace of humanism.

In 1962 Clark wrote a lecture entitled 'The Blot and the Diagram', which was an attempt to come to terms with contemporary art. His aim was to understand the present by using the past as a guide, but however hard he tried he could not see anything but decline, stating, 'the development of science ... has touched that part of the human spirit from which art springs, and has drained away a great deal of what once contributed to art'.[17] He additionally maintained that any attempt to view abstraction with detachment was immediately interpreted as an attack. This lecture, printed as an article in the *Sunday Times*, brought a strong rebuttal from Clark's friend John Russell, the paper's art editor, who warned him that 'The public longs to hear from you that modern art doesn't really count and they can safely disregard it.'[18] Russell's main attack was on Clark's premise that we should not be asking whether new art is as good as the Parthenon, but whether it makes sense of life today. The affair attracted a great deal of attention, and Clark claimed that 'The Blot and the Diagram' was 'the most quoted and translated of all my works before *Civilisation*'.[19]

Meanwhile, Clark was still in enormous demand as a lecturer, and had lost none of his old magic. In 1962 he delivered an after-dinner speech to

a short-lived '1958 Club' on Platonic notions of beauty. Surprisingly, and possibly with an eye to posterity, he scribbled afterwards on his invitation: 'This is the oddest thing I have ever done – and was really a tour de force, as I kept an audience of half-drunk business men quiet for half an hour when I talked about Plato's Philosophy.'[20] He repeated his success the following year at the annual conference of the Institute of Directors, speaking at the Albert Hall on 'Industry and the Arts'. Bill Williams, secretary of the National Art Collections Fund, described how Clark 'roused great fervour among them by his plea that industry and commerce should seek to become major patrons of art'.[21] A group of directors clubbed together to examine what could be done for the arts, and the Institute even set up an Art Advisory Bureau – although, like many such good intentions, it was soon forgotten. One of Clark's best published lectures was given in Oxford in 1967 – 'A Failure of Nerve: Italian Painting 1520–1535', describing the strange period after the death of Raphael.[22]

During earlier decades Clark had been deeply concerned with the art of the present, but as this interest waned he became more interested in saving the past, growing anxious about the destruction of architectural landmarks and settings. Clark had always been an architectural conservative, but he was now becoming a fervent preservationist. It is difficult now to understand the public indifference of those times towards the destruction of historic city centres and architectural masterpieces such as Bath. In 1965 Clark gave a speech at the Royal Festival Hall to members of the National Trust in which he pointed out that 'with the help of our democratic institutions, our local authorities and planning committees have done more in a few years than time, neglect or enemy action had done in centuries to obliterate history and destroy the visible beauty of England'.[23] Yet he would never support preservation for its own sake – he always sought out specific economic and social arguments as to why any particular building or landscape should be saved. Nor did he hold conventional views about the things that constituted the national heritage. He believed that there should not be any general restriction on the export of works of art, and held that museums in Britain were already too full. He wrote that 'from the constitutional point of view, a general restriction is a most violent and inequitable attack on property, usually reducing by about half the value of a work of art ... An Italian picture in an English private collection does not belong to England.'[24] He disliked claims that such paintings and sculptures formed part of Britain's national heritage – especially when the country was destroying its historic city centres and failing to restore its

ancient cathedrals, which he felt were far more worthy of government preservation and support.

Clark played a major role in the creation of one arts institution in which past and present should in theory have found a happy union. The idea of a National Theatre had a long gestation; the 1949 National Theatre Act and the identification of the South Bank site brought it closer to reality, but all governments had accorded it low priority. In 1951 the Queen Mother – then Queen – had laid a foundation stone, but nothing further happened for a decade. One of the moving spirits of the revived enterprise was the National's first chairman, Oliver Lyttelton, Viscount Chandos, a decorated wartime Grenadier Guardsman, sometime Tory minister and friend of the Prime Minister, Harold Macmillan. An ambitious man with a sense of public duty, Chandos was the epitome of the old-fashioned establishment which was being challenged by the forces of youth. However, it was his leverage with the Treasury and the Prime Minister that brought the project back to life.

Clark's practical involvement in the National Theatre project began in 1960, when he had just given up the Arts Council. He was made chairman of a new executive committee which included representatives from the two leading theatrical companies of the day, the Old Vic and the Royal Shakespeare Company.[25] This committee reported to the so-called Joint Council, chaired by Chandos, and was tasked with preparing building plans and cost estimates to set before the government. From the beginning Clark was a very active chairman, writing long memoranda to Chandos setting out practical recommendations for the composition of the commit-tee. He asked for a deputy to be appointed to the artistic director, Laurence Olivier, and urged that there should be more actors on the committee in general.[26] Many, including Peter Hall, the founder of the RSC and Olivier's successor as director of the National, were against the appointment of actors, but Clark asserted that it would be they 'who will have to work in the National Theatre, and on whom its success depends'.[27]

The architect appointed to the project was Brian O'Rorke, who was required to provide one amphitheatre with 1,200 seats and one prosce-nium theatre with eight hundred seats – although Clark was far from certain that 'the wretched O'Rorke' was up to the job.[28] Clark was regarded as a tactful chairman who brought practical management skills, and above all experience of the workings and preferences of the Treasury. At first he remained fairly pessimistic about the outcome, as he told Janet Stone:

'much National Theatre business … I have an awful feeling that it will all come to nothing.'[29] He invited the theatrical impresario Prince Littler, whom he had got to know through the ITA, on to his committee, at the same time warning him, 'I have made it clear that if the Government do not take an interest in our proposals I am off.'[30] Once again Clark found himself in a position – not unlike his early days at the ITA – in which he was attempting to make things happen against a background of divergent opposed interests and Treasury reluctance.

The crisis over the creation of the National Theatre came in autumn 1960, while Laurence Olivier was away in New York, playing in a production of Jean Anouilh's *Becket*. Clark wrote to him at the Algonquin Hotel reporting that things were 'not going so well. The chief reason is that the Arts Council is against it and seems to be conspiring with the Old Vic to do it down.'[31] The venerable Old Vic saw a National Theatre as a rival for funds, and wanted its own new building. The Arts Council correctly foresaw that the National would require a large annual subsidy from its own budget, which would diminish its freedom of action. Clark offered to go to the Arts Council to tease out what was going on, and told Olivier, 'I am very much afraid that they will recommend the Treasury to make a small grant, which they will expect us to turn down, and then be able to say that we had abandoned the scheme.' He added: 'I have not given up hope and will continue to make a great nuisance of myself, as sometimes this does the trick, even for a hopeless case.'[32]

By December things were so bad that Clark wrote a seven-page memorandum to the Chancellor of the Exchequer, Selwyn Lloyd, which Chandos approved: 'I think your draft is quite admirable – perhaps I am prejudiced in its favour because it is written with great clearness and in English.'[33] This was followed by a deputation led by Clark to see the Chancellor for an hour-long meeting – 'Which,' as he told Laurence Olivier, 'is a very long time for a politician to give the arts.' As Olivier was still in New York, Clark wrote to him, 'we were not a bashful party', adding that he was guardedly optimistic, believing that the Chancellor was 'favourable, but I fancy everybody else in the Government is against it'.[34] Hopes however were dashed when Selwyn Lloyd told the House of Commons in March 1961 that there would be no money for the National, and that what funds there were would go to the Old Vic and the RSC – just as Clark had foreseen. The general assumption was that the RSC would become the *de facto* National Theatre; Clark and his committee appeared to have been stitched up.

Pressure was brought to bear, however, by Clark and others.[35] The Chancellor had a change of heart, and in July he announced the government's support for the National in the form that had always been envisaged. It was Clark who chaired the momentous meeting at Chandos's Grosvenor Place office on 22 July at which the ubiquitous lawyer and fixer Arnold Goodman was asked to prepare a constitution for a new National Theatre. The following year Clark was formally invited to join its board for five years. Characteristically, he wrote to Janet: 'The first ... meeting is on Thursday – my heart sinks at the thought.'[36]

With the election of Harold Wilson's Labour government in 1964 the impetus for an ambitious new building was enthusiastically taken up by the new minister responsible, Jennie Lee.[37] The main loser was Chandos, who remained chairman but with his Tory power base gone – he turned overnight from being all-powerful into an object of derision. Moreover, he was uneasily coupled with Laurence Olivier, who wished to identify himself with the forces of change, and wrote, 'there can hardly have been two men with less in common than Chandos and myself, save for the intensity of enthusiasm we shared for the erection of a national theatre'.[38]

But there was one man who had even less in common with Chandos, seeing him as representative of all that he most hated: the influential critic Kenneth Tynan, the Lucifer of the story, appointed as the National Theatre's literary manager, but demoted to consultant by Chandos. Olivier was the highly respected – but easily led – director alongside the flamboyant and iconoclastic *enfant terrible* Tynan. Clark's role changed, and he was invited to chair the Drama Committee, which although it did not propose new plays, was delegated by the board to approve the repertory proposed by Olivier and Tynan – a perilous commission. Clark was caught in the middle of the appalling rows between Chandos and Tynan which were a paradigm of the generational antagonisms that characterised the period. Olivier, ever keen not to appear fuddy-duddy, invariably sided with Tynan. Catherine Porteous remembers how Clark used 'to laugh about Tynan giving speeches for Larry Olivier to read out at meetings which were full of philosophy and psychology, saying, "Poor Larry, he hasn't the faintest idea what any of it means."'[39] Clark respected Tynan as a critic and as a man who got things done, but Porteous believes that Clark 'in the end thought he had developed into too much of a loose cannon, and began to resent anyone questioning his decisions and/or motives. I think Clark also raised his eyebrows at Tynan's personal vanity.' Jennie Lee confirmed Clark's board position, which as he told a friend made him 'a

sort of buffer between [Chandos] and the more revolutionary elements on the staff of the Theatre'.[40] Clark found himself out of sympathy with the new school of British drama, although his natural instinct for quality was sometimes intrigued. 'I added to my depression by going to see the new Pinter play [*The Homecoming*],' he told Janet in August 1965; 'really rather good, but sordid and heartless to a degree … this is part of the price we have paid for ridding ourselves of hypocrisy'.[41]

The first serious row over a proposed production at the National Theatre arose in 1964 over a plan to stage Frank Wedekind's *Spring Awakening*, a tale of repressed adolescents that the censor, the Lord Chamberlain's office, had banned (the Royal Court had circumnavigated the problem with a licensed performance). Clark was in favour of staging the production with some alterations, believing that 'the adolescent sexuality [was depicted] with great feeling but the poetic passages were mawkish'.[42] The theatre board overruled him, and the play was not produced. Two years later Clark was on the other side of the argument over the Spanish playwright Fernando Arrabal's *The Architect and the Emperor of Assyria*. Clark felt bound to tell Olivier, 'We all thought it was pretentious nonsense and inexpressibly tedious. It is a mixture of Beckett, Ionescu and Anouilh; gimmicks from all three and odiously clever, but without a spark of conviction'.[43] The play went ahead, but Chandos at least was relieved to have an ally in Clark: 'I have a suspicion that you don't find the Drama Panel an entirely agreeable occupation, but I don't know how we should have got on without you, and if you had said [no] … I feel that I should have emigrated'.[44] Clark wrote a reflective response to Chandos, wondering why things 'had taken a direction so very different from what most of us had anticipated. Apart from our director's [Olivier's] obsessive fear of being thought old-fashioned, there are two factors I had not reckoned on: first that producers would feel themselves incapable of putting on straightforward productions, and secondly that famous actors would refuse to repeat their great performances of the past … perfectly incomprehensible to all the great actors of France'.[45] The Mermaid, the Chichester Festival and the RSC at the Aldwych were all putting on an increasing number of classic productions, and Tynan, Olivier and the National Theatre management wanted to associate themselves with new-wave drama and the younger type of dramatists who were writing for the Royal Court.

The climactic row came in 1967 with the German playwright Rolf Hochhuth's *Soldiers*, the plot of which implied that the recently deceased

Winston Churchill (a friend of Chandos) was responsible for the death of the Polish hero and patriot General Władysław Sikorski. This premise was wildly speculative and unhistorical – but for Tynan it was the perfect tease, and he hoped that with it he might be able to force Chandos's resignation. Even Olivier privately thought it was a bad play, and told his wife Joan Plowright, 'I don't like the bloody thing – but if you think I am frightened of doing new stuff, you'll despise me, won't you?'[46] The dispute erupted in public, and it fell to Clark to restore peace. Preparing for the showdown meeting, he told Janet: 'Tynan deserves to be sacked twenty times over, but it would be a great mistake to do so. I shall have to try and smooth O. Chandos and [his] understandably enraged feelings.'[47] The board refused to stage the play, which in Chandos's view 'grossly maligned' Churchill. Olivier declined to sack Tynan – 'I had chosen golden youth,' he later remarked – but Tynan's power at the National Theatre was diminished by the affair. Clark had now had enough, and needing to concentrate on *Civilisation* he resigned from the board the following year, telling Kenneth Rae that he now rarely came to London, and was out of touch: 'It distresses me to feel that I am in a false position and cannot give a proper service to the National Theatre.'[48] To Janet he was more frank: 'Isn't it lovely to have left the National Theatre. I *hated* it.'[49]

Since 1964 Clark had been a trustee of the British Museum, frequently intervening on matters of both policy and acquisition.[50] John Pope-Hennessy, the museum's director from 1974, rated him 'the best Trustee that I have ever known. It was natural that he should be so, because of his immense breadth of knowledge and generosity of character, and he was always the one Trustee I would look to for advice.'[51] As soon as Clark was appointed, each of the departmental keepers offered to take him for a walk around their collection, in the hope of making an ally for future acquisitions; but as he wrote to a friend, 'it is quite clear to me that what is most needed in the British Museum in almost every Department is money spent on installation and display'.[52] Although space was the fundamental problem, Clark believed that the greatest challenge of the museum was to resolve the tension between visual pleasure and visual record. If the National Gallery existed to give pleasure as a museum of art, he observed that the British Museum was a museum of societies, and aesthetic considerations often came second. He described a trustees' meeting to Janet, followed by 'agonising buffet lunch … then we go round one or other of the depts, exhausting on an empty tum, and actually v. depressing, as they

all have such *masses* of stuff in store, enough to furnish 40 museums, all waiting for the hypothetical student who never comes'.[53]

When Sir John Wolfenden was appointed director of the museum in 1968 he produced what Clark thought was 'a deplorable paper' called 'Trustees' Policy on Acquisitions'. Clark pointed out to the chairman, Lord Eccles, that 'documents of this kind if they are not answered or debated, are sometimes invoked by the author at awkward moments',[54] and wrote a fascinating response questioning the desirability of the museum having any formulated policy at all at this stage of its development. The problem, he thought, lay with the changing directions the museum had followed in the course of its history, starting as a visual accompaniment to natural philosophy but then diverting to encompass some of the highest achievements of the human imagination, such as its Michelangelo drawings. He believed that some departments would always have a documentary emphasis, while others would incline to artistic values, and that therefore no general acquisitions policy was possible.[55] While he recognised the necessity for a museum of classification, 'in a room containing several thousand Greek vases, your faculties are numbed'.[56] Despite his seeming preference for the 'art' departments, Clark told Eccles that what the museum needed was more archaeologists on the board of trustees. Even more surprisingly, he recommended the talents of his old enemy Geoffrey Grigson: 'he has been continually offensive about me for forty years but I have a good deal of respect for him'.[57]

There was one point on which Clark was certainly divergent from museum policy: the Elgin marbles. He was in favour of their return, although he never said this in public. As early as 1943 he had written to the museum director Thomas Bodkin: 'I am, quite irrationally, in favour of returning the Elgin marbles to Greece, not to be put back on the Parthenon, but to be installed in a beautiful building on the far side of the Acropolis, which I think the British Government should pay for. I would do this purely on sentimental grounds, as an expression of our indebtedness to Greece.'[58]

31

Civilisation: The Background

My idea of Civilisation *could not have been more cloudy and was very much that of a controller trying to establish colour television on BBC2. I pulled the trigger but did not make the explosion.*

DAVID ATTENBOROUGH, March 2013[1]

When David Attenborough, the controller of BBC2, invited Kenneth Clark for lunch in September 1966 'to discuss a project', nobody could have imagined the success of the series of thirteen programmes that would result. Attenborough's motivation was strategic – to launch colour TV in Britain. He had been controller of BBC2 for a year, and it was decided by BBC management that colour would be introduced on the new 'highbrow' channel. Colour television had a very bad reputation; it had been introduced in America in 1953, and was, in Attenborough's view, a catastrophe: 'The colour was garish and the variability between sets was horrible.' BBC technicians had been quietly working on producing an acceptable level, comparable to what audiences could enjoy at the cinema. Attenborough had the task of trying to convince people to buy the extremely expensive new colour television sets of the upgraded 625 lines standard. He decided that 'in order to do that I thought I needed to convince people and opinion-formers that colour was worth having, I had the notion to create a series which would look at all the most beautiful pictures and buildings that human beings in Western Europe had created in the last two thousand years and put them on television with appropriate music that had been written at that particular time.'[2] Crucially, he was supported in this ambitious project by Huw Wheldon, the BBC controller of programmes.

There was no doubt in the minds of senior staff at the BBC that Clark should be approached. As Attenborough put it: 'I wanted someone those

opinion-formers would watch and respect – and K was the obvious choice. We had not met, and he had a daunting reputation. We had his books in the house, and he was one art historian who was read by non-specialists. There were younger presenters, but they were mostly modernists, and this series would hardly touch contemporary art – and the only other popularly known art historians all had German accents!'[3]

Attenborough and Stephen Hearst (assistant head of music and arts) invited Clark to lunch at BBC Television Centre in order to sell the idea. Attenborough outlined his plan, and Clark described how he was munching his smoked salmon rather apathetically when Attenborough used the word 'civilisation', and 'suddenly there flashed across my mind a way in which the history of European civilisation from the dark ages to 1914 could be made dramatic and visually interesting'.[4] He later said that he felt what used to be known in books of devotion as 'a call'.[5] At this point Huw Wheldon burst through the door and asked in a cheerful manner, 'How's it going, chaps?' But Clark had detached himself from the conversation, and was no longer listening to the rest of the party talking amongst themselves. In his mind he already pictured himself standing on the Pont des Arts in Paris, at the very heart of European civilisation. He was mapping out the series in his head, and later claimed that it all came to him, in its final form, during that lunch. According to his memoirs, by the end of the lunch he had agreed to do the series, and that he would do it alone – but this seems unlikely from the evidence.

Shortly after the lunch, Humphrey Burton, the BBC's head of music and arts, wrote to Clark suggesting the BBC's approach: 'We would like to have you as General Editor of this series. We would like you to lay down the principles upon which the series should be built, define the areas to be covered etc.'[6] This letter crossed in the post with one from Clark to Attenborough which expressed his doubts about the project. Firstly, he said that he would 'have to vet almost every picture sequence and probably edit the scripts'. Having established his bid for control of the material, he pointed out that he was ambitious to finish a number of books before he was seventy. Attenborough shrewdly guessed that there were also family reservations, but by the end of the letter Clark was keeping the door open, enclosing 'a sketch of how I was thinking of treating the programmes'.[7] This document is missing, but we can follow Clark's early steps through his notebook at the Tate archive.[8] He planned fourteen episodes – which the BBC reduced to thirteen, to fit into its three-month schedules. At an early stage his dilemma about Spain surfaced; he was uncertain whether

to make the Rome of the Popes the centrepiece of the Counter-Reformation, or the Escorial, 'which would be a perfect focus for the whole programme'. As we shall see, his decision to exclude Spain altogether would lead to ruffled Hispanic feathers.

Clark could not make up his mind about the project, as he confided to Janet: 'Should I do it? It would mean a year's work (of course I wouldn't write it all, only plan it, and perhaps introduce each episode) ... the programmes would be rather a potted world history affair – on the other hand it could have a slight value at a time when the standards of European culture are being forgotten – which can't be a good thing.'[9] One of his main concerns was the BBC itself, or what he referred to as 'current BBC policy'. By this he meant the corporation's reputation for innovative, occasionally zany arts programmes, exemplified by *Monitor*, a fortnightly arts magazine on which several young directors and presenters cut their teeth, notably Ken Russell and John Berger. The trendiness of the BBC worried Clark, who feared that his version of the subject, without any fashionable sociology, might seem hopelessly out of date to a young director – and he was almost right.

Clark's notebook has an interesting coda: 'Warn BBC not Marxist, not a history of economics, nor of political ideals ... religion will play a bigger part than economics.' He did actually sketch out an episode called *The Cash Nexus* – a departure from this scheme: 'But it must be made clear at some point how far some of the most valuable things in Civilisation are made possible only by fluid capital.'[10] This was an echo of his old Oxford teachers F.W. Ogilvie and G.N. Clark, but economics was not in the end to play a major role in the series, partly because Clark knew very little about it, and as he told Humphrey Burton: 'I have forgotten any history I ever knew, but I seem to have a good memory for visual images and these would really be the basis of my programmes.'[11] Although Clark was clear from the beginning that the series would not be a history of art, the story was always going to be told through the art. Burton reassured him that 'we are <u>not</u> interested in a neo-Marxist approach. What we want is <u>your</u> view, and with great respect I don't believe that there is anything old-fashioned about what you say.'[12]

Monitor may have seemed to Clark too experimental for his purposes, but there was another nascent model at the BBC. In 1964 the corporation had broadcast a twenty-six-part series, *The Great War*, narrated by Michael Redgrave, each programme one hour long, but without an authorial voice. The true parents of *Civilisation* are perhaps Mortimer Wheeler's mini-

series *The Glory That Was Greece* (1959) and Compton Mackenzie's *The Grandeur That Was Rome* (1960), or indeed Clark's own series for ATV on *Temples*. These programmes represented the birth of the 'authored' series with which we have become so familiar. Wheldon and Attenborough saw the future when they envisaged *Civilisation* with an informed talking head on the screen every week for three months. As Attenborough realised, 'Talking heads can be the very best television ever. Secondly, there was a scholarly reason why it was important – we were anxious that K Clark should make assessments of these things.'[13] He points out that 'Although ambitious and expensive, *Civilisation* was not as brave a series to launch as people imagined. The BBC in those days did a lot of things that had tiny audiences, like hours of opera at huge expense. There were no penalties for failure, so it was not as brave as people thought. Radio 3 was doing high-brow stuff for years and nobody cared. All part of the Reithian BBC.'[14] What was unprecedented was the scale and budget of the projected series, with £15,000 initially allocated to each episode.

The choice of director, made by Wheldon, Burton and Attenborough, was Michael Gill – who was everything that Clark most feared about the BBC. Gill was close to the *Monitor* world, with many notable contemporary art film credits behind him and a hankering to push boundaries. As his wife, the actress Yvonne Gilan, explained: 'We were hedonists and both very left-wing and belonged to CND and had a mission. We lived in a hip artistic world of creators. Michael didn't think the barbarians were at the gate, and Michael would have probably wanted to be the barbarian at the gate.'[15] Gill liked the idea of Clark even less than Clark liked the idea of him. He had heard him talk on *The Brains Trust* and at Edinburgh University (where Gill read psychology and philosophy), and thought him 'cold and self-satisfied'. In fact the two men were more similar than they realised: both had had an isolated lonely childhood; they were both introverted, intellectual and left-leaning. Although Gill was the son of a bank manager and lived in Kensington, production assistant David Heycock recalls, 'Michael pretended he was working-class … he told me that his wife was a Trotskyite.'[16] When he was introduced to Clark over coffee at BBC Television Centre, the impression Gill received was one of disdain. It was mutual. Their first private meeting, at which Clark outlined his vision of a series of lectures delivered in a studio while the camera travelled without him to locations, was no more successful. Gill wanted Clark on location for every scene, and to change the way television was done.

Clark reported his worries to Janet: 'The administrators who have called me in are charming, but alas, my producer is painfully anti-pathetic – an ectoplasmic emanation from the New Statesman correspondence columns. I don't know what to do, I hate to say anything, as it seems "prima donnaish" but a year's work with someone like that, at my time of life, is no joke. I suppose I must ask him to lunch alone, and make sure that I am not mistaken.'[17] Both Clark and Gill confided to Burton that their partnership was unlikely to work. Gill asked to be taken off the project: 'I felt that Clark was too senior and inflexible in his ways.'[18] At the same time Clark told Burton, 'My style and content might be a bit too square and stuffy,' and suggested that John Berger might be more sympathetic to Gill.[19] Burton likened the situation to the difficulties of mating pandas.

Another meeting was arranged at Albany, at which Clark outlined to the BBC management team his plan for an opening sequence in Paris, which seemed clichéd to Gill. He wanted something more original, and challenged the ideas Clark was putting over. The atmosphere was becoming arctic when the double doors to the bedroom were flung open and 'a plump but impressive figure swayed between them'. It was Jane, who wanted another drink, lit a cigarette, dropped it on the floor and then berated the visitors: 'I don't want you pestering him … K's a genius worth all of you together. He has to be protected.'[20] It took all of Attenborough's diplomatic skills to reassure her.

Over the coming weeks Clark sent two scripts to Gill, who rejected them both as being too much like lectures. This power struggle alarmed Wheldon and Attenborough. Clark was certainly not used to being treated like this – he was not only a grandee, but he thought he knew how television worked. It was Colin who persuaded his father to give Gill another chance: 'You are wrong, Papa … I know Michael and he is the most imaginative man, try again.'[21] The final panda-mating session took place at Saltwood. Clark told Janet: 'My producer rang up to say that he didn't like my first two scripts, and thought I had better make a fundamental change of approach. I was much upset, as I had spent three months on the general plan of the series, and couldn't see another way in which I could do it. Also, I didn't think my scripts so bad. Anyway, he came down for the day on Friday and his objections didn't amount to much – or his courage failed him, I am not sure which. His chief objection was that my script wasn't personal enough (I had thought it was too personal). I told him I was no [Malcolm] Muggeridge, and could not get away with a display of opinions

and prejudices. What people wanted from me was 1) Information 2) Clarity 3) Human stories. This is my experience after doing over 60 programmes. However, it's a good thing to have this kind of criticism, as it makes one sit up. He is a nice chap, tho' not quite as clever as he thinks he is, and much the victim of modern mind-food.'[22]

The BBC began to assemble a talented team for the production. The series was too much for one director, and Peter Montagnon was appointed to make four of the episodes. Montagnon is a gentle and cultivated man, whom Clark described as 'an educator and something of a poet (formerly a sculptor and then a member of the secret service)'.[23] The third director, who only made one episode (number four), was Ann Turner. She was the most knowledgeable of the team, a first-rate technician in charge of the logistics and stills. Clark said she 'made the impression of senior tutor in a ladies' college'.[24] The lighting and camera crew, 'Tubby' Englander and Ken Macmillan, came from *Royal Palaces*. Macmillan was to become Clark's favourite on the crew: 'he was an artist, silent, withdrawn and independent'.[25] Tubby Englander was 'a small and compact man, with a neat moustache and horn-rimmed spectacles, always impeccably dressed in a dark suit, which contrasted oddly with the conventionally unconventional garments of the crew'.[26] Macmillan describes their first reaction to being put on the team: 'We just thought of it as another arts series. We had no idea of the scale or ambition. The key moment was David Attenborough's decision to shoot on 35mm, which quadrupled the picture quality and greatly increased the cost. *Royal Palaces* was the only previous 35mm colour film done at the BBC.'[27] The decision also multiplied by several times the amount of equipment that would need to be hauled around Europe. Clark initially asked if he could have two consultants, Ernst Gombrich and John Hale, and the three of them met for lunch at the St James's Club. Peter Montagnon remembers 'Gombrich turning up to script meetings and he had a precision that was valuable. K listened to him and could be swayed.'[28] Clark's contract with the BBC is dated 13 January 1968. He was to receive £800 per episode, which was raised to £1,000 for the last eight after he complained about all the travelling.[29] The fee was low compared with *Royal Palaces*, but the possibility of sales rights was greater, and he received over £10,000 on these, before the main bonanza of the publication of the book.[30]

Once Michael Gill and Clark each began to accept what the other wanted, their cooperation was to be cordial and beneficial. As Attenborough has explained: 'K had sufficient humility to know that he

was moving into a new category of documentary … and eventually produced the sort of thing Gill and Montagnon were looking for. The sort of thoughts I think that Michael and Peter gave K were how in fact he would be placed within the picture and when was he to be moving and when was the moment for reflection. Particularly when was the moment when words had to come to an end, and when the skill of the director could take stills of pictures, buildings and landscapes and people, and allow that to be put together in such an imaginative way with the right kind of music, that it would make the right impact. Not merely a pause between thought but something powerful. Those montages when they turn up are one of the great glories of the series.'[31] Montagnon thought that Clark was 'a useful commodity in TV terms, but there was the problem of his being so mannered and this we had to take into account. We wanted K to look more human.'[32]

There was one ugly episode early in the story. The three directors had been invited down to Saltwood for planning purposes, and Montagnon noticed that 'Jane was drunk, which worried us. What effect would it have on the series to have an anchorman with a psychotic wife? I discussed it with my psychoanalyst wife who said she would be very unpredictable, which was correct.'[33] Jane, who put her husband's television essays well below his books in order of importance, thought that Civilisation was a bad idea, and wanted him to finish Motives. She decided to be disruptive, and towards the end of the lunch announced that the Queen Mother had been to Saltwood recently, and had left generous tips for the staff. She failed to mention that the Queen Mother had arrived with an enormous entourage, and had spent the night. The figure Jane suggested was £20, a large sum which none of the visitors could muster in cash.* When Montagnon offered a cheque, Clark said that that would be acceptable, but Jane countered with, 'You'd better be careful, K, it might bounce.' Montagnon later reflected on 'the tip business; we put it down to her drunkenness. We thought it outrageously funny at the time, and of course we claimed it back from the BBC.' But they were surprised by Jane's behaviour – as Ann Turner put it, 'We thought it was all a bit much.' The most extraordinary part of the story is that Clark backed his wife's preposterous demand; his peculiar code of chivalry meant that he would never publicly cross her.

* Tipping after lunch was never expected in a country house, and even after spending a night, £1 per night per person would have been considered generous in 1967.

There remained one serious argument – over the title of the series. Gill did not like the word 'civilisation', and Clark did not want the word 'art' to be in it – he thought it would put most English people off. Reverting to old practice, he wanted to turn the title into a question 'What is Civilisation?' – but the trouble was, he didn't know the answer. He thought of civilisation negatively: he knew what it was *not*, but he could not define it: 'Civilisation was not a state but a process; and what I must look for was not civilisation, but civilisations.'[34] 'No *a priori* definition of civilisation was ever going to work. Like Goethe, one could only describe its growth, the discovery of courtesy in the thirteenth century, of reason in the seventeenth century, toleration and love of nature in the eighteenth century, humanitarianism in the nineteenth century.'[35] When he described it to Janet, he wrote: 'Civilisation is very largely the shape given to a sudden flow of creative energy. It involves curiosity, fluidity, confidence and hope. Now fit the works of art and architecture into that.'[36]

He decided, as a starting point for the series, to adopt a Clarkian antithesis, finding the most barbarous epoch (the seventh century, in his view) and using this as a zero point from which to look backwards and forwards. 'I was determined to show Western man trying to discover himself,' he explained in an interview. 'I was also determined to show that civilisation could die by its own inbred imperfection. In this I was influenced in reaction, I think, by books like Clive Bell's book on *Civilisation*, which put forward the thesis that civilisation meant good company and going to bed with anyone you liked.'[37] In his notebook he asked himself the question 'What are the enemies of Civilisation?', and divides his answer between 'external' (war, plagues, etc.) and 'internal' (rigidity, exhaustion, lack of confidence, hopelessness, disintegration). It was in these latter that he found such a troubling echo in the contemporary world. The programmes were imbued with the warning that civilisations do not crumble from without, but from within. With reflections like these Clark won the battle of the title, but for everyday purposes he dubbed it '*Civvy*', and that was the name the crew adopted.[38]

32

The Making of *Civilisation*

It was heaven, visits to all my favourite places,
congenial people and returning to all my favourite books.

KENNETH CLARK on BBC Radio 4's *Woman's Hour*,
19 March 1969[1]

Civilisation came at exactly the right time for Kenneth Clark. His programmes with ATV were running out of steam, and although he still believed himself capable of writing the 'great book', he couldn't grasp it. He had become depressed, and felt imprisoned at Saltwood.* The making of the series transformed his outlook; nothing he had done previously had so enjoyably combined his love of art, writing and action. It is easy to believe that Clark was put into the world to make *Civilisation*. He always claimed that he sat down and wrote each programme without any special reading – when asked if he had undertaken any research he replied, 'None at all. Quite to the contrary. All I did was to forget things. The difficulty was to eliminate.'[2] This is borne out by his ability to write what many regard as the finest episode, *Grandeur and Obedience*, in only three days while in Rome.[3] He did however go back to original sources, such as Luther's letters. He wrote most of the episodes at Saltwood, and his altered mood is caught on a warm day in May 1967, when he wrote to Janet: 'I am not one for the physical life, but on an afternoon like this I can think only of my love, and not of the question of how much the dome of St Peter's is really by della Porta ... Add to the warmth the scent of lily of the valley and narcissi which our gardener's dear wife has put

* 'Here I am, as usual, *very* depressed at coming home – You have known it before. I become almost suicidal. I suppose it is partly the renewal of responsibilities, and partly ... the feeling that I am in prison.' Letter to Janet Stone, 6 March 1966 (Bodleian Library).

in my room, and you can see that I am in an extasy [sic] like a Baroque Saint.'[4]

Elimination was indeed the difficulty, and the greatest problems were presented by Versailles and Spain. Neither appealed to Clark, but he agonised over them, 'and got very depressed about it. But last night Jane said: "Why bring in Louis XIV?" and with this the cloud lifted. I really hate him and the whole concept of Versailles and I think it anti-civilisation. Whereas I think the Rome of the Popes, and the Counter-Reformation was a creative moment – or century almost. Instead of the horrible king one has the saints – Carlo Borromeo, Philippo Neri, to say nothing of Sta Teresa and S. Ignatius Loyola so I am now rubbing up my Catholic resolution with great enthusiasm. What a fan mail of Protestant abuse I shall receive!'[5] In the end Versailles made only a brief appearance, and Clark showed little sympathy for courts in general (apart from those of Urbino and Mantua).

Spain presented a greater problem, and its omission would cause lasting offence to the Hispanic world. Clark conceded that had he been writing a history of art, Spain would have had to feature; but he compounded his difficulties when he attempted to explain: 'When one asks what Spain has done to enlarge the human mind and pull mankind a few steps up the hill, the answer is less clear. *Don Quixote*, the Great Saints, the Jesuits in South America? Otherwise she has simply remained Spain, and since I wanted each programme to be concerned with a development of the European mind, I could not change my ground.'[6] The fact that Spain was at the time a totalitarian state under General Franco did nothing to commend it to Clark; nonetheless, as Peter Montagnon recalled: 'Most of us were a bit edgy and nervous when he didn't propose to put in Spain as a subject or what went on in Spain … he was capable of being imperious … sometimes he wanted to argue things out with us and sometimes he didn't. But I think that's a function of his age and background.'[7]

Programmes were scripted to every single word, which generally negated last-minute changes of mind. Clark was usually content with his taxonomy, but told Janet: 'My chief mental occupation is the realisation that I must add another programme to the series on the Classical ideal. It would be absurd to leave out Palladio, Poussin, Racine etc. the hard core of Civilisation.'[8] The BBC did not smile upon the idea; its three-month, thirteen-episode scheduling was sacrosanct, and therefore the Classical ideal was reduced to an uneasy preface to the Rococo episode. The central narrative of each programme was structured around three or four heroes. Michael Gill was initially against all these 'old warhorses' being trotted out,

A BRIEF SUMMARY OF THE EPISODES OF *CIVILISATION*

1 *The Skin of Our Teeth**: The Dark Ages, the survival of Christianity and the establishment of Charlemagne's empire.

2 *The Great Thaw*: The reawakening of Europe, the great cathedrals of France.

3 *Romance and Reality*: The Gothic spirit and chivalry, culminating in St Francis of Assisi and the genius of Giotto and Dante.

4 *Man the Measure of All Things*: Humanism, the Florentine Renaissance and the court of Urbino.

5 *The Hero as Artist*: The patronage of Pope Julius II and the High Renaissance; Raphael, Leonardo and Michelangelo.

6 *Protest and Communication*: Printing and the Reformation: Erasmus, Dürer, Luther, Montaigne and Shakespeare.

7 *Grandeur and Obedience*: The Counter-Reformation, the rebuilding of St Peter's in Rome; Bernini and the Baroque.

8 *The Light of Experience*: Art and philosophy in northern Europe, the establishment of science, Newton.

9 *The Pursuit of Happiness*: The great Rococo churches of Germany; Bach, Handel, Mozart and Watteau.

10 *The Smile of Reason*: The French Enlightenment, the Paris salons, the Encyclopaedia, Voltaire, the Scottish Enlightenment, the founding of the United States.

11 *The Worship of Nature*: The new belief in the divinity of nature; Rousseau, Wordsworth, Turner and Impressionism.

12 *The Fallacies of Hope*: The Romantic movement, the French Revolution, Beethoven, Byron, David, Delacroix.

13 *Heroic Materialism*: Nineteenth-century humanitarianism, the Industrial Revolution, Brunel, Tolstoy – and the confused and destructive twentieth century.

* The title of this episode caused trouble in America, as the motion-picture rights to Thornton Wilder's play of the same name had been sold. At Yale there are four thick files of lawyers' letters on the matter. Wilder's lawyers advised him that they would not succeed if they sued Clark for damages, but they threatened action nevertheless, and the BBC was obliged to change the US title to *The Frozen World*.

but Clark was a natural hero-worshipper, and saw that the character of an epoch would be more vividly portrayed by describing individuals of genius than by attempting to expound an abstract idea.[9] As he realised, the problem was always how to keep the story visible. Gill gave Clark a bit of script leeway, as Ann Turner recalled: 'Michael very wisely said to him, no, he must go to the places and re-feel them as it were, because what he felt when he was a young man in the thirties might be very different to how he felt in the sixties.'[10] He was right, and Clark was allowed to make some unscripted additions at Assisi.

Peter Montagnon believes that *Civilisation* had its own organic development, and remarkably few principles were established: 'We sucked it and saw.'[11] Ken Macmillan agrees: 'We worked so hard we never thought about the real importance of what we were doing. We never thought about the context of *Civilisation* in its times. We were artisans who made no intellectual judgements.'[12] The filming of the programmes was driven by economics and logistics – getting the camera in the right place at the right time. It was Ann Turner's job to overcome the extraordinary difficulties of obtaining permission to film in a museum or church when the light was at its best – and then to coordinate the crew and all their equipment to be set up and ready to film on time. To make matters harder, as a woman she was not allowed into monastic houses. On the other hand, she found Clark easy, cooperative and professional. 'Ann specialised in rostrum work and was a super researcher,' Ken Macmillan recalled, but 'she was slightly patronised by Michael. She could be difficult because she was unworldly and a little gauche but we all had huge respect and affection for her.'[13]

The BBC was the only television organisation in the world that could have attempted something as culturally and economically ambitious as this – the scale of the production was unprecedented. The research, filming and editing took three years (1966–69); the film crew of twelve travelled eighty thousand miles, visited eleven countries, used 117 locations and filmed objects in 118 museums and eighteen libraries. Two hundred thousand feet of film were shot (the length of six feature-length movies) and £500,000 was spent. As Clark told Janet: 'Of course, it is a fearfully extravagant medium. One travels for days – five trucks of men and equipment etc for 35 seconds of film or none.'[14]

The series was not made in chronological sequence – filming began not in Paris, where the opening scene is set, but in Italy. The production was accomplished in a series of campaigns, and during any one trip material for three or four programmes would be filmed – always with very tight

schedules that took enormous risks with the weather. The three directors – each responsible for their own programmes – rotated, while the main crew continued filming. Typically filming would continue for six to eight weeks at a time, and during any week as many as five locations might be visited (although Florence took seven days). Only after the crew had set up and filmed scenic views (a process that might take several days) would Clark fly in to join them. Macmillan recalled, 'I didn't see K until the set at Carcassonne, which is episode 3, I think.'

Clark was shaking off the lecture format, but this had one downside, as he told his publisher Jock Murray: 'I am deeply immersed in the Civilisation programmes and think they are taking a good shape … the BBC came up with various worries: sometimes they think they are too highbrow, sometimes not highbrow enough … but whatever their merits as television, the programmes will not be printable.'[15] Although he had learned a lot at ATV, his performance was still judged as too stiff by the crew: Montagnon described how he 'would hold himself in such a way that he looked as if he had an internal problem'. Modern audiences have often been struck by Clark's poor dentistry. Today a producer might attempt to remedy the problem, but as Montagnon admits, 'It never occurred to us to suggest sorting out his teeth. K was encouraged to dress the way he did every day. He was so sure of himself he would have taken badly to being told how to dress.'[16]

There was a strong camaraderie amongst the crew. Montagnon recalled, 'Tubby and Ken worked well. Ken was a man on the up. Occasionally, we would all go out and get drunk on location. I remember Ken and myself climbing back into the hotel room one night in Germany. We needed a bit of relaxation with such long filming schedules.'[17] The crew would start at seven or eight in the morning for the light, then set up for Clark, who would appear at ten. Jane sometimes joined him on set, where she was always his first concern. *Civvy* turned out to be an Indian summer for their marriage, which had not been so happy for years – it was their last burst of luxury on a Grand Tour that covered favourite old haunts and took them to significant new ones like Aachen and Conques. Clark was enjoying himself hugely, and looked forward to every day's filming. The BBC made life as comfortable as possible for him, providing a car and driver. 'It was all incredibly grand,' remembered Maggie Crane, one of the crew. 'We would spend all day or several days getting the shots set up and K would arrive at the last moment. He would insist on showing us things as we drove up France which had nothing to do with the series.'[18]

At first Clark had approached the crew with a degree of diffidence, but this soon wore off. Ken Macmillan describes the process: 'He was never patrician or haughty to us, but had a shy charm. At first he would have dinner with Michael or Peter alone with Jane, but he gradually discovered the fun of the crew, who were a very mixed bunch. He then took to joining us for dinner, and it was probably a new experience for him to be part of a working team. He loved being included in the group, which created affection. He would sit rather quietly through dinner and rarely drank much, except a brandy after with a thin cigar.'[19] Clark frequently surprised the crew. Macmillan recalls that they had a large autocue which they used for every shot: 'He read every line, but he was very good at sounding warm and sincere on camera. He rapidly de-iced with us, and I remember on the ferry to Iona he waved at me, "You should come and look at this which will interest you," and it was eight lusty highland girls dancing a reel together.'[20] Clark was to astonish the crew during the filming of one of the early episodes when he carried the medieval Cross of Lothair up to the altar of Aachen Cathedral, and burst into tears. Michael Gill, who before that point had thought of Clark as a cold and unemotional man, had to change his opinion. Nor was this the last time that the crew would be surprised to see Clark suddenly weeping: it happened again during the filming of episode 6, *Protest and Communication*, when he was standing at the church door at Wittenberg – the shot took six takes because as he proclaimed Luther's putative words 'Here I stand!' he kept breaking down.

Macmillan felt that if Jane was present, 'Clark became more edgy and anxious. He would whisk her away before any trouble; and at dinner he would say: "Come on Jane, time to go up!" Jane was very nice if slightly fey. She always had a silver flask in her handbag.'[21] Jane was certainly high-risk on set, and an anxiety to Michael Gill. The Clarks usually stayed at different hotels from the crew, more for reasons of privacy than luxury – Clark, with his elephantine memory, would specify not only the hotel but the room he wanted.[22] Gill found Clark's hotel and restaurant choices distressingly grand and banal, but they may simply have reflected an older generation's desire for a dependable meal and a good night's sleep. The crew were ambivalent about Jane: 'We were aware that he had mistresses,' Peter Montagnon explained, 'but we could see that Jane was a difficult creature. She was too far gone to be charming. We were happier when she was not there, as she could hold things up, especially if they had rows – which resulted sometimes in K taking to drink himself. I remember watching him in the car mirror sitting in the back drinking whisky from

the bottle.'[23] Clark, on the other hand, thought that Jane 'rather enjoys the sense of concerted action that film-making produces.'[24] The crew were surprised that when she henpecked her husband in public he never reacted or attempted to restrain her. He also made no reference to Jane's drinking, although they certainly witnessed it. Ann Turner remembered that during filming at Santa Maria Maggiore in Rome they left Jane 'at the foot of the church steps, and when we came out she was plastered'.[25]

Michael Gill and Peter Montagnon had an excellent working relationship, and divided the programmes according to their own tastes and what came up. Gill was the most astringent of the three directors, and for him the focus was always on the idea, the word and the story. Ken Macmillan thought that 'Michael was basically a journalist, and writing was always the most important element for him. He wasn't particularly visual, and that's where we came in. I think he understood that.'[26] Clark and Ken would often have an idea for a different shot to Gill; they would catch each other's eye, Clark would wink, and without Gill realising Ken would quietly set it up. Clark also had a close rapport with Basil Harris, the sound recordist, which perturbed the directors. Montagnon recalled: 'We were annoyed that he listened so much to Bas – although this was no bad plan because Bas was usually right.'[27]

The differences between the Montagnon and Gill episodes are interesting. The crew thought that Peter had rather more imaginative ideas and took more risks, but Michael was the more effective and reliable director; his programmes were technically better, and more tightly constructed. Michael directed the first episode, *The Skin of Our Teeth*, which along with the last was always going to be the most difficult to get right. There was endless argument about how the series should begin – with a bang, or slide into it? The Paris opening, if a little clichéd, worked well. Gill loved the fact that Clark was prepared to say that civilisation was almost snuffed out, and 'we nearly didn't make it'.[28] Peter Montagnon directed episode 2, *The Great Thaw*, and Clark thought he made a terrible hash of it, redeemed by editing.* If Peter was out of sympathy with the subject, Clark thought 'he

* 'I saw no 2 again on Friday. It is *foully* badly directed. The script is OK and the material sublime, but poor little Peter has muffed it all along the line – no continuous rhythm, no sense of my being in the places or even relating what I was saying. A missed opportunity! … Of course it was 80 per cent worse before Michael and I doctored it – in fact so bad that we seriously thought of postponing the whole series in order to do it again.' Letter to Janet Stone, 6 March 1969 (Bodleian Library).

could go terribly wrong' – he was at his best with exuberant subjects such
as the Catholic revival, *Grandeur and Obedience*, and the Rococo episode,
The Pursuit of Happiness.

Ann Turner may have been patronised by Michael, but she was the
person on whose knowledge and organisation the series most depended.
Clark correctly thought that she 'felt she was being slighted and so was
given a programme which the other two did not like'.[29] Michael gave her
episode 4, *Man the Measure of All Things*, about the Florentine Renaissance,
because as Montagnon admitted, 'Michael and I found the content unsym-
pathetic, too absolutist, and disagreed with the idea of man as the measure
of all things'.[30] The crew found Ann a nervous director. This should have
been Clark's favourite episode, as Florence was his spiritual home, but he
felt 'I talked much too fast … and the whole thing does not have the
relaxed feeling of the other programmes'.[31] There was an external reason
for this anxiety: in 1966 the city had suffered a terrible flood, the effects of
which were made worse because floodwater was contaminated with oil
stored in basements. This had a gravely deleterious effect on marble, paint-
ings, documents and works of art on paper. Quite apart from Clark's
distress at the damage Florence had suffered, either filming had to be dras-
tically curtailed or the crew had to move to another location. As Gill, who
was in London, recalled, 'Neither option seemed very palatable.' Uncertain
how to proceed, he put a call through to Italy: 'I asked Clark if he would
like a day [to consider the options]. The answer came at once and briskly,
"Oh no, I'll write [episode] Number Five. It's got the advantage of keeping
us in Italy … I'll have it ready for you when you arrive."'[32] That was only
three days away, and the script was finished, as Clark had promised, by the
time Gill arrived. Gill judged it 'fresh, caustic, and pithy … one of the best
scripts I had read. Well, well, I thought; if he continues like this there may
be a book here anyway.'[33]

Clark particularly enjoyed filming at Assisi and Urbino: 'Assisi is more
uplifting – in this it is second only to Chartres. But Urbino is such a sweet
place – so compact, so humane and without any of the air of exploitation
which is a slight drawback at Assisi (very slight – less than Stratford). As
for the palace of Urbino, it is the most ravishing interior in the world.'[34] He
observed, however, that 'All producers long to get away from works of art,
and take film of sheep being milked, etc.' Gill insisted that each episode
should at some point bring in the present, and on the hills above Urbino
they found scenes straight out of Giorgione. The Mayor of Urbino certainly
saw the benefits of filming the town, and put on a banquet for the crew;

the wisdom of his actions was proved when *Civilisation* put Urbino on the tourist map. *Grandeur and Obedience* is the only episode filmed in one location, Rome. It and episode 9, *The Pursuit of Happiness* (both directed by Montagnon), are the most emotional in the series. Michael Gill might have toned these down, but Peter revelled in them, and for episode 7 he recalled 'hiring an aeroplane to fly over the Vatican with a photographer pilot with myself and Ken. The Vatican came to trust us and left us alone: the prestige of the BBC helped a great deal.'[35] There were two especially memorable scenes in this episode. The first was of Bernini's sculpture *The Ecstasy of St Teresa* in the church of S. Maria della Vittoria: perfect, sensuous camerawork on a great subject by a great artist, illustrating the Catholic revival, and accompanied by the saint's words telling of her moment of ecstasy – which Clark then unstitches by showing a plain portrait of the real Teresa. The other great scene was the ending. Montagnon recalled: 'When we were filming in the Vatican, K wanted to finish the programme about the Baroque with some enormous room, because he said the mind of the seventeenth century was used to living in these huge rooms.'[36] They hit on the idea of a mesmerically long shot reversing back down the interminable Gallery of Maps.

The Pursuit of Happiness is the most indulgent of the programmes, and one of the most original. Clark enjoyed revisiting German pilgrimage churches and showing them to Jane for the first time. This episode was to be about music – a key factor in the series. Clark and Montagnon chose the music for all the episodes so that the extracts had been written within twenty years of the art they illustrated, but as Clark told Janet: 'What to do with Bach!! He was so Protestant, one can hardly illustrate him by Catholic architecture, and there is no Bach town like Dürer's Nuremberg.'[37] They had no choice but to have Bach's music alongside the Rococo churches, and nobody complained. Montagnon recalled: 'It was extraordinarily difficult to light the great church of Vierzehnheiligen to get the detail. We had an enormous number of lights, perhaps twenty, with two special lighting crews who took all day to set up. Otherwise it came out flat as a pancake.'[38] He believes that Clark revealed himself most fully in this episode, and came out with his innermost feelings. Clark's inclusion of the Rococo passage from Laurence Sterne's *Sentimental Journey* was a masterstroke, and seemed to describe perfectly the world of Watteau's paintings.

Perhaps the most unsung member of the *Civilisation* team was the brilliant editor, Allan Tyrer, considered the best in television, brought in for *Monitor* by Huw Wheldon. Peter Montagnon singled out the point in *The*

Pursuit of Happiness when Clark is reading the passage from Sterne, and there is the elision of string music just as he reads the words 'the natural notes of some sweet melody' – 'a masterpiece and the work of wonderful Allan'.[39] Michael Gill generously said of the episode, 'I am certain that this is the best film so far. Even without the music it's clear that it is magical ... if the flower people have not all been blown away by 1969 this film should become their anthem.'[40] Clark agreed, as he told Mary Potter: 'The Rococo is a dream – in fact the best programme I have ever seen on Television!'[41] Montagnon concluded, 'This episode is more a work of art than a work of history.'[42]

David Attenborough had anticipated that the directors would come back and ask for more money: 'Peter and Michael had the wit to come and ask me after they had shown me a particularly effective section of a rough cut they had put together, and I recklessly said, "Michael, that's exactly what we're looking for. Wonderful."'[43] Attenborough was able to come up with extra finance by a simple ruse. Television was funded in those days by the hour or slot, and repeats were unknown. Attenborough thought, 'This was so marvellous that anybody seeing this would want to see it for a second time. So I decided there and then that we would show each episode twice in the same week, and that meant that I halved my per-hour cost, which was great.'[44] The main surprise for Attenborough was that the programmes 'encompassed not just art but Beethoven and Montaigne, something I had not expected. But whichever way you look at it, they are important figures – and the fact that the series made anyone aware of them made it all worth it.'[45] The programmes were to be fifty minutes long; as their commercial success depended on sales to the US they had to be able to accommodate regular commercial breaks within an hour, and when Time Life executives came over to London this was their main concern.

Gill and Montagnon evolved the idea of letting the camera linger and caress certain works of art to music, and such sequences came to be known facetiously as 'commercials': a notable example was the moment of sheer eroticism as the camera rises slowly up the thighs of Donatello's bronze *David*. Gill was always looking for ways of using images that would go beyond Clark's script. Two scenes have remained the subject of much debate. One is the actors on set declaiming Shakespeare in episode 6, *Protest and Communication*. Although this was a Montagnon production, it was Gill's idea to show actors performing extracts from *Macbeth*, *King Lear* and *Hamlet*. Many, including Attenborough at the time, thought these scenes were out of place, and inconsistent with the style of the

programmes.[46] They certainly interrupt the narrative, and Clark afterwards admitted, 'we could never decide what to do about [Shakespeare].' He thought the awkwardness arose from the choice of 'an old actor [playing Lear] who had a great success in the part in the 1920s and very little success since.'[47] The other much-debated scene was the so-called 'Osterley-on-Sea' moment in episode 12, *The Fallacies of Hope*. Gill thought that a visual metaphor was needed for leaving the finite, symmetrical, enclosed world of the eighteenth century for the infinite and uncontrolled world of Romanticism that lay ahead. Clark passes under the portico of Osterley Park, a Neoclassical mansion which is actually located in a London suburb, and in a *coup de théâtre* faces a churning ocean. The crew couldn't find a convenient coast with big enough waves, and so settled for a close-up of a rocky bit of Cornwall and turned up the music. Clark regretted the contrivance, as everything else in the series was filmed with complete authenticity.*

Filming could be unrewarding, and sometimes even dangerous. Clark adored Voltaire's house at Ferney: 'the nicest country house you can imagine … looks like a Hubert Robert [i.e. pouring rain] … so we have had to transfer the exterior to the interior – a wearisome day. After hours of trouble in laying down rails, fixing lights etc I have said two sentences – about ten seconds … one must take the rough with the smooth.'[48] Clark's preferred director was generally Gill, as he was the safest pair of hands, and they found it easy to laugh together; but he reported to Janet: 'Michael Gill doesn't like my "revolutionary" script – but it isn't so bad. I was looking forward to doing the last one with Peter Montagnon, but he has taken the job of head of the University for the Air [i.e. the Open University] – dreadful trade.† We shall miss him very much, as he is so kind and thoughtful, and I have really enjoyed my programmes with him. Michael fusses me with his fashionable modern views.'[49] The filming of the programme that covered the French Revolution, however, was overtaken by the outbreak of student riots and the series of strikes later known as *les événements*. Maggie Crane recalls: 'We were staying in a small hotel near le Pont des Arts and got [tear] gassed in Paris, but it was the day before K

* 'I was rather ashamed of putting Osterley by the sea – the only fake in the series. I must say it looked rather comical to see the portico reconstructed on the Cornish coast.' Clark to Lady Pansy Lamb, 4 June 1969 (Tate 8812/1/4/98a).

† *King Lear*, Act IV, Scene vi: Edgar describes an imaginary cliff near Dover: 'Halfway down/Hangs one that gathers samphire – dreadful trade!'

arrived … We had great difficulty getting to St Denis because of the general strike. We decided to cut short Paris filming and head for Aachen: "We are like Louis XVI fleeing Paris," said K cheerfully.[50] The music for the episode was to include a rendering of 'The Marseillaise', but no recording could be found. Clark made the imaginative suggestion of driving down to the nearby Renault factory and trying to persuade the striking workers to sing it for them, but at this point Michael's radicalism failed him. They eventually found a recording of the French national anthem sung by Russian sailors.

Clark had trouble with episode 11, *The Worship of Nature*, as he told Janet: 'Still struggling with the early romantics, and I am tempted to say that the whole movement was due to the fact that two men of genius [i.e. Byron and Wordsworth] fell in love with their sisters.'[51] But while they were filming that programme they had one splendid piece of luck which made up for all the times they had to do retakes owing to noise and other street hazards: 'We found a splendidly Turneresque valley – but alas an airplane came over during the best shot. And then the light lost some of its magic. Then we went back to the summit, and suddenly there appeared (as to Ruskin) the whole line of the Alps from Mont Blanc to the Matterhorn, rising above the clouds. It was a stunning sight – we immediately set up our camera, etc. amid the clanging cowbells, and I set about a piece in which Turner, Goethe and the study of clouds all come in. I was standing with my back to the view, and by the time I got to the word *clouds* I saw the crew grinning – at that moment the whole landscape had been blotted out by a cloud, and two seconds later I was enveloped and practically invisible. What a coup de theatre if it comes off.'[52]

The episode that gave Clark the most anxiety was the last, *Heroic Materialism*, in which he felt he was out of his depth. It had to provide some sort of summary, but he had no idea how his series should end, or on what note. Covering the invention of humanitarianism, the rise of engineering, the genius of the Impressionists and Tolstoy, it gave Clark an awkward narrative, but Michael Gill came to his rescue in the envoi. While they were in Bristol shooting the works of Isambard Kingdom Brunel, Gill said to Clark, 'You know, you must end the series with a summary of your beliefs.'[53] This was unexpected, but Clark sat down in his hotel bedroom in Clifton and put down on paper what became his famous 'credo'. His story of *Civilisation* drew to an end with 1914, followed by a series of images representing the rewards and enemies of civilisation in the twentieth century: the telescopes at Jodrell Bank observatory, space travel and

Concorde, overlaid by a dystopian montage of computers, Stuka dive-bombers and atomic explosions. As Gill's wife Yvonne Gilan recalls, 'Michael had a hell of a time over their last programme. He thought the ending was confused and a mistake. K's personal testament was a way of getting around the problem of ending.'[54] Clark spoke his 'credo' in his study at Saltwood, then got up, and in his own words: 'I walked into my library, patted a wooden figure by Henry Moore, as if to imply that there was still hope, and … it was all over.'[55]

At the end of the whole enterprise Clark gave a party for the crew at Saltwood at which he told them that the making of *Civilisation* had been among the happiest two years of his life. He had enjoyed himself more than he could possibly have imagined, and wrote to David Attenborough: 'I can never be sufficiently grateful to the BBC for giving us all these holidays with pay.'[56] The BBC, which had spent £500,000 on the project (the equivalent of over £8 million today), was also cock-a-hoop. As Huw Wheldon put it to Gill, 'What a relief to be standing in gold.'[57]

33

Civilisation and its Discontents

*A kind of autobiography disguised as
a summary of Western Civilisation.*

KENNETH CLARK to Mme Auerbacher-Weil,
7 October 1970[1]

Civilisation began broadcasting in February 1969. Because comparatively few people had sets that could receive BBC2,* let alone colour, only one million people viewed the series the first time round, and it would have to wait for repeats before achieving its full impact. Despite that, David Attenborough recalled: 'We knew it was successful but none of us had the faintest idea quite how successful it was going to be … it was one of those legendary things; people invite you in to see it. I won't say the pubs shut as far as *Civilisation* was concerned, but colour television sets were in the minority.'[2] Evensong was rearranged in some country parishes so the congregation could see the programme on Sundays, and *Civilisation* parties were held in the homes of those who owned a colour television. At a time when mass travel was only just beginning, for most people the series represented the grand tour they would never make, and they trusted Kenneth Clark to take them to the best places. He succeeded as never before in opening people's eyes to art, the fulfilment of his Ruskinian mission. Flawed though it may be, for the public *Civilisation* was to be his 'great book'. Like Ernst Gombrich's *Story of Art*, it gave the subject a framework.

* BBC2, which started transmission in April 1964, used a more advanced 625-line system than the existing BBC and ITV, so viewers with older sets were unable to watch the new channel.

The first episode opens with Clark in the heart of Paris, quoting Ruskin: 'Great nations write their autobiography in three manuscripts: the book of their deeds, the book of their words and the book of their art. Not one of these books can be understood unless we read the two others, but of the three the only trustworthy one is the last.' The story was to be told through art and individuals – often thinkers and poets – but always referring back to visual sources. What went in and what was left out reflects Clark's own preferences, as was made clear in the series' subtitle: *A Personal View*. Clark put his first question standing with Notre Dame at his back: 'What is civilisation?' He answers, 'I don't know. But I think I can recognise it when I see it; and I am looking at it now.'

Clark's world view soon becomes apparent. *Civilisation* is a largely Mediterranean story, the honours divided between Italy and France, with Germany, Holland, Britain and America in supporting roles. The series is Gibbonian, in that *The Decline and Fall of the Roman Empire* portrayed the destruction of civilisation as it had grown up in Classical times and its survival as synonymous with the survival of Classical culture. In the first episode Clark presents the remnants of Roman civilisation hanging on in the eighth century as though on a cliff edge. Religion is at the heart of his story, and it is the fusion of Christianity with Classical humanism that provides many of his heroes, from Charlemagne through the Renaissance and beyond. Their hallmarks are literacy, confidence and a sense of permanence: Alcuin and the court of Charlemagne offer us the first powerful demonstration of this. As the Oxford philosopher Stuart Hampshire observed, the series 'rests on no general theory but reflections on people and places. Civilisation depends upon secure centres of power where artist and patron can flourish.'[3]

Civilisation was in a sense Clark's autobiography – through the various episodes it is possible to trace the books that he had read as a schoolboy and a student at Winchester and Oxford, particularly H.G. Wells (Clark made much of Wells's distinction between the nomadic communities of Will and the agrarian communities of Obedience), Michelet, Tawney and Ranke.[4] His early visits to Iona are recalled by the first episode, while trips to Germany when he was at Oxford and later influence the episode on the Baroque,* and holidays in France exploring cathedrals and Burgundian

* 'I had a lovely day in the peaceful, solid Bavarian countryside, and saw eight Baroque churches – half monasteries, half farms, white and clean outside, gold and silver inside.' Clark to Mary Potter, undated, c.1950 (Potter Archive).

abbeys were no doubt also important. Sometimes familiarity worked against his script; we find him struggling with the early Renaissance: 'I am strengthening it and hope to give it some of the humanity of the late medi-aeval script, but, alas, the subject is rather too familiar to me, and it is hard to give the feeling of *discovery* which is the merit of some of the others.'[5] We can perceive Clark's friendships in certain episodes: many of Maurice Bowra's tastes, such as *Fidelio* and the life of Tolstoy, had become his own; and in the passages on medieval monasticism and the Baroque saints we may recognise the influence of David Knowles. Clark had been brooding on some of his subjects for decades: his 1945 lecture 'English Romantic Poets and Landscape Painting' is an obvious forerunner of episode 11, *The Worship of Nature*, just as his Arts Council exhibition catalogue *The Fallacies of Hope* (1959), about the Romantic movement, anticipated episode 12, even taking the same name. John Pope-Hennessy gave his opinion that the programmes 'are K's true self-portrait. They show him in countless different contexts exactly as he was: sometimes incisive, some-times extremely funny, sometimes impatient, sometimes intimate, some-times almost tongue-tied.'[6]

Clark's *Civilisation* is also a view of great men performing great deeds, so different from the Bloomsbury view – Keynes apart – that civilised men eschewed the life of action. He trumpeted those Victorian virtues of activ-ism that Lytton Strachey had ridiculed in *Eminent Victorians*, and subscribed to Thomas Carlyle's view that history is about heroes, adapting the title of episode 5, *The Hero as Artist*, from Carlyle's lecture 'Hero Worship and the Heroes in History' (1840). Clark and Carlyle shared a dislike of the eighteenth century, but both allowed that even that insincere era had its heroes – Voltaire, Rousseau and the *Encyclopédistes*. Some of Clark's heroes were inherited from his boyhood. When he spoke movingly about St Francis he was echoing Monty Rendall's lectures at Winchester, although he claimed, 'I felt unworthy to write about him. But in the end I couldn't leave him out. How much do people nowadays know about him I wonder? He was *the* saint of Ruskinians like myself.'[7] But he had changed his mind about some heroes of his youth. Ever since reading Mark Pattison's essay on Erasmus as a teenager, Clark had admired him as the voice of tolerance, but as he told Janet: 'The strange thing is that I have ended up with a kind of distaste for Erasmus – the civilised man, and a much greater admiration for Luther, the destroyer of renaissance civilisa-tion'[8] – hence his emotion at proclaiming Luther's words in episode 6. Clark surprised himself in another way, as he told Janet: 'strange how my

history of civilisation has really turned into a history of religion. I fear it will please nobody.'[9]

Throughout the series Clark refers to civilisation as a cart to be pushed up the hill. This seems to suggest a determinist position, but is in fact misleading. There is no 'process of history' here; rather, it reflects Clark's belief in the inherent fragility of a central tradition of art 'beginning, as Herodotus said, in Egypt; reaching its first perfection in Greece ... reaching its second perfection in France in the twelfth and thirteenth centuries, and so forth, down to our own time'.[10] There is nothing inevitable in the story he tells, which traces the consequences of impulses generated or expressed by men of genius. Baudelaire, Clark once wrote, 'declares how these unquiet, mysterious or tragic figures [artists] are beacons to him, the lighthouses which have lit humanity on its way',[11] and he warns us: 'We got through by the skin of our teeth, and it might happen again.' The Reformation ends with the Thirty Years War, the French Revolution ends with the Terror, the Industrial Revolution causes the horrors of exploitation of labour, and the twentieth century creates the atomic bomb. Behind these observations is the pessimism with which almost every episode concludes (except for 'those hundred marvellous years between the consecration of Cluny and the rebuilding of Chartres'). Giorgione's *Tempesta* is 'the first masterpiece of the new pessimism'; in Leonardo's drawings of *The Deluge* Clark sees that 'the golden moment is almost over', while Shakespeare is controversially described as the poet of unbelief, for 'Who else has felt so strongly the absolute meaninglessness of human life?' Don Giovanni arrives to spoil the *fêtes galantes* in *The Pursuit of Happiness*. As Clark approaches his own era, his pessimism becomes more pronounced. At the time Christopher Booker observed that very few caught the precise nuances of his premonitory tone, through confusing it with the almost universally shared position that 'the modern world appears to be going to hell in a handcart'.[12]

Perhaps Clark's authorial voice has worn least well in the last episode, in the famous 'credo' that Michael Gill made him sit down and write in Bristol: 'At this point I reveal myself in my true colours, as a stick-in-the-mud. I hold a number of beliefs that have been repudiated by the liveliest intellects of our time. I believe that order is better than chaos, creation better than destruction. I prefer gentleness to violence, forgiveness to vendetta. On the whole, I think that knowledge is preferable to ignorance, and I am sure that human sympathy is more valuable than ideology ... above all I believe in the God-given genius of certain individuals, and I

value a society that makes their existence possible.'* Whether Clark real-
ised it or not, the temper of this tract situates him firmly in Bloomsbury.
It elegantly distils the substance of E.M. Forster's essay 'What I Believe',
although Clark could never have agreed that 'Hero-worship is a dangerous
vice.'[13]

The 'credo' struck an astonishing chord with members of the public;
hundreds wrote asking for copies, so that Clark's secretary Catherine
Porteous had to have them printed ready to send out. Then as now,
however, intellectuals considered it unsatisfactory. Frances Partridge, that
latterday doyenne of Bloomsbury, wrote in her diary: 'It was unexcep-
tional, but he lost some of my respect by prefacing his talk with "I must
reveal myself in my true colours as a stick-in-the-mud," said with a tone
of relish. He *doesn't* think he is one, so why not have the courage to stand
up for his beliefs.'[14] This was perhaps a misreading of the ironic modesty
with which Clark approached the impossible task of summing up what he
had learned from *Civilisation*. Or perhaps the fact was that he no longer
knew what to believe, and didn't want to come off the fence. Peter
Montagnon thought that 'the Credo was over the top. Nobody believed it
for one second, a fake dreamt up by two men in an impossible position
who had to finish an epic voyage.'[15] Far more eloquent and expressive of
Clark's state of mind was his quotation from W.B. Yeats at the end of the
last episode: 'Things fall apart; the centre cannot hold/Mere anarchy is
loosed upon the world … The best lack all conviction, while the worst/Are
full of passionate intensity.'

Nevertheless, Clark remained confident that the cultural landmarks he
had grown up with were still those worth trumpeting. It was just about the
last moment when that view could have been put across successfully to a
very wide audience: Clark as a second Moses handing down tablets of
European culture. Some critics, mostly from the political left, questioned
the whole basis of his approach: the identification with the male, Western,
bourgeois concept of civilisation – no Africa, no Asia, no Islam and no
South America. But academics and left-wing social theorists were never
going to accept Clark's view of civilisation from the top down. Nonetheless,
the success of the series proves that a very large public was willing to have
their acquaintance with this canon of famous art initiated or renewed in

* One day in 1968 Raymond Mortimer said to Clark at Albany: 'K, one thing I want to
ask you: "God-given genius" – do you mean God? There was a hesitation and he replied,
"As a matter of fact, I do!"'

this way by Kenneth Clark. Michael Ignatieff shrewdly pointed out that the cultural debate in Britain between the elitists and the populists was the class war in another form, and 'any debate about cultural standards in Britain is necessarily about who gets to talk down to whom, about which accent does the judging'.[16]

Clark's frequent swipes at Marxist historians and 'modern thinkers' gave the impression of an old-fashioned liberal historian frightened of the present age. When he talks about the dignity of man, he admits, 'the words die on our lips today'. At the end of episode 12 he speaks of what 'impairs our humanity', and offers a list of such items that still has resonance: 'lies, tanks, tear gas, ideologies, opinion polls, mechanisation, planners* and computers'. And in the final programme, as a thermonuclear reaction mushrooms on the screen, he states that 'the future of civilisation doesn't look very bright'. This is the pessimism of a man born in 1903, who had lived through the rise of fascism and two world wars, who had been profoundly affected by the devastation of the atomic bomb, and who now saw a world in disintegration. Not for the first time, Clark found himself uncomfortable at being the hero of the culturally conservative, as he told Colin Anderson: 'They were intended by the BBC as no more than a sequence of pretty pictures in colour, and I accepted this as my aim. But, as you know, I can't resist airing my prejudices – also some love of purgatory makes me enjoy saying things that will annoy the orthodox highbrow. The result has been that Generals, Admirals, Lady Dartmouth, Lord Mayors of London etc. all feel that they have found their spokesman at last. Also, I am bound to say a lot of nice humble people.'[17]

The press reaction to *Civilisation* was generally ecstatic. *The Times* ran a leader headed 'How Like an Angel', and J.B. Priestley in the *Sunday Times* thought the series was 'in itself a contribution to civilisation'.[18] The *Sun* hailed Clark as 'the Gibbon of the McLuhan Age', and Bernard Levin compared him to Goethe. Philip Toynbee in the *Observer* wrote that Clark 'is as English as a man could be who loves and understands so much that is so thoroughly un-English in the art and thought of Europe'.[19] The dissenters were rarer; the most celebrated was the left-wing Cambridge intellectual Raymond Williams, who attacked *Civilisation* on the grounds that it was 'a long last gathering up by sad and polished minds of an

* Colette recalls that the secretary of the Institute of Planners wrote a sad letter saying that they were really not as bad as tanks and tear gas.

Edwardian world view and an enacting of pieties learned very long and very hard and now with all the emphasis of a public corporation'.[20] He called it the 'old dinner-table style' propaganda for an ignoble past, and a means of rejecting the world today. Another dissenter was the art critic Edward Lucie-Smith (writing later): 'His programmes ... were, I thought, enough to make anyone opt for the barbarians ... "Oh not *again*!" I sighed, as, his eyelids crinkling with condescension, this mandarin figure ambled round yet another ancient monument'.[21] Clark occasionally played to the gallery with some after-dinner-isms, as he admitted to one correspondent: 'It is a safe rule of public life never to make jokes. I was foolish enough to break this rule several times in "Civilisation" and what I said ironically has often been taken literally'.[22] David Attenborough saw it differently: 'Clark had a way of expressing things in absolute mandarin prose, and then in the middle of it putting a colloquialism which brought you up short – and you realised that this man was not just a scholar in the high and ivory tower, but actually knew what went on in human beings' minds. I found that absolutely bewitching'.[23] Noel Annan, looking back in *Our Age*, thought that *Civilisation* showed what mettle there was in the Oxford wits.

Despite the relatively low viewing figures for the first broadcasts (if indeed they can be believed), the public response overwhelmed Clark. As he told Huw Wheldon: 'letters of gratitude continue to pour in at the rate of about sixty to seventy a day and are a considerable embarrassment to me ... the programmes seem to have had a peculiar interest for the religious. Nuns by the dozen ... many bishops, two cardinals and Father D'Arcy (twice). It is all very peculiar ...'.[24] To Janet Stone he wrote: 'The public response is *incredible* – the highest appreciation figures ever. The highbrow figures are furious and foam at the mouth in all the highbrow or "with it" papers'.[25] The letters from the public took many forms. There were some clever-dick letters hoping to catch Clark out; some long-winded letters from pompous bores; some indignant letters taking issue, saying *Civilisation* was far too Christian, or was rude to the Vikings; some letters outraged by Clark's apparent admiration for the power and wealth of the Catholic Church. But overwhelmingly there were grateful letters from people whose horizons had been expanded. People sent him their poems, asked him about painting courses. The most affecting letters were those that said the series had saved them from committing suicide. John Betjeman simply wrote, '*Civilisation* is the best telly I have ever seen'.[26]

The television producer and later Controller of BBC Radio 3, John Drummond, would recall the public impact of the series: 'I was fairly crit-

ical of *Civilisation* at the time, finding Clark's manner unengaging, until while the series was first being shown on television I sat next to a clever young woman from *The Economist* at a dinner. I was droning on about whether Clark was as reliable on political history as he was on art history when she interrupted me and said coolly, "My father is seventy-four years of age and lives in Stoke-on-Trent. He has never been interested in art. Last week he came to London to see me, and his first question was 'Where is the National Gallery?'" That is what *Civilisation* achieved, and I felt properly reproved.'[27]

Apart from the lunatics, Clark answered every letter, often at length – Colette spent three months at Albany typing the replies. There were a number of mostly minor mistakes in every episode that were picked up by the public – typically 'William' for Henry Purcell, and Mozart's G minor 'quartet' for 'quintet'.* The philosopher Bryan Magee wrote to Clark with five pages of corrections when the book came out,[28] but Clark dismissed them to Janet: 'Did I tell you that a man wrote to say that he enclosed 50 errors – but they turned out not to be mistakes of fact, only questions of opinion.'[29] In the end Clark adopted a standard letter which expressed gratitude and acknowledged 'at least two mistakes in each programme', since so many people took pleasure in pointing them out. Mistakes apart, there was one opinion in particular that brought him a storm of protest: his view that Shakespeare was without religious belief. As his friend David Knowles told him: 'I won't have Shakespeare among the pessimists or the agnostics.'[30] Clark wrote rather testily to one protester that 'Dante was … the greatest Christian poet, and Shakespeare the greatest non-Christian poet. You, as a Christian, may be loath to admit it, but there is room for non-Christians in the world, and there seem to be a lot of them about.'[31]

Looking at *Civilisation* today, one becomes aware of how sensitive the series is to the rude disorder of its times. The period was troubled: it was the height of the Cold War, of Biafran genocide, of the Vietnam War that was provoking mass protests in the United States and Britain. There were race riots in America, student riots across the whole free world. Elsewhere, there were murderous dictators: Mao Zedong, 'Papa Doc' Duvalier and the emerging Pol Pot. Above all, in the West it was a time of student

* More worryingly, in what Clark called 'my true centre', the Florentine episode, Brunelleschi did not design the cloister at Santa Croce, and current consensus is against Clark with the Louvre *Concert Party* as a Giorgione and also the *Ideal City* as a Piero della Francesca.

dissent, when young people were no longer prepared to accept the institutions that their parents had held sacred. The popular youth culture in 1969, the year *Civilisation* appeared, was that of the Woodstock festival, the birth of *Monty Python* and Led Zeppelin. Kenneth Clark, with his tweed suits and upper-class air, was not unusual at that time on television,* but his view of European culture seemed too venerable not to be lampooned – and it certainly was: a 1973 *Monty Python* sketch featured a boxing match between Clark and the heavyweight boxer Jack Bodell; as Clark extols, 'This is the height of the English Renaissance ...' he receives a knock-out punch – and Bodell wins the title of Oxford Professor of Fine Art. However, to most of the public, as Humphrey Burton points out, '*Civilisation* was a beacon of hope and positive thinking, a sense of how useful our medium could be. And I think that there was no great undertow of hostility, so far as I can recall ... Although the young were in revolt there were many, many more middle-aged and old people for whom it was the wildest thing to behold week after week. They thought after Paris and the sit-ins they could have a bit of K. Clark.'[32] There was a part of *Civilisation* that responded to this climate of upheaval. In the penultimate episode, *The Fallacies of Hope*, there is a montage of uprisings: France 1830; France, Spain and Germany 1848; France 1871; Russia 1917; Spain 1936; Hungary 1956; France and Czechoslovakia 1968; and a reference to oppression in 'Spain or Greece today'. Cecil Beaton observed the contradiction in his diary: 'When he is on tricky ground, e.g. a rich man welcoming the revolutions of the underprivileged, one is alert to criticise, but the guarded phrases in which he cloaks his opinions are so exact and clever that one cannot worst him.'[33]

Clark's omissions made him an easy target for criticism. The most obvious problem was the series' title, with its implication of the superiority of European civilisation over all others, which not even the subtitle could assuage. It tells us much about the fragmentation of the world in the late 1960s that the title did not give more offence, and was indeed passed over in most reviews. Clark himself gave differing opinions on the worst omis-

* 'The presentation was of its age. Clark was very patrician. The class barrier is people looking backwards. It was not a problem at the time' (Michael Grade to the author). Clark's suits were often described as 'impeccable', but in fact they were not always well-fitting. Anthony Powell in his *Journals* (entry for 16 September 1984) quotes Lord David Cecil as saying that he had never regarded Clark as well-dressed. Powell adds: 'Clark was always very neat, but I agree something also looked radically wrong for some reason.'

sion from the series: Byzantine art, the development of law from the Vikings, Racine, Poussin, German Romanticism and philosophy were the ones he most frequently offered. Some thought he should have brought in Picasso and Modernism. But towering above them all was the prickly question of Spain, the omission of which caused so much offence. Clark was taken to task by Catholic historians such as David Knowles, who thought he was simply wrong. Many assumed that his was a Protestant view, which was demonstrably untrue, given his praise for Counter-Reformation Rome. However, his baleful view of King Philip II of Spain had certainly discouraged him from making the Escorial Palace the centrepiece of a Spanish inclusion which he had briefly considered.[34] It was not just the Spanish who were offended, but the entire Hispanic world. From Venezuela the British Ambassador, Sir Donald Hopson, wrote to inform Clark that the showing of the series in Caracas had caused a lot of wilful misrepresentation and anti-Anglo-Saxon feeling.[35] Lengthy newspaper pieces appeared on the glories of Hispanic culture that Clark had ignored. He wrote a long letter to justify his position, pointing out that he was not anti-Catholic or anti-Baroque, as the series makes clear, and that he had included Velázquez, Goya and El Greco in his book *Looking at Pictures* (1960).[36]

To a present-day audience, another obvious omission is the lack of women in the series. Clark speaks eloquently in episode 3 about chivalry and the cult of the Virgin, but it is not until the *salon* ladies of eighteenth-century France, Madame du Deffand and Madame Geoffrin, that women play a central role in his story. He gives space to Dorothy Wordsworth, but largely as the inspiration to her brother William, and Elizabeth Fry is mentioned, but only in passing. Clark emphasised the feminine with his contention (despite the ridicule of John Sparrow and Maurice Bowra) that 'the great religious art of the world is deeply involved with the female principle', and stated his belief in the balancing power of feminine faculties with the male.

Neil MacGregor, generally an ardent admirer of the series, was particularly struck by Clark's extraordinary difficulty in dealing with Germany and the art of the north: 'The thing that most encapsulates that for me is when he compares a Raphael portrait with a Dürer portrait and he insists in seeing in the Raphael portrait qualities of balance, harmony, serenity, and he insists in seeing in the Dürer portrait nervousness and ill-suppressed hysteria.[37] It is a view of Germany largely shaped by the anti-German propaganda of the First World War. That seems to me to

leave the vision of *Civilisation* hopelessly flawed.'[38] Clark's view of Germany was certainly coloured by two world wars, but he is unlikely to have allowed that to influence his view of its art. He would have pointed to episode 9, *The Pursuit of Happiness*, which gives a positive view of German architecture and music, both of which he worshipped.

Clark was unprepared for the appreciation felt for the series by so many people. He was especially pleased when young people wrote, and it appears today that there were far more young viewers than was realised at the time. As the historian David Cannadine has written: 'I was myself one of them: in what would now be called my gap year between school and university, and I have never forgotten the impact those programmes made – opening the eyes, uncorking the ears, stimulating the sensibilities. Indeed there must have been hundreds of thousands whose lives these programmes changed for the better.'[39]

One group was conspicuously silent – Clark's fellow art historians. There were admiring pieces by his friends Ben Nicolson in the *Burlington Magazine* and Denys Sutton in *Apollo*, but only one letter from the Courtauld – from Michael Kitson (who was in fact writing to thank him for the loan of a Claude drawing). Clark wrote back: 'I am immensely pleased to have had a letter of support for one of my programmes from someone in the Courtauld Institute.'[40] He continued to believe that there was academic hostility against him, as he had told an audience in October 1967: 'In the last ten years I have changed my mind that the English do like art. I doubt if a single Oxford don has watched any of my programmes but ordinary people do – they feel something is being given to them.'* John Russell summed up what many felt when he spoke, on Clark's seventieth birthday 'for the thousands of people who have held themselves just a fraction straighter since they learned from *Civilisation* that they were the kinsmen of Dante and Isaac Newton, Michelangelo and J.S. Bach'.[41] More recently, the late novelist and art historian Anita Brookner described the series as 'one of the most influential undertakings in popular education that has been seen in this country in the last fifty years'.[42]

* Bow Dialogue with Rev Joseph McCulloch, 10 October 1967. See also an interview with Willa Petschek in the *New York Times* (3 May 1976): 'As for the carpings of academics who thought the programmes a mass of superfluities and not scholarly, Clark gave a wintry smile and said, "They may have some validity."' To James Lees-Milne, Clark wrote on 21 May 1969: 'I have long accepted my position as apostle to the low brows' (Beinecke Library, Yale).

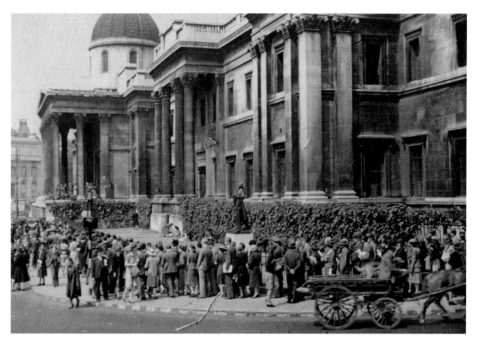

Hunger for culture: queues for a wartime concert at the National Gallery.

'He kept time with them beautifully': Clark conducting Leopold Mozart's Toy Symphony at a National Gallery concert on New Year's Day 1940.

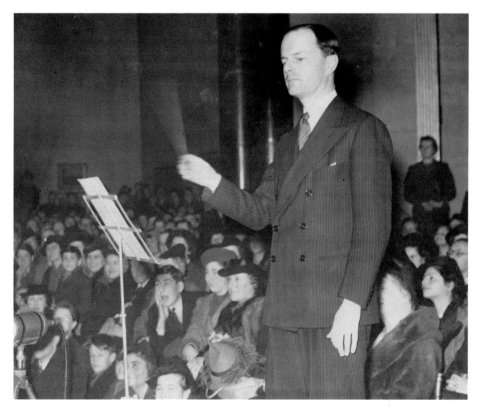

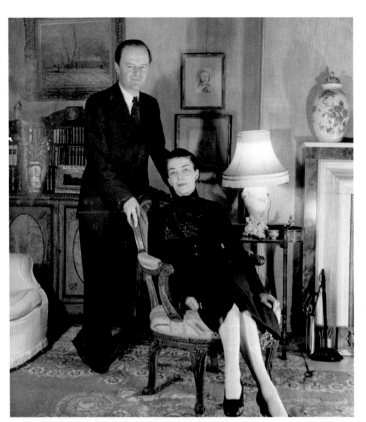

Clark and Jane at home at Upper Terrace House, Hampstead.

Seurat, Cézanne and Clark's 'blond bombshell' Renoir in the sitting room at Upper Terrace.

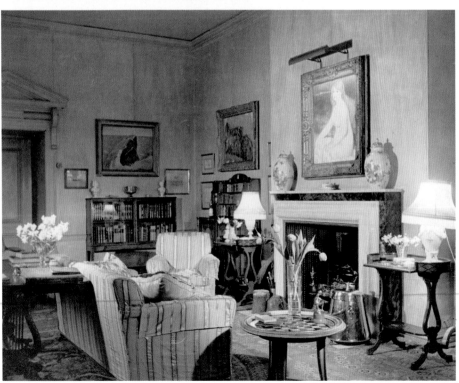

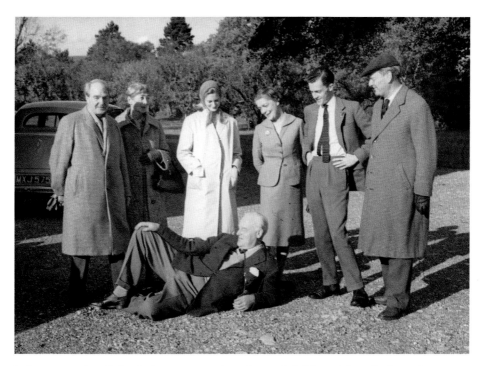

Life imitating Art: Colin Anderson a recumbent figure while Henry Moore looks on from the left. Clark is on the right, next to Jane and their son Colin.

Clark's muse and confidante, Janet Stone.

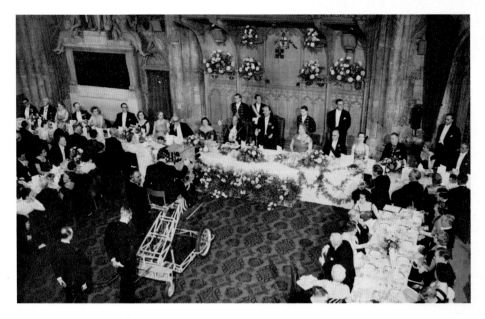

Clark at the launch of Independent Television on 22 September 1955 at the Guildhall, the first time he was seen by millions.

King of his castle: Clark at Saltwood, Kent.

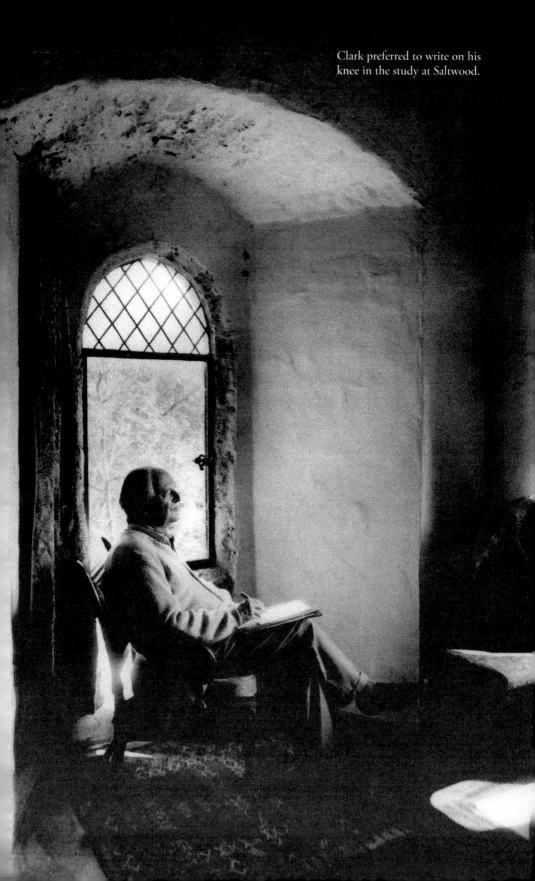

Clark preferred to write on his
knee in the study at Saltwood.

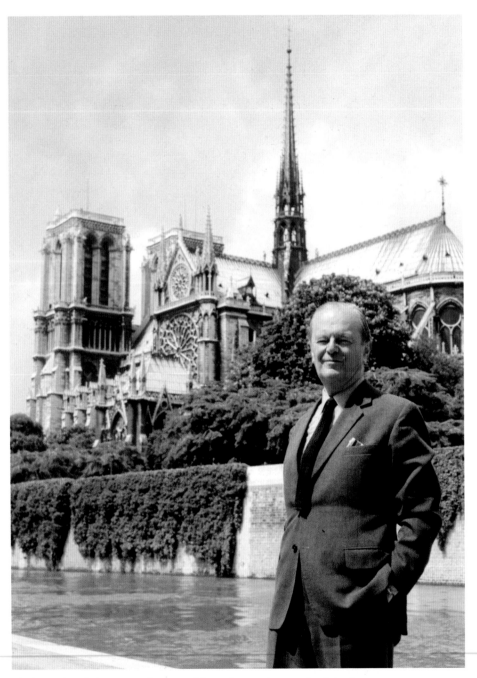

Clark standing before Notre Dame to deliver the opening words of the first programme of *Civilisation*.

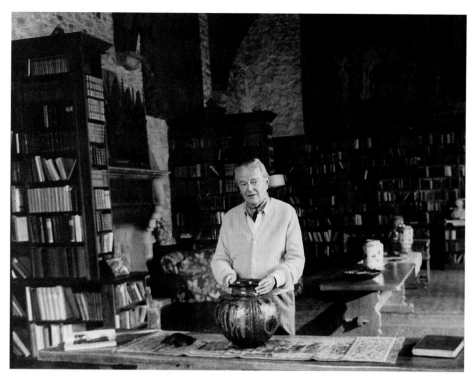

Clark in the great hall at Saltwood.

Clark with his second wife Nolwen at the Garden House, Saltwood.

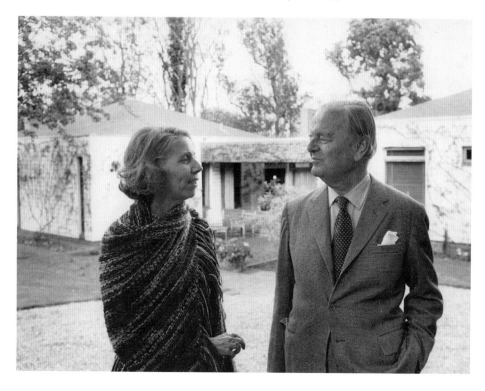

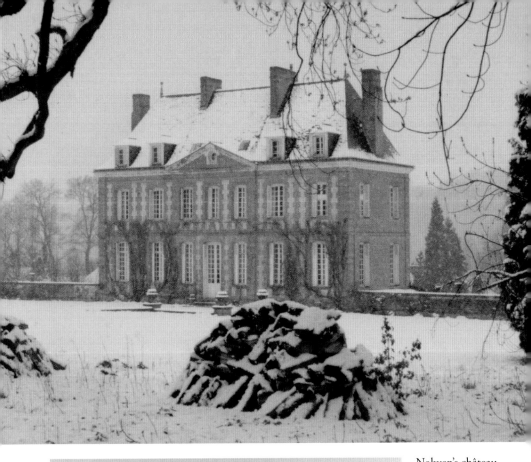

Nolwen's château,
Parfondeval,
Normandy.

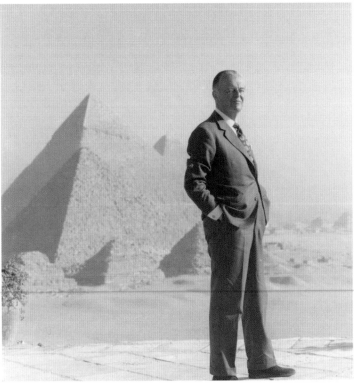

November 1974.
Clark filming
In the Beginning
in Egypt.

Ever since *Civilisation* was first broadcast, people have pondered the dichotomy between Clark's patrician image – the effortless superiority of the man in tweed suits – and what Neil MacGregor calls 'the most brilliant cultural populist of the twentieth century'.[43] The television mogul Michael Grade was in no doubt that 'It was successful because it told great stories. The best television is always about stories. The programmes were pioneering, with all that cutting and changing of location. His delivery was faultless. You knew you were in the presence of a great expert'.[44] There was a side of Kenneth Clark that believed nothing first-rate could ever be popular, but as David Attenborough recalled, 'I was with K walking down Piccadilly when people came up and complimented him on it, and he was as pleased as punch'.[45] But now Clark would have to face the altogether more daunting adulation of America.

34

Apotheosis: Lord Clark of Civilisation

I've felt a terrible fraud.
It's really quite an uncomfortable feeling.

KENNETH CLARK, *The Other Half*[1]

The year after *Civilisation* was first broadcast turned into an *annus mirabilis* for Clark. The success of the series in Britain was followed by its apotheosis in America, where Clark found himself receiving the kind of adulation normally reserved for pop stars and heads of state. At the hundredth-anniversary celebrations of the Metropolitan Museum in New York he was the principal guest, and at the National Gallery in Washington he was mobbed. *Civilisation* went viral. In his history of the BBC, Asa Briggs would write: 'Clark's own series stands out in retrospect more than it did when it was first introduced, for the initial reaction was slow and somewhat reserved, yet soon there were scores of letters of appreciation, and by 1971 *Civilisation* had won four awards and been sold to the United States and many other countries.'[2] As a direct result Clark was showered with international honours, made Chancellor of York University and given a peerage. His daughter Colette wrote: 'Like Byron, Papa woke up and found himself famous.' Fame, however, has its own subtle corruption, and his family noted that it had a bad effect on his character, making him more self-centred and less tolerant.[3]

Initially, the American networks were not interested in *Civilisation*, and turned it down. To David Attenborough, this was because the United States had no history of documentaries, and whereas the BBC had developed out of radio and the broadcast voice, American television grew from feature films and Hollywood.[4] Paradoxically, Clark came to think that this was the very reason for the eventual success of the series in America: having been brought up with the movies, Americans were comfortable with heroes.[5]

Either way, it was Clark's friends the Wrightsmans who took the lead in promoting the series in the USA. Charles Wrightsman was given a preview in London around June 1969, and whatever he might have felt about Clark's friendship with his wife Jayne he set aside. He took the scripts with him on his annual cruise around the Greek islands on his yacht, during which he showed them to the retired director of the National Gallery in Washington, John Walker, who agreed that they were superb. Encouraged, on his return to New York Wrightsman arranged a dinner and a showing of one or two programmes for William Paley, the chairman of CBS. Paley announced that he was bored, and that CBS would never put on *Civilisation*, as it would not interest enough people[6] (he would later admit that this was the first time he had made a commercial mistake by under-estimating public taste). The Wrightsmans, convinced that Paley was wrong, agreed to sponsor a preview of the series at New York's City Hall.[7]

At the same time, the National Gallery in Washington was negotiating with the BBC for the right to give the first showing, so it was in the nation's capital that *Civilisation* received its first full public airing, between October and November 1969.[8] It was an immediate hit. Charles Wrightsman told Clark: 'An amusing episode took place yesterday in Washington. The National Gallery auditorium seats only 350 people and Johnny Walker telephoned yesterday that there were 10,000 on the sidewalks waiting to get in when the doors were opened for the first series.'[9] There had been nothing like it in Washington since the visit of the *Mona Lisa* in 1963, and the gallery was almost overwhelmed, with the auditorium close to 'panic level'. What had been planned as 'Sundays only' became a daily showing for thirteen weeks. In all, 250,000 visitors viewed *Civilisation* in the first year at the gallery, and museum attendance rose by more than 50 per cent to almost two million in that year.[10]

Within a year PBS bought the series, with sponsorship from the Xerox Corporation (which spent $750,000 on its purchase and promotion). Estimates vary, but between five and ten million viewers watched the series in the USA, making Clark, his features, voice and personality familiar to millions who had never seen him in the flesh. The series' popularity may have had something to do with America's view of itself as the saviour of Western civilisation through two world wars and the Cold War.[11] The series told Americans that they were the heirs of the Enlightenment, and helped them understand what they had been defending. Porters vied to carry Clark's bags, customs officials wanted to shake his hand, and everywhere he was stopped and congratulated. Universities were particularly

enthusiastic, and the president of New York University wrote that many of his faculty members believed 'the Clark films are the most effective use of motion pictures for educational purposes they have ever seen'.[12]

Clark went out to America in November 1969 to help the promotion, but his most momentous visit was the following year.* The story is best told in his own words. When he arrived in Washington, J. Carter Brown, the young new director of the National Gallery, warned him, 'For God's sake don't go in through the front door. You'll be mobbed.' He was quietly taken to a press conference. 'After it was over I was led back … so that I might walk the whole length of the gallery upstairs. It was the most terrible experience of my life. All the galleries were crammed full of people who stood up and roared at me, waving their hands and stretching them out towards me. It is quite a long walk and about half way through I burst into tears at the sheer pressure of emotion. I thought "What do I feel like? I feel like some visitor to a plague-stricken country, who has been mistaken for a doctor."'[13]

On the platform he managed to control himself while 'The Star-Spangled Banner' was played, and he then gave a speech which he judged important enough to print as an appendix to his memoirs: '"Give all to love," your great underrated poet [i.e. Ralph Waldo Emerson] said. It's true of education as well of life. And the first advice I would give to any young person is, when you fall in love with Roman baroque or the letters of Montaigne … give up everything to study that one, all-absorbing theme of the moment, because your mind is in a plastic condition.'[14] It was Clark's own version of Walter Pater's exhortation 'to burn always with a hard gemlike flame, to maintain this ecstasy, is success in life'. After the speech he excused himself 'and retired to the "gents" where I burst into tears. I sobbed and howled for a quarter of an hour. I suppose politicians quite enjoy this kind of experience, and don't get it often enough. The Saints certainly enjoyed it, but saints are very tough eggs. To me it was utterly humiliating. It simply made me feel like a hoax.'[15]

What are we to make of this extraordinary passage? If the visit of King George V to the National Galley in March 1934 was the high point in the

* Cecil Beaton was in America during Clark's first trip, and heard him speak at the Met in New York: 'The speeches were unbelievably tedious and K made a marvellous Freudian slip when he said "I'm very conscious of this horror" instead of "honour". Too near the knuckle for general laughter.' Vickers (ed.), *The Unexpurgated Beaton: The Cecil Beaton Diaries*, entry for 20 November 1969.

life of the young Kenneth Clark, this was surely the climactic moment of the second half of his life. But the older, more reflective man no longer had the assurance to carry it off. All his life Clark had preached the gospel of art to as many as would listen, yet now he was unable to bear the mass adulation he received in response. Did he really see himself as the hoaxer he claimed? More probably he saw himself as an unworthy messenger – he was only too aware that there were better men in the world: more virtuous, more scholarly, more useful; and above all there were the artists, writers and composers who produced the great works of art that he had attempted to describe. But he also knew that he had succeeded in bringing their achievements for the first time to a great many people.

Civilisation was now sold to broadcasting companies all over the world. Catherine Porteous remembers Clark saying that 'the French and Italians were sniffy about it, because they were too jolly grand to be lectured about culture by a Briton'.[16] The French were indeed the last to buy, and although Clark did a special recording of the whole series in their language, in the end French television had an actor dub the episodes. He had a particularly difficult time while promoting the series in Cologne, where he believed his German would be adequate to take part in a television discussion with two professors, who 'talked such nonsense that I had great difficulty in keeping my temper'. They did not want to look back into history at all: 'You must not refer to the past. German youth wishes to forget that it ever existed.'[17] To make matters worse, 'the head of the documentary department said he would resign if the *Civilisation* programmes were put on, because they were an insult to the intelligence of German youth'.[18] Clark was very shaken by this, and later told the students of York University about it, as an example of how minds could become closed.

The international success of *Civilisation* made Clark realise the inadequacy of his contract with the BBC, through which he earned very little from the highly profitable foreign sales. He was particularly vexed when he discovered that, for the purposes of foreign rights, the BBC considered all of Europe one country, as were Australia and New Zealand: 'Australia and New Zealand are not the same country. They are a thousand miles apart, with completely different television stations.'[19] He wrote a measured but angry letter to David Attenborough, and another to Pat Outram, using Jane as a pretext: 'It worries me that I said anything critical about the BBC. I had really made up my mind to never mention the subject again but unfortunately Jane feels rather strongly about it.'[20] Clark told Janet Stone

he was 'in polite correspondence with the BBC about payment for my CBS programme in the US. They have offered £257-10-10 having sold it for £250,000.'[21] There was little Attenborough could do, so Clark concluded the correspondence: 'I do not feel very well disposed towards your contracts department or Television Enterprises, but towards everyone else in the BBC I feel as warmly as ever.'[22] He would never work with the BBC on another series.

One of the many surprises surrounding *Civilisation* was the extraordinary success of the book of the series. As Clark told one correspondent: 'I never intended it to become a book at all – it was simply the libretto of an intellectual soap-opera.'[23] The scripts were in fact published in the highbrow BBC magazine *The Listener* each week as the episodes were broadcast. Clark felt that without music, such as 'The Marseillaise' and the prisoners' chorus from *Fidelio*, the chapters would lose too much to be made into a book. Jane was also adamantly opposed, feeling that his conversational tone would not carry onto the page; but then she changed her mind. 'Jane was much against the project but now sees that the resulting "book" would be a useful Christmas present for eg her tailor, and is in favour,'[24] Clark told Janet. Another argument in favour of a book was to publish the 'credo', which continued to be in public demand – instead of sending out more printed copies of it, Clark could simply advise people to go and buy the book. Clark's publisher John Murray joined forces with the BBC, and a contract was drawn up on 1 August 1969 which gave Clark 10 per cent on the first ten thousand UK sales, rising to 15 per cent after twenty-five thousand.[25] In America the publisher was Harper & Row. There was much discussion over the cover. Clark wanted Raphael's *School of Athens*, but Michael Gill was worried that this would make it look too much like an art book. Other suggestions were the front of Notre Dame, the Celtic Cross at Iona, or a medieval Paris tapestry. Gill finally agreed that the Raphael was probably the best image, but successfully argued that it be strengthened by showing only a detail.[26]

The book was published in December 1969, and signed copies were sent to John Betjeman, Janet Stone, Marie Rambert, Maurice Bowra, David Knowles, the King of Sweden, Lord Crawford, John Sparrow and Lord and Lady Drogheda among others. Over the next decade it was to sell one and a half million copies, mostly in America.[27] 'The commercial success of the book has saved me from bankruptcy,' Clark admitted, 'but otherwise I am sorry I ever did it.'[28] He felt that the book did his reputation

as an art historian no good. As he told Peter Quennell, 'There must be something wrong with *any* best seller.'[29]

His greatest unhappiness, however, was over the French edition. Claudine Lounsbery, an intellectual French admirer married to a rich American, sponsored the French translation and offered it to Éditions Hermann, a Parisian art publisher owned by Pierre Berès. Clark saw the French edition as very much in the tradition of André Malraux's books (which is probably what Berès hoped), with their '*choses inattendues*'. Lounsbery tried six translators before settling on André de Vilmorin. Clark wrote to Vilmorin to say that while his translation was more Classical and purer than the original, it had missed all his irony – 'this sense of irony I believe I learned from a great French writer, now despised, Anatole France'.[30] He was sharper to John Murray, calling the translation 'dry and pedestrian'. Worse was to come; Clark was finding Berès generally difficult to deal with, but the final straw was the chosen cover, showing the two hands from Michelangelo's *Creation of Adam* in opposite corners, printed in red and purple. Clark told Berès he found it 'extremely distasteful and distressing ... in a popular (not to say vulgar) style'.[31] Lounsbery ended up taking Berès to court, where she won her case and the edition was dropped.

When *Civilisation* was first screened Clark was much in demand for interviews. The beautiful young Joan Bakewell was chosen to do a major television piece with him, which made him more than a little apprehensive, as he told Janet: 'Film interview *all day* on Friday, with a fearfully highbrow young woman, whom I have often seen on TV and taken a great dislike to – I must conquer it – she says she wants an interview "in depth"!! I have none.'[32] In the event the filming went well, and Bakewell was not as disapproving as he had feared. She 'turned out to be a good deal simpler than she seemed and enthusiastic about Salters'.[33] Under her gentle interrogation his manner became eager and flirtatious, and he cast a golden light on his childhood, which he claimed was 'blissfully happy'.[34] This came as a great surprise to his family, who had always been regaled with tales of how miserable he had been. However, he had already published an elegiac account of his early years in Suffolk, 'The Other Side of the Alde' (1963), as part of a tribute for his friend Benjamin Britten's fiftieth birthday. He was already rewriting the story of his life.

* * *

Among the many couples who had settled down on Sunday evenings to watch *Civilisation* were the Prime Minister and his wife. Legend has it that Mary Wilson rose from the sofa at the end of one episode and declared, 'Harold, that man must go to the House of Lords.' True or not, Wilson wrote to Clark in May 1969: 'I think you have something important to say and I should like you to have the opportunity of this particular forum in which to say it ... I should like you to know that there is nothing political in this recommendation. Where you take your place in the House of Lords is a matter entirely for you.'* Clark later told an interviewer: 'My father always said nobody with a peerage had ever written to him except to ask for money. But Harold Wilson wrote to me one of his wheedling letters – he wrote very good wheedling letters – and I thought it would be high hat not to accept.'[35] In fact Clark did have doubts, as he told Michael Gill: 'I suppose I didn't like the idea of being finally and unmistakably branded as a member of the Establishment.'[36] He was suffering from the peculiarly English perception that he did not belong to the establishment, and did not want to, when it was obvious to everybody that he was already at the heart of it. On the other hand, he also told his old friend Lord Crawford, 'I think the institution [the House of Lords] is a good one, and it would have been arrogant to refuse.' He stated his intention of sitting on the politically neutral cross benches, 'as I wouldn't be myself to sit with the Tories and I would frequently disagree with Labour'.[37]

Clark required two sponsors to introduce him to the House, and chose Lords Goodman and Crawford – the former instead of Rab Butler, who was unable to attend. His introduction was set for 12 November 1969. Lord Goodman wrote reassuring him that 'the only thing one needs to learn is how not to trip up in one's skirt in going upstairs. The rest of the ritual a small and mentally deficient child could master in a very few minutes.'[38] Clark chose the title Lord Clark of Saltwood, but the press immediately dubbed him 'Lord Clark of Civilisation' – a joke at first, but it seemed so natural and right that the moniker stuck. (His detractors, with Douglas Cooper at the forefront, altered this to 'Lord Clark of Trivialisation', which the satirical magazine *Private Eye* adopted.)

Friends wrote to congratulate him on his new honour. Owen Morshead looked back: 'How long ago it seems, and is, since Berenson's high-roofed

* Letter to Clark, 15 May 1969 (Tate 8812/1/4/117). When the *Daily Express* suggested that Clark received his peerage because Wilson enjoyed *Civilisation*, Clark commented, 'That would be as good a reason as any.'

Rolls brought you to Windsor – according me precedence, I suppose, over almost every one of those who are writing to you this morning.'[39] In fact he was surpassed in this by both John Sparrow and Maurice Bowra, the latter writing: 'Our Age has many faults, but it is much less philistine than the Edwardian, and in this you have played an enormous part.'[40] Clark's main motivation for accepting the peerage was that he would be able to stand up for the arts, and indeed his maiden speech in the House of Lords was about museum charges: 'This is not a financial proposition at all. It is a moral–social proposition: People must pay for their enjoyments. But in that case, as has already been said, why not charge for admission to parks, which are also kept up by public money? The answer is that too many people enjoy them to make this a politically acceptable proposal.'[41]

In the years that immediately followed *Civilisation* Clark was overwhelmed with offers of degrees and other honours. American organisations in particular queued up to present him with their medals and awards, all citing – as did, for instance, the Fairmont Art Association of Philadelphia – *Civilisation* and its contribution to the public understanding of art (he refused this offer, like many others, as graciously as he could). Academies as far away as Honolulu were eager to bestow their honours on him, and rather than hurt their feelings he would usually accept, as long as this did not involve travel. One honour that gave him enormous pleasure was his invitation to become a member of the French Académie des Beaux-Arts in 1974 (and in 1980 a member of the Académie des Arts et des Lettres).* Clark had always been strongly, if not uncritically, Francophile, and he certainly felt the superiority in many respects of French intellectual and artistic life. His old school and his Oxford college both honoured him, the former with the *Ad Portas* ceremony,† the latter with an Honorary Fellowship. At Winchester he spoke in praise of his old headmaster, Monty Rendall, whom he believed alone of his teachers 'would not have been completely shocked by the thought of this occasion.'[42]

* Clark gave a lecture to the Académie des Beaux-Arts on 8 May 1974, in which he spoke about what France meant to him: devouring Voltaire as a child in the library of Sudbourne, and his admiration for Michelet and Fontenelle (Tate 8812/2/2/2).

† This is the highest honour the school can bestow on its old boys. Introduced to one boy, Christopher Rowell, who expressed an interest in fifteenth-century French books of hours, Clark immediately arranged for him to be invited to a lecture by Millard Meiss at the RA, and sought Rowell out there – making Clark a hero for life.

By 1970 Clark had been awarded eleven honorary degrees; but of all his academic accolades, he was most surprised and delighted to be offered the chancellorship of York University. It was the Vice-Chancellor, Eric James, Lord James of Rusholme, who proposed the position to Clark in 1969.[43] As the first Vice-Chancellor of the new university, James had established a collegiate system and vigorously promoted individual excellence and meritocracy. He was a socialist who believed in elites, as did Clark, who wrote: 'I am delighted about the Chancellorship of York, partly because I like York, and partly because I have a great liking for the Vice-Chancellor; but also because New Universities seem to me our best hope.'[44] He compared York University under Eric James to Urbino under Federigo da Montefeltro, calling it 'the most perfect small educational unit in England'.[45] Rab Butler offered Clark some characteristic wisdom: 'I am Chancellor of two universities and I will give you a piece of advice: go as seldom as possible and never speak to a university society.' Clark reported this to Eric James, adding, 'I do not hold with the first, but I see there is a grain of wisdom in the second.'[46] As Chancellor Clark went up to York at least once a year to bestow degrees and give an inspiring speech on a humanist subject such as 'The Individual' or 'The Conduct of Life'. One of the pleasures of the chancellorship was the bestowal of honorary degrees, and over time he honoured the American journalist Walter Lippmann, Julien Cain (Administrateur-Générale of the Bibliothèque Nationale),[47] Lord Crawford, Sidney Nolan and David Knowles. However, the chancellorship was not to prove the quiet sinecure that he might have wished. Student unrest had spilled over into the new decade, and there were several dramas – one in May 1974, when students went on strike after cheating had been alleged, and another in February 1976 which involved the knocking down of the front door and occupation of the Senate House after a dispute over exam results. Despite these situations, which were well handled by Eric James, Clark enjoyed his role at York, standing down only after a decade in the post.

Civilisation had two broader side-effects. First, the number of museum visitors began to rise, a turning point after which museums and galleries became vehicles of mass culture rather than high culture. One of Clark's successors as director of the National Gallery, Charles Saumarez Smith, has observed, 'suddenly you had huge numbers of people looking at paintings … if you look at visitor numbers at the National Gallery they were under a million, but from that point [*Civilisation*] onwards there was a self-perpetuating increase'.[48]

The second effect was the change in television itself: the realisation that big series were more successful if they were 'authored'. *Civilisation* firmly established this new genre, and it was the BBC which immediately capitalised on the lessons learned. David Attenborough recalls 'a visit from the head of science programmes ... absolutely outraged by the success. Aubrey Singer, head of that side of the BBC's factual output, thumped on my door and came in and said I ought to be ashamed of myself, I am a man of science and you have given this great opportunity to arts. What are you playing at? That was fine by me, and there and then we agreed to do *The Ascent of Man* [with Jacob Bronowski] – then followed that with a history of *America* [with Alistair Cooke]. I could see as a broadcaster that the thing that was crying out for it was natural history ... so I resigned, and one of the reasons for resigning was in order to be able to do a successor – which was actually a series called *Life on Earth*.'[49]

These superb series established the BBC once and for all as the greatest maker of documentary series in the world. But curiously, although they (and John Kenneth Galbraith on *Economics*) were all brilliant and popular, none has quite achieved the cult status of *Civilisation*, apart from Attenborough's. I have myself been constantly made aware by museum curators, teachers, academics and others of how their lives were changed by watching the series, and how it gave them their first proximate idea of the history of art. It is also a truism that while the series has gone up and down in critical favour, the panjandrums at the BBC have been searching ever since for 'the new *Civilisation*'.

Clark himself wanted to get back to his work: 'by now I am anxious only to be left alone in order to write a few more books'.[50] He had plenty of new projects to interest him – two new television series and an increasingly public role as a conservationist. In fact, as he told Jock Murray, 'I have developed a sort of "Civi sickness" just as people working in the goldmines in Australia get fly sickness.'[51]

35

Lord Clark of Suburbia

*I am not a public figure like A.J.P. Taylor, Graham Greene,
Arthur Schlesinger or Kenneth Clark.*

ISAIAH BERLIN to Noel Annan[1]

By the early 1970s Jane's health was deteriorating, and she was beginning to find the Saltwood staircases difficult to manage. Moreover, despite the bonanza from the publication of *Civilisation*, Clark was beginning to feel the pinch financially. Taxation was high, and the castle devoured money in wages and upkeep; it distressed him to have to turn down a cause like the Students' Emergency Fund when Carel Weight asked him for a donation.[2] He decided that the answer was to build a single-storey house for himself and Jane within the castle grounds. Having friends to stay would of course no longer be practical, but then Maurice Bowra, their most frequent visitor over the years, had died in 1971.[3] But what style should the new building be in? Declaring that he was 'frightened of a reproduction Kent house',[4] Clark described how impressed he had been by his visits to Japanese dwellings. When Margaret Slythe recommended John King, a colleague at Bournemouth, Clark showed him pictures of the Katsura Summer Palace in Kyoto, and gave him instructions for a building in a moderate modernist idiom with three pavilions: one for living, one for sleeping and one for eating, all arranged around a central hall. The result was the Garden House, a bungalow on the site of the old kitchen gardens. However, as Clark told Janet, it was '*foully expensive*, simply because it isn't all made of standard parts',[5] and he had to sell some paintings to pay for it, including the big Tintoretto portrait, which had followed him and Jane around since Richmond days.

The biggest problem that now faced Clark and Jane was deciding what to take with them to their new home, as he told Lord Crawford: 'We have almost finished our change from the Castle to the Garden House. The first

stages were very agreeable as everything looked so pretty in its new setting. Then, as more things moved in, the rooms did not look so nice and we are having a great struggle to keep them empty – an extension of my daily struggle between greed and vanity. We are determined to prevent the house from being cluttered up with possessions.'[6] The most important painting was the Turner seascape, which he positioned to dominate the sitting room. This was to be Clark's last picture hang, and as he told Janet, 'I spent most of my time moving (quite small) pictures. It is very strange what will fit in and what won't. Nothing too strong will go. If I owned a Van Gogh I should have to give it away.'[7]

The move from the castle had not been without pain, and Clark was full of anxieties. He confided to Janet: 'My chief trouble is that I have become violently hostile to the new house. I *hated* it last weekend, and won't visit it today. And I weep at leaving Salters! ... I absolutely dread going to the three boxes ... it is all so small and predictable after all the waste and craziness of Salters.'[8] Inevitably, it was his library that worried him most: 'all my life-work of creating that library rather shattered'.[9] In the event he decided to keep the library and the study in the castle for his exclusive use, allowing nobody to disturb him there – which he declared in his memoirs was a rare case of having his cake and eating it. He had spent a great deal of his life doing just that.

The move from Saltwood Castle to the Garden House mirrored Clark's transition from Victorian intellectual elitist to twentieth-century populist. On 7 April 1971 he gave a small and dutiful leaving party, of which he left a shorthand record: it was a mixture of friends like John and Anya Sainsbury, official folk like the Dean of Canterbury, two vets, 'cancer man',* a schoolmaster, etc.[10] The following week he made the formal handover to Alan, to whom the castle was being bestowed, as he reported to Janet: 'on my birthday we had a very jolly and rather touching party. I signed the deed of gift to Alan, and we all had a glass of champagne ... I drank a great deal and became very talkative, and told stories like an old lion. And I must say that I have never looked back.'[11] Once they had made the move they felt relieved, as Jane told Lord Crawford: 'We *adore* this house – the views of the castle are much nicer than living there!'[12] On the other side the house led directly onto a street of the ever-expanding village of Saltwood – Clark dubbed the Garden House 'the Motel', and joked to Cecil Beaton, 'Celly says I should be called Lord Clark of Suburbia.'

* Presumably the representative of a medical charity.

The Clarks gradually settled into their new life, and routines were established, such as Clark hiding his Mars bars in the safe. The house, however, turned out to be less than satisfactory: the radiators leaked, and Clark, who was extremely impractical, had no idea how to fix anything. They depended on their cook/factotum Leonard Lindley, the loyal and attentive manservant at the Garden House (and a bit of a card) who had been Margot Fonteyn's chauffeur for seventeen years. He said of Saltwood: 'I came for six months and stayed for fourteen years.'[13]

Clark's main concern, as always, was Jane, who was by now losing much of her energy. As he told Janet: 'She never puts on the Telly or reads a book – just moons about, or rings people up, and worries about the servants' Christmas presents. It is very sad.'[14] Jane was in and out of nursing homes: 'The trouble is one gets better quite quickly and then loses interest in everything, people included,' she told Colin Anderson.[15] Clark even hoped that she might convert to Catholicism, as he thought it might help her – particularly as 'they always pottered into churches and would pray together'.[16] His own health was now also causing trouble; in 1971 he had a gall-bladder operation from which it took him six weeks to recover. Never one to waste time, he took this opportunity to set about writing his memoirs, telling Morna Anderson: 'As I have never spent a day in hospital in my life I do not know how disagreeable it will be, and I am not in the least worried. It is a bore to be out of action … but what luck that I have started the autobiog which is the ideal occupation for convalescence.'[17] The two volumes of memoirs, written over the next four years, were to be his last great achievement.

Cecil Beaton took Irene Worth down to lunch at the Garden House, and left a characteristically feline pen portrait of life there: 'a slightly straggling Japanese one-floor building … admittedly the drawing-room is rather beautiful and it shows off to great advantage a fine Turner and Degas … but [Colette] was right. As we drove down a road with worse and worse villas each side, we turned off and bang in front this, another suburban bungalow, had a rather horrid picture window and red brick low walls … I feel the move is a great mistake and it was difficult to enthuse. But the visit was interesting for after lunch (a bit of nonsense talked about how brilliant the cook was … a dreary meal with the main course veal, covered in sizzling chewing-gummy cheese, and how we … should go and thank him in the kitchen. "Don't tip him," said Jane, but "he'd be so pleased to be thanked"). K held forth in the most delightful way. His mind is as clear as ever … I warmed to K. He is the best company

even if one has reservations about his point of view, his idea of the truth. He is a cold-blooded fish [but] one feels that he has a heart, otherwise how else could he put up with Jane's continual drunkenness? Jane was sozzled by lunchtime and took a long time getting to the dining-room, but she is one of the nicest drunks for her goodness and benign attitude come to the surface. She must be a very Christian creature for in her cups she only becomes sweeter.'[18]

Alan was by now making his own name as a military historian and a somewhat maverick Tory candidate for Parliament, and was already keeping the diary that is his chief claim to fame. He and 'young Jane', as she was known in the family, had two children: James, born in 1960, and Andrew two years after. At first the couple were not sure that they wanted the responsibility of the castle, since it came with no means of support apart from the value of the remaining art collection, but the place worked its charm on them. Alan confided to his diary: 'I always feel strangely randy there' – was it the effect of the sea, he wondered.

It was certainly awkward for young Jane having her parents-in-law still about and apt to interfere. The main area of contention was inevitably the contents of the castle. Alan described the problem: 'I am concerned that relations with my parents may be deteriorating ... this morning we were in Canterbury. When we returned [Alan's housekeeper] Mrs Yeo said that they had both been over and "gone upstairs". This has happened a great many times since my parents moved out. They lie awake in the Garden House and brood on the various items of "contents" that they left behind ... sometimes Lindley, who fancies himself as an *antiquaire manqué* is sent over in the car to collect objects, which whenever practicable, he does without referring to us.'[19] Rows would follow, with tears and recriminations on both sides. James Lees-Milne recorded a conversation with Alan's old friend, Michael Briggs: 'He [K] has already had trouble with Alan, now installed in Saltwood Castle. It is the usual story when a father having made over a property to his eldest son continues to live on in the property ... Alan has sold off a parcel of land for building, which is v. near the Castle and K's new bungalow. Hence – conflict.'*

* Lees-Milne, *A Mingled Measure*, entry for 1 July 1972, p.257. Lees-Milne added that Briggs 'says that K Clark treats him with the utmost courtesy because he is a friend of his son Alan, and makes it plain that this is his sole reason for doing so. The politer K is the more Michael realises how much he disdains him. I don't suppose this is strictly true.'

Clark told one of his correspondents, 'I have given the castle to my son, who lives there in a somewhat bizarre splendour.'[20] In fact, he admired what the younger Jane had done when she 'turned the entrance into a sort of *manoir* in the Normandy style, with cocks and hens, ducks and pigeons, and eleven peacocks. This has a humanising effect on the medieval exterior.'[21]

Having settled the castle on Alan, Clark rewrote his will. He had already made considerable provision for Jane, so the question was how to be fair to the twins Colin and Colette. He left the Turner – which was far and away the most valuable item in the art collection – to Colin, and all the remaining contents of the Garden House to Colette (bar some specific bequests to Janet and others). As none of the Clark children were bibliophiles he decided on a different fate for his most important books, which were to go (with his collection of letters from Edith Sitwell) to the Morgan Library in New York. He left a note explaining this decision: 'There are two reasons why I offered the Morgan Library a choice of my books. One is that, in spite of the size of the Library, it does not feel like an institution. The books seem to be loved and cared for as they are in a private library. The other is that during the last fifty years the United States has been infinitely generous to Great Britain … as far as I know the movement has been all one way.'* He also liked the director of the Morgan Library, Charles Ryskamp, a fellow member of the bibliophile Roxburghe Club. When the books, most of them Italian and sixteenth- and seventeenth-century (some relating to Clark's studies on Alberti and Leonardo), were removed from Saltwood before Clark died, Alan was much upset, as he recorded in his diary: 'My father came over with Mrs Sly [Margaret Slythe] and taken over 30 books from the library. V. depressing. He is such a shit, so sly and weak, without the *slightest* concept of succession and the boys.'[22]

The Clarks were not good grandparents, Jane being too far gone and Clark, a solitary child, having no natural affinity with infants (although in 1972 he used up his two free passes for the Tutankhamun exhibition at the

* The Morgan made him an Honorary Fellow of the library in 1972, and that may have given him the idea of the gift. He pointed out to Ryskamp in a letter dated 28 April 1972, 'my children are not interested in rare books'. The library was the only organisation Clark actually suggested doing lectures for – writing to Ryskamp on 24 August 1972 that he was coming to the USA and offering '"Blake and Visionary Art", which was passed by Geoffrey Keynes so I suppose it is not disreputable'.

British Museum to take James and Andrew). He saw less of his other grandchild, Colette's son Sam, because, as he told Janet, 'I never see Celly now and miss her very much. Col appears a good deal, but he is such a strange fellow I know him much less well than the other two.'[23] He was about to get to know Colin rather better, for they were to collaborate on two television series.

Following *Civilisation*, Clark was constantly in demand for television appearances, and although he was out of love with the BBC he agreed to participate in its film about Berenson at I Tatti, made in 1970. It took the form of a conversation between Clark, Umberto Morra, the biographer and writer Iris Origo, and Nicky Mariano's sister Alda Anrep. The programme presented a particular problem for Clark, as he afterwards told the BBC's Stephen Hearst: 'I was rather worried about the passage in my script ... on the effect that working for dealers had on B.B.'s judgement ... I do realise that there are still a number of people who are longing to attack B.B.'s reputation and if I were to give them a chance they would make far more of it.'[24] Clark was already starting to reassess his views on Berenson, and was shortly to become the main witness for and endorser of Meryle Secrest's damaging account of BB's dealing activities.

The next two television series Clark made were with his son Colin as director. Colin's career in film and television had been mixed, and it seems that his further employment was dependent on directing his father, whom Lew Grade wanted back at ATV; the press release spoke of him as 'returning to his television home'. The chosen subject was *Pioneers of Modern Painting*, five programmes on Cézanne, Monet, Seurat, Manet and Munch. Although essentially lectures, they were shot on location in France and Norway (where Clark was amazed to see how true Munch was to nature). If he had an overall point of view in this series, it was that these artists, if rebels in their own time, were not 'born free' but were in fact disciplined students of history. With hindsight Clark judged the programmes a failure, as he later told J. Carter Brown: 'They seem to fall rather uncomfortably between entertainment and education.'[25]

Colin decided to set up his own television production company, with offices in Knightsbridge, to create the next series, *Romantic versus Classic Art* (a book of which was later to be published as *The Romantic Rebellion*). The thirteen episodes were largely based on Clark's Slade Lectures, and included several of his old favourites: Constable, Blake, Rodin and Turner – and some new names, including Piranesi and Fuseli. Exploring the

dance between Classicism and Romanticism, the series was to culminate with Ingres and Delacroix.

By now, however, Jane's health had declined so much that Clark refused to leave her while shooting lasted, so the series had to be filmed mostly in the study at Saltwood. Colin found a researcher, Robert McNab (recruited through the Courtauld Institute noticeboard), whose role was to go through the scripts meticulously with Clark identifying the pictures required. Clark never had much confidence in Colin, and McNab remembers that 'One day K turned up unexpectedly at Knightsbridge to inspect Col's offices when he was away. He was probably aware that he was paying for them.' McNab recalled: 'The series, which was quite old-fashioned, came out of the ashes of a scheme Col thought up to film all K's lectures. I liked Col, although people disparaged him ... K complained that he made no money out of it because Col had given all the royalties to the backers.'[26] McNab enjoyed working with Clark, but observed that he could be mean with money.[27] The series was in fact Clark's most effective attempt at 'pure' art history on television, earning a modest success particularly in America; although as he noted, 'I doubt if I received a single letter about it, which shows how much the reception of "Civilisation" had depended on a kind of self-identification by the viewer.'[28]

If during the early 1970s Clark's television programmes mostly derived from earlier material, he gave some of his most original and memorable lectures at this time. One, 'Mandarin English', might be seen as a homage to Logan Pearsall Smith and those he had held dear – Gibbon, Sir Thomas Browne, Jeremy Taylor – and to Clark's own heroes, Ruskin and Pater. Another, 'The Artist Grows Old', the 1970 Cambridge Rede Lecture, was an exploration of 'old-age style' in art and poetry, which Clark characterised as 'a sense of isolation, a feeling of holy rage, developing into what I have called transcendental pessimism'.[29] This exploration of late Michelangelo, Titian, Milton and Rembrandt was exactly the kind of work Clark did best. He was less happy with his lecture on 'The Universal Man', given at the Ditchley Park Foundation in Oxfordshire (a body dedicated to Anglo–American relations) and exploring Alberti, Thomas Jefferson and Benjamin Franklin. 'The old imposter pushed it through,' he told Janet, 'and one had the impression that one *can* fool all of the people all the time ... a large audience of pure unalloyed establishment. I have never seen so many under one roof before, because even at Buck House there are always a few bounders. My lecture – incredibly shallow – was said by the ladies to be "above their heads".'[30] James Lees-Milne was in the audience,

and wrote in his diary: 'very suave, very balanced, and plenty of food for thought. No lecture by K disappoints ... Lord Perth in giving thanks suggested that K was [a universal man] himself. I think this may be so.'[31]

Clark kept up with Leonardo scholarship all his life, and continued to write about the artist, with an article on the *Mona Lisa* for the *Burlington Magazine** and a lecture, 'Leonardo and the Antique' (1970), for Michael Kitson at the Courtauld Institute. When he reviewed the newly discovered Leonardo notebook in the *New York Review of Books* – whose editor Robert Silvers commissioned Clark to write a number of pieces, on subjects ranging from Alberti to Balthus, which raised his profile in the United States – he did not pull his punches. He accused the Madrid authorities of a disgraceful cover-up over their failure to recognise the notebook, and exposed their attempt to take the credit when a young American student, who was not even a Leonardo specialist, finally identified it.† The doyen of Leonardo studies by this time was an Italian scholar, Carlo Pedretti, with whom Clark was on excellent terms (it was Pedretti who had revised Clark's old Windsor drawings catalogue when it was republished in 1968–69). Pedretti, unaware of the ambivalence towards Clark among the British art establishment, innocently enquired whether anybody would be doing a *Festschrift* for his seventieth birthday in July 1973. Clark gloomily responded, 'I am sure that no one else has thought of such a thing.'[32] It is worth noting that when *Apollo* magazine asked Clark to write his own brief résumé for notes on contributors, he gave his 'present occupation' not as art historian but as 'author'.[33] He himself could show great thoughtfulness towards colleagues: when Anita Brookner, whom he had barely met, published a brilliant but overlooked work about French critics from Diderot to Huysmans, *Genius of the Future* (1971), he not only sent her a fan letter but wrote to Raymond Mortimer begging him to review it in the *Sunday Times*.[34]

During the 1970s Clark was to become increasingly involved in the conservation movement. He was deeply distressed by the philistine atti-

* *Burlington Magazine*, March 1973, pp.143–51. 'Now I am engaged on rather a ridiculous project. The Burlington Magazine had the perfectly sensible idea of sponsoring a series of lectures on portraiture, and then had the perfectly idiotic idea that the first lecture should be on Mona Lisa, which is not a real portrait in any sense of the word, and they asked me to give it.' Letter to Kate Steinitz, 2 October 1972 (Tate 8812/1/4/68).

† *New York Review of Books*, 12 December 1974. Clark said in his review that the Madrid authorities' 'state of mind could be made the subject of an interesting novel'.

tude shown to old buildings in the pursuit of profit. The movement to rescue them was in its infancy at this time, and there was still a general apathy about old buildings. As Clark told the House of Lords: 'To conserve what is best in the architecture of the past is not to be a conservative ... it is to simply realise that no society, no association of human beings, can cut itself off from its history, or pull up its deepest roots, without impoverishing, or even destroying its spirit.'[35] To him the chief tragedy of conservation was that 'all modern architecture, or at least the only likely style of modern architecture, cannot be assimilated into an old town.'[36] This was particularly evident in Bath, the jewel of eighteenth-century British architecture, to which he had felt a sentimental attachment since his teenage years. Clark became a vice-chairman of Bath Preservation Trust in 1970, at a time when whole streets of old buildings were being pulled down around the Lansdowne and Bond Street areas. He believed that 'If there are such things as national treasures, Bath is one of them ... At the present rate every month is vital, and in eighteen months it may be too late.'* As he told Eric James: 'Conservationists have cried "wolf" so often that one tends to think they are exaggerating, but in this case they are understating because all the depredations that I saw have been done since I was there last year, and heaven knows what will have happened by next year.'[37] He was especially dismayed that the destruction of the streets in the name of 'welfare' was actually in the financial interests of developers. James Lees-Milne observed that at meetings of the trust 'K was treated like the sage he is. All deferred to his opinions and when he spoke all stopped talking and listened attentively.'[38]

Clark was happy to use his position in the House of Lords to raise the subject of Bath. He pointed a finger at the fashionable architect Hugh Casson, the darling of the establishment, who combined the role of paid consultant to Bath Council with membership of the Royal Fine Arts Commission, which Clark saw as a clear conflict. Inevitably this brought an angry reaction from Casson, and a sharp exchange of letters followed.[39] Clark thought the real villain, however, was Bath Council, which had allowed houses to deteriorate in order to justify pulling them down. He wanted the matter to be taken out of its hands: 'Bath belongs to us all ...

* Speech, July 1972 (Tate 8812/1/4/39). In 1972 Geoffrey Rippon invited Clark to join the Council for Architectural Heritage Year, which was coming up in 1975. He accepted, but pointed out that they should not wait until 1975 because so much was being lost every month, particularly in Bath.

it is a national possession if anything is, and I personally much resent spending huge sums of money on Italian pictures which we do not require and which, if we did not buy them, would not be destroyed but made accessible in some other gallery, when our own great buildings are being pulled down or, in the case of cathedrals, in danger of falling down.'[40]

Every conservation group wanted Clark's name and prestige on its side. While John Betjeman used television to achieve his ends, Clark used his access to politicians and power; but he chose his battles with great care. He believed that in order to influence any outcome it was essential to go down and examine the proposal on the ground, and most importantly to offer a carefully estimated and thoroughly practical alternative. His friend Cecil Day-Lewis, Poet Laureate and chairman of the Greenwich Society, involved him in a successful attempt to prevent the Greenwich New Road and save St Alfege's church.[41] This was followed by a far more bruising battle over the proposed route of the M3 across Winchester meadows. Once he had been down to see the site, Clark offered to intervene with the Minister, or even the Prime Minister.[42] He wanted to draw attention to the wider issue of roads in beautiful places, which he felt was demonstrably better handled in France and Italy.* He was certainly not against motorways, which he accepted were essential for economic life, and had little patience with people who thought fields and open land more important than a town like Winchester. However, the Capability Brown Park at Petworth was a different matter, and Clark felt strongly that such beautiful parkland – hallowed by Turner – must not be reduced. He was shocked by the hostility of the townspeople of Petworth towards Petworth Park, and wrote to the Minister of Transport, John Peyton: 'I can see what a problem this kind of "democratic" sentiment poses for the Department of the Environment. It is certainly an argument against government by referendum. I suppose on the same grounds one could argue in favour of selling the contents of the National Gallery and using the site for a gigantic fun-fair. In these cases the governments have to understand the word democracy in a philosophical sense rather than a quantitative sense. And on this basis one could argue that the beauty of Petworth Park will continue to affect men's minds long after the present inhabitants of Petworth have disappeared.'[43]

* This was certainly true of the preservation of historic town centres, but less applicable to landscape and natural beauty.

Clark involved himself in conservation battles in York, Hythe, Hampstead, Covent Garden and for Christ Church, Spitalfields. Some development proposals were actually the consequence of his own television programmes; the proposed hotels and roads on Iona were the direct result of his moving descriptions in the first episode of *Civilisation*, as he was all too aware: 'I am only afraid that the result of my enthusiasm may have added to the number of tourists, as a great many Americans write to ask me how to get to Iona.'[44] How well he saw that we kill the things we love. The limits of Clark's conservationist instincts are, however, shown by his reaction when invited to become president of Saltwood Village Preservation Society. He told the secretary: 'I am all in favour of preserving the general aspect of the village, but I am not in favour of preserving picturesque buildings of no great architectural merit that are unsuitable for human habitation, and in general I would put social amenities higher than picturesqueness.'[45]

Clark still enjoyed travelling during the early 1970s. He went to Lugano to stay with Baron Thyssen and admire his fabulous art collection; to Czechoslovakia, where he saw Titian's *The Flaying of Marsyas* at Kroměříž ('and my God it is worth it: like reading a new scene in King Lear Act IV'[46]); to Venice to give the keynote lecture for Venice in Peril;[47] and to Paris, where he was chairman of the exhibition 'British Romantic Art' in 1972.* He still went every year to America. New York was the main focus of these visits, as he described to Janet Stone: 'Dinners every night ... always the same five rich ladies ... really very nice people, but it is rather comic to meet them every night – Mrs Astor, Mrs Whitney, Mrs Lasker, Mrs Wrightsman, Mrs Ryan – Oh I have left out Mrs Tree.'[48] These US trips would have tightly-packed schedules, typically involving one function every day, travel to a different city every third day, and the giving of speeches, the laying of wreaths (for instance on Thomas Jefferson's grave) and so forth – all of which, for a man turning seventy, must have been taxing. He would then usually stay with the Wrightsmans in Palm Beach, where as he told Jane, 'the only drawback is Charlie's conversation which is extremely monotonous and persistent. It consists

* 'It is really a splendid collection, which would have delighted Gericault and Delacroix, but it is receiving no publicity. The French characteristically said that they would do a catalogue on the same lines as that done for a recent show of Romanian Graphics.' Letter to Ben Nicolson, 3 January 1972 (Tate 8812/1/4/68).

almost entirely of stories of crimes committed on innocent citizens by negroes.'[49]

Jane joined Clark for a holiday in 1973, when (perhaps surprisingly) he agreed to lecture on a cruise off the Turkish coast.* It was to be their last trip together. He described the expedition to Janet: 'an unmitigated disaster ... When we came on board and saw our cabin, Jane, her spirit already broken by the babble of American voices in the bus, began to weep, and went on weeping on and off for 12 hours. Now she succeeds in controlling herself by taking vast quantities of drugs and leaves her cabin for about 2 hours a day ... I hadn't quite realised how incapable of ordinary life she had become.'[50] Matters had not improved a week later: 'There is something terribly depressing in the utter futility of all these elderly Americans, but they are *mon cher public*. I am afraid my image as a sage is being rapidly destroyed.'[51]

Clark still went up to London, and was distressed when his reputation as a ladies' man caught up with him. He was at a dinner for Oliver Chandos at the St James's Club when a fellow guest accosted him: 'Sir Kenneth Clark? The Bart?' When Clark denied it (he was a knight, not a baronet), he received the bewildered response: 'But you must be the Bart, the other Sir Kenneth Clark is a frightful shit, everybody says so.'[52] Clark tells this story in his memoirs as an example of his unclubbability, but as he ruefully told Janet Stone, 'Good to hear the truth occasionally!'[53]

Janet remained *maîtresse en titre* and Clark's most favoured confidante. She was, according to the diarist Frances Partridge, skittishly proud of the liaison: 'She wants to give the impression she is having an affair with Kenneth Clark without actually saying so.'[54] Two months after giving rise to this observation Janet did reveal to Partridge that for the past fifteen years Clark had been madly in love with her, suggesting that he would like to leave Jane and marry her instead; but this conversation was followed by a letter from Janet begging Partridge to keep her secret.[55] Janet had always been careful to write loving, almost gushing, letters and postcards to Jane, offering to visit her when she was ill. She was a talented photographer, and Clark arranged an exhibition of her portraits at the New Metropole Arts Centre in Folkestone. He told a friend that Janet's portraits 'have not quite

* Smithsonian Sites, 'Ancient Civilisation Cruise'. Clark gave talks on Islamic art, the earliest civilisations, Caravaggio (impromptu) and Greek art. The cruise turned out to be a disaster in every way; there was a terrible storm at Palermo and they had to leave the ship. See Clark, *The Other Half*, Epilogue, pp.233–8.

the carrying power of a real professional but they have the merit of great sympathy with the sitter, and the list of her sitters is, as you see, really interesting.[56]

One woman who reappeared in Clark's life around this time was Meryle Secrest, an American journalist of English origins. When Clark first met her she had been working at the *Washington Post*, for which she interviewed him in the afterglow of *Civilisation*. She then persuaded the *Smithsonian* magazine to let her do a longer piece, and this had required her to visit Saltwood in the days when Clark still lived at the castle. Secrest opens her autobiography *Shoot the Widow: Adventures of a Biographer in Search of Her Subject* (2007) with a racy account of lunch at Saltwood (at which she wore a Robin Hood outfit), ending with Clark making a pass at her in the study. By 1971 she and Clark had reached such a point of familiarity that he was advising her how to write to him: 'If you do please address the letter to the St James' Club, Piccadilly, W.1. as … all my letters are opened, much love K.'[57] He clearly had a bad conscience over some matter the following year, when he wrote: 'I can't tell you how delighted I was to get your letter. I had been longing to get into touch with you again, but felt ashamed to do so, as I thought you would think that I had treated you badly.'[58] Secrest would play an important role in the Clark story during his last years: first when she began to write a biography of Bernard Berenson – encouraged and aided by Clark – and then when she moved on to writing Clark's own life.

For Clark's seventieth birthday in 1973, Jock Murray threw a lunch for him and Jane at the Café Royal, which still retained something of the glamour of the 1890s about it. The guest list reads like the story of their life: friends from Oxford days, from social life, the *Civvy* crew, balletomanes, girlfriends and family.[59] Each guest was presented with a copy of a specially printed edition of Clark's Romanes Lecture, 'Moments of Vision', designed with engravings by Reynolds Stone in a typeface that he had named 'Janet'. Murray made an elegant speech: 'You did not ask for bread, but you have been given Stones.' Jane sat between two of her great admirers, Henry Moore and Lord Crawford; the occasion was a warm and happy one. As they left the restaurant and crossed Regent's Street, Jane turned to her husband and said, 'Wouldn't it be a good thing if we could be run over by a bus.'[60]

The week before Christmas 1973 Jane had a severe stroke, and over the next few weeks Clark was to spend all his time visiting her in hospital. She became enfeebled, and it looked for a while as if she might not recover; but

then she began to make progress, and returned to the Garden House in January 1974, with four nurses to look after her in shifts. She was a difficult patient, as Clark told Colin Anderson: 'As you know, Jane is like the little girl in the rhyme, "when she is good, she is very, very good, but when she is bad she is horrid".'[61] Alan noted his mother's arrangements with bleak accuracy, writing that she 'returns tomorrow by ambulance to the Hythe nursing home and then (putatively) to the Garden House and a regime with special beds, chairs and apparatus that can only end when she dies'.[62]

36

Another Part of the Wood

How am I to live through the next five years?

KENNETH CLARK to Janet Stone, 14 June 1974

As Alan had predicted, Jane's stroke changed everything: the mid-1970s became a period of broken engagements, nurses, wheelchairs, and Jane's final decline and death. Despite the turmoil, Clark continued to make a number of public interventions* – the old lion could still roar – and it was also a period of surprising productivity. Clark always worked well under strain, which drew from him the compromises in which (as he had told Mary Potter) he found a kind of helpful coercion. As ever, he unburdened himself to Janet Stone: 'Jane cannot be left at all, has a naughty child's desire to exert power which is the only thing that gives her any pleasure.'[1] He described their routine: 'Write from 6.30 to 7.45 in bed. Rise. See Jane, always radiant at that hour. Get out b'fasts. Chores, letters, frequent visits to J fill the mornings with a blissful break to pick flowers in the snow. Long lunch as Jane eats incredibly slowly. Short snooze. Attempt at work till 4 o'clock. Music/reading aloud 5–7.30 … No supper and pack up after the news. As far as the outside world is concerned I might just as well be dead.'†

* He was outraged when he received an academic letter from a curator at the Ipswich Museum, dated 2 April 1976, which had a large printed legend requiring all correspondence to be addressed to the Director of Recreation and Amenities at the Civic Centre. He wrote a letter to *The Times* on 29 April 1976, not mentioning which museum was involved, but headed 'Big Brother' and lamenting 'this kind of bureaucratic surveillance' (Tate 8812/1/4/196).

† Letter to Janet Stone, 4 September 1975 (Bodleian Library). There were lighter moments: '[Jane] can't bear me doing things without her … she thinks up the most incredibly bitter and cruel things to say. However, last night she had to laugh – she yelled at me "I heard all your conversation with your Lady friend" (on the telephone extension). It was an old lady of 85 who lives in Saltwood and had kindly rung up to ask after Jane.' Letter to Janet Stone, 11 June 1974 (Bodleian Library).

Perhaps the most unexpected shift in Clark family politics was the fall of Colin from Jane's favour and the rise of Alan – who could be very charming when it suited him. As Clark wrote to Janet: 'Al easily the favourite member of the family now – and rightly, he is so attentive, jolly, and warm-hearted. Col has a tendency to give Mama lectures on how much better off she is than other people. Also he tells people that she is well – very "chipper" to the world, and this naturally infuriates her.'[2]

Clark would gloomily tell his friends that he saw nobody, but equally he complained when people disturbed him. It was his visits to Covent Garden that he missed most, and his main distraction was to write the first volume of his memoirs, entitled, after Shakespeare, *Another Part of the Wood*.* He told Catherine Porteous that he also had the opening lines of Dante in mind, adding enigmatically, 'we're not out of the woods yet, is a good motto for life'.[3] He claimed to have written the book entirely from memory: 'I followed the principle of not looking up any documents or diaries, and this gives it a certain lightness, and consistency, but I suppose that it will be full of inaccuracies.'[4] In fact, as the Tate archive demonstrates, he went to some trouble to check the points he made and to verify some facts, but the book is notwithstanding full of inaccuracies. These are mostly chronological, although occasionally he purports to recall events at which he was not actually present, such as the meeting with Neville Chamberlain at Downing Street in 1937.†

Clark called his autobiography 'a gallery of portraits', and hoped that 'the reader must deduce my character from the portraits of those who influenced me'.[5] He adopted a detached, almost ironic tone in dealing with his life, which reminded some of the opening of *David Copperfield*, and others of Lytton Strachey. He told one reader that he had been fond of Tacitus in his youth, and 'I hope you will have recognised traces of this influence in my use of certain epithets.'[6]

The first portrait – and the best – is that of his father, who sets the tone for the monsters that follow. Rosamond Lehmann simply wrote: 'I lost my heart to your father.'[7] Not surprisingly, there was a degree of whitewash in the portrait: no mention of their arguments over shooting, or of Clark

* *A Midsummer Night's Dream*, Act II, Scene ii.

† See Chapter 13 for Lord Duveen's reappointment as a National Gallery Trustee. Philip Allott wrote from Trinity College, Cambridge, to point out twenty-six misprints in the book. Clark responded that this was 'indeed disgraceful', and added that he himself had discovered a lot more. Letter, 22 December 1974 (Tate 8812/1/4/34).

having to pick his drunken father out of the gutter. However, by far the most memorable part of the book is Clark's account of his own childhood, a beautiful and evocative piece of writing. His old colleague at the Arts Council, Ifor Evans, told him, 'I think the first chapter is the best piece of serio-comic writing in English.'[8] After the elegiac idyll of Clark's Suffolk and south of France memories, Winchester blows everything apart with a classic intellectual's description of the tribal barbarities of the English public school. Here again we confront one of the central questions about Clark: how it was that the young man who never fitted in was so successful at winning over those who mattered: his captivation of first Monty Rendall, then Bowra, Bell, Berenson, Sassoon and George V? He seems to have taken it for granted that they would fall under his spell (and later he would assume as much of his lecture and television audiences, not to mention his girlfriends). Perhaps it was because, alongside Clark's good looks and charm, he had the effect on them that Bernard Levin observed: 'And still they gazed, and still the wonder grew, that one small head could carry all he knew.'*

Clark treated his memoirs as a literary exercise: they were intended first and foremost to be amusing, and he was indeed a master of the anecdote. However, this approach had disadvantages, as he acknowledged to Jock Murray: 'I have been stung with remorse at the number of injustices which have crept into the book, chiefly on account of my being too anxious to entertain.'[9] Throwaway remarks about living people – I.G. Robertson at the Ashmolean – or dead contemporaries – Ian Rawlins, the train enthusiast at the National Gallery – caused much offence.[10] Most readers enjoyed such passages, including Burnet Pavitt, who thought the book was 'as light as a soufflé … please, please follow it up, – and don't spare the lemon juice … One or two (friends) received a piece of your mind, but without the candour (the drop of lemon), the pictures would have been so much less vivid.'[11] Some complained that the memoirs were not revelatory enough, but Clark was of a generation that was uncomfortable with Freudian self-examination, as he told David Cecil: 'I always feel that self-revelations are only half revelations, even in Rousseau. Perhaps St. Augustine is the only exception.'[12]

The world Clark describes seems distant, sealed-off and secure; in it everybody knows everybody, and the futures his friends can look forward

* Levin was quoting Oliver Goldsmith's 'The Deserted Village'. (Unidentified American newspaper article by Levin about *Civilisation*, Tate 8812/1/4/89.)

to are never in doubt – Bobby Longden, for instance, is sure to become headmaster of Eton one day. However, Clark insists that the best part of it has been his friendships with artists and his home life, which caused some reviewers to raise their eyebrows. He described the book to Myfanwy Piper as 'a slim volume – fifty more pages would have improved it, but I was so afraid of becoming a bore'.[13] The tone is indeed self-deprecating, which British reviewers recognised as Clark's Grand Manner; but it puzzled Americans, who wrote to him commiserating that he had been such a failure – which annoyed him. As he told his old Oxford friend Alix Kilroy: 'I am so glad you enjoyed the Autobiography. It was meant to be funny and was accepted as such by most English reviewers. American reviewers, on the other hand, find it very sad, and think that I am a disappointed man. In fact I have been fortunate far beyond my deserts except in the last five or six years'.[14] One of the most perceptive reviews was by John Russell in the *New York Times*, who quoted Leon Edel on 'that finely attuned English amateurism which is the despair of Americans'.[15] *Time* magazine noted Clark's vein of self-contempt and his dislike of his own class;[16] Anthony Powell in the *Daily Telegraph* saw in him both steel and charm, and identified two Kenneth Clarks – one cool, worldly and ruthless, the other highly strung, with a gift of extra-sensory perception.[17] Geoffrey Grigson wrote a not unexpectedly hostile review in the *Guardian*, pointing out the name-dropping throughout the book.[18] 'But these were our friends,' Clark protested – even though he would have admitted that as such, they had been chosen with discrimination.

Once the book was published, Clark left Jane for twelve days in November 1974 to make a film in Egypt with Michael Gill. He had always been fascinated by Egypt, and the growth of a civilisation on the banks of the Nile 'with the suddenness of a sunrise'. *In the Beginning* had also appealed to him because 'the extraordinary thing about Egyptian civilisation is that it lived entirely through images'.[19] He also had to 'replenish my bank account';[20] the admirable film was sponsored by *Reader's Digest*, and made for PBS America.[21]

 Clark arrived in Egypt with certain prejudices about its people, which his first encounter did nothing to dispel. He told Catherine Porteous: 'Oh it was appalling … the hours of bureaucracy at Cairo airport, the lights *kept* going out and the immigration officials had to examine multitudinous documents by cigarette lighter!'[22] Things improved once he was exposed to the works of art, and he felt 'completely rejuvenated simply by

talking about them'. On a return visit the following February he wrote to Janet from Luxor: 'I am too old to work so hard ... lots of sun, and I am red as a turkey cock ... I have come to like the Egyptians – They are so anxious to be friends, and have a Biblical dignity up here ... (not in Cairo!) ... I am in the old Winter Palace, in King Farouk's room – of an appropriate size. Nothing works – the lights go on and off and give shocks, this morning the tap of my bath blew off and water shot all over the room'.[23] Unfortunately, artistic differences arose between Gill and Clark, who thought the result was 'a disaster ... Michael wanted to do an art film with lots of music. I wanted to do an ideas film ... it has to be cut from 100 minutes to 58'.[24] Gill put Hollywood music on the soundtrack, which made Clark roar with laughter during the screening. As he told an American friend, 'The result is a parody of Chu Chin Chow'.[25]

Clark's next venture was closer to home. John Sainsbury, his neighbour in Kent, approached him in 1974 with the idea of setting up a company, to be called Ashwood, making educational films about art, to be funded by his Linbury Trust. 'K changed my life,' Sainsbury noted, 'and I thought this would be a wonderful thing – like having Ruskin on film'.[26] The first offerings were to be five films on Rembrandt (of which only three were eventually made), presented by Clark and directed by Colin. But Clark soon realised he was past his best, as he told Myfanwy Piper: 'I spent the summer writing five programmes about Rembrandt. The scripts didn't seem bad, but, alas, when I came to perform them, last week, I found that I had lost the vital spark, I gave a very dismal performance (it happened to be one of Jane's bad weeks which always depresses me). So no more television, which is a nuisance, as I need the money'.[27] Further films were in fact planned, and Clark tried to persuade the leading critic of modern art David Sylvester to collaborate with him on a project about the origin and purpose of abstract art. Ashwood did not flourish, but nonetheless the venture had a happy outcome, since through it Clark introduced Sainsbury to John Hale, the chairman of the National Gallery (which acquired the rights to the three Rembrandt films), and this led to Sainsbury's appointment to the gallery's board of trustees; in Lord Sainsbury's view, 'Rembrandt led to the Sainsbury Wing. That's my theory'.[28]

Clark continued to write, although most of his output now consisted of introductions: he wrote a pleasing piece on Reynolds Stone when John Murray produced the definitive book of his engraved work. But only after a renegotiation of his fee did he agree to write an introduction for an

American edition of Vasari's *Lives of the Artists*. Vasari, Clark thought, was 'a turgid and inflated painter' and no scholar, although a great storyteller and bringer to life of artists, and produced 'the most vivid, entertaining, and convincing picture of Italian art at its greatest period'.[29] Of greater significance was his introduction to a book of Henry Moore's drawings, 'with all the apparatus of criticism and scholarship. It is quite a big job. I am treating Henry as if he were an Old Master, with the difference that one cannot ring and ask Rembrandt when and why he did a certain drawing, and one can ask Henry'.[30] He also began work for the World Wildlife Fund on a project that he soon regretted, *Animals and Men* – he was bullied into this by his Albany neighbour Fleur Cowles. The book turned out to be a potboiler which John Berger damned as 'trivial, commercial kitsch'. Clark's favourite project by far at around this time was an introduction to a book on Botticelli's illustrations of Dante, 'these beautiful visions, fluttering yet precise'.[31] He dedicated this to the rapidly declining Jane. It was published just before her death, 'and gave her more pleasure than anything else in the last month of her life'.[32]

He still occasionally made interventions on a public stage; he spoke in the House of Lords against a wealth tax on works of art.[33] His opinions continued to be sought on major proposals, such as a Turner gallery at Somerset House (he was initially in favour, but on examination turned against the idea, believing the Seilern collection would be a more appropriate use of the rooms).[34] He was not predictable in his attitudes or opinions, and would never automatically support the *status quo*.

Clark had served as president of the London Library since 1965, despite not even being a member when invited to the post (similar perhaps to his chairmanship of ITA despite not owning a television). His role was mainly to preside over the library's AGM,* but in 1975 he found himself embroiled in a crisis that took some trouble to defuse. The chairman, Michael Astor, who had done much to improve the economic position of the library, had not consulted the membership on several important changes – leading to an attack by some members, and the threat of legal action to the constitutional position of the committee. 'We are the establishment and that is enough for them,' Astor dismissively told Clark.[35] Clark nevertheless had

* At his first AGM in 1965 Clark told the members: 'Logan Pearsall Smith, a man of letters if ever there was one, used to say that there were only two perfect institutions in the world, the Great Western Railway and the London Library. The Great Western Railway has changed; the London Library has not' (Tate 8812/1/4/236).

a degree of sympathy with the malcontents, who were led by the journalist Christopher Booker, although he believed that 'they have made a great mistake in trying to hitch their grievance on to legal quibbles'. They were not 'merely a bunch of destroyers. I think it was a real mistake to make all those alterations in the entrance hall etc. without informing the members or the staff more fully.'[36] He continued to steer a moderate line, doing his best to reconcile the committee and its opponents. He finally handed over the presidency to Noel Annan in 1980, and his portrait, small cigar in hand, is still the last photograph that members see on the stairs before they enter the reading room.

Clark's taste for Early Church reading had not abated: 'I like information, especially about early Christianity, which seems to me the most extraordinary episode in the world. Alas, I seem to have read everything available on the subject. I shall re-read St Augustine's Confessions (sublime) and perhaps St Jerome's Letters (very good).'[37] Possibly for this reason he developed a taste for giving talks in churches, during the lunch hour at St James's Piccadilly, opposite Albany, and particularly at St Mary-le-Bow in Cheapside, a church with a tradition of lectures that went back to the seventeenth-century natural philosopher Robert Boyle. The latter talks were known as 'Bow Dialogues', and were conducted as an interview by the rector or his wife. Clark did several of these, answering questions on Church history, contemporary art and society, usually with a lawyer's exactitude – although sometimes he let himself go: 'Today is similar to the slack period after the death of Giotto; there was another slack period around 1570 when patrons like Rudolph II didn't know where to go, another slack period after death of Poussin. We are in a slack period today, but it differs in that these blighters today think they are all marvellous. It is an art that only appeals to a *côterie*. The greater part of it is rubbish and hoax, done by smart alecks.'[38]

Clark's greatest public recognition came in spring 1976, when he was made a member of the Order of Merit, the highest award for distinguished service (usually for intellectual achievement, and restricted to twenty-four living members) that the British monarch can bestow. Letters of congratulation poured in once again, but as he told Noel Annan, 'I feel like sinking through the floor before anyone finds out what a fraud I am.'[39] He enjoyed his first gathering of the members of the Order at the palace: 'Funny thing, I thought it was made up entirely of academics and scien-

tists. Not a bit: All my old pals were there, the whole lot of them. Well, Henry Moore, Graham Sutherland … that's funny isn't it? It was a very amusing old boys meeting. We were just the old gang.'[40]

He had one other royal engagement that year. Although he usually tried not to leave Jane's bedside, in the month before her death he went, rather surprisingly, to stay at Lennoxlove House in Scotland, seat of the Duke of Hamilton. The Queen Mother was also a guest. As he told Janet: 'QM loves art society – too much standing – I have lost my royal legs – QM looked at *everything* and talked to *everyone* … at dinner yesterday I was the only member of the middle-classes. All the rest were Dukes (Argyll rather nice) Earls (Selkirk nice, Minto less so) and of course the new Duke of Hamilton who seems to be a *brave type*. It is all so incredibly not me that it is faintly amusing – but only faintly – and to tell the truth I am sorry I came.'[41]

Jane's bedside was now as likely to be at the Nuffield Hospital in London as the Garden House in Kent. She suffered a series of setbacks before she died. In March 1975 Clark wrote to Janet: 'She had a very severe diabolical visitation last night … kept the TV on full blast to keep him away … the devil was due for a return. He has been away for months, and I have been expecting the old boy for a long time. Physically, I think these visitations may be a sign of health, as they are a form of rebellion.'[42] Another setback came with the death of Lord Crawford in December 1975, which had a strong emotional effect on her: 'Jane still weeping at the death of David Crawford – the only man she ever loved without qualification!'[43] Clark wrote an obituary for Crawford, describing his goodness and listing the great public services he had performed. By February 1976 he was warning Morna Anderson that 'Jane is very ill and in pain – lives on painkillers. I think she doesn't any longer hope to recover.'[44] In April the Clarks changed their Albany apartment from B5 to B2, so that Jane no longer had to be brought upstairs.

One day Jane asked for pen and paper, the significance of which Clark did not immediately recognise. Her mind, which up to that point had been very confused, had cleared, and she wrote letters of farewell to the family. Together she and Clark spent a happy afternoon holding hands and discussing the Florentine artists of the *quattrocento*.[45] He read her Keats' 'Eve of St Agnes' until she said, 'I am feeling a bit sleepy.' He said, 'We will read some more tomorrow,' to which she answered calmly and even gratefully, 'I shan't be alive tomorrow.' She immediately went to sleep, and never woke up.[46] Alan takes up the story from the castle: 'woken this morning

by banging noises at main door. "Lady Clark died last night." Jane and I dressed quickly, hoping to beat Col. Found my father in "tremendous form" wiping his mouth with the back of his hand, having just eaten brown eggs and grapefruit ... then went to see Mama ... found her face composed, determined, rather beautiful, not in any way distorted.'[47]

Jane's funeral was a miserable affair. It took place in a soulless local Kent crematorium, and apart from immediate family, only her two brothers and their adult children were present; Clark did not even invite them back for tea or a drink. In fact he made no effort whatsoever – just as at the wedding fifty years earlier. A chilling sidelight on the story concerns the butler Leonard Lindley, who had gone on a rare holiday abroad with his wife, and missed Jane's death and funeral. He had been devoted to her, and was staggered on his return to find a matter-of-fact note from Clark informing him that Lady Clark had died – and giving instructions for his breakfast.[48]

Jane's will was a matter of some speculation, because she had rewritten it so often. Clark felt sure that she owned nothing, but he had forgotten that he had made a great deal over to her in the days before spouses were exempted from death duty tax. The family were surprised not only by how much she left, but also that the main beneficiary was Alan and not Colin. Alan had received an inkling of this when earlier in the year he had by accident been sent a copy of his mother's latest will, in which he had been surprised to read that he was the residual beneficiary, though at the time he thought it must be a misprint.[49] But besides having fallen out of favour with his mother, Colin only had stepchildren at this time, and Jane wanted to keep the money on the Clark side of the family. This was a blow for Colin, but as Alan wrote in his diary, 'a tremendous liberation for me'.[50] However, Jane had left her greatest treasure, the Henry Moore shelter sketchbook, to the British Museum – as both Clark and Moore himself had hoped.

As for Clark, after the initial burst of relief at Jane's death, he was utterly bereft. He wrote to Myfanwy Piper: 'You are right – the habit of looking after Jane was not only "a labour of love" but had become a sort of addiction and I feel a desolate emptiness.'[51] His lady friends rallied round: Morna Anderson, Irene Worth, Joan Drogheda and above all Mary Potter did all they could to console him and keep him busy. Those who knew Clark well saw that Jane was the love of his life and a part of his soul. Six months after her death he told Janet about a conversation with Jayne Wrightsman, 'who hated Jane and never ceases to tell me so, which is

tactless, [and] said to me yesterday "some part of you died with Jane" and added "you have lost all your sparkle". Perhaps this is true.'[52] To his daughter Colette and the rest of his family it is a profound truth that Clark never recovered from Jane's death. In so many ways she had created him in the first half of their marriage, and in the second half she performed a ritual of protection and torment which he meekly accepted. She was ultimately the ringmaster of the curious performance with Clark and all the girlfriends. Jane had always been his excuse to disengage.

Clark busied himself as best he could, staying with old friends and finishing the second volume of his memoirs, *The Other Half*. John Russell mused over the title, which he felt 'has a lingering ambiguity which I have been trying to identify. Conceivably, it is an amalgam of "how the other half lives" ... and of the perfect bartender's enquiry "The other half sir?"' Clark admitted that 'I was much influenced by the thought of the barman's enquiry.'[53] The book, as he realised, could never be as amusing as the first volume – it needed to cover too many people who were still living, and he was beginning to lose his appetite for life.[54] If the first volume was a work of art, he believed the second would be merely a record of events and people. In fact *The Other Half* is full of interest, as it covers several of the most important episodes of his life, including the war and the development of television.

Clark received the usual fan mail, and noted sardonically: 'My statement in "The Other Half" that I did not like getting letters ... seems to be the only thing that the average reader can remember in the book, and it impels him or her immediately to sit down and write me a letter.'[55] The reviewers were respectful, if a little sceptical: 'A tone of arch bemusement ... each success appears under cover of a failure,' wrote Peter Conrad in the *TLS*.[56] The most penetrating review was by Christopher Booker, who saw Clark's life as a magic pageant floating onwards – always being with the right people at the right time – Air Chief Marshal Newall keeping him informed about the Battle of Britain, Miss Joan Hunter Dunn happening to be in the canteen of the MoI – the actors remaining relentlessly famous, an eerie masque of waxwork animated *tableaux* so that 'a feeling of terrible claustrophobia begins to mount'. Booker concluded that 'what comes through is the self-portrait of a man, who by a steely effort of will, has subordinated everything in his life to the preservation of an almost flawless mask'.[57]

Clark concluded the second volume of his memoirs with a David Copperfield-like statement: 'It now remains for me to see what I do with

the rest of my life.'* For Janet Stone, the story from this point becomes one of tragic sadness. On the last day of 1976 Clark wrote to her: 'the fact is that I am IN LOVE with you. I have loved you for many years, but a few weeks ago I fell in – like a child into a pond ... It is an extraordinary experience to have at my age.'[58] How much of this outpouring was brought on by loneliness and despair is an open question – for Clark freedom from Jane was an alarming prospect. His system of romantic attachments had always depended on safety in numbers, and now he felt dangerously exposed. Several women of course expected him to marry them. Elizabeth Kirwen-Taylor (living in nearby Hythe) was the most pressing, as he told Janet: 'She lives in a world of fantasy except that she always wants money ... I don't know how to calm her down – she knows that I won't marry her, but she wants to be part of the family – and the family don't want *her*. It was sweet of you to say what you did about my marrying. *Don't worry.* It may be that in the end solitude etc will lead me to marry but it would only be to some-one who understood how much we love each other and whom you would like. But I hope it won't have to happen for a long time. You are my love.'[59]

His son Colin observed that at this point 'everything did catch up with him. "I can no longer go for a walk on my own," he groaned. "I start think-ing about all those ladies." His compulsion for the ladies was combined with a strange detachment, and he didn't seem to mind which one was there.'[60] Clark discussed marriage with Mary Potter, but kind and adoring though she was, this was not for one minute a practical proposition – he would not have wanted to live in Aldeburgh any more than she would have wanted to leave it. As Reynolds' health was slowly declining, Janet must have dreamed that Clark would wait and one day marry her. However, many of Clark's friends have wondered whether this was ever really his intention, and in truth Janet appealed to him partly because she was married. Although Clark still enjoyed the relationship (and indeed his other romantic friendships), the system had been rendered insecure by Jane's death. He needed to marry again in order to restore the equilibrium. But whom should he choose?

Clark was more of a snob than he cared to realise; he needed somebody who would be as much at home at Wilton House as at the Warburg

* Clark, *The Other Half*, p.243. Clark's other great accolade in 1977 was to be presented with New York City's Gold Medal, the highest honour the city could bestow (it had not been given to anyone in the arts for twenty years) – although he ruefully commented that free taxis would have been more useful.

Institute – and preferably someone with an independent life of her own, who would leave him to work and pursue his friendships. He did indeed find a suitable candidate, and it was to Janet that he broke the news: 'The trouble is that when I'm alone I get so depressed … and I love having someone about to talk to and look after … and fortunately there is such a person – the lady I stayed with in Normandy. She is an adorable character, and would understand my feelings for you. In fact I genuinely believe (this is often said in books and plays) that you would be friends. Of course I could never love her as I do you – that is a once for all love. But I am very fond of her, and she seems to suit me and I her … although she is a bit of a chatter box, I think they [his children] will like her … I have always told Nolwen that you are my love and she understands the situation.'[61]

In this Clark was under a grotesque misapprehension, not only about Janet's feelings with regard to his remarriage, but also those of his new fiancée, Nolwen Rice, about his arrangement with Janet. Meanwhile he wrote cheerfully to Colin: 'I am writing to tell you that I am going to re-marry … I have told only one or two close friends and you can imagine that one or two of them have taken a poor view of my decision. Tant pis. It has given me something to live for.'[62]

37

Last Years and Nolwen

I am very well looked after,
but that isn't a substitute for vitality.

KENNETH CLARK to Janet Stone, 1 August 1979

Nolwen Rice had a colourful family background. She was the elder of two daughters of Count Frédéric de Janzé, a French aristocrat from an old Norman family, and his American wife Alice, who had been an alluring and scandalous figure at the heart of the Happy Valley set in Kenya.[1] Nolwen's parents separated when she was a child, and she was partly brought up at her father's family's beautiful seventeenth-century château at Parfondeval in Normandy, which she eventually inherited. She left her first husband, Lionel Armand-Delille, for an Englishman with an estate in Kent, and during this second marriage divided her life between Kent and France (as she would later continue to do with Clark). Her second husband, Edward Rice, died around the same time as Jane, and bereavement drew her and Clark together.

The arrival of Nolwen came as a great surprise to Clark's children, whose response Colin summarised: 'my Father got married again, rather too quickly we felt, to a lady none of us knew'.[2] In fact Nolwen and Clark had known each other for some time as neighbours, and there are records of the Rices coming over to lunch a number of times before Jane died. Nolwen told Roy Strong that the courtship took place after Jane's death, over six teas. One day Clark turned to her and said, 'You and I should be joined.'[3]

What was she like? Nolwen is one of those people about whom there can be no agreement. There is nobody in Kenneth Clark's story about whom the author received such strong and partisan opinions, both for and against. She was beloved by several literary and artistic men, including the

historian James Pope-Hennessy and the artist James Reeve. Roy Strong described coming under her spell one night at dinner: 'she's enchanting, lively, with huge beautiful eyes'.[4] There was to be no love lost, however, between her and the Clark children. To Alan she was predatory, grasping and false, while to Colette she was 'one hell of an operator'. A relation by marriage described her as 'manipulative and mischievous, more than a match for Edward Rice – there was never a dull moment'.[5] One of her Kent neighbours commented: 'She was extrovert and amusing – she showed K off like a trophy. She was skilful and had K in her power.' Nolwen was a great talker – some thought too much so – and Henry Moore, for one, felt she overwhelmed Clark.[6] She certainly looked after him well, and there is no doubt that it was a great comfort for him to find companionship; but Nolwen wanted control over his life, and given Clark's arrangements, this led to some bruising encounters. Consequently his last years began to take on the character of a power struggle: Nolwen wresting him from his girl-friends and from a family deeply suspicious of her; Janet Stone attempting to hold on to her relationship with him; Alan trying to maintain steward-ship of the Garden House; Leonard Lindley trying to retain control of the kitchen; and Meryle Secrest attempting to piece together Clark's past from an ever more alarmed subject. At the centre of all this was an increasingly enfeebled Clark, with Nolwen his protector and gaoler.

Clark enjoyed telling people that Nolwen was marrying down. He was, like everybody else, rather dazzled by the charm of Parfondeval. Britain in the late 1970s was a miserable, strike-bound place, the Garden House increasingly suburban – you could hear the traffic – and the pleasures of Normandy made a delightful escape. As Clark told Mary Potter: 'The house itself is perfectly charming. It is red brick, 1620, perfectly preserved and all the rooms panelled with 17th or 18th century *boiseries*. An excess of furniture, as in an old French engraving. As it has belonged to my host-ess's family for 400 years, the furniture has the look of having grown up with the place.'[7] Three months later he reported: 'Celly, with her gift for telling uncomfortable truths, says that I am not marrying Nolwen but Parfondeval. Not quite true – but then I ask whether I should have married her if she lived in an ugly house in Passy, I see there is something in it.'[8] There was a small estate around the château that Nolwen farmed, but it gave no impression of great wealth.

Inevitably, Janet Stone was devastated to hear of the forthcoming marriage, and the recriminations began. Clark wrote to her with extra-ordinary hypocrisy: 'It is terrible to think that my decision has made you

so unhappy. I knew how much we love one another, but I thought you had quite enough in your life – dear children, grandchildren, and a sweet husband, who is also a great artist – to fill your time and your mind. Reynolds is no longer very fit, and surely looking after him must occupy your mind. Do please, my darling, try to think of this.'⁹ Janet found the situation incomprehensible, as she wrote to a friend: Clark had so constantly told her she was the *only one*, and he *cannot* marry again, for that reason. She added that the day before he announced the marriage, Clark had rung three times from Normandy to hear her voice and to arrange a meeting.¹⁰ John Sparrow wrote to Clark offering to intervene, shrewdly realising that the story might not be over: 'I hope that your apprehensions of recriminations on the part of Janet will prove groundless. You can rely on me, if the need arises, to persuade her to accept philosophically the changed – or not wholly or fundamentally changed? – position.'¹¹

Janet buried her feelings and wrote a letter of congratulation to Nolwen, to which she received a courteous response. It was not long before they met, and in a letter to Morna Anderson Clark described Janet's sorely mistaken assessment: 'It has been something of an anxiety to introduce Nolwen to so many of my old friends, but as far as I can assess their responses, it has gone quite well. My favourite comment is poor Janet Stone's "She is like a small grey mouse, scurrying about – but then I like small things." The word "things" is particularly well chosen.'¹² Sadly, Janet would soon discover that this mouse could roar. Nor was Janet the only girlfriend to be curious about Nolwen: Jayne Wrightsman rang Colette from the confidentiality of the beach hut at the Palm Beach house so that Charles should not overhear, asking 'what on earth this was all about'.¹³ Of all Clark's girlfriends the one who was most accepting and welcoming was Mary Potter. She established a warm relationship with Nolwen, who therefore had no qualms about Clark's annual visits to Aldeburgh.

The wedding was a private ceremony attended only by family, and a few very close friends such as the Droghedas and Jock Murray, at noon on 24 November 1977 at St Etheldreda's Catholic church in Ely Place, London. Clark's best man was the bachelor man-about-town Burnet Pavitt, with whom he had been friends since Covent Garden days. Pavitt later told James Lees-Milne that at the altar the priest handed him a silver plate with the ring. As Pavitt fumbled to pick it up, Clark could not help himself, and began a lecture on the ring: 'Have you ever seen a more beautiful object? It is Coptic.' The priest admitted he hadn't, and invited them to admire his Puginesque chasuble: 'K duly admired. All the while the bride was waiting

with outstretched finger.'[14] The reception was a buffet lunch at Albany, organised by Clark's cook Joan Dawson, who remembers: 'At the reception he sat on the sofa between two ladies, and Catherine Porteous whispered to me, "They are two of the disappointed ones." To my surprise Lord Clark didn't want coffee, "No, Mrs Dawson, it is about time that they all left. I have just got married and would like to be alone with my wife."'[15]

The early part of the marriage was something of an idyll. A routine was established between Kent and Normandy, as farming the estate meant that Nolwen needed to be at Parfondeval for longish periods. Life at the château was agreeable; Clark enjoyed local walks, and continued to write to Janet: 'Life here is very pleasant, much of it spent in the kitchen. No cook or gardener, hefty woman to make beds, N cooks very well and light-heartedly, while I act as an inefficient scullion ... The house is perfection, and the farm buildings and the valley really beautiful.'[16] He told Janet that during the summer 'I rise late and do a little writing, and take long walks in the very pretty countryside, and talk or sing to myself. I sing old music hall songs – chiefly George Robey – which are the ones I remember the best.'[17] It soon became evident, however, that Nolwen's health was not good, as Clark told Colette: 'This I had not expected; Nolwen is always ill; an unexpected turn of events.' Her ailment was explained as brucellosis – a farmers' affliction – and as Clark wryly pointed out, it generally struck before church on Sunday.[18]

Back in England, Clark enjoyed introducing Nolwen to places that he loved. But life at Saltwood was more complicated. Nolwen didn't have enough to do, and wanted to adjust the routine. This caused resentment and hurt to Lindley, who was resistant to change: 'Lady Clark thought she understood him, but she didn't. If I had been able to care for him, he would still be alive and I don't care who knows it.'[19] Lindley believed that Nolwen made Clark feel like a child, and infantilised him. Relations between Nolwen in the Garden House and Alan at the castle rapidly sank to freezing point. One of the main bones of contention between Nolwen and the Clark children was the contents of the Garden House. Although these would be left (apart from specific bequests) to Colette, Alan was possessive about everything at Saltwood, and there was a palpable tension on the subject.* Certainly a great deal of important art ended up with

* Before his father's death Alan referred to Clark as 'more or less of a nuisance, but got to keep in with him for inheritance purposes'. Alan Clark, *Diaries: Into Politics 1972–1982*, entry for 6 January 1981.

Nolwen, either in France or in her London flat. Clark had every right to give his new wife whatever he wanted, but as far as his children were concerned it was not without persuasion on her part.* Fortunately for Nolwen, Colette – the main loser – was the least acquisitive of the children, and accepted the situation with dignified restraint.

Clark now found it difficult to write books, but still published *An Introduction to Rembrandt* (1978), based on his TV series. He also made a return to his roots with an introduction to a book on Aubrey Beardsley (1978), written in a fit of nostalgia about the artist who 'meant so much to me when I used to live at Sudbourne'.[20] John Sparrow was particularly delighted with it: 'Beardsley – Superb! ... You opened my eyes to his talents, and even persuaded me that he had genius ... I love the phrase "do-it-yourself diabolism". It would have been worth writing the essay for that phrase alone!'[21] The invitations to lecture still flooded in, from university societies, Rotary clubs, arts clubs and more, but in 1978 the Saltwood secretary wrote: 'I am very sorry but I am afraid I must tell you that Lord Clark has made up his mind not to address local societies any more. He is now seventy-five, he has a great deal of writing to do for which he must conserve his energies, and he tires easily.' Clark made an exception for a charity lecture at Petworth on 'Turner at Petworth', because he thought it would give Nolwen pleasure to stay at the house. He spoke without notes in front of Turner's paintings for about fifteen minutes, then ran out of steam, gazed out of the window onto the park and turned to the audience: 'It is such a lovely evening, let's all go and enjoy the sunshine.'[22]

The following year Clark had the shock of the exposure of Anthony Blunt as the 'Fourth Man' of the Cambridge spies. Catherine Porteous told him the startling news at Albany one morning: 'He said nothing for a moment, and then said, "I am devastated" – long pause – "but I am not, in fact surprised." He then asked for a stiff drink, even though it was about 10 a.m. Although K had never been close to Blunt, he was a very old friend and colleague, and he thought "it was a tragedy that it all came out before Blunt died".'[23]

* It began with Clark telephoning Colette and saying that he had to give Nolwen something. Seurat's *Sous Bois* was proposed, but he told Colette that she would receive the Samuel Palmer of *The Harvest Moon*. When Clark died Colette went to claim the picture, but Nolwen informed her that her father had given it to her already. Nolwen sold it to the British Museum. A signed note dated 22 December 1982 (Saltwood archive) lists twenty works of art given to Nolwen, including the Seurat, the Palmer, several medieval ivories and sculptures, and works by Renoir, Pissarro, Jack Yeats and Sutherland, and the plates by Duncan Grant and Vanessa Bell.

Clark now found himself frequently in demand to attend memorial services, either representing the Queen – as for both Benjamin Britten and Graham Sutherland – or giving the address for old friends, such as Colin Anderson.

Parfondeval may have started out as a paradise, but it gradually became a cage for Clark, and he looked for distractions. His secretary Catherine Porteous remembers that he never wrote her as many letters as he did from there, because he often had nothing else to do all day. He became restless, writing to Janet: 'Relieved that N's son and d in law are staying as I had been alone with her for so long and one needs a little variety … I agree with you that I must find a way of going down to [Litton Cheney] – whatever Nolwen may say I will not be separated from you.'[24] Indeed, he was up to all the old subterfuges: 'My darling – it was lovely to hear your voice this morning. It was an ideal moment as Nolwen was on the other 'phone. She tends to come in when she hears my phone, and in fact did so, which accounts for my somewhat abrupt ending.'[25] A few weeks later he was telling Janet how pleased he was to be back at Saltwood: 'I love pottering about the garden and looking at books. Of course it is a futile kind of existence and I ought to be ashamed of myself. But after 75 one loses all moral sense.'[26] Then in June 1979 Reynolds Stone died, and although Clark did not go to the funeral he wrote to Janet: 'I wish you also had your old friend KC although I could have done little enough … I think of you all day with love and deep sympathy. And I do believe that you will be happy again.'[27]

As far as Nolwen was concerned, the death of Reynolds dramatically raised the stakes. It was one thing to have a rival in the married Janet, but quite another for that rival to now be a free woman, and still pining for Clark. At this point Janet, no doubt encouraged by Clark, played into Nolwen's hands. In her very distinctive italic hand she wrote a letter to Clark at Parfondeval marked 'Personal'. Nolwen decided she had had enough, and wrote Janet a letter of startling frankness.[28] She told her in the strongest terms to leave her husband alone – Nolwen was there to protect her husband; she was not Jane, and nor was she prepared to sanction such a relationship under her nose. Finishing with a final swipe to the effect of 'Go and get a life,' Nolwen declared that friendship between them was now impossible.

This brutal document – which was sent without Clark's knowledge – had a predictable effect on a hysterical Janet. However tactless and silly it had been of her to send the provocation of a letter marked 'Personal', it was

harsh of Nolwen to take it all out on Janet, whom Clark had been encouraging all along. This put an effective end to the relationship between Clark and Janet; any letters that followed were for information, and no more than courteous in tone. Nolwen had won. However, this left Clark a disappointed man, and one who had lost much of his motivation, which he would never regain. He wrote to Colette from Parfondeval: 'I am longing to go home.'[29]

A new anxiety however was now bubbling to the surface. When earlier Meryle Secrest had written her biography of Berenson under Clark's patronage, he had enjoyed helping her. At the time he had written: 'I spent the morning talking to the very nice and intelligent lady who is doing a book on BB. She has a new and charming husband, much younger than herself ... I was amused to find in her the kind of American prudery that one gets in Henry James. She was very shocked by the morals of I Tatti.'[30] Secrest had not been given access to the I Tatti archive, which was a severe handicap; however, Clark had given her the somewhat curious advice, 'Better not to use the Archive and put yourself under the obligation of letting him* censor your manuscript.'[31] In the event Secrest's book *Being Bernard Berenson*, published in 1979, had been well received – except by the art history establishment and Berenson's admirers, who felt that Clark should have known better than to support a non-academic book which, in John Pope-Hennessy's phrase, 'led to a grave devaluation of his [Berenson's] currency'.[32] As early as summer 1977 Clark had written to Secrest: 'You end your letter by asking if I would like you to write my biography. I could think of no one who could write it better, but I do not think it need be written. I have not done enough to merit a biography, and my two volumes of autobiography will be all that anyone can want.'[33] It was not long before he changed his mind and was enthusiastically cooperating in his own biography; as one of his lady friends put it, 'he wanted Meryle to justify his stature'. He even allowed Meryle to take him back to Suffolk, where he showed her Sudbourne Hall and mused about his childhood. He was enjoying it, and told her, 'at every step I grow more curious as to who I am'.[34] In fact he did not want to be revealed – he wanted an account of what he had achieved.

When Clark saw the synopsis for Secrest's proposed biography he responded: 'It is, of course, far too laudatory, but on the whole it gives a fair idea of my life. The only part where you will have to do some work is

* i.e. Cecil Anrep, Nicky Mariano's nephew, who inherited BB's literary estate.

on my public activities, which occupied the greater part of my time for about forty years – say 1930 to 1970.'[35] Although he did not initially feel the need for a right of veto over Secrest's material he was keen to have the chance to comment on the text, which was originally to be published by Jock Murray. Clark sent Secrest a list of people to interview, which left out his girlfriends, but Meryle was nothing if not assiduous, and was soon heading to Litton Cheney. 'It is good of Mrs. Stone to have invited you to stay,' Clark told her, 'because the journey down to Dorset is quite long. On the other hand, I think you might have had a rather distressing evening.'[36] Reynolds had died exactly a month earlier, and Janet was in an anguished state of mind and wanted her part in Clark's story to be told.

Clark, however, did not want any reference to his girlfriends in the book, and began to answer Secrest's questions evasively. He asked Mary Potter: 'How did it go with Meryle? She is a nice person, but her former profession (journalist) has made her somewhat insensitive, & too pressing in her curiosity about people's lives. I don't care a damn what she says about me, I shall be forgotten by the time the book comes out, and my friends … do not need to read it.'[37] James Lees-Milne recorded a visit from Meryle: 'Mrs Secrest came. A voluble, gushing, friendly lady … Tells me that K asked her to include all the love affairs.'[38] Colin Anderson, however, had earlier warned Clark, 'We are being asked questions by Meryle that are quite beyond us,'[39] and John Sparrow drolly observed that an anagram for Meryle Secrest was 'Merely Secrets'. Clark would have preferred discretion – and Nolwen certainly did – but by now he realised that Meryle, who had also unearthed his affair with Mary Kessell, was unstoppable. He apprehensively told Colette that he was concerned about Meryle's fascination with his love life – although he had to admit that she was 'incredibly industrious'.[40]

The question that now raged was whether Clark and Jock Murray should read Meryle's manuscript (Jock thought yes, Clark inclined to no), and whether it should be published during his lifetime (again, Jock thought yes, Clark thought no). Naturally Meryle's concern was that Clark's heirs should not meddle with her text. Clark wrote to Alan: 'I am sure that she will be equally fair in her treatment of me (as B.B.), but she is also capable of rather severe moral judgements, and she may say things which my family will not like.'[41] A year later, when Janet asked how Meryle's book was going, Clark answered: 'You ask about Meryle … she is a victim of all contemporary manias, psycho-analysis etc … she keeps on trying to push back into my childhood to find some suitable evidence of

sexual or other peculiarities – alas, all painfully normal. I think she would give it up were she not in need of money – and has bought a new country house – and she has sold the rights of KC to both Jock and Weidenfeld.'[42]

Clark was rapidly turning against the project, and told Meryle that he was distressed by her selection from his letters to Janet: 'Can you not suppress – many of them would be used in a very damaging way.'[43] Shortly afterwards he wrote to warn Janet: 'I am afraid Meryle has become a nuisance to us all. She is a very tenacious *journalist*. I ought to have recognised this from the start, but far from that I committed the inexcusable folly of agreeing that she should write my life … I can guess from the things she has *not* asked me about what the general tone of the book will be.'[44] At this stage Janet had already agreed to lend Meryle her letters, which had been packed up and taken to London by her son-in-law, prior to being shipped to America. But now she had a change of heart. She wrote an anguished letter to Clark, and Jock Murray retrieved the correspondence.* Meryle did however take to America a carefully selected and important tranche of mostly pre-war letters from Saltwood (including all the pre-1945 letters from Berenson), which Clark apparently allowed her to do.† Alan's widow Jane believes that her father-in-law found Meryle's

* See Janet Stone to Clark, 25 January 1983 (Tate 8812/1/3/3070). Ian Beck, Janet's son-in-law, gave this account of the retrieval of the letters to the author: 'The telephone rang one morning. It was not Ms Secrest, but Jock Murray, K's publisher. He was boiling over with anger and was quite fierce. He said he was sending a taxi that morning to collect the box of letters and on no account was anybody else to have them, to look at them, and certainly not read them. Ownership of the letters did not confer copyright, the contents were not in Janet's gift to dispense or words to that effect. Sure enough he arrived by taxi soon after and carted the box away with him' (email to author, 10 February 2014). As a result, and after consultation with the bibliophile Anthony Hobson, the letters were deposited at the Bodleian Library with a thirty-year moratorium.

† These included important letters from Clark's mother and father, Maurice Bowra, Lord Crawford, C.F. Bell, Benjamin Britten, Mary Kessell, Gerald Kelly, David Knowles, Owen Morshead, John and Myfanwy Piper, Edith Russell-Roberts and Edith Sitwell. The letters have been the subject of controversy ever since. Meryle Secrest claims that Clark told her she could keep them, a contention contested by the Clark family. The fact that the letters were missing first came to light when Charles Ryskamp arrived to collect the Edith Sitwell letters for the Morgan Library, and they could not be found. Clark asked Catherine Porteous if she knew what Secrest had borrowed, as no lists existed (letter Porteous to Clark, 15 February 1983, in Catherine Porteous's archive). Ryskamp then made arrangements with Secrest to have the Sitwell letters delivered to the Morgan, where they are today. See Appendix I for the fate of the rest of the letters.

questions tiresome, and it may be that he acquiesced in the removal of the letters as an expedient to be left alone. The upshot of Clark's disillusionment with Meryle was that the biography would not be published during his lifetime, nor with his permission to quote from documents.[45] Jock Murray would eventually withdraw, and Lord Weidenfeld took the project over as its sole publisher.

Clark had not given up writing, but increasingly his projects involved republishing old essays and lectures. He was full of unrealised new ideas – the Murray archive in Albemarle Street is a graveyard of undeveloped themes: 'Collectors and Collecting', 'Aesthete's Progress', 'The Limits of Classicism', 'Art of the Church', 'First Civilisations'. Here was an old general still commanding armies in his mind, for none of these projects would be finished. The most revealing of them exists only in fragmentary form: 'Aesthete's Progress' was intended to be 'a quasi-autobiographical account of my responses to works of art'. It offers some interesting material not to be found in *Another Part of the Wood*.[46]

One of the changes instigated by Nolwen was to appoint her niece by marriage, Maggie Hanbury, as Clark's literary agent. Maggie was initially brought in to negotiate *Feminine Beauty*, a book proposed by Lord Weidenfeld. Clark had never had an agent before, but as he was using a publisher other than his old friend Jock Murray, it made sense. However, Maggie saw her role as being Clark's main agent, even negotiating terms with Murray, which caused Jock Murray understandable upset. It was galling for a distinguished publisher, who had honourably and devotedly looked after Clark's interests for thirty years, to have to pass everything through an agent – although they soon reached an accommodation.[47] Clark's verdict on *Feminine Beauty* (1980), which he dedicated to Nolwen, was very Bowraesque: 'I cannot say it is good, but it is not wholly bad.' The book traces the depiction of female beauty in art from fourth-dynasty Egypt, and gave Clark his last ride from the ancient world down to the present, ending with Marina, Duchess of Kent, looking very like his late wife Jane – dark, elegant and sharp – followed by a seaside photograph of 'the glorious Marilyn Monroe'.

At the end of his life Clark put together two compilations of essays and lectures, *Moments of Vision* (1981) and *The Art of Humanism* (1983). One reviewer said of the former: 'the author himself is really like a sort of grand museum, and every great museum needs a few inferior examples, just by way of illustrating its enormous range'.[48] *Moments of Vision* is of interest,

however, because it includes some of his best pieces: 'Pater', 'Mandarin English', 'The Artist Grows Old', and the title lecture. *The Art of Humanism* was a return to Clark's roots, with essays on Alberti and Renaissance artists. It also contains the delicious *aperçu* that the restoration of Mantegna's *Triumphs* at Hampton Court by Paul Nash under the guidance of Roger Fry meant that they 'had a flavour of the 1920s almost as strong as *The Boyfriend*'.

Clark gave up the set in Albany to Alan in 1981, and Catherine Porteous went through the archive: 'I have been through the files gradually over the past year or two and have thrown out a good deal. Should I use my discretion and do another cull, or send everything else down to Saltwood as it stands?'[49] Clark by now was starting to lose his memory; Catherine noticed that he began to write the same letter twice, and his handwriting became even smaller. Nolwen had taken over the management of his life, and dealt with all his business affairs. A sad example of his diminished state is given by Alan in his diary: '*Tuesday 20th July 1982, Saltwood Great Library* – My father has had a *coup-de-vieux* and is now in unhappy decline. There is scarcely any longer a point in going over [to the Garden House] to call on him. He just sits, on his low green velvet chair by the big window. Col was very aggrieved the other day because as he approached my father smiled simperingly and said: "Ah, now, who's this?" "It's your younger son, Colin, Papa." "Aha" (Of course my father knew perfectly well who it was. He just gets irritated with Col blatantly sucking up to him and talking a lot of recycled balls about art). Aha. Of course my father would never have spoken like that to Celly. She would have cackled, said "You're completely ga-ga" or something equally brutal. He is frightened of her as he is of most women.'[50] Colin also recorded this encounter, adding, 'I think that it was the saddest moment of my life.'[51]

The last year of Clark's life, 1983, was spent suffering from arteriosclerosis, mostly at Saltwood or in Hythe Nursing Home; although Nolwen was a devoted carer, he was too frail to spend much time at Parfondeval. He fell in hospital and broke his hip, which marked the beginning of the end. On 15 May he told Alan, 'I am perfectly clear, and I say this with all deliberation, that I will not be alive in a week's time.'[52] A week later Alan went to say goodbye: 'Papa, I think you're going to die very soon. I've come back to tell you how much I love you and to thank you for all you did for me, and to say goodbye.'[53] Nolwen rang the castle the next morning with the news that Clark had died in the night.

Even from his deathbed, Clark still had the power to surprise. James Lees-Milne recounts an episode at the memorial service: 'An Irish Catholic priest gave another dissertation, claiming that before his death K sent for him, received Communion according to the proper rites, and said, "Thank you, Father, that is what I have been longing for." Very surprising.'[54] What are we to make of this reported conversion? Was it a remarkable example of Pascal's wager? Nolwen, a Roman Catholic, would certainly have arranged the priest. She told Colette that her father was nervous at the end, but after being given extreme unction a beatific smile came over his face; he then went to sleep, never to wake up. Probably Clark felt that it was correct to leave the world in a sacramental way – a rite of passage to counterbalance baptism. He certainly would have thought it bad manners to refuse Nolwen and reject the priest. For Michael Levey this was 'a sharp reminder of his elusive, complex personality, leaving as it were one last, unexpected facet to be revealed only posthumously'.[55] Clark's long fascination with the Catholic Church and its history had been pointing to such an outcome. Did he not once give a lecture on the Louvre in which he said: 'For a work of art to enter the Louvre was like entering the Catholic Church. It would find itself in some pretty queer company, but at least it would be sure that it had a soul.'[56]

Clark's funeral took place in the church at Hythe, rather than at Saltwood, where Alan had fallen out with the vicar; a large congregation gathered, including the entire crew of *Civilisation*. The burial, however, was in Saltwood's cemetery, and the mourners followed the coffin for the committal. Henry Moore, who was very ill, made a rare public appearance for his old friend, and with tears running down his cheeks got up from his wheelchair and, supported on two sticks, threw the first handful of soil. The Queen sent a telegram to Nolwen at the Garden House: 'Lord Clark's loyal and distinguished service to my Father and his outstanding contribution to the world of Arts and Letters will always be remembered.'

Epilogue

Lord Clark's death drew international attention. As Michael Levey pointed out: 'Few art historians – few scholars altogether – can expect their death to attract the international coverage that Clark received. In Europe alone, from Zürich to Madrid, via Amsterdam, Rome and Paris, the newspapers united to convey the event: *Kenneth Clark gestorben ... falleció el crítico de arte ... Kunsthistoricus overleden ... è morto ... la mort de Kenneth Clark*.'[1] The obituaries were long and respectful. John Russell's piece in the *New York Times* was typical: it hailed Clark as a pre-eminent figure in British cultural life, and the most naturally gifted art historian of his generation. Only Levey's obituary looked below the surface and attempted to explore the complexity of the man in all his contradictions, recalling how 'each meeting seemed, to some, to have to start from the beginning again. Rapport was something of an uncertain quality, never to be assumed, still less guaranteed.'[2] The same elusiveness was caught by James Lees-Milne in his diary entry on hearing the news of Clark's death: 'Now, I have always regarded him as the greatest man of my generation. I have never known him intimately. Few men have. He did not care for men, and greatly loved women. Was a proud, aloof man with a gracious manner that did not put one at ease. But whenever he gave praise one felt that God Almighty had himself conferred a benediction.'[3]

The memorial service, which was of an unprecedented hour-and-a-half length, took place on 13 October 1983 at St James's church Piccadilly, to which Clark had so often crossed the street from Albany to seek solace. John Sparrow read from Bacon's essay 'On Studies', Alan Clark from the *Devotions* of John Donne; surprisingly, there was nothing from Ruskin. Yehudi Menuhin played the chaconne from Bach's D Minor partita. A rather formal address was given by John Pope-Hennessy; behind Clark's mask of pragmatism, he said, 'there was, not exactly an artist, but someone who looked at works of art with an artist's understanding of what they

were designed to do and how they had occurred'.[4] Listening to Pope-Hennessy's solemn recitation of Clark's *oeuvre* made Roy Strong wonder whether 'on the Day of Judgement God would turn out to be an art historian raising us up or casting us to oblivion according to the quality of one's articles in the *Burlington Magazine*'.[5]

Perhaps what was missing from the service was more of Clark's own voice. Alan described the day in his diary: 'My father's memorial service was strange. A motley collection of strays. Poetic justice, as he himself never went to anybody's ... I read the lesson in a very clear and sardonic voice, trying to convey that they were all a shower, Nolwen in particular. If you die in old age, of course, you get a completely different kind of attendance than if you are taken by the Gods.'[6] Roy Strong was struck by how few people were there, and noticed other omissions: 'no reference to Jane at all, no evocation of the warmth, charm and atmosphere that was the essence of the man ... as we left Jock Murray offered us tea at Murrays which we declined. Otherwise, we, along with the rest of the Establishment in its old blacks from the back of the wardrobe, hurried away in the pouring rain.'[7]

Clark's will was proved on 13 March 1984. Alan and Colette were the executors, while his literary executors were Jock Murray and Maggie Hanbury. The Garden House and its remaining contents went, as expected, to Colette. All three children shared the residual estate, barring specific bequests to grandchildren and staff. Janet Stone received the David Jones watercolour of Petra, Nolwen £40,000, Leonard Lindley and his wife £8,000. The Ashmolean received the Giovanni Bellini *Virgin and Child*, and the British Museum the Henry Moore drawings, with a life interest to the children. The probated figure was £5,315,157, an enormous sum at the time.*

<div align="center">* * *</div>

* The most valuable item was the Turner seascape, now jointly owned by Alan and Colin, which had been valued earlier by Sotheby's at £850,000. This turned out to be a very low assessment. In June–July 1984 Sotheby's held a sale of paintings and works of art from Clark's collection. Apart from the Turner it was an eclectic gathering, strong in drawings, medieval works of art and illuminated pages, Renaissance medals and majolica, as well as works by Pasmore, Sutherland, Potter, Nolan, Piper, and above all Henry Moore. It was a snapshot of Clark's magpie acquisitions which reached an impressive total of £9,082,469. The greater part of that was accounted for by the Turner, which achieved a price of £7,370,000 and was acquired by the Canadian Thomson family.

One day in 1983 Alan Clark was rummaging around a desk in Saltwood when he came across 'some of my father's old engagement diaries of the Forties and Fifties. Endless "meetings" fill the day. Civil servants drift in and out. Lunches. Virtually indistinguishable from my own. What's the point? Nothing to show for it at all. He will be remembered only for his writings and his contribution to scholarship. His public life was a complete waste of time.'[8] Then as now, few of us appreciate how Kenneth Clark's committee work constitutes a hidden legacy by virtue of which the arts have become a natural part of the life and success of the nation, financially supported by government. This state of affairs we take for granted, but in the days when Clark sat on the early committees of CEMA, Covent Garden or the National Theatre, it would have seemed a very uncertain outcome. His influence on the formation of so many institutions that offer the public greater access to art, theatre, opera and design is unparalleled – the only comparison can be with Maynard Keynes. If he first learned the responsibility of giving public service at Winchester, Clark pragmatically and brilliantly exploited the opportunities offered by the war, by new technologies and by television to bring works of art closer to the public, and to open people's eyes to them. His outstanding wartime leadership at the National Gallery is at odds with his sense of failure at the MoI, but the experience he gained then, and in the nascent organisations in which he was involved, set the stage for all that followed; his subsequent work with Independent Television would have constituted a distinguished career in itself.

Part of Clark's effectiveness arose from his ability to connect Oxford and Cambridge, Bloomsbury, Hampstead and Whitehall – he was uniquely balanced between the worlds of scholarship, creativity and power. Until the 1960s he epitomised his time, perfectly expressing the *Zeitgeist* of what Noel Annan called 'Our Age', whose liberal values he shared. Yet he was never predictable, and in the writing of this book I have constantly been surprised by the line he took on any issue. But the values behind his thinking were consistent, and were invariably those of a Bowrista. Clark might not have asked himself 'What would Maurice do?', but that question unconsciously informed his thinking: Bowra remained a beacon and a guide. The chivalry of Monty Rendall, the free-thinking iconoclasm of Bowra, the enthusiasm of Fry, and the range of Berenson all have to be taken into account in an understanding of Clark's approach to life. In his autobiography he quoted E.M. Forster's 'Only connect,' but this he found harder in reality, not only with the seesaw between the active and the contemplative man, but also because

of his highly compartmentalised private life. He was more successful in finding a unity in art.

When Graham Sutherland told John Sparrow that he felt he did not really know Clark, Sparrow replied, 'None of us do.' The patterns of disengagement that are such a feature of his life always lead us back to the little boy at Sudbourne closing the door with relief when the other children left, to return to his own private world. Engagement came with his sense of duty; disengagement was a means of getting back to his thoughts and his work – and nobody worked harder or longer. As he told Janet Stone: 'Action is the healthiest drug, and I dread the various forms of melancholia which accompany inaction.'[9] This was ruefully commented on by many of his girlfriends, one of whom remembered: 'He was terrifying when he was in that mood, like a train rushing through a station.'[10] The fact that he often appeared ruthless to others was baffling to him. If what went on behind the mask can be seen anywhere, it is in the letters to Janet Stone, which are the most revealing window into his thought.

Possibly the hardest thing to fathom is his constant refrain of failure. Did he really think of his achievements as such? Perhaps disappointment would be closer to the mark – he knew his worth, but could be refreshingly frank about his limitations. These were first brought home to him by his failure to achieve a first class degree at Oxford, although it is doubtful that this preyed upon him for long. It is difficult to see what more he could have expected to achieve, apart from finishing his work on *Motives*. The claims of failure arose partly from his self-deprecating grand manner, but equally from a process of ageing and the tragic sense of life. What weighed on him most was the feeling of having let people down in his private life, and that he was in some way morally defective – his mother in him at war with his father. On one subject he knew he was irreproachable: his support for artists. He always preferred to see himself as an artist whose vocation was not to paint, but to support and write about his subject. His veneration for artists, and his patience with them, are among his defining characteristics, along with his lifelong patronage of Henry Moore and Graham Sutherland, and his work with the War Artists' Advisory Committee. With artists and through his public lecturing Clark did connect.

How did Kenneth Clark wish to be judged? He would have agreed with Flaubert: '*L'homme c'est rien, l'oeuvre c'est tout.*' Even though he had many admirers, he had no pupils, and left behind no school of art history. He did not have an overall philosophical viewpoint or a novel methodology to be a great art historian in the mould of Warburg or Gombrich. His approach

was an idiosyncratic compound of elements that are highly personal. Clark grew up in the long shadow of the Victorians, and put Pater and Ruskin at the centre of his intellectual pantheon. He naturally moved into the world of Edwardian and Berensonian connoisseurship, and absorbed something of Bloomsbury and Roger Fry; his discovery of Germanic art history was the final element in the brew. After the Windsor drawings catalogue, he never made any attempt to be an archival scholar art historian, and his love of writing led him away from devoting his life to connoisseurship in the Berenson mould. In the Foreword to *Civilisation* he confessed, 'I cannot distinguish between thought and feeling.' Clark was always deeply sensitive to works of art, and in this as in so much else, he followed Ruskin.* Again like Ruskin – and Pater – his work reminds us that art history can be beautifully written, and Clark increasingly defined himself as a writer. All his best qualities are admirably on display in *The Nude*. To the professional world of art history this is Clark at his brilliant best, the arresting generalisations leavened by knowledge and passionate engagement with works of art. Among his own books his favourites were *The Nude*, *Ruskin Today* and *Piero della Francesca*.[11]

How do we judge Clark against Ruskin and Fry? Each in his time was viewed as the most authoritative English figure writing about art. Ruskin, appalled by the iniquities of an industrial society, turned himself into one of the great humanitarian spirits of his age, crying out against wickedness – in which he included ugliness. With his passion, certainty and faith, Ruskin is as characteristic of the nineteenth century as Clark with his scepticism, irony and detachment is of the twentieth. And Roger Fry, although his writings are seldom read today, opened the eyes of a generation to French art, and in particular to Cézanne – he was a taste-changer in a way that cannot be said of Clark. What all three had in common was an unremitting desire to reach a broad public. Perhaps Ruskin has left through his writings a greater depth of influence on art and society, but Clark left an imperishable imprint on so many national institutions. And through television he could exert an influence that went far beyond Britain.

In the end, Kenneth Clark was an educator. *Civilisation* was, as Anita Brookner suggested, one of the most influential undertakings in popular

* The limits of this approach were pointed out by Simon Schama in his seminar on Clark at the National Gallery in 2009. He observed that Clark's account of Rembrandt's *Bathsheba* describes an idea of what he sees, or wants to see, but without any reference to the subject that Rembrandt was actually painting, i.e. Bathsheba reading David's letter.

education. It had the rare quality of being uncompromisingly serious, and yet popular. While everybody – even its critics – could see that it satisfied a need, nobody foresaw how many young people would have their lives changed by it. Today *Civilisation* is acknowledged as a milestone in television history, representing as it does the creation of a genre: the authored documentary series still stretches down to our times. There is also the lingering sense that a new generation should be given a chance to frame their world and culture in the way that Clark could for an earlier one. His example still haunts the moguls of the BBC.*

Perhaps Clark wrote his own epilogue in one of his lectures, 'Art and Society': 'Our hope lies in an expanding *élite*, an *élite* drawn from every class and with varying degrees of education, but united in a belief that non-material values can be discovered in visible things ... I believe that the majority of people really long to experience that moment of pure disinterested, non-material satisfaction which causes them to ejaculate the word "beautiful"; and since this experience can be obtained more reliably through art than any other means, I believe that those of us who try to make works of art more accessible are not wasting our time.'[12]

* At the time of going to press the BBC is in fact filming a new ten-part history of art entitled *Civilisations*. It is to be presented by Simon Schama, Mary Beard and David Olusoga, and has been widely described as inspired by Clark's series.

Appendix I:
The Clark Papers

A major concern of the scholarly world after Kenneth Clark's death was the fate of the Saltwood archive, which it rightly suspected was one of the most important non-political archives of the twentieth century. Alan initially opened negotiations with the Getty Museum in Los Angeles, at which point Alan Bowness, then director of the Tate Gallery (before it bifurcated), successfully stepped in and persuaded him to negotiate a sale in lieu of tax to the Tate, using the proceeds to pay off some of the estate duty liabilities. The archive was the largest the Tate had acquired at the time; the catalogue alone runs to 765 pages. It is held today at Tate Britain, and forms the basis of this biography, covering all aspects of Clark's life from his National Gallery days onwards, the vast majority of files being post-war.

The pick of the early letters Meryle Secrest had taken to America, and Alan now tried to retrieve them. With Clark's death Meryle was able to publish her biography. By then the family had washed their hands of the book, and Jock Murray had withdrawn as its joint publisher.[1] Alan wrote witheringly to Meryle: 'I must explain that I am not in the slightest bit concerned about your book: you write whatever you like and ... I have no objection to the emphasis which you place on the personal side of my father's life. Indeed if it had been better written, in a somewhat more Lytton Strachey style, it could have been very enjoyable.'[2] Meryle's biography came out in September 1984, and received a mixed reaction from the London literary world. All the top reviewers were wheeled out, but there was a feeling that the book did not do justice to Clark's intellectual life and public achievements. Alan, who Meryle mistakenly suspected was behind the sharper reviews, described the book as 'worthless' and written in 'housemaid's English', which inevitably hurt her. From the account in her 2007 autobiography it is clear that she had formed a feeling of mutual dislike for the Clark family.

In the same letter in which he expressed his lack of concern about the biography, Alan also asked Meryle for the return of the letters she had taken with her to America. She claimed that Kenneth Clark had allowed her to keep them, which surprised Clark's archivist Margaret Slythe and his secretary Catherine Porteous. When the letters were not returned, Alan consulted lawyers. The problems were considerable: the involvement of US lawyers would be expensive; more serious was the fact that no one knew what letters Meryle had in her possession, since no list existed. Alan had no idea what exactly he was asking for, nor the basis on which the letters had been taken to America.

The matter went into limbo until Alan died in 1999, after which Meryle did two things. In October 2000 she returned a tranche of family letters and photographs to Alan's widow Jane – she later told the author that Alan's hostility had prevented her from returning them sooner. In the meantime she sold all the non-family letters, to which she added the letters Lord Clark had written to her while she worked on his biography. These were sold by private treaty, via Bloomsbury Book Auctions, to Harvard University for deposit at I Tatti, where they may be consulted today.[3] Their importance to I Tatti was due to the fact that they included all the pre-war letters from Bernard Berenson to Clark. The Tate Gallery, to which they were also offered, turned them down because of concerns about provenance.

Appendix II:

'Suddenly People are Curious About Clark Again'[1]

Kenneth Clark's academic reputation suffered an eclipse after his death. His conservative attitude became more out of tune with contemporary social appreciation of the meaning and purpose of art. In fact this process had begun during his lifetime, and was exemplified in most people's minds by the *Ways of Seeing* television series and book by John Berger (1972). Peter Fuller called it 'Berger's anti-Clark lecture', and it is easy to see why, for Berger quotes passages from *Landscape Into Art* and *The Nude*. In fact *Ways of Seeing* was aimed as much at the deceits inherent in filming art for television as at Clark, for whom Berger felt admiration and exasperation in equal measure.

It is surprisingly difficult to find examples of frontal attacks on Clark during the decade after his death, but the growing breed of academic art historians tended to regard him as a grandee from another age.* To the professionals he was a gentleman aesthete of the old school, albeit one who wrote like an angel. For a time it seemed as though Mary Glasgow's prediction, 'I have a feeling that posterity will not say the right things about him,'[2] might be true. But the book, and later DVD, sales of *Civilisation* show that Clark's following among the general public remained enthusiastic.[3] Those who were inclined to denigrate him during his lifetime continued to do so, but those who admired him were unaffected. The fact that interest in Clark persisted owed much to *Civilisation* and the quality of his prose, but also to his enigmatic personality and intriguing private life.

* The Courtauld Institute named its new lecture theatre at Somerset House after Clark, a fund-raising initiative suggested by Catherine Porteous. A group of Clark's friends including Lord Drogheda, Michael Levey, Jock Murray, John Piper and Irene Worth signed a round-robin letter (23 October 1985, copy in author's archive), and the Henry Moore Foundation got the ball rolling with a £50,000 donation. The *Civilisation* crew all donated, except Michael Gill, who felt he had done enough already to promote Clark's legacy.

There was, however, an undefined sense that there was more to him than that, and that the narrative was far from complete. Recently, a series of radio and television programmes, and a major exhibition at the Tate Gallery, have begun to re-examine his legacy. Inevitably they focused on *Civilisation*. Although the clothes and the patrician manner make the series look increasingly like a period piece, the episodes – with all the original objections – remain stubbornly interesting to a now older generation who want to renew their acquaintance with it. For younger audiences Clark's manner and clothes, and the cascade of information, hold less charm: attempts to show episodes to classes of modern students have rarely been wholly successful.[4]

The Clark story began to attract revised media attention with John Wyver's 1993 documentary *K: Kenneth Clark 1903–1983*. Wyver was fortunate to secure interviews with all three children – particularly Colin, who was notably frank on camera. Lew Grade, Ernst Gombrich, Michael Gill and Myfanwy Piper all gave interesting interviews – it was just about the last moment that such a group could be convened. Four years later came a programme on Radio 4, *K: The Civilised World of Kenneth Clark*, to which James Lees-Milne contributed: 'I listened to Radio 4 documentary on K Clark … the closing words came from me – "He may not have had a great soul, but he had a great mind."'[5] In 2003, on the same channel, came Miranda Carter's *Lord Clark: Servant of Civilisation*, in which Neil MacGregor reflected on Clark's legacy: 'I think Clark articulated better than anybody else the notion that access to high culture is the right of every citizen, and that you changed society by ensuring that your citizens have access to the best, and he showed that it could be done and he's made it easy for people to go on defending that ideal.'[6] Art programmes were by now very well established on television, with all tastes catered for by the likes of Robert Hughes and Brian Sewell, but as MacGregor opined: 'Nobody can talk about pictures on the radio or on the television without knowing that Clark did it first and Clark did it better.'[7]

The year 2009 was something of a watershed in Clark studies. First there was Radio 4's *Seeing Through the Tweed*, which began by suggesting that Clark was in danger of becoming regarded as a caricature out-of-touch 'toff': 'He seemed to be the tweedy relic of a cultural elite which was being punched around by a younger generation.'[8] Stefan Collini identified his detractors: 'Three groups criticised Clark: academics, social theorists on the left, and … democratic and other community-based arts enterprises.' It took David Attenborough to make the point that 'People don't

necessarily dislike toffs. Toffs who speak directly are quite appealing.' The programme gave airtime to the view of Clark as a relic of a deferential society, but came to the conclusion that although he was never a populist, he was a populariser.

In the same year came a seminar on Clark at the National Gallery, 'Back to Civilisation', organised by a young scholar, Jonathan Conlin (who published that year a pioneering book on *Civilisation* in the 'TV Classics' series). The seminar was led by the gallery director Nicholas Penny, but the star turn was David Attenborough, representing the *Civvy* crew, who with his customary charm opened his talk with: 'Now look here, we don't want to appear like a lot of old soldiers polishing our medals!' No one was more surprised by the enormous success of the day than Michael Gill's TV critic son Adrian, who thought it was 'astonishing that the large lecture hall was packed. All day.'[9]

A major milestone of the Clark 'revival' was the 2014 exhibition at Tate Britain organised by Chris Stephens and John-Paul Stonard, 'Looking for Civilisation'. This was the most thorough exploration of Clark's public life to date, and attempted to chart his role in the transition from the arts being patronised by a minority to becoming a matter of general interest. It was accompanied by an hour-long BBC *Culture Show* special produced by Kate Misrahi and broadcast on a Saturday evening on BBC2. Finally, the Clark–Berenson letters were published in 2014, superbly annotated by Robert Cumming. Interest in Kenneth Clark shows little sign of abating among an older generation, although a younger generation of admirers has yet to discover him.

Acknowledgements

Her Majesty the Queen graciously gave me permission to quote from letters in the Royal Archive at Windsor Castle.

The following very kindly agreed to be interviewed: Sir David Attenborough OM, Madeleine, Countess of Bessborough, Sir Alan Bowness, Professor Christopher Brown (on Rembrandt and Martin Davies), Humphrey Burton, Miranda Carter, Rose Carver, Faith Clark, the Earl of Crawford, Lord Crickhowell, Joan Dawson (the cook at Albany), the late Sir Denis Forman, Angelique Gaussen, Yvonne Gilan (Mrs Michael Gill), Philida Gili, Adrian Gill, Rosalind Gilmore, Lord Grade, Sheila Hale, Maggie Hanbury, Carolyn Holder, John and Caryl Hubbard, Neil MacGregor, John Mallet, Mary Moore, Sir Nicholas Penny, Clarissa Piper, Michael Redington, James Reeve, Sir Hugh Roberts, Gill Ross, Francis Russell, Philip Rylands, Lord Sainsbury, Meryle Secrest, the late Brian Sewell, Margaret Slythe, Emma Stone, Humphrey and Solveig Stone, Sir Roy Strong, Catriona Williams, Ivor Windsor and John Wyver.

The surviving crew of *Civilisation* gave me fascinating material: David Heycock, Ken Macmillan, Peter Montagnon, Ann Turner and Maggie Crane. Robert McNab worked with Clark on *The Romantic Rebellion*, and helped me greatly on his television career.

The following gave me assistance in various ways: Dr Ayla Lepine, who helped me with *The Gothic Revival*, Artemis Cooper, John Julius Norwich, David and Lucy Abel-Smith, Stephen Conrad, Bill Zachs, Robin Taylor, Christopher Booker, Dudley Dodd, John Somerville, Tim Llewellyn, Richard Heathcote, Luke Syson (on Leonardo), Victoria Glendinning, Hannah Kaye, Louis Jebb, Professor Brian Foss (on War Artists), Ben Moorhead (about his grandmother Elizabeth Kirwan-Taylor), Professor Alan Powers, Professor David Watkin, Martin Royalton-Kisch, William Shawcross, Jennifer Fletcher, Lady Roberts, Daniel Rosenthal (on the National Theatre), Henry Irvine (who unlocked the mysteries of the

Ministry of Information archive at Kew, and for his great knowledge of the subject), Audrey Scales (who gave me wonderful reminiscences of working for Clark), Simon Pierse (for his knowledge of Clark in Australia), Louisa Riley-Smith and Michael Delon (the principal collector of Kenneth Clark material).

Special thanks to Robert and Carolyn Cumming, who edited the Clark–Berenson letters and were very generous with their knowledge and material. Catherine Porteous, Lord Clark's former secretary, knows more than anybody else, pointed me to a great many of his old friends and colleagues, and made numerous excellent suggestions. Margaret Slythe, the former archivist at Saltwood, supplied me with a fascinating memoir of life there.

The organisers of the 2014 Tate exhibition and I had an exceptionally happy collaboration: Chris Stevens, John-Paul Stonard and Peter Rumley. The same is true of Kate Misrahi and Tracey Li, the makers of the *Culture Show* special on Clark aired on 31 May 2014.

The following archivists and librarians were particularly helpful to me: Claire Cabrie of Paisley Library; Suzanne Foster of Winchester College Archive; Ian Rawes and Rachel Garman from the Sound Archive of the British Library; Gavin Clarke of the National Theatre Archive; and Clare Smith of the National Museum of Wales. In Oxford I was greatly assisted by Richard Ovenden and his team at the Bodleian Library, Chris Fletcher and Colin Harris. The other Oxford librarians who were extremely helpful were Gaye Morgan at All Souls, Clare Hopkins at Clark's old college Trinity, Cliff Davies at Wadham, and Caroline Palmer and Jon Whiteley at the Ashmolean Museum. The staff of the London Library were ever helpful and knowledgeable, in particular Guy Penman. Further thanks to Pam Clark and Allison Derrett of the Royal Archives, Windsor; Dr Patricia McGuire of King's College, Cambridge; Jude Brimmer of the Benjamin Britten Estate, Aldeburgh; Valerie Potter, who lent me Mary Potter's correspondence; Jane Allen of the Orford Museum, who was able to add flesh to the Sudbourne story; Alan Crookham of the National Gallery, who never stopped producing interesting material and checked the chapters relating to the gallery; Sue Breakell of the Design Council Archive at Brighton; Richard Calvocoressi, the director of the Henry Moore Foundation, who made my visit there a delight; Ian Marsland at the ITA Archive at Bournemouth University; Paul Cartledge of Yellow Boat Music; Kenneth Dunn at the National Library in Scotland, who produced all the Crawford papers; John Murray for the John Murray London archives; and the staff of Bernard Berenson's old home near Florence, I Tatti, who were

exceptionally hospitable. My greatest thanks, however, are to the staff of the Tate Britain Clark Archive, who were the soul of patience and kindness when I spent a year there.

A number of friends read either the whole or part of the manuscript and gave me extremely sound advice: Jane Ridley, Peter Rumley, John-Paul Stonard, Adam Sisman and Richard Davenport-Hines (who taught me the rudiments of biography), Professor Edward Chaney, Giles Waterfield, Professor David Ekserdjian, Jane Martineau, Caroline Elam (whose remarks were especially valuable), Charles Saumarez Smith, Professor Sir David Cannadine (staunch friend and encourager), Dr Jonathan Conlin and Nicolas Barker.

I was appointed to this task by Lord Clark's daughter-in-law, Jane Clark. She has given me continuous support and access to everything at Saltwood, and has been generous and helpful in every way. Lord Clark's daughter Colette has been the main witness, and her friendship and advice have been of immense importance from the beginning. The book could not have been written without the support of these two remarkable ladies. My predecessor as authorised biographer, Fram Dinshaw, handed the baton to me with grace and generosity. His support, knowledge and advice have been invaluable. He also provided the transcripts of the letters to Janet Stone which I have used so often.

Finally, thanks to the home team: three researchers who assisted me, Sophie Bostock and Lucy Garrett in the UK, and Helen Lally in the US; my agent Georgina Capel; my editor at HarperCollins, Arabella Pike; my meticulous copy editor Robert Lacey; my assistant Kate Atkins, who patiently brought the material together; and to Charity, who has lived with it and given me unstinting support and excellent advice from the very beginning.

Notes

Fuller details of the archives and collections referred to in these notes can be found in the Bibliography, page 459.

Foreword

1. Clark, *Another Part of the Wood*, p.273
2. Letter to Denys Sutton, 7 July 1969, Tate 8812/1/4/111. Clark was referring to Sutton's edition of Roger Fry's letters

Chapter 1: 'K'

1. *Daily Telegraph*, 10 October 1974
2. Clark, *Another Part of the Wood*, p.237
3. Clark, 'Aesthete's Progress', John Murray Archive
4. Letter to John Hubbard, 30 May 1972, Tate 8812/1/4/36
5. Clark, *Another Part of the Wood*, p.45
6. Yvonne Gilan to author
7. Colin Clark, *Younger Brother, Younger Son*, p.6
8. *Sunday Times*, 27 September 1959, p.5
9. Michael Levey, obituary of Kenneth Clark, *Proceedings of the British Academy*, Vol. LXX, 1984
10. *Sunday Times*, 16 September 1984, p.42
11. *Burlington Magazine*, July 1973, Vol. CXV, No. 844, p.415

Chapter 2: Edwardian Childhood

1. Either the year is wrong or Knowles saw an advance copy. I Tatti
2. Colin Clark, *Younger Brother, Younger Son*, p.3
3. See BBC interview with Joan Bakewell, 28 February 1969, in which he paints a happy picture

4. Letter to Lord Crawford, 10 August 1944[?], Crawford Papers, National Library of Scotland
5. Letter to Meryle Secrest, 7 November 1978, I Tatti
6. As expressed in episode 13 of *Civilisation*
7. See obituary in the *Paisley and Renfrewshire Gazette*, 22 October 1932, under the heading 'Death of well-known Paisley gentleman: Notable Yachtsman'
8. Letter to Meryle Secrest, 22 October 1980, I Tatti
9. Clark, *Another Part of the Wood*, p.2
10. Letter to Janet Stone, 12 August 1976, Bodleian Library
11. Cyril Connolly obituary, Tate 8812/2/2/697
12. Clark, *Another Part of the Wood*, p.4
13. Information supplied by the Orford Museum
14. Clark, *Another Part of the Wood*, p.27
15. Ibid., p.4
16. Ibid., p.11
17. Kelley (ed.), *From Osborne House to Wheatfen Broad: Memoirs of Phyllis Ellis*, p.37
18. Ibid.
19. Clark, *Another Part of the Wood*, p.14
20. Ibid.
21. Letter and memoir of Lam by Isobel Somerville to Clark, no date but around September 1975, after publication of *Another Part of the Wood*, Tate 8812/1/4/36–37

22. They published the first Golliwogg books in New York in 1895, which started the genre
23. Clark, *Another Part of the Wood*, p.7
24. Clark, 'The Other Side of the Alde' (unpaginated)
25. Clark, *Another Part of the Wood*, p.12
26. Ibid., p.13
27. Clark, 'The Other Side of the Alde'
28. Thomas Baggs 'Happiness' Memorial Lecture in Birmingham, 26 October 1987, Tate 8812/2/2/373
29. Clark, 'The Other Side of the Alde'
30. Clark, *Another Part of the Wood*, p.27
31. Ibid., p.43
32. Clark's Introduction to Ruskin's *Praeterita*
33. Clark, *Another Part of the Wood*, p.30
34. Ibid., p.33
35. Ibid.
36. Acton, *Memoirs of an Aesthete*, p.34
37. Clark, *Another Part of the Wood*, p.36
38. Interview, John Murray Archive

Chapter 3: Winchester

1. Clark, *Another Part of the Wood*, p.37
2. Mark Amory, *Sunday Times Magazine*, 6 October 1974
3. Clark, *Another Part of the Wood*, p.37
4. Later Sir William Keswick (1903–90)
5. Secrest, *Kenneth Clark*, p.39 and Mark Amory, *Sunday Times Magazine*, 6 October 1974. Both describe the scene with slight variations
6. Towards the end of his life Clark revealed the names of his tormentors – and two others who beat him – in a letter to Ralph Ricketts, 28 November 1974, Tate 8812/1/4/36. He would occasionally run into them later: 'The failed artist who beat me for being a critic was called Grey and became an architect and came up before [me at] the Royal Fine Arts Commission.'
7. Clark, *Another Part of the Wood*, p.38
8. Letter from J.A. Aris to Clark, 23 June 1971, Tate 8812/1/4/36
9. 'Monty', an unpublished manuscript by Charles G. Stevens, Winchester G255/5
10. Clark, *Another Part of the Wood*, p.76
11. Ibid., p.39
12. Ibid., p.56

13. 'Apologia of an Art Historian', the Inaugural Address on the occasion of his election as President of the Associated Societies of the University of Edinburgh, 15 November 1950
14. Letter to Myfanwy Piper dated 'Saturday', c.late 1940s, Tate Piper Archive 200410/1/1/793
15. Clark, *Another Part of the Wood*, p.75
16. Letter to Janet Stone, 9 September 1955, Bodleian Library. Interestingly, Cyril Connolly was also to make something of a cult of this story at Oxford
17. Kelley (ed.), *From Osborne House to Wheatfen Broad: Memoirs of Phyllis Ellis*, p.37
18. Clark, *Another Part of the Wood*, p.65
19. Ibid.
20. Ibid., p.72
21. Letter to Colin Anderson, 14 January 1980, Tate 8812/1/3/51–100
22. Clark was to give the address at Brown's memorial service, reproduced at the front of Brown's posthumous memoirs, *Exhibition*
23. 'Monty', an unpublished manuscript by Charles G. Stevens, Winchester G255/4
24. Clark, *Another Part of the Wood*, p.62
25. Now in the Delon Archive with Rendall's card
26. Clark, *Another Part of the Wood*, p.64
27. Ibid., p.58
28. Speech to the National Trust, 8 March 1965, Festival Hall. He mischievously added, 'Who would fight to save Dolphin Square?'
29. Letter to Janet Stone, 24 August 1954, Bodleian Library
30. Secrest, *Kenneth Clark*, p.39
31. Sparrow was to publish Donne's *Devotions* at the Cambridge University Press when he had just turned seventeen
32. *The Wykehamist*, 3 March 1922, p.159
33. Secrest, *Kenneth Clark*, p.44
34. Tate 8812/2/2/270
35. Brivati, *Hugh Gaitskell*, p.8

Chapter 4: Oxford

1. Delon Archive
2. The late Lord Quinton
3. Clark, *Another Part of the Wood*, p.94

4. Ibid., p.95

5. Robert Longden (1904–40), headmaster of Wellington School, killed by a stray bomb that fell on the school

6. Clark, *Another Part of the Wood*, p.97. It was a matter of extreme regret to Clark that the letters were burnt in a fire caused by an electrical fault at Upper Terrace House in Hampstead

7. The title stemmed from Bowra's standard answer whenever asked anybody's age

8. Isaiah Berlin, *Letters: Vol. III*, p.458

9. Clark, *Another Part of the Wood*, p.100

10. Connolly, *The Evening Colonnade*, p.40

11. Bowra, *Memories*, pp.160–1

12. British Library National Sound Archive, Disc 199, 'Maurice Bowra', BBC, 1 August 1972

13. Letter to Wesley Hartley, 19 February 1959, Delon Archive

14. Letter from Cyril Connolly to Noel Blakiston, 3 August 1926. Connolly, *A Romantic Friendship: The Letters of Cyril Connolly to Noel Blakiston*, p.156

15. Clark, *Another Part of the Wood*, p.112

16. Jacob Burckhardt (1818–97), author of *Der Cicerone* and *The Civilization of the Renaissance in Italy*

17. Lecture, 'The Study of Art History', probably given to the Courtauld Institute c.1950. Copy in possession of the author

18. 'Walter Pater', in Clark's collection of lectures *Moments of Vision*, p.130

19. Letter to Benedict Nicolson, 13 December 1934, private collection, copy at the *Burlington Magazine*

20. C.F. Bell (1871–1966), Keeper of Fine Art Department, Ashmolean Museum, 1909–31

21. Clark, *Another Part of the Wood*, p.106

22. John Sutro (1903–85), the founder of the celebrated Oxford Railway Club, which gave banquets on trains. He became a film producer

23. Review of *Pissarro* by A. Tavarant and *The Way to Sketch* by Vernon Blake, both in the *Cherwell*, 6 June 1925, and review of *Relation in Art* by Vernon Blake in *Oxford Outlook*, Vol. VIII, No. 36, January 1926

24. Letter to C.K. Simond, 25 June 1969, Tate 8812/1/4/89. Discussing David's painting *The Oath of the Tennis Court*, Clark made the surprising statement, 'I used to be a devotee of tennis; in fact I played for Oxford'

25. Bowra, *Memories*, p.160

26. Later Sir Colin Anderson (1904–80), chairman of P&O and a major patron of art

27. Later 5th Baron Sackville (1901–65); he would live with the Clarks at Upton during the war

28. Mark Amory, *Sunday Times Magazine*, 6 October 1974

29. Review by Anthony Powell of Meryle Secrest, *Kenneth Clark*, *Daily Telegraph*, 14 September 1984

30. Letter from David Knowles to Clark, 22 July 1973, I Tatti

31. Letter to his father, 4 February 1925, Saltwood

32. Letter to his mother, 12 June 1924, Saltwood

33. Ibid., 22 July 1924

34. Ibid., 23 July 1924

35. Michael Sadler (1861–1943) was the Master of University College who acquired paintings by Cézanne, Gauguin and Kandinsky

36. Introduction to 1962 edition of *The Gothic Revival*, p.9

37. Mark Pattison (1813–84), Oxford don, priest and literary figure

38. Letter from Bowra to Clark, 8 August 1925, I Tatti

Chapter 5: Florence, and Love

1. Manuscript, John Murray Archive

2. Ibid.

3. Denis Mahon (1910–2011), art historian largely responsible for the re-evaluation of seventeenth-century Italian painting, who was always profoundly grateful for Clark's early support

4. Clark, *Another Part of the Wood*, p.127

5. Mariano, *Forty Years with Berenson*, p.132

6. Letter to his father, 16 September 1925, Saltwood

7. Clark, *Another Part of the Wood*, p.128

8. Letter to his father, 16 September 1925, Saltwood

9. Clark, *Another Part of the Wood*, p.131

10. Review by Anthony Powell of Secrest, *Kenneth Clark*, *Daily Telegraph*, 14 September 1984

11. Clark, *Another Part of the Wood*, p.132

12. Letter to his mother from Poggio Gherardo, 29 September 1925, Saltwood

13. Clark, *Another Part of the Wood*, p.132

14. Letter to Berenson, 10 October 1925, Cumming (ed.), *My Dear BB*, p.6

15. Talk given on 12 February 1926, Trinity College Archives

16. Taped conversation by Bevis Hillier, in possession of author

17. Letter to Mary Berenson, 20 January 1926, Cumming (ed.), *My Dear BB*, p.9

18. Tribble, *A Chime of Words: The Letters of Logan Pearsall Smith*, pp.113–14

19. Mariano, *Forty Years with Berenson*, p.133

20. Mrs Mark Pattison on Walter Pater's prose

21. Tribble, *A Chime of Words: The Letters of Logan Pearsall Smith*, p.23

22. Letter to Mary Berenson, 31 March 1926, Cumming (ed.), *My Dear BB*, p.12

23. Clark, *Another Part of the Wood*, p.188

24. E.M. Forster, *Two Cheers for Democracy*, p.113

25. Caroline Elam points out that Fry was far more interested in subject-matter than is generally realised: see his writings about Piero di Cosimo's *Forest Fire* when it was first exhibited at the Burlington Fine Arts Club in 1921. Fry worries away at the subject-matter, and it's clear that he has read Lucretius's *De Rerum Natura* in order to do so. See *Burlington Magazine*, Vol. XXXVIII, 1921, pp.131–8

26. Letter to his mother, 10 June 1926, Saltwood

27. Letter to Janet Stone, 8 June 1977, Bodleian Library

28. She later married Clark's Winchester contemporary Lord Eccles

29. Letter to his mother, 3 August 1926, from St Ermin's Hotel, Westminster

30. Letter to John Sparrow, 25 August 1926, All Souls College

31. Letter to his mother, 3 September 1926, Saltwood

32. Clark, *Another Part of the Wood*, p.115

33. Letter to his mother, 21 September 1926, from Dresden. Clark was never to feel entirely comfortable with Germany, despite admiring its music, literature and architecture

34. Kenneth, Alan, Colin and Russell

35. Information from Colette Clark

Chapter 6: BB

1. Clark, 'Aesthete's Progress', John Murray Archive, p.15

2. Letter to Leon Pomerance, 6 May 1971, Tate 8812/1/4/198

3. See their *New History of Painting in Italy from the Second to the Sixteenth Century* (1864–66)

4. BBC documentary on Berenson, 1970, script at Tate 8812/1/4/55

5. Joseph Duveen (1869–1937) was born into a family of Dutch origin. He became the leading international dealer in Old Master paintings of his day, and was eventually knighted and given a peerage for his generous gifts to British galleries and museums

6. BBC documentary on Berenson, 1970, script at Tate 8812/1/4/55

7. Umberto Morra (1897–1981), Virginia Woolf's Italian translator

8. *Burlington Magazine* leader on Berenson, Vol. CII, No. 690, September 1960, p.383

9. Ibid.

10. Samuels, *Bernard Berenson: The Making of a Legend*, p.348

11. Strachey and Samuels (eds), *Mary Berenson: Letters and Diaries*, p.258

12. Colette was staying at the Old Rectory at Litton Cheney in Dorset, the home of Reynolds and Janet Stone

13. Letter to Janet Stone, 21 April 1962, Bodleian Library

14. Clark, *Another Part of the Wood*, p.161

15. Ibid., p.164

16. Letter to John Sparrow, 19 December 1926, All Souls College

17. 'The Sage of Art', *Sunday Times Magazine*, 11 October 1959

18. Letter to Mary Berenson, 11 January[?] 1927, from St Ermin's Hotel, Cumming (ed.), *My Dear BB*, p.25

19. Strachey and Samuels (eds), *Mary Berenson: Letters and Diaries*, p.263

20. Clark, *Another Part of the Wood*, p.168

21. Ibid.
22. Letter to Mary Berenson, 8 February 1927, Cumming (ed.), *My Dear BB*, p.26
23. Strachey and Samuels (eds), *Mary Berenson: Letters and Diaries*, p.275
24. David Pryce-Jones, *Cyril Connolly*, p.95
25. Cyril Connolly to Noel Blakiston, 21 March 1927, Connolly, *A Romantic Friendship: The Letters of Cyril Connolly to Noel Blakiston*, p.289
26. Letter to Cyril Connolly, undated, University of Tulsa
27. Letter to Charles Bell, undated, from St Ermin's Hotel, Ashmolean Museum
28. Strachey and Samuels (eds), *Mary Berenson: Letters and Diaries*, p.275
29. Letter to Berenson, 21 June 1935, Cumming (ed.), *My Dear BB*, p.415
30. Clark, *Another Part of the Wood*, p.152
31. Letter from Berenson, 21 October 1937, Cumming (ed.), *My Dear BB*, p.190
32. Letter to Berenson, 1 January 1938, ibid., p.192
33. William Mostyn-Owen, 'Bernard Berenson and Kenneth Clark: A Personal View', in Joseph Connors and Louis A. Waldman (eds), *Bernard Berenson*, pp.231–47, I Tatti, The Harvard University Center, 2014
34. Ibid.
35. Ibid.

Chapter 7: *The Gothic Revival*

1. Clark, *The Gothic Revival*, p.224
2. He is referring to the Jacquemart-André Museum Baldovinetti painting in Paris, Cumming (ed.), *My Dear BB*, p.30
3. Letter to Mary Berenson, 15 June 1928, ibid., p.35
4. T.S. Boase (1898–1974), historian of the Crusades turned art historian; director of the Courtauld Institute 1937; President of Magdalen College, Oxford, 1947; Vice-Chancellor of Oxford University 1958–1960. Clark later found that he disagreed with him on almost everything
5. Letter to Mary Berenson, 15 June 1928, Cumming (ed.), *My Dear BB*, p.35
6. Ibid., p.36
7. His 1928 contract with Constable's gave Clark a royalty of 15 per cent on home sales, and 10 per cent in the British colonies and dominions, Tate 8812/1/4/122–127
8. The whole story is set out by C.F. Bell in a feline handwritten 'Introduction' that he bound into his own copy of *The Gothic Revival* housed at RIBA. The early chapters probably relied more on Bell's notes than Clark acknowledged. I am grateful to Dr Ayla Lepine for pointing out this document
9. Ibid.
10. Clark, *The Gothic Revival*, Introduction, p.9
11. Ibid., p.2
12. Ibid., p.9
13. The High Anglican movement that exercised influence on 'correct' Gothic during the 1840s–50s
14. Letter to the Director, Prints and Drawings, V&A, 24 February 1927, Glasgow University, Laver Archive C23
15. Clark, *The Gothic Revival*, Introduction, p.4
16. Geoffrey Scott, *The Architecture of Humanism*
17. Review in *Architectural Review*, Vol. LXV, June 1929, pp.302–5
18. Review in *Quarterly of the Incorporation of Architects in Scotland*, 1929, p.22. Sir John Summerson, CH (1904–92) was to become the leading British architectural historian
19. In *No 35*, a magazine, 'At The Architectural Association', Autumn 1929, pp.5–12. Stephen Dykes Bower (1903–94) was a church architect and Gothic Revivalist
20. *Times Literary Supplement*, 8 November 1928, p.823
21. The son of the collector Michael Sadler, who added an 'i' to his surname
22. Clark, *The Gothic Revival*, Introduction, p.1
23. Clark, *Another Part of the Wood*, p.174
24. Letter to his mother, 16 February 1929, Saltwood
25. Letter to Berenson, 7 November 1928, Cumming (ed.), *My Dear BB*, pp.40–1
26. Clark, notebook, Tate 8812/2/1/20
27. See Clark, *Another Part of the Wood*, p.108; also 'The Study of Art History', lecture probably given to the Courtauld

Institute c.1950. Copy in possession of the author

28. Clark, *Another Part of the Wood*, p.108
29. '*Motives* will be pure Warburg and will be my best book.' BBC, 'Interview with Basil Taylor', 8 October 1974, British Library National Sound Archive, Disc 196
30. Letter from Berenson to Clark, dated 'May 1929', I Tatti

Chapter 8: The Italian Exhibition

1. Undated letter, I Tatti
2. Francis Haskell, 'Botticelli in the Service of Fascism', in *The Ephemeral Museum*
3. Clark, 'Aesthete's Progress', John Murray Archive
4. Sir Robert Witt (1872–1952), a British drawings collector who was to be one of the three founders of the Courtauld Institute of Art, where the photographic reference library is named after him
5. Clark, *Another Part of the Wood*, p.181
6. Francis Haskell, 'Botticelli in the Service of Fascism', in *The Ephemeral Museum*, p.112
7. Ibid., pp.121–2
8. Lord Lee of Fareham (1865–1947), politician, art-world operator and collector, who would later play a major role in Clark's life
9. Clark, *Another Part of the Wood*, pp.177–8
10. This is partially contradicted in a letter to Berenson (undated, March 1930, I Tatti), in which Clark claims not to have catalogued the pictures from English and American collections
11. Letter to Umberto Morra, undated, I Tatti
12. Clark, *Another Part of the Wood*, p.182. There were in fact two catalogues, one which went with the exhibition, and a larger 'commemorative' catalogue published in 1931
13. Clark, 'Aesthete's Progress', John Murray Archive
14. Henry 'Bogey' Harris (1870–1950) was a collector friend of Clark's at whose sale he bought several drawings (see letter to Berenson, 8 December 1950). Harris's collecting mentor was Herbert Horne (1864–1916), whose collection may still

be visited at the Museo della Fondazione Horne in Florence

15. St John Hornby (1867–1946), joint founder of the stationers W.H. Smith, and owner of the Ashendene Press
16. Clark, *Another Part of the Wood*, p.184
17. Ibid., p.189. Abraham Warburg (1866–1929), always known as 'Aby', whose approach and library were to change the face of art history. Clark was later to have a hand in the library coming to London – see also ibid., pp.207–8
18. Ibid., p.189
19. Radio broadcast, BBC Third Programme, 13 June 1948, reprinted JWC Institutes 1947–48
20. Letter to Mme Auerbacher-Weil, 7 October 1970, Tate 8812/1/4/356
21. Lecture, 'The Study of Art History', probably given to the Courtauld Institute c.1950. Copy in possession of the author
22. See Clark, 'Ruskin at Oxford: An Inaugural Lecture', p.14
23. Lecture, 'The Study of Art History', probably given to the Courtauld Institute c.1950. Copy in possession of the author
24. BBC, *Let's Find Out*, in which the questions were put by teenagers, 15 February 1966, British Library National Sound Archive
25. Letter to his mother, 1 March 1929, Saltwood
26. Letter to Berenson, 4 June 1931, Cumming (ed.), *My Dear BB*, p.93
27. Clark, 'Aesthete's Progress', John Murray Archive
28. Letter from Morshead to G.S. Gordon, President of Magdalen, 20 April 1933, I Tatti
29. Letter from Morshead to Clark, 31 October 1928, I Tatti
30. Clark, 'Aesthete's Progress', John Murray Archive
31. 'A Note on Leonardo da Vinci', *Life and Letters*, Vol. II, February 1929, pp.122–32
32. Martin Kemp, Introduction to Folio Society edition of Clark's *Leonardo da Vinci*, p.19
33. Letter to his father, 1 November 1929, Saltwood
34. It is now in the Gallery of Western Art in Tokyo

35. Letter to his mother, 18 October 1930, Saltwood
36. Although a socialist, MacDonald was Prime Minister of the National Government at the time
37. Letter to his mother, undated (postmark 1931), Saltwood
38. Pope-Hennessy, *Learning to Look*, p.27
39. Clark, 'Aesthete's Progress', John Murray Archive
40. Ibid.

Chapter 9: The Ashmolean

1. Letter from Berenson, 10 June 1931, Cumming (ed.), *My Dear BB*, p.103
2. Letter to Berenson, undated, c.1928, Cumming (ed.), *My Dear BB*, p.38
3. Ibid., 4 June 1931, pp.94–5
4. Letter from Berenson, 10 June 1931, ibid., p.103
5. Letter to Berenson, 22 June 1931, ibid., p.104
6. Letter from C.F. Bell to Clark, 22 June 1931, I Tatti
7. Letter from C.F. Bell to University Registrar, 24 June 1931, Ashmolean
8. Interview, *New Yorker*, 10 March 1951, p.27
9. Clark, *Another Part of the Wood*, p.198
10. Ibid.
11. Tate 8812/1/4/317
12. Sir Sydney Cockerell (1867–1962) was director of the Fitzwilliam 1908–37, and transformed the museum
13. Letter from E.T. Leeds to Clark, 25 July 1931, I Tatti
14. Clark, *Another Part of the Wood*, p.198. Ian Robertson (d.1982)
15. Letter to Berenson, 22 June 1931, Cumming (ed.), *My Dear BB*, p.104
16. Tate 8812/4/2/1–3
17. Letter to Berenson, 8 November 1931, Cumming (ed.), *My Dear BB*, p.111
18. Secrest, *Kenneth Clark*, p.86
19. Letter to Berenson, 8 November 1931, Cumming (ed.), *My Dear BB*, p.111
20. Colin Harrison, 'Kenneth Clark at the Ashmolean', *The Ashmolean*, Spring 2006, p.21
21. Letter from C.F. Bell to Berenson, 1 May 1932, I Tatti
22. Pope-Hennessy, *Learning to Look*, p.63

23. See Caroline Elam's essay 'La fortuna critica e collezionistica di Piero di Cosimo in Gran Bretagna', in Serena Padovani (ed.), *Piero di Cosimo*, exhibition catalogue (Uffizi, Florence), note 40, p.183
24. Clark, *Landscape Into Art*, p.40
25. Report of Keeper, 1934
26. Now attributed to Francesco Botticini
27. Colin Harrison, 'Kenneth Clark at the Ashmolean', *The Ashmolean*, Spring 2006, p.22
28. Letter to Berenson, 31 January 1932, Cumming (ed.), *My Dear BB*, p.114
29. Letter from Isaiah Berlin to Colette Clark on her father's death, 22 May 1983. Family possession
30. Secrest, *Kenneth Clark*, p.86
31. Information from Colette Clark
32. Letter to Janet Stone, 24 July 1956, Bodleian Library
33. Charles Collins Baker (1880–1959), keeper at the National Gallery 1914–1932 and Surveyor of the King's Pictures during the same period
34. Letter from Morshead to Clark, 24 March 1932, I Tatti
35. Letter to Jane, August 1932, Saltwood
36. See Chapter 6
37. Letter from C.F. Bell to Berenson, 8 December 1932, I Tatti
38. Clark in a lapse gives the wrong date in his autobiography – 9 April as opposed to 9 October
39. Clark, *Another Part of the Wood*, p.201
40. Trewin, *Alan Clark: The Biography*, p.16
41. Letter to Mrs Shaw Smith, 24 February 1959, Tate 8812/1/3/3401–3450
42. Letter from Clark to Edith Wharton, 13 December 1933, Indiana University Library
43. Pope-Hennessy, *Learning to Look*, p.35
44. Clark, *Another Part of the Wood*, p.178
45. Lee, *A Good Innings: The Private Papers of Lord Lee of Fareham*, p.302
46. Interview with author
47. Letter to Meryle Secrest, 22 October 1980, I Tatti
48. *Oxford Times*, 8 June 1934
49. Tate 8812, Press cuttings

Chapter 10: Appointment and Trustees

1. Letter to Berenson, 5 February 1934, Cumming (ed.), *My Dear BB*, p.144
2. Notebook, Vol. I, Box 101/17, Crawford Papers, National Library of Scotland
3. Vincent (ed.), *The Crawford Papers: The Journals of David Lindsay, 27th Earl of Crawford and 10th Earl of Balcarres, During the Years 1871–1940*
4. Sir Philip Sassoon (1888–1939) was born into a merchant family. His mother was a Rothschild, and he was educated at Eton and Oxford.
5. Letter to Berenson, 28 August 1933, Cumming (ed.), *My Dear BB*, p.136
6. Letter from M. MacDonald to Clark, 18 August 1933, Tate 8812/1/4/241–243. Eastlake, as PRA, had been a trustee, and was on equal terms with them. Lord Carlisle however was a trustee who became acting director
7. All these letters of congratulation are in Tate 8812/1/4/141–143
8. Keeper National Gallery 1934–38
9. Letter from Isherwood Kay to Clark, 2 September 1933, Tate 8812/1/4/141–143
10. Letter to Edith Wharton, 22 August 1933, Indiana University Library
11. Ibid.
12. Tate 8812/1/3/890/1
13. Diary, I Tatti
14. Tate 8812/1/3/890/1
15. Letter to Edith Wharton, 6 April 1934, Indiana University Library
16. Lady Katharine Horner (1885–1976) inherited her father William Graham's collection of early Italian and Pre-Raphaelite pictures. When not in London she lived at Mells in Somerset
17. Letter from Berenson to Jane, 16 January 1934, Cumming (ed.), *My Dear BB*, pp.140–1
18. Clark, *Another Part of the Wood*, p.220
19. Ibid., p.224
20. Notebook, Vol. I, Box 101/17, Crawford Papers, National Library of Scotland
21. Lecture, 'Art and Democracy', Tate 8812/2/2/42
22. Samuel Courtauld (1876–1947), chairman of the family textile firm that provided the fortune which enabled him to put together his great collection of Impressionist paintings, housed today at Somerset House. That and the Courtauld Institute of Art constitute his extraordinary legacy to the cultural life of the UK
23. Letter to Berenson, 9 October 1933, Cumming (ed.), *My Dear BB*, p.138
24. Letter from Lord Duveen, 16 September 1935, Tate 8812/1/3/951–1000
25. BBC, 'Interview with Basil Taylor', 8 October 1974, British Library National Sound Archive, Disc 196
26. Today it is with the rest of his collection at the Courtauld Institute gallery
27. The story is set out in a letter from Clark to Evan Charteris, 20 July 1934, Getty Research Institute
28. Letter to Isherwood Kay, Tate 8812/1/1/24
29. The list was an unofficial agreement with the Treasury. It was the fact of the agreement that the Treasury wanted kept quiet
30. Letter to James Lees-Milne, 9 June 1977, Beinecke Library, Yale. The Act Clark is referring to is 'The Review of the Export of Works of Art' (1952)
31. Letter from Berenson, 31 March 1936, Cumming (ed.), *My Dear BB*, p.181
32. The book of the series was entitled *The Romantic Rebellion*, p.136
33. Letter from Clark to d'Abernon, 31 January 1936, National Gallery Archive 26/25/3
34. Letter from Gerald Kelly to Clark, 23 December 1935, I Tatti
35. Slade lecture on Delacroix, 6 June 1949, Oxford. Clark personally owned a Delacroix of a Tasso subject (Bührle Collection, Zürich)
36. Letter to Edith Wharton, undated, c.1934, Indiana University Library
37. Memo from Morshead to Queen Mary, 22 January 1935, Royal Archives, QM/PRI/CC48/457

Chapter 11: By Royal Command

1. Conversation reported in a letter from Morshead to Clark, 2 April 1932, I Tatti
2. Memo from Morshead to Queen Mary, 4 October 1933, Royal Archives, QM/PRIV/CC48/348

3. Morshead reported the contents of the letter to Clark: 11 June 1932, I Tatti

4. Letter from Morshead to Clark, 11 June 1932, I Tatti

5. Letter from Morshead to Clark, 11 October 1933, I Tatti

6. BBC Radio London, 'Interview with Roger Clark', 27 August 1976, British Library National Sound Archive

7. Letter from Lord Wigram to Philip Sassoon, 19 March 1934, Philip Sassoon files, National Gallery, 26/71/1

8. Diary, Sunday 25 March, I Tatti

9. Letter from Morshead to Clark, 6 April 1934, I Tatti

10. Memo from Morshead to Queen Mary, 12 April 1934, Royal Archives, QM/PRIV/CC48/403

11. Letter from Berenson, 6 July 1934, Cumming (ed.), *My Dear BB*, p.153

12. Clark, *Another Part of the Wood*, p.237

13. Interview with Sir Hugh Roberts, GCVO

14. Letter to Meryle Secrest, 4 June 1980, I Tatti

15. Memo to the Lord Chamberlain, 4 September 1942, Windsor

16. Clark mostly patronised Messrs Drown and Horace Buttery

17. Letter to the Duchess of York, 28 March 1936, Royal Archives, QEQM/PRIV/PAL: 28.3.36

18. Letter to Queen Elizabeth, 1 May 1937, Royal Archives, QEQM/PRIV/PAL: 1.5.37

19. Three postcards to Edith Wharton, April 1937, Beinecke Library, Yale

20. Secrest, *Kenneth Clark*, p.117

21. Letter to his mother, 14 May 1937, Saltwood

22. Memo from Morshead to Sir Alexander Hardinge, 10 April 1937, Royal Archives, PS/PSO/GVI/C/022/207a

23. Later Lord Adrian, Nobel Prize-winning scientist. See undated letter (November 1938), Clark to Sir Alexander Hardinge, Royal Archives, PS/PSO/GVI/C/022/392

24. Jane Clark, diary, 15 April 1938, Saltwood

25. Letter to Queen Elizabeth, 18 March 1938, quoted in Owens, *Watercolours and Drawings from the Collection of Queen Elizabeth the Queen Mother*, p.13

26. Letter from Queen Elizabeth to Clark, 13 December 1938, Saltwood

27. Letter to Queen Elizabeth, 10 December 1942, Royal Archives QEQM/PRIV/PAL: 10.12.42

28. Letter to Berenson, 10–14 June 1934, Cumming (ed.), *My Dear BB*, pp.154–5

29. Letter to Gerald Kelly, 1 November 1939, Royal Archives, RC/PIC/MAIN/STATE PORTRAITS

30. Letter to Janet Stone, 14 May 1958, Bodleian Library

31. Letter to Jock Murray, 11 April 1980, John Murray Archive

Chapter 12: The Great Clark Boom

1. Clark, *Another Part of the Wood*, p.211

2. Cyril Connolly in the *New Statesman*, January 1937, quoted by Clive Fisher, pp.153–4

3. Interview in John Wyver's film *K: Kenneth Clark 1903–1983*, 1993

4. Secrest, *Kenneth Clark*, p.114

5. According to Michael Luke (*David Tennant and the Gargoyle Years*, p.145), Douglas Cooper bought the painting from David Tennant, the owner of the Gargoyle Club, and then sold it on immediately to Clark, who sold it when he gave up Portland Place. It is now in the Duncan Phillips Collection, Washington, where it is called *Studio, Quai St. Michel*

6. Ironside would hold the post from 1937 to 1946

7. Ben Nicolson, diary, 21 July 1937, private collection, copy at *Burlington Magazine*

8. Now in the National Gallery, London

9. Walker, *Self-Portrait with Donors: Confessions of an Art Collector*, p.290

10. Clark, *The Nude: A Study in Ideal Form*, p.156

11. Colin Clark, *Younger Brother, Younger Son*, p.18

12. Reading to Oxford Union, Tate 8812/2/2/728

13. Trewin, *Alan Clark: The Biography*, p.24. It was on Alan's suggestion that John Aspinall later bought Port Lympne and saved it

14. Clark, *Another Part of the Wood*, p.224

15. Letter to Edith Wharton, postmarked 28 September 1936, Beinecke Library, Yale

16. Clark, 'Aesthete's Progress', John Murray Archive

17. Ibid.
18. Interview with Colette Clark
19. Drogheda, *Double Harness: Memoirs*, p.106
20. Letter from Peter Quennell to Meryle Secrest, 20 September 1979, I Tatti
21. Colin Clark, *Younger Brother, Younger Son*, p.23
22. Michael Levey, obituary of Kenneth Clark, *Proceedings of the British Academy*, Vol. XXV, 1984
23. Mark Amory, *Sunday Times Magazine*, 6 October 1974
24. Jane Clark, diary, 9 April 1937, Saltwood
25. 12 November 1934
26. Clark, 'Aesthete's Progress', John Murray Archive
27. Colin Clark, *Younger Brother, Younger Son*, p.18
28. Letter to Edith Wharton, 18 June 1936, Beinecke Library, Yale
29. Colin Clark, *Younger Brother, Younger Son*, p.167
30. Review by Anthony Powell of Secrest, *Kenneth Clark*, *Daily Telegraph*, 14 September 1984
31. Ben Nicolson, diary, 29 July 1936, private collection, copy at *Burlington Magazine*
32. Letter to Ben Nicolson, 31 July 1936, private collection, copy at *Burlington Magazine*
33. I am grateful to Dudley Dodd for this story. Bobby Gore (1921–2010) worked for the National Trust
34. Clark, *Another Part of the Wood*, p.219
35. Sir Nikolaus Pevsner (1902–83), later editor of the astonishing Buildings of England series
36. Harries, *Nikolaus Pevsner: The Life*, p.546
37. Letter from Jane to Berenson, 11 February [almost certainly March] 1939, Cumming (ed.), *My Dear BB*, p.206
38. Interview in John Wyver's documentary *K: Kenneth Clark 1903–1983*, 1993
39. Clark, *Civilisation*, p.346
40. Letter to Abraham A. Desser, 28 March 1973, Tate 8812/1/4/88. In fact the opera production was in 1956
41. Information from the Clark family. There were reasons for this connected with his poor relationship with her husband, Duff Cooper, during the war
42. Clark, *Another Part of the Wood*, p.224

43. Jane Clark, diary, 20 April 1938, Saltwood
44. Letter to Janet Stone, 31 December 1976, Bodleian Library
45. Interview with Colette Clark
46. Letter from Julie Kavanagh to Meryle Secrest, 23 October 1989, I Tatti
47. Colin Clark, *Younger Brother, Younger Son*, p.13

Chapter 13: Running the Gallery

1. Connolly, *A Romantic Friendship: The Letters of Cyril Connolly to Noel Blakiston*, p.134
2. The so-called Titian *Gloria*; letter to A.L. Nicholson, 3 December 1935, I Tatti
3. Saumarez Smith, *The National Gallery: A Short History*, p.131
4. Clark's views are well set out in 'Ideal Picture Galleries', *The Museums Journal*, Vol. XLV, No. 8, November 1945. He made exceptions for smaller museums such as the Ashmolean
5. Ibid.
6. Letter from John Pope-Hennessy to Colette Clark, 25 May 1983, private collection
7. Saumarez Smith, *The National Gallery: A Short History*, pp.124–5
8. Letter to Harold Isherwood Kay, 19 October 1934, Getty Research Library
9. Letter to Jane, undated, Saltwood
10. Keeper's Bulletin to Clark, 3 November 1936, National Gallery Archives
11. Minutes, 10 May 1938, National Gallery Archives
12. Later Lord Harlech
13. Letter from David Ormsby-Gore to Clark, Tate 8812/1/3/2400
14. Minute, 17 April 1938, National Gallery Archives
15. Neil MacGregor interview for *Lord Clark: Servant of Civilisation*, BBC Radio 4, 3 July 2003
16. *Daily Mirror*, 14 May 1936
17. 17 December 1937
18. Interview with author
19. Nicholas Penny made this interesting observation. As early as 1926 Clark was writing to Mrs Berenson about photographing details (letter to Mary Berenson, 14 February 1926)

20. Letter from Sydney Cockerell to Clark, Tate 8812/1/4/4316
21. *The Listener*, 27 January 1939
22. *Sunday Times*, 22 January 1939
23. Clark, *Another Part of the Wood*, p.275
24. See Clark's lecture, 'The Aesthetics of Restoration', 20 May 1938, Royal Institution
25. Letter to unknown correspondent, 10 September 1973, Tate 8812/1/4/204
26. Letter to *Burlington Magazine*, December 1973, Vol. CXV, No. 849
27. Minute, 11 December 1934, National Gallery Archives
28. Letter to Sir Gerald Kelly, 29 January 1935, Saltwood
29. *The Times*, 23 December 1936
30. See National Gallery Archives, file 268.1
31. Letter to William Gibson, 8 May 1941, National Gallery Archives. By the time he wrote his memoirs he had changed this view, and thought science was of less importance
32. See 'Storm over Velasquez', *The Listener*, 20 January 1937
33. Letter to Lord Crawford, 3 August 1936, Crawford Papers, National Library of Scotland
34. Letter to Jane, 24 November 1936 (crossed out, and erroneously replaced with '1937'), Saltwood
35. Ibid., 25 November
36. Lecture on 'Collecting', 11 June 1980, Paris, Tate 8812/2/2/206
37. See Clark, 'Sir William Burrell: A Personal Reminiscence', Tate 8812/2/2/158. Also letter from Clark to Sir William Burrell, Tate 8812/1/3/550–600
38. Letter from Gulbenkian to Clark, 10 April 1936, Tate 8812/1/4/163a
39. Letter to Samuel Courtauld, 29 June 1936, National Gallery Archives
40. Letter to *The Times*, 31 July 1936, published 5 August 1936
41. Letter to Isherwood Kay, 16 August 1936, National Gallery Archives
42. Clark, *Another Part of the Wood*, p.231
43. Letter to Gulbenkian, 7 February 1939, Tate 8812/1/4/163a
44. Letter from Gulbenkian to Clark, 10 January 1939, Tate 8812/1/4/163a

45. Letter to Gulbenkian, 11 August 1937, Tate 8812/1/4/163a
46. Clark, *Another Part of the Wood*, p.232
47. Letter to Lord Balniel, 10 August 1939, Crawford Papers, National Library of Scotland
48. Letter to Gulbenkian, 9 March 1939, Tate 8812/1/4/163a
49. Ibid., 6 June 1939
50. Letter from Gulbenkian to Clark, 3 June 1939, Tate 8812/1/4/163a
51. Letter from Lord Crawford to Clark, October 1939, Crawford Papers, National Library of Scotland
52. Letter to Lord Crawford, 27 July 1939, Crawford Papers, National Library of Scotland
53. Sent to Ben Nicolson, 5 May 1953, *Burlington Magazine* Archive
54. Geddes Poole, *Stewards of the Nation's Art*, p.287. Jane Clark's diary records, 'PM's secretary telephoned K re Duveen trusteeship,' 19 January 1938, Saltwood
55. Clark, *Another Part of the Wood*, p.266
56. For anyone interested in Clark's position in this matter see his undated 'Report on the Relations of the National Gallery and the Tate Gallery', Tate 8812/1/4/244
57. Clark, *Another Part of the Wood*, p.233
58. C. Frank Stoop was one of the first British collectors of Picasso
59. Letter to Jane, undated, c.1935, Saltwood
60. Clark, *Another Part of the Wood*, p.235
61. Ibid., p.234
62. Rothenstein, *Brave Day, Hideous Night*, p.8
63. Rothenstein, *Time's Thievish Progress: Autobiography Vol. III*, p.47
64. Ibid., p.18
65. Diary, 1936–1939, Crawford Papers, National Library of Scotland

Chapter 14: Lecturing and *Leonardo*

1. *Times Literary Supplement*, No. 1745, 11 July 1935
2. This was not in fact first realised by Clark, but by Giovanni Morelli and others in the nineteenth century
3. Letter to John Pope-Hennessy, Tate 8812/1/5/2556
4. See letter to Berenson, 27 June 1939, for his less enthusiastic second view, Cumming (ed.), *My Dear BB*, pp.212–13

5. Tate 8812, Press cuttings
6. Clark, *Another Part of the Wood*, p.242
7. Ibid., p.243
8. Manuscript for lecture on 'Collecting' delivered in Paris, 11 June 1980, Tate 8812/2/2/206
9. Attributed to the circle of Giusto Le Court, a Flemish sculptor working in Venice and influenced by Bernini
10. The dinner took place on 6 November 1936. I am grateful to Stephen Conrad for this information and reference
11. Letter to Theodore Sizer, 27 October 1938, Stirling Library, Yale
12. Interview with author, 2013
13. Kemp, *Leonardo*, p.63
14. Ibid., p.21
15. Ibid., p.10
16. Now in the National Gallery, Washington
17. Kemp, *Leonardo*, p.223
18. See Luke Sysons, Leonardo da Vinci exhibition catalogue, National Gallery, London, p.63
19. Letter to Arts Editor, 18 May 1949, Tate 8812/1/4/189
20. BBC Radio, 1 February 1973, British Library Sound Archive, Disc 196
21. Letter from Vita Sackville-West to Clark, 11 August 1939, I Tatti
22. *New Statesman*, 5 August 1939, pp.219–20
23. Letter from Berenson, 12 August 1939, Cumming (ed.), *My Dear BB*, p.215
24. Michael Levey, obituary of Kenneth Clark, *Proceedings of the British Academy*, Vol. LXX, 1984
25. Clark, *Another Part of the Wood*, p.259
26. Harries, *Nikolaus Pevsner*, p.138
27. First published as 'A Western Criticism of Chinese Painting', *The Listener*, 22 January 1936
28. Although frequently used as a lecture, it was also published as 'An Englishman Looks at Chinese Paintings' in the *Architectural Review*, Vol. CII, July 1947, pp.29–33
29. Postcard to Clive Bell, undated, King's College, Cambridge BLM/11
30. See Clark's letter to *The Times* on the subject, dated 27 March 1939
31. Letter to the Academic Assistance Council, 8 May 1934, Papers of the Society for the Protection of Science and Learning appeals, Bodleian Library
32. Jack Beddington, who initiated the Shell poster campaign – Betjeman's 'Beddy Ol Man' would reappear at the MoI
33. Letter, 15 February 1937, Tate 8812/1/3/2651–2700
34. Jacob Burckhardt, *The Civilisation of the Renaissance in Italy*, published in German in 1860 and in English in 1878
35. Clark, *Another Part of the Wood*, p.258
36. Ibid.
37. Letter to Jane, undated, c.1940s, Saltwood. Elsewhere Clark states that it was the publication of a book by a French scholar which made his unnecessary
38. 'The Universal Man', lecture given in July 1971 at the Ditchley Park Foundation, Oxfordshire (a body dedicated to Anglo-American relations), exploring Alberti, Jefferson and Benjamin Franklin

Chapter 15: Director versus Staff

1. Published in *Apollo*, January 1984
2. Clark speaking at the BADA dinner in May 1936, Tate 8812, Press cuttings
3. Clark, *Another Part of the Wood*, p.263. Leo Planiscig (1887–1952)
4. Penny, *The National Gallery Catalogues: The Sixteenth Century Italian Paintings, Vol. 1, Bergamo, Brescia and Verona*, p.296
5. Michael Levey, obituary of Kenneth Clark, *Proceedings of the British Academy*, Vol. LXX, 1984. Levey told Caroline Elam that the curator in question was Neil MacLaren
6. Ernst Gombrich (1909–2001), whom Clark rated as the greatest among contemporary art historians
7. Letter to Samuel Courtauld, 8 July 1937, National Gallery Archives
8. Letter to Edith Wharton, 11 July 1937, Beinecke Library, Yale
9. Letter to Berenson, 22 July 1937, Cumming (ed.), *My Dear BB*, p.186
10. Undated letter, presumably around October 1937, ibid., p.189
11. Letter from Berenson, 21 October 1937, ibid., pp.190–1
12. *Burlington Magazine*, November 1937, Vol. LXXI, No. 416, pp.198–201

13. C.F. Bell, letter to *The Times*, 5 November 1937

14. Letter to *The Times*, dated 5 November 1937

15. *Daily Telegraph*, 20 December 1937

16. Letter to G.H. Blore, 25 January 1938, National Gallery Archives

17. Letter to Janet Stone, September 1968, Bodleian Library

18. Penny, *The National Gallery Catalogues: The Sixteenth Century Italian Paintings, Vol. 1, Bergamo, Brescia and Verona*, p.296

19. Clark, *Landscape Into Art*, pp.57–8

20. Told to the author by Philip Pouncey, c.1988

21. Pope-Hennessy, *Learning to Look*, p.54

22. Walker, *Self-Portrait with Donors*, p.293

23. Minute of meeting Lord Balniel and Harold Isherwood Kay, undated, c.March 1938, Crawford Papers, National Library of Scotland

24. Ibid.

25. Letter to Lord Duveen, 24 January 1936, Tate 8812/1/3/953

26. Minute of meeting Lord Balniel and Harold Isherwood Kay, 1 April 1938, Crawford Papers, National Library of Scotland

27. Letter to Lord Balniel, 23 April 1939, Crawford Papers, National Library of Scotland

28. Minute of meeting Lord Balniel and Harold Isherwood Kay, 1 April 1938, Crawford Papers, National Library of Scotland

29. Minute of meeting Lord Balniel and Martin Davies, 1 April 1938, Crawford Papers, National Library of Scotland

30. Ibid.

31. Letter to Lord Balniel, 23 April 1938, Crawford Papers, National Library of Scotland

32. Letter to his mother, 9 February 1938, Saltwood

33. Conlin, *The Nation's Mantelpiece*, p.158

34. I am very grateful to Professor Christopher Brown for supplying this portrait of Martin Davies

35. Letter to Lord Balniel, 23 April 1938, Crawford Papers, National Library of Scotland

36. Ibid., 3 May 1938

37. Interview with Colette Clark

38. Letter from the Duke of Buccleuch to Clark, 12 January 1938, National Gallery Archives

39. Letter from Clark to Victor Mallet, 28 January 1938, National Gallery Archives

40. Trewin, *Alan Clark: The Biography*, p.20

41. Letter to Lord Balniel, 17 October 1938, Crawford Papers, National Library of Scotland

42. Letter to Ben Nicolson, 14 April 1939, private collection, copy at *Burlington Magazine*

Chapter 16: *The Listener* and the Artists

1. *The Listener*, 22 February 1940, No. 580, 'The Artist and the Patron: Eric Newton interviews Kenneth Clark'

2. BBC Radio, *Let's Find Out*, 15 February 1966, British Library National Sound Archive

3. Clark, *Another Part of the Wood*, p.248. Today all but two plates have gone missing, last seen at auction in Germany

4. Herbert Read (1893–1968), poet and the leading British apologist for international modern art

5. All quotes from 'The Future of Painting', *The Listener*, 2 October 1935, No. 351

6. See 'Ben Nicholson and the Future of Painting', *The Listener*, 9 October 1935

7. Roland Penrose (1900–84), collector and biographer of Picasso, and a surrealist painter himself

8. Letter to *The Listener*, 9 October 1935, written under his pseudonym Douglas Lord

9. Letter to Edith Sitwell, 12 August 1949, Harry Ransom Center, University of Texas

10. Letter to Janet Stone, 4 September 1975, Bodleian Library

11. A review of the Rouault exhibition at the Mayor Gallery, *The Listener*, 23 October 1935, No. 354

12. Letter from Ben Nicholson to Clark, 5 May (no year, but presumably 1936), I Tatti

13. Letter from Charles Collins Baker to D.S. MacColl, 7 January 1936, University of Glasgow, MS MacColl B30. Clark once wrote that 'MacColl stands like a tall flamingo among the quacking ducks'

14. Published in *Commercial Art*, 17 August 1934, Vol. XVII
15. Clark, 'Aesthete's Progress', John Murray Archive
16. 'Henry Moore at Eighty', *Sunday Times*, 30 July 1978
17. Letter to Sir Alan Lascelles, 17 November 1944, Windsor Royal Archives
18. Berthoud, *Henry Moore*, p.157
19. Secrest, *Kenneth Clark*, p.109
20. Ibid.
21. Clark, *Another Part of the Wood*, p.254
22. Clark, 'Aesthete's Progress', John Murray Archive
23. Secrest, *Kenneth Clark*, p.107
24. Letter from Graham Sutherland to Clark, February 1938, Tate 8812/1/3/3101–3150
25. Letter to Henry Moore, 3 August 1939, Henry Moore Foundation
26. Secrest, *Kenneth Clark*, p.107
27. Letter to Gertrude Stein, 5 January 1939, Beinecke Library, Yale
28. Letter from Graham Sutherland to Clark, undated, from Menton, Tate 8812/1/4/120
29. Hillier, *John Betjeman: New Fame, New Love*, p.102
30. Secrest, *Kenneth Clark*, p.110
31. Fraser Jenkins, *John Piper: The Forties*, exhibition catalogue, Imperial War Museum 2000–01, p.20
32. Lycett Green, *John Betjeman: Letters, Vol. I: 1926–1951*, p.240, letter from Betjeman to Clark, 5 October 1939
33. Harris, *Romantic Moderns*, p.107
34. Clark, *Another Part of the Wood*, p.251
35. The Trust brought in about £500 a year, of which half was recovered tax. Pasmore received £15 a month. See letter from Clark to Guy Little (his accountant), 6 January 1944, Tate 8812/1/1/27. The Trust was dissolved in 1952
36. Letter from Graham Bell to Clark, undated, I Tatti
37. Clark, *Another Part of the Wood*, p.251
38. These were mostly given via the CAS in 1946
39. Quoted in Chris Stephens, 'Patron and Collector', 'Looking for Civilisation' catalogue, 2014, pp.97–8

Chapter 17: Packing Up: 'Bury Them in the Bowels of the Earth'

1. Clark, *The Other Half*, p.5
2. Jane Clark, diary, 3 June 1939, Saltwood
3. BBC Empire Broadcast, 28 August 1939, Tate 8812/2/2/676
4. Clark, *Another Part of the Wood*, p.277
5. Bosman, *The National Gallery in Wartime*, p.19
6. Letter to his mother, 17 August 1939, Saltwood
7. BBC Empire Broadcast, 29 August 1939, Tate 8812/2/2/676
8. Letter from Lord Balniel to Clark, 20 September 1939, Crawford Papers, National Library of Scotland
9. Letter to Jane, undated but postmarked 2 December 1939, Saltwood
10. Letter to Lord Balniel, 26 October 1939, Crawford Papers, National Library of Scotland
11. Clark, *The Other Half*, p.6. Unfortunately this story is deflated by Rawlins, who while acknowledging that they did consider letting out the tyres, adds that in the event it turned out to be unnecessary. See Rawlins, *War Time Storage*, p.13
12. BBC Home Service talk, *Pictures Come Back to the National Gallery*, 10 June 1945, Tate 8812/2/2/683
13. Letter to William Gibson, 21 August 1941, National Gallery Archives
14. Clark, *The Other Half*, p.7
15. Letter to Jane, 28 February 1937, Saltwood
16. See Accountant's File, Percy Popkin, Tate 8812/1/4/344
17. One of the more surprising consultations was when Read wanted to apply for the directorship of the Wallace Collection
18. Letter from Herbert Read to Clark, 4 April 1939, Tate 8812/1/3/2651–2700
19. Ibid., 3 May 1939
20. Guggenheim, *Out of this Century*, London, p.200
21. Letter from Herbert Read to Clark, 12 September 1939, Tate 8812/1/3/2664
22. Letter to Miss Dorazio, 7 June 1973, Tate 8812/1/4/301
23. Ibid.

24. BBC Radio London, 'Interview with Roger Clark about Bernard Berenson', 27 August 1976
25. This account is held at I Tatti among the Clark Papers. Nicolson published a very similar account in his *Diaries* (entry for 14 June 1939)
26. Clark, *Another Part of the Wood*, p.273
27. These notes are held with the Lippmann Papers at Stirling Library, Yale
28. Clark, *Another Part of the Wood*, p.273
29. Letter to his mother, undated, c.October 1939, Saltwood
30. Clark, *Another Part of the Wood*, p.278

Chapter 18: The National Gallery at War

1. Conlin, *Oil and Old Masters: How Britain Lost the Gulbenkian*, p.160
2. Lees-Milne, *Ancestral Voices*, p.163 (entry for 2 March 1943)
3. Michael Levey, obituary of Kenneth Clark, *Proceedings of the British Academy*, Vol. LXX, 1984
4. Tate 8812/2/2/677
5. Bosman, *The National Gallery in Wartime*, p.40
6. 'From the Audience', Hess et al., *The National Gallery Concerts*, p.7
7. Letter from Myra Hess to Clark, 14 June 1941, Tate 8812/1/3/1301–1350
8. Letter from Miss Lamont to Clark, 2 January 1940, Saltwood
9. Letter to Berenson, 1 November 1939, Cumming (ed.), *My Dear BB*, p.234
10. Nancy Thomas (1918–2015), Clark's secretary at the National Gallery 1936–39. She went on to become a distinguished BBC producer
11. Letter to Berenson, 1 November 1939, Cumming (ed.), *My Dear BB*, p.234
12. Letter to his mother, 9 October 1939, I Tatti
13. Letter to the Earl of Radnor, 16 September 1941, Tate 8812/1/1/7–8
14. Letter to Lord Balniel, undated, Crawford Papers, National Library of Scotland
15. *The Times*, 19 January 1942
16. The idea had in fact first been proposed by Echoes PR agency in 1936 as 'Picture of the Week'
17. Broadcast 6 February 1942

18. Letter to Lord Stanhope, 11 December 1941, Tate 8812/1/1/10
19. Letter to Eric Maclagan, 6 January 1940, Tate 8812/1/1/2
20. Browse, *Duchess of Cork Street*, p.81
21. Ibid., pp.83–4
22. Letter to Spender, 8 May 1942, Tate 8812/1/1/8
23. Henri Bergson, French philosopher (1895–1941); famous for his *élan vital*
24. Mellor et al., *Recording Britain: A Pictorial Domesday of Pre-War Britain*, p.7
25. *Spectator*, 16 June 1944
26. Lascelles, *King's Counsellor: Diaries*, p.101
27. Letter from William Gibson to Courtauld, 4 December 1940, National Gallery Archives
28. Letter to William Gibson, 7 December 1940, National Gallery Archives
29. Letter from Gulbenkian to Clark, 11 September 1942, Tate 8812/1/4/165b
30. Letter from William Adams Delano to Clark, 21 July 1942, Tate 8812/1/4/165b
31. Letter from Gulbenkian to Clark, 5 March 1943, Tate 8812/1/4/165b
32. Lees-Milne, *Ancestral Voices*, p.280 (entry for 8 December 1943)

Chapter 19: The Ministry of Information

1. McLaine, *Ministry of Morale*, p.217
2. Clark, *The Other Half*, p.9
3. I am much indebted in this chapter to Henry Irving, the senior researcher on the London University MoI history project. He has directed me to various papers at Kew and made invaluable suggestions on the text
4. Letter to Jane, undated (postmarked 7 September 1939), Saltwood. The 16th Earl of Perth, after a distinguished diplomatic career, was briefly Director-General of the MoI
5. Letter to Jane, 11 September 1939, Saltwood
6. Letter to Lord Lloyd of Dolobran, 20 September 1939, National Gallery Archives, 268.3
7. Letter from Lord Lee to Lord Macmillan, 18 September 1939, Tate 8812/1/3/1601–50
8. Trewin, *Alan Clark: The Biography*, p.34

9. Nicolson diary, 3 August 1940, Balliol College Archive
10. Clark papers are to be found in numerous files at the MoI Archive at Kew, and particularly in the minutes of various committees he sat on. See TNA, INF
11. Sir John Reith, later Lord Reith (1889–1971), Director-General of the BBC and its most influential servant, who set a pattern of public-service broadcasting
12. Sir Alfred Duff Cooper, later Viscount Norwich (1890–1954), Conservative Party grandee and diplomat; married to the equally celebrated Lady Diana Cooper
13. 'Artists and War', Clark, *The Highway*, Special Art Supplement, December 1939
14. Clark, *The Other Half*, p.14
15. Letter from Henry Moore to Clark, 23 December 1939, Tate 8812/1/3/2040
16. Letter from Lord Bearsted to Balniel, 20 December 1939, Crawford Papers, National Library of Scotland
17. Letter to his mother, postmarked 15 February 1940, Saltwood
18. Interview with Kenneth Clark, *Kinematograph Weekly*, 11 January 1940
19. *Daily Herald*, 19 January 1940
20. Letter to Sir Victor Schuster, 15 October 1941, Tate 8812/1/1/10
21. *Sunday Times*, 4 February 1940
22. Nicolson diary, 2 April 1940, Balliol College Archive
23. Clark, *The Other Half*, p.37
24. Tate 8812/1/1/6
25. Colin Clark, *Younger Brother, Younger Son*, p.188
26. Letter from Betjeman to Clark, 20 January 1949, Tate 8812/1/3/251–300
27. Taped interview with Clark by Bevis Hillier, in possession of the author
28. Hillier, *New Fame, New Love*, p.145
29. Ibid., p.161
30. 10.15 a.m., 21 February 1940, Tate 8812/2/2/2
31. Lecture given 26 November 1940. Text Tate 8812/1/1/70
32. Taped interview with Clark by Bevis Hillier, in possession of the author
33. Beddington was behind the Shell poster campaign that Clark admired. He dreamt up one of the more popular MoI slogans: 'Be Like Dad; Keep Mum'
34. Clark, *The Other Half*, p.15
35. McLaine, *Ministry of Morale*, p.10
36. Nicolson diary, 27 May 1940, Balliol College Archive
37. I am grateful to Henry Irving for pointing this out
38. Part 1, Policy Committee Meetings, 1 May 1940, Kew National Archive, TNA, INF 1/848
39. Speech given at the Royal Festival Hall, 8 March 1965, Tate 8812/1/4/293
40. Nicolson diary, 8 November 1940, Balliol College Archive
41. Ibid., 27 May 1940
42. Ibid., 8 June 1940
43. Two undated letters from Jane Clark to Lord Crawford, Crawford Papers, National Library of Scotland
44. Nicolson diary, 21 October 1940, Balliol College Archive
45. Letter to Lord Crawford, undated, Crawford Papers, National Library of Scotland
46. Nicolson diary, 17 April 1941, Balliol College Archive
47. Knox, *Cartoons and Coronets: The Genius of Osbert Lancaster*, p.49
48. Letter to Jane, 15 September 1940, Saltwood
49. See Nicolson diary, 5 February 1941, Balliol College Archive. The pamphlet was completed by 25 February
50. Letter to Jane, 15 September 1940, Saltwood
51. MoI, National Archive Kew, TNA, INF 1/250
52. Clark memorandum, 30 August 1940, MoI, National Archive Kew, TNA, INF 1/251
53. Ibid., 21 July 1941, TNA, INF 1/312
54. Ibid., 22 January 1941, TNA, INF 1/849
55. Letter to Dr Melville B. Miller, 28 January 1971, Stirling Library, Yale
56. Clark, *The Other Half*, pp.34–5
57. Lycett Green, *John Betjeman: Letters, Vol. I: 1926–1951*, p.289
58. Memos from Norman Brook to Walter Monckton, 9 July 1941. Also Monckton to Brook, 11 July 1941, Kew National Archive, TNA, INF 1/869
59. Nicolson diary, 29 August 1941, Balliol College Archive
60. Clark, *The Other Half*, p.22

Chapter 20: Artists at War

1. Tate 8812/1/4/441a
2. Letter to Mr Waddams, 7 December 1981, Tate 8812/1/4/444
3. See letter from Henry Lewes to Clark, 6 May 1969, in which he quotes Jane Clark, Tate 8812/1/4/55
4. Letter to Mr Waddams, 7 December 1981, Tate 8812/1/4/444
5. Letter to Betjeman, 20 September 1939, Tate 8812/1/4/441a
6. Clark believed that he was considered 'a dangerous revolutionary' in RA circles; see Clark, *The Other Half*, p.23. 'Interfering bloody nuisance' would be closer to the mark
7. 'The Artist in Wartime', *The Listener*, 22 October 1939
8. Letter from Edward Bawden to Clark, 12 December 1939, Tate 8812/1/4/441a
9. 'The Artist in Wartime', *The Listener*, 22 October 1939
10. Letter to Sir Ronald Storrs, 19 March 1941, Tate 8812/1/1/10. Clark added facetiously: 'If only it were possible to discourage the Jews from painting'
11. Letter to Cecil Day-Lewis, 16 October 1942, Tate 8812/1/1/27
12. Letter to Paul Nash, 19 February 1941, Tate 8812/1/1/4
13. Foss, *War Paint: Art, War, State and Identity in Britain 1939–1945*, p.167
14. Letter from Jane to Lord Crawford, 1 September 1941, Crawford Papers, National Library of Scotland
15. Lycett Green, *John Betjeman: Letters, Vol I: 1926–1951*, pp.542–51
16. Letter from Jane to Lord Crawford, dated 'Monday', Crawford Papers, National Library of Scotland. In fact the first invoice in January 1941 was for thirty-two guineas
17. Clark, *The Other Half*, p.24
18. Clark, *Henry Moore: Drawings*, p.150
19. 'War Artists at the National Gallery', *The Studio*, January 1942, p.5
20. Harries, Meirion and Susie, *The War Artists*, p.188
21. Letter to Mervyn Peake, 7 May 1942, Tate 8812/1/3/2451
22. Note 'To whom it may concern', 20 August 1942, Tate 8812/1/1/6
23. Quoted in Thomas Dilworth 'Letters from David Jones to Kenneth Clark', *Burlington Magazine*, Vol. CXLII, April 2000, p.215
24. Ibid., p.216
25. Letter to J.M. Keynes, 10 January 1941, King's College, Cambridge, JMK/PP/45/147
26. Foss, *War Paint: Art, War, State and Identity in Britain 1939–1945*, p.175
27. Letter from Paul Nash to Clark, undated, Tate 8812/1/3/2210
28. Ibid., Tate 8812/1/3/2215
29. Letter to Paul Nash, 1 May 1942, Paul Nash Archive, Tate 7050/348–362
30. Ibid., 3 October 1944
31. Letter from Wyndham Lewis to Augustus John, 17 August 1943; see Meyers, *The Enemy: A Biography of Wyndham Lewis*, pp.271–4
32. Letter from Betjeman to Clark, 14 March 1941, Tate 8812/1/3/299
33. Letter to Betjeman, 19 March 1941, Tate 8812/1/2/300
34. Letter to P.N.S. Mansergh, 10 February 1942, Tate 8812/1/1/3
35. Letter to Frank Pick, 9 January 1941, Tate 8812/1/1/6
36. Ibid., 28 May 1941
37. 'War Artists at the National Gallery', *The Studio*, January 1942, p.3
38. Nicolson diary, 22 May 1941, Balliol College Archive
39. Letter from Mary Kessell to Clark, 6 September 1945, I Tatti
40. BBC, 19 October 1941, British Library National Sound Archive, Disc 210

Chapter 21: The Home Front

1. Letter to his mother, 1 March 1942, Saltwood
2. Trewin, *Alan Clark: The Biography*, p.252
3. Alan started at St Cyprian's, and was moved to Cheltenham
4. Letter from Jane to Lord Crawford, 25 June 1940, Crawford Papers, National Library of Scotland
5. Ibid., undated
6. See letter from Clark to Michael Kennedy, 13 September 1968, Tate 8812/1/4/43. The daughter used the surname Elgar

7. Casino of Pius IV in the Vatican gardens

8. See Clark, *Another Part of the Wood*, pp.178–80

9. Hinks, *The Gymnasium of the Mind*, p.80

10. Letter, 27 March 1941, Saltwood

11. Letter from Jane to Lord Crawford, undated, Crawford Papers, National Library of Scotland

12. Jane Clark, diary, 1 January 1941, Saltwood

13. Ibid.

14. Interview with Colette Clark

15. Letter to his mother, 8 September 1944, Saltwood

16. Interview with Mrs Catriona Williams

17. Letter to his mother, 25 September 1945, Saltwood

18. Letter to John Piper, undated, Piper Archive, Tate 200410/1/1/793

19. Mostly by Duncan Grant and Graham Bell; see list at Tate 8812/1/4/110

20. He attached special importance to her letters, and gave them to the Morgan Library in New York. See also his article in *Horizon*, July 1947, Vol. XVI, 'On the Development of Miss Sitwell's Later Style'. Clark later said: 'Edith Sitwell is not only a good poet but a great poet. I think she used the word gold too often and I suggested that her confessor [she had become a Catholic] should ban her from using the word for six months.' *With Great Pleasure*, BBC, 12 September 1976

21. Letter to Myfanwy Piper, undated, Piper Archive, Tate 200410/1/1/793

22. Letter from T.S. Eliot to Jane Clark, 13 November 1943, Saltwood

23. Thomas asked Clark for help in avoiding army service; see letter to Clark, 16 March 1940, Tate 8812/1/3/3201–3251. Thomas and Clark shared a love of detective fiction

24. Quennell (ed.), *A Lonely Business: A Self Portrait of James Pope-Hennessy*, p.31. Letter to Clarissa Avon, 6 November 1940

25. Lees-Milne, *Ancestral Voices*, p.270 (entry for 18 November 1943)

26. Ibid., p.163 (entry for 2 March 1943)

27. Letter to Berenson, 14 September 1939, Cumming (ed.), *My Dear BB*, p.231

28. Letter to Harold Nicolson, 19 December 1942, Tate 8812/1/1/30

29. See letter to Osbert Peake, 22 August 1940, and to Asquith, 29 August 1940, Tate 8812/1/4/182

30. Letter from Helen Roeder to Clark, 3 September 1940, Tate 8812/1/4/182

31. Letter to the Chief Constable of Cornwall, 8 June 1940, Tate 8812/1/4/182

32. Speech by Clark at opening of the Warburg exhibition 'British Art and the Mediterranean', 2 December 1941

33. See letter from Fritz Saxl to Clark, 28 June 1940, Warburg

34. Draft letter from Fritz Saxl to Clark, apparently unsent, May 1941, Warburg

35. Jane Clark, diary, 7 March 1942, Saltwood

36. Letter to Roger Hinks, 20 January 1942, Saltwood

37. Letter to Prof. Albert Richardson, 8 August 1944, Tate 8812/1/1/58

38. Letter from Jane to Lord Crawford, undated, Crawford Papers, National Library of Scotland

39. See correspondence with Savoy, Tate 8812/1/1/34–35

40. Berenson, *Sketch for a Self-Portrait*, p.15

41. Letter, 14 June 1941, Tate 8812/1/12

42. *Evening Standard*, 28 December 1942, Tate 8812, Press cuttings

43. Mount Square, Hampstead, and her studio on Downshire Hill

44. Interview with author

45. Letter from Mary Kessell to Clark, postmarked 21 February 1943, I Tatti

46. Letter from Mary Kessell to Clark, 2 October 1944, I Tatti

47. Letter from Mary Kessell to Clark, undated, I Tatti

48. Letter from Myfanwy Piper to Clark, undated, I Tatti

49. Letter to his mother, 25 September 1945, Saltwood

50. Letter from Myfanwy Piper to Clark, undated, 1940s, I Tatti

Chapter 22: The Best for the Most

1. *Horizon*, 7 January 1943, p.5

2. See letter to John Grierson, 1 July 1947, Tate 8812/1/4/433

3. Radio interview, 12 February 1940, 'The Artist in the Witness Box', Tate 8812/2/2/736. A truncated version with

the quote removed was published in *The Listener*, 22 February 1940, No. 380

4. Letter to *The Times*, 7 April 1941
5. Reprinted in E.M. Forster, *Two Cheers for Democracy*, p.102
6. Briggs, *The BBC: The First Fifty Years*, p.211
7. Michael Gill, unpublished notes for autobiography, p.2, John Murray Archive
8. Letter to Harold Nicolson, 8 July 1942, Tate 8812/1/1/30
9. There is a lot of argument about who approached whom. This account follows Clark's (see below)
10. 'State Patronage of Music and the Arts, The Work of C.E.M.A.', manuscript in Tate 8812/2/2/223
11. See Clark's Introduction to 'Civil Defence Artists' exhibition, Cooling Gallery, London, January 1942
12. Sinclair, *Arts and Cultures*, p.31
13. See letter to R.A. Butler, 11 December 1944, Saltwood
14. Clark, *The Other Half*, pp.26–7
15. Sinclair, *Arts and Cultures*, p.43
16. Lewis, *Penguin Special: The Life and Times of Allen Lane*, p.188
17. Letter to Jim Ede, 10 May 1943, Tate 8812/1/1/20
18. Lewis, *Penguin Special: The Life and Times of Allen Lane*, p.256
19. See Sue Breakell, 'The Exercise of a Peculiar Art-Skill': Kenneth Clark's Design Advocacy and the Council of Industrial Design, unpublished at the time of going to press
20. Ruskin, *Lectures on Art*, inaugural lecture, para 6
21. Letter to Oscar Lundberg, 23 June 1942, Tate 8812/1/1/1–64
22. See letter from Clark to Henry Kowal, 5 May 1942, Saltwood. Kowal had written to Clark after hearing him on *The Brains Trust*
23. Tate 8812/2/5/1
24. Clark, *The Other Half*, pp.71–2
25. Clark, review in *New Statesman*, November 1944
26. Letter, 3 August 1945, Tate 8812/1/2/6601–6650
27. Letter from Myfanwy Piper to Clark, undated 1945, I Tatti

28. Letter from Berenson to Clark, 30 August 1945, Cumming (ed.), *My Dear BB*, p.255
29. Interview with author
30. Letter from Gulbenkian to Clark, 12 May 1946, Tate 8812/1/4/1650
31. Letter from Morshead to Clark, 13 January 1947, I Tatti
32. Letter from Clark to the Lord Chamberlain, 28 September 1944, Tate 8812/1/4/248
33. Letter to Eric Maclagan, 10 October 1944, Tate 8812/1/4/248
34. Letter from Morshead to Clark, 25 October 1944, I Tatti
35. Letter from John Pope-Hennessy to Clark, 28 July 1945, Tate 8812/1/3/2551–2600
36. Clark, *The Other Half*, p.77
37. Letter from Morshead to Clark, 27 November 1945, I Tatti
38. Glasgow, *The Nineteen Hundreds: A Diary in Retrospect*, p.199
39. Clark, *The Other Half*, pp.74–5

Chapter 23: Writing and Lecturing

1. Clark, *The Other Half*, p.87
2. Interview with author
3. Letter to Michael Radcliffe, 10 August 1976, Tate 8812/1/4/426
4. Rothenstein, *Time's Thievish Progress*, p.48
5. Interview with author
6. Letter to Berenson, December 1945, Cumming (ed.), *My Dear BB*, p.256
7. Letter from Gulbenkian to Clark, 23 January 1946, Tate 8812/1/4/165c
8. Clark, *The Other Half*, p.126
9. On 21 March 1948 Clark gave a brilliant radio talk on Ruskin, interweaving his social and artistic theories and demonstrating how interchangeable they were
10. BBC, 'Interview with Basil Taylor', 8 October 1974, British Library National Sound Archive, Disc 196
11. Letter to Herbert Read, 10 March 1948, Tate 8812/1/2/5402–5450
12. Letter from Stephen Spender to Clark, 2 May 1963, Tate 8812/1/3/3001–3050
13. Professor J.R. Hale. Information from Sheila Hale

14. Letter to the Warden of New College, 18 April 1950, Saltwood

15. Letter from Colin Anderson to Clark, 31 March 1949, Tate 8812/1/4/285

16. See letter to Kurt Wolff, 5 October 1956, Tate 8812/1/4/286

17. John Walker in the *Burlington Magazine*, Vol. XCII, No. 573, December 1950, pp.357–8

18. Lees-Milne, *Midway on the Waves*, p.214 (entry for 24 October 1949)

19. Clark, *Landscape Into Art*, p.68

20. Ibid., p.143

21. Letter to Jock Murray, 3 May 1950, Tate 8812/1/4/285

22. Radio broadcast, BBC Third Programme, 13 June 1948

23. Pope-Hennessy, *Learning to Look*, p.120

24. See lecture, March 1964, Tate 8812/2/2/1042

25. Stonard, 'Looking for Civilisation' catalogue, 2014, p.24

26. Letter to Janet Stone, 7 May 1954, Bodleian Library

27. For a full discussion on the subject see Elam, 'Roger Fry and the Re-Evaluation of Piero della Francesca', Council of the Frick Collection Lecture Series

28. Letter to Dr Bela Horovitz, 16 June 1950, Tate 8812/1/4/336

29. Mario Salmi did, however, publish continuously about the artist from the 1940s onwards

30. I owe these observations to Caroline Elam

31. Letter to Carel Weight, 29 December 1949, Tate 8812/1/2/6851–6900

32. *Burlington Magazine*, June 1952, pp.175–8

33. Letter from Bowra to Clark, 27 March 1951, Tate 8812/1/4/342

34. See letter of resignation to Nikolaus Pevsner, 10 February 1948, Tate 8812/1/4/331

35. Letter to Jock Murray and list, undated, Tate 8812/1/1/29

36. Letter to Philip Lake, 3 July 1944, Tate 8812/1/4/151

37. Letter to Henry Kissinger, 17 April 1952, Tate 8812/1/2/1542

38. *Sunday Times*, 16 September 1984, p.42

39. Letter to Ben Nicolson, 5 September 1947, Tate 8812/1/3/2250–2300

40. Letter to Leonard Russell, 28 September 1951, Tate 8812/1/4/192

41. Letter to Charles Tennyson, 14 December 1943, Tate 8812/1/1/36

42. Letter to Berenson, 22 May 1948, Cumming (ed.), *My Dear BB*, p.289

43. Letter to Lord Ismay, 10 November 1948, Tate 8812/1/4/151

44. Letter to Berenson, 16 November 1949, Cumming (ed.), *My Dear BB*, pp.321–2

45. Letter to E.L. Woodward, 18 July 1949, Tate 8812/1/2/7152–7200

46. Letter to Gavin Stamp (who had reminded him of this fact), 20 April 1979, Stamp Archive

47. Letter to Janet Stone, 29 March 1958, Bodleian Library

48. 'Ornament in Modern Architecture', *Architectural Review*, December 1943

49. See letter to Betjeman, 20 December 1951, Tate 8812/1/3/328

50. Letter to M. Salaman, 26 July 1949, Tate 8812/1/2/5854

Chapter 24: Upper Terrace

1. The article later appeared in English in *Vogue*

2. Cooper (ed.), *Great Private Collections*, Introduction, p.15

3. Lees-Milne, *Midway on the Waves*, p.168 (entry for 31 March 1949)

4. Ibid., p.184

5. Jebb (ed.), *Diaries of Cynthia Jebb*, 23 June 1947

6. Interview with author

7. The present Earl of Crawford in an interview with author

8. Interview with author

9. Letter from Jane to John Sparrow, undated, All Souls College

10. The highly romanticised film based on Colin's books *The Prince, the Showgirl and Me* and *My Week with Marilyn*

11. Letter to Berenson, 23 August 1948, Cumming (ed.), *My Dear BB*, p.294

12. Interview with author. The following year Jane had a twisted intestine. See letter from Clark to Myfanwy Piper on the subject, 4 October 1952, Tate 200410/1/1/793

13. Letter to Berenson, 6 October 1951, Cumming (ed.), *My Dear BB*, p.352

14. Trewin, *Alan Clark: The Biography*, p.73
15. Letter from Betjeman to Jane Clark, 16 November 1949, Lycett Green (ed.), *John Betjeman: Letters, Vol. I: 1926–1951*, p.496
16. Letter from Jane to Colin Anderson, undated, private collection
17. Grigson, *Recollections: Mainly of Writers and Artists*, p.163
18. Colin Clark, *Younger Brother, Younger Son*, p.20
19. See letter to Hugh Brigstoke, 14 March 1973, Tate 8812/1/4/111
20. See letter to Frederick Hartt, 22 June 1972, Tate 8812/1/4/15
21. Letter to Francis Brennan, 22 January 1952, Tate 8812/1/2/6438
22. Letter from Jane to Eric Westbrook, 16 February 1949, Tate 8812/1/4/107
23. Bowness, *British Contemporary Art 1910–1990*, Introduction, p.9
24. See list at Tate 8812/1/4/232
25. Bought from Agnew in 1951 for £6,000. It initially hung in the dining room at Upper Terrace House
26. Letter from Mary Kessell to Clark, undated, 1945, I Tatti
27. Letter to Berenson, 5 April 1947, Cumming (ed.), *My Dear BB*, pp.261–2
28. Letter from Berenson, 2 April 1951, ibid., pp.343–5
29. Letter from Mary Kessell to Clark, 4 November (no year), I Tatti
30. Information from the family
31. Letter to Mary Potter, 27 March 1949, private collection
32. Letter to Mary Potter, undated, c.1950, private collection
33. Interview with Colin Clark in John Wyver's film *K: Kenneth Clark 1903–1983*, 1993
34. Letter to Morna Anderson, 23 April 1949, private collection
35. Letter to Morna Anderson, 25 September 1949, private collection
36. Clark, *The Other Half*, p.42
37. Letter from Janet Stone to Clark, dated 'Wed', c.1948, Bodleian Library

Chapter 25: Town and Country

1. Letter to Ben Nicolson, 14 February 1952, *Burlington Magazine* Archive
2. Information from Peter Rumley
3. Clark had first spotted Berger's writing in the *New Statesman*; when the Faber publisher Charles Monteith asked for his opinion of a book on recent developments in the arts, Clark responded: 'I would find it more amusing if you commissioned Mr Henry [sic] Berger whose criticisms … are uneven but stimulating and written from what might be called an enlightened (and therefore unorthodox) Marxist point of view.' Letter to Charles Monteith, 8 March 1954, Tate 8812/1/2/2143
4. Letter to Janet Stone, 24 February 1959, Bodleian Library
5. Letter to Colin Agnew, 6 February 1947, Tate 8812/1/2/51–100, probably referring to the *Immaculate Conception* at Melbourne
6. See report by Director of National Gallery of Victoria, Tate 8812/1/4/269
7. £14,000 from the Radnor Collection
8. Speech to NACF, 14 June 1967, Tate 8812/2/2/670
9. Letter from Professor Joseph Burke to Clark, 30 January 1948, Tate 8812/1/4/33
10. Letter to Jane, undated, c.January 1949, Saltwood
11. Secrest, *Kenneth Clark*, p.174
12. Colin Clark, *Younger Brother, Younger Son*, p.43
13. Letter to Berenson, 28 March 1949, Cumming (ed.), *My Dear BB*, p.306
14. Interviewed 21 January 1949
15. 'The Idea of a Great Gallery', lecture delivered at University of Melbourne, 27 January 1949
16. For an excellent account of the visit see Simon Pierse, 'Sir Kenneth Clark: *Deus ex Machina* of Australian Art', in Marshall (ed.), *Europe and Australia*, p.105
17. Clark, *The Other Half*, p.155
18. Clark got the price wrong, and quoted £250 instead of the correct amount, £350
19. See Tate 8812/11/4/5
20. See Pierse in Marshall (ed.), *Europe and Australia*, p.107

21. The account in the autobiography is inaccurate, and does not acknowledge Burke's role. See Pierse, ibid.
22. Clark, *The Other Half*, p.151
23. Letter from Clark to Nolan, 16 February 1950, Tate 8812/1/5/2264
24. See Pierse in Marshall (ed.), *Europe and Australia*, p.116
25. Ibid., p.113
26. Clark had managed to get Frederick Ashton temporarily out of the RAF for the ballet *Quest*. Jane adored him
27. Letter from Audrey Scales to author, 25 July 2014
28. Drogheda, *Double Harness: Memoirs*, p.225
29. Ibid., p.240
30. Interview in 'Remarks at the National Gallery of Art Washington on being awarded the Art Medal', 18 November 1970
31. Letter to Janet Stone, 11 January 1957, Bodleian Library
32. Sinclair, *Arts and Cultures*, p.123
33. Ibid.
34. Interview with author
35. Letter to author, 3 June 2014
36. There is a photograph of the office when Clark occupied it in *The Survey of London, Vol. XXX: The Parish of St James Westminster*, London 1960, plate 139
37. Interview with author
38. Nicolson (ed.), *Harold Nicolson: Diaries and Letters 1945–1962* (entry for 21 December 1954)
39. Letter from Raymond Mortimer to Clark, 22 December 1954, Saltwood
40. Letter to Janet Stone, 16 October 1957, Bodleian Library
41. Letter from Bill Williams to Clark, 29 April 1960, Tate 8812/1/3/3451–3500
42. Letter to Janet Stone, 27 March 1960, Bodleian Library
43. Letter to Janet Stone, 24 July 1961, Bodleian Library
44. Interview with author

Chapter 26: The Naked and the Nude

1. Clark, *The Other Half*, p.87
2. Letter to Edith Sitwell, 10 November 1950, Sitwell Collection, Harry Ransom Center, University of Texas
3. Letter to David Finley, 6 November 1950, Tate 8812/1/4/13
4. The Trees were socialites who for a time owned Ditchley Park, Oxon. Nin Ryan was a socialite. The Wrightsmans were major art collectors who were to play a big role in Clark's life in the future
5. Letter to Berenson, 8 December 1950, I Tatti
6. Dean Acheson, statesman; Joe Alsop, journalist friend of John F. Kennedy; Walter Lippmann, journalist; Felix Frankfurter, justice and friend of US presidents
7. Letter to John Walker, 17 October 1950, Tate 8812/1/4/13
8. Letter from John Walker to Clark, 27 October 1950, Tate 8812/1/4/13
9. See letter to Jock Murray, 26 June 1950, Tate 8812/1/4/285
10. The terms were 15 per cent on the first 5,000 copies sold in the UK, rising to 17½ per cent thereafter. In America the publisher was the Bollingen Foundation, which offered a flat 10 per cent on all copies sold
11. Letter to Mary Potter, 15 August 1952, Potter Archive
12. Clark, *The Nude*, p.xxi
13. Letter to Jock Murray, 1 September 1951, Tate 8812/1/4/285
14. Letter to Mary Potter, 23 September 1950, private collection
15. Two letters to G.L. Pritt, 14 January and 25 February 1952, Tate 8812/1/2/101– 150. His proposal was not to have grander wines, but good cheap wines
16. Letter to John Walker, 16 February 1953, Tate 8812/1/4/13
17. Letter to Berenson, 20 January 1953, Cumming (ed.), *My Dear BB*, p.373
18. Letter from Walter Lippmann to Clark, 24 March 1953, Stirling Library, Yale
19. Clark, *The Nude: A Study of Ideal Art*, Preface, p.xxi
20. Letter from Gertrud Bing to Clark, 31 January 1957, Tate 8812/1/4/314
21. See Introduction to Japanese edition of *The Nude*, Tate 8812/1/4/356
22. Ibid.
23. Clark, *The Nude: A Study of Ideal Art*, p.245

24. John-Paul Stonard's essay on *The Nude* in Shone and Stonard (eds), *The Books that Shaped Art History*, Chapter 8, and Clark, *The Nude: A Study of Ideal Art*, p.110

25. Letter from Gertrud Bing to Clark, 31 January 1957, Tate 8812/1/4/314

26. Letter from Berenson, 9 December 1956, Cumming (ed.), *My Dear BB*, p.433

27. Letter from Bowra to Clark, 10 December 1956, I Tatti

28. See Nead, *The Female Nude: Art, Obscenity and Sexuality*

29. See John-Paul Stonard's essay on *The Nude* in Shone and Stonard (eds), *The Books that Shaped Art History*, Chapter 8, and Clark, *The Nude: A Study of Ideal Art*

30. See Clark's 'Motives' in Meiss (ed.), *Problems of the 19th and 20th Centuries: Studies in Western Art*, pp.189–205

31. Letter to Janet Stone, 31 July 1961, Bodleian Library

32. BBC, 'Interview with Basil Taylor', 8 October 1974, British Library National Sound Archive, Disc 196

33. Letter to Janet Stone, 23 July 1967, Bodleian Library

34. Letter to Janet Stone, 29 October 1961, Bodleian Library

35. Letter to Janet Stone, 12 September 1966, Bodleian Library. Francis Haskell and Michael Jaffé were to become the respective heads of the art history departments at Oxford and Cambridge

36. Erwin Panofsky (1892–1968). Letter to Sir Humphrey Milford at the Oxford University Press, 9 July 1942, Tate 8812/1/1/3

37. Letter to Noel Annan, 6 April 1951, Tate 8812/1/1/207

38. Letter to Antal, 20 May 1949, Tate 8812/1/2/222

39. 'Apologia of an Art Historian', the inaugural address on the occasion of his election as President of the Associated Societies of the University of Edinburgh, 15 November 1950

40. Lecture, 'Is the Artist Ever Free?', Tate 8812/2/2/61

41. Clark, *The Other Half*, p.93

42. Review, 'Stories of Art', *New York Review of Books*, 24 November 1977

43. Letter from Audrey Scales to author, 25 July 2014

44. Letter to Janet Stone, 11 September 1957, Bodleian Library

45. Professor Christopher Brown, the former director of the Ashmolean Museum, told the author that it was reading *Ruskin Today* that made him want to become an art historian

46. Interview with author

47. Lugt was the author of the Louvre Rembrandt catalogue

48. Letter to Janet Stone, 4 February 1964, Bodleian Library

49. Interview with author

50. Letter to Janet Stone, 7 August 1966, Bodleian Library: 'No idea how Rembrandt will be received – the few who have read it seem pleased only they don't seem to cotton on to the thing I value most – that it is an attempt to study the creative process'

51. Letter to Janet Stone, 2 October 1966, Bodleian Library

Chapter 27: Inventing Independent Television: 'A Vital Vulgarity'

1. Cumming (ed.), *My Dear BB*, p.417

2. *Sunday Times*, 8 July 1973

3. There was already a growing audience for commercial radio stations based in Luxembourg and Normandy

4. Interview in John Wyver's film *K: Kenneth Clark 1903–1983*, 1993

5. Bow Dialogue with Betty McCulloch, 14 October 1975, British Library National Sound Archive

6. Tate 8812/2/2/1029

7. Interview with author

8. Interview with author. Sir Denis Forman (1917–2013) became the driving force behind Granada Television

9. Letter to Janet Stone, 4 August 1954, Bodleian Library

10. Clark, *The Other Half*, p.140

11. Interview with author

12. Sendall, *Independent Television in Britain: Vol. I*, p.59

13. Ibid., p.66, memo, 25 September 1954

14. Ibid.

15. Ibid., p.87

16. Letter to Sir Robert Renwick of ABDC, 25 November 1954. Renwick was in negotiation with the *News of the World*

and the *Daily Express*. Bournemouth ITA Archive, Box 750 IBA/01204. It was the rejection of the ABDC as a newspaper owner that caused Sir Charles Colston to resign

17. In the end the Kemsley Group did not proceed

18. Speech, 27 July 1956, quoted in Sendall, *Independent Television in Britain: Vol. I*, p.149

19. In April 1956 ATV directors went to see Clark, as a crisis was looming. The company was losing £1 million a year, and its capitalisation needed reconstruction

20. Letter to Janet Stone, 16 September 1955, Bodleian Library

21. Letter to Janet Stone, 17 December 1955, Bodleian Library

22. Letter to BBC director George Barnes, 7 September 1957, King's College, Cambridge GRB/1/1/9

23. Interview with Willa Petschek, *New York Times*, 3 May 1976. Sidney Bernstein at Granada was based in Manchester. His company gave the world *Coronation Street*. ATV produced the equally popular *Emergency Ward 10*

24. Interview in John Wyver's film *K: Kenneth Clark 1903–1983*, 1993

25. Interview with author

26. See Bournemouth ITA Archive, ITA 55/30

27. Quoted in Sendall, *Independent Television in Britain: Vol. I*, p.112

28. 'From the Few to the Many', a lecture on broadcasting that Clark gave in differing forms, Tate 8812/1/2/4893

29. Letter to Lord Hill, 30 May 1956, ITA 2008

30. See Fraser memo, 7 March 1955, ITA 55/30

31. Such a programme subsequently existed. Memo, 11 August 1956, ITA Box 254

32. Letter to Janet Stone, 2 August 1956, Bodleian Library

33. Letter to Janet Stone, 22 August 1956, Bodleian Library

34. Letter to Janet Stone, 13 November 1956, Bodleian Library

35. Hill, *Both Sides of the Hill: The Memoirs of Charles Hill, Lord Hill of Luton*, p.169

36. Letter to Berenson, 7 September 1957, I Tatti

37. Pilkington Report, 1962, Vol. II, Appendix E, p.1113

38. Sendall, *Independent Television in Britain: Vol. I*, p.113

39. Interview in John Wyver's film *K: Kenneth Clark 1903–1983*, 1993

Chapter 28: The Early Television Programmes

1. Clark, *The Other Half*, p.214

2. BBC, *The Future of Television*, transmitted 1 November 1957

3. See John Wyver, 'Kenneth Clark: A Selected Filmography' in 'Looking for Civilisation' catalogue, 2014

4. Interview with author

5. Ibid.

6. Letter from Robert Peace Heller to Clark, 19 September 1957, Tate 8812/1/4/32

7. Letter to Benjamin Britten, 17 January 1958, Britten/Pears Archive

8. Clark wrongly stated that this dog belonged to his other son, Alan

9. Clark, *The Other Half*, p.207

10. Letter to Quentin Lawrence, 18 March 1958, Tate 8812/1/4/72

11. Ibid.

12. Interview with author

13. Broadcast 1 December 1958

14. Interview with author

15. Ibid.

16. Letter to author from Audrey Scales, 6 October 2014

17. Interview with author

18. Ibid.

19. Letter to Ben Nicolson, 26 July 1974, Tate 8812/1/4/68

20. BBC Radio London, 27 August 1976, British Library Sound Archive

21. *News Chronicle*, December 1959, Tate 8812, Press cuttings

22. Interview with Fram Dinshaw in John Wyver's film *K: Kenneth Clark 1903–1983*, 1993

23. Letter to Robert Heller, 24 February 1959, Tate 8812/1/4/32

24. Letter to Robert Heller, 14 January 1960, Tate 8812/1/4/32

25. Letter to Clark from Robert Heller, 27 March 1960, Tate 8812/1/4/32

26. Letter to Janet Stone, 19 September 1964, Bodleian Library
27. Letter to Clark from J.R. Ackerley, 17 December 1964, Tate 8812/1/3/1–50
28. ATV had generally paid Clark £600 a programme. See Tate 8812/1/4/408
29. Letter to Janet Stone, 8 April 1966, Bodleian Library
30. According to Cecil Beaton, Clark was told to delete the word 'sycophants' when describing the courtiers of Henry VIII. See Vickers (ed.), *Beaton in the Sixties: More Unexpurgated Diaries*, pp.164–5 (entry for 24 December 1966)
31. Letter to Lord Crawford, 10 October 1966, Tate 8812/1/4/140
32. Letter to Janet Stone, 7 February 1966, Bodleian Library
33. 'You know I had the same crew throughout; Tubby [Englander] has received lots of praise, and deservedly, but more should be said about Ken Macmillan who has the best eye of the lot.' See letter to Anthony de Lotbinière, 27 February 1969, Tate 8812/1/4/98b
34. Interview with author
35. Letter to Janet Stone, 21 October 1966, Bodleian Library
36. Vickers (ed.), *Beaton in the Sixties: More Unexpurgated Diaries*, pp.164–5 (entry for 24 December 1966)
37. Letter to Clark from David Windlesham, 20 October 1966, Tate 8812/1/4/408
38. Letter from Michael Adeane to Clark, 24 October 1966, Tate 8812/1/4/408
39. Vickers (ed.), *Beaton in the Sixties: More Unexpurgated Diaries*, pp.164–5 (entry for 24 December 1966)

Chapter 29: Saltwood: The Private Man

1. Letter to Janet Stone, 13 December 1954, Bodleian Library
2. Letter to Berenson, 16 November 1957, Cumming (ed.), *My Dear BB*, p.450
3. I owe much of this account to the former Saltwood archivist, Margaret Slythe
4. Notes by Margaret Slythe sent to author, 23 January 2012
5. Colin Clark, *Younger Brother, Younger Son*, p.23
6. Letter to Janet Stone, 4 March 1959, Bodleian Library
7. Letter to Janet Stone, 8 June 1959, Bodleian Library
8. Later Lord and Lady Sainsbury of Preston Candover
9. Interview with Lord Sainsbury of Preston Candover
10. John Mallet, private diary, 2 September 1963
11. Letter to Janet Stone, 5 July 1964, Bodleian Library
12. Interview with author
13. Clark, *The Other Half*, pp.200–1
14. Notes given to the author
15. Letter to Janet Stone, 30 December 1965, Bodleian Library
16. Letter to Janet Stone, Christmas 1957, Bodleian Library
17. Letter to Janet Stone, 28 December 1958, Bodleian Library
18. Colin Clark, *Younger Brother, Younger Son*, p.12
19. Letter to Major Villiers, 24 February 1970, Tate 8812/1/4/398
20. He gave a lecture for them, entitled 'The Image of Christ: Painting and Sculpture', at Canterbury Cathedral, 4 November 1970
21. Letter to Janet Stone, 21 October 1954, Bodleian Library
22. Colin Clark, *Younger Brother, Younger Son*, p.209
23. Trewin, *Alan Clark: The Biography*, p.87
24. Letter from Berenson, 27 December 1957, Cumming (ed.), *My Dear BB*, p.452
25. Letter to Berenson, 14 July 1958, ibid., p.458
26. Interview with Audrey Scales
27. Letter to Janet Stone, 10 April 1960, Bodleian Library
28. Interview with author
29. Colin Clark, *Younger Brother, Younger Son*, p.8
30. Letter to Janet Stone, 5 June 1960, Bodleian Library
31. Violette Verdy rose to become the director of the Paris Ballet
32. Letter to Janet Stone, 21 February 1961, Bodleian Library
33. Letter to Janet Stone, 27 March 1961, Bodleian Library
34. Clark, *The Other Half*, p.192
35. Faith was the daughter of a diplomat, Sir Paul Wright

36. Undated, C.M. Bowra Archive, Wadham College, Oxford
37. When Jane became too lame to use the stairs, the Clarks moved to a ground-floor set
38. Interview with author. Joan Dawson was the Albany cook from the late 1960s through the 1970s, until Clark gave up the apartment
39. Interview with author
40. Ibid.
41. Ibid.
42. Ibid.
43. Letter to Janet Stone, 3 March 1957, Bodleian Library
44. Letter to Janet Stone, 26 April 1956, Bodleian Library
45. Letter to Janet Stone, 7 August 1956, Bodleian Library
46. Interview in John Wyver's film *K: Kenneth Clark 1903–1983*, 1993
47. John Mallet, private diary, 2 September 1963
48. Michael Levey, obituary of Kenneth Clark, *Proceedings of the British Academy*, Vol. LXX, 1984
49. Letter to Janet Stone, 16 October 1966, Bodleian Library
50. Letter to Janet Stone, 7 May 1954, Bodleian Library
51. Interview with Catherine Porteous
52. Letter to Janet Stone, 7 February 1954, Bodleian Library
53. Letter to Janet Stone, 2 July 1954, Bodleian Library
54. Letter to Janet Stone, 27 August 1956, Bodleian Library
55. Clark wrote the Introduction to Reynolds' book on engraved work published by John Murray in 1977
56. Email to author from Margaret Slythe
57. Letter to Janet Stone, 24 July 1956, Bodleian Library
58. Letter to Janet Stone, 16 March 1958, Bodleian Library. Letter from Myfanwy Piper, 12 March 1958, Tate 8812/1/3/2520
59. On the other hand there is an undated letter, c.March 1956, to Berenson from Washington, in which Clark describes making friends with Jayne Wrightsman
60. Interview with author
61. Jayne Wrightsman to Clark, undated, set of eight postcards (first one missing) at Saltwood. A greater mystery surrounds a set of intimate letters from Mrs Wrightsman at the Tate Archive. These were seen by Dr Fram Dinshaw at the end of a snowy afternoon c.January 1990. Even a hasty reading left him with the distinct impression that Jayne had been seriously contemplating elopement. On his next visit to the archive the letters had been removed from circulation, and they remain unavailable. Jayne Wrightsman paid for the Clark Archive at the Tate to be catalogued
62. Letter to Janet Stone, 25 June 1968, Bodleian Library
63. Interview with author
64. Her books, inscribed by Clark from 1967 onwards, are in the Delon Archive
65. Letter to Janet Stone, 6 September 1961, Bodleian Library
66. *Civilisation*, episode 13, *Heroic Materialism*, p.344
67. Interview with author
68. BBC, 13 September 1976
69. Tate 8812/2/2/1130; and BBC, 12 September 1976, British Library National Sound Archive
70. Letter to Janet Stone, 8 July 1957, Bodleian Library
71. Clark, *The Other Half*, p.108
72. Ibid.
73. 'Walter Pater', in *Moments of Vision*, p.139
74. See address at St James's Piccadilly, 19 March 1975, Tate 8812/2/2/905
75. Letter to Janet Stone, December 1971, Bodleian Library
76. Letter, 1 May 1972, Tate 8812/1/4/397
77. Letter to Rev William Baddeley, 1 January 1975, Tate 8812/1/4/393
78. Letter to Janet Stone, 11 August 1960, Bodleian Library
79. Letter to Janet Stone, 16 February 1958, Bodleian Library
80. Hardy and Pottle (eds), *Isaiah Berlin, Building: Letters 1960–1975*, p.431. Letter from Berlin to Nicolas Nabokov
81. Speech, 'Labour Art', 13 June 1962, Tate 8812/2/2/53
82. Letter to Janet Stone, 17 June 1970, Bodleian Library

Chapter 30: Public Man: The 1960s

1. Letter to Janet Stone, 31 December 1959, Bodleian Library
2. Letter to Janet Stone, 16 April 1966, Bodleian Library. Clark's committees did not abate in the 1960s, during which he added the Advisory Panel of the V&A and the board of the Scottish National Gallery to the roster. In 1965 Rupert Hart-Davis offered him the presidency of the London Library, of which he was not a member at the time, but he accepted
3. Letter to Janet Stone, 6 November 1960, Bodleian Library
4. Walker, *Self-Portrait with Donors: Confessions of an Art Collector*, p.292
5. Letter to Janet Stone, 23 November 1959, Bodleian Library
6. BBC Radio 4, *The World at One*, 12 January 1978, British Library National Sound Archive, Disc 198
7. Colin Clark, *Younger Brother, Younger Son*, p.171
8. Clark, 'Aesthete's Progress', John Murray Archive. This was probably the exhibition of Peggy Guggenheim's collection of the artist at the Correr Museum in July/August 1950. Her own museum opened the following year
9. See Bow Dialogue, 14 October 1975, British Library National Sound Archive. A Pollock painting even makes a brief appearance in *Civilisation* – see episode 11, *The Worship of Nature*
10. Ibid.
11. *Kenneth Clark, Moments of Vision: In Honour of the Centenary of His Birth, 1903–1983*, p.49, 'Iconophobia'
12. Interview with John Hubbard
13. Letter to Sir Murray Porter, 21 July 1975, Tate 8812/1/3/2727
14. Michael Gill, unpublished notes for autobiography, John Murray Archive
15. Letter to Meryle Secrest, 28 August 1970, I Tatti
16. Letter from Jane Clark to Margery and David Finley, April 1964, David Finley Papers, NGA Washington, 28A1 Box 4. I am grateful to John-Paul Stonard for pointing out this letter

17. *Kenneth Clark, Moments of Vision: In Honour of the Centenary of His Birth, 1903–1983*, 'The Blot and the Diagram'
18. Letter from John Russell to Clark, 22 December 1962, Tate 8812/1/3/2769
19. Letter to Myron Gilmore, 7 October 1970, Tate 8812/1/4/198. See also Partridge, *Ups and Downs: Diaries* (entry for 20 February 1963), where she records a discussion about the article with Raymond Mortimer, who was impressed by it. She was not
20. Tate 8812/2/2759
21. Letter from Sir William Emrys Williams to Clark, 5 February 1964, Tate 8812/1/4/239
22. 'A Failure of Nerve: Italian Painting 1520–1535', H.R. Bickley Memorial Lecture, Oxford 1967
23. Speech, 8 March 1965, Tate 8812/1/4/293
24. Letter to Raymond Mortimer, 27 October 1950, Tate 8812/1/2/4487
25. Clark had in fact been invited to join the PR committee of a nascent National Theatre in 1937, and had tried to establish a National Theatre at the outbreak of war as a rallying symbol. See Elsom and Tomalin (eds), *The History of the National Theatre*, p.168
26. Letter to Lord Chandos, 26 July 1960, Tate 8812/1/4/292
27. Letter to Kenneth Rae, 1 September 1960, Tate 8812/1/4/292
28. Letter to Olivier, 5 October 1960, Tate 8812/1/4/292. O'Rorke had been on the case throughout the 1950s, but his role was superseded shortly afterwards
29. Letter to Janet Stone, 26 July 1960, Bodleian Library
30. Letter to Prince Littler, 25 August 1960, Tate 8812/1/4/292
31. Letter to Olivier, 29 October 1960, Tate 8812/1/4/292
32. Ibid.
33. Letter from Oliver Chandos to Clark, 2 December 1960, Tate 8812/1/4/292
34. Letter to Olivier, 14 December 1960, Tate 8812/1/4/292
35. The crucial influence was Sir Isaac Hayward, leader of the London County Council
36. Letter to Janet Stone, 7 August 1962, Bodleian Library

37. Jennie Lee, later Lady Lee of Asheridge (1904–88), was appointed the first Minister of the Arts 1964–1970
38. Lewis, *The National*, p.35
39. Interview with author
40. Letter to Sir Ashley Clarke, 9 August 1966, Tate 8812/1/4/122–127
41. Letter to Janet Stone, 6 August 1965, Bodleian Library
42. Daniel Rosenthal, *The National Theatre Story*, p.89
43. Letter to Olivier, July 1966, Tate 8812/1/4/292
44. Letter from Chandos to Clark, 29 July 1966, Tate 8812/1/4/292
45. Letter to Chandos, 3 August 1966, Tate 8812/1/4/292
46. Lewis, *The National*, p.35
47. Letter to Janet Stone, 5 May 1967, Bodleian Library
48. Letter to Kenneth Rae, 29 February 1968, Tate 8812/1/4/292
49. Letter to Janet Stone, 12 February 1968, Bodleian Library
50. Clark would occasionally intervene over purchases such as a Byzantine steatite relief carving in the style of an ivory, the authenticity of which worried him. See letter to R.L.S. Bruce-Milford, 11 July 1972, Tate 8812/1/4/228
51. Letter from John Pope-Hennessy to Colette Clark, 25 May 1983, private collection
52. Letter to Basil Gray, 19 February 1964, Tate 8812/1/4/227
53. Letter to Janet Stone, 9 February 1964, Bodleian Library
54. Letter to Lord Eccles, 17 October 1969, Tate 8812/1/4/226
55. See 'Trustees Policy on Acquisitions' paper, Tate 8812/1/4/226
56. Speech to NACF, 14 June 1967, Tate 8812/2/2/670
57. Letter to Bentley Bridgewater, 31 March 1970, Tate 8812/1/4/228
58. Letter to Thomas Bodkin, 3 September 1943, Tate 8812/1/1/17

Chapter 31: *Civilisation*: The Background

1. Interview with author
2. *Civilisation* DVD extra
3. Interview with author
4. Clark, *The Other Half*, p.210
5. Clark, 'Looking for Civilisation', lecture, Tate 8812/2/2/174
6. Letter from Humphrey Burton to Clark, 6 October 1966, Tate 8812/1/4/89
7. Letter to David Attenborough, 6 October 1966, Tate 8812/1/4/90
8. Clark, notebook, Tate 8812/2/1/11
9. Letter to Janet Stone, 2 October 1966, Bodleian Library
10. Clark, notebook, Tate 8812/2/1/11
11. Letter to Humphrey Burton, 8 December 1966, Tate 8812/1/4/90
12. Letter from Humphrey Burton to Clark, 28 November 1966, Tate 8812/1/4/89
13. *Civilisation* DVD extra
14. Interview with author
15. Ibid.
16. Ibid.
17. Letter to Janet Stone, 22 November 1966, Bodleian Library
18. Michael Gill, unpublished notes for autobiography, p.7, John Murray Archive. In fact, as his son Adrian believes, 'Michael Gill's career was in a difficult place when *Civilisation* came along. He had just made *Three Swings of the Pendulum* which was pretty bad.' Interview with author
19. Letter to Humphrey Burton, undated, Tate 8812/1/4/90
20. Michael Gill, unpublished notes for autobiography, pp.11–12, John Murray Archive
21. Colin Clark, *Younger Brother, Younger Son*, p.31
22. Letter to Janet Stone, 16 April 1967, Bodleian Library
23. Letter to Charles Wrightsman, 21 October 1969, Tate 8812/1/4/14a. Peter Montagnon had been involved in the infamous Berlin tunnel in his secret service days. He now lives in the south of France
24. Clark, *The Other Half*, p.211
25. Ibid., p.213
26. Ibid.
27. Interview with author
28. Ibid.
29. The contract file is at the BBC Archive, Caversham T53/175/1, or Tate 8812/1/4/55

30. See letter from David Attenborough to Clark, 21 October 1970, Tate 8812/1/4/88
31. *Civilisation* DVD extra
32. Interview with author
33. Ibid.
34. 'Looking for Civilisation', Tate 8812/2/2/174
35. British Library Sound Archive
36. Letter to Janet Stone, 6 November 1966, Bodleian Library
37. Undated interview with Clark, John Murray Archive
38. The clipboards throughout the production read 'Western Civilisation'

Chapter 32: The Making of *Civilisation*

1. BBC, British Library National Sound Archive, Disc 199
2. Interview with Meryle Secrest, 24 March 1969, *Washington Post*, Tate 8812, Press cuttings
3. Michael Gill, unpublished notes for autobiography, pp.3 and 9, John Murray Archive
4. Letter to Janet Stone, 11 May 1967, Bodleian Library. Lily of the valley was Clark's favourite flower
5. Letter to Janet Stone, 30 April 1967, Bodleian Library
6. Clark, *Civilisation* (book of the series), Introduction, p.xvii
7. BBC Radio 4, *Archive on 4: Seeing Through the Tweed*, broadcast 28 November 2009
8. Letter to Janet Stone, 21 July 1967, Bodleian Library
9. *Radio Times*, 8 December 1970, Tate 8812/1/4/88
10. BBC Radio 4, *Archive on 4: Seeing Through the Tweed*, broadcast 28 November 2009
11. Interview with author
12. Ibid.
13. Ibid.
14. Letter to Janet Stone, 5 March 1968, Bodleian Library. The convoy consisted of two Commer vans, two station wagons and a Land Rover, plus crew cars
15. Letter to Jock Murray, 10 May 1967, John Murray Archive
16. Interview with author

17. Ibid.
18. Ibid.
19. Ibid.
20. Ibid.
21. Ibid.
22. Letter to Carol Jones, 19 January 1968, Tate 8812/1/4/90
23. Interview with author
24. Letter to Nicky Mariano, 16 March 1967, Tate 8812/1/4/198
25. Interview with author
26. Ibid.
27. Ibid.
28. Interview with Adrian Gill
29. Letter to Charles Wrightsman, 21 October 1969, Tate 8812/1/4/14a
30. Interview with author
31. Letter to Charles Wrightsman, 21 October 1969, Tate 8812/1/4/14a
32. Michael Gill, unpublished notes for autobiography, p.3, John Murray Archive
33. Ibid., p.10
34. Letter to Janet Stone, 1 March 1968, Bodleian Library
35. Interview with author
36. Interview in John Wyver's film *K: Kenneth Clark 1903–1983*, 1993
37. Letter to Janet Stone, 13 August 1967, Bodleian Library
38. Interview with author
39. Ibid.
40. Letter from Michael Gill to Clark, 26 October 1967, Tate 8812/1/4/90
41. Letter to Mary Potter, 16 February 1968, Potter Archive
42. Interview with author
43. *Civilisation* DVD extra
44. Ibid.
45. Interview with author
46. Today he thinks it was a good idea – interview with author
47. Letter to Charles Wrightsman, 21 October 1969, Tate 8812/1/4/14a
48. Letter to Janet Stone, September 1968, Bodleian Library
49. Letter to Janet Stone, 19 August 1968, Bodleian Library
50. Interview with author
51. Letter to Janet Stone, 25 February 1968, Bodleian Library
52. Letter to Janet Stone, 13 October 1968, Bodleian Library
53. Clark, *The Other Half*, p.222

54. Interview with author
55. Clark, *The Other Half*, p.222
56. Letter to David Attenborough, 5 October [1968?], Saltwood
57. Letter from Michael Gill to Clark, 26 October 1967, Tate 8812/1/4/90

Chapter 33: *Civilisation* and its Discontents

1. Letter from Clark to Mme Auerbacher-Weil, 7 0ctober 1970, Tate 8812/1/4/356
2. *Civilisation* DVD extra
3. 'For a Million Noblemen', *The Listener*, 15 January 1970, pp.90–1
4. Michelet's *History of France*, Tawney's *Religion and the Rise of Capitalism*, and Ranke's *History of the Popes*
5. Letter to Janet Stone, 28 January 1968, Bodleian Library
6. At Clark's memorial service; published in *Apollo*, January 1984
7. Letter to Janet Stone, 14 January 1968, Bodleian Library
8. Ibid.
9. Ibid.
10. Lecture, 'Apologia of an Art Historian', 1950
11. Ibid.
12. Review reprinted as 'On Dover Beach' in *The Seventies*, 1980
13. Included in E.M. Forster, *Two Cheers for Democracy*, p.77
14. Partridge, *Good Company: Diaries*, p.199 (entry for 20 May 1969)
15. Interview with author
16. Walker, *Arts TV: A History of Arts Television in Britain*, p.3
17. Postcard to Colin Anderson, 21 May 1969, private collection
18. *The Times*, 17 May 1969, and *Sunday Times*, 25 May 1969
19. *Observer*, 30 November 1969
20. 'Poor B.B.', *The Listener*, 20 March 1969
21. *New Statesman*, 19 February 1971, p.251
22. Letter to A.J.D. Eton, 6 September 1973, Tate 8812/1/4/91
23. BBC Radio 4, *Lord Clark: Servant of Civilisation*, presented by Miranda Carter, produced by Thomas Morris, broadcast 3 July 2003
24. Letter to Huw Wheldon, 4 June 1969, Tate 8812/1/4/89. Father Martin D'Arcy

was a fashionable Jesuit priest who converted many high-profile people
25. Letter to Janet Stone, 23 March 1969, Bodleian Library
26. Letter from Betjeman to Clark, 3[?] February 1969, Tate 8812/1/4/98a
27. Drummond, *Tainted by Experience*, pp.181–2
28. Letter from Bryan Magee to Clark, 2 January 1970, Tate 8812/1/4/356
29. Letter to Janet Stone, 10 January 1970, Bodleian Library
30. Letter from David Knowles to Clark, 6 January 1970, I Tatti
31. Letter to Professor North, 1 March 1977, Tate 8812/1/4/386
32. BBC Radio 4, *Archive on 4: Seeing Through the Tweed*, presented by Richard Weight, broadcast 28 November 2009
33. Vickers (ed.), *Beaton in the Sixties*, p.384
34. Clark's draft for the Introduction to the Spanish edition of *Civilisation*, Tate 8812/1/4/287
35. Letter from Sir Donald Hopson to Clark, 25 July 1972, Tate 8812/1/4/91
36. Letter to Sir Donald Hopson, 4 August 1972, Tate 8812/1/4/91
37. Clark was echoing a passage in which Ruskin contrasts Dürer's portrait of Erasmus with that by Holbein
38. BBC Radio 4, *Lord Clark: Servant of Civilisation*, presented by Miranda Carter, produced by Thomas Morris, broadcast 3 July 2003
39. David Cannadine, 'Kenneth Clark: From the National Gallery to National Icon', Linbury Lecture, National Gallery 2002, pp.17–18
40. Letter to Michael Kitson, 4 March 1969, Tate 8812/1/4/98a
41. *Sunday Times*, 8 July 1973
42. *Sunday Times*, 16 September 1984
43. BBC Radio 4, *Archive on 4: Seeing Through the Tweed*, presented by Richard Weight, broadcast 28 November 2009
44. Interview with author
45. Ibid.

Chapter 34: Apotheosis: Lord Clark of Civilisation

1. Clark, *The Other Half*, p.244
2. Briggs, *The BBC: The First Fifty Years*, p.339
3. Information from Colette Clark
4. Interview with author
5. Letter from Clark to John Lappin, 29 December 1970, Tate 8812/1/4/94a
6. Walker, *Self-Portrait with Donors: Confessions of an Art Collector*, pp.285–7
7. By way of explanation Clark wrote Charles Wrightsman a fascinating letter about the series and its production, 21 October 1969, Tate 8812/1/4/14a
8. The full story of the race between New York and Washington is told in Harris, *Capital Culture: J. Carter Brown, the National Gallery of Art, and the Reinvention of the Museum Experience*, pp.180–3
9. Letter from Charles Wrightsman to Clark, 5 November 1969, Tate 8812/1/4/14a
10. Harris, *Capital Culture*, p.183
11. Cannadine, *The Undivided Past*, chapter on *Civilisation*
12. Letter from James M. Hester to Peter Robeck, 15 January 1970, Tate 8812/1/4/14b
13. Clark, *The Other Half*, p.225
14. Ibid., pp.245–6
15. Ibid., p.225
16. Interview with author
17. Clark described the discussion in a speech at York University, July 1970, Tate 8812/2/2/1145
18. Letter to Stephen Hearst, 3 March 1970, Tate 8812/1/4/56a
19. Colin Clark, *Younger Brother, Younger Son*, p.149
20. Letter to David Attenborough, 9 March 1970, Tate 8812/1/4/55; letter to Pat Outram, 10 March 1970, Tate 8812/1/4/55
21. Letter to Janet Stone, 24 August 1970, Bodleian Library
22. Letter to David Attenborough, 28 October 1970, Tate 8812/1/4/88
23. Letter to Prof R.W.B Lewis, 4 January 1971, Tate 8812/1/3/3401–3450
24. Letter to Janet Stone, 16 February 1969, Bodleian Library
25. Clark was asked by his publisher John Murray to sign a letter of release from the BBC – his original contract obliged him to pay the BBC 25 per cent of his receipts if the book was published by anybody else
26. Letter from Michael Gill to Clark, 24 August 1969, Tate 8812/1/4/87
27. A note in the John Murray Archive dated 25 June 1981 reveals sales to be 532,016 in the UK and 1,561,799 in the USA
28. Letter to Janet Stone, 11 April 1975, Bodleian Library
29. Interview with Peter Quennell, *Saturday Review*, 28 August 1971, p.31
30. Letter to André de Vilmorin, 29 May 1972, Tate 8812/1/4/93
31. Letter to Pierre Berès, 9 May 1974, Tate 8812/1/4/87
32. Letter to Janet Stone, 12 February 1969, Bodleian Library
33. Letter to Janet Stone, 16 February 1969, Bodleian Library
34. Clark was the subject of *Late Night Line-Up*, 28 February 1969, interviewed by Joan Bakewell. On 19 March he was Guest of the Week on *Woman's Hour*
35. Interview with Willa Petschek, *New York Times*, 3 May 1976
36. Letter to Michael Gill, 18 June 1969, Tate 8812/1/4/117
37. Letter to Lord Crawford, 21 January 1969, National Library of Scotland
38. Letter from Lord Goodman to Clark, 7 November 1969, Tate 8812/1/4/174
39. Letter from Morshead to Clark, 14 June 1969, Tate 8812/1/4/118
40. Letter from Bowra to Clark, 15 June 1969, Tate 8812/1/4/117
41. Hansard, Vol. CCCXIII, No. 38, p.1405
42. Speech, Tate 8812/1/4/173
43. Lord James (1909–92) was science master at Winchester 1933–45, headmaster of Manchester Grammar School 1945–62, and became York's first Vice-Chancellor in 1962. It appears to have been Professor Hans Hess, a historian then at York, who first mooted the idea of Clark for Chancellor
44. Letter to Miss Reader Harris, 21 June 1969, Tate 8812/1/4/118

45. Speech, York University, 13 July 1973. Clark enjoyed corresponding with Eric James, and wrote a particularly interesting letter about Platonic aesthetics, 3 March 1975, Tate 8812/1/2/1501
46. Letter to Eric James, 25 June 1969, Tate 8812/1/4/118
47. Julien Cain (1887–1974) was a member of the Académie des Beaux-Arts. Clark maintained that he had 'turned the Bibliothèque Nationale [of which he was director] from the worst to the best run library in the world', Tate 8812/1/4/43
48. BBC Radio 4, *Lord Clark: Servant of Civilisation*, presented by Miranda Carter, produced by Thomas Morris, broadcast 3 July 2003
49. *Civilisation* DVD extra
50. Letter to Sir William Haley, 12 July 1969, Tate 8812/1/4/118
51. Letter to Jock Murray, 16 March 1972, John Murray Archive

Chapter 35: Lord Clark of Suburbia

1. Quoted in eulogy at Isaiah Berlin's memorial service – see Huth, *Well-Remembered Friends*
2. Letter from Carel Weight to Clark, 6 February 1970, Tate 8812/1/4/367
3. Some of their mutual friends wrote to Clark, including Colin Anderson: 'one must write to someone about Maurice, so I write to you'. Bowra's old college, Wadham, commissioned a hideous statue which Clark unveiled
4. Letter to Janet Stone, 4 November 1969, Bodleian Library. No doubt he was also influenced by visits to John and Anya Sainsbury next door at Ashton, where Hugh Casson had built a long, low bungalow, but with much finer views than those of the Garden House
5. Letter to Janet Stone, 16 May 1970, Bodleian Library
6. Letter to Lord Crawford, 4 June1971, Crawford Papers, National Library of Scotland
7. Letter to Janet Stone, 10 July 1971, Bodleian Library
8. Letter to Janet Stone, 19 March 1971, Bodleian Library

9. Letter to Janet Stone, 5 July 1971, Bodleian Library
10. 5.30–7.30 p.m., 7 April 1971, Tate 8812/2/1/12
11. Letter to Janet Stone, 15 July 1971, Bodleian Library
12. Letter from Jane to Lord Crawford, undated, Crawford Papers, National Library of Scotland
13. Secrest, *Kenneth Clark*, p.40
14. Letter to Janet Stone, 26 November 1971, Bodleian Library
15. Postcard from Jane, 15 December 1972, private collection
16. Colette Clark, interview with author
17. Postcard to Morna Anderson, 12 May 1971, private collection
18. Vickers (ed.), *The Unexpurgated Beaton: The Cecil Beaton Diaries*, pp.377–80
19. Trewin, *Alan Clark: The Biography*, pp.237–8
20. Letter to Adey Horton, 8 January 1973, Tate 8812/1/4/362
21. Clark, *The Other Half*, p.204
22. Alan Clark, *Diaries: Into Politics 1972–1982* (entry for 6 December 1980). The books entered the Morgan Library in early 1981
23. Letter to Janet Stone, 17 January 1969, Bodleian Library
24. Letter to Stephen Hearst, 26 June 1970, Tate 8812/1/4/55
25. Letter to J. Carter Brown, 9 May 1972, Tate 8812/1/4/449
26. Interview with author. Robert McNab was a Courtauld student under Alan Bowness and John Golding: 'The view on K at the Courtauld was "not scholarship". They were nitpicking about *Leonardo*, although as students we were all the victims of *Civilisation*'
27. Interview with author
28. Clark, *The Other Half*, p.227
29. Clark, 'The Artist Grows Old', Rede Lecture, Cambridge 1972, p.21
30. Letter to Janet Stone, 2 August 1972, Bodleian Library
31. Lees-Milne, *A Mingled Measure*, p.265 (entry for 30 July 1971)
32. Letter to Carlo Pedretti, 5 March 1972, Tate 8812/1/4/330. The *Burlington Magazine* did run a glowing leader, 'Kenneth Clark at 70', in July 1973

33. Letter to *Apollo* magazine, 13 February 1970, Tate 8812/1/4/20
34. Letter to Raymond Mortimer, 22 October 1971, Tate 8812/1/4/338
35. House of Lords speech, 11 April 1973, Tate 8812/2/2/212
36. Letter to Lord Esher, 18 April 1973, Tate 8812/1/4/349b
37. Letter to Eric James, 3 July 1972, Tate 8812/1/4/471
38. Lees-Milne, *A Mingled Measure*, p.256
39. See correspondence, Tate 8812/1/4/439b
40. Letter to Philip Noel Baker, 31 July 1972, Tate 8812/1/4/39
41. Letter to Cecil Day-Lewis, 14 December 1969, Tate 8812/1/4/349a
42. Letter to Cyril Robinson, 6 May 1971, Tate 8812/1/4/349a
43. Letter to Rt. Hon. John Peyton, 21 September 1973, Tate 8812/1/4/335
44. Letter to Lord McLeod of Fuinary, 30 October 1972, Tate 8812/1/4/195
45. Letter to General Denniston, 11 March 1966, Tate 8812/1/4/399
46. Letter to Janet Stone, 30 May 1970, Bodleian Library
47. 'Venice in Peril', Keynote Lecture, Venice, 13 May 1972. The subject he chose was 'The Relations of Venice and Florence During the Renaissance'
48. Letter to Janet Stone, 12 November 1970, Bodleian Library
49. Letter to Jane, 8 March 1971, Saltwood
50. Letter to Janet Stone, 16 October 1973, Bodleian Library
51. Letter to Janet Stone, 25 October 1973, Bodleian Library
52. Clark, *Another Part of the Wood*, p.13
53. Letter to Janet Stone, 24 July 1970, Bodleian Library
54. Partridge, *Ups and Downs: Diaries* (entry for 23 June 1973)
55. Ibid.
56. Letter to John Eveleigh, 1973, Tate 8812/1/4/154
57. Letter to Meryle Secrest, 20 June 1971, I Tatti
58. Ibid., 24 November 1972
59. There is still a copy in the John Murray Archive. The date of the lunch was 18 July 1973
60. Clark, *The Other Half*, p.233
61. Letter to Colin Anderson, 12 December 1973, Tate 8812/1/3/64
62. Alan Clark, *Diaries: Into Politics 1972–1982* (entry for 26 December 1973)

Chapter 36: *Another Part of the Wood*

1. Letter to Janet Stone, 14 June 1974, Bodleian Library
2. Letter to Janet Stone, 25 September 1974, Bodleian Library
3. Catherine Porteous, unpublished diary (entry for 21 September 1974)
4. Letter to Sir William Collins, 16 July 1973, Tate 8812/1/4/113
5. Letter to Denys Sutton, 18 August 1972, Tate 8812/1/4/20
6. Letter to Philip Allott, 22 December 1974, Tate 8812/1/4/34
7. Letter from Rosamond Lehmann to Clark, undated, Tate 8812/1/3/1662/2
8. Letter from Lord Evans to Clark, 14 April 1976, Tate 8812/1/4/174
9. Letter to Jock Murray, 22 June 1974, Tate 8812/1/4/286, pt3
10. Clark was sufficiently anxious about libel to ask Charles Wrightsman for an introduction to the legal firm Slaughter & May
11. Letter from C. Burnet Pavitt to Clark, 18 October 1974, Tate 8812/1/4/34
12. Letter to Lord David Cecil, 23 January 1975, Tate 8812/1/4/34
13. Letter to Myfanwy Piper, 22 September 1974, Tate 200410/1/1793
14. Letter to Alix Kilroy, 2 December 1975, Tate 8812/1/3/1551–1600
15. *New York Times*, 30 March 1975
16. *Time* magazine, 21 April 1975
17. *Daily Telegraph*, 10 October 1974
18. *Guardian*, 10 October 1974
19. Letter to Michael Gill, 4 November 1974, Tate 8812/1/4/148
20. Letter to Mary Potter, 16 December 1974, Potter Archive
21. Screened 2 June 1975
22. Catherine Porteous, unpublished diary (entry for 18 November 1974)
23. Letter to Janet Stone, February 1975, Bodleian Library
24. Letter to Janet Stone, 2 March 1975, Bodleian Library

25. Letter to Munroe Wheeler, 29 July 1975, Beinecke Library, Yale
26. Interview with author. As chairman of Ashwood, Clark appointed Peter Montagnon and Eric James to the board
27. Letter to Myfanwy Piper, 22 September 1974, Tate 200410/1/1/793
28. Interview with author
29. See text at Tate 8812/1/4/1. Clark told Harry Abrams that the $1,000 offered for the Introduction to Vasari was not enough, given the labour of rereading all Vasari's *Lives* as well as over six hundred letters. He eventually received $2,500 for it. See letter, 15 December 1975, Tate 8812/1/4/1
30. Letter to Sir Bernard Miles, 14 August 1973, Tate 8812/1/3/2009
31. Clark, *The Other Half*, p.241
32. Ibid.
33. Speech, 26 June 1974, Tate 8812/1/4/174
34. See Tate 8812/1/4/432
35. Letter from Michael Astor to Clark, 17 February 1975, Tate 8812/1/4/237
36. Letter to Michael Astor, 28 February 1975, Tate 8812/1/4/237
37. Letter to Janet Stone, 9 February 1975, Bodleian Library
38. Bow Dialogue with Betty McCulloch, 23 November 1976, British Library National Sound Archive
39. Letter to Lord Annan, 14 April 1976, King's College, Cambridge
40. Unidentified correspondent
41. Letter to Janet Stone, 17 October 1976, Bodleian Library
42. Letter to Janet Stone, 11 March 1975, Bodleian Library
43. Letter to Janet Stone, 18 December 1975, Bodleian Library. Lord Crawford was certainly an admirer of Jane, and her letters to him at Edinburgh suggest a warm intimacy
44. Letter to Morna Anderson, 8 February 1976, private collection
45. Clark, *The Other Half*, p.242. See also description in Colin Clark, *Younger Brother, Younger Son*, p.7
46. Jane died on 14 November 1976. This account of her death is taken from Clark, *The Other Half*, p.243, and a letter to Meryle Secrest, 3 December 1976, I Tatti

47. Alan Clark, *Diaries: Into Politics 1972–1982* (entry for 14 November 1976)
48. Information from Colette Clark
49. Alan Clark, *Diaries: Into Politics 1972–1982* (entry for 31 January 1976)
50. Trewin, *Alan Clark: The Biography*, p.253
51. Letter to Myfanwy Piper, 27 November 1976, Tate 200410/1/1/793
52. Letter to Janet Stone, 8 July 1977, Bodleian Library
53. Letter from John Russell to Clark, 7 December 1977, and Clark's response, 20 December 1977, Tate 8812/1/3/2751–2800
54. Clark, *The Other Half*, p.xii
55. Letter to Mrs Huws Jones, Tate 8812/1/4/35
56. Peter Conrad in the *Times Literary Supplement*, 4 November 1977
57. Reprinted in *The Seventies*, pp.215–19
58. Letter to Janet Stone, 31 December 1976, Bodleian Library
59. Letter to Janet Stone, 13 August 1977, Bodleian Library
60. Colin Clark, *Younger Brother, Younger Son*, pp.6–7
61. Letter to Janet Stone, 18 August 1977, Bodleian Library
62. Letter to Colin Clark, 25 September 1977, private collection

Chapter 37: Last Years and Nolwen

1. She is the subject of a biography: *The Temptress*, by Paul Spicer
2. Colin Clark, *Younger Brother, Younger Son*, p.32
3. Roy Strong, *Diaries 1967–1987*, p.351
4. Ibid., p.350
5. Interview with author
6. Information from Mary Moore
7. Letter to Mary Potter, 2 August 1977, Potter Archive
8. Letter to Mary Potter, 3 October 1977, Potter Archive
9. Letter to Janet Stone, 9 October 1977, Bodleian Library
10. Letter from Janet Stone to Dr Frank Tait, 18 October 1977, Stone Archive
11. Letter to Clark from John Sparrow, 20 October 1977, Tate 8812/1/3/2901–2950
12. Letter to Morna Anderson, 5 December 1977, private collection

13. Information from Colette Clark
14. Lees-Milne, *Holy Dread*, p.143 (entry for 11 January 1984)
15. Interview with author
16. Letter to Janet Stone, 24 December 1977, Bodleian Library
17. Letter to Janet Stone, 18 August 1979, Bodleian Library
18. Interview with Colette Clark
19. Secrest, *Shoot the Widow*, p.41
20. Letter to Brinsley Ford, no date
21. Letter from John Sparrow to Clark, 11 March 1979, Tate 8813/1/3/2901–2950
22. Information from Lady Egremont
23. Information from Catherine Porteous
24. Letter to Janet Stone, 7 June 1978, Bodleian Library
25. Letter to Janet Stone, 21 July 1978, Bodleian Library
26. Letter to Janet Stone, 2 September 1978, Bodleian Library
27. Letter to Janet Stone, 22 June 1979, Bodleian Library
28. This letter, dated 23 March 1980, is in the Stone Archive at the Bodleian Library
29. Letter to Colette Clark, 1 July 1980, family possession
30. Letter to Janet Stone, 24 March 1976, Bodleian Library
31. Letter to Meryle Secrest, 20 February 1976, I Tatti
32. Secrest, *Being Bernard Berenson*. See review by John Pope-Hennessy, republished in his *On Artists and Art Historians*, pp.261–6
33. Letter to Meryle Secrest, 23 August 1977, I Tatti
34. Letter to Meryle Secrest, 5 July 1979, I Tatti
35. Letter to Meryle Secrest, 7 March 1979, I Tatti
36. Letter to Meryle Secrest, 23 July 1979, I Tatti
37. Letter to Mary Potter, 1 October 1979, Potter Archive
38. Lees-Milne, *Deep Romantic Chasm*, p.184 (entry for 6 November 1981)
39. Letter from Colin Anderson to Clark, 8 January 1980, private collection
40. Letter to Colette Clark, 1 July 1980, family possession
41. Letter to Alan Clark, 20 April 1979, Tate 8812/1/4/289

42. Letter to Janet Stone, 4 August 1980, Bodleian Library
43. Letter to Meryle Secrest, 8 October 1982, I Tatti
44. Letter to Janet Stone, January 1983, Bodleian Library
45. Letter to Jock Murray, 11 June 1982, Tate 8812/1/4/289
46. Letter to Jock Murray, 8 December 1980, Tate 8812/1/4/289. Quite a substantial fragment is held in the John Murray Archive, on which the author has drawn for the early chapters of this book
47. Maggie Hanbury was working for C. & J. Wolfers Ltd at the time. She still looks after the Clark estate today, from the agency under her own name
48. Anatole Broyard, *New York Times*, 14 April 1982
49. Letter from Catherine Porteous to Clark, 26 August 1981, Tate 8812/1/3/2601–2650
50. Alan Clark, *Diaries: Into Politics 1972– 1982* (entry for 20 July 1982)
51. Colin Clark, *Younger Brother, Younger Son*, p.33
52. Alan Clark, *Diaries: In Power 1983–1992* (entry for 15 May 1983)
53. Ibid. (entry for 21 May 1983)
54. Lees-Milne, *Holy Dread*, p.125 (entry for 13 October 1983)
55. Michael Levey, obituary of Kenneth Clark, *Proceedings of the British Academy*, Vol. LXX, 1984
56. Lecture on the Louvre, Tate 8812/2/2/546

Epilogue

1. Michael Levey, obituary of Kenneth Clark, *Proceedings of the British Academy*, Vol. LXX, 1984
2. Ibid.
3. Lees-Milne, *Holy Dread*, pp.94–5 (entry for 22 May 1983)
4. The text was printed in *Apollo* magazine, January 1984
5. Strong, *Diaries 1967–1987*, pp.347–8
6. Alan Clark, *Diaries: In Power 1983–1992* (entry for 13 October 1983)
7. Strong, *Diaries 1967–1987*, pp.347–8
8. Alan Clark, *Diaries: In Power 1983–1992* (entry for 15 August 1983)

9. Letter to Janet Stone, 3 March 1957, Bodleian Library
10. Margaret Slythe
11. Letter to Charlotte Kohler, 9 August 1972, Tate 8812/1/4/440
12. 'Art and Society', reprinted in *Moments of Vision*, pp.79–80

Appendix I: The Clark Papers

1. John Murray was Clark's publisher, and Weidenfeld & Nicolson was Secrest's publisher. They had agreed to do a joint book, but Jock Murray withdrew
2. Letter from Alan Clark to Meryle Secrest, 9 February 1984, copy in the John Murray Archive
3. This transaction remains a controversial one with the Clark family, who are nevertheless content that these papers should remain at I Tatti

Appendix II: 'Suddenly People are Curious About Clark Again'

1. Interview with Chris Stephens, Tate Gallery, in article by Rachel Cooke, *Observer*, 18 May 2014

2. Glasgow, *The Nineteen Hundreds: A Diary in Retrospect*, p.198
3. Over the ten-year period from 2005 to 2015, DVD sales of *Civilisation* averaged 4,500 a year (information from BBC Worldwide)
4. Professor Alan Powers at Greenwich University and Professor Robert Cumming at Boston University are two academics who have tried *Civilisation* on their students, with mixed results
5. BBC Radio 4, *Life Story*, presented by Peggy Reynolds, produced by Sarah Brown, broadcast 3 July 1997; Lees-Milne, *The Milk of Paradise* (entry for 4 July 1997)
6. BBC Radio 4, *Lord Clark: Servant of Civilisation*, presented by Miranda Carter, produced by Thomas Morris, broadcast 3 July 2003
7. Ibid.
8. BBC Radio 4, *Archive on 4: Seeing Through the Tweed*, presented by Richard Weight, broadcast 28 November 2009
9. *Sunday Times*, 1 March 2009

Bibliography

Selected Books and Other Works

Acton, Harold, *Memoirs of an Aesthete*, London 2008
Anderson, Sir Colin, *Three Score Years and Ten*, privately printed, London 1974
Andrews, Julian, *The Shelter Drawings of Henry Moore*, London 2002
Annan, Noel, 'Thomas Carlyle', in *Founders and Followers*, lectures on the occasion of the 150th anniversary of the London Library, 1992
Attenborough, Sir David, *Life on Air: Memoirs of a Broadcaster*, London 2003
Batchelor, John, *Mervyn Peake: A Biographical and Critical Exploration*, London 1974
Berger, John, *A Painter of Our Time*, London 1958
Berger, John, *Ways of Seeing*, London 1972
Berthoud, Roger, *The Life of Graham Sutherland*, London 1982
Berthoud, Roger, *The Life of Henry Moore*, London 1987
Bosman, Suzanne, *The National Gallery in Wartime*, London 2008
Bowness, Alan (Introduction), *British Contemporary Art 1910–1990*, The Contemporary Art Society 1991
Bowra, C.M., *Memories*, London 1966
Breakell, Sue, 'The Exercise of a Peculiar Art-Skill': *Kenneth Clark's Design Advocacy and the Council of Industrial Design*, unpublished at the time of going to press
Briggs, Asa, *The BBC: The First Fifty Years*, Oxford 1985
Brivati, Brian, *Hugh Gaitskell*, London 1996
Brown, Oliver, *Exhibition: The Memoirs of Oliver Brown*, London 1968
Browse, Lillian, *Duchess of Cork Street: The Autobiography of an Art Dealer*, London 1999
Cain, John, *The BBC: 70 Years of Broadcasting*, London 1992
Carpenter, Humphrey, *Benjamin Britten*, London 1992
Carter, Miranda, *Anthony Blunt: His Lives*, London 2001
Chapman, James, *War and Film*, Trowbridge 2008
Checkland, Sarah-Jane, *Ben Nicholson: The Vicious Circles of His Life and Art*, London 2000
Clark, Alan (ed.), Lee of Fareham, *A Good Innings: The Private Papers of Viscount Lee of Fareham*, London 1974
Clark, Alan, *Diaries: In Power 1983–1992*, London 1993
Clark, Alan, *Diaries: Into Politics 1972–1982*, London 2000
Clark, Colin, *Younger Brother, Younger Son: A Memoir*, London 1997
Cohen, Rachel, *Bernard Berenson: A Life in the Picture Trade*, Yale 2013
Conlin, Jonathan, *The Nation's Mantelpiece: A History of the National Gallery*, London 2006
Conlin, Jonathan, *Civilisation*, London 2009
Connolly, Cyril, *A Romantic Friendship: The Letters of Cyril Connolly to Noel Blakiston*, London 1975
Cooper, Douglas, *The Work of Graham Sutherland*, London 1961

Coultass, Clive, *Images for Battle: British Film and the Second World War 1939–1945*, London 1989

Cumming, Robert (ed.), *My Dear BB: The Letters of Bernard Berenson and Kenneth Clark, 1925–1959*, Yale 2015

Day-Lewis, Sean, *Cecil Day-Lewis: An English Literary Life*, London 1980

Drogheda, Lord, *Double Harness: Memoirs*, London 1978

Drummond, John, *Tainted by Experience: A Life in the Arts*, London 2000

Elsom, John and Tomalin, Nicholas, *The History of the National Theatre*, London 1978

Firth, J.D'E., *Rendall of Winchester*, Oxford 1954

Fisher, Clive, *Cyril Connolly: A Nostalgic Life*, London 1995

Forster, E.M., *Two Cheers for Democracy*, London 1951

Foss, Brian, *War Paint: Art, War, State and Identity in Britain 1939–1945*, Yale 2007

Geddes Poole, Andrea, *Stewards of the Nation's Art*, Toronto 2010

Gill, Michael, *Growing into War*, Gloucestershire 2005

Glasgow, Mary, *The Nineteen Hundreds: A Diary in Retrospect*, Oxford 1986

Grigson, Geoffrey, *Recollections: Mainly of Writers and Artists*, London 1984

Haffenden, John, *William Empson: Vol. I: Among the Mandarins*, Oxford 2005

Hardy, Henry and Holmes, Jennifer (eds), *Isaiah Berlin, Enlightening: Letters 1946–1960*, London 2009

Hardy, Henry and Pottle, Mark (eds), *Isaiah Berlin, Building: Letters 1960–1975*, London 2013

Harries, Meirion and Harries, Susie, *The War Artists*, London 1983

Harries, Susie, *Nikolaus Pevsner: The Life*, London 2011

Harris, Alexandra, *Romantic Moderns: English Writers, Artists and the Imagination from Virginia Woolf to John Piper*, London 2010

Harris, Neil, *Capital Culture: J. Carter Brown, the National Gallery of Art, and the Reinvention of the Museum Experience*, Chicago 2013

Hart-Davis, Duff, *King's Counsellor: Abdication and War – The Diaries of Sir Alan Lascelles*, London 2006

Hayes, John, *The Art of Graham Sutherland*, Oxford 1980

Hess, Myra, et al., *The National Gallery Concerts*, London 1944

Hillier, Bevis, *John Betjeman: New Fame, New Love*, London 2002

Hillier, Bevis, *John Betjeman: The Bonus of Laughter*, London 2004

Hinks, Roger, *The Gymnasium of the Mind: The Journals of Roger Hinks 1933–1963*, Salisbury 1984

Howard, Anthony, *Crossman: The Pursuit of Power*, London 1990

Kelley, Pete (ed.), *From Osborne House to Wheatfen Broad: Memoirs of Phyllis Ellis*, Norfolk 2011

Kenneth Clark, Moments of Vision: In Honour of the Centenary of His Birth, 1903–1983. With an introduction and notes by Michael Delon, privately printed, Roselle, New Jersey, 2003

Knox, James, *Cartoons and Coronets: The Genius of Osbert Lancaster*, London 2008

Lees-Milne, James, *Ancestral Voices: Diaries 1942–1943*, London 1975

Lees-Milne, James, *Prophesying Peace: Diaries 1944–1945*, London 1977

Lees-Milne, James, *Caves of Ice: Diaries 1946–1947*, London 1983

Lees-Milne, James, *Midway on the Waves: Diaries 1953–1972*, London 1985

Lees-Milne, James, *Ancient as the Hills: Diaries 1973–1974*, London 1997

Lees-Milne, James, *Through Wood and Dale: Diaries 1975–1978*, London 2001

Lees-Milne, James, *Deep Romantic Chasm: Diaries 1979–1981*, London 2003

Lees-Milne, James, *Holy Dread: Diaries 1982–1984*, London 2003

Lees-Milne, James, *The Milk of Paradise: Diaries 1993–1997*, London 2005

Lewis, Jeremy, *Cyril Connolly: A Life*, London 1997

Lewis, Jeremy, *Penguin Special: The Life and Times of Allen Lane*, London 2005

Lowe, John, *The Warden: A Portrait of John Sparrow*, London 1998

Lycett Green, Candida (ed.), *John Betjeman: Letters, Vols I and II*, London 1994 and 1995

McGuire, J. Patrick and Woodham, M. Jonathan (eds), *Design and Cultural Politics in Postwar Britain: Britain Can Make It Exhibition of 1946*, London 1998

McLaine, Ian, *Ministry of Morale: Home Front Morale and the Ministry of Information in World War II*, London 1979

Mariano, Nicky, *Forty Years with Berenson*, London 1966

Meyers, Jeffrey, *The Enemy: A Biography of Wyndham Lewis*, London 1980

Mitchell, Leslie, *Maurice Bowra: A Life*, New York 2009

Morey, Dom Adrian, *David Knowles*, London 1979

Mostyn-Owen, William, 'Bernard Berenson and Kenneth Clark: A Personal View', in Joseph Connors and Louis A. Waldman (eds), *Bernard Berenson: Formation and Heritage*, I Tatti, The Harvard University Center 2014, pp.231–47

Nicolson, Nigel (ed.), *Harold Nicolson: Diaries and Letters 1930–1939*, London 1966

Nicolson, Nigel (ed.), *Harold Nicolson: Diaries and Letters 1939–1945*, London 1967

Nicolson, Nigel (ed.), *Harold Nicolson: Diaries and Letters 1945–1962*, London 1968

Partridge, Frances, *Good Company: Diaries 1967–1970*, London 1994

Partridge, Frances, *Ups and Downs: Diaries 1972–1975*, London 2001

Pierse, Simon, 'Sir Kenneth Clark: *Deus ex Machina* of Australian Art', in David R. Marshall (ed.), *Europe and Australia*, Melbourne 2009

Pilkington Committee, *Report of the Committee on Broadcasting, 1960*, HMSO, London 1962

Pope-Hennessy, John, *Learning to Look*, New York 1991

Pope-Hennessy, John, edited by Kaiser Walter and Michael Mallon, *On Artists and Art Historians: Selected Book Reviews of John Pope-Hennessy*, Florence 1994

Potter, Julian, *Mary Potter: A Life of Painting*, London 1998

Pronay, Nicholas, 'The Land of Promise: The Projection of Peace Aims in Britain', in K.R.M. Short (ed.), *Film and Radio Propaganda in World War II*, London 1983

Pronay, Nicholas and Spring, D.W. (eds), *Propaganda, Politics and Film 1918–1945*, London 1982

Pryce-Jones, David, *Cyril Connolly: Journal and Memoir*, London 1983

Pryce-Jones, Alan, *The Bonus of Laughter*, London 1987

Quennell, Peter, *The Marble Foot: An Autobiography 1905–1938*, London 1976

Quennell, Peter (ed.), *A Lonely Business: A Self Portrait of James Pope-Hennessy*, London 1981

Rodgers, William T. (ed.), *Hugh Gaitskell 1906–1963*, London 1964

Rosenthal, Daniel, *The National Theatre Story*, London 2013

Rothenstein, John, *Brave Day, Hideous Night*, London 1966

Rothenstein, John, *Time's Thievish Progress: Autobiography Vol. III*, London 1970

Samuels, Ernest, *Bernard Berenson: The Making of a Connoisseur*, Harvard 1979

Samuels, Ernest, *Bernard Berenson: The Making of a Legend*, Harvard 1987

Saumarez Smith, Charles, *The National Gallery: A Short History*, London 2009

Saunders, Gill, Mellor, David and Wright, Patrick, *Recording Britain: A Pictorial Domesday of Pre-War Britain*, London 1990

Secrest, Meryle, *Kenneth Clark: A Biography*, London 1984

Secrest, Meryle, *Shoot the Widow: Adventures of a Biographer in Search of Her Subject*, Toronto 2007

Sendall, Bernard, *Independent Television in Britain, Vol. I: Origin and Foundation 1946–62*, London 1982, and *Vol. II: Expansion and Change 1958–68*, London 1983

Shone, Richard and Stonard, John-Paul (eds), *The Books that Shaped Art History*, Chapter 8: 'Kenneth Clark's *The Nude: A Study of Ideal Art*, 1956', London 2013

Sinclair, Andrew, *Arts and Cultures: The History of the 50 Years of the Arts Council of Great Britain*, London 1995

Slythe, Margaret, *Kenneth Clark, Lord Clark of Saltwood: Guides to the Published Work of Art Historians, No. 1*, revised edition, Bournemouth 1971

Spalding, Frances, *The Tate: A History*, London 1998

Spalding, Frances, *John Piper, Myfanwy Piper: Lives in Art*, Oxford 2009

Stansky, Peter, *Sassoon: The Worlds of Philip and Sybil*, Yale 2003

Stephens, Chris and Stonard, John-Paul (eds), *Kenneth Clark: Looking for Civilisation*, exhibition catalogue, Tate Britain 2014

Strachey, Barbara and Samuels, Jayne (eds), *Mary Berenson: A Self-Portrait from Her Letters and Diaries*, London 1983

Strong, Roy, *The Spirit of Britain: A Narrative History of the Arts*, London 1999

Sutton, Denys (ed.), *Letters of Roger Fry: Vols I and II*, London 1972

Syson, Luke with Keith, Larry, *Leonardo da Vinci: Painter at the Court of Milan*, exhibition catalogue, London 2011

Trewin, Ion, *Alan Clark: The Biography*, London 2009

Tribble, Edwin (ed.), *A Chime of Words: The Letters of Logan Pearsall Smith*, New York 1984

Vickers, Hugo (ed.), *The Unexpurgated Beaton: The Cecil Beaton Diaries*, London 2002

Vickers, Hugo (ed.), *Beaton in the Sixties: More Unexpurgated Diaries*, London 2003

Walker, John, *Self-Portrait with Donors: Confessions of an Art Collector*, Boston 1974

Walker, John, *Arts TV: A History of Arts Television in Britain*, London 1993

Watkin, David, *The Rise of Architectural History*, London 1980

White, Eric W., *The Arts Council of Great Britain*, London 1975

Williams, Philip M., *Hugh Gaitskell: A Political Biography*, London 1979

Zwemmer, *Books from the Library of Kenneth Clark*, London 1989

Selected Lectures, Articles, Broadcasts and Obituaries About Kenneth Clark

Amory, Mark, 'Clark the Magnificent', *Sunday Times Magazine*, 6 October 1974, p.33

Cannadine, David, 'Kenneth Clark: From National Gallery to National Icon', Linbury Lecture, National Gallery, 2002

Coleman, Terry, 'Lord Clark', *Guardian Weekend*, 26 November 1977

Conlin, Jonathan, 'Oil and Old Masters: How Britain Lost the Gulbenkian', *Times Literary Supplement*, 31 October 2003; see also Conlin (2006, pp.169–75)

Conlin, Jonathan, 'Good Looking', *Art Quarterly*, Spring 2012, pp.53–4

Conlin, Jonathan, 'An Irresponsible Flow of Images: Berger, Clark and the Art of Television, 1958–1988', lecture given to the University of Southampton, 2013

Delon, Michael, 'A Candid Conversation with Lord Kenneth Clark', *Daily Princetonian*, Vol. CII, No.124, Wednesday 22 November 1978, p.6

Elam, Caroline, 'Roger Fry and the Re-Evaluation of Piero della Francesca', New York 2004

Gombrich, E.H., 'Review of Piero', *Burlington Magazine*, June 1952, pp.176–8

Hammer, Martin, 'Kenneth Clark and the Death of Painting', *Tate Papers*, Issue 20, 19 November 2013

Harris, Colin, 'Kenneth Clark at the Ashmolean', *The Ashmolean*, Spring 2006, pp.20–2, re 'Civilisation' (book review), *The Connoisseur* 175 (703), pp.62–3

Hilton, T., 'Civilisation' (book review), *Studio International* 179 (920), March 1970, pp.125–6

Kemp, Martin, Introduction to Folio Society edition of Clark's *Leonardo da Vinci*, London 2005

'Kenneth Clark at 70', *Burlington Magazine*, No. 844, Col. CXV, July 1973, p.415

Lepine, Ayla, 'The Persistence of Medievalism: Kenneth Clark and the Gothic Revival', *Architectural History*, Vol. LVII, 2014, pp.323–56

Levey, Michael, Obituary of Kenneth Clark, *Proceedings of the British Academy*, Vol. LXX, 1984

McLean, F.C., 'From the Few to the Many', in *Telecommunications: The Next Ten Years*, The Granada Guildhall Lectures, 1966

Panayotova, Stella, 'From Toronto to Cambridge' (on Lord Lee), *University of Toronto Quarterly*, Vol. LXXVII, No. 2, Spring 2008

Petschek, Willa, 'Views of a Civilized Man', *New York Times*, May 1976

Quennell, Peter, 'Kenneth Clark: A Man for All Media', *Saturday Review*, 28 August 1971, pp.10–12, 31

Read, Herbert, 'Ben Nicholson and the Future of Painting', *The Listener*, No. 352, 9 October 1935, p.604

Rosen, Charles, *New York Review of Books*, 7 May 1970

Rumley, Peter T.J., 'Kenneth Clark: A Civilising Influence', *SPAB Magazine*, Summer 2014, pp.54–8

Russell, John, 'A Guiding Star of our Civilisation', *Sunday Times*, 8 July 1973

Sotheby's Sale of Paintings and Works of Art from the Collections of the late Lord Clark of Saltwood OM CH CBE, Wednesday 27 June–5 July 1984 (three parts: 27 June, 3 June, 5 July 1984)

Sparrow, John, '*Civilisation*', *The Listener*, 8 May 1969, pp.629–31

Townsend, Christopher, '*Civilisation*', *Art Monthly*, July–August 2014, No. 378, pp.8–11

Williams, R., 'Television: Personal Relief Time', *The Listener*, No. 81, 20 March 1969

Wyver, John, 'From the Parthenon', *Art Monthly*, No. 75, April 1984, pp.22–5

Radio and Television

K: Kenneth Clark 1903–1983, television documentary produced by John Wyver, 1993

K: The Civilised World of Kenneth Clark, part of the series *Life Story*, written and presented by Peggy Reynolds and produced by Sarah Brown, broadcast on BBC Radio 4, 3 July 1997

Lord Clark: Servant of Civilisation, presented by Miranda Carter and produced by Thomas Morris, broadcast on BBC Radio 4, 3 July 2003

Seeing Through the Tweed, presented by Richard Weight, broadcast on BBC Radio 4, *Archive on 4*, 28 November 2009

Sir Kenneth Clark: Portrait of a Civilised Man, directed by Kate Misrahi, broadcast on BBC 2, *The Culture Show*, 31 May 2014

Selected Books and Pamphlets by Kenneth Clark

(With Lord Balniel) *A Commemorative Catalogue of the Exhibition of Italian Art held in the Galleries of the Royal Academy, Burlington House, London, January to March 1930*, Oxford 1931

A Catalogue of the Drawings of Leonardo da Vinci in the Collection of His Majesty the King at Windsor Castle, 2 vols, Cambridge University Press 1935

'The Future of Painting', *The Listener*, No. 351, Wednesday 2 October 1935, pp.543–4, 578

'The Art of Rouault', *The Listener*, No. 354, Wednesday 23 October 1935, p.706

One Hundred Details from Pictures in the National Gallery, London 1938

Leonardo da Vinci, Cambridge 1939

Florentine Painting: Fifteenth Century, London 1945

The Nude: A Study in Ideal Form, London 1956

Looking at Pictures, London 1960

The Gothic Revival: An Essay in the History of Taste, London 1965

Rembrandt and the Italian Renaissance, London 1966

A Catalogue of the Drawings of Leonardo da Vinci in the Collection of Her Majesty the Queen at Windsor Castle, 2nd edition prepared with the assistance of Carlo Pedretti, 3 vols, London 1968

Civilisation: A Personal View, London 1969

Piero della Francesca, London 1969

The Romantic Rebellion, London 1973

Landscape Into Art, London 1973

Henry Moore: Drawings, London 1974

An Introduction to Rembrandt, London 1978

Feminine Beauty, London 1980

Moments of Vision, London 1981
The Art of Humanism, London 1983

Selected Lectures, Articles, Introductions and Broadcasts by Kenneth Clark

'On Lord Lee's new version of Raphael's "Holy Family with the Lamb"', *Burlington Magazine*,
 January 1934, p.13
'Pictures Turn to Posters: the Shell-Mex Exhibition' in *Commercial Art and Industry*, No. 17,
 June 1934, pp.65–72
'Four Giorgionesque Panels', *Burlington Magazine*, Vol. LXXI, No. 416, November 1937,
 pp.198–201
'The Aesthetics of Restoration', a lecture given at the Royal Institution, 20 May 1938
Introduction to *Roger Fry: Last Lectures*, Cambridge 1939
'The Artist and the Patron: Eric Newton Interviews Kenneth Clark', *The Listener*, No. 580, 22
 February 1940, pp.380–1
'Baroque and the National Shrine', *Architectural Review*, No. 559, July 1943, pp.2–12
'Ornament in Modern Architecture', *Architectural Review*, No. 564, December 1943,
 pp.147–50
'Leon Battista: Alberti on Painting', Annual Italian Lecture of the British Academy, in
 Proceedings of the British Academy, Vol. XXX, 1944
'English Romantic Poets and Landscape Painting', privately printed, London 1945 (reprinted
 from Vol. LXXXV of *Memoirs and Proceedings of the Manchester Philosophical Society*)
'An Englishman Looks at Chinese Painting', *Architectural Review*, Vol. CII, July 1947, pp.29–33
'Ruskin at Oxford: An Inaugural Lecture', delivered at the University of Oxford, 14 November
 1946, Oxford 1947
'The Warburg Institute', broadcast 13 June 1948 on the BBC Third Programme, reprinted in
 Journal of the Warburg and Courtauld Institutes, 1947–48
'The Idea of a Great Gallery', lecture delivered at the University of Melbourne, 27 January 1949
Introduction to John Ruskin's *Praeterita*, London 1949
'The Limits of Classicism', The Henry Sidgwick Memorial Lecture, 7 May 1949 (reprinted in
 Cambridge Review)
'Apologia of an Art Historian', the inaugural address on the occasion of his election as
 President of the Associated Societies of the University of Edinburgh, 15 November 1950
Clark on the Masolino/Masaccio question after the acquisition of two early Quattrocento
 pictures, *Burlington Magazine*, November 1951, pp.339–47
Obituary of Sir Eric Maclagan of the V&A, *Burlington Magazine*, November 1951, p.358
'Apologia of an Art Historian', *University of Edinburgh Journal*, Summer 1951, pp.232–9
'Turner, RA, 1775–1851: A selection of twenty-four oil paintings from the Tate Gallery',
 London 1952
'The Relations of Photography and Painting', *Photographic Journal*, May 1954, pp.125–42
'Art and Photography', *The Penrose Annual*, 1955, pp.65–9 (This is KC's reprinted article that
 originally appeared as 'The Relations of Photography and Painting' in 1954 in the
 Photographic Journal. It was also reprinted in *Aperture*, Vol. III, No. 1, 1954)
'Andrea Mantegna: The Fred Cook Memorial Lecture', delivered to the Royal Society of Arts,
 26 March 1958. In the *Journal of the Royal Society of Arts*, Vol. CVI, No. 5025, August 1958,
 pp.663–80
'The Romantic Movement', Introduction to Arts Council exhibition, 1959
'Rembrandt's Self-Portraits', delivered at the Royal Institution of Great Britain's Weekly
 Evening Meeting, Friday 20 October 1961. In *Proceedings of the Royal Institution*, Vol.
 XXXIX, No. 177, 1962, pp.145–71
'Motives', in Millard Meiss (ed.), *Problems of the 19th and 20th Centuries: Studies in Western
 Art*, Acts of the 20th International Congress of the History of Art, Vol. IV, Princeton 1963,
 pp.189–205

Introduction to Douglas Cooper (ed.), *Great Private Collections*, London 1965

'The Value of Art in an Expanding World', *Hudson Review*, Vol. XIX, No. 1, Spring 1966, pp.11–23

'A Failure of Nerve: Italian Painting 1520–1535', H.R. Bickley Memorial Lecture, Oxford 1967

'The Other Side of the Alde', Litton Cheney 1968 (first published in *Tribute to Benjamin Britten on His Fiftieth Birthday*, London 1963)

'Sir Kenneth Clark Talks to Joan Bakewell About the *Civilisation* Series', *The Listener*, No. 81, 17 April 1969, pp.532–3

'Mandarin English', The Giff Edmonds Memorial Lecture, 1970

'Ad Portas', lecture given at Winchester College, 9 May 1970, in *The Wykehamist*, No. 1189, 3 June 1970, pp.473–4

'The Image of Christ: Painting and Sculpture', lecture given in Canterbury Cathedral, 4 November 1970

'The Artist Grows Old', The Rede Lecture 1970, Cambridge 1972

'In Praise of Henry Moore', *Sunday Times*, 30 July 1978

'What is a Masterpiece?', The Walter Neurath Memorial Lecture, London 1979

'Young Michelangelo', in J.H. Plumb (ed.), *The Italian Renaissance*, Boston 1989

'A Note on Leonardo da Vinci', *Life and Letters*, Vol. II, No. 9, pp.122–32

'Aesthete's Progress', an autobiographical manuscript in the John Murray Archive, London

Manuscript Libraries and Archives Consulted

USA: New York Public Library; Pierpont Morgan Library, NY (Edith Sitwell); Getty Museum and Library; Rice University; Woodson Research Center (Julian Huxley); Delon Archive, New Jersey; University of Tulsa (Cyril Connolly); Washington State University; Library of Congress, Washington DC; Houghton Library, Harvard; Washington University, St Louis; Beinecke Rare Books and Manuscripts Library, Yale (Edith Wharton); Yale University Library (Walter Lippmann); Humanities Research Center, University of Texas; Princeton University Library Manuscripts Division, Department of Rare Books and Special Collections (Raymond Mortimer); Lilly Library, Indiana University, Bloomington (Edith Wharton). Not in the US but a part of Harvard, the Berenson Archive at I Tatti near Florence. Finally the Victoria University Library in Toronto, Canada (Roger Fry).

UK: British Library National Sound Archive; Royal Archives, Windsor; King's College, Cambridge; Benjamin Britten Estate, Aldeburgh; Orford Museum; National Gallery, London; Tate Britain Clark Archive; Warburg Institute, London; Design Council Archive, Brighton; National Archive, Kew (Ministry of Information); Winchester College; Henry Moore Foundation, Perry Green; The National Theatre Archive; Bournemouth University (ITA); Glasgow University Library (MacColl); National Library of Scotland (Crawford); John Murray Archive, London; National Museum of Wales (Sutherland); Paisley Central Library. Oxford University holds several libraries with Clark material: All Souls, Ashmolean Museum, Balliol College, Bodleian Library, Trinity College, and Wadham College.

Index